P9-BJT-907

DATE DUE

			PRINTED IN U.S.A.

Garland Publishing, Inc.

Pages lxxvii and lxxxvii of the introduction are trans-
posed. Garland Publishing regrets the error in the original
printing.

Henri Matisse

ARTIST RESOURCE MANUALS
VOLUME I
GARLAND REFERENCE LIBRARY OF THE HUMANITIES
VOLUME 1424

ARTIST RESOURCE MANUALS

Wolfgang M. Freitag, *Series Editor*

Henri Matisse
A Guide to Research
Catherine C. Bock-Weiss

12

HENRI MATISSE
A GUIDE TO RESEARCH

CATHERINE C. BOCK-WEISS

GARLAND PUBLISHING, INC.
NEW YORK AND LONDON
1996

Copyright © 1996 by Catherine C. Bock-Weiss

Library of Congress Cataloging-in-Publication Data

Bock-Weiss, Catherine C.
 Henri Matisse : a guide to research / by Catherine C. Bock-Weiss.
 p. cm. — (Artist resource manuals ; v. 1) (Garland reference li-
 brary of the humanities ; v. 1424)
 ISBN 0-8153-0086-7
 1. Matisse, Henri, 1869–1954—Criticism and interpretation—
 Bibliography. I. Title. II. Series. III. Series: Garland reference library
 of the humanities ; vol. 1424.
 Z8554.32.B63 1996
 [N6853.M33]
 016.7'092—dc20 96-19440
 CIP

Printed on acid-free, 250-year-life paper
Manufactured in the United States of America

To my husband,
Raymond L. Weiss

and

in memory of my father,
Frank J. Bock
(1901-1994)

Series Preface

"Our ideas about the past are the results of an immense cooperative effort."
(E.H. Gombrich, *The Story of Art*).

Each generation sees any important artist differently. With the series Artist Resource Manuals, Garland offers a new kind of reference guide that traces the history of the critical reception of major artists by tracing the literary evidence. Collecting and presenting the facts on how artists were received and their oeuvre perceived will provide the foundations for a better understanding of the masters. Each volume has at its core an historical essay that deals in depth with fame and fortune of the artist from his or her own time through the successive ages to the present. This is followed by a selective, critical, annotated bibliography section that encompasses a listing of essential primary sources as well as a bibliography of the secondary literature. Among the primary sources are the artists' own programmatic, theoretical, and autobiographical writings. The bibliography of secondary literary sources includes monographs, oeuvre catalogues, catalogues of exhibition and auction sale catalogues; articles in newspapers, *festschriften*, museum bulletins, and yearbooks are given consideration commensurate with their importance. Also included and discussed are reflections of the artist's works in other creative media, e.g. in poetry and in fiction, in plays, musical compositions, film and television productions. Each volume is to have several indexes, as well as chronological tables, location guides to works in public and private collections, and other scholarly apparatus as appropriate to the individual artists. The series is open ended. It will encompass all periods of documented art history, western as well as non-western, and represent artists active in all visual media.

Wolfgang M. Freitag

Contents

Foreword

The art of the extraordinary French artist, Henri Matisse (1869-1954), has provided visual pleasures and intellectual challenges to its viewers for the last hundred years. A parallel delight and mental stimulus are afforded by the best critical responses to Matisse's paintings, sculpture, and graphic works. The most significant literature has been produced by a surprisingly small number of persistent Matisse interpreters--critics, artists and writers, art historians and museum curators, art theorists and estheticians--who have returned again and again to reflect on the artist and his work. The quality of this writing has transformed for me what might have been a tedious, though useful, task of bibliographic retrieval into an intellectual adventure.

Far too many books and articles, however, are merely picture-albums, pastiches of previously published material, or empty rhetorical encomiums produced on demand by professional writers or journalists. If I am able to steer the reader away from this mass of secondary material toward the essential corpus of truly informative, critical, and often brilliant literature on Matisse, this guide will serve a useful purpose.

I have gathered, summarized, and evaluated the major literature on the artist primarily from France, the United States, Germany, and the Scandinavian countries, where major Matisse collections bear witness to early and intense interest in the artist's work. Although the former Soviet Union possesses rich collections of some of Matisse's most important work, historical circumstances have prevented the production of a concomitantly rich body of critical or historical literature until relatively recently. Likewise, although Matisse had a strong following in Germany from before World War I, the Nazi rise to power and the post-World War II situation effectively broke the thread of an ongoing discourse on Matisse's art and its significance. Switzerland, England, and Italy have produced relatively less criticism of theoretical interest, although the English writer Roger Fry became

arguably the most influential critic in all subsequent "formalist" literature on Matisse in English.

Though comprehensive, with over 1400 entries summarized and as many exhibitions detailed, this research guide to the literature on Henri Matisse makes no claim to be exhaustive. Too much has been written, and too much of it is in the nature of journalistic ephemera, to merit retrieving. I must also admit at the outset that a coarser sieve was used to gather Japanese, Central European, and even Russian materials, since these have not appeared in more traditional international research sources. I made no special effort to pursue these, as I believe national reception-histories are best researched by on-site native speakers.

The decision to list Matisse's exhibitions--solo and group shows--was a practical one. It allowed me to group pamphlet-sized catalogues and short reviews under the event that occasioned them, not mingled with more substantive writing. Exhibition catalogues, of course, contain some of the most innovative writing and the weightiest scholarship; when this is so, the catalogue is also listed separately (ordinarily under Monographs or Specific Media). Significant catalogue essays are also cross-listed by their authors' names under Articles or more specific content-classification, as are substantive review-essays. Reviews of shows of major historical importance are more fully documented than less significant ones. Ordinarily, I have not listed which specific Matisse works were shown in the exhibitions, so this list of exhibitions will not be useful for those seeking the exhibition-history of individual works.

In the section on Individual Works by Matisse, I have listed only those artworks to which I have found articles wholly or substantially devoted. The titles of Matisse's works have been given in English in the section devoted to them but are cross-listed by their French titles in the index of titles. No attempt has been made to give a complete bibliography on the work and its reproduction history. The reader must consult the scholarly catalogues of the museums or collections that house specific works, where commentaries and essential documentation can be found.

Since there are two excellent collections of Matisse's own words and writings, Dominique Fourcade's *Henri Matisse, Écrits et propos sur l'art* (Paris, 1972) and Jack D. Flam's *Matisse on Art* (New York, 1973; rev. ed., Berkeley and Los Angeles, 1995), I have not separately listed all items that appear in them. Flam's latest edition of *Matisse on Art* contains the most complete "Bibliography of Writings, Statements, and Interviews with Matisse" in print. My section on Matisse's writings and interviews is selective and confines

itself to substantial published collections of correspondence, anthologies of writings by Matisse, and a few "free-standing" texts by Matisse of special interest that might otherwise be overlooked. I have listed articles that include statements by Matisse recorded in interviews under the interviewers' names under Articles, if general, or under the appropriate heading, if devoted exclusively to one work or medium. If a critical essay has been excerpted in Jack Flam's *Henri Matisse, a Retrospective* (New York, 1988), an extremely useful anthology of Matisse criticism in translation, I indicate that when summarizing the article.

For a bibliography on Films and Audiovisual Materials, the reader should consult Russell T. Clement's recent book, *Henri Matisse, a Bio-Bibliography* (Westport, Connecticut: Greenwood Press, 1993), pp. 213-15. Clement's bibliography is not a critical one, however; its occasional and irregular annotations duplicate those that are already available for more recent works in sources such as the *International Repertory of the Literature of Art (RILA)* and *ARTbibliographies MODERN*. As is often the case when a bibliography depends on a broad sweep of data bases and not on the intimacy with the material provided by a scholar who has worked for many years in the field, Clement's bio-bibliography is indiscriminate, at the mercy of the errors of those who originally entered the data, and organized in ways not necessarily useful to the actual researcher. My bibliography is selective, critically annotated, and organized for ease of use; the two works do not finally duplicate one another.

A work of this nature is indebted to the staffs of many institutions and to many individuals. Among the former I wish to thank my colleagues Jack P. Brown, director of the Ryerson and Burnham Libraries of the Art Institute of Chicago, and Roland Hansen, Director of Reader Services of the John M. Flaxman Library of the School of the Art Institute of Chicago; Judith Cousins, Research Curator, and Rona Roob, Director of Archives, of the Museum of Modern Art, New York; Mme Dragomir of the Archives du Louvre, Denise Gazier of the Bibliothèque d'art et d'archéologie (Fondation Jacques Doucet), François Chapon of the Bibliothèque Littéraire Jacques Doucet, Françoise Woimant of the Departement de l'Estampe Moderne, Bibliothèque Nationale, and Marcel Billot of the Archives Couturier, Menil Fondation, Paris. I gratefully acknowledge the assistance of the library staffs of Northwestern University, Evanston, Illinois, The Baltimore Museum of Art, The Metropolitan Museum of Art, The Frick Collection Library, The Library of Congress and The National Gallery of Art, Washington, D. C., the British Museum Library, London, and the Bibliothèque Forney, Paris. For the encouragement

and assistance of individuals, thanks are also due to Isabelle Monod-Fontaine, curator of the Musée nationale d'art moderne, Paris, and Dominique Szymusiak, director of the Musée Matisse, Le Cateau-Cambrésis; also to Jack Flam, John Elderfield, Pierre Schneider, Dominique Fourcade, and Yve-Alain Bois. For aid at various times and in various ways, I am grateful to Hanne Finsen, Naomi Sawelson-Gorse, Margot Fassler, John Klein, John O'Brian, Roger Benjamin, Milton Ehre, Thomas Sloan, Frances Bock, Florence B. Ryan, Junko Brink, Laurent Giovannoni, Alexei Petroff, Marc Krisco, and Edith Saint-Germain. For their patience and expertise in finally bringing the document into publishable form, I warmly thank Lisa Lekberg, Departmental Coordinator of the Department of Art History, Theory, and Criticism of the School of the Art Institute of Chicago, and Julia Allen of the Publications Department of the School.

I am grateful to Wolfgang M. Freitag, general editor of the series Artist Resource Manuals, for his wise combination of patience and prodding during the long preparation of this Guide; also to Phyllis Korper, senior editor of Garland Publishing, Inc., for her expert editorial advice.

Support for travel to the necessary research libraries has been provided by a Travel To Collections Grant from the National Endowment for the Humanities in the summer of 1992, and by two Faculty Research Grants from my home institution, The School of the Art Institute of Chicago. To both granting institutions, I express my deep appreciation.

Lastly, on a personal note, I want to thank my friend and colleague, Thomas Sloan, chairman of the Department of Art History, Theory and Criticism at SAIC, whose saving sense of humor helped to banish the melancholy sometimes attendant upon a seemingly interminable project. And to my husband, Raymond L. Weiss, a loving thank you for his unflagging enthusiasm for the project, his patient reading of many drafts of the introduction, and his keen editorial suggestions that have enormously benefited the manuscript.

Introduction:
Henri Matisse: Critical Responses and Contemporary Reassessments

The literature on the French artist, Henri Matisse, now spans a full century. (His first exhibition review appeared in 1896.) Although this period coincides with the rise and development of modern art, the discourse on Matisse is largely self-contained, remote from some of the most vital issues of modern culture. The Matisse literature sheds little light, for example, on the relation of "advanced" art to forms of anti-art, popular culture or the mass media or the role of art in a changing, increasingly technologized, society. Until very recently, few writers on Matisse were concerned with his relation to the political and cultural questions that have been central to histories of twentieth-century art.

The literature on Matisse has been primarily concerned with the artist's development, his procedures, his shifts in style, his approach to materials, and his artistic profile in a relatively autonomous narrative. A number of circumstances account for this. First, after the first decade and a half of the century, Matisse was no longer perceived as a major innovator nor did he produce a school (although his former students did disseminate throughout Europe a coloristically heightened Post-Impressionism, which became identified in the interwar years as School of Paris modernism). But because of the quality of Matisse's work which was kept before the public eye, he continued to be written about. Lacking requisite context, the discussion of Matisse's oeuvre tended to collapse back upon itself and, having little relevance for the continuing appearance of new avant-gardes and developments in technology, acted to reinforce persistent romantic concepts about art and artists that are deeply rooted in nineteenth-century art discourse. It also acted to preserve a certain view of French culture as classical, that is, as

sustaining tradition. Second, and more important, Matisse exercised considerable control over his public image and its reception, skillfully directing the terms in which his work was discussed, namely, those of the century's first two decades. After his death in 1954, the Matisse heirs continued to influence the major writings on him by restricting access to personal papers and biographical information and by perpetuating the public profile and artistic discourse that the artist himself had established. The monograph by Alfred H. Barr, Jr., moreover, written with the collaboration of Matisse and his family and published just three years before the artist's death in 1951, cast a long "authorized" shadow over the next twenty years.[1]

In 1970, the centennial of the artist's birth, a major retrospective in Paris was organized by Pierre Schneider, long-time friend of the Matisse heirs. The catalogue disclosed a great many new facts and proposed a strong unifying thesis on Matisse's oeuvre, one that was substantially compatible with the image of Matisse and his career established by Barr.[2] Those paintings and sculptures long considered the artist's finest by American, Russian, and British scholars--that is, the early "fauve" and "cubist" works (1905-1917) and the later paintings and cut-paper work (1933-1954)--were strongly represented in Schneider's exhibition. They dazzled French audiences, which had been more familiar with Matisse's near-impressionist odalisques and interiors of the 1920s. The catalogue essay elaborated the view first set forth by Matisse's son-in-law, Georges Duthuit, that the artist's work breathed a spirituality akin to that of Eastern cultures (the Byzantine, Islamic axes) and that, by surrounding viewers with a kind of radiant environment, it effected in them a renewal of life force, a psychic healing.

Finally, the last years--1970 to the present--have been dominated by the collected texts of Matisse's spoken and written words, published in French in 1972 and in English in 1973.[3] Through these

[1] Alfred H. Barr, Jr. , *Matisse, His Art and His Public* (New York: Museum of Modern Art, 1951).

[2] Pierre Schneider, *Henri Matisse: Exposition du centenaire* (Paris: Réunion des Musées Nationaux, 1970).

[3] Dominique Fourcade, *Henri Matisse, Écrits et propos sur l'art* (Paris: Hermann, 1972), hereafter *EPA;* and Jack D. Flam, *Matisse on Art* (London, New York: Phaidon, 1973 1978; rev. ed., Berkeley and

newly available anthologies of writings, Matisse's own views of his work and achievement--from the grave, as it were--have partially controlled the discourse about him. These texts, as much as the artist's actual works, have been given pride of place in the last decades dominated by linguistic, psychoanalytic, and textual studies. The intelligence and lack of dogmatism in Matisse's occasional writings have delighted their cryptographers, for the astute subtleties, inconsistencies, and false leads of Matisse's statements provide, in their totality, an exceedingly open text. Even the artist "from the grave," however, has not been able to forestall textual studies that exercise free interpretive play on the "texts" that are Matisse's paintings, drawings, and decorations. The post-structuralist work on Matisse's oeuvre has begun. No matter; Matisse predicted this state of affairs: "A painter doesn't see everything he has put in his painting. It is other people who find these treasures in it, one by one, and the richer a painting is in surprises of this sort, in treasures, the greater its author."[4]

Beyond a more complete view of the artist and his creative process, then, the value of the literature on Matisse does not lie directly in a sharpened understanding of vanguard art. It lies, rather, in its portrait of the "normal" modern (that is, romantic with a residue of academically classical) esthetics of the century, an esthetics that revolutionary art had attempted, without notable success, to eradicate. When a tradition is challenged, its value is crystallized. With a new clarity, supporters of traditional esthetic norms reformulate their premises in order to demonstrate their continuing relevance. Over time, however, tradition, which is porous and enormously absorptive, expands to incorporate aspects of the vanguard in a new synthesis. Although this process is accelerated in the twentieth century, in contrast to the glacial pace of change in other eras, the reconciliation of dialectical positions occurs more slowly, yet more inevitably, than some histories of modern art would have us believe.

Cultural institutions change slowly, but change is a necessary condition of their survival. The most recent historical studies on Matisse have been concerned with the mechanisms by which cultural

Los Angeles: University of California Press, 1995), hereafter *MOA,* with page number references to the 1995 edition.

[4] Matisse, cited in Pierre Courthion, "Recontre avec Matisse," *Les Nouvelles littéraires* (June 27, 1931): 1; Flam, *MOA,* 105.

institutions maintain their power and persuasive force; also, with how market forces affect the dealer-artist-public relationship. The rise of modernism and of the reputations of artists as modern or as radically avant-garde has been shaped by particular institutions both in the United States and abroad. In Europe, state patronage and the partisanship of the literary/intellectual community had more relevance to the situation of the visual arts during Matisse's lifetime; in the United States, on the other hand, museums and dealers aggressively used public relations and advertising techniques to promote a particular view of modernism.[5]

Paradoxically, the history of the "forward retention of custom"[6] can function as a critique of the parallel narrative of the avant-garde, now in considerable disarray. Like their more conservative counterparts, socially liberal or radical thinkers are also passionately partisan; they espouse, however, the idea of a progressive or revolutionary avant-garde in the arts that can actively and effectively intervene in political change. This idea of a coherent avant-garde is also a socio-historical construct whose maintenance is vital to an empowered ideology and its advocates. The literature on Matisse is in part a polemical terrain on which is played out this tug-of-war between politicized views of culture.

The writing on Matisse has been primarily French and American, with Britain seconding these with a small but important body of writing. The overwhelming majority of the French writing is a national, often nationalistic, literature that enlists Matisse in a discourse about the French national character and the nature of its intellectual and cultural genius. The French literature's seemingly ahistorical concern with esthetic values and distinctions barely masks France's ongoing crisis of identity and prestige in the face of the

[5] For studies of the American situation, see Serge Guilbaut, ed., *How New York Stole the Idea of Modern Art; Abstract Expressionism, Freedom, and the Cold War* (Chicago and London: University of Chicago Press, 1983) and John O'Brian, "MoMA's Public Relations, Alfred Barr's Public, and Matisse's American Canonization," *RACAR, Revue d'art canadienne / Canadian Art Review* 18, 1-2 (1991; but published 1994): 18-29. For a discussion of the impact of French nationalism and imperialism on aspects of Fauvism, see James D. Herbert, *Fauve Painting, the Making of Cultural Politics* (New Haven and London: Yale University Press, 1992).

[6] Francis Bacon, "Of Innovations." *Essays* (London, 1625).

twentieth century's geo-political and economic dislocations and competitions. Matisse's work never seriously questioned the deeply entrenched national self-image and bourgeois values upon which his culture's modern esthetic is based; indeed, Matisse reassuringly exemplifies them.

The English-language literature on Matisse's work, in apparent contrast, celebrates its revolutionary character and emphasizes its historical innovations. Products of more underdeveloped or conservative visual cultures, American and British writers had nothing to lose in constructing an international genealogy of avant-garde artists, with Matisse honored as Cézanne's elder, non-prodigal son and Matisse's Fauve color-explosions viewed as a primary eruption of European modernism. This construction is based on an evolutionary model of style that exempts itself from too great attention to subject matter or iconographic themes; or, rather, sees changes in style and artistic processes *as* content. Concerned with a progressive, linear history of stylistic innovations, the Matisse English-language criticism (from Fry to Barr to Greenberg) nevertheless barely conceals its concern with essential characteristics (of the medium, processes, form, structure, signs) and its desire to fix the "modern" in the framework of abstraction and autonomy. This view turns out to be, paradoxically, as conservative in its own way as that of the French.

Neither French nor Anglo-American discourses relinquish the idea of the artist as originator, as authentic source and ultimate warrant of his or her work's meaning. Nor do they abandon the eighteenth century doxa that art's function is to delight, move, and instruct its immediate audience and to edify society. Since the 1970s these certitudes have been challenged, but Matisse is as yet only marginal to the new social histories, the new deconstructive criticism, the new gender and post-colonial discourses, as we shall see.

The writing on Matisse is inextricably bound up with the exhibition history of his work: what is seen generates what is written. And, conversely, what is written then generates what is seen. After Matisse's appearance as a controversial artist at the Salon d'Automne in 1905, the literature on him revolves around the poles of attack and defense. Even in less controversial periods of the artist's life, when the writing seems to comprise celebratory appreciations of the artist's achievement, its combative subtext always presupposes an opposing position against which the article or book argues. This is true down to

the extended catalogue essays--by John Elderfield and Yve-Alain Bois--
found in the most recent major Matisse exhibitions of 1992 and
1993.[7]

I will develop these general observations through a closer look
at the Matisse scholarship, divided into periods of roughly fifteen to
twenty years, each of these marked off by major personal or
professional events in Matisse's life (or afterlife). The first three
sections, which deal with the writings on the artist during his lifetime,
are more concerned with the esthetic assumptions that underlie these
critical texts; the last two sections are concerned with how the artist's
oeuvre has been written into the historical accounts of modernism.

I. Period of Innovation, 1905-1918:
From first public notoriety of the Salon d'Automne to the move from
Paris to Nice.

II. Early Nice Period, 1919-1933:
From move to Nice to the international retrospectives (1930-31), his
first book design (1932), and completion of the Barnes Foundation
Mural in Merion, Pennsylvania (1933).

III. Mature and Final Years, 1934-1954:
From resumption of a flat, decorative painting style (culminating in
cut-paper works and the chapel at Vence) to Matisse's death.

IV. The Formalist Reputation, 1955-1969:
From the artist's death to the Centenary Exhibition.

V. Reassessments, 1970-1993:
From the Centenary Exhibition to the Museum of Modern Art
Retrospective.

[7] John Elderfield, *Matisse, A Retrospective* (New York: Museum of
Modern Art, 1992) and Yve-Alain Bois, *Henri Matisse, 1904-1917*
(Paris: Centre Georges Pompidou, 1993). The essays from the *Matisse
Retrospective* (Brisbane, 1995; edited by Carol Turner and Roger
Benjamin) were published too late for me to discuss here; the catalogue
is included nevertheless under Exhibition Catalogues, and its individual
essays are listed by author under their appropriate individual content-
headings.

I
Period of Innovation, 1905-1918:
From first public notoriety of the Salon d'Automne
to the move from Paris to Nice.

Although Matisse's work changes substantively over the first two decades of his career, the literature that seeks to understand and appraise these transformations remains fixed in the terms and valuations of late nineteenth-century artistic discourse. The literature is surprisingly repetitious, almost homogeneous, circling back on a small number of interrelated esthetic values grounded in the earlier romantic ideals of the century. Matisse himself is heir to these ideas and ideals. His own major statement of the period, "Notes of a Painter (1908)," as well as his declarations recorded in interviews of the period, maintain and develop these values. Since Matisse's early evolution occurs in a period of intense artistic and political ferment and rapid social change, we might have expected otherwise.

The criteria of evaluation and tropes of merit that are established at the outset are those by which both friendly and hostile critics continue to judge the worth of the artist's production until 1918. These normative concepts include: "individuality" and "temperament" in play with the "laws" of painting; being true both to "nature" and to "self"; the distinction between "impression" and "expression"; the respective roles of "sensation" and "imagination"; the "mastery" of technical means and the "discovery" of personal technique; the relation of the "classical" to the "primitive" or naïve, and of the functions of the decorative and the abstract. The concepts are fundamental both to French academic theory and practice and to the more advanced criticism by which Realism, Impressionism, and Symbolism were assessed. By the time Matisse received his first review (1896) these traditions, the modern as well as the academic, were fully developed.[8]

[8] See Richard Shiff, *Cézanne and the End of Impressionism* (Chicago: University of Chicago Press, 1984), for a subtle and penetrating discussion of the criticism of Cézanne and its esthetic basis. My own discussion is greatly indebted to his analysis of this critical discourse.

The artist who provided a catalyst for these terms during this period was Paul Cézanne, whose death in 1906 falls roughly at its mid-point. In the decade previous to his death, the suddenly influential painter crystallized in his person, in his artistic process, and in his paintings, a synthesis of impressionist-symbolist aesthetic theory and generated the discourse that clarified this consolidation. After his death, that discourse was the basis for understanding the practice and rationale for the newest avant-garde development, Cubism. Cézanne was seen as both the culmination of late-nineteenth century practice and the "primitive of [his] own way," still to be discovered. [9] The writing on Matisse is situated wholly within this Cézannean discourse --both that on Matisse's early years of color exploration, which was labeled Fauvism (1899-1907), and on his later years of experiment with new methods of spatial construction, both decorative and planar (1908-1918). In a circular logic, Matisse could in fact encourage himself in these early years by saying: "If Cézanne is right, I am right; and I knew that Cézanne was not mistaken."[10]

In spite of Matisse's international reputation in those years, the first monograph on Matisse was not published until Marcel Sembat's small study of 1920 in the Nouvelle Revue Française Modern Artists series.[11] All the writings on the first stage of Matisse's career are shorter pieces: exhibition reviews, interview essays, and a handful of substantive essays appearing in either journals or longer studies of modern art. The quality of these reviews and articles is unusually high, the product of their authors' considerable education in the fine arts as well as the sophisticated level of public cultural exchange in Paris. The first eight years of Matisse criticism are dominated by Roger Marx (1859-1913), whose introduction to Matisse's first one-person show at Vollard's Gallery in 1904 was the longest published piece on Matisse until that time.[12] Marx's catalogue essay sums up and elaborates the basic points that he had been making

[9] Cézanne, cited by Joachim Gasquet, *Cézanne* (Paris, 1921), 84, 81.

[10] Matisse, "Entretien avec Jacques Guenne," *L'Art vivant* 18 (September 15, 1925): 4.

[11] Marcel Sembat, *Matisse et son oeuvre* (Paris: Nouvelle Revue Française, 1920).

[12] Roger Marx, *Henri Matisse* (Paris, 1904); exhibition catalogue.

since his first mention of Matisse in a review of 1896.[13] It provides the base, as well, for the subsequent journalistic reviews by others, including the important critic Louis Vauxcelles, who had begun writing for the liberal daily, *Gil Blas,* in 1904.

Marx defends Matisse's work first of all on an *ad hominem* basis, namely, that the artist is hard-working, assiduously learning his métier, and that he is sincere, true to his own temperament, intent on exploring his own individuality. Secondly, his work shows technical skill in its solid composition and sure surface handling, the result of his academic study of the Masters in the Louvre. As Matisse begins to investigate color around 1897 and his tonal subtleties give way to "rich glowing tones laid onto the canvas in broad flat strokes," Marx praises Matisse's "profound and lucid sight" (his "eye," an impressionist criterion) and recognizes the influence of Cézanne which, by 1904, was everywhere evident in the advanced Salons.

This criticism betrays the persistence of romantic standards through the post-impressionist period (sincerity, passionate pursuit of excellence, individuality) as well as the high value placed on an almost artisanal mastery of traditional painting techniques. The study of masters from all earlier periods and schools insures that young painters will not be slaves of their own era or of immediate predecessors, and will draw "universal laws" from great works of the past.

Marx spoke from inside the art establishment, having the power to encourage state purchases of copies and originals from his favored young artists, but also as one who by 1904 welcomed "militant originality" by rebels against "routine practice." In 1896 he had referred, ironically, to a "'hotbed of revolutionaries'" nurtured in the studio of Gustave Moreau. Although at that earlier date he noted the alarm of the academicians with skepticism, in 1904 he acknowledges a certain degree of its truth.[14]

[13] Roger Marx, "Le Salon du Champs-de-Mars," *Revue encyclopédique* 6 (April 25, 1896): 279-86.

[14] Marx was well placed in the French fine arts establishment as Inspecteur Principal des Musées Départementaux, editor-in-chief of the *Gazette des beaux-arts,* and major critic for its supplement, *Chronique des arts et de la curiosité,* and for the *Revue encyclopédique* (after 1900 called *Revue universelle).*

Until 1904, Matisse was identified as a pupil of Moreau and, increasingly, as he explored impressionism and Cézanne's technique, as a member of the "modernist side" of Moreau's studio. Marx's faith in Matisse was based in great part on standards the critic held in common with two of Matisse's teachers, Moreau and Eugène Carrière. Both artists, while upholding the necessity of learning from tradition and the masters of the past, had arrived, through the force of their temperaments, at an original style. Originality, whose function was to renew and extend traditional esthetic norms of artmaking (always in danger of atrophy), was the prerogative of strong, willful personalities whose explorations of the self and of nature resulted in formal or technical innovation. Marx could acknowledge this originality in artists like Moreau, Carrière and Puvis de Chavannes, all firmly grounded in academic skills; he came also to accept Cézanne as a "classical" original, one who upheld "the art of the museums" while integrating the best aspects of impressionist innovation.

Marx's appreciation of Matisse as an heir of this tradition-renewing innovation undergirded the 1896-1904 criticism of Matisse. Louis Vauxcelles, the critic who was to replace Marx over the next decade in promoting the artist's reputation, had essentially the same point of view. Vauxcelles (the pseudonym of Louis Mayer [1870-1943]), was a protegé of the symbolist poet/critic Gustave Kahn, and an admirer of Roger Marx and Gustave Geffroy, the friend and defender of Cézanne.[15] Vauxcelles' critical position, that of his turn-of-the-century mentors, remained constant throughout his career. Since his eye was less certain than his convictions, however, he often modified or reversed his views about individual artists and emerging styles in his rapid newspaper reviews. Essentially derivative in his esthetic judgments, he ultimately persuaded himself of the majority opinion about particular artists. His voice is an important one, however, in the reviews of Matisse from 1905-1915.

[15] Exactly Matisse's age, Vauxcelles was a vigorous champion of liberal causes, including advanced art, and of the work of his generation. Present at the birth of both "Fauvism" and "Cubism," he is credited with naming them. Like Marx, Vauxcelles believed in Matisse as a serious and gifted artist and, in principle, wanted to support innovation when it appeared.

An expanded critical dialogue developed when Matisse underwent a brief but significant conversion to Neo-Impressionism (his pointillist *Luxe, Calme et Volupté* created a sensation at the Salon des Indépendants in 1905), followed by his radically different Salon d'Automne works of 1905 (*Woman with a Hat* and *Window at Collioure*) that earned him the epithet Fauve. The terms of this dialogue were drawn from neo-symbolist modernism, addressing issues of decoration, theory, and style in relation to nature and tradition.

The charge that Matisse was too theoretical, that he aimed at pure painting, was brought by Maurice Denis in 1905 and was to persist until about 1910, when Cubism swept the theoretical field.[16] Denis (1870-1943) was a painter-designer and the precocious theorist for the 1890 generation of Symbolists known as the Nabis. When he turned his attention to Matisse in 1905, he had already begun to articulate a current of conservative modernism that had been present in French letters from before 1890. Still a fervent supporter of Gauguin and more recently of Cézanne, Denis was attempting at this time, nevertheless, to integrate his still-evolving position on modern neo-symbolist esthetics with a newly-rationalized defense of nationalist, Catholic-revival neo-classicism.

Although Matisse had been approvingly described from the beginning as a "searcher," systematically exploring the terms of his métier, it was not until he allied himself with the Neo-Impressionists that he was associated negatively with "theorists" and "abstractionists." In his 1905 review of Matisse's Salon d'Automne exhibition entries, Denis claimed that 1) Matisse, whose work was "the most vital, the newest and most discussed" of the younger painters, only spoiled his fundamentally instinctual gifts by his adherence to "pseudo-scientific theories" like that of Neo-Impressionism; and 2) Matisse erred in attempting to produce "painting that is outside every contingency, painting in itself, the pure act of painting."[17] Denis acknowledged that his own 1890 symbolist generation had been largely responsible for stressing the plastic constituents of painting as automonous elements,

[16] Maurice Denis, "La Peinture, le Salon d'Automne de 1905," *L'Ermitage* (November 15, 1905). Eng. trans. in Jack Flam, *Henri Matisse, a Retrospective* (New York: Hugh Lauter Levin Assoc., 1988), 47-50; hereafter, Flam, 1988.

[17] Denis, ibid.; Flam, 1988, 48.

able to signify both individual emotion and universal laws of expression. They themselves had generated the belief in painting as a pure, autonomous act.

Since Denis had begun to reinstate classical and religious themes in his work and to acknowledge a "Latin" historical heritage, he recoiled from the extremes to which Matisse pursued his plastic distortions. In a 1908 article on the dangers of liberty-become-anarchy, Denis faults Matisse and his followers for wanting "to ignore material practice entirely and, expect[ing] everything to come from reasoning and from theory, [they] believe that inspiration or sensibility will make up for every blunder of the hand."[18] Paradoxically, Denis here posits two "origins" for Matisse's work, namely, theory and personal sensibility, and reproaches him for a concomitant lack of interest in traditional technical means. Reading Matisse's "Notes of a Painter" in late 1908,[19] however, convinced Denis that Matisse's generation is evidently "less theoretically minded [than Denis's] and believe[s] more in the power of instinct."[20] Matisse's statement, with its essentially self-contained and conservative esthetic views, effectively removed him from the possibility of being drawn into a political polemic on Denis's terms.

Denis's earlier charge of "blunders of the hand," however, was sometimes described in terms of awkwardness, naïveté, or primitive sincerity and, when applied to Cézanne, was seen as a virtue, a guarantor of the artist's sincerity. Marx, for example, defended Moreau's students as having a "virile frankness" of technique, and as fearing neither "excess *(outrance)* nor laborious struggle *(effort)*," thus coupling the questionable quality of excess with the unquestionable

[18] Maurice Denis, "Liberté épuisante et stérile," *La Grande revue* 52, 7 (April 10, 1908).

[19] Henri Matisse, "Notes d'un peintre," *La Grande revue* 52, 24 (December 25, 1908): 733-45. I am indebted to the pioneer study of Roger Benjamin, *Matisse's "Notes of a Painter," Criticism, Theory, and Context, 1891-1908* (Ann Arbor, Michigan: UMI Research Press, 1987) for my discussion of Matisse criticism before 1909.

[20] Maurice Denis, "De Gauguin et de Van Gogh au classicisme," *L'Occident* (May 1909).

virtue of hard work.[21] Raymond Bouyer, an early critic who spoke of Cézanne "brutalizing the palette and brush" by his forceful, blunt technique, nevertheless defended it as the vigor necessary to rejuvenate painting, a healthy excess permitted to youth.[22] But other early reviewers-- Gustave Coquiot as early as 1901 and Charles Morice in 1903--accuse Matisse respectively of eccentric deformations and of "useless, inexpressive, and ugly distortions betraying the *denial* of sincere effort" (emphasis added).[23] The latter reversal (since distortions were viewed as tokens of sincere indviduality and effort in the Cézanne criticism) is unusual, but Morice calls Matisse's deliberate awkwardness "feigned," not arising directly from the need for expression. Matisse is faulted, in other words, not for clumsiness but for "faking" his clumsiness.

Later critics were to provide other motivations for Matisse's penchant for "ugliness," from the perverse desire to shock to the mercenary desire to increase patronage from a public thirsting for novelty. Since many critics found *some* of Matisse's works beautiful (that is, having refined color, sensuous surfaces, solidity of composition), they had to suppose that his ugly, awkward, excessive work arose not from temperament, but from the "spirit of systems" (Denis), that is, from excessive intellectual curiosity and the love of analysis and experimentation. Thus the charge of ugliness meets that of theory.

Beside "Notes of a Painter," through which his ideas and practices were widely disseminated throughout Europe, Matisse had another means at his disposal to clarify his intentions. This was the interview article, which he was able to use with great effectiveness throughout his life. The interview results in a respectful essay by someone who, having talked to Matisse at length, defers to the artist's own view of his endeavor by mostly repeating or paraphrasing Matisse's remarks. Studio interviews of this early period include those

[21] Roger Marx , "Petites expositions," *Chronique des arts et de la curiosité* (May 4, 1901): 138.

[22] Raymond Bouyer, "Un Salonnier aux Salons de 1899," *L'Artiste* 3 (1899): 163.

[23] Gustave Coquiot, "Le Salon des Indépendants," *Gil Blas* (April 20, 1901), and Charles Morice, "Le XIX Salon des Indépendants," *Mercure de France* 46 (June 1903): 389-405.

by: Apollinaire (1907); Gellett Burgess (1908, published 1910); Caffin and Estienne (1909); MacChesney and Goldschmidt (1912, both published in 1913); and Robert Rey (1914).[24] The interviews are notable for the sharpened distinction they reinforce between the normalcy of Matisse's life as a man--reasonable, measured, candid--and the putative outrageousness of his art and the resulting accusation of charlatanism. Matisse controlled these interviews by his lucid discussion of his aims and procedures, shading his emphasis to counteract current exaggerated or false impressions in the popular mind.

The avant-garde poet Guillaume Apollinaire, paradoxically enough, is the first writer to stress what would later become a major claim about Matisse's work by nationalist, often politically conservative, critics; namely, its Frenchness. The poet, noting that Matisse has enriched himself in the study of all "plastic writing"--that of the Egyptians, ancient Greeks, Cambodians, Peruvians, African negroes-- emphasizes, nevertheless, that Matisse's achievement is best gauged by his broad assimilation of European culture and art. Apollinaire's remarks stress the rationality of Matisse's art, its French simplicity and clarity, the tact and taste that guide the instinctive side of Matisse's search for plastic expression. But Matisse, eager to counteract the lingering accusations of his being too theoretical, in the remarks quoted by Apollinaire, stresses almost exclusively his search for his own personality, his reliance on intuition, his sincerity.

The Caffin interview, published in *Camera Work* in January 1909, rehearses Matisse's reputation in the Paris art world: a small circle of admirers, surrounded by those who think of him as a fraud or victim of self-deception. Caffin finds the painter lucid and plausible, attempting to "organize" his sensations and "simplify" forms, learning from African and Oriental art how to "secure a unity of expression in

24 Guillaume Apollinaire, "Henri Matisse," *La Phalange* 2 (December 15-18, 1907): 481-85; Gellett Burgess, "The Wild Men of Paris," *Architectural Record* 27, 5 (May 1910): 401-14; Charles Caffin, "Henri Matisse," *Camera Work* (January 1909): 17-18; Charles Estienne, "Des Tendances de la peinture moderne: Entretien avec M. Henri-Matisse," *Les Nouvelles* (April 12, 1909); Clara T. MacChesney, "A Talk with Matisse, Leader of Post-Impressionists," *New York Times Magazine* (March 9, 1913); Ernst Goldschmidt, "Strejtog I Kunsten: Henri Matisse," *Politiken* (December 24, 1911); and Robert Rey, "Henri Matisse," *L'Opinion* (January 10, 1914).

the interpretation of an abstract idea." The other two interviews by Americans, MacChesney and Burgess, also stress, sometimes with exaggerated naïveté, the gulf between the citizen-artist--wholly palatable in his respectibility, and his art--indigestible in its innovations. Both writers, nevertheless, sympathetically record Matisse's own account of himself through the screen of their own limited understanding of esthetics (MacChesney) and of the French language (Burgess). The Danish painter and art historian Ernst Goldschmidt uses the same rhetorical device for his non-French audience: the contrast between expectation and reality, between the innovation of the painting and the conventionality of the painter. The French interviewers, Charles Estienne and Robert Rey, also conduct inquiries whose major aim is reassurance. Estienne reassures his readers that this "leader of a school" of modern art has a rationale, a method, an end in view that is neither incomprehensible nor unworthy.

By 1907 it was clear that Matisse would not move toward the Cézanne-inspired interest in volumetric structure and new spatial construction that would occupy the young Cubists. After a trip to Italy, Matisse's ideal seemed more and more to lie with the large decorative panels that his new Russian patron, Sergei Shchukin, was ready to commission or buy. A trip to Russia in 1911 confirmed his interest in a more hieratic and iconic mode of non-imitative representation, and Islamic miniatures showed him how to use pattern and compressed planar divisions to suggest a purely plastic space. An interview as late as 1914 (with Robert Rey) could still cast Matisse in the familiar role of a possible savage, trickster, or enigma, that is, as a figure of baffling innovation. Others within the avant-garde saw Matisse as a has-been, utterly superceded by the more revolutionary band of Picasso-ites. André Salmon's assessment of 1912 is the most harsh.[25] Matisse's work, he gloats, has proved sterile and incoherent in its development, and shows virtuosity devoid of method. (All these points contrast, of course, with the Cubism of Salmon's friend Picasso.) Worse, Matisse's taste is said to be that of a modiste, second-rate and superficial, and his gifts are judged to be feminine: mere skill, adaptability, prompt assimilation, a precise but unimaginative knowledge.

[25] André Salmon, *La Jeune peinture française* (Paris: Messein, 1912), 9-40.

In the pre-World War I period, however, the less partisan assessments acknowledge Matisse's real contribution to modern French painting. Alexander Mercereau's article on Matisse, appearing in both Russian and French in 1909 in *Zolotoye Runo [Toison d'or]*, in the most extended journal coverage given to Matisse until that time, traces Matisse's development as a logical one, based on the sensitivity to sensation found in Impressionism.[26] Knowledge, not mere personal taste, governs Matisse's decision to structure his canvases by expressive line and simplified color; his conscious will leads him to high goals for art. Matisse works for "clarity and serenity of spirit in the most beneficial and exalted atmosphere--an atmosphere of ideas, conquered by the refinement of feelings."

Michel Puy's extended comments on Matisse, collected in *Le Dernier état de peinture* in 1911, built on his earlier review of the Fauves in 1907, in which he noted that Matisse's turn to the decorative utilizes to good advantage his exceptional technical skills and gifts as a harmonist.[27] Privileged with an intimate knowledge of the artist's temperament through his brother, the painter Jean Puy, Matisse's early studio mate and personal friend, the critic perceptively notes in 1907 that the artist is driven by an "internal force he knows poorly," but which drives him to desire "repose, peace, a relaxation almost purely physiological, [but] which constitutes a profound human feeling in an age when mankind, beset by professional cares, grows exhausted and worn out." In Puy's later article of 1909, a more considered evaluation is given of Matisse's role in the artistic tendency to move from observation of reality toward the abstract. Matisse represents the tendency to "decorative speculation," while the Cubists favor "a purely mathematical world." Stressing the evolutionary over the revolutionary, Puy notes that, on the whole, young modern painters have logically seized the methods offered by their era--the craft of painting and general principles of art. Matisse is exceptional in producing works of a stunning decorative sumptuosity, which yet stir a profound emotional response in the viewer.

[26] Alexander Mercereau, "Henri Matisse et la peinture contemporaine," *Zolotoye Runo [Toison d'or]* 6 (1909), I-III.

[27] Michel Puy, "Les Fauves," *La Phalange* (November 15, 1907): 450-59; idem, "Henri Matisse," *Le Dernier état de peinture* (Paris: Le Feu, 1911).

In 1910 appeared the most nuanced and intelligent discussion of Matisse's work since that of Maurice Denis in 1905, Jacques Rivière's review in the *Nouvelle revue française* of Matisse's Bernheim-Jeune retrospective.[28] Rivière notes, as a *difficulty*, Matisse's faculty of hyper-conscious conception, his acute clairvoyance about the work to be made. This faculty prevents Matisse's work from unfolding spontaneously, from maturing in its making, from remaining vitally connected to the "primitive sensation," the "inner necessity" that inititated it. The intellectual work of analysis is too thorough, according to the critic, resulting in an artificial and gratuitous abstraction in Matisse's work. Rivière nevertheless admires the "clean and violent richness" of Matisse's "weightless" color that "shines with an intellectual splendor." Matisse's drawings are generated internally "under the influence of the frame," while his painting "imitates itself by proliferating [forms] from within"; their details, however, "still derive from the initial schema and they retain its abstract character." Because for Matisse art is primarily "plastic speculation," Rivière concludes that he is driven to make his work "as unique as possible, without precedent or analogy." Matisse's work hastens to "conclusions" and thereby loses the possibility of emerging with a deeper orginality from a longer generative process.

Full of sophisticated insights based on a connoisseur's close attention to the work, Rivière's criticism nevertheless opposes the new intellectualizing abstraction of the period. His critique is based on the importance of the artist discovering, not forcing or "making," his originality; the "inner necessity" of temperament must play the paramount role. Generating "expressive" distortions by the dictates of the framing edge or the inner rhythm of lines and forms is also perilous for Matisse. The necessary groping of the artist in ignorance and blindness (while he is evolving his work-in-process) is forced and artificial in Matisse; for Rivière, Matisse's is a "voluntary blindness" that apes the real thing but fails to produce a parallel compulsion and spontaneity that can be sensed in the work. Lack of expressive power-- that is, formal perfection without emotional depth--was a charge often made against Matisse in later years. Rivière attempts to analyze how Matisse's method prevents this emotional content.

[28] Jacques Rivière, "Une Exposition de Henri Matisse," *Nouvelle revue française* 16 (April 1910): 531-34.

Three years later, in the article that Matisse designated the best that had been written on him until that time, Marcel Sembat answered Rivière's criticism by addressing head-on the question of originality.[29] Citing the jibes and accusations of the scandalized public about Matisse's person and work, Sembat counters them by claiming with confidence that no one questions either the talent of the artist or the originality of his work. Sembat admits, however, that the sincerity and profundity of Matisse's originality *is* questioned. Though Matisse's paintings cannot be analyzed conceptually, their authority, mastery, and harmonious clarity can be experienced when the viewer stands in front of them. "Matisse is original without trying to be," claims Sembat. But Matisse's final originality lies in his ability to offer the viewer a "harmony of feeling," a quality that was present *instinctively* from the earliest works and which the artist himself, while searching for himself, *discovered* in them.

According to Sembat, the unity of feeling in Matisse's work results from and is manifested in a style that is at once indivisible and synthetic. The example given is Matisse's *Seated Nude* of 1909. Matisse's *Moorish Cafe* of 1913, evolved from a more realistic, anecdotal version, is also analyzed in detail. The aim of Matisse's process of simplifying and abstracting is to arrive at what Matisse terms "the way my feelings point, toward *ecstasy*," therein finding "peace of mind." And Sembat, refuting Rivière's judgment, recounts the story of Matisse's transposition of the color of the goldfish in *Moorish Cafe* from vermillion to yellow, so that the hue of the adjacent pink flower, tenderly and possessively described by the painter, would not be retinally altered to violet: "I want my flower pink," Sembat quotes Matisse as saying. "Otherwise it's not my flower any more." For Sembat this demonstrates that Matisse's technical knowledge of color is at the service of feeling, not the result of an intellectual or formal necessity. Moreover, says Sembat, the transposition of colors also preserves the real, "so as to express it in its essence."

Sembat also distinguishes the role of feeling in the conventions of the decorative. Matisse's panels are spatially flat, because decorative. "Let masters of intimate, agonizing art excavate [the surface plane]. Let Rembrandt excavate! Matisse keeps his sorrows

[29] Marcel Sembat, "Henri Matisse," *Les Cahiers d'aujourd'hui* 4 (April 1913): 185-94.

to himself! He does not wish to broadcast them. He wants to offer only peace of mind."[30] As Matisse attained greater self-possession, Sembat claims, he was able to wrest essential features from nature that are abstract, that is, the *"Emotional Abstract"* (emphasis and capitalization in the original). Matisse's work issues from effort, but not from procedures that arise from a system. Matisse's art, Sembat concludes, is the "product of an instinct that has finally raised itself to self-consciousness, but whose drive remains instinctual, for conscious analysis comes only later." Matisse has the last word in the article: "You know, *afterwards* I explain why I do something, but *at first*, when I do it, I feel the necessity as a whole!" (emphasis in the original).

Equally perspicacious, if more malicious, is Gertrude Stein's published "portrait" of Matisse, appearing in *Camera Work* in 1912, but written in 1909.[31] In her dense prose in the "continuous present," with its repetitions and circlings-back, Stein presents a Matisse whose greatness is unquestioned (or is it?), whose followers want to do what he does (or do they?), who is telling "again and again" and "very often" about his "being living" and his suffering, and of some who were listening very often (or were they?) to one who is "greatly and clearly expressing something being struggling" (or is he?). Stein's sly portrait might be called "Matisse's Doubt" or "The Public's Doubt," but it is decidedly not Stein's doubt. She is quite certain that opinion on Matisse is divided and that some who once listened to him and followed him were no longer doing so. Though not mentioned by name, Matisse's younger rival Picasso is everywhere present as the absent Other in Stein's portrait of Matisse.

The last word on Matisse from this period will be from Apollinaire, who had followed Matisse's career for a decade with admiring, though sometimes critical, reviews. Almost alone in his enthusiasm for the painter's 1913 *Portrait of Mme Matisse,* Apollinaire's favorable response to it and other critics' admiration for the Moroccan paintings exhibited earlier in 1913 inaugurated Matisse's

[30] Matisse was to emphasize the same point about his Barnes Mural when writing to Alexander Romm in his letter of February 14, 1934; Flam, *MOA*, 115-16.

[31] Gertrude Stein, "Henri Matisse," *Camera Work* (August 1912): 23-25.

reentry into active contact with the younger (mostly Cubist) Parisian vanguard. From 1913 to 1918, Matisse produced work that rivaled Picasso's in its austere and ambitious near-abstraction. There was little regular criticism in the disrupted war years, but in 1918 Matisse and Picasso exhibited together at the Paul Guillaume gallery. Apollinaire, who would die of influenza in November of that year, wrote: "If one were to compare Henri Matisse's work to something, it would have to be an orange. Like the orange, Matisse's work is a fruit bursting with light."

The rest of the review, however elegantly stated, relies on the most familiar justification of Matisse's work, namely, that it results from the painter following his instinct, which chooses among his emotions, judges and limits his fantasy, and "look(s) searchingly into the depths of light, nothing but light." This probity was inspired by Matisse's "total good faith and by a genuine desire to know and to realize himself."[32] To these traditional tropes of sincerity, self-discovery, instinct-guided emotion, Apollinaire adds the paradox that Matisse's work becomes increasingly sumptuous as he strips it of the non-essential in a radical process of simplification.

I have lingered in some detail on the criticism of the first period of Matisse's career because the basis of appreciation established by the critics during the artist's most experimental years remains a serviceable base for them to defend work of a far more accessible kind, that of the next decade. The later periods, which I will treat in a more general way, presume the reader's familiarity with the critical tropes of the first fifteen years.

II

Early Nice Period, 1919-1933

If the period of 1890-1914 was generally one of artistic innovation in Paris, the post-War period was one of cultural consolidation, integration and, sometimes, reaction. The war had profoundly altered the pre-war mood of national optimism, faith in technology, and the uncritical embrace of the concept of progress. While some political and cultural groups believed that the forward

[32] Guillaume Apollinaire, "Matisse," *Oeuvres de Matisse et de Picasso.* (Paris: Galerie Paul Guillaume, 1918); exhibition catalogue.

momentum of society and its institutions was possible through bold new initiatives, revolutionary actions, and/or rational planning, more voices spoke in favor of a braking process on the plunge toward an unknown future. These voices--heard in the cultural as well as political community--called for a period of sorting out and evaluating innovations, of integrating them with the most authentic and cherished values of the past. By the end of the decade, the advanced Paris art community for the most part judged Dada, Constructivism, and Surrealism to be radical but transitional (and essentially non-French) phenomena. A "classicized" version of Cubism, the call to ordered rationalism known as Purism, and various appeals to consolidation on the basis of French national traditions were the alternate possibilities presented in the critical writing of the period.[33]

At fifty, in the prime of his mature years, Matisse had removed himself quite deliberately from active participation in the Parisian art community by living primarily in Nice, absenting himself from the rough-and-tumble of the ongoing art theorizing and art politics of the capital. His style had altered to a seemingly realist-impressionist mode. It seemed to some that this change was less a move of exploration and a fresh search, as he himself claimed, than a temporary renunciation of his more abstract work and a reconsideration (if not recantation) of its premises.

Until the middle of the decade, writers struggled to interpret these changes and to judge the quality and importance of the new work. In 1925, at the age of fifty-five, Matisse received the highest number of votes in a poll conducted by the magazine *L'Art vivant* for the contemporary artists most worthy to be represented in a proposed new Museum of Modern Art.[34] This vote not only indicated Matisse's

[33] For this period see: Christopher Green, *Cubism and its Enemies* (London and New Haven: Yale University Press, 1987); Kenneth E. Silver, *Esprit de Corps: the Art of the Parisian Avant-Garde and the First World War, 1914-1925* (Princeton: Princeton University Press, 1989); *Le Retour à l'ordre dans les arts plastiques et l'architecture, 1919-1925* (Saint-Etienne: University de Saint-Etienne, C.I.E.R.E.C.: 1974); and Elizabeth Cowling and Jennifer Mundy, eds., *On Classic Ground, Picasso, Léger, de Chirico and the New Classicism 1910-1930* (London: Tate Gallery, 1990); exhibition catalogue.

[34] Georges Charensol, "Conclusion: Pour un musée français d'art moderne," *L'Art vivant* (October 1, 1925): 37 ff.

secure place in the esteem of the art community, but also rendered him, in a way, irrelevant to vanguard art. He had become the establishment figure of independent art: acceptable, uncontroversial, bankable. In the second half of the decade, however, which culminated in the series of international Matisse retrospectives in 1930 and 1931, critical opinion of Matisse's situation was less certain.

After 1925, Matisse began to produce sculptures and paintings of greater formal inventiveness and to exhibit his more abstract pre-1917 work. This coincided with the attempt of some critics to realign the history of independent art (the prevailing term for art outside the official Salon system) with the formal innovations of the first two decades. In this climate, and following his return to monumental decoration in the Barnes Foundation mural, Matisse was once more reinserted into the discourse of advanced art. At age sixty, in 1930, he was again an interesting figure. His much-publicized trip to Tahiti, his several visits to the United States to garner prizes and commissions, his new work in book illustration and design, the vigor and energy of his physical and mental presence in international settings--all belied the image of an aging, complacent artist from a bygone era.

Three important interviews with Matisse punctuate the "early Nice period." They inaugurate the period in 1919, mark its center in 1925, and signal its end in 1929-30. The first is an interview with a Danish critic Ragnar Hoppe, before whom Matisse defends his new work in pre-war values and terms.[35] Matisse claims to be sincere, working from inner necessity and instinct, and he spurns the easier path for the more difficult: "For the time being, I am working predominantly in black and gray, with neutral, subdued tones, because I felt that this was necessary for me right now. It was quite simply a question of hygiene. If I had continued on the other road, which I knew so well, I could have ended up as a mannerist. One must keep one's eye, one's feeling, fresh: one must follow one's instincts." Second, Matisse claims that he must move forward, try something new, make progress: "When you have achieved what you want in a certain sphere, when you have exploited the possibilities that lie in one direction, you must, when the time comes, change course, seach for something new. . . I

[35] Ragner Hoppe, "På visit hos Matisse," reprinted in *Städer och Konstnärer, resebrev och essäer om Konst* (Stockholm: Albert Bonners, 1931).

am seeking a new synthesis. . . . I worked as an impressionist, directly from nature; I later sought concentration and more intense expresssion both in line and color, and then, of course, I had to sacrifice to a certain degree other values, body and spatial depth, the richness of detail. Now I want to combine it all." Third, Matisse claims that what he does is the result of great effort, of lengthy and difficult labor, of ever improving his technical skills: "You may think, like so many others, that my paintings appear improvised, haphazardly and hurriedly composed. If you don't mind, I'll show you some drawings and studies so you may better understand how I work. [He shows some fifty drawings preliminary to a single portrait] . . . and of course I did a lot of movement and composition studies [besides]. . . . One learns something every day; how could it be otherwise?" When the interviewer, remaining coolly skeptical, reproaches Matisse for making only studies or outdoor sketches, not any "real compositions, larger things," Matisse pleads circumstance: he can't do more in the space of the small Paris and Nice studios, but invites his visitor out to his larger studio at Issy where he "works on all [his] decorative projects."

Matisse had clearly retained his pre-war criteria. At the same time, however, Matisse set himself apart from the classicism of the "return to order" artists and critics, as well as from the cubist theoreticians who tended to stress authorial autonomy and will-to-form. He also stands apart from those who sought the deeply rooted "origins" of French art in a pre-modern tradition going back to the French "primitives." Matisse's course-correction appears instead under the aegis of the early modernism of Courbet and Manet. The goal seems to be a synthesis of Matisse's own origins in a *réaliste/intimiste* tradition with his later work of "intensive expression in line and color." He remains aloof from the effort to classify, rationalize, and prognosticate that some--such as Lhote, Ozenfant, Kahnweiler, Léonce Rosenberg, Raynal, and Reverdy--were making. Matisse avoids pronouncing universal dicta; his new manner, he says, is "for the time being" and useful only "for me right now." In the important Hoppe interview, Matisse both attaches himself to naturalism/ impressionism (direct contact with nature) and detaches himself from it by referring to an intervening mental memory-image (in the spirit of Baudelaire and Proust).

Hoppe's interview was printed in a Danish journal and, hence, was not widely known at the time. Matisse's ideas are echoed,

however, in the 1920 monograph by his close friend and patron Marcel
Sembat, the first on the artist to be published in a format that was to
dominate the literature for a long time: an album of reproductions
introduced by a brief biographical/ critical text on the artist.[36] Sembat
uses two phrases that were to become like a mantra for these years:
Matisse is now "master of himself" and "master of his [technical]
means." This double mastery obviates the need to emphasize the artist's
moi, to flaunt the recklessness and intensity of his "search for himself"
as a sign of sincerity, and the need for further "experimentation" with
each separate plastic element. Sembat reviews Matisse's difficult
beginnings, his discovery of Impressionism through the lesson of
Cézanne, the scandals of the Fauve period, and he notes the importance
of the great decorative works gone to Russia. He affirms Matisse's
sympathetic interaction with Cubism. The brutal power and
individuality of the earlier works are still present in Matisse's current
production, Sembat insists, only disciplined, submitted to a
harmonious ensemble. "He reenters, it will be said, the tradition of the
great Masters! Actually, he has never left it," Sembat concludes,
rhetorically feathering the sharp edge of distinction between Matisse's
present and his innovating past, as well as refuting any charge of a
reactionary "return" to tradition.

 That the charm and seeming facility of the Nice works are but
the flowering of Matisse's gifts, the proof of their maturity, was a
common assertion in the literature that echoes Sembat's position. To
support this, a great deal was made of Matisse's preliminary sketches
and many drawings; Matisse himself published a book of his drawings
in 1920 and asked to be understood as a searcher, a learner, a servant of
his sensation in front of the model. Charles Vildrac, who wrote
introductions to two of these albums of Matisse's post-war work (1920,
1922), says that Matisse is taking the human subject seriously again,
attending to the "moral" or human aspect of painting.[37] Still, he
insists, the image is "Matisse's image" of a banal world into which the
artist has breathed a soul through his considered and arduous effort to
realize plastic, poetic equivalents.

[36] Sembat, *Matisse et son oeuvre* (Paris, 1920).
[37] Charles Vildrac, *Cinquante dessins par Henri-Matisse* (Paris:
Bernheim-Jeune, 1920); idem, *Nice, 1921, Seize reproductions d'après
les tableaux de Henri-Matisse* (Paris: Bernheim-Jeune, 1922).

Although certain publications--from mainstream (*L'Art vivant* and *L'Amour de l'art*) to advanced (*Cahiers d'art* and, in the 1930s, *Minotaure* and *Verve*)--supported Matisse unconditionally on the basis of his French balance between intelligence and *sensibilité*, lucid consciousness and unconscious urge, others disagreed. Gustave Coquiot, updating his 1914 book on modern art, in 1923 bluntly declares of Matisse: "He is no longer himself."[38] "What's going on?" demands Jean Cocteau in 1920; "The sun-soaked *fauve* has become a Bonnard kitten."[39] René Schwob, in an extended article in *L'Amour de l'art* in 1920, spends many pages in praise of the artist's pre-war accomplishments and ends with the following wistful hope: "And, in his future syntheses, perhaps after a period of excessive docility, he will know anew how to impose onto the things of this world the lone sovereignty which matters: that of the mind."[40] André Gide notes that it's all well and good to ask to be evaluated on the curve of the development of one's work (Matisse's request), but that an artist is finally judged on the merits of individual works and that it is rash for Matisse to have stopped making "paintings."[41]

André Lhote, painter and art writer for the *Nouvelle revue française*, perceptively notes in 1919 that Matisse, scorning the *a priori*, always works through the painting process.[42] He works through sensual data and his own sustained sensations, and only then toward the more abstract form and general idea. This, according to Lhote, is in contrast to the Cubists who work from an idea (of, say, a geometric form) and then motivate the form by making it into an object. Whereas Cubists are sometimes too much driven by theory, according to Lhote, Matisse's recent work shows too great a "nonchalance" that appeals too easily to a lazy and thoughtless public. Indeed, the art market was able

[38] Gustave Coquiot, "Matisse," *Cubistes, futuristes, et passéistes* (Paris: Ollendorf, 1923), 117.

[39] Jean Cocteau, "Déformation professionelle," *Le Rappel à l'ordre* (Paris: Librairie Stock, 1926); first published May 12, 1919.

[40] René Schwob, "Henri Matisse," *L'Amour de l'art* 1, 6 (1920): 192-96.

[41] André Gide, "Feuillets d'Automne," *Nouvelle revue française* (1920).

[42] André Lhote, "Exposition Matisse," *Nouvelle revue française* (1919).

to absorb an infinite number of small-scale "School of Paris" easel paintings--nudes, still lifes, landscapes--during the international boom of the 1920s; only museums and adventurous patrons sought out the more challenging work.[43]

Thus, in the call to serious painting after the war, Matisse's critics, while recognizing the artist's gifts and his technical mastery, faulted him for not producing "paintings," that is, large-scale, ambitious compositions, preferably multifigured and having real "subject matter." His sketchy, intimate interiors with models and still life motifs seemed somehow beneath his abilities. Matisse had established himself as an intelligent artist, but his recent works were patently not intellectual. The most able critics had not forgotten the ambition of the pre-war painting, those historically significant works in the Grand Style. Matisse was expected to do more than work modestly out of Realism or Impressionism.

For many mainstream critics, of course, personalized realism was enough; it was even the epitome of health to revitalize Zola's definition of art as a "corner of the world seen through a temperament." They were pleased, reviewing in the journals and large-circulation dailies, to place Matisse at the head of Segonzac, Favory, Utrillo, Vlaminck, Kisling, Marquet, Bonnard, and others "lyric realists." The sincerity, simplicity, earthiness, and directness of contact with nature that this view of art proffered coincided neatly with a certain view of French culture--in fact, provincial culture, which had seized the national imagination. For a major European power, France was still surprisingly rural (though urbanization accelerated in the 1920s), and rural depictions of "nature" embodied nostalgic and romantic idealizations of the past. Critics such as Vauxcelles, Fels, George, and others supported artists who worked directly from nature, an implicit criticism of rootless urbanism and soulless technology.

In the 1925 interview with Jacques Guenne, the editor of *L'Art vivant*, Matisse looks back anecdotally to his education and early struggles.[44] But embedded in the familiar story of hardships overcome

[43] See Malcom Gee, *Dealers, Critics, and Collectors of Modern Painting, Aspects of the Parisian Art Market Between 1900 and 1930* (London and New York: Garland Publishing, 1977).

[44] Jacques Guenne, "Entretien avec Henri Matisse," *L'Art vivant* 18 (September 15, 1915): 1-6.

and academic success spurned, lies another message. In the middle of the interview, Matisse says:

> Slowly I discovered the secret of my art. It consists of a meditation on nature, on the expression of a dream which is always inspired by reality. With more involvement and regularity I learned to push each study in a certain direction. Little by little the notion that painting is a means of expression asserted itself, and that one can express the same thing in different ways.

Matisse addresses several contemporary issues here. First, the proper referent of a painting is a dream rather than nature, but a dream inspired by or arising from nature. This describes the work that Matisse was currently engaged in but does not repudiate his model-less work. Second, style is a tool; changes in style do not reflect uncertainty or inconstancy. "One can express the same thing in different ways"; styles may change, but the dream expressed can remain the same. As Matisse once said, Cézanne is not an Impressionist, because he always painted the same picture--a Cézanne. (Impressionists were understood to paint different paintings, each reflecting a unique moment of the day.) Third, the artist does not imitate nature, but fashions an imaginative, subjective image of it. Still, the imaginative image would not be possible without the experience of nature, and it captures something of nature's "truth." In closing the interview, Matisse obliquely responds to those urging him to paint "pictures," that is, potential masterpieces in the Grand Manner. Concerning his youthful hard times, Matisse remarks, "I have never regretted this poverty. I was very embarrassed when my canvases began to get big prices. I saw myself condemned to a future of nothing but masterpieces!" Once more, the standard is sincerity, being true to oneself. Maintaining integrity demands, in fact, flexibility of approach.

In 1925-26, the exhibition of Matisse's *Decorative Nude on an Ornamental Ground* and his work on a cantilevered sculpture, *Large Seated Nude*, attracted the attention of critics, who felt that these works foreshadowed another shift of Matisse's style, a move toward something closer to his pre-Nice mode. As if to support their surmise, Matisse exhibited two 1916 paintings, *Bathers by a River* and *The Piano*

Lesson, for a two-painting show at Paul Guillaume's gallery, reminding his public that this, too, is still Matisse. In a review of these works, Sylvain Bonmariage recalls a statement that Matisse had made to him and to Metzinger before a particularly abstract cubist painting (around 1909? probably later): "'That's Cubism... I mean by that an immense step toward pure technique.' And Matisse added: ' We are all heading there.'"[45] Bonmariage suggests that in the exhibited 1916 paintings Matisse had arrived there, and that his genius is revealed in these works, "completely stripped of all anecdotal details, of all the artifices that, in many of his works, prevent us from penetrating them."

The strong call by certain critics to remember that Matisse is more than the sum of his Nice works is powerfully illustrated in the incisive article of André Levinson, "Matisse à soixante ans," an indignant and ironic attack on Florent Fels's monograph on Matisse.[46] The Fels text was typical of the journalistic writing appearing in the popular art magazines in the 1920s. Not greatly taxing the reader's critical intelligence, this writing treats the artist as a culture-hero, an interesting personality whose humanity animates the art work and gives it value. "Painting is not an esthetic exercise," Fels had proclaimed in his 1925 book, *Propos d'artistes*: "It is a durable form of human emotion."[47] In his Matisse monograph, Fels explicitly rejects "painting conceived as an end in itself, [that] ridiculous and narrow principle, that painting is a special world, having its own laws, its own specific life." Rather, echoing Bergson, Fels says that "the work of art is only a moment of universal life, a manifestation of the *élan vital.*"

[45] Sylvain Bonmariage, "Henri Matisse et la peinture pure," *Cahiers d'art* 1, 9 (1926): 240. See also Georges Duthuit's lecture at the vernissage of this show, published for the first time in *Georges Duthuit , Écrits sur Matisse* (Paris: École Nationale Supérieure des Beaux-Arts, 1992), 47-69, as "Les Tableaux qui nous entourent ce soir"

[46] André Levinson, "Matisse à soixante ans," *L'Art vivant* 6 (January 1930): 24-28; Florent Fels, *Henri-Matisse* (Paris: Chroniques du Jour, 1930).

[47] Florent Fels, "Matisse," *Propos d'artistes* (Paris: Chroniques du Jour, 1925).

The artwork, Fels asserts, is the medium though which "modern creators . . . assert their personality."

Levinson rejects this goal of self-expression and the revelation of nature through sentiment. Levinson makes a case for "pure art, disinterested, in the philosophic sense of the word." For Levinson, Matisse's ambitious pre-war paintings were what a canvas should be: "a true *spectacle*, a thing for viewing, the putting into play of an optic, a complex of visual sensations which, by means of the eye, goes to the brain, producing there a kind of dry intoxication and lucid exaltation in which there is no grandiloquence, no confused or murky elements."

Levinson reminds his reader that, between 1906 and 1913, Matisse's "historic vocation was fulfilled and attained" by the creation of a new mode of expressive decorative painting, that is, by Matisse's move to near-abstraction through shifting the terms of "decoration" to a flattened--but self-contained and nature-referring--easel painting. He developed the *tableau-objet* at the moment that Cubism reached the same end through different means.

Levinson reaches into pre-war esthetics (that begun by Mallarmé and continued by Paul Valéry) to counteract the support of "lyric realism" that dominated Fels's discourse. Writers like Fels had, however, only to maintain the existing criteria of sincerity, individuality, direct interpretive contact with nature, and a technique "found" in the process of direct transcription of immediate perception; they did not have to develop *ab nihilo* a new position. But neither did Levinson. He had only to restore the currently suppressed aspects of pre-war criteria: formal innovation in continuous evolution, experimentation with the expressive possibilities of the plastic elements themselves, an awareness of the exigencies of one's historical moment, and an involvement in esthetic theory.

Fels's mongraph on Matisse was brought out by Éditions Chronique du Jour; they also brought out editions in English and German with new texts written by Roger Fry and Gotthard Jedlicka respectively. The three versions had the identical format and illustrations but different texts.[48] Roger Fry's *Henri-Matisse* places

[48] Roger Fry, *Henri-Matisse* (Paris: Chroniques du Jour, and New York: E. Weyhe, 1930) and Gotthard Jedlicka, *Henri-Matisse* (Paris: Chroniques du Jour, 1930). Jedlicka was pressed into service after Hans Purrmann declined to do a German edition. His account, fairly

Matisse's work in the larger esthetic framework of the dual problematic of painting: its nature as both a diversely colored plane surface and as an illusion of the three-dimensional world. He also points to the duality of the artist's role: that of a seer and of a maker or artisan. With Cézanne as his model of an artist who did not sacrifice plasticity for surface unity, Fry praises Matisse, who also works self-critically. Both Matisse and Cézanne work succesfully with the "allusive-elliptical" nature of pictorial representation. Fry also notes that Matisse has begun to reinvestigate the premises of his "stark, structural" work of 1910-17, ending the cycle of the more relaxed Nice style of 1918-26. Fry's text, along with Levinson's, is an important base for later formalist criticism on Matisse.

Besides Levinson and Fry, the American art historian Meyer Schapiro also sketched a larger historical framework for Matisse's contribution to modern painting.[49] Viewing the Matisse retrospective exhibition at the Museum of Modern Art in 1931 and responding to Alfred Barr's catalogue essay, Schapiro attempts to configure Matisse's total oeuvre entirely in terms of the pictorial innovations of Impressionism, broadly conceived. Bracketed by two impressionist-based manners, the innovative work of 1907-17 could be understood not so much as an alternate formal mode as one still containing elements of the impressionist style: "the flatness of the field or its decomposition into surface patterns, the inconsistent, indefinite space, the deformed contours, the peculiarly fragmentary piecing of things at the edges of the picture, the diagonal viewpoint, the bright, arbitrary color of objects, unlike their known, local color, [thus] constitut[ing] within the abstract style of Matisse an Impressionist matrix." Schapiro did not deny the sharp 1905 turn from "formless" naturalism to his "abstract, decorative" manner nor the 1917 turn from the latter to a naturalism saturated with the "quality of design" of the preceding period. Schapiro nevertheless analyzes the continuities (content as well as form) of what seemed in 1932 to be nearly the whole of a life's work. At the beginning of a decade that would see a return to figurative art with

anecdotal and based on published sources, preceded his interviews with Matisse and later substantial writings on the artist.

[49] Meyer Schapiro, "Matisse and Impressionism," *Androcles* 1, 1 (1932): 21-36; Alfred H. Barr, Jr., *Henri-Matisse* (New York: Museum of Modern Art, 1931; trade ed. by W. H. Norton, 1931); exhibition catalogue.

social purpose, Schapiro credits Matisse with having avoided the error of treating the "archaic stage" of the discovery of abstract form, in which form became the subject matter of art (so liberating to Matisse's sensibility from 1907-17), as a final or fixed style. Schapiro ends with a close scrutiny of *Decorative Figure on an Ornamental Ground,* applauding its return to the intensity, weight, and scale of Matisse's more ambitious painting, but without any "return" to an "irrecoverable" plastic quality of the past. As a Marxist critic, Schapiro honors the forward thrust of history, its progression, and does not advocate a "return" even to the heroic years of early twentieth-century modernism.

In the interviews he gave Tériade after his return to France in October 1930, Matisse, ready to embark on his Barnes Foundation mural, points to a decisive change of direction. [50] Always an astute, even obsessive, observer of his own work, the "curve" of his own career, Matisse seems to realize by means of the international retrospectives that something is over, that a new turn in his work is underway. Without repudiating the work of the 1920s, Matisse points to a new conception of himself--once more embedded in an interview that seems largely anecdotal, concerning Matisse's recent voyage to the United States and Tahiti:

> Most *painters* require direct contact with objects in order to feel that they exist, and they can only reproduce them under strictly physical conditions. They look for an exterior light to see them clearly in themselves. Whereas the *artist* or the poet possesses an interior light which transforms objects to make a new world of them--sensitive, organized, a living world which is in itself an infallible sign of the divinity, a reflection of divinity. That is how you can explain the role of the *reality created by art* as opposed to objective reality, by its irrelevant essence *[essence indifférente]* (emphases added).

[50] Henri Matisse, interviewed by E. Tériade, "Entretien avec Tériade," *L'Intransigeant* (October 20 and 27, 1930); Flam, *MOA,* 89, for the quotation that follows. I have slightly altered Flam's translation.

This extraordinary statement suggests, among other things, that Matisse has acquired a new self-image, that of an artist rather than simply a painter. The artist is a creator of worlds, of new spaces and new light; he creates a new reality that can be distinguished from "objective reality" by the artist's unconcern for the essence of the object in its physical materiality. In his statements throughout the 1930s and 1940s, Matisse was to spell out, progressively, what constituted this conception of the artist. In practical terms, moreover, Matisse began to function as more than a painter in the next decade. He became a muralist, book designer, textile and glass artist, designer for the theatre, and ultimately the creator of the "sensitive, organized and living world" that was the Chapel of the Rosary at Vence. To use Richard Shiff's terminology, the artist shifted from being a discoverer to being a maker, from being a searcher to becoming a finder, from expressing an individual sensibility to constructing a world available to individual sensibilities. Although Matisse himself signaled this change in his artistic project, writers in the 1930s were slow to see him as anything but a master easel painter and, once more, a modern one because of a certain style: the flat, simplified, unmodeled color-forms of the paintings of the 1930s and 1940s.

III
Mature and Final Years, 1934-1954:
From resumption of a flat, decorative style (culminating in cut-paper works and the Chapel at Vence) to Matisse's death.

It would perhaps be fair to say that French art criticism from 1930 to 1955, including that on Matisse, never really develops a historical sense, never constructs a plausible narrative about how and why modern art developed in the twentieth century as it did. It never decides how putative avant-gardes would function in this narrative--as real ruptures or as temporary extremisms meant to bring tradition back into balance. French writers like to see Fauvism and Cubism as revolutionary but then rather quickly explain them as corrective phenomena. Either Fauvism is treated as a youthful movement of enthusiasm and energetic excess, properly followed by a mature turn to measured reason (a life-cycle model) or it is framed in a dialectical opposition to its partner, Cubism. From these two, a synthesis is

achieved by merging color and structure, instinct and intellect. Since French genius is always perceived to be found in the measured balance of polarities, French esthetics always looks for a return to normalcy, to harmony, to a just proportion of elements in an ideal balance.

Matisse spoke as a microcosm of French culture when he confessed to the Bussy family with shamefaced pride: "I am interested only in myself."[51] French art writers in the 1930s and 1940s are really interested only in the nature of French culture, not in modernism as an international phenomenon. When the issue of "Frenchness" is repeatedly taken up by critics, it is not as something unfolding in time, but as a set of more or less permanent characteristics abstracted from the flow of events, incarnated in particular individuals and institutions. Matisse was perceived as such an individual and, increasingly in the last two decades of his life, as such an institution.

The last twenty years of Matisse's life were ones of enormous political dislocation and personal upheaval: the economic collapse of the early 1930s, the rise of fascism throughout Europe, the leftward shift of political allegiances accompanying the Spanish Civil War and the subsequent polarization of left and right, the short-lived utopianism of the Popular Front government, the French defeat and German occupation, and the post-war reconstruction. Of all this, only hints can be gleaned from the writing on or by Matisse.

Matisse's later life falls into two distinct periods marked by the end of World War II. From 1933 to 1945, Matisse's artistic reputation was at its peak and his production richly varied, though his personal life was tumultuous. He had the last great passion of his life, was legally separated from his wife of forty years because of it, nearly died of an embolism after surgery for colon cancer, and lived through the Nazi occupation during which his daughter and his estranged wife were imprisoned for Resistance activity. In the post-war decade until his death in 1954, on the other hand, Matisse's private life was relatively uneventful, though physically restricted; nevertheless, he developed the new medium of decorative cut-paper compositions and lavished three-and-a-half years of intensive effort on his culminating work, the Chapel of the Rosary at Vence, dedicated in 1951. The critical

[51] Matisse, quoted by Jane Simone Bussy in "A Great Man," *Burlington Magazine* 128, 995 (February 1986): 80-85; Flam, 1988, 323.

literature, which until 1947 was essentially a discourse about painting, becomes (after *Jazz,* the illustrated books, and the beginning of the chapel) a literature that tries to come to terms with public decorations, the social and spiritual role of the artist, and issues of viewer response.

In the 1930s the first serious attempts to define and evaluate Fauvism as an art movement demonstrate a deficient historical sense. Perhaps Matisse complicated matters when he spoke in 1936 of his return to Fauvism, encouraging a broad definition of Fauvism as a return to "purity of means" whenever and wherever art had become overrefined and enervated.[52] Necessary in 1900, Matisse seems to imply, Fauvism was again demanded thirty-odd years later--a cyclical view of historical imperatives. The Fauve exhibits of 1927, 1934 and 1935, 1942, and 1950, held in the full disarray of this era of political and artistic disorientation, did little to situate the movement historically.[53]

After Maurice Raynal's first synthetic treatment of modernism, *Anthologie de la peinture en France de 1906 à nos jours* (1927), and Basler and Kunstler's *La Peinture indépendante en France* (1929),[54] the French undertake a few general surveys of modern art in the 1930s. But there is nothing in the French literature comparable to the comprehensive and authoritative exhibitions mounted by Alfred Barr at the Museum of Modern Art in New York, *Cubism and Abstract Art; Fantastic Art, Dada, and Surrealism* of 1936; and *Picasso, Forty Years of His Art* in 1937. Together, the catalogues for these shows sketch a concise history of twentieth-century modernism. Barr relegates Fauvism to the role of a transitional stage of decorative, colorist experimentation that was superceded by the first true modern movement, Cubism. The text in Bazin and Huyghe's 1934 *Histoire de*

[52] Matisse, "Constance du fauvisme," *Minotaure* 2, 9 (October 15, 1936): 3; Flam, *MOA,* 122-23.

[53] See Exhibition Section, 1927-1950.

[54] Maurice Raynal, *Anthologie de la peinture en France de 1906 à nos jours* (Paris: Montaigne, 1927) and Adolphe Basler and Charles Kunstler, *La Peinture indépendante en France, vol. I, De Manet à Bonnard; vol. II, De Matisse à De Segonzac* (Paris: Crès, 1929). It must be noted that these two works originated as journal articles, and the chapters or sections retain the self-contained, occasional quality of the short article.

l'art contemporaine (Paris: Alcan, 1934), first published as a series of articles in 1933, however, is typical of the French approach, which does not want to concede such an important role to Cubism.

Uncertain how exactly to evaluate Fauvism, Bazin and Huyghe divide it into three somewhat confusing parts. First, there is the early, historical Fauvism in which the youthful enthusiasm of specific artists cleared the ground of painting so that its essential elements--line, color, and surface--could be valued. Huyghe does not consider Matisse's current (1930s) work to be of this type though, because its color is rational and calculated, not personal and spontaneous. The second kind of Fauvism is of a truly expressive or pathetic type (closer to German or Central European Expressionism), exemplified by Vlaminck and Rouault, and by Jewish artists of the School of Paris. [55] The third type is the style current in Paris at the moment: a balance between structure and tradition (Derain) and a bourgeois sensibility ordered to the world of reality and mundane intimacy (Bonnard, de Segonzac, Favory). Here, says Huyghe, Matisse's persistent "bourgeois sensibility" places him, with Bonnard and the others, in the last classification. Thus, Fauvism is made to conform to a balanced image of French art that avoids extremes and finds a middle ground. "The Fauves [reclaimed]," says Salmon in the same study, "by revolutionary action, the classic paths lost by academic instruction."

Huyghe's and Bazin's history is a set of elastic and imprecise categories created for a French modernism that, while still claiming to be revolutionary, remains very much tied to a moderately stylized realist tradition and to the biographies of talented individuals. Non-objective art (in French eyes, a foreign import from Holland, Russia, and Germany) and Surrealism have no real part in their accounts. Surrealism, a sub-heading under the more general "The New Subjectivity," is a movement, according to Huyghe, whose defense of irrationality is subtended by a refined lucidity and logic. Dada and Surrealism together receive seven pages in a 530-page book on contemporary art.

[55] In the later 1930s it became customary to identify the work of Jewish artists from the School of Paris as the School of Montparnasse or the Jewish School of modern art. See Kenneth Silver, *The Circle of Montparnasse, Jewish Artists in Paris, 1905-1945* (New York: Jewish Museum, 1985); exhibition catalogue.

More and more in France, modern art was seen as a matter of masters, not movements; of superior talents, not manifestos. A pattern fails to emerge; a principle of historical necessity or agency is not assumed. Newness itself becomes suspect in the general international acceptance of independent art. Not without irony did Léon Werth note as early as 1925: "The mistress of the house shows [modern paintings] with pride, with the same sort of pride that she shows a dress from the rue de la Paix."[56] Newness could be equated with the merely fashionable, and the fashionable commodity item, a dress in the latest Paris style, at that. Straining for novelty on the part of an artist or groups of artists is seen as the ploy of those without authentic originality, that is, an originality that is deeply personal and based on a thorough grounding in tradition.

Interpretations of Fauvism from this period usually inclined toward the tendentious in some way. The first show to feature the Fauves as an historical movement was at the Gallery Bing in 1927, twenty years after the movement dissolved. Polish-born Waldemar George, author of the catalogue essay, attempted to make the movement the cradle of all later modernism.[57] Though "an experiment and a revolution," Fauvism constructively prepared the way for a variety of movements to follow, even Cubism. Fauvism, "crossroad of modern painting," in George's words, even enabled German art to rediscover its own essential nature, its expressionist soul. In a review of the 1927 Fauve exhibition, André Salmon, on the other hand, offered another model of Fauvism which, with that of George's, was to dominate the Fauve literature for many years.[58] Matisse is barely mentioned by Salmon, except as the leader of a generic pre-cubist modernism. For Salmon, Fauvism was not a movement but a circumstance of friendships and the anarchist times; his essay is anecdotal and he

[56] Léon Werth, "La Peinture en province," *L'Art vivant* (August 1, 1925): 23.

[57] Waldemar George, "Le Mouvement fauve," *L'Art vivant* 54 (March 15, 1927): 208; reprinted from the catalogue essay for the exhibition. George does not see Matisse as the creator or even major figure of Fauvism; for him, Matisse merely made use of Fauvism as a stage in his own personal development.

[58] André Salmon, "Les Fauves et le fauvisme," *L'Art vivant* 54 (May 1, 1927): 321-24.

emphasizes colorful personalities without generalizing the characteristics of the movement.

Whenever Fauvism is figured as the product of violent or anarchic temperaments--often the view in the 1930s--and not as the consequence of intention, program, or historical conditions, Vlaminck rather than Matisse is the preeminent figure. This was also the position of Louis Vauxcelles who wrote on Fauvism for a 1934 exhibition sponsored by the *Gazette des beaux-arts* and, in the late 1930s, a longer series of articles that featured Vlaminck as the major Fauve, by reason of his temperament.[59] Matisse is often pronounced the major Fauve, while at the same time paradoxically held to be the exception in the group: his temperament is not impulsive, his brush stroke is not expressive and, though he continued to make color his major means, that color is more intellectual than emotive.

Between the 1927 Fauve exhibition and the one in 1934 appeared what is probably still the single most important yet idiosyncratic essay on Fauvism, meant to counteract the current views of Fauvism: Georges Duthuit's five-part series from 1929 to 1931 in *Cahiers d'art*. Rich in citations from Matisse and the other recently interviewed major Fauves, the essays place Matisse clearly at the center of Fauvism's innovations in color, its non-mimetic goals, its new relation of the individual sensibililty to the experience of nature, its fresh ways of structuring the picture-surface--all of which characterize Fauvism's contribution to modern painting.[60] Duthuit mocks the accounts of Vlaminck and Derain as self-serving and muddled, and quotes Matisse as saying that he does not know what Fauvism-as-a-movement means. Nor does Duthuit. Fauvism is nothing, for him, outside of Matisse's innovations.

Duthuit's first article on Matisse, appearing in 1920 in the journal *Action,* had adumbrated the point of view he developed in all his later articles on his future father-in-law.[61] (Duthuit married Marguerite Matisse in 1923.) According to Duthuit, Matisse provides the viewer

[59] Louis Vauxcelles, "Les Fauves, à propos de l'exposition de la *Gazette des beaux -arts,*" *Gazette des beaux-arts* 12 (1934): 273-82.

[60] Georges Duthuit, "Le Fauvisme, I," *Cahiers d'art* 4, 5 (1929); Part II 4, 6 (1929); Part III 4, 10 (1929); Part IV 5, 3 (1930); Part V 6, 2 (1931).

[61] Georges Duthuit, "Matisse," *Action* 3 (April 1920): 49-58.

with an experience of enhanced vitality, even ecstasy, through the contemplation of the transfigured matter of his artwork. A student of Byzantine art and a follower of Bergson, Duthuit puts Matisse's viewer in an active mode, responding to a work that has a powerful presence but that imposes no specific response. Matisse's art provides a kind of atmosphere of meditation that the viewer is free to experience either subliminally or with more focused attention. This theory of the artwork as providing an experience analogous to religious trancendence and to a ritual healing, would be developed from Duthuit's thought by Pierre Schneider from 1970 onward.

The greatly revised and expanded version of Duthuit's essays, *Les Fauves*, was published in 1949 (English ed. *The Fauvist Painters*, 1950), the same year that he published "Matisse and Byzantine Space" in the English-language journal *Transition Forty-Nine*.[62] He answers the postwar agitation for socially engaged and collective art by offering the culturally integrated art of Byzantium as a model of what is desirable in the relation of art to society. He suggests that Matisse offers something parallel to Byzantine art's unified esthetic experience by means of his life-enhancing, light/ space-oriented environments. Duthuit's final summation of his position on Matisse's art as geared to viewer experience is his essay of 1956, "Material and Spiritual Worlds of Henri Matisse," again reaching an American audience directly, this time in the journal *Art News* [63] and engaging the issue of spirituality that arose partly in response to Matisse's chapel, as we shall see below.

During the years of German occupation, Fauvism was sometimes used to extol French rural virtues at the expense of urban cosmopolitanism, a view taken by Maurice Vlaminck, who became virulently anti-modern and anti-semitic. The issue of the "Frenchness" of modern art versus its international character had already become an issue in the xenophobic and anti-semitic thirties. The School of Paris came to be associated with foreign, mostly Jewish, artists from colorful and bohemian Montparnasse--Soutine, Pascin, Modigliani, Chagall,

[62] Georges Duthuit, *Les Fauves: Braque, Derain, van Dongen, Friesz, Marquet, Matisse, Puy, Vlaminck* (Geneva: Éditions des Trois Collines, 1949); translated by Ralph Manheim as *The Fauvist Painters* (New York: Wittenborn, Schultz, 1950); idem, "Matisse and Byzantine Space," *Transition Forty-Nine* 5 (1949): 20-37.

[63] *Art News* 55 (1956): 22-25.

Kisling, Lipschitz, Orloff, Zadkine, among others, were Jewish--while prominent foreigners in Paris included Picasso, Dali, Miro, Kandinsky, Mondrian, Foujita, and Torres-Garcia, to name but a few. A number of right-wing voices were the most virulent in the 1920s. By the mid-1930s, however, even André Salmon, Louis Vauxcelles, Adolph Basler, and Waldemar George, critics who championed modernism and had written positively on individual Jewish artists (all but Salmon were themselves Jewish), were among those who lamented the "swarm" of foreign and Jewish artists who crowded the depressed art market as well as the Quartier Montparnasse, threatening both the livelihood of French artists and the measured classicism of true French art.

Matisse criticism may not have been directly involved in this pernicious swell of opinion, which had its dire consequences at the end of the 1930s and during the Vichy years, but all of these critics wrote on Matisse, extolling his "French" virtues of measure, tact, reserved sensuality, classical humanism, continuity with tradition, respect for the material world and for his métier. From 1939 to 1945, this line of approbation might be seen as wholly Vichy-ite as well, except that the communist, Louis Aragon, and the socialist Resistance leader Jean Cassou, also use it to the fullest when writing on Matisse during these years. (During the occupation, "nationalism" was a form of anti-Nazism; in the post-war period it was sometimes anti-Soviet or anti-American.) National pride and patriotism, naïve chauvinism, or cultural self-awareness can be other than murderous xenophobia or crypto-fascism; but, in the case of George, who openly admired Italian fascism and considered cosmopolitan internationalism the road to cultural degeneration, the connection with a certain pro-fascist rhetoric is indisputable.

Writing on Matisse in *Chroniques du jour* early in 1931, George is highly critical of the notion of progress in art, to which Matisse is said to have contributed.[64] Rather, there is no such thing as progress, only change; Matisse has merely contributed to the divorce of art from nature, of culture from life, by the sterile, anti-humanist concept of "absolute" painting. George does not persist in this line of attack, however, and returns to champion Matisse (*Formes*, June 1931)

[64] Waldemar George, "Psychanalyse de Matisse: Letttre à Raymond Cogniat," *Chroniques du jour* (April 1931); idem, "The Duality of Matisse," *Formes* (June 1931): 95.

after seeing his retrospective show at the George Petit Gallery: "Matisse," he exclaims, "[is the] paragon of French painting." George, delighted with the preponderance of moderate early Nice canvases, rejoices: "The crowning merit of Matisse is to have engaged modern art, that sublime paradox, on its own ground and with its own weapons--and beaten it! And only a French artist could have brought off such a victory."

Matisse had lived his life absorbed in his profession, attentive primarily to his own needs, and this pattern did not change during the upheavals of the 1930s and 1940s. He had initially chosen a life in art --leaving him "free, solitary, and at peace"--to put him at a remove from the turmoil, the wrenching change, and nervous disequilibrium of modern life, and from the conflicts in his own personality. Matisse's concentration on his own well-being and that of his art increased in times of personal and world crises. Artwriters on Matisse seldom directly connected his activity with external events, seemingly grateful that he had placed himself above the fray, as it were. As one of France's Great Living Masters (the Spanish Picasso was more ambiguously so), he came to stand for something immutable and immune from historical exigencies, namely, for French culture, French genius, French *gloire*. This rhetoric was used in the art world more narrowly in the 1920s to place Matisse beyond the confrontations of late Dada and continuing Cubism, of Constructivism and Surrealism, of geometric abstraction and expressive realism. His work somehow seemed to reconcile the conflicting claims of esthetic schools or political "camps." The language of superiority and exemption with respect to Matisse's status was shaped and already in place in the 1920s, available to be inserted into the more politically-driven rhetoric on transcendent French values of the 1930s and 1940s.

During the 1930's and early 1940s, Matisse himself published a number of important texts about his work that stay strictly within the framework of esthetics: on color, on drawing, and on "signs."[65] He

65 Matisse, on color--"Modernism and Tradition" (1935), "The Constancy of Fauvism" (1936), "Testimonial" (1943), "Role and Modalities of Color" (1945), "On Color" (1945), "The Path of Color" (1947); on drawing--"Divagations" (1937), "Notes of a Painter on his Drawing (1939), "How I Made My Books" (1946), "Exactitude Is Not Truth" (1947); on developing "signs"--Louis Aragon's "Matisse-en-

clarifies the role of color in the contribution his generation made to the history of painting: color became expressive, no longer imitative. He proposes a concentration on the plastic means instead of a search for style; he maintains that the artist's emotion is still the key to transforming the motif into a significant arrangement of color and line; he insists that art is a matter of relationships. Sensitive to criticism, he sometimes responds directly, as he did to Roger-Marx's claim that Matisse's subject matter leaves the artist (and hence the viewer) emotionally unmoved and that the subject is only a pretext for a subtle play with plastic elements.[66] In response, Matisse stoutly affirms his emotional engagement with his models and uses the psychological term "sublimation" to describe his artistic transformation of his female subjects.

Matisse increasingly refers to his work as a language or as a chess game, a development of personal signs that are expressive within specific contexts. In the early 1940s (only a few years before he himself ceases to paint altogether), Matisse admits that painting's influence has shrunk in a world of photographic images and colorful advertising design; hence, there is a need for works of absolute emotional sincerity and a purity of (reduced) means.[67] In 1952, he predicts an end to easel painting in favor of murals.[68] In messages to young artists, he insists on the need for hard work and acquired skills as prerequisites for the artist to give free play to his "unconscious." (If this seems to be a response to the then-current "art informel," in general, Matisse refrained from commenting on the art of young contemporaries.) He also notes the need for more public, collaborative art and suggests that he would like to make "large-scale compositions"--murals, in effect.

Thus, while reaffirming the values of his youth, he indicates his awareness of the new language of surrealism, the linguistic turn taken in the artistic discourse of the time, and the increased interest in

France" (1943). All of these can be found reprinted in both Flam, *MOA*, and Fourcade, *EPA*.

[66] Roger-Marx, *Dessins de Matisse* (Paris: Braun, 1939); Matisse's response in "Notes of a Painter on his Drawings" (1939).

[67] Matisse, "Matisse's Radio Interview, First Broadcast"; Flam, *MOA*, 145.

[68] André Verdet, "Entretiens avec Matisse." *Prestiges de Matisse* (Paris: Éditions Émile-Paul, 1952); Flam, *MOA*, 211.

public, even popular, art. Nevertheless, in a time of socially-conscious movements, he insists that the artist's fundamental question is first "What do *I* want?"[69]

Matisse spoke so concisely and clearly about his aims, his working process, his development, that writers could often do little but paraphrase his observations and analyses. This basic information was simply given a literary or poetic reframing by writers like Jean Cassou, René Huyghe, Raymond Cogniat, Germain Bazin, E. Tériade, Christian Zervos, and Waldemar George, all of whom wrote extensively on the artist. These names comprise a roster of well placed and increasingly prominent figures in official and semi-official French art institutions; they are the new "establishment" that embraced modernism and attempted to integrate it into a history of French art. Besides journal articles, all wrote catalogue essays on Matisse, introductions to albums of reproductions, exhibition reviews, and contributed to general studies or anthologies on modernism. They had occasion to write on Matisse again and again over several decades, often recycling old material into fresh literary bouquets. Their writings are occasional or thematic, often promotional, less frequently historical or critical in nature. [70]

The period witnessed an increase of foreign as well as French monographs on the artist: Albert C. Barnes and Violette de Mazia's *The Art of Henri Matisse* (1933), Pierre Courthion's *Henri-Matisse* (1934), Raymond Escholier's *Matisse* (1937), Alexander Romm's *Henri Matisse* (1935, 1937), Courthion's *Le Visage de Matisse* (1942), Isaac Grünewald's *Matisse och expressionismen* (1944), Gino Severini's *Matisse* (1944), Leo Swane's *Henri Matisse* (1944), Giovanni Scheiwiller's *Henri Matisse* (1947), Alfred Barr's *Henri Matisse, His Art and His Public* (1951), and Gaston Diehl's *Henri Matisse* (1954). (Barr's monograph, the most comprehensive and scholarly to have

[69] Matisse, "De la coulour," *Verve* 4, 13 (December 1945): 9-10; Flam, *MOA,* 158.

[70] In spite of this, some--such as Jean Cassou and René Huyghe-- wrote penetrating and piercingly beautiful texts on Matisse that still stand today as models of French artwriting at its best. See Jean Cassou's text in *Henri Matisse, Carnet de Dessins,* vol. I (Paris: Huguette, Berès and Berggruen & Cie, 1955) and René Huyghe, "Matisse et Couleur," *Formes* 1, 5-10 (January 1930): 31-32.

appeared to that time, will be discussed below.) International in authorship, these works are often based on first-hand knowledge by friends and former students. They are usually liberally laced with citations from Matisse's writings and interviews. Hostile critics had remarked negatively upon Matisse's foreign students (German, American, Scandinavian, Russian, Romanian, Czech, Hungarian, and Japanese) in the years when Matisse conducted his Academy. Ironically, these very students carried the artist's name and fame abroad and, with it, acceptance of the School of Paris or French modernism.

During the 1930s the three important magazines of advanced art--*Minotaur, Verve*, and *Cahiers d'art*--devoted entire issues to Matisse and frequently reproduced his work in multiple-page spreads. *Minotaur,* oriented toward Surrealism, and *Verve*, a luxury magazine also published in an English-language edition, printed important statements by the artist and kept his latest work before the public. Both were under the direction of Matisse's friend, Tériade, whose 1929 and 1930 interviews had intimately revealed the artist's response to his travels and to his new mural commission. *Minotaur* and *Verve* not only contained important statements by Matisse on Fauvism, but showed him as a "Fauve," publishing in full color his latest flat, decorative paintings and his earliest cut-paper work. After the war, *Verve* continued to be a showcase for the artist's latest work.

Christian Zervos, friend and documenter of Picasso, was the editor of *Cahiers d'art*, which championed Cubism and semi-abstract art. Zervos nevertheless also wrote extensively on Matisse. He valued Matisse's oeuvre as essentially pictorial, respecting and instantiating plastic values that endure after the quarrels of the schools, the superficial differences of styles, and the ultimately irrelevant clash of manifestoes. In spite of supporting an historical avant-garde, both Tériade and Zervos still emphasize genius, authenticity, self-expression, timeless traditions of quality, and the discovery of the self through art. That Matisse's work appears side-by-side in these magazines with prehistoric cave paintings, medieval manuscripts, tribal sculpture, children's art, and photography proclaims that all are recognizably art because of certain formal qualities and their universal human significance.

Under the occupation, young French painters took--from the available models of established gerontocracy--Pierre Bonnard, George Braque, and Jacques Villon as their major guides. Intimacy and

modesty of subject matter along with the personal deployment of the color-space of modernist composition attracted the young generation under the banner of "Tradition française." This label was a clandestine expression of patriotism that hid behind acceptable Vichy terminology.[71] But Matisse was also revered; his *Henri Matisse desssins: thèmes et variations* (Paris: M. Fabiani, 1943) was published with a glowing text by the communist Louis Aragon, who proclaimed Matisse the most French of all, in his essay, "Matisse-en-France." Also published during the war was Henri Montherlant's *Pasiphäe: Chants de Minos* (Paris: M. Fabiani, 1944), a luxury book designed by Matisse and illustrated with linocuts. From Switzerland during the war, Pierre Courthion published a monograph on Matisse --rich in new material taken directly from interviews with the artist--and articles in the journal *Labyrinthe*.[72] After the war, an article by Courthion in *Labyrinthe* is illustrated by the Brassai's 1939 photos of the artist, pure and detached in his white artist's smock, drawing from the nude in a sunny, flower-filled studio. In 1945 the photos seem to say: "Miracle! this national treasure has survived a close call with death and is still as productive as ever! So France will survive."

Not until after the war did Matisse publish his cut-paper stenciled book, *Jazz*, with its brilliant, flat "illuminations" so like those of the eleventh-century French manuscript, the *Apocalypse of Saint-Sever*, of which a deluxe facsimile copy was published in 1943, the very year Matisse began *Jazz*. (Reproductions of the manuscript had already appeared in 1938 in *Verve*, in proximity to Matisse's earliest cut-paper efforts.)[73] Romanesque art had been the symbol of the true

[71] For the pre-War and occupation periods, see: *L'Art dans les années 30 en France* (Saint-Etienne: Musée d'Art et d'Industrie, 1979), exhibition catalogue; *Paris-Paris, 1937-1957* (Paris: Musée National d'Art Moderne, 1981), exhibition catalogue; Laurence Bernard Dorléac, *Histoire de l'art: Paris 1940-1944: ordre national, traditions, et modernités* (Paris: Sorbonne, 1986); and Michèle C. Cone, *Artists Under Vichy* (Princeton: Princeton University Press, 1992).

[72] Pierre Courthion, *Le Visage de Matisse* (Lausanne: Marguerat, 1943); idem, "Le Peintre et son modèle," *Labyrinthe* 8 (May 15, 1945): 6-7.

[73] André Lejard, introduction to *Henri Matisse* (Paris: Hazan, 1948) for references to the Beatus manuscript, and Avigdor Arikha, "Matisse

"Tradition française" during and after the war; younger art historians, such as Bernard Dorival and Pierre Francastel, insisted that French art had remained true to its medieval roots: a simple, lucid, non-elitist art for and of the people, untouched by Italian (Renaissance) and German (Expressionist) influences. This approach can be seen to lie behind the literalness and naïveté of Jean Dubuffet's scenes of Paris life painted in 1943 and 1944. Both Matisse's and Dubuffet's spontaneity, childlike narratives, brutal humor, rough *grafitti*, and direct scissoring into humble colored paper, were *desiderata* both during and after the dreary and shameful wartime condition, taking on both a resistant note of rebellion and a hopeful one of a new beginning.[74] Even Matisse's last, most brilliant paintings of 1947-48 disguised their sophistication and seemed to provide an artless gaiety and ease of execution. His luminous (and colorist) brush drawing in black and white (1946) also used a seeming simplicity of method for complex ends. Matisse chose to illustrate late medieval and Renaissance texts-- *Florilège des amours de Ronsard,* begun in 1941 and published 1948, and the *Chansons d'amour de Charles d'Orléans,* begun in 1942 and published in 1950-- and did so in medievalizing designs of a certain *faux naïveté.*

The post-war scene was highly politicized. Picasso, who had stayed in Paris, sharing the occupation hardships both with ordinary people and with Parisian intellectuals and writers, was the star of a 1946 exhibition, *Art et résistance.* (His sometimes favored treatment by the German High Command was overlooked.) A member of the French Communist Party from 1944, Picasso enjoyed its prestige as the party of the Resistance until the mid-fifties. In 1947, the Surrealists returned with a major show *L'Exposition Internationale de Surrealisme,* organized by Breton. Paradoxically, this non-political show favoring abstraction (Masson, Matta, Lam were prominent) was denounced by Aragon and the Communists for these very qualities. The Surrealists had become "Americanized" in the eyes of the French left, which was promoting a Soviet-dictated, propagandistic Realism.[75] In

et *l'Apocalypse de Saint-Sever:* Beatus et *Jazz,*" reprinted in *Peinture et regard, écrits sur l'art 1965-1990* (Paris: Hermann, 1991).

[74] For this period, see Sarah Wilson, "Les Jeunes peintres de Tradition française," *Paris-Paris, 1937-57,* 106-116.

[75] See Sarah Wilson, "'La Beauté révolutionnaire'? Réalisme socialiste and French Painting 1935-1954," *Oxford Art Journal*

this climate, a Soviet critic denounced both Matisse and Picasso by name as bourgeois formalists in a 1947 article in *Pravda*. [76]

It is all the more remarkable that, while acting the fierce advocate of Soviet Realism, Louis Aragon published his most admiring prose about Matisse: "Apologie du luxe (1946)," "Matisse ou les semblances fixées (1947)," "Matisse or the French Painter" for the catalogue of the 1948 *Matisse Restrospective* in Philadelphia, and "Au Jardin du Matisse," for the catalogue of the 1950 exhibition *Henri Matisse: chapelle, peintures, dessins, sculptures* at the communist-run Maison de la Pensée Française. Without grossly simplifying Aragon's subtle point of view, one can say that he presents Matisse as a revolutionary who provides a vision (or experience) of happiness and, hence, provides the stimulation to work actively to achieve it in society. He is revolutionary, acccording to Aragon, because he is an artist whose work is in continual rupture with complacent convention and who is never content with the status quo. Jean Cassou, imprisoned for Resistance activities during the war and, in 1947, appointed director of the resuscitated Musée National d'Art Moderne, also wrote frequently about Matisse in these years, always stressing the intelligence of his sensuality and the voluptuousness of his thought. For the socialist Cassou, Matisse's thought is always developed and realized through his materials and in his artistic process, in the manner of an artisan/worker. Thus these writers of the left sometimes rendered the apolitical Matisse an active agent in the political-artistic debates of the time.

From 1948-1952, Matisse would be most discussed in terms of the chapel he was designing and building at Vence. The lively debate concerning religious art paralleled, in its way, the purely artistic and political controversies of the period. A Dominican priest, Père Marie-Alain Couturier, himself an artist who had trained at the Académie Ranson and who had worked with Maurice Denis and George Desvallières in their Atelier d'Art Sacré, became after the war a champion of modern and, especially, abstract art, which he considered

(October 1980): 61-69; and Louis Roux, ed., *Art et idéologies, l'art en occident, 1944-1949* (Saint-Etienne: Université de Saint-Etienne, C.I.E.R.E.C., 1976).

[76] Françoise Will-Levaillant, "Note sur 'L'Affaire' de la Pravda," *Cahiers du Musée national d'art moderne* 9 (1982): 146-49.

essentially spiritual. Rather than commission works from mediocre artists of faith, he actively campaigned to enlist major modern artists in the furnishing of churches, even though they might be neither Christians nor believers at all. Couturier was instrumental in commissioning Léger, Bazaine, Chagall, Lipchitz, Manessier, Lurçat, and Matisse for decorations for churches at Assy and Audincourt.[77] At first he was not directly involved in Matisse's chapel. Since it was built, however, for Dominican nuns in Vence and involved the Dominican friar Frère Rayssiguier as its on-site consultant, Couturier also became involved as a liturgical adviser to Matisse on the project and ran interference for him with the clerical establishment.

The Dominican priest posed for the figure of Saint Dominic that Matisse drew on tiles behind the altar of the chapel and for a similar altar decoration for the church at Assy. Couturier wrote on sacred art in general and the need for a vigorous "incarnation" of theological truths in powerful works of art. All sincere, finely-wrought works of the human spirit were, according to Couturier, fundamentally allied to the religious. This broad characterization is not so far from Matisse's early (1908) assertion that his feeling for the human figure bespoke his "almost religious awe toward life." Articles on Matisse's chapel and Matisse as a religious artist began to appear both in Catholic publications and art journals. Although Couturier, quoting Matisse from recollected conversations and interviews, made him appear to be more conventionally religious than he was, there is no discounting the fact that Matisse turned more to religious analogies in his writing and discussions at this time.[78] Still, he never "returned to the church" by

[77] For a history of this, see Marcel Billot's "Le Père Couturier et l'art sacré," *Paris-Paris, 1937-1957*, 197-200.

[78] In his book *Jazz* he had made use of a long paraphrase from the *Imitation of Christ*, a venerable book of Christian piety, to describe the joy of the person who lives without hatred or regret. He also used the deity as a way to describe a certain surrender to the unconscious which permitted him to create (or otherwise surpass himself) without conscious effort. The attitude of someone receiving Communion is described by Matisse as a parallel to the purity, sincerity, and emptiness of the mental state of the artist when setting to work--always, but especially on religious subject matter. Matisse had set his "soul" (a word he admitted he disliked) in order when he was near death in 1940

receiving the last rites. As his closest companion Lydia Delectorskaya makes clear, he remained fundamentally an unbeliever and employed a certain affectionate malice toward his Christian interlocutors by giving them a hint of what they wanted to hear, and then withdrawing it or qualifying it in the next breath.[79]

The chapel itself was published extensively, often in lavish photo-spreads with descriptive texts : *France illustration, Life, Vogue,* and other liturgical and architectural magazines gave it full treatment during the course of its building, at the time of its dedication, and throughout the 1950s. The chapel was well received, but there was some negative comment on the summary and somewhat coarse nature of Matisse's "mural" drawings, on the undistinguished quality of the architecture itself, and on the lack of proper religious gravity in the work.[80] Aragon is reported to have joked that, later, when society was fully secularized, the building could be used as a dance hall.[81] Matisse assured him that, in the event that Church properties would ever again be confiscated by the State, he had made provision for the place to become a State-run museum.[82]

In short, the literature at the end of Matisse's life attempts to keep pace with his new decorative works--the tile murals, the silk-screened or woven wall hangings, the stained glass windows, the books and graphic designs, the large and small-scale cut-outs. For most critics, these works crown a body of quality works in many media and

and, in his hospitalizations and while working on the chapel, he was surrounded with a more religious entourage than was usual.

[79] See Lydia Delectorskaya's comments, "Que l'un fût de la chapelle," in Aragon's *Matisse, roman,* vol. II (Paris: Flammarion, 1971), 183-86.

[80] See, for example, Sabro Hasegewa, "Matisse through Japanese Eyes," *Art News* 53 (April 1954): 27-29; William Justema, "Activities of Matisse at Vence," *Liturgical Arts* 20 (May 1952): 100; and John Lane, "Matisse: Painter into Architect, His Venture at Vence," *Liturgical Arts* 20 (February 1952): 61-62.

[81] Barr, 1950, 281; refuted at surprising length by Aragon in "Que l'un fût de la chapelle," *Matisse, roman,* 181-227.

[82] See Marcel Billot, ed., *Henri Matisse, La Chapelle de Vence, Journal d'une création* (Paris: Cerf, Menil Foundation, Éditions Albert Skira, 1993) for the documents (letters, journals) between Matisse, M.-A . Couturier and L.-B. Rayssiguier.

they are evaluated in the familiar terms of innovation, risk, sincerity, intensive labor and long-hewn skills, intellectually ordered "fauvist" colors, and unerring taste and measure in composition and design. The old tropes functioned very well for these late works as a whole and, once more, Matisse's own reflections on his current projects--which often cast a synthesizing look back at earlier works and periods--were given pride of place by contemporary artwriters.

In France, at the time of Matisse's death, Parisian hegemony in the arts was challenged by the international prominence of the new American abstraction, later known as the New York School. Nonfigurative art, which had for so long seemed foreign to French taste and sensibility, was being seriously debated and practiced by younger French artists. Although Matisse's international prestige was second only to Picasso's in 1954, his was not an immediately relevant example to the young "tachistes" or practitioners of "art informel." Marcel Brion's book *Art abstrait* (Paris: Albin Michel, 1956) contains not a single index reference to Matisse. One must look primarily to the American and English writers in the next fifteen years for a literature that frames a major historical role for Matisse's contribution to modern painting and sculpture.

IV
The Formalist Reputation, 1955-1969:
From the artist's death to the Centenary Exhibition.

Although Matisse's chapel and late decorations were documented and generally admired at the time of the artist's death in 1954, his work in paper cut-outs became fully known and appreciated only in the following decade. Cut-paper works were shown along with work in all other media before Matisse's death and in the retrospectives immediately thereafter; but the chapel, with its designs, furnishings, and maquettes, dominated the public view of the artist's last years of production. Well represented at Matisse's 1949 *Oeuvres récent 1947-1948* exhibit in Paris, the paper cut-outs had to compete for attention with his dazzling ink-brush drawings and the brilliant last series of paintings. At the 1950 Maison de la Pensée Française exhibition, they were shown with a wealth of sculpture (fifty-one works, with all five *Jeannette* heads shown together for the first time) and the Chapel maquettes. There was thus a tendency to regard the paper cut-outs either

as maquettes or sketches for works destined to be carried out in other media (tapestry, silkscreen, stained glass, ceramic, metal) or as a form of graphic art (Matisse had designed a great many book and catalogue covers, posters, and journal layouts by means of designs in the paper cut-out technique in the last years of his life). Major exhibitions in Tokyo (1951), New York (1951 [Retrospective]), Copenhagen (1953), Paris (1956 [Retrospective]), showed paper cut-outs along with other media. It was not until 1959, however, that the first major museum exhibition limited to these works was mounted, in Bern's Kunsthalle (also shown in Amsterdam) in 1959, under the title *Henri Matisse, les grandes gouaches découpées.*

In the catalogue essay for the 1959 Bern show, Franz Meyer clearly gives the new assessment of the cut-paper work. He announces Matisse's break with pictorial media in the dramatic opening sentence: "In 1948 Matisse painted his last canvas."[83] The late work, Meyer maintains, cannot be termed "painting in another medium." What follows after 1948, and especially after the completion of the chapel, according to Meyer, is a completely new body of work that has a unity that can now be recognized and analyzed. Different from cubist or dada collage, Matisse's cutouts are reduced wholly to color and to a single process--cut-and-paste. Far from the layered ambiguity and ruptured signification of the cubist and dada collage modes, Matisse's work is reductivist, elementally simple, and deploys a fundamentally new interaction of color, shape, and line. The large dimensions of the late works relate to architecture, to the wall, to space that can be experienced only directly by and in the real space of the beholder. Meyer denies, however, that the work is in essence either decorative or abstract. Matisse's thematic content is more evident than ever: a vision of paradisiac vastness and wholeness, oceanic buoyancy of spirit, Sun and Light raised to mythic proportions. Meyer's insights foreshadow the subsequent more formalist interpretation of Matisse's work in terms of process, material, structure, and the viewer's optical-spatial response.

[83] Franz Meyer, *Henri Matisse, les grandes gouaches découpées* (Bern: Bern Kunsthalle, 1959); exhibition catalogue. Two other canvases were actually painted in 1951, *Katia in a Yellow Dress* and *The Blue Gandoura* , but these are considered by some to have been left unfinished.

Meyer's observations about the *content* of Matisse's late work, namely, the mythic/mystical themes, found greatest resonance, however, in the French literature. This concern with content may have also been stimulated by an article by Georges Duthuit, "Tailleur de Lumière," in *The Last Works of Henri Matisse*, an issue of *Verve* of 1958, devoted entirely to the cut paper work.[84] Duthuit defends the work from detractors who either imply something of the childlike, even childish, in the creations of the old master or charge that he made murals only for bourgeois interiors. Since no public sites were offered in the artist's lifetime, Duthuit counters, the intimate social environment of a private home, no matter how wealthy, is a far better site for the work than museums (the only other bidders for the large works). Duthuit claims that Matisse's direct carving in blocks of pure color, so rudimentary in its attack on matter, is, nevertheless, dematerialized when those colored "shadows" take their place on their shadowless white grounds, "Elysian fields" of light-reflective expanding surfaces. A dazzling experience, Duthuit claims, it constitutes a mystical transaction in the here and now by means of humble materials and processes.

Reviewing the Bern show in 1959, Jean Leymarie related the new work to Matisse's earlier decorative works of 1911, such as *Still Life with Eggplants*, with its original flower-patterned false frame and the expanses of ornamented spaces that expand laterally from the trinitarian eggplants.[85] Painted in distemper on paper, the *Eggplant's* medium is not unlike the humble and fragile painted papers of the cut-outs. Leymarie also finds the new medium relevant "to the contemporary philosophies of intuition and the immediate, and [it] rejoins the most penetrating research of contemporary art, based on speed and improvisation, direct contact with material, the fusion of painting-sculpting, the decorative demand." This assessment is Leymarie's special pleading for Matisse's relevance to the 1950s painterly abstraction of *art informel*, but it would be artists of the 1960s who found more to learn from Matisse.

[84] "The Last Works of Henri Matisse," *Verve* 9, 35-36 (1958), in French and English editions.

[85] Jean Leymarie, "Le Jardin du paradis," *Les Lettres françaises*, August 6, 1959; expanded version also published in *Quadrum* 7 (1959): 103-114.

Leymarie was to write the catalogue essay "The Painting of Matisse" for the Los Angeles Matisse Retrospective exhibition of 1966, which toured in Chicago and Boston.[86] When Leymarie begins his catalogue essay with: "Painter, sculptor, draftsman, engraver, decorator, theorist. . . thinker and personality," he reveals the posthumous French recognition accorded Matisse for the full range of his work and thought. After reviewing the trajectory of Matisse's painting achievements, Leymarie concludes with the late works as the epitome and fulfillment of all the earlier pictorial work. Leymarie, in the Duthuit tradition, stresses that Matisse is a "pagan poet of light-without-shade, shining and serene," and ends his essay by citing Matisse's "profoundest wish: 'I have attempted to create a crystalline environment for the spirit.'"

The decorative implications of all of Matisse's work were taken up by Nancy Marmer at the time of the 1966 Los Angeles Retrospective, in what she called the artist's "strategy of decoration."[87] Marmer, younger by a generation than Leymarie and fully aware of contemporary Minimalism and Pop Art, notes that Matisse's decorative elements always function structurally and sometimes abstractly, a fact that is not lost on the young hard-edged abstractionists such as Elsworth Kelly, Jack Youngerman, and Kenneth Noland. Marmer terms Matisse's decorative "strategy" a "tough-minded estheticism" that is shared by the young American painters.

The dominant discussion outside of France was on the anti-pictorial nature of the cut-outs; their method was regarded as fundamentally different from Matisse's oil painting process that from the very beginning depended on developing the image-composition as a whole. The cut-outs, on the other hand, were individual units or gestalts, complete in themselves before being joined, juxtaposed, or integrated into another whole. Leymarie had noted this in 1959, but it was taken up especially in the Anglo-American criticism of the 1960s. The cut-outs could be seen in the framework of a number of interrelated discourses, those of abstract art, of decoration, of minimalism, and of

[86] Jean Leymarie, "The Painting of Matisse," *Henry Matisse Retrospective* (Los Angeles: UCLA Art Gallery, 1966), 9-16; exhibition catalogue.

[87] Nancy Marmer, "Matisse and the Strategy of Decoration," *Artforum* 4, 7 (March 1966): 28-33.

collage. That the cut-outs were hard-edged made them an alternative to the expressionist loaded-brush of the 1950s abstraction; that they were so simple and repetitive and accessible made them congenial to Pop Art; that they depended on a direct experience of their gestalts in specific configurations made them relevent to minimalist esthetics; that they flaunted their decorative nature made them subversive to the hegemony of oil painting as a privileged medium; and that they were related to collage drew them into the avant-garde status reserved to cubist and dada collage, though they were acknowledged as fundamentally different. Suddenly, Matisse's cut-outs were about a whole new process of artmaking, a new relation to the viewer, a new way of thinking about art.

Another way the cut-outs became relevant in the late 1950s and the 1960s is through the issue of color. Matisse had returned to working in flat color-shapes in the mid-1930s and had himself related the return of saturated color to a new Fauvism. A correlation was drawn in these years between the direct color-cutting of the paper cut-outs and the use of color as the privileged element in Fauvism. There was a cluster of major Fauve exhibitions in the early 1950s: *Die Fauves und die Zeitgenossen* in Bern (1950); *I Fauves* at the Venice Biennale (1950); *Le Fauvisme* in Paris (1951); *Symbolistes, divisionnistes, fauves; hommage à Gustave Moreau* in Paris (1952); *Le Fauvisme* in Rennes (1952); and *Les Fauves* in New York (MoMA) in 1952, which highlighted Fauvism's expressive brushstroke and emotional immediacy--aligning it with Abstract Expressionism. The 1960s witnessed another explosion of international shows: *Triumph der Farbe, die europäischen Fauves* in Berlin (1959); *Les Sources du XXe siecle: les arts en Europe de 1884 à 1914* in Paris (1960); *Les Fauves* in Paris (1962); *Gustave Moreau et ses elèves* in Marseilles (1962); *La Cage aux Fauves du Salon d'Automne 1905* in Paris (1965); *Les Fauves* in Tokyo (1965); *Les Fauvisme français et les débuts de l'expressionisme allemand* in Paris (1966); *Matisse und seine Freunde, les Fauves* in Hamburg (1966); *Fauves and Expressionists* in New York (1968); *Fauvisme in de Europese Kunst* in Malines (1969); and *Die Fauves* in Basel (1969). Fauvism emerged as an international phenomenon, rather than merely a short-lived French "école." Often paired with German Expressionism as a parallel and related tendency, Fauvism was also framed in an historical perspective that identified it as a form of international Post-Impressionism, strongly tied to the

initiatives of Gauguin, Munch, Van Gogh, and Cézanne. Historians also began to see more clearly the relation of turn-of-the-century symbolist esthetics to the ideas of Expressionism and proto-abstraction that Fauvism embodied.

The international acceptance of abstract painting in the 1950s also had its effect on the conceptualization of Fauvism in formal and historical terms. The new literature on Fauvism attributed the characteristics of the movement less to individual temperament, to youthful sowing of "wild oats," and the discovery of self, and more to historical conditions and fundamental shifts in artistic sensibility. Just as Matisse's generation had identified color as an individual element to be emphasized and explored, so too, belatedly, the historians of Fauvism began to isolate color--along with concomitant issues of opticality, space-perception, surface, arabesque, and touch--as "plastic problems" to be examined.

A number of balanced surveys appeared in the mid-fifties and the sixties: J-E. Muller's *Le Fauvisme* (1956, 1966), a fine general treatment; J. Leymarie's *Le Fauvisme* (1957), distinguished by its excellent color plates and the detailed analysis of Matisse's color development; Hans Neumayer's *Fauvismus (Zeit und Farbe)* (1956) with its northern emphasis on the expressive intent of the Fauve's color-usage; G. Jedlicka's *Der Fauvismus* (1956), which also sees French Fauvism somewhat through a "German Expressonist" lens; U. Apollonio's *Fauves et cubistes* (1959), which explicitly links the first two twentieth-century modern movements; C. Chassé's *Les Fauves et leurs temps* (1963), a curious catch-all of French painters who worked with a loaded brush, impetuous stroke or heightened color from 1900 to 1910; and J.-P. Crespelle's *Les Fauves* (1962), comprehensive and handsomely produced. Indeed there was something like an industry of popular books on Fauvism in the 1950s, as Fauvism joined Impressionism as a movement of broad public appeal. In the decades when Abstract Expressionism had "triumphed" even in the popular mind, the esthetics of Fauvism could be understood as a still figurative prototype or variant of that movement.

Two doctoral dissertations produced in the late sixties, but only published later, are the best new historical studies of Fauvism in this decade. Marcel Giry's *Le Fauvisme: ses origines, son évolution* (1981), material from which had been published as early as 1968, closely examines the progressive Salons through French documentary

sources and attempts to rethink the movement in terms of its subjective--even symbolist--lyricism and its formal differences from Impressionism.[88] Finally, however, in spite of new data, Giry's conclusions adhere fairly closely to the traditional French narratives of the movement. The other study, Ellen C. Oppler's *Fauvism Reexamined*, completed in 1969 and published in 1976, is a wonderfully comprehensive study of the social, political, and artistic matrix out of which Fauvism emerged.[89] The author reexamines the myths about the movement, the claims of its participants, the nature of its originality, and the extent of its influence, bringing it right up to the moment when Cubism began to emerge from the same milieu. Oppler's study is notable for its historical soundness, its wealth of new documentation, its broad grasp of the interrelatedness of the Parisian cultural scene and the struggle for the political allegiance of the French intellectual *cenacles* in a period of international tension and rising nationalism. She also gives full treatment to the paradox of the rise of the notions of "primitivism" and "classicism" at a time when their definitions were fluid enough to be used by either the political left or right for extra-artistic goals. The ideals of "primitivism" and "classicism," of course, had complex studio ramifications as well.

In 1976, when the Museum of Modern Art in New York mounted its first Fauve show since 1952, John Elderfield, its curator, made ample use of Oppler's pioneer study, adding to it his own discriminating eye and fine formal analysis of fauvist "style(s)."[90] Elderfield was the first to distinguish sharply between a Fauve group of friends, a Fauve movement identified in the art press as such, and a rapidly-evolving fauvist style.

Elderfield's scholarly and formally sensitive catalogue followed in the Museum of Modern Art's long tradition of producing

[88] Marcel Giry, "Le Salon d'Automne 1905," *L'Information d' histoire de l'art* (January-February 1968): 16-25; idem, *Le Fauvisme: ses origines, son évolution* (Neuchâtel: Ides et Calendes, 1981); Eng. ed., *Fauvism; Origins and Development* (New York: Alpine Fine Arts, 1981).

[89] Ellen C. Oppler, *Fauvism Reexamined* (New York: Garland, 1976); reprint of dissertation, Columbia University, 1969.

[90] John Elderfield, *The "Wild Beasts," Fauvism and its Affinities* (New York: Museum of Modern Art, 1976); exhibition catalogue.

pathbreaking historical exhibitions with significant catalogues. Alfred
H. Barr, Jr.'s 1951 study, *Matisse, His Art and His Public*, was the
first comprehensive study of the artist that employed the full
methodology of art historical scholarship to establish the facts of
Matisse's biography. It is a year-by-year history of the development of
his style, a critical analysis of the major works--in all media--of
Matisse's long career, and a history of the reception of his work, by
both collectors and critics. [91] Barr interviewed Matisse on particulars in
person and by questionnaire (and did the same with his family and
friends), in a manner foreign to the rather informal, Matisse-controlled
interviews to which the artist was accustomed. This extraordinary
study, which is still the basic text on the artist in spite of its lacuna of
the three last years of Matisse's life and some inevitable factual errors,
includes the valuable studio notes of Sarah Stein when she was
Matisse's pupil, reprints the "Notes of a Painter" in English (first
published in the 1931 MoMA catalogue), and contains a comprehensive
bibliography by Bernard Karpel of works on Matisse to 1951.

It is remarkable that Barr did not need to change his basic
reading of Matisse's oeuvre from his catalogue essay in the earlier
MoMA Retrospective of 1931.[92] In that earlier catalogue, far sooner
than any of his European counterparts, Barr had worked out a series of
stylistic alternations in Matisse's artistic development--the alternation
between a realist-impressionist mode and a more abstract-decorative
manner--both in a spirit of avant-garde experimentation. In spite of this
scenario of alternation, Barr is clear about when the "masterpieces" were
made--between 1905 and 1917. Especially from 1913-1917, Matisse
"worked with a power of invention and an austerity of style scarcely
equalled at any other time in his career," and for Barr the excellence of
these works arises from their being close to "abstract design" and
Cubism. His analysis of the early Nice period, whose works he values
less, is nevertheless astute and appreciative. He notes that the active
brushstroke of the early 1920s work is not for the sake of luminosity,
but for decorative purposes, and hence not impressionist. (The response
to Barr by Meyer Schapiro, discussed in the previous section, posits an
alternative view of Matisse's "Impressionism.") And Barr already
remarks, in 1931, that Matisse had turned in 1926 to a renewed period

[91] Barr, *Matisse, His Art and His Public*, 1951.
[92] Barr, *Henri Matisse*, 1931.

of experiment and of geometric structure, crowned by the effort involved in the Barnes Foundation mural, barely begun in 1931.

This view of a Matisse who contributed to the boldest will of the avant-garde to experimentation and abstraction, in spite of a personal ebb and flow of greater or lesser fidelity to appearance, is elaborated in Barr's 1951 text and is assumed by later American writers on Matisse. But despite this dynamic concept of the thrust of modernism toward reduction, abstraction, and continuous experimention, the old criterion of quality saves even the more naturalistic work of Matisse's from being wholly condemned. According to Barr, the same feeling for color, line, and composition that undergirds the "abstract" work functions to save the more realist work from mere illustrative prettiness or banality. Part of Matisse's "genius" is to follow his own path, even if it led sometimes, temporarily, away from the progressive collective effort of experimental modernism.

If Barr established this modernist history of Matisse's career, another American, Clement Greenberg, furthered this view in his struggle to theorize the history of a modernism at the half-way point of the century. As John O'Brian has demonstrated, Greenberg's appreciation of Matisse is central to his gradual evolution of a flexible theory of modern painting; the complexity of the critic's response to Matisse helped him to avoid a certain rigidity in his theories.[93] If Matisse first became important to Greenberg because of the painter's ability to provide delectation, he ended by earning the critic's admiration for his oeuvre's power to edify or instruct, to serve as a model.

Improbably enough, Matisse is linked in Greenberg's writing to Jackson Pollock: both manipulate their materials in ways that produce enjoyment for the viewer. In response to a critic who questioned his praise of Jackson Pollock as a mere predilection on Greenberg's part for violent romanticism, Greenberg responds in a letter of 1947:

[93] John O'Brian, "Greenberg's Matisse and the Problem of Avant-Garde Hedonism," *Reconstructing Modernism, Art in New York, Paris, and Montreal, 1945-64*, edited by Serge Guilbaut (Cambridge, London: MIT Press, 1990), 144-171. I am indebted to O'Brian's work on Greenberg in the discussion that follows. O'Brian is also the editor of *Clement Greenberg, The Collected Essays and Criticism*, 4 vols. (Chicago, London: University of Chicago Press, 1986-1993).

I do not prescribe to art, and I am willing to like anything, provided I enjoy it enough. That is my only criterion, ultimately. If I happen to enjoy Pollock more than any other contemporary American painter, it is not because I have an appetite for violent emotion but because Pollock seems to me a better painter than his contemporaries. *I also happen to think Matisse is the greatest painter of the day.* Is he an exponent of violence, irrationality, sensationalism or 'unwholesome romanticism'? Or is Cubism that? For I think Cubism the highest school of painting in our century (emphasis added).

It is notable that Greenberg has had to admit Matisse's greatness, not on the basis of highest historical importance, but in terms of quality and in terms of--surprisingly--his content or significance in the broadest sense. The latter point had been made a year earlier when the critic defended Matisse's hedonism as a form of positivism and materialism:

Positivism and materialism when they become pessimistic turn into hedonism, usually. The pathbreakers of the School of Paris, Matisse, Picasso, and Miró too . . .began to *provide* [pleasure]. But whereas the surrealists and the neo-romantics conceived of pleasure in terms of sentimental subject matter, Matisse, Picasso, and those who followed them saw it principally in luscious color, rich surfaces, decoratively inflected design. In Matisse's hands this hedonism signifies at times something quite other than the decadence many other people think to see in it. . . . his new [1946] still lifes, benefiting at last by post-Cubism, mark one more peak of Matisse's art. Their controlled sensuality, their careful sumptuousness, prove that the flesh is as

capable of virtue as the soul and can enjoy itself with
equal rigor (emphasis in the original).[94]

Thus Greenberg considered Matisse to be profoundly in touch with the
most fundamental tenor of the century, its pessimistic materialism
transmuted into hedonism. Greenberg parallels Aragon's nearly
contemporaneous "Apologie du Luxe," which lauds Matisse's hedonism
in terms of its materialist utopian vision.

Far from representing a "bourgeois sensibility" as Huyghe had
maintained, Greenberg claims that Matisse escaped it by his "cold
hedonism and ruthless exclusion of everything but the concrete,
immediate sensation [which] will in the future, once we are away from
the present *Zeitgeist*, be better understood as the most profound mood
of the first half of the twentieth century."[95] Already in 1948, before he
had seen Matisse's late cut-outs, his 1947-1948 paintings such as *Red
Studio,* or his large brush-and-ink drawings at the Pierre Matisse
Gallery in 1949, Greenberg had credited the urge to large-scale work
among Americans to the interest in Matisse's color and Picasso's
drawing and composition:

> Here in America there is also a general recognition
> among the most advanced young painters that Matisse
> and Picasso are indispensable to a great contemporary
> style but, in distinction to the French, they incline to
> accept more of Matisse than of Picasso. In
> Greenwich Village the attempt is being made to create
> a larger-scale easel art by expanding Matisse's hot
> color, raised several degrees in intensity, into the
> bigger, more simplified compositional schemes
> which he himself usually reserved for blacks, greys,

[94] Greenberg, *The Nation* (June 29, 1946); cited in O'Brian,
"Greenberg's Matisse," 153.

[95] Greenberg, *The Nation* (June 7, 1947), cited in O'Brian,
"Greenberg's Matisse," 159.

and blues--all of this to be articulated and varied with
the help of Picasso's calligraphy.[96]

Of course, by the mid-sixties all of these observations had
come to pass, both in abstract expressionism and color field painting.
Greenberg was able to assess Matisse's influence on young American
painters even more succinctly in his review-essay written on the
occasion of the 1966 Los Angeles retrospective, in which the full range
of Matisse's achievement could be seen (although only one large paper
cut-out, *The Sheaf* [1953], was shown).[97] Greenberg begins by
reasserting his claim to Matisse's quality and adds to it the French
painter's ability to teach. "[Matisse] establishes a *relevant* and abiding
standard of quality . . . he tells us in our time, more pertinently than
any other master can, what the art of painting is fundamentally about"
(emphasis in the original). Greenberg regards Fauvism as an
"unfinished" movement, interrupted by the impact of Cubism and
resumed toward the end of Matisse's life. Fauvism is developed to its
limits in Matisse's late 1947-1948 oils and in his paper cut-outs. It
ends where Cubism ends, according to Greenberg, in "altogether flat
abstract art," a post-cubist mode. Between these two Fauve epochs,
though not producing work in the 1920s that "advance[s] the historical
front of art," Greenberg affirms, Matisse nevertheless produced work
that included some canvases of "matchless perfection"; for example,
White Plumes (1919), *The Artist and his Model* (1919), and *Still Life
with Three Vases* (1935).

Greenberg explicates a notion of Matisse's "touch" in which
tactility operates (in the thin, stained, "breathing" pigment-application)
to project pure opticality and weightlessness. He also lauds Matisse's
cool deliberation that precedes execution, leaving the latter with the
charm of spontaneity, of a "slapdash" look. The oxymorons are fresh--
deliberative intuition, rigorous enjoyment, cold hedonism--but
Greenberg joins his French counterpart Jean Cassou, for example, in

[96] Greenberg, "The Situation of the Moment," *Partisan Review*
(January 1948), cited in O'Brian, *Greenberg, Collected Essays,* vol. 2,
194.

[97] Clement Greenberg, "Matisse in 1966," *Boston Museum Bulletin*
64, 366 (1966): 66-76.

ceding to Matisse both terms of these contrasting characteristics: the Apollonian center.

In 1973, Greenberg again synthesizes his views on Matisse in an essay, "Influences of Matisse," written for an Acquavella Galleries Matisse exhibition.[98] Here the critic again lists Matisse's "aerated" color touches as an important example for young painters but also the centrifugal opening out of Matisse's compositions toward an "all-over" centerless state, proper to mural painting. For Greenberg, this expansiveness makes the viewer continually aware of the "taut continuum of the picture surface." This quality was of crucial importance to Greenberg's theory of the progressive self-consciousness of twentieth-century art about its constitutive elements. Greenberg is rare in seeing at this time the influence on young painters of Matisse's cool, "post-prismatic" color (as in *Rose Marble Table* or *Bathers by a River)*, not the hot, saturated hues of Fauvism.

Greenberg also praises Matisse's coolness, modesty, and courage in not claiming for art more than it could offer; for rejecting the versions of "cant and fake feeling" and rhetoric common in his day. Greenberg says that the work itself speaks--through "form" and the "feeling" that the form expresses in an unrhetorical and honest way. Sincerity, quality, command of his medium and his means--this most formalist and influential American critic has not strayed so far from earlier French criteria in his evaluation of Matisse's contribution to modern art.

A new voice on Matisse was heard in the introduction to the Museum of Modern Art's 1966 selective exhibition, *Matisse, Sixty-four Paintings.* Lawrence Gowing, distinguished British painter, teacher, and art historian, expanded that show's essay, "Matisse, Harmony of Light," for the major *Matisse Retrospective* mounted by the Tate Gallery in 1968. (A further development of this text resulted in the 1979 monograph, *Matisse.)*[99] Gowing's text shows an

[98] Clement Greenberg, "Influences of Matisse," *Henri Matisse* (New York: Acquavella Gallery, 1973); exhibition catalogue.

[99] Lawrence Gowing, *Sixty-Four Paintings* (New York: Museum of Modern Art, 1966), exhibition catalogue; idem, *Henri Matisse: a Retrospective Exhibition* (London: Hayward Gallery, 1968), exhibition catalogue; idem, *Matisse* (London, New York: Thames and Hudson, Oxford University Press, 1979).

extraordinary sensitivity to the psychological makeup of Matisse as a man and integrates that understanding into his analysis of Matisse's search for the equivalent of light through color. Gowing explores Matisse's complicated psychic combination of timidity and stubbornness, repression and ruthlessness, for its effect on the controlled, yet ecstatic, sensuousness of his pictorial production. Gowing is at his best analyzing particular works with breathtaking virtuosity. He is also remarkably astute in penetrating the formal bourgeois mask that the artist habitually presented to the world, without descending to a vulgar psychologizing. "Looking to the end of the story," writes Gowing, "we can see that at root [Matisse] was demanding not less than the independent abstract re-creation of ideal conditions of existence--states of visible perfection from which the least possibility of physical frustration was eliminated."

Gowing's catalogue and the Tate exhibit itself produced a lively dialogue among artists about Matisse. Andrew Forge, Howard Hodgkin, and Phillip King argued Matisse's relevance in print in the *Studio*, discussing such matters as the "systemless" nature of Matisse's achievement, his care for "how the figure behaves" including the "figures" in the paper cut-outs, his persistence in returning to sensation as a starting place, the physicality of his color, and the contrast between Matisse's and American painters' use of color.[100] Generally laudatory, their opinions were challenged by Robert Melville in the *Architectural Review*.[101] Melville thought that Matisse's choice of rare and beautiful objects to paint, places him in the realm of interior decoration; he disliked the facile Art Nouveau curves that render some of Matisse's compositions shallow in more ways than one. He also thinks Gowing exaggerates Matisse's color effects, remarking that Gowing seems to desire a "psychedelic binge" of oceanic immersion in color and then to persuade himself that he finds it in Matisse's work.

Another young British artist, the sculptor William Tucker, responds to Matisse's sculpture at the Waddington Gallery in 1969 in a remarkable catalogue essay that would become the nucleus of a series of articles in 1970 and then part of a book on modern sculpture in

[100] Andrew Forge, Howard Hodgkin, and Phillip King, "Relevance of Matisse: a Discussion," *Studio* 176 (July 1968): 9-17.
[101] Robert Melville, "Matisse," *Architectural Review* 144 (October 1968): 292-94.

1974.[102] In the essay, Tucker first sketches out his theory about the tactile and the visual, the "grasped" and the "seen" in Matisse sculpture. These aspects normally work in tension and at cross-purposes to one another, but Matisse brings them into dynamic resolution in his best pieces. Tucker also suggests Matisse's relevance to "perceptual" (that is, minimal) sculpture, where content and fabrication are less dominant stimulants to the sculptor. While concentrating with a practitioner's astuteness on the sculpture itself, Tucker isolates it neither from Matisse's major project, painting, nor from his drawing.

Tucker's brilliant analysis of Matisse's work, along with a series of articles on Matisse's sculpture by Albert E. Elsen in 1968, opens the door to further work on the artist's sculpture. The only monograph on Matisse's sculpture, the indispensable scholarly study by Albert E. Elsen, *The Sculpture of Henri Matisse*, a revision and expansion of his earlier articles, appeared in in 1972.[103] (Alicia Legg's comprehensive catalogue essay for a major exhibition of Matisse's sculpture at the Museum of Modern Art appeared in the same year.) Elsen brings his formidable knowledge of Rodin and nineteenth- century sculptural practice to bear on his study of Matisse's three-dimensional oeuvre. Elsen's thorough, perceptive, and comprehensive treatment of the full range of Matisse's sculptural output has been complemented by the *Catalogue raisonné* of the sculpture, published in 1996.[104]

The literature on Matisse's sculpture had always been minor. One might cite a few outstanding articles during the artist's lifetime: Gaston Poulain's "Sculpture d'Henri Matisse" (1930); Lloyd Goodrich's

[102] William Tucker, "The Sculpture of Matisse," *Henri Matisse, 1869-1954, Sculpture* (London: Waddington Gallery, 1969), exhibition catalogue; idem, "Four Sculptors: Part 3: Matisse," *Studio International* (September 1970): 82-87; idem, "Matisse's Sculpture: The Grasped and the Seen," *Art in America* 63 (July-August 1975): 62-68.

[103] Albert E. Elsen, *The Sculpture of Henri Matisse* (New York: Abrams, 1972); Alicia Legg, *The Sculpture of Henri Matisse* (New York: Museum of Modern Art, 1972); exhibition catalogue.

[104] Claude Duthuit, *Henri Matisse--catalogue raisonné des ouvrages sculptés*. Paris: Ed. by the author with the collaboration of Françoise Garnaud and preface by Yve-Alain Bois, 1996 (forthcoming).

"Matisse's Sculpture" (1931); P.-L. Rinuy's "1907: Naissance de la sculpture moderne, le renouveau de la taille directe en France" (1933); Pierre Guéguen's "Sculpture d'un grand peintre" (1938); Jean Cassou's introduction to a 1953 Tate Gallery exhibition, *The Sculpture of Henri Matisse and Three Paintings with Studies;* and a review of that exhibition by David Sylvester, "The Sculpture of Matisse" (1953).[105] Good overview essays include B. Hüttinger and U. Lindes's Introduction to the catalogue *Henri Matisse, Das Plastische Werk* (1959); Herbert Read's "The Sculpture of Henri Matisse" from the Los Angeles 1966 Retrospective; and Hilton Kramer's review of that exhibition "Matisse as a Sculptor" (1966).[106] In general, critics have felt more free to offer negative evaluations of certain of Matisse's sculptures or to see the entire sculptural oeuvre as insignificant or minor--either with respect to the artist's overall achievement or to the history of modern sculpture. Not until more comprehensive shows of the sculpture and some close analysis of specific works did more favorable evaluations emerge.

In the late 1960s, work that dealt with specific aspects of Matisse's work, either iconographically or stylistically, began to be published, and this continued strongly into the 1970s. A case in point is Carla Gottlieb's 1964 intensive art historical study of "The Role of the Window in the Art of Matisse," in which the author treats the theme of the window in European art, in Matisse's work in general, and in a wide variety of his individual works. She also treats the motif in symbolist literature as a model or equivalent of modern art itself.[107] Equally significant is the beginning of close analysis of the development of the artist's style in Jack Flam's important study

[105] Gaston Poulain, "Sculpture d'Henri Matisse," *Formes* 9 (November 1930): 9-10; Lloyd Goodrich, "Matisse's Sculpture," *Arts* 17 (February 1931): 253-55; Paul-Louis Rinuy, "1907: Naissance de la sculpture moderne, le renouveau de la taille directe en France," *Histoire de l'art* 3 (1933): 67-76; Pierre Guéguen, "Sculpture d'un grand peintre," *XXème siècle* 4 (1938); Jean Cassou, *The Sculpture of Henri Matisse and Three Paintings with Studies* (London: Tate Gallery, 1953), exhibition catalogue; David Sylvester, "The Sculpture of Matisse," *Country Life* 113 (January 23, 1953): 224.

[106] Hilton Kramer, "Matisse as a Sculptor," *Bulletin of the Boston Museum of Fine Arts* 64, 336 (1966): 49-65.

[107] Carla Gottlieb, "The Role of the Window in the Art of Matisse," *Journal of Aesthetics and Art Criticism* 22 (Summer 1964): 393-422.

garde (arguably male-dominated) forms of collage.[122] The lowly status
of the decorative had been equated with the "feminine" in twentieth-
century art, and Schapiro, as a feminist, intends to invest it with
"human, social, and political significance" in her large-scale, boldly
colored and patterned, pasted compositions. Broude discusses Matisse
and Kandinsky as examples of male artists who came to abstraction by
way of the decorative, the former being credited with more openly
acknowledging this and being more "androgynous" with regard to the
decorative.

Also feminist in its treatment of Fauvism, Cubism, and
German Expressionism is Carol Duncan's article "Virility and
Domination in Early Twentieth Century Vanguard Painting."[123]
Duncan analyzes the habitual use of a female model, often a barely
disguised mistress or prostitute, in reclining or supine positions, as
significant for the analysis of a masculinist and sexualized view of
artistic creative power, in which the female is also the subject of that
power in social, sexual, and economic ways. In modern art, idealized
female beauty is forthrightly relinquished for a more naked sexuality--
the province of the earthy, self-affirming, instinctual artist who fulfills
his appetites and impulses. The male's response is made the "general"
response. Duncan partially excludes Matisse from her harshest
criticism because of Matisse's tendency to, again, androgynize the
figure, especially in works such as *Joy of Life.*

Margaret Werth's study, "Engendering Imaginary Modernism:
Henri Matisse's *Bonheur de Vivre"* is a far more poststructuralist, even
postmodern, analysis of the same painting, *Joy of Life.*[124] Werth's
essay is part of a larger study of Western art's complex use of the

[122] Norma Broude, "Miriam Schapiro and 'Femmage': Reflections on
the Conflict Between Decoration and Abstraction in the Twentieth-
Century Art," *Feminism and Art History, Questioning the Litany*
(New York: Harper and Row, 1982), edited by Norma Broude and Mary
D. Garrard.
[123] Carol Duncan, "Virility and Domination in Early Twentieth
Century Vanguard Painting," *Artforum* (December 1973): 30-39,
reprinted (revised) in *Feminism and Art History,* edited by Norma
Broude and Mary D. Garrard.
[124] Margaret Werth, "Engendering Imaginary Modernism: Henri
Matisse's *Bonheur de Vivre,"* *Genders* 9 (Fall 1990): 49-74.

powerful group of museum curators and private scholars was assembled. Together they would be the major force behind the powerful surge of Matisse exhibitions and accompanying scholarship of the next two decades.

The course of contemporary art and of formalist art criticism in the 1950s and 1960s thus brought about an appreciation of Matisse as an innovator in the fields of color, planarity, and tactile surface and of composition through shape, edge, and serial repetition. Although these views privileged the early and late works of Matisse (pre-1917, post-1931), these formalist grounds allowed the early Nice works to be valued by American and British writers on the basis of the same criteria, as we have seen in Barr, Greenberg, and Gowing. Although Matisse's subject matter and sensibility saved him from being considered an emptily "decorative" artist, these aspects of his work also blocked his entry to the pantheon of "pure" abstractionists or non-objective artists, except insofar as the critics themselves could do the "abstracting" by ignoring or downplaying image and content in the artist's work.

V

Reassessments, 1970 -1993:
From the Centenary Exhibition to the Museum of Modern Art
Retrospective.

In the late sixties and early seventies, a sea-change of attitude toward art and art writing occurred on both sides of the Atlantic, partly in response to the cultural reevaluations and social changes of the period. An existentialist frame of reference gave way in France to that of structuralism and linguistic formalism, while the dominance of Sartrean literature of political engagement was swept away by post-1968 radical activisms. Some aspects of Greenbergian formalism were received in France as a refreshing alternate model of theory and critical style. In the United States minimalism and conceptual art had replaced the romanticism of Abstract Expressionism as the reigning esthetic paradigm. A revolutionary neo-Dada, which had coexisted with the more intellectual minimalism and conceptualism, itself gave way to a new interest in cybernetics and the electronic information explosion, and to race and gender issues.

Matisse studies were caught up in this change at first in a fairly limited way. Attention to Matisse was rekindled by two events

of the early 1970s. The first was the 1970 major retrospective in Paris, *Henri Matisse, Exposition du Centenaire*, organized by Pierre Schneider with the cooperation of the Matisse heirs. The second was the publication of separate French and English collections of Matisse's writings and interviews: Dominque Fourcade's *Henri Matisse, Écrits et propos sur l'art* (1972) and Jack D. Flam's *Matisse on Art* (1973).[109] The Paris centenary exhibition of Matisse's birth, with important works drawn from Russian as well as American collections, exposed the French and European public to the full range of Matisse's more "abstract" works from the early and late periods and demonstrated their importance for the history of twentieth-century art. By means of the collected writings, moreover, Matisse's own voice could be heard once more explicating the premises of his art, outlining the stages of his research, insisting on the sincerity and laboriousness of his efforts. Schneider, Flam, and Fourcade were all to be major interpreters of Matisse for the following two decades.

Pierre Schneider--poet, critic, former secretary to Georges Duthuit, and writer for *Tel Quel*, the anti-Sartrean journal of letters that propagated structuralism and the nouveau roman from 1960 on--evolved a reading of Matisse's themes and processes that was fully disclosed only in his 1994 monograph, *Matisse* (Flammarion, 1984, rev. 1993) but that was first sketched in his 1970 catalogue for the Matisse Centenary show. Schneider makes a case for Matisse's revolutionary credentials on new grounds. He quotes the arch-revolutionary Marcel Duchamp (who had presided over his own neo-Dada revival in the 1960s); Duchamp had said that "the greatest of all is Matisse." According to Schneider, Matisse, like Duchamp at the beginning of the century, recognized the bankruptcy of post-Renaissance art. But whereas Duchamp mounted a negative critique, Matisse constructed a new solution. The old esthetic based on beauty and on imitation was rejected by Matisse in favor of one based on intuition and feeling, on the goal of well-being and service to the "greater spiritual family."

Matisse's language, Schneider observes, is the language of relationships--metaphors, analogies, and equivalents, all of which bridge both the gap between things and that between art and life. "I do not paint things, " Schneider quotes Matisse as saying, " I paint the harmony between things." Matisse also painted (and effected in the act

[109] Schneider, Fourcade, and Flam, notes 2 and 3.

of painting) the harmonious identification of himself with the world. Unity with nature and release from the ego's demands are the result. "Rapport is the kinship between things, it is the common language; the rapport is love, yes, love," Matisse insisted. The enclosed world of goldfish in glass bowls and the transparent substance of the window are two of Matisse's most beloved motifs; according to Schneider, they are places where the separation between interior and exterior is visually and psychologically bridged. In Matisse's later work, metaphoric images are further reduced to the terseness and clarity of signs.

Schneider turns the viewer's attention to the emotional richness, the content, and the function of Matisse's art. He deals with these issues in a free and fluid interpretation of Matisse's oeuvre as a text, a signifying whole that invites a ruminative reading. In a study that is thematic rather than chronological, he probes for the fundamental structural patterns that underlie the whole enterprise of Matisse's artmaking. Schneider maintains that Matisse sublimates sensory impressions into sacred epiphanies; Matisse uses "mindless" decoration to achieve mind-enhancing states of bliss. Schneider's psychological profile of the artist as a seeker of something analogous to religious contemplation is accompanied by much new biographical data, excerpts from unpublished letters, and previously unpublished material, including art works, from the Matisse family archives.

The author pursues his theme in his important 1975 article "Striped Pajama Icon *[Conversation],*" where the painting is viewed as an instance of the artist's ability to reveal in the everyday domestic event, the point where the "what" of bourgeois reality and the "how" of modern painting lose their tension in a harmony of opposites.[110] Schneider interprets Matisse's mythological themes in the light of the Golden Age, the religion of happiness, in his catalogue essay for the 1981 exhibition *Henri Matisse, Das Goldene Zeitalter.* [111] Schneider's wise and weighty (it runs to nearly 800 pages) monograph *Matisse* was

[110] Pierre Schneider, "Striped Pajama Icon," *Art in America* 63, 4 (July 1975): 76-82.
[111] Pierre Schneider, *Henri Matisse, Das Goldene Zeitalter* (Bielefeld: Kunsthalle, 1981); exhibition catalogue.

received in 1984 as a major publishing event, felt at every level of Matisse scholarship during the next ten years. [112]

Closely following upon the 1970 centenary catalogue, Louis Aragon's two-volume work *Matisse: roman* appeared in 1971. Aragon's study, like Schneider's later book (both were published simultaneously in French and English), is poetic, personal, and partisan in its interpretation of Matisse's work. Whereas Schneider's thesis everywhere informs his discussion of the artist, Aragon's text is more heterogeneous and occasional. The book contains previously published articles and new essays, with marginal comments recorded by Matisse himself on the essays that were published during his lifetime. It treats art and the poetic project in a more general way, with Matisse and Aragon himself as exemplifying the practice of art. The overriding note in Aragon's book is wonder--at Matisse's sensibility and sagacity, and a secret and smiling complicity between one creative artist and another. Both Aragon and Schneider allow themselves speculations, divagations, and interpretive flights foreign to more empirically minded American art historians. It is a kind of post-structuralism *avant la lettre*, a free play with the text "Matisse" by literary men writing their own open texts.

Another such open reading of Matisse's work (and written texts) was Marcelin Pleynet's "Système de Matisse," published in 1972. Informed by binary structuralist polarities such as scientific/ subjective, active invention/ passive copy, subject (self)/ model (other), matter/ essence, exposure/ repression, grammar/ preverbal image, painted woman/ mother, Pleynet's semiotic and psychoanalytic analysis of Matisse's "system" considers fully his sexuality (desire) and his language (signs). After a rumination on Matisse's life, work, and writings, the author claims that Matisse's "program" negotiates these creative and critical oppositions, weaving a tissue of contradictions into an interlocked whole, reflected in his name: Ma-tisse. Pleynet continued to write on Matisse in the following decades, culminating in his monograph *Henri Matisse, Qui êtes-vous?* (Lyons: La Manufacture, 1988).

When the writings of Matisse were published in French in Dominique Fourcade's invaluable collection and in English in Jack

[112] Pierre Schneider, *Matisse* (Paris: Flammarion, 1984); Eng. ed., *Matisse* (New York: Rizzoli, 1984); reissued with slight revision and a new preface, Flammarion and Rizzoli, 1993.

Flam's fine anthology, the effect was as stunning as the Centenary show. Entire issues of *La Nouvelle revue française* and *XXe siècle* (1970), *Critique* (1974), *Arts Magazine* and *Art in America* (1975) were devoted to the Matisse exhibition and/or texts. Fourcade's collection facilitates thematic study by being indexed according to topics such as Inconscient, Fenêtre, Espace, and Divin. The footnotes are also rich in citations that could be quoted only in short excerpts for "fair use," or from letters. Flam's anthology, on the other hand, contains only relatively long, published texts, but each is preceded by a substantial introductory note and accompanied by informative footnotes. The whole is also preceded by an excellent synthesizing preface on the artist's career and is followed by a post-1951 bibliography.

Jean-Claude Lebensztejn's intricate structuralist review-essay of both books, "Les Textes du Peintre," and Yve-Alain Bois's semiotic analysis of them, "Legendes de Matisse," both appeared in the special issue of *Critique* of 1974.[113] Lebensztejn's analysis includes a discussion of three aspects of Matisse's color: its auto-referentiality; its ability to function only by means of relations, that is, syntagmatically; and color's constructive properties that ultimately, in Matisse's work, merge with "drawing," to create an expanding visual field that overflows and tests the limits of painting and of art itself. Bois, formerly a student of Roland Barthes, also scrutinizes the artist's texts and works under a semiotic lens through a series of evocative concepts, such as Labyrinth, Limit, Window, Structure, and Return, among others. Through these, he explores the paintings in terms of language and silence, of fluid or fixed (transparent) signs, and of the artist's "doubleness" in both his writing and his art. Already present in this early study are the ideas that Bois would unpack and develop in later important articles on Matisse: "Matisse Redrawn" and "Matisse and 'Arche-drawing'."[114]

[113] *Critique* 30, 324 (May 1974).

[114] Yve-Alain Bois, "Matisse Redrawn," *Art in America* 73 (September 1985): 126-31; idem, "Matisse and 'Arche-Drawing'," *Painting as Model* (Cambridge, London: MIT Press, 1990). Other articles of note on the texts are Kate Linker's "Matisse and the Language of Signs" and Mark Roskill's "Matisse on His Art and What

Untouched to a greater or lesser extent by the interdisciplinary currents of French structuralism and post-structuralism, important traditional art historical studies appeared in the 1970s and 1980s, one in the guise of a biographical monograph, others as catalogues of the major Matisse collections, and still others in exhibition catalogues. The last include *Matisse in Morocco; Matisse, the Early Years in Nice;* and *Matisse, the Paper Cut-Outs,* each of which investigates very particular, under-researched aspects of Matisse's oeuvre. In 1986 Jack D. Flam produced the first volume of *Matisse, the Man and His Art, 1869-1918,* the most ambitious art historical study of Matisse since Alfred Barr's comprehensive monograph of some thirty-five years earlier.[115] The first of a projected two-volume study, Flam's parallel title betrays an objective similar to Barr's. Flam works his way chronologically through Matisse's life and career, detailing influences, developments of style, and personal crises. He also pauses to analyze in some detail particular works or groups of work, both iconographically and stylistically, in all media. Biography, history, style history, interpretive analysis of works, and psychological analysis of the producing artist--all are woven into a relatively seamless narrative. Flam impressively adds new information on Matisse's personal life, corrects dating of specific works, offers counter-arguments to existing interpretations.

The same kind of traditional art historical research was deployed in collection catalogues. Under John Elderfield, The Museum of Modern Art produced an exemplary catalogue in 1979 *Matisse in the Collection of the Museum of Modern Art,* where each work in the collection is carefully discussed and documented. Equally comprehensive are the catalogues from the other major Matisse collections: Isabelle Monod Fontaine's *Matisse: Collections du Musée Nationale d'Art Moderne* (1979), substantially enlarged with Anne Baldassari in 1989 as *Matisse: Oeuvres de Henri Matisse du Musée Nationale d'Art Moderne;* A. Izerghina's *Henri Matisse, Paintings and Sculpture in Soviet Museums* (1978); Dominique Fourcade's *Matisse au Musée de*

He Did Not Say" in *Arts Magazine* 49, 9 (May 1975): 76-78 and 62-63.

[115] Jack D. Flam, *Matisse, the Man and His Art, 1869-1918* (Ithaca and London: Cornell University Press, Thames and Hudson, 1986).

Grenoble (1975); and Brenda Richardson's *Dr. Claribel and Miss Etta Cone: the Cone Collection of the Baltimore Museum of Art* (1985).

Within the art world in the 1970s, the "decorative" became a major topic, both as a vital and controversial aspect of contemporary art practice and as an underlying construct that shaped Matisse's esthetic. The 1977 exhibition *Henri Matisse, the Paper Cut-Outs* (shown in Washington, D.C., Detroit, and Saint Louis) was, therefore, extremely timely.[116] The dazzling display of all the major works in the medium could not have been more relevant in a decade in which contemporary "pattern painting" challenged both the high-minded posture of politically engaged art and the lingering hegemony of abstract art (seen to be implicitly gender-specified as male).

The Matisse catalogue confines itself to the role of the cut-outs in Matisse's oeuvre. John Hallmark Neff's essay, "Matisse, His Cut-Outs and the Ultimate Method," demonstrates the synthetic and culminating quality of the works, claiming that Matisse, in the gesture of cutting, integrated his action with his conception, attaining creation in pure process. Dominique Fourcade, on the other hand, in his catalogue contribution "Something Else" terms admirable the courage of Matisse in tackling an entirely new project but finds the results somewhat less than fully successful. Jack Flam's essay in the same catalogue is confined to Matisse's seminal paper cut-out work, *Jazz*, newly appreciated for the richness of its iconography, the variety of its color-composition solutions, and the depth of its text, written by the artist. The catalogue, introduced by Jack Cowart, includes self-sufficient paper cut-outs, maquettes, works transposed into other materials, and cut-outs used in graphic designs. Richly illustrated with documentary photos (as well as the works exhibited) and carefully annotated, the catalogue is a model of intelligent scholarship. Also included is a "Technical Appendix" by Antoinette King on the conservation of these often-fragile works and a "Documents Appendix" of letters concerning the cut-outs from Matisse to patrons, curators, dealers, and writers.

116 *Henri Matisse, the Paper Cut-Outs* (Washington, D. C., 1977. The Bern exhibition of 1959 had been quickly followed by the Paris Musée des Arts Décoratifs and New York MoMA shows of 1961: *Henri Matisse, les grandes gouaches découpées* (Paris: Musée des Arts Décoratifs, 1961) and *The Last Works of Henri Matisse, Large Cut Gouaches* (New York: Museum of Modern Art, 1961).

The history of Matisse's early decorative commissions had been opened up by John Hallmark Neff in his dissertation, parts of which were published in the mid-1970s. A two-part article, "Matisse and Decoration," sketches changing views of the decorative as found in manuals of the period on the decorative arts (with surprising parallels to Matisse's formulations). Neff also discusses the decorative nature of the Shchukin commissions leading up to the *Dance* and *Music* panels. A second article, "Matisse and Decoration: the Shchukin Panels," expands our understanding of the iconography of *Dance* and *Music*, establishing for the first time that Matisse's *Bathers by the River* (1916) was originally projected as the third panel in this series. Two decorative commissions by Matisse, long forgotten or unknown, were brought to light by Neff in "An Early Ceramic Triptych *[Nymph and Satyr]* by Henri Matisse," and "Matisse's Forgotten Stained Glass Commission."[117] Neff's original research is crucial in establishing the artist's very early involvement with the applied arts.

The significance of the decorative for early modernism is extensively traced by Joseph Masheck in his article "The Carpet Paradigm: Critical Prolegomena to a Theory of Flatness." Masheck traces the metaphor of the "Persia carpet" for those qualities of flatness of design, objectlessness, and formal beauty that are to be found in late nineteenth-and twentieth-century proto-abstract art.[118] Rich in references to the history of design as well as of painting (subtly distinguishing yet entwining the two) and in references to literature of the period, Masheck's study examines the "carpet paradigm," inextricably linking the abstract to the decorative, until its decline in the era of Cubism. While not specifically on Matisse, the study has many applications to Matisse's work, as does Stephen Levine's "Décor/

[117] John H. Neff, "Matisse and Decoration, an Introduction, Part I," *Arts Magazine* 49 (May 1975): 59-61 and "Matisse and Decoration, Part II," (June 1975): 85; idem, "Matisse and the Shchukin Panels," *Art in America* 63 (July-August 1975): 38-48; idem, "An Early Ceramic Triptych by Henri Matisse," *Burlington Magazine* 114 (December 1973) 848-53, and "Matisse's Forgotten Stained Glass Commission," ibid., 114 (December 1972): 867-70.
[118] Joseph Masheck, "The Carpet Paradigm: Critical Prolegomena to a Theory of Flatness," *Arts Magazine* 51 (September 1976): 93-110.

Decorative/Decoration in Claude Monet's Art."[119] The latter study on the changing valuation of the decorative during the Symbolist period has immense implications for understanding Matisse's investment of decoration with significant content, a possibility Levine shows as present in Matisse's early artistic milieu.

An art historian of Islamic art, Amy Goldin, some of whose students became known as "Pattern Painters" in the 1970s, also wrote on Matisse's work from the standpoint of the decorative. Her essay, "Matisse and Decoration: the Late Cut-Outs," boldly confronts the differences between decoration and ornamentation and between decorative genres (bland, contentless, intercultural) and pictorial ones (focused, content laden, culture specific).[120] She claims for Matisse a risky turning from one mode to the other--not entirely successfully, in Goldin's judgment, as she notes that Matisse was not naturally adept in pattern-making, but more skilled in handling the field-and-frame problems of large mural surfaces. Subsequent articles by Goldin, "Patterns, Grids, and Paintings" and "The Body Language of Pictures," pursue this issue in a more general way. The latter article responds to Dominique Fourcade's critical assessment (in *Henri Matisse, the Paper Cut-Outs*) of the failure of Matisse's paper cut-outs to achieve a satisfactory spatiality and to integrate color and line.[121] Stimulated by Fourcade's critique of Matisse, Golden explores formal questions fundamental to evaluating Matisse's late work.

Decorative issues drew Matisse somewhat into the politics of feminism as well. In the 1970s some women artists used pattern, mural scale, and "dressmaking" materials as a challenge to the high art conventions of self-referential, minimalist abstraction. In "Miriam Schapiro and 'Femmage': Reflections on the Conflict Between Decoration and Abstraction in Twentieth-Century Art," Norma Broude discusses the work of Miriam Schapiro, who invented the term "femmage" to distinguish the collage format she uses from other avant-

[119] Stephen Z. Levine, "Décor / Decorative / Decoration in Claude Monet's Art," *Arts Magazine* 51 (February 1977): 136-39.

[120] Amy Goldin, "Matisse and Decoration: the Late Cut-Outs," *Art in America* 63 (July-August 1975): 49-59.

[121] Amy Goldin, " Patterns, Grids and Paintings," *Artforum* 14, 1 (September 1975): 50-54; idem, "The Body Language of Pictures," *Artforum* 16, 7 (March 1978): 54-59.

"Matisse in 1911: At the Crossroads of Modern Painting."[108] In this article, the author carefully investigates a number of works of that year, including *The Painter's Family, Interior with Eggplants, Goldfish and Sculpture, The Red Studio* and *The Blue Window*. He analyzes the exact nature of Matisse's response to Cubism in the invention of another kind of spatial allusion, based on the deployment of pattern, the use of single-color composition, and/or the structuring of composition by grid-like zones.

Instead of overall assessments and broad generalizations, those articles begin the real work of in-depth study of separable aspects of the artist's considerable oeuvre. Two Ph.D. dissertations begun at this juncture were to have repercussions in the next decades: John W. Cowart's "'Écoliers' to 'Fauves,' Matisse, Marquet, and Manguin Drawings: 1890-1906" (Johns Hopkins University, 1972) and John Hallmark Neff's "Matisse and Decoration, 1906-1914: Studies of the Ceramics and the Commissions for Paintings and Stained Glass" (Harvard University, 1974). The former study closely examines the Beaux-Arts training in drawing undergone by these future Fauves and analyzes the development of their drawing techniques in relation to the comparable one in color usage that is more traditionally associated with Fauvism. Neff's study unearths a wealth of new data on Matisse's early (and largely unknown or underrated) decorative works and situates this work in the milieu that valued these works as fundamental to modernist aspirations.

Neff and especially Jack Cowart were to become important agents in the effort to mount significant scholarly exhibitions on aspects of Matisse's work in the next two decades. Both were involved --along with Jack Flam and Dominique Fourcade--in the *Henri Matisse: the Paper Cut-Outs* show of 1977; Cowart and Fourcade mounted the *Matisse: the Early Years in Nice* exhibition of 1986-87. With Pierre Schneider, Cowart organized the *Matisse in Morocco* show of 1990, enlisting the aid of John Elderfield of the Museum of Modern Art and Albert Kostenevich, chief curator of modern art at the Hermitage Museum in Leningrad. Thus, with the future collaboration of Isabelle Monod-Fontaine of the Musée Nationale d'Art Moderne of Paris, a

[108] Jack D. Flam, "Matisse in 1911: At the Cross-Roads of Modern Painting," *Actes du XXIIe congrès international d'histoire de l'art* (1969), vol 2 . Budapest, 1972, 421-30.

utopic, the pastoral, and the Golden Age, a usage that often embodies the tension between reposeful erotic pleasure and the social and psychological demands of modern life. The sexual ambiguities of Matisse's arcadian figures and the stylistic and emotional discrepencies of the image, according to Werth, destabilize the viewer's position in relating to the scene. Werth uses a psychoanalytic model to discuss the projection of infantile fantasies of maternal seduction, castration, and the primal scene in Matisse's figures from *Joy of Life*.

Critiques of Matisse's subject matter, particularly his Odalisques, multiplied with the 1984 exhibition *Henri Matisse, The Early Years in Nice, 1916-1930*. Some writers found it objectionable on political grounds that the often scorned 1920s works received a respectful and somewhat revisionist treatment in the exhibition catalogue and that current taste (that of the figurative, pluralistic 1980s) found the works pleasurable. The most forthright criticism was mounted in "Matisse's Retour à l'Ordre," [125] by Kenneth Silver, for whom these works pander historically to the right-wing French government's conservative "call to order." According to Silver, the Odalisque paintings, one of which was purchased by the French government in 1922, exemplify France's post-war exploitation of its colonies, evoked by Matisse's harem-like settings. Silver also views them as "anti-modern" because they reverse the pre-war impulse to challenge the realist-impressionist "representation" of the bourgeois world; he contrasts Matisse's pre-war male portraits painted in Morocco with those of the ubiquitous idle females of the 1920s. Marilyn Board joins Silver in seeing the Nice works as symptomatic of the pervasive patriarchal dominance, colonialist imperialism, and psychosexual fantasies of French culture of the period in her essay "Constructing Myths and Ideologies in Matisse's Odalisques." [126]

The issue was joined again with the Museum of Modern Art exhibition *Matisse in Morocco* of 1990. Roger Benjamin takes up the issue in "Matisse in Morocco: A Colonizing Esthetic?", in which the

[125] Kenneth Silver, "Matisse's Retour à l'Ordre," *Art in America* 75, 6 (June 1987): 110-23.

[126] Marilyn Board, "Constructing Myths and Ideologies in Matisse's Odalisques," *Genders* 5 (Summer 1989): 21-49.

question is weighed without ideological pre-judgment.[127] His subtle
review of the Moroccan work admits the stimulus of North Africa to
Matisse's utopian thematics and his modernist (painterly and
abstracting) style but suggests that the artist's use of the "Orient"
cannot be divorced from prevailing French attitudes towards the Third
World found in the ethnography, literature, painting, and photography
of the period.

Fauvism also has been treated from the viewpoint of the
political left, occasioned by the Los Angeles County Museum's
traveling exhibition *The Fauve Landscape* in 1990.[128] The catalogue
considers only the geography of the Fauve landscapes and townscapes,
which links them to those of Impressionism in choosing highly
popular and much photographed tourist sites. What these vacation
spots mean--in terms of bourgeois leisure, the commercialization of
villages and small towns, the spoliation of the countryside by industry,
the packaging of "nature" for rapid consumption, and the nostalgic
longing for arcadian sites--are seen by the catalogue contributers in
social and political terms. Fauve paintings play to these bourgeois
tastes, it is maintained, while giving them a modern "fine art" gloss.

James Herbert, one of the catalogue essayists, expands these
ideas in his book *Fauve Painting, the Making of Cultural Politics* an
ambitious attempt to relate French chauvinist, colonialist, and
nationalist agendas to the work of Fauve painters.[129] Matisse's
paintings, in particular, are seen to instantiate the pervasive
exploitation of others--women, North Africans, Negro culture--in the
deceptively neutral acts of gazing, painting, and vacationing. Roger
Benjamin, another contributor to the *Fauve Landscape* catalogue,
continues the discussion of these issues in his article "The Decorative
Landscape, Fauvism, and the Arabesque of Observation," but proposes

[127] Roger Benjamin, "Matisse in Morocco: A Colonizing
Esthetic?", *Art in America* 78, 11 (November 1990): 155-165, 211,
213.

[128] Judi Freeman, ed., *The Fauve Landscape* (Los Angeles and New
York: Los Angeles County Museum of Art and Abbeville Press, 1990),
with contributions by Roger Benjamin, James D. Herbert, John Klein,
and Alvin Martin.

[129] James D. Herbert, *Fauve Painting, the Making of Cultural
Politics* (New Haven and London: Yale University Press, 1992).

that one look more closely at the (highly artificial) conventions of landscape to which the Fauve painters were heir, rather than concentrating on the sites represented.[130] He also discusses the arabesque and its tradition as a decorative figure by which the landscape is both abstracted and feminized.

In the scholarship of the last decades, art historians have more fully explored the relationship between Fauvism and the art of Black Africa, North Africa, and Persia. The pioneer work that traced this link was Robert Goldwater's "The Primitivism of the Fauves," in his study *Primitivism and Modern Painting,* first published in 1938 and continuously in print since then. Jean Laude's study *La Peinture française (1905-1914) et 'L'Art nègre'* has also dealt searchingly with the question in a subtle and balanced way. Finally, Jack Flam's contribution "Matisse and the Fauves" presented new scholarship in the superb two-volume catalogue for the controversial exhibition *"Primitivism" in 20th Century Art: Affinity of the Tribal and the Modern* of 1984. Flam's careful historical essay stays close to the empirical data on the African works that Matisse owned or could have examined and grounds his findings on close analyses of specific works.[131]

Although much fundamental research on Matisse remains to be done, progress has been made since 1970. The Matisse heirs have produced three partial catalogues raisonnés: on Matisse's prints, on the books that he designed or illustrated, and on his sculpture.[132] The

[130] Roger Benjamin, "The Decorative Landscape, Fauvism, and the Arabesque of Observation," *The Art Bulletin* 72, 2 (June 1993): 295-316.

[131] Robert Goldwater, *Primitivism and Modern Painting* (1938), enlarged as *Primitivism and Modern Art* (Cambridge, Mass. and London: The Belknap Press of Harvard Universtiy, 1986); Jean Laude, *La Peinture française (1905-1914) et "L'Art nègre,"* 2 vols. (Paris: Éditions Klincksieck, 1968); William Rubin, ed. , *"Primitivism" in 20th Century Art: Affinity of the Tribal and Modern,* 2 vols. (New York: Museum of Modern Art, 1984).

[132] Marguerite Duthuit and Claude Duthuit, *Henri Matisse: Catalogue raisonné de l'oeuvre gravé* , with the collaboration of Françoise Garnaud, preface by Jean Guichard-Meili. 2 vols. (Paris: C. Duthuit, Imprimerie Union, 1983); Claude Duthuit, *Henri Matisse: Catalogue raisonné des ouvrages illustrés* , with the collaboration of

closest thing to a catalogue raisonné of the paintings is Mario Luzi and Massimo Carrà's *L'Opera di Matisse: Dalla rivolta Fauve all'intimismo 1904-28*, which is by no means complete or fully accurate but still useful.[133] Some of Matisse's correspondence--with Pierre Bonnard, Charles Camoin, Théodore Pallady, among others--has been published.[134]

In Matisse's *"Notes of a Painter," Criticism, Theory, and Context, 1891-1908*, Roger Benjamin published a detailed study of Matisse's most important essay, placing it in the context of "the intellectual conditions which attended its production."[135] Benjamin reviews the antecedant critical writings that affected Matisse's essay, discusses the reception-history of the artist's work to which Matisse's text responds, and elucidates the artist's use of the word "expression" in terms of its contemporary usage. This important work examines Matisse's esthetic ideas in their historical framework against a conditioning, but not determining, ground. A number of other important studies document the artist's relation to specific artistic styles or movements: John Golding's *Matisse and Cubism* (1978), which is still the ur-text on this topic; Catherine C. Bock's *Matisse and Neo-Impressionism, 1898-1908* (1981), a study which argues that

Françoise Garnaud, introduction by Jean Guichard-Meili. (Paris: Imprimerie Union, 1987), in French and English; Claude Duthuit, *Henri Matisse: Catalogue raisonné des ouvrages sculptés*, with the collaboration of Françoise Garnaud, introduction by Yve-Alain Bois. (Paris: Imprimerie Union, 1996).

[133] Mario Luzi and Massimo Carrà, *L'Opera di Matisse: Dalla rivolta Fauve all'intimismo, 1904-1928* (Milan: Rizzoli, 1971); Fr. ed. , with new introduction by Pierre Schneider, *Tout l'Oeuvre Peint de Matisse 1904-1928* (Paris: Flammarion, 1982); Dutch ed. 1976.

[134] Antoine Terrasse, ed., *Bonnard-Matisse Correspondance (1925-1946)*. preface by Jean Clair (Paris: Gallimard, 1991); English and French ed., *Bonnard/ Matisse: Letters Between Friends, 1925-1946*. (New York: Abrams, 1992); Danièle Giraudy, ed., "Correspondance Henri Matisse-Charles Camoin," *La Revue de l'art* 12 (1971): 7-34; Barbu Brezianu, ed., "Correspondance Matisse-Pallady (extraits)," *Secolul* 20, 6 (1965).

[135] Roger Benjamin, *Matisse's "Notes of a Painter," Criticism, Theory, and Context, 1891-1908* (Ann Arbor, Mich: UMI Research Press, 1987).

pointillism's "scientific" study of color was fundamental to Matisse's relational use of it; Feveshteh Daftari's chapter on Matisse in *Influence of Persian Art on Gauguin, Matisse, and Kandinsky* (1991), which closely traces the actual Persian works the artist could have seen and what he might have drawn from them; Kenneth Bendiner's "Matisse and Surrealism" (1992), the first intensive study of the impact of Breton's movement on Matisse's ideas and practice; and Albert Kostenevich's and Natalya Semyonova's *Matisse en Russie* (1993, Eng. ed., *Collecting Matisse*), a close look at Matisse's dealings with his two Russian patrons and his critics, with documentation drawn from Russian archives. Matisse's paintings in the former Shchukin and Morosov collections are given a fresh and penetrating review by Kostenevich.

The only straightforward biography of Matisse has appeared recently, Haydon Herrera's *Henri Matisse: A Portrait,* of 1993, which, however, simply compiles information that has already appeared in the literature; there is no new research.[136] Happily forthcoming is a projected biography by Hilary Spurling, whose first article on Matisse's early art training in Saint Quentin is rich in new documentation treated with the utmost discernment and breadth of inquiry.[137] Working independently and from public sources, Spurling has already swept away long-held myths about the artist's provincial background and training (or lack of it) in his pre-Paris art education.

Traditional art history has produced much of value on Matisse in the past quarter-century, but scholarly gaps remain. Well-documented catalogues raisonnés on the artist's paintings and drawings are eagerly anticipated and fuller biographies await the availability of more of Matisse's personal papers. A complete edition of his correspondence would be welcome. Iconographic studies of the artist's subjects--on the order of those written on the goldfish, the sleeping women, the window, dance, and the Golden Age--need to be undertaken. Our understanding of Matisse's recurrent use of particular motifs would

[136] Haydon Herrera, *Henri Matisse: a Portrait* (New York: Harcourt Brace, 1993).
[137] Hilary Spurling, "How Matisse Became a Painter," *Burlington Magazine* 135, 1084 (July 1993): 463-70. The first volume of the two- or three-part biography is projected by Hamish Hamilton, London, and Knopf, New York, for 1996 or 1997.

benefit by studies with psychological, political, and sociological perspectives. Ecomonic issues of patronage, markets, and international production could offer broader insight on the forces accounting for reputations--their rise and fall--and on the critical construction of the ideas of vanguard art and modernist painting, implicit in the writings on Matisse.[138]

What is striking in the most recent work of the last fifteen years is the shift in emphasis from preoccupation with Matisse's creative process to greater interest in the spectator's active experience of Matisse's work. That is, there is less concern about how Matisse effected the transformation of a given motif and his emotion into the finished figuration of it, and greater scrutiny of how the viewer reads or processes the work, is affected and construed by it.

The last two most ambitious articles on Matisse are catalogue essays for recent major exhibitions. One is by John Elderfield, who has written extensively on Matisse and Fauvism and continues the high level of dedicated scholarship at the Museum of Modern Art; the other is by Yve-Alain Bois, the younger French theorist now teaching in the United States. The two exhibitions were *Henri Matisse: a Retrospective* (Museum of Modern Art, New York, 1992-93) and *Henri Matisse, 1904-1917* (Paris, Centre Pompidou, 1993), the former a traditional behemoth exhibition that covered the artist's whole career

[138] For very recent additions to the literature in these areas, see Donald Kuspit, " The Process of Idealization of Women in Matisse's Art," in *Signs of Psyche in Modern and Postmodern Art* (Cambridge, 1993), for psychological analysis of the artist's treatment of women as subjects; William Wood, "Boudoir Scissorhands: Matisse, the Cut-Outs and the Canon," in *RACAR, Revue d'art canadienne/ Canadian Art Review* (Spring 1991): 5-17, and John O'Brian, "In Loco Parentis: Art Markets, American Dealers, and Matisse." *Block Notes* 1 (1993), for studies of the commercial and critical ramifications of the production of certain of Matisse's designs as less-expensive multiples; and the splendid essays in Roger Benjamin and Carol Turner, eds. *Matisse* (Brisbane, 1995) exhibition catalogue for a Matisse retrospective in Australia. The last-named catalogue appeared as this study was going to press, so that due to time constraints, although the articles are listed separately, their content is given only the most cursory treatment and does not reflect their complexity and richness. A true dialogue between major Matisse scholars has begun, however, in these essays, which augurs well for the future of Matisse studies.

and all media except prints, and the latter a focused survey of the years traditionally considered to be Matisse's most adventurous and the most crucial to the history of modern painting. The American show privileges the Great Artist (in the French way) while the Paris show privileges the history of progressive art (in the Anglo-American way)--a sign that the earlier distinctions outlined in this essay no longer obtain. Both catalogue essays are notable for their intellectual reach and methodological freshness.

Elderfield uses a phenomenological approach to certain key works and employs a range of semiotic and literary models to penetrate the underlying themes in the artist's work. Attempting to see Matisse "whole," he analyzes the artist's material and formal strategies as functions of the paintings' meanings, and the meanings as functions of his whole intensely subjective artistic endeavor. Bois's article is a culmination of the critic's previous Matisse essays, which attempt to probe the exact nature and moment of Matisse's unique contribution to the history of post-Renaissance painting. Bois had argued in "Matisse and 'Arche-drawing'" that Matisse's great contribution to advanced painting was the discovery that "quantity [of color, of surface] equals quality [of expression]." This principle could be used to integrate design with color in such a way that contour (drawing) no longer establishes figure-ground relations but articulates the surface planarity of the canvas. In his latest essay, Bois adds to this the notion that the compositional organization in Matisse's paintings is perceived by the spectator as explosive, circulating, pulsating: a primary visual shock followed by the slow, expanded perception of the whole field with a diffused but participatory attention. As in Elderfield, what seems like a formal analysis becomes in fact the author's fresh attention to the way the work is experienced, and to the artist's psychological need to discharge his emotion into the work itself in the very act of painting. Both Elderfield's and Bois's essays deploy a wide range of theoretical tools to understand Matisse's "system" not so much to aggrandize the artist's achievement but to understand a process which signifies the broader modes of thinking, making, and acting that the arts can still embody.

Matisse's art and the literature that has structured our appreciation of it have seemed, as we noted at the outset, largely disengaged from the major events of this century. One might well ask whether the two--the art and its surrounding discourse--perfectly

exemplify Walter Benjamin's comment in "On Some Motifs of Baudelaire." Benjamin writes: " Man's inner concerns do not have their issueless private character by nature. They do so only when he is increasingly unable to assimilate the data of the world around him by way of experience."[139] One might also speculate that, rather than the simple continuation of Romanticism's escape from the dislocations of modern society, Matisse's oeuvre may be engaged (whether more or less successfully) in the very struggle to assimilate and, if possible, transform the dissonant data of his century. He provides, doubtless, a site of autonomous, utopic experience that functions as a temporary surcease from intolerable trauma, but he also offers a paradigmatic experience of work that is still independent, integrating, and constructive--both for the artist-maker and for the viewer-respondent. Modest outcomes, perhaps, for art in our day, but the most ambitious artists of the century--from Picasso to Duchamp to Mondrian and including Matisse--never envisioned for art more than it could do. What was within the scope of art's practice was both important enough and difficult enough for a lifetime's dedication.

[139] Walter Benjamin, "On Some Motifs in Baudelaire," *Illuminations* (New York: Schocken, 1969, paperback), 158; ed. by Hannah Arendt; trans. by Harry Zohn.

Matisse Chronology

1869 December 31; birth of Henri-Émile-Benoit Matisse at Le Cateau-Cambrésis, home of his maternal grandparents.

1872 Birth of his brother, Émile-Auguste (dies 1874).

1874 Birth of brother, Auguste-Émile.

1882-7 Attends the Collège de Saint-Quentin and the Lycée Henri-Martin at Saint-Quentin.

1887 Studies law in Paris.

1888 Passes law examinations in August; returns to Saint-Quentin.

1889 Works as a clerk in a law office in Saint-Quentin; studies drawing in early morning classes at the municipal École Quentin de La Tour, a school of decorative arts.

1890 Begins to paint while recuperating from appendicitis; studies with Emmanuel Croizé, a gifted young teacher.

1891 Goes to Paris to study art; works with Gabriel Ferrier and Adolphe-W. Bouguereau at the Academy Julien.

1892 Fails to pass entrance examination to the École des Beaux-Arts in February; meets Albert Marquet in classes at the École des Arts Décoratifs in October; meets Georges Rouault and Simon Bussy when accepted by Gustave Moreau as a student.

1894 Birth of his daughter Marguerite Émilienne to his companion, Caroline Joblaud, in Paris.

1895 Enters the École des Beaux-Arts after passing entrance examinations in March; paints in Britanny with Emile Wéry in summer; sees large Cézanne exhibition at Vollard's gallery.

1896 Exhibits five paintings at the Salon of the Société Nationale des Beaux-Arts, and is elected an associate member.

1897 Exhibits *The Dinner Table,* a major work encouraged by Moreau, at the Salon of the Nationale; meets Camille Pissarro; on third summer trip to Britanny, acquires two Van Gogh drawings through John Russell, an Australian painter.

1898 Marries Amélie Noémie Alexandrine Parayre in January; spends honeymoon in London; from February to August lives in Ajaccio, Corsica. Reads Paul Signac's "From Eugène Delacroix to Néo-Impressionnisme" in *La Revue blanche.* Moreau dies in April. Spends August through January 1899

in Beauzelle and Fenouillet, near Toulouse, his wife's native
region.

1899 Son, Jean Gérard, born in Toulouse in January. Returns to
Paris, living at 19, Quai Saint-Michel; works in studios of
Fernand Cormon and Eugène Carrière for a short time; meets
André Derain and Jean Puy.

1900 Birth of son, Pierre, in June at Bohain; paints decorations for
the Exposition Universelle; begins sculpture classes in the
evenings at the École d'Art Municipale and works under
Bourdelle at the Grande-Chaumière for the next three years.

1901 Exhibits first time at Salon des Indépendants; meets Maurice
Vlaminck at Van Gogh retrospective at Bernheim-Jeune
Gallery. Visits Switzerland with his father to recover from
bronchitis; his allowance is discontinued after his father sees
his work at the Indépendants.

1902 Shows at Berthe Weill gallery; stays with parents in Bohain in
winter because of lack of money.

1903 Lives with his family in Lesquielles-Saint-Germain, near
Bohain, from July to end of the year. Exhibits at first Salon
d'Automne in Paris.

1904 First one-man show at Vollard's in June, catalogue by Roger
Marx. Becomes friendly with Signac and visits with him in
Saint-Tropez during the summer, beginning *Luxe, Calme et
Volupté.* Begins to hyphenate his name to distinguish it from
that of another painter, Auguste Matisse.

1905 Exhibits neo-impressionist canvas, *Luxe, calme et volupté,* at
the Indépendants. Summers in Collioure where he paints first
"Fauve" canvases with Derain. *Woman with Hat* purchased by
the Steins from the Salon d'Automne, where future "Fauves"
are first noted by the critics; rents a studio at the Couvent des
Oiseaux at 56, rue de Sèvres.

1906 One-man show at Galerie Druet; shows *Bonheur de Vivre* at
Indépendants. Goes to Biskra, Algeria, for two weeks in
March; meets Picasso and future patron, Sergei Shchukin.
Does first lithographs; buys first African sculpture.

1907 Visits the Steins in Florence, Italy, in the summer; also sees
Arezzo, Padua, Siena, and Venice; late summer in Collioure.

1908 Opens his school in January at 56, rue de Sévres; moves to the
Hôtel Biron at 33, Boulevard des Invalides. Makes two trips to
Germany with Hans Purrmann: first to Munich, Nuremberg
and Heidelberg in Spring, then in Fall to Berlin for his show
at Paul Cassirer's gallery (an exhibit both reduced in size and
closed earlier than expected.) First American show at 291

gallery; a small retrospective at the Salon d'Automne.
Publishes "Notes of a Painter" in *La Grande revue* in
December.

1909 Summers in Cavalière; moves to a house in suburban Issy-les-
Moulineaux in Fall; signs a contract with Bernheim-Jeune
Gallery.

1910 Retrospective at Bernheim-Jeune Gallery in February; second
exhibition at 291 Gallery. Sees exhibit of Islamic art in
Munich; exhibits *Music* and *Dance* at Salon d'Automne.
Death of his father; depressed, he travels in Spain: Seville,
Granada, and Cordoba.

1911 Closes his school in late Spring; summers in Collioure; visits
Moscow in November at Shchukin's invitation.

1912 Visits Morocco from January to April; returns in Autumn
until February of 1913, returning by way of Corsica. Sees
exhibition of Persian miniatures at Musée des Arts Décoratifs.

1913 Shows Moroccan paintings at Bernheim-Jeune Gallery.
Exhibits at Armory Show in New York and at Berlin
Secession. Summers at Issy; rents a studio again at 19, Quai
Saint-Michel.

1914 Works on etchings, lithographs; exhibits at Gurlitt Gallery in
Berlin, where the work is confiscated at the outbreak of war.
Goes to Collioure when World War I begins, becomes friendly
with Juan Gris there. Mother and brother behind enemy lines
in Le Cateau.

1915 Exhibits at Montross Gallery in New York; visits Arcachon,
near Bordeaux, in summer; visits Marseille with Marquet in
November.

1916 Works in Paris and Issy; begins to work with the model
Lorette.

1917 Meets Monet; summers at Issy; in December visits Marseille,
then Nice, and sees Renoir in Cagnes.

1918 Spends winter in Nice; summers at Issy, then goes to
Cherbourg. Visits Bonnard in Antibes, Renoir in Cagnes;
settles in a room at the Hôtel Mediterranée in Nice.

1919 Exhibits at Bernheim-Jeune Gallery and Leicester Galleries in
London. Summer in Issy; trip to London to design sets and
costumes for Diaghilev's ballet *Le Chant du Rossignol* in
Fall.

1920 Death in January of Matisse's mother in Bohain. Exhibits at
Bernheim-Jeune Gallery; sees *Le Chant du Rossignol* in
London; visits Etretat in July. Begins to work with model

Henriette Darricarrère, who will be his main model for the next seven years.

1921 Exhibits at Bernheim-Jeune; summers at Etretat; rents a larger apartment at 1, Place Charles-Félix in Nice, where he will remain until 1938.The Luxembourg purchases *Odalisque with Red Trousers,* the first French museum purchase of a Matisse.

1922 Begins an series of lithographs; divides time between Nice and Paris.

1923 Daughter Marguerite marries Georges Duthuit, a Byzantine Art scholar.

1924 Retrospective at Bernheim-Jeune Gallery; largest retrospective to date at the Ny Carlsberg Glyptotek, Copenhagen.

1925 Travels to southern Italy with wife, daughter, and son-in-law.

1927 Exhibits at Valentine Dudensing Gallery in New York; wins first prize at Carnegie International in Pittsburgh.

1928 Mme Matisse comes to live permanently with her husband in Nice; in Fall, they move to a new larger space on the fourth floor of the same building. Works more in etchings, drypoint and lithography; continues to work in sculpture which he resumed in 1925.

1930 In Spring, travels to Tahiti, stopping off in New York and San Francisco on the way. Spends three months in Tahiti. Returns to the United States to serve on Carnegie International jury (first prize awarded to Picasso); visits Barnes Foundation in Merion, Pennsylvania, (where Barnes proposes his mural commission) and Etta Cone in Baltimore, Maryland. Retrospective at Thannhauser Gallery in Berlin.

1931 Retrospective at Galeries Georges Petit in Paris and important exhibitions at the Kunsthalle in Basel and the Museum of Modern Art in New York. Birth of Marguerite and Georges Duthuit's son, Claude, in Paris.

1932 Begins a new version of the Barnes Foundation mural after discovering that he had worked for a year with the wrong dimensions. *Poésies de Stéphane Mallarmé* with illustrations by Matisse is published by Skira.

1933 Completes Barnes mural and travels to Merion for its installation; recuperates at a spa near Venice; restudies Giotto's frescoes at Padua.

1934 Works on illustrations for James Joyce's *Ulysses.*

1935 Begins to work with Lydia Delectorskaya as his major model; she will remain with him until his death as companion, secretary, and model.

1936 Exhibits at Paul Rosenberg Gallery, Paris, henceforth his
 major dealer; publishes drawings in special issue of *Cahiers
 d'Art;* begins small cut-paper work.
1937 Accepts commission for costume and sets for Ballets Russes
 de Monte Carlo's production, *Rouge et Noir;* exhibits in
 special room of the Exposition Internationale's show, *Maîtres
 de l'Art Indépendant.*
1938 Moves to the Hôtel Regina in Cimiez, a suburb of Nice;
 paints an overmantel for Nelson A. Rockefeller's New York
 apartment.
1939 Separates from his wife, Amélie Matisse; première of *Rouge
 et Noir* in Monte Carlo; revises scenery for Paris opening in
 June; auction in Lucerne of Matisse work confiscated from
 German museums by Nazi government; visits Geneva to see
 an exhibition of Spanish painting and tapestries from the
 Prado. When France enters the war, returns to Paris in
 October; then returns to Nice.
1940 Obtains a Brazilian passport but decides to remain in France;
 stores work in Paris at the Banque de France; legal separation
 from Mme Matisse is finalized.
1941 Is operated in Lyons for duodenal cancer, nearly dies from
 post-operative embolism. Returns to Nice in May; begins
 work on illustrations for *Florilège des amours de Ronsard,*
 Henri de Montherlant's *Pasiphaé,* and drawings for *Thèmes et
 variations.*
1942 Works on *Poèmes* of Charles d'Orléans; in contact with
 Picasso and Bonnard.
1943 Moves to Villa "Le Rêve" in Vence because of air raids in
 Cimiez; works on cut-outs for what will be known as *Jazz.*
 Thèmes et variations is published with text by Louis Aragon.
1944 Works on illustrations for Baudelaire's *Fleurs du Mal;*
 Pasiphaé: Chant de Minos (Les Crétois) is published with
 linocut designs and illustrations by Matisse. Mme Matisse
 and Marguerite are arrested for resistance activities.
1945 Matisse stays in Paris from July to November at 132,
 Boulevard Montparnasse. Exhibits in joint one-man show
 with Picasso at Victoria and Albert Museum in London;
 retrospective at Salon d'Automne; inaugural show at Galerie
 Maeght in Paris with six paintings from 1938-1944 with
 photographs of preceding states.
1946 Illustrates *Lettres d'une réligieuse portugaise* and Pierre
 Reverdy's *Visages;* makes cut-paper maquettes for *Océania*
 tapestries.

1947 Tériade publishes *Jazz;* Baudelaire's *Fleurs du mal* and André
 Rouveyre's *Repli,* both with Matisse's illustrations, are
 published.
1948 Begins work on the Chapel of the Rosary for the Dominican
 sisters at Vence; designs a St. Dominic for the church of
 Notre-Dame-de-Toute-Grace in Assy. Retrospective at the
 Philadelphia Museum of Art; *Florilège des amours de Ronsard*
 is published. Etta and Claribel Cone's collection is bequeathed
 to the Baltimore Museum of Art upon the former's death.
1949 Returns to the Hôtel Regina in Cimiez. First substantial
 showing of cut-paper work, at Pierre Matisse gallery in New
 York; retrospectives in Lucerne and at the Musée National
 d'Art Moderne in Paris.
1950 Exhibition of Vence chapel maquettes and large selection of
 sculptures at the Maison de la Pensée Française in Paris; wins
 Grand Prize at Venice Biennale (which he asks to share with
 his friend Henri Laurens); publication of *Poèmes de Charles
 d'Orléans.*
1951 Consecration of the Chapel of the Rosary in June;
 retrospective at the Museum of Modern Art in New York,
 accompanied by the publication of Alfred H. Barr, Jr.'s
 monograph, *Henri Matisse, His Art and His Public.*
1952 Matisse museum at Le Cateau-Cambrésis is inaugurated;
 continues to work almost exclusively on ambitious paper cut-
 out works, including *Swimming Pool,* the largest of his cut-
 outs.
1953 First exhibition devoted exclusively to the cut-outs, at
 Berggruen et Cie. in Paris; retrospective at the Ny Carlsberg
 Glyptotek in Copenhagen.
1954 Publishes *Portraits,* with an introduction composed especially
 for the volume of thirty-nine portraits; completes maquette for
 a rose window at the Union Church of Pocantico Hills, New
 York, commissioned by Nelson A. Rockefeller in memory of
 his mother, Abby Aldrich Rockefeller. Dies on November 3,
 1954, in Nice; is buried at Cimiez, November 8.

I

Primary Documentation

Archives

1. Matisse-**Barr** Papers, Museum of Modern Art Archives, New York, N.Y.

 Among the extensive archives documenting Alfred H. Barr's tenure at the Museum of Modern Art is a substantial collection of papers, letters, clippings, photographs, and other materials pertaining to Matisse, particularly those relating to Barr's 1951 *Matisse Retrospective* and his book *Matisse, His Art and His Public*, published in the same year. The richest Matisse archive in the United States.

2. **Bernheim-Jeune** Archives, Paris, France.

 Records of contracts, transactions and sales when Bernheim-Jeune was Matisse's dealer from 1909 to 1926. These have been published by Guy-Patrice and Michel Dauberville, eds. *Henri Matisse chez Bernheim-Jeune*, 2 vols. Paris: Éditions Bernheim-Jeune, 1995. 728 works are reproduced from the gallery's photographs, each dated on the day taken. A complete list of Bernheim-Jeune solo and group shows in which Matisse participated is provided, with the catalogues reproduced. Henri Dauberville's "La bataille de l'impressionnisme" and Jean Dauberville's "Souvenirs" from *En encadrant le siècle* are also reprinted. An invaluable publication.

3. Simon **Bussy** Correspondence, Musée du Louvre, Paris, France.

 Correspondence with Matisse over the years with his former studio mate and fellow artist; restricted right to publish. Other

1

copies of the Matisse-Bussy correspondence, the originals of which are in London, are at the Center for Advanced Study in the Visual Arts, National Gallery of Art, Washington, D.C.

4. Claribel and Etta **Cone** Papers, Baltimore Museum of Art, Baltimore, Maryland.

Letters from Matisse to his patrons; documents about Matisse. Also sketches and maquettes from the artist's *Poésies de Stéphane Mallarmé*.

5. Pierre **Courthion** Papers / Matisse Correspondence, Getty Center for the History of Art and the Humanities, Archives of the History of Art, Santa Monica, California.

An extensive archive of Matisse correspondence as well as the raw interviews and materials from which Courthion drew for his books on Matisse. Letters include correspondence with André Level, Christian Zervos, André Lhote, Charles Thorndike, Henri Donias, and Olga Merson, among others.

6. [Marie-Alain] **Couturier** Collection at Yale University Institute of Sacred Music, Worship, and the Arts, Yale University, New Haven, Connecticut.

Copies of the papers of Père Marie-Alain Couturier, O.P., the originals of which are held at the Menil Foundation in Paris. Besides the letters, diaries, written papers, and other items that pertain to Couturier's career, the archives includes six volumes of materials on Matisse's Chapel of the Rosary at Vence--the papers of both Père Pie-Raymond Rayssiguier and Couturier, both of whom worked with Matisse on the project.

7. Photographies de **Druet,** Bibliothèque Nationale, Departement des Estampes, Paris, France.

Photographs of Matisse's early works by the artist-dealer Druet.

8. Isabella Stewart **Gardner** Papers, Archives of American Art, Smithsonian Institution, Washington, D.C.

Correspondence between Gardner and Matthew Stewart Prichard, who wrote about Matisse and his work while Prichard was in Paris before 1914.

9. Henri **Manguin** Archives, Jean-Pierre Manguin, Curator.

Letters from Matisse from the first decade of the century.

10. **Matisse** Archives, Les Héritiers Matisse, Paris, France.

The Matisse family archives directed by the artist's grandson, Claude Duthuit. All of Matisse's personal papers and family and business correspondence here; use restricted.

11. **Matisse** Archives, Musée Matisse, Nice-Cimiez, France.

Papers and artworks donated by Matisse and his family to the museum of the city where Matisse lived since 1918 and where he died.

12. Archives **Matisse**, Musée Matisse et Herbin, Cateau-Cambrésis, France.

Papers and artworks donated by the Matisse family to the museum in the city of Matisse's birth.

13. **Matisse** Holdings, Bibliothèque Littéraire Jacques Doucet, Bibliothèque Sainte-Geneviève, Paris, France.

Letters to Marie Dormoy, Tristan Tzara, André Rouveyre, among others; maquettes and materials related to the books *Pasiphaë, Chants de Minos, Lettres Portugaises,* and other works. A very rich archive; restricted use.

14. Archives **Matisse**, Bibliothèque d'art et d'archéologie, (Fondation Jacques Doucet), Paris, France.

Letters, miscellaneous catalogues and invitations, and the Louis Vauxcelles archives of writings, letters, and journal clippings.

15. **Matisse** Files, San Francisco Museum of Art, San Francisco, California.

Papers, correspondence on Matisse's dealings in San Francisco over the years.

16. **Pierre Matisse** Gallery Records, Archives of American Art, Smithsonian Institution, Washington, D.C.

 Some business records of the artist's dealings with his son's gallery; letters. The complete archival holdings from the gallery are being organized and catalogued and, at some future date, will be available for scholars in a public venue.

17. Henry **McBride** Papers, Beinecke Rare Book and Manuscript Library, Yale University, New Haven, Connecticut.

 Some correspondence with Matisse by this critic who defended the artist from the 1920s; photographs of the artist and critic.

18. Walter **Pach** Papers, Archives of American Art, Smithsonian Institution, Washington, D.C.

 Correspondence with Matisse by this painter who helped organize the Armory Show of 1913 and who acted informally as Matisse's promoter in the U.S. during the 1910s and 1920s.

19. Jean **Puy** Archives, Jean Rajot, Curator.

 Some correspondence between Matisse and his old friend and former studio mate.

20. Paul **Rosenberg** Papers, Morgan Library, New York, N.Y.

 Contracts, correspondence with Matisse's dealer from 1936 to 1942.

21. The André **Rouveyre** Archives, Det Konglige Bibliotek, Copenhagen, Denmark.

 The rich correspondence between Matisse and his old friend, Rouveyre, is being edited by Hanne Finsen; copies of the letters are also at the Bibliothèque Littéraire Jacques Doucet, Bibliothèque Sainte-Geneviève, Université de Paris.

22. Gertrude **Stein** Notebooks, Collection of American Literature, Beinecke Rare Book and Manuscript Library, Yale University, New Haven, Connecticut.

 Personal papers of Stein with Matisse correspondence, notebooks, and other documents concerning Matisse and their mutual circles.

23. Fonds Louis **Vauxcelles,** Bibliothèque d'art et d'archéologie (Fondation Jacques Doucet), Paris, France.

 Papers and scrapbooks by this major Matisse critic of the early years.

24. Fondation **Wildenstein,** New York, N. Y.

 Includes the Archives Albert **Marquet.**

Matisse's Writings and Interviews

The following list is of selected major sources; the most complete bibliographies of interviews given and articles written by Matisse is to be found below in no. 28, Jack Flam. *Matisse on Art*, rev. ed., 1995, and no. 29, Dominique Fourcade. *Henri Matisse, Écrits et propos sur l'art*, 1972.

25. Brezianu, Barbu, ed. "Matisse-Pallady, Corespondenta inedita." *Secolul* 20, 6 (1965): 161-72, in Romanian; also published in French as "Matisse et Pallady, leur amitié et leurs rélations artistiques." In *Actes du XXe Congrès International d'histoire de l'art (1969)*, 431-48. Budapest: 1972. Vol. II.

 Correspondence between Matisse and his friend and former co-student in the studio of Gustave Moreau, Théodore Pallady. The letters and postcards between Matisse and the Romanian painter date from 1939 to 1944. Although most are from Pallady to Matisse, an important letter from Matisse (December 7, 1940) describing his works in progress is given in full.

26. Clair, Jean, ed. *Bonnard-Matisse: correspondance, 1925-1946*. Introduction and notes by Antoine Terrasse. Paris: Gallimard, 1991. Translated by Richard Howard as *Bonnard / Matisse: Letters Between Friends*. New York: Abrams, 1992; originally appeared as "Correspondance Matisse-Bonnard 1925-1946; présentation de Jean Clair." *Nouvelle rev. française* 18, 211 and 212 (July 1 and August 1, 1970): 82-100, 53-70.

 Valuable correspondence between the two artists mostly during the occupation period, 1940-45. Notes and short introduction by Bonnard's nephew, Terrasse, with a longer essay by Clair.

 Review: Bock-Weiss, Catherine. *Art Journal* 52, 2 (Summer 1993): 97-101; Watkins, Nicholas. *Burlington Mag.* 134 (November 1992): 736.

27. Flam, Jack D., ed. *Matisse on Art*. London, New York: Phaidon, 1973; reprints. New York: E. P. Dutton, 1978, 1993; Span. ed., 1978, Ger. ed., 1982.

 An annotated anthology of forty-four essays or statements by Matisse, with an excellent introduction and notes to each

selection. The whole is introduced by a biographical note and a fine synthetic treatment of the artist's career development. A post-1951 bibliography is also appended. An indispensable source for Matisse's most important writings in English translation.

Reviews: Neff, John H. *Burlington Mag.* 116, 852 (March 1974): 161-2; Gowing, Lawrence. *Art in America* 63 (July-August 1975): 17; Motherwell, Robert. *New York Times Book Rev.* (June 4, 1978): 12, 42+; Rosenberg, Harold. *New Yorker* (July 10, 1978): 59-61; Schwartz, J. *Artweek* 9, 35 (October 21, 1978): 20.

28. Flam, Jack D., ed. *Matisse on Art.* Revised edition. Series: Documents of Twentieth Century Art. Berkeley and Los Angeles: University of California Press, 1995.

This is a substantially revised edition of the earlier work of the same name. Eight new texts--all interviews--have been added, notes to the selections updated and amplified, the bibliography brought up to date. A very full year-by-year chronology replaces the introductory overview of Matisse's life and development which introduced the earlier anthology. The new introduction, "A Life in Words and Pictures," is a rich reflection on the nature of Matisse's written texts and interviews and their function at various stages of the artist's self-presentation to his public during his long career. For a valuable collection, this is a welcome revision that is fresh enough to seem nearly like a completely new work.

29. Fourcade, Dominique, ed. *Henri Matisse, Écrits et propos sur l'art.* Paris: Hermann, 1972.

An anthology of Matisse's formal written statements, along with published interviews, speeches, extracts from letters, and miscellaneous citations of the artist's words. There are some two hundred eighty items, some very brief, and footnotes that are filled with collateral quotations, often from texts for whom only "fair use" extracts are permitted. This very rich collection is usefully indexed according to names and ideas and themes; for example, Dance, Space, Intuition, Representation, Rapport, Color. An irreplaceable resource for Matisse's statements and sayings.

Review: Gowing, Lawrence. *Art in America* 63 (July-August 1975): 17.

30. Fourcade, Dominique. "Autres propos de Henri Matisse." *Macula* 1 (1976): 92-115.

An important supplement to Fourcade's book, *Écrits et propos sur l'art*, which includes interviews translated from German, Swedish, Finnish, and Danish sources, among others. The accompanying essay by Fourcade contains a valuable reflection on Matisse's relationship to Cézanne.

31. Giraudy, Danièle, ed. "Correspondance Henri Matisse-Charles Camoin." *Rev. art* 12 (1971): 7-34.

Correspondence between Matisse and his friend and former studio companion, Charles Camoin, from 1905 to 1946, to be used with caution. Dating, transcription, and notes for some letters are unreliable; some errors have been corrected by later scholars, for example, Flam, no. 89, 497-502.

32. Goldschmidt, Ernst. "Strejtog I Kunsten: Henri Matisse." *Politken* (December 24, 1911). French trans. in "Autre Propos de Henri Matisse," *Macula* 1 (1976): 92-93. Eng. trans. in Flam, no. 88, 28-29; a more complete version in Flam, no. 28, 60-63.

Interview at Issy in 1911 by a Danish painter and art historian, in which Matisse speaks of his use of color in painting and of the color-inspiration he finds in his flower garden. An important interview.

33. Huppert, Janine C. "Montherlant vu par Matisse." *Beaux-Arts* 243 (August 27, 1937). Substantial excerpts in Fourcade, no. 29, 179 n. 32.

A report of Matisse's description of his attempt to do a portrait of Montherlant, whom he finally could not capture to his satisfaction. He later learned that the author had been terribly preoccupied with a personal matter at that time and was not fully present to Matisse. To be read against Montherlant's own account, "En écoutant Matisse," *L'Art et les artistes* 33, 189 (July 1938): 336-39. Flam, no. 28, 127-29; Fourcade, no. 29, 214 (excerpt).

34. Kostenevich, Albert, ed. "Matisse's Correspondence with His
 Russian Collectors." In *Collecting Matisse*. Paris:
 Flammarion, 1993. Translated by Andrew Bromfield from the
 French ed. *Matisse et la Russie*. Paris: Flammarion, 1993,
 no. 122.

 The letters of Matisse to Shchukin, Morosov, Romm (in the
 1930s), and a few others to Soviet museum directors, from the
 archives of the Hermitage. Edited by Albert Kostenevich,
 Matisse scholar and presently curator at the Hermitage.

35. "Lettres autographes de peintres. Lettres de Matisse à ses hôtes
 en Tahiti." Sales catalogue, Hôtel Drouot, March 10, 1986.

 Matisse correspondence (1930-1950) with Pauline Schyle, his
 hostess in Tahiti, before and (mostly) after his visit.

36. Luz, Maria. "Témoinages: Henri Matisse." *XXe Siècle* 2
 (1952): 55-57. Flam, no. 28, 207-209; Fourcade, no. 29, 246-
 48.

 An important text by Matisse on his recent cut-paper work,
 recalled from a 1951 interview which was then submitted for
 the artist's approval.

37. Matisse, Henri. *Henri Matisse, Farbe und Gleichnis;
 gesammelte Schriften. Mit den Errinnerungen von Hans
 Purrmann*. Hans Purrmann, ed. Zürich: Im Verlag der Arche,
 1955; 2nd. ed., Frankfurt and Hamburg: Fischer, 1960.

 A collection in German translation of eleven of Matisse's
 most important writings, with a reprint of an article by Hans
 Purrmann "Über Henri Matisse," originally published in *Werk*
 33, 6 (1946): 185-92, no. 688.

38. Matisse, Henri. "Notes d'un peintre." *La Grande Revue* 52, 24
 (December 25, 1908): 731-45. German trans: "Notizen eines
 Malers" in "Deutsche Übertragung." *Kunst u. Künstler* 7, 8
 (Mai 1909): 335-47; Russian trans: *Toison d'or (Zolotoye
 Runo)* 6 (1909); first published English trans. by Margaret
 Scolari. *Henri-Matisse, Retrospective Exhibition*. New York:
 Museum of Modern Art, 1931. Exhibition catalogue, no. 52.

39. Matisse, Henri, recorded by Sarah Stein. "Matisse Speaks to
 His Students." In Alfred H. Barr, Jr., *Matisse, His Art and
 His Public*, 550-52. New York: Museum of Modern Art,
 1951; reprinted Flam, no. 28, and Fourcade, no. 29.

 The studio notes recorded by Sarah Stein as Matisse's pupil in
 1908. An invaluable source of Matisse's esthetic ideas of the
 period, particularly rich for his remarks on sculpture.

40. Matisse, Henri, et al. *Testimony Against Gertrude Stein*. The
 Hague: Servire Press, February 1935. A supplement pamphlet
 to *Transition* 23 (1934-35).

 In response to the alleged errors and misperceptions of Gertrude
 Stein in her recently published *Autobiography of Alice B.
 Toklas*, a group of artists and writers published a pamphlet
 setting the record straight. Matisse's contribution defends his
 wife against perceived slurs and corrects errors of fact about his
 early training, the purchase of *La Femme au chapeau*, and
 other anecdotal matters. He claims that he did not see Stein
 again after the first months of World War I, due to an
 unfulfilled commitment on Stein's part to help Juan Gris
 financially during the War.

41. Matisse, Henri. *Jazz*. Paris: Éditions Verve, 1947. Edition of
 two hundred seventy (and one hundred without text).

 A book of twenty unbound pochoir plates derived from paper
 cut-out designs with text pages composed and handwritten by
 the artist. Matisse considered this text to be autobiographical,
 a kind of personal testament. It is reprinted in full in Flam,
 no. 28, and Fourcade, no. 29.

42. Matisse, Henri. "On Art and the Public." *Transition Forty-
 Nine* 5 (1949): 117-20. Complete Fr. version in "L'Art et le
 public--une grande enquête des Lettres Françaises." *Lettres
 françaises* 99 (March 15, 1946).

 A short paraphrase of what Matisse might answer to a
 questionnaire by *Les Lettres françaises* on the question of art
 and the public.

43. Matisse, Henri, to José Gómez Sicre. Unpublished
 conversation. Summer 1949.

An interview recorded by an associate, corrected by Matisse; typescript in the Archives of the Museum of Modern Art.

44. Matisse, Henri. "La Chapelle du Rosaire." In *Chapelle du Rosaire des Dominicaines de Vence*. Vence: La Chapelle du Rosaire, 1951; printed by Mourlet Frères; other eds. 1955, 1956, 1958, 1963.

A book of photographs of the Chapel of the Rosary preceded by a short statement by Matisse on the chapel as the culmination of his life-long artistic effort. Flam, no. 28, and Fourcade, no. 29.

45. Matisse, Henri. "Chapelle du Rosaire des Dominicaines de Vence." *France Illustration* 320 (December 1, 1951): 561-70. Reprinted as "La Chapelle de Vence, aboutissement d'une vie." *XXe Siècle, Hommage à Henri Matisse* (1970): 71-73. Flam, no. 28, and Fourcade, no. 29.

A detailed statement of the artist's goals in adjusting the colors of the stained-glass windows in his chapel to the tile murals on its walls, which together orchestrate the spiritual expression of the whole decor.

46. Matisse, Henri. *Portraits*. Monte Carlo: Mourlot, 1954.

An album of some ninety-three portrait drawings preceded by a text entitled "Portraits," in which Matisse comments on portraiture and his own artistic process in producing them. Reprinted in Flam, no. 28, and Fourcade, no. 29.

II

General Studies, Catalogues, and Collections of Essays

47. Alpatov, Mikhail V. *Matiss, Zivopis, skul'ptura, grafika, pisma [Matisse. Paintings, Sculpture, Graphic Work, Letters].* Moscow and Leningrad: Sovetskij khudoznik, 1969. Exhibition catalogue. Translated by Helmut Barth as *Henri Matisse.* Dresden: VEB Verlag der Kunst, 1973.

 This compact, handsome volume, the first Russian monograph on Matisse to appear in the West since Romm's book of 1935, gives a thorough general treatment of Matisse's career and artistic development and complete scholarly coverage of the works exhibited with many color plates that vary widely in quality. Included are some twenty letters in French from Matisse: to Ivan Morosov (1911-13), Alexander Romm (1934-36), Tcherniowsky (1934) , and the director of the Museum of Modern Art in Moscow (1935). Two letters to Alexandre Romm were first published in "Dva pisma," *Iskusstvo* 4 (1934): 199-203.

48. Aragon, Louis. *Apologie du Luxe.* Series: Les Trésors de la peinture française. Geneva: Albert Skira, 1946. Translated into German as *Dem wahren Luxus gewidmet.* Genf: Kunstverlag Albert Skira, 1947.

 Large-format luxury folio of fifteen full-page tipped-in plates, with an essay on the Baudelairean qualities of "luxe, calme et volupté" in Matisse's work. Aragon defines the artist's "luxe" as natural beauty, color, and charm. Matisse's luxury is not the product of indolence but of work, which is its

13

legitimation and moral force. Aragon includes a lyric commentary on Matisse's triptych, *Leda and the Swan,* which was in Matisse's studio when the author undertook his initial interviews with the painter some six years earlier.

49. Aragon, Louis. *Henri Matisse: roman.* 2 vols. Paris: Gallimard, 1971. Translated by Jean Stewart as *Henri Matisse, a novel.* New York: Harcourt Brace Jovanovich; London: William Collins Sons, 1972.

An anthology of new and previously-published essays on Matisse by his friend, the surrealist poet and communist activist, Louis Aragon. The texts (1941-1968) are poetic, highly discursive and personal. This deluxe, lavishly illustrated, two-volume work contains some fourteen unpublished Aragon essays on Matisse, ruminative and full of personal anecdotes about the painter. It also includes valuable annotations to and comments on Aragon's texts by Matisse himself at the time of their original publication. The many color plates and reproductions of drawings and prints are of extremely high quality.

Substantial portions of this work had already been published: "Matisse ou la grandeur." *Poésie* 42, 1 (Nov / Dec. 1941), under the signature: B. d'Ambérieu; "Matisse-en-France" in *Henri Matisse dessins: Thèmes et variations.* Paris: M. Fabiani, 1943; "Ecrit en 1969" in *Je n'ai jamais appris à écrire ou les Incipit.* Geneva: Albert Skira, 1969; "Apologie du luxe" in *Apologie du luxe.* Geneva: Albert Skira, 1946; "Matisse ou les semblances fixées" in *Pierre à Feu.* Cannes: Galerie Maeght, 1947; "Matisse et Baudelaire" in *Vingt-trois lithographies de Henri Matisse pour Les Fleurs du Mal de Baudelaire.* Paris: 1946; "Matisse parle [poème]" in *Le Nouveau Créve-coeur.* Paris: Gallimard, 1948; "Matisse ou le Peintre français" (in English) in *Henri Matisse Retrospective.* Philadelphia: Philadelphia Museum of Art, 1948, reprint. *Arts de France* 23-24 (1949): 12-23 and *Le Jardin des arts* 106 (September 1963): 2-13; "Ronsard ou le quatre-vingtième printemps." *Les Lettres françaises* (December 30, 1948); "Au Jardin de Matisse" in *Henri Matisse: chapelle, peintures,*

dessins, sculptures. Paris: Maison de la Pensée Française, 1950; "Le Sourire de Matisse [obituary]." *L'Humanité* (November 5, 1954); "Le Ciel découpé" in *Miroirs de l'Art: Les Collages.* Paris: Hermann, 1965; "Henri Matisse dans sa centième année ⌊poème⌋." *Les Lettres françaises* (1969).

Reviews: Forge, Andrew. Review. *Studio* 185 (March 1973): 138-9; Jouffroy, Alain. "Le Rayon vert de Matisse." *Opus Int.* 33 (March 1972): 14-19; Lemagny, J.-C.-L. Review. *Gaz. beaux-arts* 79, 6 (March 1972): supp. 38-9; de Magny, Olivier. Review. *L'Oeil* 204 (Dec. 1971): 31-2; Moulin, Raoul-Jean. "Aragon ou l'avenir de voir." *Opus Int.* 33 (March 1972): 20-23; *Les Lettres françaises* 1330 (April 15-21, 1970) [issue devoted to Aragon on Matisse, reproducing texts from the book]; Santi, Gualtiero de. "Il Matisse di Louis Aragon." *D'Ars* 14, 66-67 (November-December 1973): 82-83; Werner, A. Review. *American Artist* 37 (March 1973): 65.

50. Barnes, Albert C., and Violette de Mazia. *The Art of Henri Matisse.* New York: Scribners, 1933. Reprint. Merion, Pennsylvania: Barnes Foundation Press, 1959, 1963.

This idiosyncratic study of Matisse by Albert Barnes, art collector and founder of the foundation in Merion, Pennsylvania, that bears his name, is primarily an examination of some of the over fifty works by Matisse in the Barnes Collection. In harmony with John Dewey's general views of "art as experience" and using his own method of "plastic analysis," Barnes lays out his methodology and discusses Matisse's use of decorative traditions. He treats in turn all the art elements--color, shape, line, etc.--as they are utilized by Matisse and provides extended formal analysis of sixteen major works, including *Joy of Life* (1905/6), *The Seated Riffian* (1912/13), *The Music Lesson* (1917), *Three Sisters Triptych* (1917), and *French Window at Nice* (1919/20). Although pedantically formalist and limited in its approach, the book contains one hundred fifty half-tone reproductions and provides insight on attitudes of the period in such chapters as "The Psychology of Matisse," "Matisse's

Rank as an Artist," and "Matisse Compared with his
Contemporaries."

Reviews: "Challenging Matisse [summary of Thomas
Craven's review in *N.Y. Herald Tribune]." Art Digest* 7
(March 15, 1933): 11; *Apollo* 17 (June 1933): 275-76; *Art
Digest* 7 (February 1, 1933): 23; Charlot, Jean. "Pinning a
Butterfly." *Creative Arts* 12, 5 (May 1933): 354-59;
Burlington Mag. 63 (October 1933): supp. 13; *Connoisseur*
91 (May 1933): 328; *Parnassus* 5 (October 1933): 29; *Print
Collectors Quarterly* 20 (April 1933): 86.

51. Barnes, Rachel, ed. *Matisse*. London: Bracken Books, 1992.

Small-format book of colored plates of Matisse's paintings and
drawings, mostly from museum collections, each accompanied
by a paragraph of the artist's own comments on his work or
working process. Citations, however, are not necessarily close
in time to the making of the painting. One still life from 1941
is badly misdated to 1904. A short general introduction by the
editor precedes the plates.

52. Barr, Alfred H., Jr. *Henri Matisse*. New York: Museum of
Modern Art, 1931. Exhibition catalogue. Published in a trade
edition by W.H. Norton, 1931.

In this twenty-page essay written on the occasion of the
Museum of Modern Art's first retrospective of Matisse's work,
Barr sets out the evaluative theses that would dominate the
appreciation of Matisse in the U.S. for the next half-century.
Twenty years later, in the monograph that accompanied the
1951 MoMA retrospective (no. 53), Barr had only to expand
these ideas, not revise them. Barr establishes the works that
mark--in the cyclical recurrances within the artist's production--
the innovative periods of Matisse's life where his work is
ambitious, austere, and abstract. The other cycle, necessary
but inferior, comprises the more realistic, relaxed, accessible,
intimate style characterized by the work of 1918-29. Both
types of work, according to Barr, following Matisse's own
assertions, seek the same ends but by different means. Barr
explains the term "expressive" by equating it with Matisse's

formal means--color, composition, and the harmonious ordering of physical sensation.

53. Barr, Alfred H., Jr. *Matisse, His Art and His Public.* New York: The Museum of Modern Art, 1951. Exhibition catalogue. Reprint. New York: Arno, 1966 (without color plates); London: Secker & Warburg, 1975.

The first full-scale scholarly monograph on the artist, published when Matisse was eighty years old. The text alternates biographical material--much of it new in 1951 and based on questionnaires to the artist and to those close to him-- with a style-history of the artist's work in all media: painting, drawing, printmaking, sculpture, and decorative projects. As the title indicates, this pioneering study is also a record of Matisse's private and public patronage throughout his lifetime and includes a list of the artist's works in public museums in English-speaking countries. Also notable is the most complete bibliography, to that date, of books and articles by and about Matisse, compiled by Bernard Karpel, then Librarian of the Museum of Modern Art. Barr included English translations of several of Matisse's important statements on art, including "Notes of a Painter" (1908), first published in English in Barr's 1931 catalogue, *Henri-Matisse*, and the artist's previously unpublished studio instruction (1908), gathered by his friend, patron, and pupil, Sarah Stein. This book remains the indispensable foundation study of the artist's career.

Reviews: *Architectural Rev.* 113 (February 1953): 124; Baker, Kenneth. Review. *Studio Int.* 189 (March 1975): 158-9 [1975 reprint]; Bazarov, K. Review. *Art & Artists* 9 (March 1975): 48-49 (1975 reprint); Blunt, Anthony, "Matisse's Life and Work." *Burlington Mag.* 95 (December 1953): 399-400; Curtis, John. "The Art de Luxe of Henri Matisse." *Studio* 144 (November 1952): 129-35 [review of book and MoMA exhbition]; Kuh, Katherine. Review. *College Art Journal* 11, 4 (1952): 309-10; *Liturgical Arts* 21 (November 1952): 28; *Mag. of Art* 45 (May 1952): 236-38; Nicolson, Benedict. Review. *Art Bull.* 34 (September 1952): 246-49.

54. Basler, Adolphe. *Henri Matisse.* Series: Junge Kunst, 46.
 Leipzig: Klinkhardt & Biermann, 1924. Reprint. *Der
 Cicerone* 21 (November 1924): 1001-1009; with slight
 revision in Charles Kunstler and Adolphe Basler, *La Peinture
 indépendante en France.* Vol. 2. Paris, 1929; and under the
 name Philippe Marcel in *Art d'aujourd'hui* (Spring / Summer
 1924): 33-47.

 A slim (sixteen pages of text with fifty-two reproductions)
 volume by an habitué of Montparnasse café circles, this early
 monograph introduces Matisse to German readers in the
 context of a broad defense of modern art. Matisse and his
 students have educated the public to the qualities in Renoir,
 Cézanne, and Gauguin, as well as in ancient and non-Western
 art. Basler portrays Matisse as the true interpreter of Cézanne
 in the structure and solidity of his canvases and as the inheritor
 of Symbolism's reliance on analogy and equivalence to render
 nature by suggestion rather than imitation. Having passed
 through an austere (pre-1916) period, according to Basler,
 Matisse now complements his qualities as an easel painter
 with those of a decorator. The current works of Matisse are
 both praised and damned for their grace, musicality and taste,
 Basler predicting that Matisse will take an honorable place
 alongside Renoir as Pater and Lancret have alongside Watteau.

55. Benjamin, Roger. *Matisse's "Notes of a Painter," Criticism,
 Theory, and Context, 1891-1908.* Ann Arbor, Michigan: UMI
 Research Press, 1987.

 This important and nuanced text surrounds Matisse's 1908
 essay "Notes of a Painter" with an exhaustive account of the
 "intellectual conditions which attended its production."
 Benjamin surveys and puts into context the critical discourse
 that accompanied Matisse's exhibitions from 1896 through
 1908, carefully analyzes the painter's essay itself in the light
 of antecedant critical and theoretical debates and writings, and
 completes his study by examining the status of the term
 "expressionism" in French writing before 1909. A
 fundamental study for the understanding of Matisse's art
 "theories," the book is notable for its author's awareness of

contemporary theory as he undertakes a careful historical reconstruction of the ideologies and theories that condition Matisse's statement. The original text of "Notes" is reproduced in facsimile from *La Grande Revue* 52 (December 25, 1908): 731-45.

56. Benjamin, Roger. *Henri Matisse.* Rizzoli Art Series, edited by Norma Broude. New York: Rizzoli, 1992.

A new approach in an old format, namely, the color-plate album of masterpieces preceded by a short summary of the artist's career and importance. Benjamin's treatment transcends the hackneyed genre by managing to introduce major contemporary critical issues into his short text "The Body in Decoration." He deals with Matisse's relation to the decorative and to popular art, with feminist concerns about Matisse's obsessive use and abuse of the female figure, with issues of Orientalism and eroticism, identity, and authorship. A superb condensation of current approaches to the artist's oeuvre.

57. Bernier, Rosamond. *Matisse, Picasso, Miro As I Knew Them.* New York: Alfred A. Knopf, 1991.

One hundred profusely illustrated pages of journalistic retelling of details of Matisse's later life by the former editor of *L'Oeil* and writer for *Vogue.* The author had personal contact with the artist and recounts some fresh anecdotes, but the substantive material has been recounted elsewhere. Approximately equal time is given to Picasso, also personally acquainted with Bernier, with a shorter chapter on Miro.

Review: Julius, M. *Contemporary Review* 260, 1514 (March 1992): 166-7; Simon, R. *Times Lit. Supp.* 4643 (March 27, 1992): 17; Thierry-de-Saint-Rapt, Solange. "Rencontre avec Rosamond Bernier de *l'Oeil* au conférence du Metropolitan." *L'Oeil* 447 (December 1992): 18-21; *Virginia Quarterly Rev.* 68, 2 (Spring 1992): 52.

58. Bertram, Anthony. *The World's Masters: Henri Matisse.* The World's Masters Series, 10. London: Galerie Paul Guillaume

and The Studio Ltd., 1930, 1934; New York: W. E. Rudge, 1930.

A pocket-size album of twenty-four reproductions of Matisse's paintings with a general seven-page introduction in an early series on major artists. Bertram's intelligent text aims mainly to wean his audience away from the expectation of veristic imitation and to appreciate the intrinsic qualities of Matisse's line and color, governed, not by rules, but by sensibility. The illustrations are all from the Paul Guillaume Gallery, photographs of works either presently or formerly in Guillaume's collection.

59. Besson, Georges. *Matisse*. Paris: Braun, 1945. Reprint. Paris: 1954 [with updated cover in color].

Small monograph (twelve pages of text, sixty illustrations) with text in French, English, and German by a collector, entrepreneur, and critic, with whom Matisse had become friendly as early as 1917. A neatly condensed summary of the painter's plastic achievements which acknowledges the seemingly contradictory quality of Matisse's style: "learned ingenuousness, erudite improvisation, managed instinct." Plates are valuable documents, as many are of paintings which were later reworked into their definitive states.

60. Beutler, Christian. *Henri Matisse, 1869-1954*. Series: Welt in Farbe, Taschenbücher der Kunst. Munich, Vienna, Basel: K. Desch, 1954.

A slim pocket-sized volume of medium-quality plates is preceded by a general introduction that surveys Matisse's life and the development of his style.

61. Bock, Catherine C. *Henri Matisse and Neo-Impresssionism, 1898-1908*. Ann Arbor, Michigan: UMI Research Press, 1981.

The importance of Matisse's debt to neo-impressionist color theory is detailed in this study of Matisse's early development. Bock demonstrates that Paul Signac's 1899 text *D'Eugène*

Delacroix au néo-impressionnisme offered Matisse a coherent history of modernism, provided flexible guidelines in post-impressionist composition and color theory, and pointed the way to the expressive and decorative achievements of the colorist movement known as "Fauvism." Matisse's friendship with the pointillist Henri-Edmond Cross is also detailed, with its consequent strengthening of Matisse's acquaintance with symbolist aesthetics.

Review: Watkins, Nicholas. Review. *Burlington Mag.* 125 (January 1983): 42-43.

62. Bowness, Alan. *Matisse et le nu.* Paris: Albin Michel, 1968; Bibliothèque d'art UNESCO, 1969.

Bowness comments with a connoisseur's sensitivity on some thirty nude studies reproduced in this little book of plates, primarily from the point of view of formal analysis and of the development (or modification) of the artist's style. The author takes at the artist's word that what is primary are "the lines and special values that are spread throughout the whole canvas or paper, in framing its orchestration, its architecture," rather than the female figure as such, erotic or otherwise.

63. Brill, Frederick. *Matisse.* Series: The Colour Library of Art. London: Paul Hamlyn Ltd., 1967, 1969. German ed., Wiesbaden, 1967.

An intelligent fourteen-page text introduces a book of forty-eight color plates of discriminatingly chosen paintings by Matisse. The text displays a sensitivity to the artist's spatial play with colored planes that one would expect from a writer familiar with contemporary (mid-1960s) color-field painting. A short biographical chronology, Matisse's text "Notes of Painter" (under the title "Matisse on Painting"), and short commentaries on each painting are also included. The color plates are quite good for an inexpensive book of this type.

64. Cassou, Jean. *Matisse.* Series: Couleurs des maîtres. Paris: Braun, 1939, 1947. New York: Tudor, 1939; Eng ed. as

Paintings and Drawings of Matisse. London: Faber and Faber, 1948. Berlin: Kunstreihe des Safari-Verlags, 1959.

A slim book of poor color reproductions of twenty-four of Matisse's paintings. More valuable is the preface, written by the French-Spanish poet and curator Jean Cassou and illustrated on nearly every page with handsome line drawings by Matisse from the late 1930s. Cassou's graceful homage to Matisse on the eve of the "phony war" as the quintessential French artist of his generation, standing in relation to Cézanne, Van Gogh, and Gauguin as Valéry stands to Mallarmé, foreshadows the role that would be given Matisse after the war. Matisse's work is light, lucid, reasoned; charming without being trivial, sensuous without being vulgar, fecund without striving for novelty. Intellectual, but without falling into mechanical formulas, according to Cassou, Matisse achieves wisdom through instinct.

Reviews: Cogniat, R. Review. *Beaux-Arts* (June 30, 1939): 2; Babelon, J. Review. *Gaz. beaux-arts* 6, 21 (May 1939): 325.

65. Cena, Olivier, ed. *Matisse, une si profonde légérité.* . . . Paris: Special issue of *Télérama* (Les Hors-Serie), 1993.

Essentially a publicity journal on the occasion of the exhibition, *Henri Matisse, 1904-1917,* at the Musée National d'Art Moderne, this special issue of *Télérama* nevertheless contains a number of interesting interviews with those who knew Matisse. Among these are interviews with Claude Duthuit on his grandfather, Soeur Jacques-Marie (Monique Bourgeois) on the artist's religious beliefs, Jacqueline Duhême on her role as studio assistant from 1947-1952 (excerpts from her book *Line et les autres*), Nadia Sednaoui on being his model (from 1948), Dina Vierny and Paule Caen--also former models--on his household and habits. There are also reminiscences by Adrien Maeght, René Char, Françoise Gilot, Cartier-Bresson, and Henry Deschamps of the Mourlot Lithography Studio where Matisse's prints were pulled. Other articles, well illustrated with many color plates, by Olivier Cena, Michel Butor, Laurent Boudier, J.-M. G. Le Clézio,

Tahar Ben Jelloun, and other writers are poetic meditations on Matisse's work.

66. Clement, Russell T. *Henri Matisse, a Bio-Bibliography.* Series: Bio-Bibliographies in Art and Architecture, 2. Westport, Conn., London: Greenwood Press, 1993.

A comprehensive bibliography, irrregularly annotated, on the published works by or about Henri Matisse. Divided between Primary Bibliography (Archival Material, and Writings, Statements and Interviews by Matisse) and Secondary Bibliography, the latter is divided broadly into four sections: Life and Career, Works, Influence and Mentions, and Exhibitions (Solo and Group). In most books on Matisse, his "Life and Career" and "Works" are not clearly separated, thus there is considerable arbitrariness in the author's sub-divisions of these categories. Fortunately, the index is detailed; works, names of authors, and subjects are each given their own listings. The Archival Materials section and that on Audiovisual Materials are especially good. This is a useful bibliographic tool in spite of some errors, omissions, and duplications. The exhibition catalogues are well-described under Exhibitions, but are not otherwise retrievable. For example, the catalogue, *Matisse in Morocco, The Paintings and Drawings 1912-1913*, is neither listed under the sub-head, "Matisse in Morocco" nor is it to be found in the index under Subjects: "Morocco."

67. Courthion, Pierre. *Henri-Matisse.* Series: Maîtres de l'art moderne. Paris: Rieder, 1934.

The author of this short monograph professes himself anti-historical and anti-nationalist in his evaluation of Matisse. He claims for Matisse, rather, a more universal Mediterraneanism over mere Northern Frenchness, and values the artist's quality over his innovations. His evaluation of the artist is the standard one of the period: Matisse's intellectual probity and measured sensibility compensate for a certain lack of pictorial imagination and emotional force. The interview section (pp. 41-46) is notable for Courthion's obtuseness in pressing

parallels between Matisse's work and that of Velasquez and Delacroix--parallels which Matisse rejects in favor of his admiration for El Greco and Goya. The young Swiss art historian had already written monographs on Delacroix, Poussin, Courbet and Lorrain by 1934. The book contains fifty-eight pages of text and sixty quality half-tone illustrations. "Rencontre avec Matisse," originally appeared in *Les Nouvelles littéraires* (June 1931):1

68. Courthion, Pierre. *Le Visage de Matisse.* Lausanne: Marguerat, 1942. Originally published as "Henri Matisse 1942." *Formes et Couleurs* 2 (1942): 3-26.

This monograph, small in format but with twelve quality black and white reproductions and four tipped-in plates in color, was produced in Switzerland during the German occupation of France. The author's observations on the artist, to whom he had free access in the Hotel Regina in preparation for a biography that never saw publication, contain some subtle psychological observations on Matisse's recent work, his manner of working, his relation to the objects depicted, and his degree of abstraction. Dated July 14, the subtext of the book is Matisse's "Frenchness" and the symbolic relevance of his work at the current moment of national defeat. The hagiographic tone of Courthion's 1934 book, however, has been replaced by a genuinely informed and critical approach.

69. Cowart, Jack, with Dominique Fourcade and Margrit Hahnloser-Ingold. *Henri Matisse, The Early Years in Nice 1916-1930.* Washington, D.C.: National Gallery of Art, 1986. Exhibition catalogue.

An exhibition catalogue which seriously addresses the implications of the radical rupture in Matisse's life and work occasioned by his move to Nice in 1918. Jack Cowart's essay "The Place of Silvered Light: An Expanded, Illustrated Chronology of Matisse in the South of France, 1916-1932" (no. 450) establishes a detailed record of Matisse's moves from apartment to apartment, his short trips and returns to the family house at Issy, and his use of specific, named models

during these years. New historical evidence and period
photographs are culled from archival sources. Dominique
Fourcade, in his essay "An Uninterrupted Story" (no.
513) offers an interpretation of the period's oeuvre in terms of its
relation to Matisse's lifelong project, a matter more of a
"surprising moment of transformation" in the artist's
"journey" than of a leave-of-absence from ambitious effort and
achievement. Fourcade's subtle and sensitive study proposes
these years as the artist's prolonged investigation of light that
is both non-impressionist and non-expressionist, of a new
treatment of space, and of a cinematic sequencing of scenes in
a serial progression. A historical survey of Matisse's patrons
of the period, "Collecting Matisses of the 1920s in the 1920s"
(no. 548), by Margrit Hahnloser-Ingold--herself the daughter
of such collectors--rounds out the texts in this important and
impeccably documented catalogue.

Reviews: Gibson, Eric. "American Round-up." *Studio Int.*
200, 1016 (May 1987): 32-34, and "The New Matisse,
Explorations of Interior Space." 1017 (August 1987): 48-49;
Hobhouse, Janet. "Odalisques: What Did These Sensuous
Images Really Mean to Matisse?" *Connoisseur* 217 (January
1987): 60-67; Neff, John H. "The Exhibition in an Age of
Mechanical Reproduction." *Artforum* 25, 5 (January 1987):
86-90; Perl, Jed. "Matisse: Into the Twenties." *New Criterion*
5 (February 1987): 6-13; Silver, Kenneth. "Matisse's Retour
à l'Ordre." *Art in America* 75, 6 (June 1987): 110-23, 167-
69; Watkins, Nicholas. Review. *Burlington Mag.* 129, 1009
(April 1987): 273-74.

70. Cowart, Jack, and Pierre Schneider, with John Elderfield,
 Albert Kostenevich, and Laura Coyle. *Matisse in Morocco,*
 The Paintings and Drawings, 1912-1913. Washington, D.C.,
 and New York: National Gallery of Art and Harry N. Abrams,
 1990. Trans. by Anne Michel, except for essays by Pierre
 Schneider and John Elderfield. French ed: *Matisse au Maroc,*
 Peintures et Dessins, 1912-13, Paris: Adam Biro, 1990.
 Exhibition catalogue.

This beautifully produced catalogue provides an extensive
examination of Matisse's two painting sojourns in North
Africa, using a wealth of new documentary material and
illustrating even the sketch-book studies of the artists on site.
Besides important essays by Pierre Schneider ("The Moroccan
Hinge," no. 724), Jack Cowart ("Matisse's Moroccan
Sketchbooks and Drawings: Self-discovery through Various
Motifs," no. 1031), John Elderfield ("Matisse in Morocco: An
Interpretive Guide," no. 488), and Albert Kostenevich ("The
Russian Collectors and Henri Matisse," no. 1335), the book
includes complete scholarly catalogue entries (paintings), a
detailed chronology of Matisse during his visits, and other
valuable documentation by Laura Coyle and Beatrice Kernan.
An exemplary text which provides much detailed information
while not neglecting a broad assessment of the importance of
the Moroccan trips to Matisse and his overall development.

71. Daftari, Feveshteh. *Influence of Persian Art on Gauguin,*
 Matisse, and Kandinsky. New York and London: Garland
 Publishing, 1991. Ph.D. dissertation, Columbia University,
 1988.

 This careful work, written by an Iranian knowledgeable about
 the Persian art on which he writes, answers the question: what
 Persian art could these artists have seen in Europe, how did
 these works possibly influence the moderns--either by
 confirming their own ongoing research or by presenting certain
 stylistic devices not found in the Western tradition that they
 could use. In the chapter on Matisse (Chapter 2, 156-252),
 the author reviews the Islamic exhibitions to which Moreau
 might have alerted his students in the 1890s, highlights
 twentieth-century exhibitions, permanent and temporary, and
 discusses the metalwork, ceramics, textiles, as well as the
 miniatures, from which Matisse might have drawn inspiration
 and instruction. There is a wealth of specific information in
 this important account, which is always judiciously weighed
 to arrive at (rightly) guarded conclusions.

72. Delectorskaya, Lydia. *L'Apparente facilité. . . : Henri*
 Matisse, Peintures de 1935-1939. Paris: Adrien Maeght,

1986. Translated by Olga Tourkoff as *With Apparent ease. . ..: Henri Matisse, Paintings from 1935-1939.* Paris: Adrien Maeght, 1986.

A remarkably complete account of the work Matisse drew and painted from March 1935 to September 1939, as recorded by his Russian model, Lydia Delectorskaya, who was to remain his secretary-companion until his death. Each painting and every stage of each work is illustrated during this important period when Matisse produced such major paintings as *Pink Nude, Roumanian Blouse, La Verdure,* the *Large Blue Robe and Mimosas,* and the Rockefeller overmantel, *Song.* Delectorskaya also recorded Matisse's comments dictated at the end of each work day from January 21 to March 9, 1936. An invaluable and intimate record of the artist's working process in the late 1930s; richly illustrated with reproductions and documentary photographs.

73. Diehl, Gaston, with notices by Agnès Humbert. *Henri Matisse.* Paris: Éditions Pierre Tisné, 1954. English ed., New York: Universe Books, 1958. German ed., Munich: Neuausgabe, 1958, 1970.

This most extensive biographical study in French written in Matisse's lifetime is partly based on original research in the archives of the artist's native region. Diehl provides a detailed and sensitive account of Matisse's early development, grapples honestly with the diversity of the artist's approaches during the "cubist" decade (1910-1918), and is especially perceptive in discussing the problematic twenties work from a number of angles--biographical, formal, thematic, social, and economic. The last period of Matisse's life (1928-1954) is hurried through, but the final chapter--a thoughtful assessment of the artist's contribution to twentieth-century culture, along with the Gide, Valéry, Poincaré, Brunschwig, Bergson generation-- is well worth reading. Also admirable are the scholarly notes by Agnes Humbert on individual works There are forty high-quality tipped-in plates in color and one hundred excellent halftones in black and white.

74. Diehl, Gaston. *Henri Matisse.* Series: Les Grands peintres modernes. Paris: Nouvelles Éditions Françaises, 1970.

A curiously assembled reprise (slightly revised) of the essential information in the 1954 monograph by Diehl.; unbound pages in a leatherbound cover and slipcase. Forty-eight too-bright plates with short commentaries comprise most of the material.

75. Diehl, Gaston. *Henri Matisse.* Series: Les Miniatures Hyperion, 20. Paris: Fernand Nathan, n. d. Translated by Rosamund Frost. New York: Hyperion, 1970.

A small booklet of plates with a short, general text to introduce the work.

76. Durozoi, Gérard. *Matisse, les Chefs d'oeuvre.* Series: Les Chefs-d'oeuvre. Paris: Hazan, 1989. Translated by John Greaves as *Matisse.* New York: Portland House, 1989; distributed by Crown Publishers.

A reasonably fresh text in a clichéd format, namely, general introductory text followed by plates of the most important works, each of the latter with its own commentary. Plates are of indifferent quality; some good photos of Matisse including a rare 1944 shot by Cartier-Bresson of the painter laughing.

77. Duthuit, Georges. *Georges Duthuit, Écrits sur Matisse,* assembled, edited, and annotated by Rémi Labrusse. Series: Collection Beaux-Arts histoire. Paris: École nationale supérieur des Beaux-Arts, 1992. English texts translated into French by Bee Formantelli.

A collection of the writings on his father-in-law, Henri Matisse, by the Byzantine scholar, Georges Duthuit. This anthology contains some hard-to-find early texts from the 1920s, unpublished texts from conferences or unsubmitted manuscripts, and essays that were originally published in English, besides others that are more readily available. Eleven texts are presented along with correspondence (pp. 206-74) and recorded conversations (pp. 277-97) between the two men whose relationship was not always amicable but always

mutually respectful. The whole is preceded by an excellent intellectual biography of Duthuit entitled "Georges Duthuit, Henri Matisse: le critique et son peintre." Indispensable volume for understanding the line of interpretation of Matisse's work that runs from Matthew S. Prichard to Duthuit to Pierre Schneider, the line that sees Matisse's achievement as akin to that of Eastern art which is more architectual and decorative, more musical (and abstract), more the result of a collective esthetic and of ritual, than that of the West. An extremely valuable collection.

78. Elderfield, John, with Riva Castleman and William S. Lieberman. *Matisse in the Collection of the Museum of Modern Art.* New York: Museum of Modern Art, 1978.

One of the Museum's publications on aspects of its permanent collection, this carefully researched study of MoMA's rich collection of Matisse works is a model of its kind. Each work is given a full scholarly treatment of its state and provenance, its preliminary sketches, sources, and related works, as well as formal and iconographic analysis. Riva Castleman provides commentary on the prints (no. 268), William S. Lieberman on the drawings (no. 291). An indispensable study on these particular works by Matisse, including such important paintings as *Piano Lesson, Moroccans, Variation on a Still Life by de Heem,* and *The Red Studio,* among others.

79. Elderfield, John. *Henri Matisse, A Retrospective.* New York: Museum of Modern Art, 1992. Exhibition catalogue. Hardcover edition distributed by Harry N. Abrams, Inc., New York.

The author proposes, in an ambitious, five-part essay, to see Matisse "whole," that is, without an artificial periodization of his oeuvre, without positing an irrevocable duality in his work and personality, and without minimizing his iconography in favor of his formal achievements or vice versa.

First, the author traces the rise of the major Matisse interpretations that counteract the dominant critical label "materialist hedonist"--namely, that Matisse's work is saved

by its abstraction, its spirituality, and/or its subjectivity--by demonstrating that the criticism arises consistently in relation to that on Picasso. A view of modernism is thus constructed which privileges Picasso and accepts Matisse as avant-garde only insofar as he assumes "Picasso" characteristics. Next, Elderfield analyzes the nature of the artist's project as the construction of a representational sign, the realization of the motif as an image, but an emotional, mental image recalled from a visual one. Painting, a plastic sign, thus effects a displacement and marks an absence, by the sublimated desire arising from the "emotion of the ensemble" as metaphor. Section Three deals with the "theatricality and absorption," the "seen and the grasped," and the given and the withdrawn in Matisse's portrayal of women. Primal themes and scenes are discussed in Section Four in the context of Neo-Impressionism and Fauvism, of childhood as the Golden Age, and of the Imaginary, using *Luxe, Calme et Volupté* and *Bonheur de Vivre* as originary and exemplary. Section Five closes with a more historical treatment of Matisse's role in "The Birth of Modern Painting." A profound and provocative essay on Matisse's painting project by an author who has deeply meditated on Matisse's works in all media, singly and in ensembles. Here, he makes fresh use of psychological and semiotic tools to probe the artist's themes and processes. This catalogue is also extremely valuable for the stunning new chronology, compiled by Judith Cousins, based on extensive new archival research, and the notes by Beatrice Kernan.

Review: Cottington, David. "Matisse: Myth and History." *Art History* 17 (June 1994): 278-84.

80. Elgar, Frank. *Matisse*. Greenwich, Conn: New York Graphic Society, 1960.

A slight, small-format introduction to the artist's work by a knowledgable modern art historian. Workmanlike text on the artist's life and artistic development accompanying twenty colored plates.

81. Escholier, Raymond. *Henri Matisse*. Series: Anciens et
 Modernes. Paris: Floury, 1937.

 A book by Matisse's friend, Escholier, then the director of the
 Musée de l'Art Moderne de la Ville de Paris, containing new
 biographical material and many direct statements by the artist.
 A sort of compensation for Matisse's being overlooked for a
 major mural commission at the 1937 International Exposition,
 the book is an affectionate and highly readable homage to an
 artist of international reputation whose current work was yet to
 be appreciated fully in his own country. The author is most at
 home writing of Matisse's origins and early triumphs and
 about his more accessible easel painting; he relies on long
 quotes by André Lhote (for historical perspective) and Louis
 Gillet (on Matisse's Barnes Foundation mural) for added
 support. Of small format, the book is well illustrated with
 eight color plates (many of recent work) and sixty black and
 white halftones.

82. Escholier, Raymond. *Henri Matisse, ce vivant*. Paris:
 Arthème Fayard, 1956. Freely translated as *Matisse from the
 Life*, London: Faber & Faber, 1960. Translated by G. and H.
 M. Colville as *Matisse: A Portrait of the Artist and the Man*,
 New York: Praeger, 1960. Translated into German as *Matisse:
 Sein Leben und Schaffen*, Zurich: Diogenes, 1958. Translated
 by Albert Kostenevich as *Matiss*. Leningrad: Iskusstvo, 1979.

 This text acts as a revision and expansion of the earlier 1937
 work (no. 81). Of note are some unpublished letters to the
 author from Matisse in his later years. There is not, however,
 much new information or interpretation on the late career of
 Matisse in this expanded version. Escholier cites extended
 passages from the literature published on the artist in the two
 preceding decades, especially Barr, Aragon, the commentary
 concerning the Vence Chapel, and catalogue essays from
 major Matisse exhibitions since 1937.

 Review: [of German trans] *"Henri Matisse; Sein Leben und
 Schaffen* by Escholier." *Werk* 47 (October 1960): supp. 207;
 Lynton, N. "Review." [of Eng. trans.] *Burlington Mag.* 104
 (May 1962): 220; *Connoissseur* 148 (December 1962): 326.

83. Essers, Volkmar. *Henri Matisse: 1896-1954, Meister der Farbe*. Cologne: Benedikt Taschen, 1986. Translated by Catherine Jumel as *Henri Matisse: 1869-1954, Maître de Couleur*, Fribourg: Medea, 1987. Translated into English by Michael Hulse, Cologne: Benedikt Taschen, 1987.

This is yet another generously illustrated introduction to Matisse's work for the general public. No new research; intelligent use of published sources.

84. Faern, José, gen. ed. *Matisse*. Eng. ed., James Leggio; translated from the Spanish by Teresa Waldes. English Series: Great Modern Masters. New York: Abrams/ Cameo, 1995.

Primarily a picture-book with many colored plates, this popular survey of Matisse's career and development is unusually intelligent in its arrangement of related works that visually inform the reader of thematic continuities, stylistic developments, and Matisse's processes of simplification. The text, though minimal and anonymous, is crisp and accurate in its generalizations and in its details.

85. Faure, Elie. *Henri Matisse par Elie Faure--Jules Romains-- Charles Vildrac--Léon Werth*. Paris: Cahiers d'aujourd'hui, Crès et Cie, 1920, 1923 [with new illustrations].

A richly illustrated monograph with separate essays by the four authors. Faure makes a case for Matisse as an intellectual, even metaphysical, artist, who, by mastering his instinct and powerful sensations during a period (c. 1910-1916) of testing, abstracting, and tempering his compositional structures, emerges (c. 1920) purified and mature, able to integrate his instinctive and intellectual sides. Romains notes that the audacity of Matisse's early work has been united with the structure that marks a timeless classicism, and that Matisse's oeuvre will be counted as among the works that define the early twentieth century. Vildrac's essay also emphasizes Matisse's intellectual control over methods that remain, nevertheless, instinctive and will never fall into academicism. Werth's essay, a witty commentary on modern art, esthetics,

and patronage, relates a fable of a des Esseintes-like decadent connoisseur (cf. J. Huysman's *De Rebours*) whose jaded symbolist taste can be satisfied finally only with a Matisse canvas--a work "mingling a mathematics and a caprice, a precision with charm." The texts remain the same in the 1923 edition, which is a more luxurious production with updated, mostly post-war, illustrations.

86. Fels, Florent. *Henri-Matisse.* Paris: Chroniques du Jour, 1930. Identical format and illustrations, with different texts, produced in English (Roger Fry, no. 92) and German (Gotthard Jedlicka, no. 116), 1930.

Fels's monograph mingles fairly random esthetic observations, artworld anecdotes, biographical bits about Matisse, and statements by the artist that, while valuable in themselves, are presented out of context and with no interpretation. This impressionistic form of art writing, lacking the rigor of a clear thesis or theoretical foundation, arose from the journalistic review articles that were published in the new art magazines of the twenties. Fels is anti-intellectual and favors a style which "avoids the impressionist accident and the cubist catastrophe" in favor of an expressive realism.

87. Ferrier, Jean-Louis. *Matisse 1911-1930.* Series: Encyclopedia de l'Art-ABC, 44. Paris: Fernand Hazan, 1961. (Duthuit's *Matisse, Période Fauve* is no. 2 in the series; no. 1175.)

A pocket paperback of fifteen color plates, with a succinct, intelligent discussion of the artist's achievement and importance, as seen from the perspective of the early 1960's and valuable for that precise statement of contemporary evaluation.

88. Flam, Jack D., ed. *Matisse, a Retrospective.* New York: Hugh Lauter Levin Associates, 1988, distributed by Macmillan.

A valuable anthology of critical writings on Matisse, translated from French, German, Russian, Dutch, and Japanese sources. A very intelligent and complete selection of texts

dating from 1896 to 1954, some are translated and/or reprinted
for the first time; two key texts by Matisse are also included:
"Notes of a Painter" (1908), and "Notes of a Painter on his
Drawing" (1939). The serious scholar is advised that there are a
few minor factual errors in the notes and, more seriously, that
there is no indication when an article has been shortened or
excerpted. The book is handsomely produced and richly
illustrated.

89. Flam, Jack D. *Matisse, the Man and His Art, 1869-1918.*
 London and Ithaca: Cornell University Press, 1986.

The first of a projected two-volume artistic biography, Flam's
book is the first serious successor, thirty-five years later, to
Barr's complete treatment of Matisse's life and oeuvre. Flam's
text integrates biographical and psychological insights with
interpretations of Matisse's works, both individually and
serially, that is, in their historical development. The book
incorporates all the post-Barr scholarship on the artist, corrects
data on the artist's life and on specific works, is meticulously
documented and contains a judicious bibliography of the most
essential Matisse literature. After Barr, this is the most
essential critical/biographical work on Matisse; the second
volume is eagerly awaited.

Review: Review: Bryson, Norman. Review. *Times Lit.
Supp.* (March 27, 1987): 328; Cook, Lynne. Review. *Art
Monthly* 105 (April 1987): 30-31; Elderfield, John. Review.
Art in America 75, 4 (April 1987): 13-21; Herbert, James D.
"Matisse without History [Reviews of both Schneider (1984)
and Flam (1986)]." *Art History* 11, 2 (June 1988): 297-302.

90. Fourcade, Dominique. *Matisse au Musée de Grenoble.*
 Grenoble: Musée de Grenoble, 1975.

A small, but extremely important, study on the works of
Matisse at the Musée de Grenoble, the first museum of modern
art in France, established as such by Andry-Farcy in 1919. The
museum received the Agutte-Sembat collection of Matisse
works in 1923 on the deaths of these early collectors. With
additional gifts from the Matisse family, it became the most

comprehensive and earliest public collection of the artist's work in France. Fourcade's essay is remarkable for synthesizing the whole innovative strategy of Matisse's early painting through his analysis of the particular works in this collection. Among others, these include the artist's free copy of Carracci's *The Hunt, Marguerite Reading, Oriental Rugs, Seated Nude* of 1909, and the incomparable *Still Life [Interior] with Egg Plants.* A number of important drawings are also evaluated, while *Large Woodcut, Seated Nude* stands in for Fauve painting of 1904-05 (not in the collection) and is brilliantly analysed for its innovations in Matisse's all-over figure-ground compositional practice thereafter. A very rich essay, full of new insights and discoveries, on a singular collection.

91. Fournet, Claude. *Matisse, Terre-Lumière.* Series: Collection Écriture / Figures, directed by Michel Delorme. Paris: Éditions Galilée, 1985.

A poet's evocation of Matisse in a text as delicate as a butterfly's wing. The painter is seen in Mallarméan terms of whiteness, emptiness, space, transparency, breath, and silence. The small book is beautifully produced on coated stock, richly illustrated with reproductions of sculpture and some of Matisse's finest drawings.

Review / interview: Girard, Xavier. "Claude Fournet, Picasso, Matisse, roman." *Art Press Int.* 98 (December 1985): 49.

92. Fry, Roger. *Henri Matisse.* Paris: Chroniques du Jour; New York: E. Weyhe, 1930. (Identical format and illustrations, with different texts, produced in French [Florent Fels, no. 86] and German [Gotthard Jedlicka, no. 116], 1930.)

Fry situates his discussion of Matisse in the dual problematic of painting (that is, its nature as a diversely colored surface and as an illusion of the three-dimensional world) and in the duality of the artist's role (that is, as a seer and as a maker/ artisan). With Cézanne as the model of an artist who did not sacrifice plasticity for surface unity, Fry praises Matisse who works consciously and successfully with the allusive-elliptical

nature of pictorial representation. He calls attention to the
painter's linear rhythm and plastic color sense as well as his
extraordinarily self-critical development. Fry is one of the
critics of the period to note that Matisse has begun to
reinvestigate the premises of his "stark, structural" work of
1910-1916, ending the cycle of the more relaxed Nice style of
1917-1926. Of the latter work, Fry astutely notes that "the
more cultured rich" succumbed to the style because they
recognized in it "the etherealized expression of their own
aspirations" in its "epicurean simplicity" and refined hedonism.
This is an important and influential text for the appreciation of
Matisse in English-speaking countries.

93. Fry, Roger. *Henri Matisse.* London and New York:
 Zwemmer and E. Weyhe, 1935. French edition: Paris, 1936.

 Same text as 1930 edition (no. 92), with substantial changes
 in illustrations.

94. George, Waldemar. *Matisse.* Series: Médecines / Peintures,
 77. Arceuil: Innothéra, 1956.

 In a pharmaceutical journal's special issue given over to a
 monograph on Matisse, George gives his postwar assessment
 of the recently deceased artist--ironically enough, amidst
 advertisements for calmatives, restoratives, purgatives, and
 cold remedies. His account of Matisse's career and development
 is workmanlike, comprehensive, and accurate. Interestingly,
 George interprets Matisse's 1917-1925 period as a
 countermove against the *"irréalisme,"* that is, surrealism, of
 the period which had become a "dogma" and, moreover, an
 "evasion or compensation" for the troubles of the times. The
 author remarks that in the post-World War II period Matisse
 had once more become relevant to young colorist painters.

95. Gilot, Françoise. *Matisse and Picasso, A Friendship in the
 Arts.* New York: Doubleday, 1990.

 Amplified reminiscences by the woman who was Picasso's
 companion from 1946 to 1953 and the author of *Life with
 Picasso* (1964). Gilot focuses on Matisse, his relationship

with Picasso, and his encouragement of the author who is also a painter. Although conversations are reinvented and events telescoped or embellished, Gilot is an intelligent and sensitive participant in the earlier discussions on art, aesthetics, and life. In spite of occasional factual errors, as a whole the portraits of the artists ring true. The double portrait of the two competitive friends is, without slighting Picasso and his genius, a homage to the older artist whom the author greatly admires.

Review: Christy, Marian. "Françoise Gilot, inédites revelaciones sobre Pablo Picasso." *Correo del Arte* 78 (March 1991): 17.

96. Girard, Xavier. *Henri Matisse, Les Chefs-d'oeuvre du Musée Matisse de Nice-Cimiez.* Cahiers Henri Matisse 7. Dijon: Musée des Beaux-Arts de Dijon, 1991. Exhibition catalogue.

Elegant catalogue, edited by Xavier Girard, the director of the Musée Matisse at Nice, handsomely illustrating a rich selection of oils, bronzes, drawings, prints, and other books and objects from the collection, including material related to the Chapel at Vence Girard provides brief introductory essays on the establishment of the museum's collection and on each section (Peintures, Dessins, Sculptures, Gouaches découpées, Gravures, La Dance, and Chapelle de Vence) but the wealth of the catalogue is in its commentaries on each work and the full documentation as to provenance, exhibition history, and bibliography of the works included. Over ninety works are exquisitely reproduced in this sumptuous volume which situates them historically and also interptets them in broad thematic and stylistic contexts.

97. Girard, Xavier. *Henri Matisse: "Une Splendeur inoui . . ."*. Series: Découvertes Gallimard. Paris: Gallimard, 1993. Trans. into English by I. Mark Paris as *Henri Matisse, The Wonder of Color.* Paris: Harry N. Abrams, 1994.

A popular, small-format book that covers the traditional ground of biography intermingled with stylistic development. Totally modern in its layout, the book presumes the short

attention-span of its readers by breaking up the text and page-
layouts into information-bites. The nearly marginless pages
are crammed with documentary photographs, reproductions of
Matisse's art works, side-bars of direct citations from
Matisse's words or from critics' comments, and running text.

98. Girard, Xavier, ed. *Matisse aujourd'hui.* Nice-Cimiez: Musée
 Matisse, 1993. Cahiers Henri Matisse 5.

A series of short essays, originally papers at a conference in
Nice in 1987, on the relevance of Matisse at the present
moment, a moment at last not unduly influenced, according to
the editor, by the doxa on the artist propagated by Matisse
himself. The seventeen essays are of varying length and
substantiality. Old hands, such as Jack Flam (no. 1046), Jean-
Claude Lebensztejn, Marcelin Pleynet, Dora Vallier, Jean
Guichard-Meili, and Jean-François Chevrier are represented as
well as newer voices such as Jean Arrouye who analyses the
Stations of the Cross of the Vence Chapel (no. 1166), Deepak
Ananth who deals with the "Oriental frames" in Matisse's
work, Yves Michaud who writes on the influence of Matisse
on Hantaï and Viallat, Eric de Chassey who reviews the
American response to Matisse between 1940 and 1970, and
Jacques Soulillou who probes the semiotic ramifications of
Matisse's use of "signs." The other authors are Daniel
Dobbels, Chantal Thomas, Catherine Francblin, Monique
Frydman, Pierre Buraglio, and Jacques Martinez.

99. Golding, John. *Matisse and Cubism.* Glasgow: University of
 Glasgow Press, 1978.

The only study, actually an expanded lecture of some nineteen
pages, precisely on Matisse's relation to Cubism by an
eminent scholar of the movement. Golding's insights are to
be felt in all subsequent writing on Matisse's 1910-1917 work.
Matisse's contribution to the cubist experiment is examined,
as is his alternate exploration (c.1910-1911) of the space of
Islamic miniatures, his attempt to place cubist spatial
conventions at the service of larger spatial vistas, his use of

the grid under the sympathetic guidance of Juan Gris, and his ultimate use of colored "compositional cells" to organize some of his finest work of the period. Golding concludes that Cubism "suggested to [Matisse] ways in which he could manipulate space in a freer and more abstract fashion that would parallel or complement the coloristic abstraction achieved during years in which he had been assimilating and consolidating the Fauve experiment."

100. Göpel, Barbara, and Erhard, eds. *Hans Purrmann, an Hand seiner Erzählungen, Schriften und Briefe zusammengestellt.* Wiesbaden: Limes Verlag, 1961.

This text gathers into a single volume the published articles of Purrmann which include a number on Matisse by his friend and former pupil. Includes "Aus der Werkstatt Henri Matisse" (1922), "Introduction to Thannhauser Exhibition" (1930), "Über Henri Matisse" (1946), and miscellaneous writings on Matisse, including Purrmann's answers to Barr's 1951 questionnaires in preparation for his book.

Review: Luzzatto, Guido L. "Il Giudizio di Hans Purrmann sui Maestri Francesi." *Commentari* 11, III-IV (July-December 1960): 284-291.

101. Gowing, Lawrence. *Henri Matisse, 64 Paintings.* New York: Museum of Modern Art, 1966. Exhibition catalogue.

This short catalogue essay, "Matisse: the Harmony of Light," is the genesis of Gowing's book on Matisse (no. 103); it is the retained nucleus of that text and of the expanded version of 1968 (no. 102). In its original form, "Matisse: the Harmony of Light," was reprinted in 1979 as a Medaenas Monograph on the Arts (The Artist's Limited Edition), a large-format portfolio, in conjunction with the Museum of Modern Art. Reprinted in Kaplan, P. and S. Manso, eds. *Major European Art Movements, 1900-1945.* New York: E.P. Dutton, 1977. See no. 103 for a more extensive discussion of contents.

102. Gowing, Lawrence. *Henri Matisse: a Retrospective Exhibition.* London: The Arts Council of Great Britain, 1968.

A developed version of the 1966 catalogue (no. 101), with modifications of earlier views. For example, Gowing gives more weight to the importance for Matisse of neo-impressionist color usage in the 1966 text than in this version; a further modification of his views on this relationship reaches its maturity in the final, more complete study (no. 103).

103. Gowing, Lawrence. *Matisse*. London: Thames and Hudson; New York: Oxford University Press, 1979.

This text is an expansion of the author's first study of Matisse, the Museum of Modern Art's exhibition catalogue, *Henri Matisse, 64 Paintings*, of 1966 (no. 101). Gowing, himself a painter, is unsurpassed in his interpretation of Matisse's early development as a colorist in search of light (Fauvism) and no less analytically brilliant in his treatment of Matisse's work in the 1910s, namely, the decorative panels and the "cubist" experiments. That the expanded text favors the early part of Matisse's career is indicated by the fact that seventy per cent of the text is devoted to the first half of the painter's life. Besides scanting the later work, the author really deals with Matisse only as a painter. Still, this is an essential study of Matisse's pictorial achievement and a subtle study of his psychological makeup. Gowing's insights into Matisse the man are as probing as those into Matisse the painter.

Review: Schneider, Pierre. "Matisse." *Burlington Mag.* 122, 928 (July 1980): 510; Perl, Jed. "Matisse." *Art in America* 68, 9 (November 1980): 21-25; Watkins, Nicholas. Review. *Art Monthly* 33 (February 1980): 27-28.

104. Greenberg, Clement. *Matisse*. New York: Harry N. Abrams and Pocket Books, Inc., 1953; London: Collins, 1955.

A small but important monograph by a critic who, having learned from Hans Hofmann how to look at Matisse, was in the process of developing his ideas on the history of modernism as a narrative of two-dimensional anti-illusionism. By 1952, Greenberg was America's most influential critic, but he had insisted on the importance of Matisse for the previous

fifteen years. The book consists mainly of commentary on individual paintings, reproduced in medium-quality plates.

105. Grünewald, Isaac. *Matisse och expressionismen.* Stockholm: Wahlström & Widstrand, 1944.

A lively and admiring account of Grünewald's former teacher, Matisse; well illustrated with mostly line drawings. Author draws on his early experiences in Paris, and on the years 1908 to 1914. In eighteen short chapters (that on "Matisse as Sculptor" is only four pages long), many aspects of Matisse's work are introduced, but little is developed in depth or with original insights. Of special value is the chapter on the Swedish critics and their objections to the work of Matisse and his pupils. The expressionism of the title is the standard idea that the artist, avoiding anecdote and emotional subject matter, renders his plastic means expressive, achieving a "mean" of feeling somewhere between that of his forebears, Cézanne and Van Gogh.

106. Guadagnini, Walter. *Matisse.* Milan: Mondadori, 1993. Translated into English by Richard Pierce, Milan and New York: BDD Illustrated Books, 1993.

A well-produced book of plates of Matisse's paintings and sculptures, with a substantial preface and texts introducing periods of Matisse's oeuvre. While offering no new research, the twenty-two page preface is gracefully written and rich in documentary photos (all previously published) of the artist. Brief biography and bibliography. Some of the three hundred color plates are very far off the true color of the paintings. A recent entry into the seemingly insatiable market for picture-books of the artist's work with a general introductory text.

107. Guichard-Meili, Jean. *Henri Matisse, son oeuvre, son univers.* Paris: Fernand Hazan, 1967. Translated by Caroline Moorehead as *Matisse.* Series: World of Art Profile. New York and Washington: Frederick A. Praeger, 1967. Translated by Susanne B. Milczewsky as *Matisse.* Cologne: M. Dumont Schaubert, 1968.

A balanced general survey of Matisse's oeuvre in all media, with a special attempt made to situate the artist's beginnings in his late nineteenth-century milieu, and to treat his subjects and themes as well as his formal innovations. The author pays attention to the present location of Matisse's works in private collections and museums (though the information is incomplete and sometimes inaccurate) and gives a brief bibliographic survey of the literature on the artist. Unusually comprehensive for a general survey of this length.

108. Guichard-Meili, Jean. *Matisse.* Series: Les Grands Maîtres de Notre Temps. Paris: Éditions Aimery Somogy, 1986.

A slight expansion and rearrangement of the 1967 text (no. 107). Errors have not been corrected in the updated list of present locations of works; in fact, new errors occur.

109. Guillaud, Jacqueline, and Maurice. *Matisse, le rythme et la ligne.* Paris, New York: Éditions Guillaud, 1987; Stuttgart: Klett-Cotta, 1987. Translated into English by Jack Flam, Timothy Best, and Eleanor Levieux as *Matisse, Rhythm and Line.* New York: Clarkson N. Potter, Inc., 1987.

A lavishly produced picture book of Matisse paintings, graphics, and book illustrations which are interspersed with statements by Matisse appropriate to the images. Two major texts are reproduced: Susan Lambert, "About the Matisse Lithographs," (originally published as *Matisse Lithographs,* New York, 1982, no. 242), and Brenda Richardson, "Dr. Claribel and Miss Etta," (substantial portions of Chapter 3 of *Dr. Clarabel and Miss Etta, The Cone Collection,* Catalogue of the Cone Collection of the Baltimore Museum of Art, Baltimore, 1985, no. 1289). While frequently aptly chosen, the quotations by Matisse are given without source, date, or context. Moreover, the texts are printed in sizes, colors, and arrangements that are often irritatingly arbitrary. Still, the volume, with its gold interleafing and high-quality printing, is a visual feast and provides 714 illustrations of some works infrequently reproduced . Among the latter are a generous sampling of the book maquettes and drawings from the

Baltimore Museum of Art and the Bibliothèque Jacques Doucet, and graphics from the Bibliothèque Nationale and other French museums and collections. The factual material in the book (biography, bibliography, information on works in series) is startlingly inaccurate and/or inadequate.

110. Herrera, Hayden. *Matisse, A Portrait.* New York: Harcourt Brace, 1993.

A "portrait" that gathers biographical information and reminiscences about the artist that have already appeared in the major studies on Matisse, for example, Barr (1951), Escholier (1960), Gowing (1979), Flam (1973 and 1986), and Schneider (1984). Besides lacking any new data, this "biography" offers few fresh insights into or personal interpretation of the artist's personality or character. It is, nevertheless, a useful compendium of personal information on the artist for the general reader. Well illustrated with photographs and reproductions in black and white, many of the book's color plates are singularly poor in color fidelity to the originals.

Review: Denvir, Bernard. "The Ferocious Fauve," *New York Times Book Rev.,* 1993.

111. Horter, Earl, ed. *Picasso, Matisse, Derain, Modigliani.* Philadelphia: H. C. Perleberg, 1930.

An album of good quality, half-tone reproductions of figure paintings and drawings by four modern artists, serving as an introduction to modern art for Americans who might be conservative in their tastes; twenty-four works by Picasso, eleven paintings and five drawings by Matisse. Although except for the 1916 painting of Lorette, *Italian Woman,* all Matisse paintings are 1920s odalisques, Horter notes: "The works of Matisse could not be covered in a single volume, but the plates shown here give a comprehensive idea of the varied phases of his paintings and drawings--his drawings alone proving him one of the foremost draftsmen of all time." Four of the drawings are of Henriette from 1919-20.

112. Hunter, Sam. *Henri Matisse.* Series: Metropolitan Museum of
 Art Miniatures. New York: Book of the Month Club, 1956.

 A slender paper-bound pamphlet with twenty-four tipped-in
 plates of good quality is accompanied by a slight, but
 extremely intelligent, general text that follows the critical lead
 of Roger Fry in valuing Matisse as an artist who is able to
 "again and again put his whole art in question, unbiased by
 past achievement." The author sees him in the tradition of
 Manet and Cézanne, using a radical empiricism before nature
 to initiate a rational, but totally transformative, experiment in
 art. Nearly four decades after its composition, this critical
 analysis of Matisse's contribution remains as freshly perceived
 and true as when it was written.

113. Huyghe, René. *Matisse.* Series: Le Grand Art in Livres de
 Poche, 13. Paris: Flammarion, 1953.; Cercle d'Art, 1989.

 A short text (four pages) by Huyghe as introduction to plates
 with commentaries by Lydia Huyghe; same plates as
 Greenberg (1953), no. 104.

114. Izerghina, A. *Henri Matisse Paintings and Sculpture in Soviet
 Museums.* Leningrad: Aurora Art Publishers, 1978.
 Translated by R. J. Rosengrant from the original Russian
 edition. Translated into French by M.-H. Corréard, A. Pascal,
 and T. Gurewitch, Leningrad, Aurora Art Publishers, 1990.

 An extremely valuable annotated catalogue of the great works
 by Matisse at the Pushkin State Museum of Fine Arts in
 Moscow and the Hermitage Museum in Leningrad; each is
 well illustrated and meticulously researched for provenance,
 bibliography, and exhibition history. Izerghina provides an
 introductory essay that gives an overall account of Matisse's
 life and work.

 Review: Perl, Jed. "Review." *Art in America* 68, 9
 (November 1980): 21-25.

115. Jacobus, John. *Henri Matisse.* Series: Library of Great
 Painters. New York: Abrams, 1973; London: Thames and
 Hudson, 1973; Ital. ed. Milan: Gazanti, 1974; French ed.

Paris: Cercle d'Art, 1974. Reissued in concise edition by
Abrams, 1983; French ed. Paris: Ars Mundi, 1986; German
ed. Cologne: Du Mont, 1989.

A general study of Matisse's life and oeuvre, lavishly
illustrated with plates of rather mediocre quality. After a
graceful and synthesizing introduction, the author provides
commentary on forty major works that is both formally
sensitive and learned in its art historical comparisons and
references. An introductory survey more well informed than
most, Jacobus's text develops the idea that Matisse symbolized
the artist's creation of a magical harmony through the motif of
his own studios portrayed as pictorial environments.

Reviews: Gowing, Lawrence. "Matisse [review of Jacobus'
book, Flam's *Matisse on Art* and Dominique Fourcade's *Henri
Matisse: Écrits et propos sur l'art]*." *Art in America* 63 (July-
August 1975):17; Werner, A. "Matisse." *American Artist* 39
(August 1975): 12-13.

116. Jedlicka, Gotthard. *Henri-Matisse*. Paris: Chroniques du Jour,
 1930.

The German monograph published simultaneously with that of
Florent Fels (French), no. 86, and Roger Fry (English), no.
92, in identical format and illlustrations. Jedlicka's text is less
anecdotal than Fels's and less profoundly critical than Fry's.
For a German audience, Jedlicka reviews Matisse's life and
stylistic development and defends the latest (1919-1929) works
as the culmination and flowering of Matisse's life-long
esthetic project. He sees no real break between early and late
work, the latter having the suppleness and charm that the
"warm-up discipline" of the earlier, more abstract, works made
possible. An interpretive, persuasive text more than an art
historical or critical effort. His placement of Matisse in a
solid nineteenth century tradition--Delacroix, Courbet, Manet--
is more rhetorical than historical, but the author claims that
Matisse had "pulled his weight" in the emancipation of color
and form that marks modern painting.

117. Kampis, Antal. *Matisse*. Budapest, 1959.

A short general text on the artist accompanying a series of plates reproducing the artist's work.

118. Kawashima, Riichiro. *Matisse*. Tokyo: Atelier-Sha, 1934, 1936; Flam, no. 88, 291-94.

A book of twenty-six plates (six in color), preceded by fourteen pages of text by a Japanese artist who was a regular visitor to Paris, and who interviewed Matisse in 1931 during the Georges Petit Gallery retrospective. Matisse explains his work in terms he thinks an Asian might appreciate, especially with reference to the artist's reverent attitude toward nature, his respect for traditions both Western and Eastern, the musical structure of art works, and the necessity for industriousness and hard work. But the author notes that Matisse also stresses individuality and personal expression and, in fact, though Kawashima sees no lessening of the artist's powers in his later work, he expresses a preference for Matisse's works of c. 1915, for their originality and contemporaneity. The direct quotes from Matisse offer characteristic views of the artist.

119. Klein, John R. "The Portraits and Self-Portraits of Henri Matisse." Ph. D. dissertation, Columbia University, 1990.

Klein discusses Matisse's portrait oeuvre as a social transaction between artist and sitter in which the artist's self-expression is in play with the sitter's individuality. As the artist's expression or self-projection (even, and especially, when formal innovation is primary) is the dominant aspect of Matisse's practice, Klein finds that the individuality of the sitter is nearly always eclipsed by the painter's pictorial and emotional needs. For this reason, Klein treats the portraits of "class-equivalent" models and family members in greatest detail, while images of paid models are not considered at all, because the author does not consider them portraits. Klein sets his study in the context of Matisse's self-construction as an artist in his early years and his public self-construction (or promotion) as a professional in his mature years. The study concludes with a close textual study of Matisse's two major

statements on portraits: "Exactitude Is Not Truth" (1947) and "Portraits" (1954).

120. Kober, Jacques, ed. *Henri Matisse, Pierre à Feu*. Paris: Galerie Maeght, Les Miroirs Profonds, 1947. Reprint in miniature edition of "Les miroirs profonds," inexpensively produced in newsprint but with five-color cover.

This luxury edition of less than 999 copies, printed by Draeger Frères for Galerie Maeght contains a five-color lithographed cover and an original woodcut along with fourteen unpublished (in 1946) heliogravures by Matisse. The essays and poems celebrate the end of war and occupation, the survival of culture, and the French spirit as much as they do Matisse, whose work is nevertheless viewed as a crystallization of all these blessings. Contributions include Aragon's "Matisse où les semblances fixées," André Marchand's interview with Matisse entitled "L'Oeil," Luc Decaunes' "Victoires de Matisse," and Kober's essay "Matisse 1946."

121. Kostenevich, Albert. *Henri Matisse*. Series: Masters of World Painting. In Russian. Leningrad: Aurora Art Publishers, 1981. Translated by Monika Wilkenson and Peter Waldron in English ed., New York: Abrams, 1981.

An album of fifteen color plates of Matisse's work, preceded by a general, workmanlike introduction by a distinguished Russian art historian and Matisse specialist.

122. Kostenevich, Albert, and Natalya Semenova. *Matisse et la Russie*. Paris: Flammarion, 1992. Translated into English as *Collecting Matisse*. Paris: Flammarion, 1993.

A wonderfully comprehensive treatment of Matisse and his Russian patrons drawn from Russian archival sources. Four historical chapters by Natalya Semyonova on the art climate of the period in Russia, the personal histories of the collectors Ivan Morosov and Sergei Shchukin, details of Matisse's visit to Russia in 1911, and the subsequent fate of the collections after 1917 are richly illustrated with archival and family photographs and documents. This is followed by an extensive

selection of the Moscow press coverage of Matisse's visit there. Equally valuable and well annotated is the complete correspondence between Matisse and his two patrons included at the end of the book. The six chapters at the heart of the book comprise a critical commentary by Albert Kostenevich, curator of the nineteenth- and twentieth-century French painting department at the Hermitage. Given the considerable interpretive scholarship already devoted to these works, Kostenevich's text is fresh and balanced. A splendid addition to recent Matisse scholarship.

123. Labaume, Vincent. *Matisse.* Paris: Hazan, 1993.

A picture-album of some eighty color plates of Matisse's paintings, with a brief introductory text, biographical chronology, and selected bibliography. Offers nothing new from the many other examples of its kind in the Matisse publications.

124. Lassaigne, Jacques. *Matisse, Étude biographique et critique.* Genève: Albert Skira, 1959. Translated by Stuart Gilbert as *Matisse, A Biographical and Critical Study.* Cleveland: World Publishing Company, 1959.

A small, elegant, square-format book with excellent tipped-in plates, a fine biographical sketch, good bibliography. Lassaigne's solid and insightful text stresses Matisse's awareness of his times but his independence from movements and trends. The author also recognizes the importance of Neo-Impressionism for Matisse, its lasting effect on his aesthetic. Especially strong in the early period of painting; graphics and sculpture are not dealt with and the chapel and cut-paper work hardly at all.

Review: Habasque, G. "Matisse." *L'Oeil* 64 (April 1960): 64.

125. Lejard, André. *Matisse, seize peintures, 1939-43.* Paris: Edition du Chêne, 1943. Reprinted as *Paintings, 1939-46,* with new introduction by Denys Stutton. London: Lindsay Drummond Ltd.; Paris: Éditions du Chêne, 1946.

An album of recent paintings by the artist, beautifully reproduced on heavy paper, with an introduction by Lejard, director of the Éditions du Chêne. The tipped-in color plates are exceptionally fine in all editions; the later edition has added two post-1943 paintings. Lejard's essay is marked by a stress on Frenchness and national traditions, on rural and natural subjects, and pre-industrial artisinal values that he helped to propagate through the group known as Jeune Peintres de Tradition Française during the occupation. He calls attention to the relation of Matisse's *Jazz* and the illuminated manuscript, *The Apocalypse of Saint Sever*, which had been published in *Verve* in Spring of 1938, the issue in which Matise's "Divagations" had appeared. A facsimile version of the *Apocalypse* was published in 1943.

126. Lejard, André. *Henri Matisse.* Paris: Fernand Hazan, 1948, 1952. Translated into English, New York: Continental Book Center, 1948. Translated into German, Saarbrücken: Saar Verlag, 1947, introduction by H. H. Gowa.

Lejard's fifteen pages of text (twenty color plates) in this small-format book accord Matisse the honor of rescuing French painting from its dependence on post-Renaissance naturalism and psychological expressionism. Fauvism was that "liberating movement" in which color came to play the major role in replacing both Italianate linear mannerism and impressionist illusionism. *Jazz, according* to Lejard, is a major turning point in Matisse's work, the first of a long research in which he becomes "worthy of color" and attains the purity and universality of the art of the Middle Ages. Illustrations very like those of Greenberg (1953), no. 104, and Huyghe (1953), no. 113.

127. Lévêque, Jean-Jacques. *Matisse.* Paris: Club d'Art Bordas, 1968. Reprint of *Le Arti* 7-8 (July-August 1967): 12-33, in Italian.

A graceful general text accompanying a generous number of plates of fair quality in a *livre de poche* format. The author

reviews Matisse's career and stylistic development, primarily
in painting.

128. Leymarie, Jean. *Matisse.* Paris: 1964, 1970. Translated into
 Italian as *Matisse.* Series: I maestri del colore, no. 50.
 Milan: Fratelli Fabbri, 1964. Translated by Ronald Alley,
 New York: Funk & Wagnalls, 1978.

 A short text of the most general nature precedes a twenty-three
 page book of plates in a series on famous artists as colorists.

129. Leymarie, Jean, Herbert Read, and William Lieberman. *Henri
 Matisse.* Berkeley and Los Angeles: University of California
 Press, 1966. Exhibition catalogue.

 A major exhibition of Matisse's work in every medium is
 accompanied by three extended essays that summarize--along
 with the essays of Lawrence Gowing and Clement Greenberg
 of the same year--the artist's reputation a decade after his death.
 Leymarie's "The Painting of Matisse" offers a complete if
 summary resume of the artist's development which
 acknowledges his debt to Cézanne and Neo-Impressionism,
 deals judiciously with his relation to Cubism, has some
 interesting insights on his transformation of "exotic" sources,
 and gives full analysis to the formal strength of the paintings
 of the 1940s. "In an era of confusion and anxiety, which so
 many artists inevitably echo in their work," Leymarie
 concludes, "Matisse adopts a compensatory vision of 'balance
 and purity,' restores the Olympian worship of happiness. . .
 the pagan poet of light-without-shade." The essays by Herbert
 Read and William Lieberman are summarized in the section,
 Specific Media: Sculpture (no. 211) and Graphics (no. 292),
 respectively.

 Review: Seldis, Henry. "Exhibition Preview, Matisse in Los
 Angeles." *Art in America* 53 (December 1965): 76-9; Werner,
 A. Review. *Art Quarterly* 30 (1967): 97, 99.

130. Liessegang, Susanne. *Henri Matisse, Gegenstand und
 Bildrealität. Dargestellt an Beispielen der Malerei zwischen*

1908 und 1918. Bergisch Gladbach, Cologne: Verlag Josef Eul, 1994.

The author seeks to surmount the unresolved polarities pointed up (but according to Licssegang harmonized only by reference to extra-pictorial "truth") in the major literature on Matisse. Leissegang uses both a structuralist and a phenomenological approach. She analyzes in close detail several works, *Interior with Eggplants, Dance, Rose and White Head, Interior with Goldfish Bowl,* and *The Painter in his Studio,* in order to examine the structural properties of these works from the point of view of what is seen. This is done in order to stress the material reality of the works and to seek to understand through them the picture-building principles enunciated in Matisse's statements--especially with respect to figure/ground relations, the role of surface and spatial clues, the recognition of primary gestalts before image-content, and the nature of the decorative in its Western tradition. Matisse's texts are used to interpret the works, and the works to understand the texts in a closed circle. An ambitious and well-developed thesis.

131. Lübecker, Pierre. *Matisse.* Series: Malerkunstens Mestre [The Masters of Painting]. Copenhagen: Gyldendal, 1955.

A Danish version of the pocket-book format produced by Abrams (with text by Greenberg) in 1953; in London by Collins in 1955. Twenty-eight color plates of decent quality are each accompanied by a short commentary and the whole is prefaced by a four-page biographical introduction. This version has a new text by Pierre Lübecker in a format otherwise identical with the Greenberg edition, no. 104.

132. Luzi, Mario, and Massimo Carrà. *L'Opera de Matisse dalla rivolta fauve all'intimismo, 1904-1928.* Milan: Rizzoli Editore, 1971. Dutch edition, Rotterdam, 1976; Spanish edition, Barcelona: Noguer, 1976. Translated by Simone Darses as *Tout l'oeuvre peint de Matisse, 1904-1928.* Minimally updated and revised by Xavier Deryng, with a new introduction by Pierre Schneider, Paris: Flammarion, 1982.

This work is an abbreviated and far from complete attempt at a *catalogue raisonné* of Matisse's painting from 1904 to 1928. It contains sixty-four full-page color reproductions and 687 small (c. 2 x 1.5 inches) black and white reproductions of paintings. The revised French version has added works after 1928 and a small selection of prints, drawings, and sculpture. The information on each work is limited to its present location, medium, size, and date. In spite of being outdated, incomplete, and a bit confusingly assembled, this documentary compendium of works, especially from 1919-1928, is a valuable reference tool, in the absence of an authorized *catalogue raisonné* of the artist's paintings.

133. Mannering, Douglas. *The Art of Matisse.* New York: Excalibur Books, 1982. Reprinted, expanded, as *The Paintings of Matisse.* London: Hamlyn Publishing Group, 1989; New York: Mallard Press, 1989.

Popular treatment of Matisse's life and career; an accessible and anecdotal retelling of Matisse's stylistic development. Sixty-six color plates of somewhat mediocre quality, twenty-eight black and white plates.

134. Marchiori, Guiseppe. *Henri Matisse.* Rome: Amilcare Pizzi, 1967; Paris: La Bibliothèque des Arts, 1967; New York: Raynal/ William Morrow, 1967. Translated by Christa Baumgartner, Stuttgart: W. Kohlhammer, 1967.

A somewhat chaotically organized book that offers little not already in the literature to that date, but contains some interesting period photos as contextual comparisons to individual Matisse works. For example, Edward Steichen's *Gloria Swanson* photographed through patterned black lace is placed next to Matisse's 1924 lithograph, *Persian Woman.* There are also errors of fact and incorrect titles on paintings in the English edition.

135. McBride, Henry. *Matisse.* New York: Alfred A. Knopf, 1930.

A common-sense, non-technical style does not obscure the sensitivity of this New York reviewer to the boldest of Matisse's works. McBride develops a few simple ideas to explain the artist's approach and does not hesitate to class him among the masters who forcefully, though mostly unconsciously, reflect their period, nation, and class.

Review: "McBride on Matisse." *Art Digest* 4 (March 1, 1930): 23; *Art News* 28 (February 15, 1930): 14; *Creative Arts* 6 (March 1930): supp. 57-58.

136. Mezzatesta, Michael P. *Henri Matisse, Sculptor / Painter.* Fort Worth: Kimball Art Museum, 1984. Exhibition catalogue.

This catalogue for a small Matisse exhibition is a model of scholarship and of fresh insights on the selected group of paintings and sculpture in the exhibit. It provides new and provocative correlative visual material, and an unusually interactive discussion of the paintings and sculptures that were being produced at the same time. The author-curator has made a real contribution to understanding particular works and has especially brought out the classical and Renaissance inspiration for some of Matisse work in the 1920s.

137. Milner, Frank. *Henri Matisse.* London: Bison Books Ltd., 1994.

A book of some eighty colored plates of frequently reproduced paintings by Matisse, printed with fair color accuracy on glossy stock; twenty-nine are on double-spread pages annoyingly divided by the book's gutter. These are preceded by a brief, but intelligent, eleven-page synthesizing introduction that stresses important, even problematic, aspects of Matisse's work throughout his career. Recent scholarship is acknowledged, if not discussed in detail.

138. Minemura, Tashiaki. *Matisse.* Tokyo: Schinchosha, 1976.

A broad historical introduction to Matisse's work for the general public, drawn from the extant literature on the artist; generously illustrated.

139. Monod-Fontaine, Isabelle. *Matisse: Collections du Musée National d'Art Moderne.* Paris: Centre Georges Pompidou, 1979.

A catalogue raisonné of the twenty-nine paintings (including large cut-paper work), thirty-one drawings, and seven sculptures in the collection of France's national museum devoted to modern art. The catalogue entries are scrupulously researched and sensitively written by Monod-Fontaine, who adroitly utilizes the available scholarship on the works and adds her own perceptive and nuanced observations. The history of acquisitions of Matisse works, here outlined, manifests a shockingly unaggressive and unenlightened policy by the state with regard to this "most French" of artists.

140. Monod-Fontaine, Isabelle, and Anne Baldassari. *Matisse: Oeuvres de Henri Matisse du Musée national d'art moderne.* Paris: Éditions du Centre Pompidou, 1989. Revised and expanded version of 1979 edition.

In the ten years between this catalogue raisonné of the expanded MNAM collection and the previous one (no. 139), the number of works had more than doubled (from sixty-one to one hundred fifty-eight). With new acquisition funds, the museum had filled in some major lacunae and had, moreover, been the recipient of significant gifts from the Matisse family. Monod-Fontaine brings her previous entries up to date and adds the new paintings, books, cut-paper works. Anne Baldassari is responsible for the research and entries on the some fifty-six new drawings in the collection. The same high standards of the earlier version are maintained. An indispensable resource for the works in question.

141. Monod-Fontaine, Isabelle. *Matisse, Le Rêve ou les belles endormies.* Paris: Adam Biro, 1989.

An evocative iconographic study of one 1935 painting, *Le Rêve,* that also traces the theme of the sleeping model in a series of related works from 1907 to 1952. The sleeping beauty is described as "the visible absent one, both available and inaccessible" who functions as a metaphor for painting itself. The short text also compares the theme with a similar one in Picasso's 1930s work and situates it in its literary and historical context. An excellent and nearly unique work of iconographic investigation, rare in the Matisse literature which so favors formal analysis.

142. Nakahara, Yusuke, and Ichiro Fukuzawa. *Picasso and Matisse.* Series: Grand Collection of World Art. Tokyo: Kodansha, 1974.

An oversize, luxury volume of some eighty-nine mostly colored plates, sixteen of which are devoted to Matisse, and about the same number devoted to his followers or colleagues, Rouault, Derain, Vlaminck, Marquet, and Dufy. The text, though brief, is thorough in giving Matisse's background development, influences on him such as Russian icons and Cézanne's paintings, and in highlighting his major achievements. A somewhat pretentious format for the general reader. In Japanese.

143. Néret, Gilles. *Matisse.* Paris: Nouvelles Éditions Françaises, Casterman, 1991. English ed., New York: Konecky, 1993.

A luxury volume profusely illustrated in black and white and tipped-in color plates that proposes a general introduction to the whole of Matisse's oeuvre. The text contains no revelations or special insights but makes intelligent use of published literature. The plates are usefully juxtaposed for telling comparisons: parallel works, studies with finished works , etc.

144. Noël, Bernard. *Matisse.* Series: Les Maîtres de l'Art. Paris: Fernand Hazan, 1983. Reprint revised and corrected, 1987. Translated by Jane Brenton as *Matisse.* New York: Universe Books, 1987; London: Art Data, 1987.

A small, handsomely produced book that makes a serious
attempt to understand the esthetic premises of Matisse's work,
distinguishing his approach from Expressionism (understood
as a Northern European phenomenon) and analyzing his
particular use of color. Noël pays attention to the artist's
viewer-response theories, commenting on specific works.
Finally, he sees Matisse's process as a "drama of the mind"
which governs the painter's transformations of the viewed
model into the painted image.

145. O'Brian, John. "Ruthless Hedonism: The Reception of
 Matisse in America, 1929-1954." Ph. D. dissertation, Harvard
 University, 1990.

 A comprehentsive and sophisticated review of Matisse's
 reception-history in the United States from the time of the
 founding of the Museum of Modern Art until the year of the
 artist's death. Particularly detailed on the relation of Alfred
 Barr, Jr.'s construction of Matisse's reputation through
 MoMA and on the role of Clement Greenberg in promoting
 Matisse's relevance in the 1940s and 1950s. An important
 study.

146. Orienti, Sandra. *Henri Matisse*. Series: I Maestri de
 Novecento, 18. Florence: G. C. Sansoni, 1971. London, New
 York: Hamlyn, 1972; Barcelona: Circulo de Lectores, 1973.

 A good general introduction to Matisse's work and its
 development with good quality half-tone plates and forty-one
 color plates of fairly good fidelity to the originals although
 purples are too intense, too blue.

147. Pleynet, Marcelin. *Henri Matisse, Qui êtes-vous?* Series:
 Qui êtes-vous? Lyons: La Manufacture, 1988.

 The author teases out, from the published details of Matisse's
 history, a kind of biography about how his personality and
 the circumstances of his development shaped the painter's
 approach to his métier. Pleynet discusses how Matisse
 grounded himself in the pictorial language of Western
 painting, with special emphasis on the role of Quentin de la

Tour and portraiture; how Matisse found his own voice in rhyming "beauté" with "volupté" (as in Baudelaire's poem, *L'Invitation au voyage*); how he developed the themes that obsessed him throughout his career, especially the nude and the dance; and how the Barnes Foundation mural initiated the qualities of "dilation" and "global expansion" that informed his later work, culminating in the spatial amplitude of the Chapel of the Rosary at Vence. A subtle, if sometimes repetitious, account of the artist's inner drives and exterior achievements.

148. Radulescu, Neagu. *Matisse.* Bucharest: Editura Meridiane, 1971. In Romanian.

A substantial, thirty-five page general text, drawing on previously published Matisse literature; seventy-one plates give a good cross-section of the artist's various modes, though the color is of poor quality. Bibliography includes a few less well-known sources in Italian and Romanian.

149. Rendall, Julian. *The Art of Henri Matisse.* New York: Gallery Books, 1989.

Book of color reproductions preceded by a general text of no special distinction. Another general introduction to the artist's oeuvre that synthesizes published sources.

150. Róman, József. *Matisse.* Budapest: Gondolat Könyvkiadó, 1975. In Hungarian.

A substantial paperback on the artist's total oeuvre, well illustrated with reproductions (six in color) and photos of the artist.

151. Romm, Aleksandr G. *Henri Matisse.* Moscow, 1935. Translated into English by Chen I-Wan, Leningrad: Ogiz-Izogiz, 1937.

A very detailed formalist analysis of Matisse's work and development is wrapped in a straightforward Marxist critique of Matisse's escapist, individualistic, hedonistic, esthetic ends. As a representative of modernism who flees social realities

into the realms of the exotic or erotic, Matisse is judged more harshly than Picasso and the Cubists who at least, according to Romm, mirror the chaos, disintegration, and fundamental antagonisms of imperialist capitalism in the modern West. A surprisingly formal and traditional study which, in spite of the dogmatic predictability of its ideological framework does not deal with the social, economic, or political context of the artist's long career.

Review: Graeme, Alice. "Matisse à la Russe." *Mag. of Art* 31 (June 1938): 366+.

152. Romm, Alexandr. *Matisse, a Social Critique.* New York: Lear, 1947. Translated by Jack Chen.

The 1937 text (no. 151) reissued with twenty new drawings and a tipped-in frontispiece in color, *The Blue Window,* added.

Review: Greenberg, Clement. "Matisse Seen Through Soviet Eyes." *New York Times Book Rev.* (January 25, 1948).

153. Russell, John. *The World of Matisse, 1869-1954.* Series: Time-Life Library of Art. New York: Time-Life Books, 1969. Revised 5th printing, 1979. Translated by Dominique de Bourg as *Matisse et son temps, 1969-1954.* New York: Time-Life, 1973. German ed., Amsterdam: Time-Life, 1973.

One in the well-produced, popular monographic series on artists published by Time-Life, Russell's book on Matisse is a full, graceful, and entertainingly written account of the artist's life and work. Several solid pages of informative text alternate with some half-dozen pages of color plates, each with its own substantial commentary that adds yet further analysis or anecdote. Matisse's beginnings are set in the context of post-impressionism, his Fauve works against northern Expressionism; his pre-war decorative panels are treated along with his new patronage and international recognition. Curiously underplayed or absent are a discussion of Matisse's trips to North Africa in 1912 and 1913 and his reaction to Cubism. Generously illustrated as well with documentary photographs.

154. Schacht, Roland. *Henri Matisse.* Series: Künstler der Gegenwart. Dresden: Kaemmerer, 1922.

This eighty-two-page monograph (with thirty-three illustrations) is a sensitive and sensible analysis of Matisse's development by an art historian with an acute understanding of the painter's project. His distinctions between Kandinsky's color usage and Matisse's show a profound understanding of both painters; Schacht is equally insightful on what Matisse learned from Cézanne.

155. Scheiwiller, Giovanni. *Henri Matisse.* Series: Arte moderna straniera, 3. Milan: Hoepli, 1947.

A pocket-sized monograph, with nineteen pages of text. First published as a Bibliographic Note in 1933; subsequently enlarged to this 1947 fifth edition. A general treatment drawing on the published literature of the time.

156. Schneider, Pierre. *Henri Matisse. Exposition du Centenaire.* Paris: Réunion des Musées Nationaux, 1970. Exhibition catalogue.

This centenary exhibition and its catalogue inaugurated a rich two-decade period of renewed Matisse appreciation and scholarship. Although relatively modest in size and with no color reproductions (a supplement of color plates accompanied it), the catalogue essay proposes a comprehensive view of Matisse that challenges Barr's (1951) and culminates in Schneider's 1984 monograph (see no. 157). Studded with quotes from previously unpublished Matisse correspondence and new biographical material, the catalogue introduced the anxiety-ridden personality of a different Matisse who had need of his art for calm and equilibrium, producing work that provides this for the viewer as well. Here is a Matisse of spiritual dimension whose secularized religious impulses are those of the East, rather than the West.

Review: Murphy, Richard. "Matisse's Final Flowering." *Horizon* 12, 1 (Winter 1970): 26-41.

157. Schneider, Pierre. *Matisse*. Paris: Flammarion, 1984.
 Translated by Michael Taylor and Bridget Stevens Romer,
 New York: Rizzoli International; London: Thames and
 Hudson, 1984. Revised edition, Paris: Flammarion, 1993, in
 French and English versions. Revisions include minor
 corrections of facts, an updated and corrected bibliography and a
 new "introduction" that deals with the discovery of the first
 version of the Barnes Foundation mural, *Dance,* with its first
 color reproduction.

 This luxurious, 752-page book is the leisurely exposition of
 the author's lifetime meditation on Matisse as man and artist.
 The leitmotif around which Schneider organizes his twenty-
 two resolutely ahistorical (but roughly chronological) chapters
 is that of Matisse's art as therapeutic and salvific rather than
 aesthetic and hedonistic. An essentially spiritual artist whose
 main theme is an arcadian Golden Age of harmony, Matisse
 alternates, according to Schneider, this theme with periodic
 explorations of its stylistic opposite that only feigns another
 theme under its guise of realism.

 Stressing the artist's preoccupation with light, Schneider
 interprets light in a symbolic, even religious, context,
 suggesting that Matisse translates the luminous into the
 numinous. Following the insights of Georges Duthuit, a
 Byzantine scholar and the artist's son-in-law, on the role of
 light and splendor of surface in mystical, hieratic art, Schneider
 draws on analogies with Eastern art (especially Islamic
 traditions), to describe how Matisse made the decorative a
 vehicle of the ineffable. Tendentious in its pursuit of this
 theme, Schneider's book is nevertheless rich in new
 information, insights, and allusions, refreshingly portraying a
 Matisse who is both intellectual and spiritual.

 The book is exquisitely written (rich in digressions on French
 culture) and produced, with numerous color plates of
 unparalleled closeness to the originals, and many black and
 white reproductions of previously unpublished drawings.
 Schneider provides new biographical material and hitherto
 unpublished letters and journal entries by Matisse. This
 material must be excavated from the text, which is

thematically ordered (except for a short section, pp. 715-740, that is specifically biographical). The 1984 edition is somewhat careless with dates, insufficient in documentation, and chary with scholarly acknowledgements; the 1993 edition seeks to remedy these faults.

Review: Brenson, Michael. "Matisse by Pierre Schneider." *New York Times*, November 20, 1984; Cohen, Ronny H. Reviews of Elderfield [Drawings], Schneider, and Watkin. *Print Collector's Newsletter* 16, 3 (July-August 1985): 104-108; Elderfield, John. "Matisse: Myth vs. Man." *Art in America* 74, 4 (April 1987): 13-21; Gaillemin, Jean-Louis. "Matisse, nus bleus, oranges et poissons rouges, entretien avec Pierre Schneider." *Beaux-Arts Mag.* 19 (December 1984): 34-62; Golding, John. "The Golden Age (review)." *The New York Rev. of Books* 32, 1 (January 31, 1985): 3-6; Herbert James D. "Matisse without History [Reviews of Schneider and Flam]." *Art History* 11, 2 (June 1988): 297-302; Klein, John. Review of Schneider's *Matisse*. *Art Journal* 45, 4 (Winter 1985): 359-67; Millet, Catherine. "Pierre Schneider, l'art sacré d'Henri Matisse." *Art Présent* 87 (December 1984): 4-8; Neff, John H. Review. *Art News* 84, 5 (May 1985): 29; Perl, Jed. "Matisse (Review of Schneider and Elderfield [Drawings])." *New Criterion* 31, 10 (June 1985): 19-27; Vallier, Dora. Review. *Critique* 457-8 (1985): 677-85; Watkins, Nicholas. "Matisse, a Sort of Spiritualist (review)." *Art History* 9, 1 (March 1986): 115-19.

158. Selz, Jean. *Henri Matisse*. Series: Les Grands Maîtres de la Peinture Moderne, no. 5. Paris: Flammarion, 1964, 1973. Translated into English by A.P.H. Hamilton, New York: Crown Publishers, 1964, 1990. Translated into Italian by Antonio G. Valiente, Madrid: Ediciones Daimon, 1966; German ed., Milan: Heidelberg, 1966.

A picture-album with a lightweight introduction to Matisse's oeuvre that can be misleading. The early discovery of color is distorted by a misleading presentation of Neo-Impressionism and its contribution. Selz states categorically that Matisse's work did not "develop" or manifest period changes; elsewhere,

Selz states that "in most of his paintings, Matisse used a thick
black line." The first of these assertions is highly debatable,
the second is patently false. One of the too-common
monographic essays riddled with discredited clichés and
generalizations that need not have been republished in the
1990s.

159. Sembat, Marcel. *Matisse et son oeuvre*. Series: Peintres
 français nouveaux, 1, edited by Roger Allard. Paris: Nouvelle
 Revue Française, 1920; reprinted with additional illustrations
 in 1921 as *Matisse,Trente reproductions de peintures et dessins
 précédées d'une étude par Marcel Sembat*.

 Sembat accounts for Matisse's seemingly less ambitious post-
 War style in terms of the artist's mature mastery of his means.
 Echoing Matisse's own *apologia* for his shift of style,
 Sembat maintains that Matisse's goals have not changed, only
 his means differ. His new methods tend to conceal the effort,
 the strain of invention, which are still fundamental to their
 production. This important essay, by a friend and critic who
 was intimately acquainted with the pre-1917 work of Matisse,
 established the interpretation of the Nice works for many
 writers of the 1920's who often simply echo its major
 premises.

160. Severini, Gino. *Matisse*. Series: Arti, "Anticipazioni," 6.
 Rome: Fratelli Bocca, 1944.

 A small popular monograph of some fifteen pages of text
 accompanying as many well-chosen reproductions of Matisse's
 paintings through 1941. Severini was close to Matisse during
 the 1910s, a significant period. Severini differs with Lhote's
 assessment of Matisse as one who works from sensation to
 idea; rather, Severini sees Matisse as one who always worked
 from a clear idea enriched and clarified by sensation in the
 process of working from nature. Severini's Matisse is
 intellectual and problem solving without being academic,
 classically balanced in his aims and methods.

161. Sutton, Denys. *Paintings, 1939-46.* London: Lindsay
 Drummond, Ltd.; Paris: Éditions du Chêne, 1946. Same
 layout and illustrations as André Lejard, *Matisse, seize
 peintures, 1939-46.* Paris: Édition du Chêne, 1946.

 An album of recent paintings by the artist, beautifully
 reproduced on heavy paper, originally published with an
 introduction by Lejard, no. 125. The tipped-in color plates are
 exceptionally fine in all editions. Sutton's essay stresses the
 fact that, although Matisse's art has revolutionary elements, it
 is basically conservative, providing a base for the continuing
 work on the "problems of painting" and validating the tradition
 of "painting from appearances." He suggests that Fauvism
 and Cubism, both sprung from Cézanne, are the generative
 legacies of pre-World War II art available to that of the post-
 war era, Constructivism and Surrealism having ended in blind
 alleys.

162. Svrcek, K. B. *Henri Matisse.* Prague: Melantrich, 1937.

 A book of twenty-five plates (one in color) with a four-page
 summary introduction for the general reader. In Czech.

163. Swane, Leo. *Henri Matisse.* Stockholm: Nordstedt and
 Söners Verlag, 1944; translated into Danish as *Matisse.*
 Copenhagen: Jespersen og Pios Forlag, 1945. With
 contributions by Tor Bjurström, Edward Hald, Jean Heiberg,
 Einar Jolin, Per Krohg, Arthur C:son Percy, Axel Revold,
 Henrik Sorenson, and Sigfrid Ullman. In Swedish.

 A complete and careful review of Matisse's artistic
 development, making intelligent use of published sources and
 giving understandable emphasis to Matisse's connections in
 Sweden and Denmark. Matisse's early career and the
 development of Fauvism is given some emphasis, since the
 Rump collection is especially rich in this period. Of special
 note is the chapter on Matisse's Scandinavian pupils, followed
 by a series of short essays by a number of them that recall or
 pay homage to Matisse. The text is handsomely designed with
 interspersed line drawings and boasts a substantial number of
 plates of paintings. Bibliography.

164. Thiel, Erika. *Henri Matisse*. Series: Welt der Kunst. Berlin:
 Henschel Verlag, 1971.

 An album of sixteen plates (five in color) of significant works,
 accompanied by short commentaries and preceded by an
 introductory essay. Summary biography and bibliography
 included.

165. Trapp, Frank A. "The Paintings of Henri Matisse: Origins
 and Early Development, 1890-1917." Ph.D. dissertation,
 Harvard University, 1951.

 An early dissertation on Matisse completed during the artist's
 lifetime (author records an important interview with Matisse at
 Cimiez, February 17, 1950) and just one year after the
 publication of Barr's important monograph. Trapp gives
 careful attention to technique and to the formal properties of
 the works discussed, making this a primarily painterly
 discussion of Matisse's early development. For so early a
 study, however, careful attention is paid to the role of Moreau
 and Pissarro in Matisse's formation, as well as his
 apprenticeship in the standard book of painting advice by
 Goupil. Neo-Impressionism is treated in detail, as well as the
 "moment" (not "movement") of Fauvism. The 1916 *Bathers
 by a River* is given a thoughtful iconographic interpretation.

166. Verdet, André. *Prestiges de Matisse. Précédé de visite à
 Matisse. Entretiens avec Matisse*. Paris: Éditions Émile-Paul,
 1952.

 A very valuable, beautifully produced, small book with an
 original cover design by Matisse (less than 2000 copies
 printed). Divided into three parts, the first and second sections
 contain important statements by the artist on his work and
 methods, just after completion of the Vence chapel. The book
 contains precious first-person testimony from Matisse at the
 end of his life, while he was working on his last large-scale
 decorative cut-paper commissions. "Visite à Matisse" not
 included in either the Fourcade or Flam anthologies.

167. Verdet, André. *Entretiens, notes et écrits sur la peinture--Braque, Léger, Matisse, Picasso.* Collection: Écritures/Figures. Paris: Galilée, 1976.

Published in 1976, these further interviews with artists by Verdet were gathered from two decades earlier. The section on Matisse comprises several fragments of conversations conducted at Saint Paul de Vence, at the villa Le Rêve, and in the Hotel Régina. Matisse tells of his interiorizing of spatial experience by watching birds, animals; he speaks of his odalisques, the chapel at Vence and there is a longer interview on his late works. Two essays are reproduced under different titles in *XXe Siècle, Hommage à Henri Matisse* (Special edition, 1970): "Rencontre à Saint Paul" appears as "Les Heures azuréennes," and "La Chapelle de Vence" as "Architecture et décoration." The language is somewhat overripe in these interviews, not Matisse's characteristic style; one suspects a certain paraphrasing by the author from sketchy notes.

168. Watanabe, Junichi, Chuji Ikegami, and Shuji Takashina. *Matisse.* Series: Les Grandes Maîtres de la Peinture Moderne, 15. Tokyo: Chuokoron-sha, 1973.

A full-scale monographic treatment of Matisse complete with colored plates, chronology, and bibliography. Essay by Takashina on the development of Matisse's art in relation to Fauvism (in contrast to German Expressionism, Fauvism is a more intellectual and positive art movement, with a strong foundation on sound technical means) and an extended piece by Junichi Watanabe which revolves around the question: why is not Matisse more popular in Japan? Based on an informal poll, Watanabe discovers that Matisse is not named among the ten most well-known modern artists, that only five per cent of his respondents say they like Matisse (as opposed to seventy per cent who name Van Gogh as their favorite). The author proposes reasons for this: Matisse is not taught in depth in the schools, he is not even understood as the major figure in Fauvism, he is not often reproduced in greeting cards or calendars, he has not been written about by a well-known

Japanese author. More than this, in the author's view, Matisse's life and art do not conform to the desire of the Japanese for the pathetic, the tragic, the sympathy-evoking in art. The desire for the emotionally expressive is by way of contrast with the orderly and dutiful patterns of Japanese life; Matisse's expression is too decorative, too cheerful, too divorced from human pain and melancholy. Watanabe then tries to explain to his readers the nature of Matisse's expression through color and composition, using the artist's own statements to support his claims about "balance, purity and serenity" as legitimate aims of expression. Extensive bibliography of works in Japanese as well as the standard works in French and English.

169. Watkins, Nicholas. "A History and Analysis of Color in the Work of Matisse." M. Phil. Thesis, Courtauld Institute of Art, University of London, 1979.

A careful study of the development and rationale of Matisse's use of color based on the analysis of his paintings; this material is utilized in the author's 1984 monograph on the artist, no.170.

170. Watkins, Nicholas. *Matisse.* Oxford: Phaidon Press; New York: E.P. Dutton, 1977. Reprint, expanded, London, Guild, 1984; New York: Oxford University Press, 1985; New York: Universe Books, 1991.

This general study of Matisse's entire oeuvre is first rate, ranking in quality if not always in scope with Barr, Diehl, Escholier, Flam, Gowing, and Schneider in the category of monographs. Particularly refreshing is the lack of hagiographical tone, the psychological insights that are offered without being belabored, and the historical context against which Matisse's life is presented. The book is lucidly and gracefully written, successfully integrating biographical material with critical analysis of the works. Watkins deals with the paintings, sculpture, cut-paper works, and decorative commissions; the graphic work and book illustrations are

treated only in passing. The illustrations, abundant, are generally of good quality.

Review: Cohen, Ronny H. Review of Elderfield, Schneider and Watkins. *Print Collectors Newsletter* 16, 3 (July-August 1985): 104-08.

171. Watkins, Nicholas. *Henri Matisse*. London and New York: Phaidon Colour Plate History Series, 1977; revised and enlarged, 1992, 1993.

An album of thirty-seven well-chosen color plates of paintings by Matisse preceded by a general introduction which, though necessarily synthetic and accessible to a traditional public, is a popular treatment of Watkins's more complete monographic study.

172. Marit Werenskiold. *De Norske Matisse-Elevenen, Laeretid og Gjennombrudd 1908-1914. Jean Heiberg, Henrik Sorensen, Per Krohg, Axel Revold, Per Deberits, et al.* Oslo: Gyldendal Norsk Forlag, 1972. In Norwegian.

Primarily on Norwegian pupils who studied at Matisse's "Academy" between 1908 and 1911, this informative text gives an account of their modernist cultural heritage in Norway from 1900 to 1909, details their experience of Matisse as a teacher and theoretician from first-hand accounts, traces their stylistic development, and follows their careers in Norway on their return from Paris. Well researched and written, the book illuminates Matisse's impact on his pupils in the wider context of their assimilation of French modernism and their subsequent artistic achievements.

173. Werth, Margaret. "Le Bonheur de vivre: The Idyllic Image in French Art, 1891-1906," Ph.D. dissertation, Johns Hopkins University, 1993.

This study investigates the uses to which the themes of the Golden Age and Fête Champêtre were used at the turn of the century. The interest in idyllic and utopian imagery accompanied a series of radical shifts in avant-garde pictorial

language in France when artists were coming to grips as well with changes in mass society. Matisse's use of these themes is the subject of a chapter in the study, an early version of which appeared as an article in *Genders* in the Fall of 1990, no. 874.

174. Wilson, Sara. *Henri Matisse*. New York: Rizzoli International, 1992. Translated by Julian Stallabrass, Paris: Albin Michel, 1992. Spanish ed. Barcelona: Poligrafa, 1992.

The familiar-format book of colored plates--preceded by a general introduction to the artist's work and brief commentary on the plates--is here given a treatment more politically engaged than is usual in this popular genre. The author, a specialist on French art and politics from 1935-1955, has brought this knowledge to bear on aspects of Matisse's life and career. Wilson especially draws attention to the connections between the artist's odalisques and orientalist fantasies and France's colonial policies in the 1920s and 1930s; his cut-paper work (particularly *Jazz)* and the politically implicated revival of Romanesque art from the mid-1930s through the 1940s; and the creation of the Vence chapel in the post-War climate of religious revival and French Communist Party maneuvers. If the links sometimes seem forced and the political issues oversimplified, the limitations of length and format appear largely responsible. An ambitious and provocative essay which encourages a more contextual treatment of the artist.

175. Yanaihara, Isaku, and Masataka Ogawa. *Matisse-Rouault.* Tokyo: Zauho Press; Kawai Shobo Shin-sha, 1972. In Japanese.

Parallel portraits of the two artists in a slender (139-page) slipcased picture-book for the general public. Essay on Matisse by Yanaihara, who sat to Giacometti for a series of portraits in Paris. Abundant color plates are untrue to originals, being too intense.

176. Zervos, Christian. *Henri Matisse.* Paris: Éditions Cahiers d'Art, 1931. Reprint, modified, of a special number of *Cahiers d'art,* 1931.

This special edition was produced in conjunction with several retrospective exhibitions of Matisse, the Paris venue being at the Georges Petit Galleries in 1931. Articles by Karel Asplund, Roger Fry, Paul Fierens, Curt Glaser, Will Grohmann, Pierre Guéguin, Henry McBride, Georges Salles, and Christian Zervos are summarized individually, by author's name, in the section "Articles."

III
SPECIFIC MEDIA

Sculpture

Books

177. Duthuit, Claude. *Henri Matisse, catalogue raisonné de l'oeuvre sculpté.* Paris: Ed. with collaboration of Françoise Garnaud and preface by Yve-Alain Bois, 1996.

Presentation of essential scholarly information on the sculptural production of Matisse. The sculpture has been re-photographed, following the Druet photographs of the period, in views that were chosen by Matisse, that is, from vantage points of the work that the sculptor thought important. The implications of these views are discussed in the important essay by Yve-Alain Bois which acts as a preface to the catalogue, no. 184.

178. Elsen, Albert E. *The Sculpture of Henri Matisse.* New York: Abrams, 1972.

First comprehensive study of the sources, character, and evolution of all Matisse's sculpture, including its affiliation to Rodin's art and to nineteenth-century academic theory. Beside relating the sculpture to the artist's efforts in other media, Elsen compares it to that of Picasso, Bourdelle, Duchamp-Villon,and Laurens. The text is based on four articles that had appeared in *Artforum* in 1968 (no. 187) and generally follows the plan of the articles that had treated 1) the early Rodin-influenced work, 2) the work that retained

conservative classical themes, 3) work influenced by the "primitive" and portraiture, and finally 4) the *Backs* and monumental decorative sculpture. A good bit of new material has been added in the monograph, and the ordering is more chronological than in the articles. This is still the indispensable primary text on Matisse's sculpture; handsomely illustrated, often with several views of a single work, studies, and related works in other media and by other artists.

Reviews: Goldstein, Carl. "Review of Elsen's *The Sculpture of Henri Matisse.*" *Art Quarterly* 36 (1973): 420-21; Gottlieb, Carla. Review. *Burlington Mag.* 116, 852 (March 1974): 160-61.

179. Legg, Alica, intro. *The Sculpture of Henri Matisse.* New York: Museum of Modern Art, 1972; reprint 1975. Exhibition catalogue.

Catalogue for exhibition of the same name at MoMA . Solid text dealing with all sixty-nine known bronzes by Matisse with related drawings and prints, as well as paintings in which sculptures are included. Legg's discussion is a workmanlike survey of the sculptural oeuvre, making intelligent use of the published literature. Complete list of sculpture exhibitions from 1904 to 1970.

180. Monod-Fontaine, Isabelle, and Catherine Lampert (general editor). *The Sculpture of Henri Matisse.* London: Arts Council of Great Britain and Thames and Hudson, Ltd., 1984.

Monod-Fontaine's very original and freshly conceived text accompanied the exhibition *The Sculpture and Drawing of Henri Matisse* organized by the Arts Council of Great Britain and shown at the Hayward Gallery, London, and at the Museum of Modern Art, New York, in 1984-85. Although the author develops her sections chronologically, she highlights particular aspects of the work: the early use of photographs of models; the relation of cubist sculpture to the 1910-14 work; the sculpture in Matisse's paintings; the classical aspects of the 1924-32 sculptures; and the relation of Matisse's late sculpture to his cut-paper work, his chapel

designs, and his prints. The relationships are surprising and often based on new documentation. Richly illustrated and succinctly elaborated, the text is an important addition to the scholarship on the artist's sculptural oeuvre. Chronology, list of major exhibitions containing sculpture, checklist of and sometimes more than one view of the works in the exhibit.

Review: Hilton, Timothy. Review. *Times Lit. Supp.* (November 23, 1985): 1344; Hyman, T. Review. *Artscribe* 50 (January-February 1985): 57-58; Klein, John. Review of Schneider, Elderfield, and Monod-Fontaine, *Art Journal* 45 (Winter 1985): 359-67; Neve, C. Review. *Country Life* 176, 4555 (December 6, 1984): 1776; Spalding, F. Review. *Arts Rev.* 36, 20 (October 26, 1984): 523; Watkins, Nicholas. Review. *Burlington Mag.* 126, 981 (December 1984): 800.

181. Tucker, William *The Language of Sculpture.* London: Thames and Hudson, 1974, 1985; published also as *Early Modern Sculpture: Rodin, Degas, Matisse, Brancusi, Picasso and Gonzales.* New York: Oxford University Press, 1974. The chapter on Matisse originally appeared in *Studio International,* September 1970, as "Four Sculptors, Part 3: Matisse," no. 218.

Tucker develops the theme of the traditional and risk-taking aspects of Matisse's sculpture by examining the latter's desire for an internal architecture of synthetic, but living, forms. Tucker also unifies the fragmentary nature of the artist's sculptural output by placing it within the larger scope of his development in painting; an indispensable short study of Matisse's sculptural project by a practicing sculptor.

Reviews: Ashton, Dore. Review. *Art Bull.* 57, 4 (December 1975): 599-600; Elsen, Albert. Review. *Art Journal* 35, 2 (Winter 1975-76): 136-38; Fry, Edward. Review. *Artforum* 13, 10 (Summer 1974): 63-64.

Articles

182. Argan, Giulio Carlo. "Matisse Scultore." *La Biennale de Venezia* 26 (December 1955): 29-33.

General treatment of the three-dimensional work of Matisse; the sculpture of a painter is compared to that of Degas, Renoir, and Picasso. Avoiding the immobility of classicism and the restless instability of romanticism, according to the author, Matisse seeks a spatial breadth and flexible manipulation of matter to suggest an infinite space.

183. Benjamin, Roger. "L'Arabesque dans la modernité, Henri Matisse, Sculpteur" with list of sculptures exhibited in Paris and principal foreign exhibitions from 1904-1915. In *De Matisse à nos jours, la sculpture du XXe siècle dans les collections des musées et du fonds régional d'art contemporain du Nord-Pas-de-Calais*, 15-25. Calais: Association des Conservateurs des Musées de Nord-Pas-de-Calais, 1992.

Benjamin sees Matisse's sculpture as "a complex dialogue with a set of [sculptural] inheritances" in which, while searching for plastic equivalents to the human form, he never abandons the tradition of representation. The author discusses Matisse's work as that which either 1) relies on the "arabesque" or *figura serpentina* for its flamelike and transparent plastic movement of the body or 2) the controlled and weighty massing of form, psychologically inert, that has its prototype in Egyptian and early Greek sculpture. Benjamin devotes some fine analysis to the "serial" works of Matisse and to the response of contemporary critics to Matisse's first exhibitions of his sculpture. Also of value is the list of sculptures exhibited in Paris and principal foreign exhibitions from 1904-1915, with Benjamin's and Claude Duthuit's tentative identifications of uncertain titles. An important study.

184. Bois, Yve-Alain. "Preface." In *Henri Matisse, catalogue raisonné de l'oeuvre sculpté*. Ed., Claude Duthuit. Paris: Ed.

with collaboration of Françoise Garnaud and preface by Yve-Alain Bois, 1995, no. 177. French and English.

Bois discusses Matisse's statement about "sculpting as a painter," by examining the "pictorial" position of Adolph von Hildebrand's *Das Problem der Form in der bildenden Kunst* and the practice of Rodin and how Matisse's work differs from either of these. Matisse's sculpture is anti-anatomical (like Rodin's) but concerned with wholes rather than fragments (like classical art). The author also discusses the materiality of Matisse's approach, his rhetoric of metaphor, and the importance of a Mannerist model (Giambologna) for Matisse's infinitely varied silhouettes (or points of view). A rich and provocative treatment of the artist's work in this medium.

185. Cassou, Jean. Introduction in *Henri Matisse, Sculpture, Drawings*. New York: Fine Arts Associates, Otto M. Gerson, 1958. Exhibition catalogue.

A short general introduction to both the sculpture and drawings of Matisse in the exhibition.

186. Cassou, Jean. Introduction in *The Sculpture of Matisse and Three Paintings with Studies*. London: Tate Gallery, 1953. Exhibition catalogue.

Author calls Matisse a Renaissance artist in the sense that no material or technique is beyond or beneath his curiosity. He is a craftsman, a decorator, a collaborator in large projects, interested in "structural conception and material mastery." Sculpture manifests the familiar mode of Matisse's genius, wherein he respects a tradition in a medium (sculpture) and harmonizes it with a brutal, direct expression (in clay) in his habitual state of "alertness and discovery."

187. Dorival, Bernard. "Sculptures de peintres." *Bull. des musées de France* 10 (1949): 252-55.

An article on recent acquisitions of sculpture by the Musée d'Art Moderne includes two bronzes by Matisse, *Femme nue assise* [Seated nude, arms behind her back, 1909] and *Femme*

nue couchée [Reclining Nude I, 1907], both from the Alphonse Kann heirs. Only the second sculpture is discussed, particularly in relation to its companion oil, *Blue Nude, Souvenir of Biskra.* Author notes that Matisse's painting reveals him as nothing but a painter, his sculpture as nothing but a sculptor, so specifically does he work within a material and métier.

188. Elderfield, John. "Matisse's Drawings and Sculpture." *Artforum* 10 (September, 1972): 77-85.

In the wake of the publication of Albert Elsen's book *The Sculpture of Matisse* (1972), the MoMA exhibition of Matisse's sculpture (1972) with catalogue by Alicia Legg, and the Baltimore Museum's show *Matisse as a Draughtsman* (1971) with catalogue by Victor Carlson, Elderfield relates Matisse's sculpture both to his drawing, with which it has much in common, and to his painting, for which it acts as an alternative mode of thinking. Nevertheless, Matisse's sculpture is linked to painting as a means of organizing sensations for use in resolving painting problems as well as by being "painterly" in handling and presenting a "view." Elderfield's usual nuanced and visually acute reading of these matters presents them as complex and often paradoxical.

189. Elsen, Albert E. "The Sculpture of Matisse: I, A New Expressiveness in Sculpture." *Artforum* 7, 1 (September 1968): 20-29; II, "Old problems and New Possibilities." 2 (October 1968): 22-33; III, "Primitivism, Partial Figures and Portraits." 3 (November 1968): 26-35; IV, "The Backs." 4 (December 1968): 24-32.

These essays were expanded into the book, *The Sculpture of Henri Matisse,* New York, Abrams, 1972, no. 178.

190. Elsen, Albert E. "Rodin et Matisse: différences, affinités, et influences." In *Rodin et la sculpture contemporaine.* Paris: Éditions du Musée Rodin, 1983. Papers from a colloquium organized by the Musée Rodin, October 11-15, 1982.

Before discussing the specific differences between Rodin and Matisse, the author outlines first the differences between nineteenth-century and twentieth-century (modern) sculptural practice The latter include Matisse's preference for *études*, for an ideal of the decorative (expression in the entire ensemble), for a deductive approach to construction, for stability and stasis over movement, etc. Elsen is careful to distinguish affinities (stemming from temperament or common sources) from influences, of which the latter are more powerful than Matisse would later admit. A final section, with perhaps the newest thesis, deals with the influence of Rodin's drawings on Matisse's graphic style. This section is developed in the author's later essay, "Rodin's Drawings and the Art of Matisse," *Arts Magazine* 61, 7 (March 1987), no. 273.

191. Flam, Jack. "La Sculpture de Matisse." *Cahiers du Mus. National d'Art Moderne* 30 (Winter 1989): 23-40.

Flam closely investigates several sculptures and related oils from the first decades of the century to explore how sculpture helped Matisse resolve the problem of plasticity as opposed to the surface planarity in painting. The continuing reciprocity between the two media is illuminated by this analysis and by Flam's close reading of a hitherto unpublished text drawn from a 1941 interview with Matisse by Pierre Courthion.

192. Flint, Ralph. "Matisse Sculptures, Brummer Galleries." *Art News* 29 (January 10, 1931): 9.

Short criticism of an early Matisse sculpture show in the U.S.; author notes that Matisse's sculpture is more experimental, less intellectual than his painting, which is more authoritative and fully achieved.

193. Fournet, Claude. "Matisse sculpteur." *Art Press* 30 (July 1979): 16-18.

Fournet, conservateur-in-chief of the Museums of Nice, meditates on the function of sculpture in Matisse's work-- always in the breach, marginal to the main media of painting and drawing. By this fact, sculpture is able to radicalize what

the other media cannot, that is, to embody materiality, the other side of "art." His process is, like Giacometti's, to disfigure and to erase the model, the material. At the same time, sculpture gave Matisse access to architectural concerns in a non-site, until he developed the cut-outs which were disposed in sited space. A rich and evocative article.

194. Goldwater, Robert. "The Sculpture of Matisse." *Art in America* 60 (March-April 1972): 40-45.

A response to the "Sculpture by Matisse" show at the Museum of Modern Art, stressing the spontaneity and playfulness of Matisse's handling of clay, his ability to work from repose to immediacy and improvisation and back again to serenity and calm.

195. Goodrich, Lloyd. "Matisse's Sculpture." *Arts* 17 (February 1931): 253-5.

An extended review of the Brummer Gallery exhibition of 1931, the first major show of Matisse's sculpture to be seen in the United States. Goodrich characterizes the sculpture of Matisse as pictorial, that is, weightless, linear, instantaneous, rhythmic. According to the author, the charm and relaxation of Matisse's 1920s paintings are present in Matisse's sculpture to the latter's detriment.

196. Gouk, Alan. "Matisse as a Sculptor; Part I: *The Serf*--Cézanne, Rodin, Matisse." *Artscribe* 51 (March-April 1985): 44-51; Part II: *Artscribe* 52 (May-June 1985): 69-71.

An acute study of the contradictory currents in Matisse's indebtedness to Rodin and Cézanne in his early sculpture. An important, original grasp of the artist's sculptural approach and achievements, sometimes critical of Tucker and Elderfield; a response to the Hayward Gallery *Sculpture and Drawings of Henri Matisse* show of 1984-85.

197. Grand, Paule Marie. "Sculptures et gouaches découpées." *Le Monde* (April 23, 1970).

A brief review of the Bernheim-Jeune exhibition that preceded the Centennial Exhibition at the Grand Palais in the summer of 1970. The author was herself a model and assistant to Matisse while he worked on the late cut-outs.

198. Guéguen, Pierre. "Sculpture d'un Grand Peintre." *XXe siècle* 4 (Christmas 1938): 3-13.

Subtitled "Thumb and Brush," this essay equates them as intruments of the artist's "computation of caresses" in sculpture and painting respectively. Claiming that Matisse's early sculpture exhibits too much of the effort of "computation," Guégen prefers the caressing qualities of the later sculpture, especially praising (and magnificently reproducing in several photos) the artist's marble version of *Tiari*, in which the "thumb's" activity is of course entirely effaced.

199. Hofmann, Werner. "Über Matisse, Maillol und Brancusi." In *Museum und Kunst*, 97-108. Hamburg: Christians, 1970.

Hofmann examines the relation of Brancusi's *The Kiss* of 1908 to two other works that also seems to have drawn their esthetic from the new interest in "primitive" sculpture, namely, Matisse's first *Back* and Maillol's *Crouching Figure,* both made "around 1908." Avoiding the pathos of Rodin and even Bourdelle-inspired archaism, according to the author, these works function as a kind of proto-Cubism.

200. Holm, Arne E. "Henri Matisse som sculptor." *Kunsten Idag* 33, 3 (1955): 26-45, 54-6.

A straightforward, workmanlike account of Matisse as a sculptor from 1900. Author cites the early influences of Rodin, Daumier, and African sculpture on Matisse's work.

201. Hüttinger, B. Introduction. In *Henri Matisse, Das Plastische Werk*. Zurich: Kunsthalle, 1959. Exhibition catalogue.

Author places Matisse in a tradition of artists who were painters, carvers, and modelers, from the fifteenth to nineteenth

centuries, ending with Gauguin and Degas. Shows Matisse's divergence from Rodin and places Matisse's series sculptures-- *Jeanette I-V, Reclining Figure I-III, Backs I-IV*, etc.--at the head of those works which reveal him to be one of the small group of really great sculptors of the century.

202. Kijima, Shunsuke. "For Rich Contours: Sculptures by Matisse." *Mizue* (Japan) 913 (April 1981): 62-73. In Japanese.

A general study of Matisse's development as a sculptor, stressing his relation to Rodin through a close study of *The Serf*, along with the painting *Male Nude* (Bevilaqua) of c. 1900. Matisse only resolved his sculptural problems in *The Serf*, by studying Cézanne, according to the author, who particularly makes a comparison of some Matisse works with the former's *Still Life with Plaster Cupid*. Return to the arabesque further completed Matisse's mastery of the "rich contour."

203. Kramer, Hilton. "Matisse as a Sculptor." *Bulletin of the Boston Museum of Fine Arts* 64, 336 (1966): 49-65.

Analysis of Matisse as a minor artist in sculpture, albeit an extraordinary one with outstanding individual works (*Serpentine,* the *Jeanette* series, and the four *Backs*). Fine discussion of the situation of sculpture in France when Matisse first chose his medium (1890s). Matisse elected the heritage of Degas, a painter-sculptor, rather than of Rodin who consumed the very possibilities he opened up; thus, Matisse's sculpture favors the informal over the heroic, the sketch over the monument, sensibility over power, process over idealization.

204. Lipchitz, Jaques. "Notes on Matisse as a Sculptor." *The Yale Literary Magazine* 123 (Fall 1955): 12.

A short note in which Lipchitz claims that Matisse was a mere modeler, concerned primarily with surfaces in his early sculpture, but became a sculptor, engaged with volume and

inner structure, by 1930; *Tiari* of that year is especially praised.

205. Metken, G. "Körper als Architectur von Formen: zu den plastischen Arbeiten von Henri Matisse." *Kunstwerk* 33, 3-4 (December 1969): 3-12.

A reflection on the essentially architectonic structure of Matisse's sculpture as seen at the 1969 Waddington Gallery exhibition in London; the author anticipates the centenary show to come in Paris, 1970. A sensitive, if brief, overview of the artist's sculptural oeuvre.

206. Monod-Fontaine, Isabelle. "Nice, Musée Henri Matisse, la donation Jean Matisse." *Rev. du Louvre* 30, 3 (1980): 185-89.

A short article on the donation of fifty bronzes by the widow of Jean Matisse to the Musée Matisse at Nice, along with the monumental oil, *Nymphe dans la forêt* (1936-38), two cut-paper works, three large brush-and-ink drawings, and a tapestry. Author briefly elaborates the donation according to several different groups of sculptural work: early, small hand-held sculptures, the five heads of *Jeannette,* works from photographs, *Two Negresses* and *La Serpentine,* two states of *Venus in a Shell* compared with the cut-paper *Blue Nude IV.*

207. Nash, Steven A. "Figures and Phantoms: Early Modern Figurative Sculpture." In *A Century of Modern Sculpture: The Patsy and Raymond Nasher Collection.* Dallas: Dallas Museum of Art, 1987. Ital. ed. Florence: Rizzoli, 1987. Exhibition catalogue.

A general essay places Matisse's work in the modern figurative tradition of Rodin, Rosso, and Maillol, with emphasis on the specific works by Matisse in the Nasher collection.

208. Norling, Ole. "Det Borgerlige Mareridt, Om Rodins Borgerne fra Calais." *Middelelser fra Ny Carlsberg Glyptotek* 45 (1989): 29-45.

Discusses the history of Rodin's commission for the sculpture, *The Burghers of Calais,* analyzes the work in terms of a narrative "drama" in the round, traces its influence on Matisse's *Serf,* and the works of Giacometti, George Segal, Bjorn Norgaard, and the painter, Georg Sand.

209. Porter, Fairfield. "Matisse Sculpture and Drawings." *Art News* 57 (January 1959): 11.

A one-paragraph review of a late 1958 exhibition at the Gerson Gallery with more insight on Matisse's sculpture than many a longer article. Author posits scale and proportion as meaning.

210. Poulain, Gaston. "Sculpture d'Henri Matisse." *Formes* 9 (November 1930): 9-10.

Author links the sculpture of Renoir, Maillol, and Henri Matisse, in their "tortuous search for their sculptural gesture" and in the revitalizing and naturalizing of the gods as French. Poulain, in a poetic text without thesis, finds Matisse's sculpture more reserved than his paintings, "delyricized," and compelling. Written on the occasion of an exhibition of sixteen bronzes and of paintings by Matisse at the Pierre Loeb gallery in Paris; good reproductions of sculptures in the exhibition.

211. Read, Herbert. "The Sculpture of Matisse." In *Henri Matisse Retrospective*, 19-24. Los Angeles: UCLA Art Gallery, 1966. Exhibition catalogue, no. 129.

A perceptive introduction to the sculptural oeuvre of Matisse that privileges the role of the arabesque in his formal distortions; the latter aim to maximize "motion in liberty" in the phrase of Georges Duthuit. A good general synthetic treatment of the entire body of work.

212. Read, Herbert. "Le Sculpteur." In *XXe Siècle. Hommage à Henri Matisse*, 121-126. Paris: XXe siècle, 1970. Special issue on Matisse.

A long extract of the 1966 UCLA catalogue essay (no. 211), lacking only the first pages on Matisse's earliest work and his contacts with Rodin.

213. Rinuy, Paul-Louis. "1907: Naissance de la sculpture moderne? Le Renouveau de la taille directe en France." *Histoire de l'Art* 3 (1933): 67-76.

Discusses the work of Joseph Bernard, Brancusi, Derain, Matisse, and Picasso in the context of the new importance given to materials, direct carving, and the tendency to abstraction. Weighs and finds fragile the argument that Gauguin was the major source of this new interest in direct carving. A more general interest in making sculptural processes less mediated, more personal and expressive, is offered as an explanation of the phenomenon.

214. Schneider, Pierre. "Matisse's Sculpture: the Invisible Revolution." *Art News* 71, 1 (March 1972): 22-5, 68-70. French trans. *Critique* 30, 324 (May 1974): 490-500; Danish trans. *Louisiana Revy* 25, 2 (January 1985): 16-23+.

Schneider discusses Matisse's sculptural achievement as the manifestation of "static energy, . . . silent mass, unrhetorical weight." He counters the appeal of sculpture to the visual (as presence) with its appeal to the real (as object) and claims Matisse overcame this dialectic. An essay of individual insights rather than sustained argument.

215. "The Sculpture of Matisse." *Life Mag.* (September 11, 1970): 40-49.

Nine pages of outstanding color reproductions of Matisse sculpture (photographer: Henry Groskinsky), with an especially effective page of the four *Backs* juxtaposed with *Bathers by a River,* a full-page image of the *Reclining Nude* (1908) in terra cotta, and fine shots of *Tiari* and the small *Torso* of 1929. A concise, but highly informed commentary accompanies the photos.

216. Sylvester, David. "The Sculpture of Matisse." *Country Life*
 113 (January 23, 1953): 224; also in *The Listener* 49, 1248
 (January 29, 1953): 190-91.

 On the occasion of the Tate Gallery exhibition of Matisse's
 sculpture, Sylvester is critical of the artist's work in this
 medium in comparison to his achievement in painting.
 Deploring the "path of facile decoration" he claims Matisse
 followed in his later work, Sylvester prefers those sculptures
 which parallel the artist's earlier "Fauve" discoveries when
 Matisse was more genuinely innovative, tough-minded, and
 emotionally engaged. An incisive and important criticism.

217. Tucker, William. "The Sculpture of Matisse." *Studio Int.*
 178 (July-August, 1969): 25-27; reprinted from the catalogue,
 Henri Matisse, 1869-1954, Sculpture. London: Victor
 Waddington Gallery, 1969. Exhibition catalogue.

 Tucker's earliest essay on Matisse's sculptural practice,
 approach, and achievement; it sketches the themes of visuality
 and tactility that will be so brilliantly developed in later
 essays. Tucker suggests Matisse's relevance in the era of
 "perceptual" sculpture (i.e., minimalism) where concept and
 fabrication are less dominant stimulants to the sculptor.

218. Tucker, William. "Four Sculptors: Part 3: Matisse." *Studio
 Int.* 180 (September 1970): 82-87.

 Tucker develops the traditional vs. risk-taking aspects of
 Matisse's sculpture by analyzing his desire for an internal
 architecture of synthetic, but living, forms. He also unifies
 the fragmentary nature of the artist's sculptural output by
 placing it within the larger scope of his development in
 painting; an indispensable study of Matisse's sculptural
 project. This article appears, slightly revised, in Tucker's
 book, *The Language of Sculpture* (1974), no. 181.

219. Tucker, William. "Matisse's Sculpture: The Grasped and the
 Seen," *Art in America* 63 (July-August 1975): 62-68.

An extraordinarily subtle study by a sculptor on the paradox of tactility and, simultaneously, view. The latter is scaled for visuality, in Matisse's sculpture: perception at a distance. Matisse's figure motif is no more than a referent (not a subject), according to the author, but also a vehicle for the powerful sexual charge of the works. This essay is perhaps the best short treatment of Matisse's sculpture.

220. Turner, Caroline. "Matisse's Sculpture." In *Henri Matisse,* 144-155. Brisbane: Queensland Art Gallery and Art Exhbitions Australia, 1995. Exhibition catalogue.

Turner's is a condensed treatment of the entire sculptural project of Matisse, viewed through the works in the exhibition. Author emphasizes the sculpture as a counterpoint to Matisse's painting, also the centrality of the female form, treated metaphorically, in his three-dimensional work.

221. Wilkin, Karen. "Matisse: A Dialogue Between Sculpture and Painting," *Sculpture Rev.* 41, 4 (1992): 6-9.

On the occasion of the Matisse Retrospective of 1992 at the Museum of Modern Art in New York, where sculpture was strategically placed near related paintings, the author muses on the problem of the tension between profile and mass in Matisse's sculpture, a problem analogous to the tension between the illusion of volumes in space and the exigencies of the flat surface in painting. Wilkin relates Matisse's solution of this problem to those of Rodin and Maillol, then to Egyptian and African sculpture. A synthetic treatment by a sensitive, lucid writer.

Graphics

Books

222. Aragon, Louis. *Henri Matisse dessins: Thèmes et variations, précédés de "Matisse-en-France."* Paris: M. Fabiani, 1943. Limited edition, 950 copies in portfolio. An inexpensive reproduction of all the drawings, but without Aragon's text, has been published as *Henri Matisse; Drawings, Themes and Variations.* New York: Dover Publications, Inc., 1995.

A large, luxury edition of Matisse's "Thèmes et variations" drawings of 1941-43, seventeen groups of freely executed pen or pencil drawings of still lifes or figures. These some one hundred fifty-eight drawings are "variations" on an original "theme" usually done more realistically in charcoal. Aragon's intimate and leisurely text, "Matisse-en-France," is a kind of elegant apology for Matisse--the latter remote, non-political, producing works of a hedonistic esthetic--during the occupation, no. 363.

223. Buchheim, Lothar-Günther. *Henri Matisse, aus dem graphischen Werk.* Feldafing: Bucheim Ed., s.d.

A small booklet, paper-covered, with a lithographed cut-paper design on the cover. A three-page essay by Buchheim, selected texts by Matisse, biography, and bibliography accompany an album of prints.

224. Cassou, Jean. *Henri Matisse, carnet de dessins.* 2 vols. Paris: Huguette, Berès and Berggruen & Cie, 1955.

Two slipcased volumes, one of which is a facsimile of Matisse's notebook sketches for his first series of *Blue Nudes I-IV.* The second contains a long essay by Jean Casssou, which reflects on drawing as the figured thought of the artist, the first fruit of the artist's intellect, the basis of his method. Matisse is placed in line with French intellectual (spiritual) artists: Poussin, Ingres, Valéry, Mallarmé, Cézanne, none of whom fell into sterile academicism because they were also practitioners, workers, artist-intellectuals. Reflections on Quatremère de Quincy's use of rhetorical figures in speaking of

art which Cassou applies to Matisse's drawing. Intelligence,
finesse, geometry are seen (ironicallly, in this post-war essay)
as the "weapons" which French civilization never lays down.

225. Castleman, Riva, and John Hallmark Neff. *Matisse Prints
 from the Museum of Modern Art.* New York: The Museum of
 Modern Art and the Fort Worth Art Museum, 1986.
 Exhibition catalogue.

A traveling exhibition with two fine introductory essays:
Castleman's "The Prints of Matisse," 5-16; and Neff's "Henri
Matisse: Notes on his early prints," 17-24, each summarized
under the names of the authors in the next section, nos. 268
and 294. Chronology, selected bibliography, fully documented
list of works exhibited; thirty-one of the ninety-one exhibited
works illustrated.

226. Cowart, William John, III. "'Écoliers' to 'Fauves,' Matisse,
 Marquet, and Manguin Drawings: 1890-1906." Ph.D.
 dissertation, The Johns Hopkins University, 1972.

An exhaustive and finely detailed analysis of Matisse's
drawings, along with those of Marquet and Manguin, in the
early years when they developed conventional academic skills
and passed from them to their own individual styles. A fund
of information on academic practice and criticism; perceptive
analysis of Matisse's graphic development in the context of
the formation of Fauvism.

227. Duthuit-Matisse, Marguerite, and Claude Duthuit. *Henri
 Matisse--catalogue raisonné de l'oeuvre gravé.* 2 vols. Paris:
 Ed. by the authors with collaboration of Françoise Garnaud and
 preface by Jean Guichard-Meili, 1986.

Two volumes, the first on Matisse's etchings and drypoints,
wood cuts, and monotypes and the second on his lithographs,
linocuts, aquatints, and other miscellanea, present the entire
graphic work of Matisse with scholarly documentation. The
last includes title, size, edition, exhibition history when
known, and essential bibliography. A graceful general
introduction by Guichard-Meili introduces the work.

Review: Field, R. S. "Henri Matisse: catalogue raisonné de l'oeuvre gravé." *Print Collector's Newsletter* 16 (May-June 1985): 62-64.

228. Duthuit, Claude. *Henri Matisse--catalogue raisonné des ouvrages illustrés.* Paris: Ed. by author with collaboration of Françoise Garnaud and preface by Jean Guichard-Meili, 1988.

A very complete scholarly treatment of Matisse's work as a book designer, illustrator, contributor of occasional visual embellishments to books, and designer of book covers. Unfinished projects and diverse book-related studies are also included. The introductory essay by Guichard-Meili is especially informative as are the direct citations by Matisse-- often from unpublished letters--concerning specific projects. The artist's essay, "Comment j'ai fait mes livres," is also included. Major texts are translated into English by Timothy Bent.

229. Dvorak, Franz. *Henri Matisse, Zeichnungen.* Vienna: Forum, 1973.

An album of plates preceded by a short, general introduction to Matisse's drawings.

230. Elderfield, John. *The Drawings of Henri Matisse.* Intro. by John Golding. New York: The Museum of Modern Art, 1985.

As much a richly inclusive meditation on Matisse's whole career in all its manifestations as a book on Matisse's drawing, this important text by Elderfield must be read alongside the two other contemporaneous "biographies" on the artist: Jack Flam's *Matisse, the Man and His Art, 1869-1918* (1986) and Pierre Schneider's *Matisse* (1984) for three synthetic studies by long-time Matisse scholars. Elderfield divides his book in four roughly chronological sections: "Epiphanies" (early work to c. 1905), "Signs" (1906 through the period of high experimentation, 1918), "Possession" (the early Nice years, 1919-1929), and "Illuminations" (1930 until his death in 1954). Full of striking original insights such as the Nice years as a period of continual crisis rather than of decorative

and sensual ease, and the decade of the 1930s being dominated by themes of confrontation and domination. The book adumbrates some of the dense network of ideas elaborated in the author's catalogue for the MoMA 1992 *Matisse: A Retrospective* exhibition, no. 79.

The catalogue proper is a model of scholarly thoroughness and precision; list of drawing exhibitions, bibliography, chronology.

Review: Klein, John. Review of Schneider, Elderfield, Monod-Fontaine. *Art Journal* 45 (Winter 1985): 359-67; Cohen, Ronny H. Review of Elderfield, Schneider, and Watkins. *Print Collectors Newsletter* 16, 3 (July-August 1985): 104-08; Perl, Jed. "Matisse." *New Criterion* 3, 10 (June 1985): 24-25.

231. Fischer, Erik. *Fire Franske Illustratorer*. Ringkøbing: A. Rasmussens, 1952.

An essay on recent tendencies in French book illustration, using the recent work of Segonzac, Dufy, Rouault and Matisse as examples. The complete personalization of the book design--the illustrations, and the text written and even composed by the artist--are the desirable culmination of these trends. Matisse's *Jazz* and *Poèmes de Charles d'Orléans* are the apogee. Danish with English summary.

232. Fourcade, Dominique. "Introduction: 'Je crois qu'en dessin j'ai pu dire quelque chose. . . .'" In *Henri Matisse, dessins et sculpture*, 11-24. Paris: Centre Pompidou, Musée National d'Art Moderne, 1975.

An essay of the first importance in the drawing literature accompanies a catalogue of sculptures from the Musée Matisse in Nice and of drawings from the Musée Cantini in Marseilles. The catalogue is a model of scholarly documentation, including chronology, provenance, and bibliography and list of exhibitions of Matisse's drawing as well as a list of paintings in which Matisse's sculpture is depicted. Fourcade's insightful essay probes the question of the inseparability of drawing from

color, and vice versa; he explores the tension of this problem in Matisse's drawing project. If Matisse can "say something" uniquely in his drawings, it is not that they differ from his paintings in scale, subject matter, nature of the tools, or degree of effort; it is because drawing permitted him the exploration of problems impossible to resolve--or even identify--in other media. Fourcade traces with great subtlety the evolution (but not the progress) of Matisse's ability to give equal value to figure and ground, blacks and whites, mark and paper.

Reviews: Barrière, G. "Matisse noir sur blanc." *Connaissance arts* 282 (August 1975): 58-67; "Paris, exposition." *L'Oeil* 240-41 (July-August 1975): 75; Werner, A. "Life-Enhancing Work of Henri Matisse." *American Artist* 48. (August 1976): 205+; Winter, P. "Paris, Ausstellung." *Kunstwerk* 2 8 (Summer 1975): 47-8.

233. George, Waldemar. *Dessins de Henri-Matisse*. Paris: Éditions des Quatre Chemins, 1925. Flam, no. 88, 222-25.

George divides drawing into two historic, psychological types: the morphological, concerned with pure form and plastic unity; and the ideographic, concerned with signs representing an idea or symbolic content. The first is structure, the second graphology. Matisse's drawings are the former, a painter's drawings in which line is a shifting framework for the color that structures the composition. Matisse's drawing comes to grips with volume, with plastic structure; it is not two-dimensional or decorative. His line makes empty spaces full, makes them speak, renders them voluptuous. Matisse's drawings in mid-20s, George claims, are a kind of "chamber drawing," written in a secret language, existing in a private domain.

234. George, Waldemar. *Dix Danseuses, lithographies de Henri Matisse*. Paris: Éditions de la Galerie d'Art Contemporain, 1927.

Large-format portfolio of plates of lithographs of the model in tutu, seated or reclining. Short essay by George precedes the display of this series. George raises interesting questions on

the nature of drawing as such and suggests that Matisse's earlier, "stylized" drawing was pre-Roman compared to a certain realism of the present 1927 style. Yet, even in the present decade Matisse is never really "classical" like Picasso; he is the cornerstone of the truly modern in that he integrates the lyrical with the intellectual through a devotion to the purely plastic.

235. Girard, Xavier, ed., with Yu. Roussakov, Jérôme Peignot, and Christian Arthaud. *Henri Matisse, l'art du livre.* Cahiers Henri Matisse 3. Nice: Musée Matisse, 1986. Exhibition catalogue.

A complete bibliography and chronology of illustrated books, albums, books, revues, monographs, catalogues, posters, and programs with Matisse illustrations or designs. Handsomely produced in the format of the first four *Cahiers Henri Matisse,* this was the most complete treatment of Matisse's books before the publication of Claude Duthuit's catalogue raisonné, no. 228. There is a comprehensive general introduction by Yu. Roussakov as well as two fine interpretive essays--"Henri Matisse: calligraphe de l' amour" by Jérôme Peignot and "L'Emotion première" by Christian Arthaud.

236. Girard, Xavier, and Geneviève Monnier, with Christian Arthaud. *Henri Matisse dessins, collection du Musée Matisse.* Cahiers Henri Matisse 6. Paris and Nice: Maeght Éditeur, Musée Matisse, 1989.

An elegantly produced catalogue of 180 drawings chosen from the collection of the Musée Matisse in Nice, presented in three sections: 1) ninety-three drawings from 1893 to 1952, including many intimate and early sheets from the Matisse family's collection, 2) twenty-seven preparatory studies for the Barnes mural at Merion, Pennsylvania, and 3) sixty preparatory drawings for the Chapel at Vence and the church at Assy. An invaluable cache of drawings not only luxuriously reproduced but with two admirable texts, the introduction by Girard and an essay, "Un Dessin est une sculpture," by Geneviève Monnier.

237. Güse, Ernst-Gerhard, with contributions by Christian Arthaud,
 Xavier Girard, and Ernst Uthemann. *Henri Matisse, Drawings
 and Sculpture*. Munich: Prestel Verlag; New York: distributed
 by te Neues Publishing, 1991. Trans. by John Ormrod, with
 Ian Taylor, slightly abridged from *Henri Matisse, Zeichnungen
 und Skulpturen*. Saarbrücken: Saarland Museum Exhibition
 Catalogue, 1991.

 Güse's introduction to this handsome book of ninety-seven
 drawings and forty-one sculptures, drawn from a yet more
 comprehensive exhibition at Saarbrücken that inluded prints,
 books, and maquettes as well, is a workmanlike survey of the
 artist's lifetime of drawing and sculpture. The author relies
 heavily on Matisse's own statements about his intentions,
 processes, and specific aims in the two media. Commentaries
 on the drawings are by Xavier Girard, on the sculptures by
 Ernst W. Uthemann; there is also an extensive chronology.

238. Hahnloser, Margrit. *Matisse, Meister der Graphik*. Fribourg:
 Office du Livre, 1987. French ed. *Matisse*. Paris: Bibliothèque
 des Arts, 1987. Collection: Maîtres de la gravure. Eng. ed.
 Matisse, The Graphic Work. New York: Rizzoli, 1988.

 A handsomely produced selection of one hundred prints in a
 variety of media from Matisse's lifetime print oeuvre. Margrit
 Hahnloser, the daughter of the Swiss collector Arthur
 Hahnloser, provides a commentary on each print that is more
 running biographical account, psychological speculation, and
 miscellaneous observation than close analysis or interpretation
 of the works. Nor is there the usual comparative discussion of
 the prints in question, that is, of their various states, of
 similar studies, predecessors, or works related for other
 reasons. The prints are an excuse for a general survey of
 Matisse as an artist in the broadest terms.

239. Hildebrandt, Hans. *Henri Matisse: Frauen, 32 Radierungen*.
 Leipzig, Wiesbaden and Munich: Insel-Bücherei Series, 1,
 1953.

 A small, beautifully produced, elegantly bound album of
 reproductions of etchings from the late 1920s, followed by ten

pages of text, most of which summarize published biographical information on Matisse.

240. Hildebrandt, Hans. *Henri Matisse, der Zeichner.* Zürich: Diogenes, 1982.

Small book of 100 drawings and prints, 1898-1952. Foreword by Jean Jouvet; eight-page general essay by Hildebrandt. Some cut-paper works are reproduced in black and white, with no indication that they differ from the drawings and graphics.

241. Humbert, Agnès. *Henri Matisse, dessins.* Paris: Hazan, 1956. Series: Bibliothèque Aldine des Arts, 37.

Small *livre de poche* with beautifully designed cover reproducing forty-two drawings by Matisse mainly from 1930 to 1945. Elegant three-page introduction which admires in Matisse's drawings "knowledge masked under the appearance of virtuosity . . . prodigious science, under the appearances of fantasy."

242. Lambert, Susan. *Matisse Lithographs.* London: Victoria and Albert Museum, 1972; reissued with different cover, New York: Universe Books, 1982.

Handsomely produced album of fifty of the ninety-five Matisse prints in the V & A Museum Department of Prints and Drawings, many acquired through the efforts of the artist's daughter, Marguerite Duthuit, in 1935. Lambert's thoughtful expository essay on Matisse's practice and esthetic in the lithographic medium introduces them.

243. Lieberman, William S. *Matisse: 50 Years of His Graphic Art.* New York: George Braziller, 1956, 1968, 1981.

Eleven pages of succinct, informative, opinionated text by Lieberman on 150 works--sixty-one etchings and drypoints, thirty-one linocuts, nine monotypes, thirty-six lithographs, three aquatints--of which thirty-one are reproduced. A still indispensable basic text, despite the subsequent catalogue raisonné, no. 227.

Review: Cooper, Ellison. Review. *Print* 11 (February 1957):
64.

244. Lieberman, William S. *Etchings by Matisse.* New York: The
Museum of Modern Art, distrib. by Simon and Schuster,
1955.

Short (three-page) introduction by Lieberman accompanies
twenty-three beautifully reproduced plates.

245. Longstreet, Stephen. *The Drawings of Matisse.* Series:
Master Draughtsmen. Alhambra, California: Borden
Publishing Co., 1973.

An album of fifty plates of Matisse's drawings from all
periods introduced by a two-page general essay on the artist's
approaches and achievements in the medium.

246. Malingue, Maurice. *Matisse dessins.* Series: Dessins des
Grands Peintres, 1. Paris: Editions des Deux Mondes, 1949.

A small booklet-album of ninety-six plates of Matisse's
drawings from 1939-1948, some fairly rare, chosen by the
artist. Checklist of plates gives date, medium, and size but
does not otherwise identify works by name or collection; five-
page preface by Malingue.

247. [Matisse, Henri]. *Matisse, Line Drawings and Prints.* New
York: Dover Publications, 1995.

Fifty reproductions of drawings and prints of female nudes,
faces, and still lifes by Matisse from 1898 to 1948; no text in
this inexpensive book of reproductions.

248. [Matisse, Henri]. *Matisse, Portrait Drawings.* New York:
Dover, 1990.

An inexpensive book of reproductions of forty-five portrait
heads; no text.

249. Moulin, Raoul-Jean. *Henri Matisse dessins.* Series: Les
Grands Maîtres du dessin, 1. Paris and Prague: Éditions Cercle

d'Art, 1968. Trans. by Michael Ross as *Henri Matisse, Drawings and Paper Cut-Outs.* London, New York: McGraw-Hill, 1969. Reissued as *Matisse: plume, crayon, fusain, papiers collés.* Paris: Cercle d'Art, 1990.

Moulin's essay does not isolate Matisse's graphic work from his efforts in all other media. Drawings, prints, book illustrations, and murals for the Chapel of the Rosary at Vence are all treated. Author emphasizes the return of Matisse to the pre-Renaissance Western and non-Western "languages" of art with respect to their treatment of spatial illusion, to the importance of non-mimetic light, to the use of decoration and the arabesque, and to his emulation of the color of the Byzantine and Russian icon traditions. An intelligent and perceptive text; color plates of the paper cut-outs brilliant in the 1968, 1969 editions. Both these and the quality of the sixty black and white plates are very inferior in the 1990 edition.

250. Mourlot, Fernand. *Les Affiches originales des maîtres de l'Ecole de Paris, Braque, Chagall, Dufy, Léger, Matisse, Miro, Picasso.* Monte Carlo: André Sauret, 1959.

One hundred and two colored plates of poster reproductions, accompanied by a substantial text on the circumstances of their making, technical information, and general biography of the artists illustrated, by the director of the famous lithographic studio that produced them.

251. Roger-Marx, Claude. *Dessins de Henri Matisse.* Paris: Les Éditions Braun, 1939. Series: Galerie d'Estampes, 5.

A large folio of thirty beautifully reproduced drawings by Matisse, dating from 1920 to 1938, preceded by Roger-Marx's essay. The author puts Matisse in the category of those draftsmen who, like seducers of women, change their strategy, their methods, according to the needs of the case, rather than find a fixed, signature mode and impose it on any subject. Like Picasso, Matisse resists his gifts, his facility, and produces drawings that seem hesitant, unsure, awkward in the face of the problem they pose. This essay is full of marvelous

insights and observations by a critic who is somewhat cool in his judgment that Matisse enchants but does not move his viewer--some human quality being absent. Ingres's nudes speak of desire; Matisse's of an absolute emotional and sexual serenity. Matisse has a temperament, the critic observes, that both loves and at the same time flees from itself.

252. Russakov, Jurij. *Anri Matiss, Novye knigi.* Leningrad: Hermitage, 1974; Fr. trans. Roussakov, Youri. *Henri Matisse, l'art du livre, collections de l'Ermitage.* Leningrad: Hermitage, 1980. Exhibition catalogue.

Catalogue for exhibition (1974) of books illustrated by Matisse and published after his death, presented to the Hermitage by Mmes. M. Duthuit and L. Delectorskaya. Includes two editions of Georges Duthuit's *Une fête en Cimérie* and J.-A. Nau's *Poésies Antillaises.* Paris: Mourlot, 1972. Total of seventy-two items, with introduction by Russakov that traces the histories of the books and analyzes Matisse's working methods.

253. Seckel, Curt. *Henri Matisse, Lob der Schönheit. Zeichnungen.* Feldafing: Buchheim Verlag, 1956.

Primarily a small-format album of drawings with introductory text; drawings mostly from the 1930s.

254. Szymusiak, Dominique. *Dessins de la donation Matisse, Musée Matisse.* Le Cateau-Cambrésis: Musée Matisse, 1988.

A catalogue of the drawing collection in the Musée Matisse in the village of his birth, Le Cateau-Cambrésis. The introduction by the museum's conservator provides the fascinating history of Matisse's personal interest in the choice of works, framing, decorating, and layout of the original museum in the Hotel de Ville. The forty-two drawings themselves, several from the artist's student years, are reproduced and scrupulously documented and commented upon.

255. Testori, Gianni. *Henri Matisse, 25 Disegni.* Milan: Editore G. G. Görlich, 1943.

A short essay on Matisse, tracing his debt to the post-impressionists, especially Cézanne, in the simplification of color and form; also his brief lesson in construction through the Cubists. Plates of drawings mostly from the 1920s and 1930s; an edition of 500 only.

256. Valsecchi, Marco. *Disegni di Henri Matisse.* Milan: Hoepli, 1944.

A book of plates reproducing Matisse's drawings from all periods with a general introduction of appreciation and historical analysis, geared to the general public.

257. Vildrac, Charles. *Cinquante dessins par Henri Matisse.* Paris: Maeght Éditeurs, 1920. Flam, no. 88, 197-98.

A book of drawings published at Matisse's expense with an introduction by Charles Vildrac. Vildrac explains Matisse's return to the figure as an attempt to redress the modernist gap opened between art and life. Since the figure was neglected by contemporary art concerned with the probing and reconstitution of the painting elements themselves, Matisse is returning to the "moral character" of painting, its human content. Like the older masters, he again "attunes his style to the style of the model" and, eschewing both the current archaizing and modishness, he searches out with humility the grave character of the model by intelligent deduction and by imagination. Written in close collaboration with the painter, this is an important statement on Matisse's Nice manner of the early 1920s.

258. Ward, Mary Martha. Introduction. In *Matisse, His Sources and His Contemporaries, Prints and Sculptures.* Chapel Hill: University of North Carolina, 1973. Exhibition catalogue.

A surprisingly ambitious and informative text that places Matisse's prints within the print revival of the late 1890s that preceded them and the work of Matisse's peers and colleagues in the "School of Paris." A judicious and detailed treatment of the somewhat unwieldly topic. Modestly produced.

259. Zervos, Christian, ed. "Dessins de Matisse." *Cahiers d'art* 11,
 3-5 (1936).

 Special issue containing thirty-six plates of drawings, Zervos's
 essay, "Automatisme et l'espace illusoire," and Tristan Tzara's
 poem "A Henri Matisse."

260. Zoubova, Maria. *Desssins de Henri Matisse. [Grafika
 Matissa]* . Moscow: Éditions d'Art [Iskusstvo], 1977.

 Documented presentation of the drawings by Matisse in the
 Soviet state collections, commentary and general introduction
 by Zoubova.

Articles

261. Ashton, Dore. "Seurat to Matisse, Drawing in France." *Art News* 73 (September 1974): 98-99.

A review of the Museum of Modern Art exhibition called *Seurat to Matisse,* in which the author makes some telling points about French drawing discipline in general and applies them briefly to works of Matisse, among others, in the show.

262. Boehm, Gottfried. "'. . . en perspective de sentiment:' Zu den Zeichnungen Matisse's und den 'papiers découpés.'" In *Henri Matisse, Das Goldene Zeitalter,* 65-71. Bielefeld: Kunsthalle Bielefeld, 1981. Exhibition catalogue.

The author posits that Matisse's drawings are a gauge of the changes and transformations that took place in Matisse's oeuvre in all media during his lifetime. One of the major ways that the artist has "rewritten" the course of twentieth century art is his polyvalent use of line, now used neither to separate, define, nor divide figure from ground, but to exchange, embrace, and expand the ground by means of the "figure." Matisse achieves this early on but enters a new phase in his post-1940 drawings and in his paper cut-outs, where the action of the cut-paper edges against the white surface-ground poses new challenges. As in cubist collage, according to the author, the edge of Matisse's cut-out neither elides nor separates areas, but "creates correspondances between inner and outer, passages and inversions." A fine and acute discussion of Matisse's contributions to the renewal of the graphic arts.

263. Bois, Yve-Alain. "Henri Matisse dessins." *Art Press Int.* 19 (July/ August 1975): 18-20.

On the occasion of the Paris exhibition, *Matisse, Drawings and Sculpture,* of 1975, Bois walks through the drawing history of Matisse adumbrating most of the themes he would take up later in "Matisse Redrawn" (1985), no. 264, and in "Matisse and 'Arche-Drawing'" (1992), no. 402,--namely, the important Fauve revolution in his drawing around 1906, in

which he discovered that quantity effects expressive quality in that medium as well as in painting. Bois also posits that Matisse's drawing is as varied in technique as it is single in its ends, that the temporal process of accretion and erasure--so important to the artist's method--is as evident in his drawing as in his strongest painting, and so on, thus building a case for the intersemioticity of the artist's work in both media.

264. Bois, Yve-Alain. "Matisse Redrawn." *Art in America* 73 (September 1985): 126-31.

Bois proposes that in 1906, the moment of Fauvism, Matisse discovered how to achieve, not only "expression by color," but also "expression by drawing: contour, lines, and their direction (Matisse, 1935)." Reflecting on the exhibit of Matisse's drawings at the Museum of Modern Art, Bois admits that there are only some three drawings of 1906 that exemplify this discovery, but that around 1935, at the time of the quotation from "Modernism and Tradition" (cited above), Matisse's drawings reinvestigate this insight. From 1935, culminating in the brush-and-ink drawings of 1947-48, Matisse is able to create "color" from the white of the paper by a dispersal of homogeneous lines and spots over the surface which modulates light by altering relationships between marked and unmarked areas. The reason that this discovery was not developed in 1907 was that it was displaced into his paintings until 1912. An important article that Bois will develop in the essay, "Matisse and 'Arche-drawing,'" published in 1990, no. 402.

265. Bowness, Alan. "Four Drawings by Modigliani and Matisse." *Connoisseur* 150 (June 1962): 116-20.

According to the author, both Modigliani and Matisse model with line--like sculptors. Their drawings are expressive, ruthless simplifications, yet "packed with information and implication." One page of text, four full-page illustrations.

266. Breeskin, A. D. "Matisse and Picasso as Book Illustrators." *Baltimore Mus. News* 14 (May 1951), 1-3.

A short but elegant description of Matisse's *Poésies de Stéphane Mallarmé* (1932), the complete maquettes of which are in the Baltimore Museum Collection, and of three books illustrated by Picasso, also owned by the museum: Ovid's *Metamorphoses* (1931), Balzac's *Chef-d'oeuvre inconnu* (1931) and Aristophanes's *Lysistrata* (1934). Author stresses the medium of the illustrated book as suitable for ambitious works of art.

267. Carlson, Victor. "Some Cubist Drawings by Matisse." *Arts Mag*. 45 (March 1971): 37-39.

The author details how the friendship of Matisse with Juan Gris from 1914 to 1917 deepened his understanding of the Spaniard's cubist vocabulary and how it informed some of his own drawings of the period.

268. Castleman, Riva. "The Prints of Matisse." In *Matisse: Prints from the Museum of Modern Art*, 5-16. New York: The Fort Worth Art Musuem and The Museum of Modern Art, 1986, no. 78.

A rather general overview of Matisse's printmaking activity with some important discussion of specific issues, for example, a reasoned dating of the problematic lithograph *Large Nude* (on stone) to 1906, the relation of the series of transfer lithographs of 1906 to the series of 1913, the occasions for the spurts of printmaking in 1913, 1922, and 1929. As all the prints in the show are black and white, the author also speaks of the artist's use of black in general and in relation to his prints.

269. Dreyer, Ortrud. "Die Arabeske, ein Strukturprinzip der Romantik." In *Henri Matisse, Zeichnungen und Gouaches Découpées*, 298-303. Stuttgart: Staatsgalerie Stuttgart, 1993. Exhibition catalogue.

Author traces the arabesque as an abstract motif, a "mythical structure" related to music, from the romantics--Runge and Schlegel--through Baudelaire, Mallarmé, and the symbolists to Matisse, by way of Moreau. The abstract sign of the

arabesque is distinguished from the ornamental; Matisse's linear simplifications in *Thèmes et variations* are used as the primary example of reduction of nature-based drawing to a symbolic level of imaginative sign.

270. Duthuit, Marguerite. "Introduction." In *Henri Matisse, lithographies rares.* Paris: Galerie Berggruen et Cie, 1954.

Matisse's daughter--who often helped in or supervised the printing of his works and who catalogued them over the years--provides an indispensable first-hand account of the artist's efforts in this medium. A very important, if brief, text.

271. Elderfield, John. "Matisse: Drawing and Sculpture." *Artforum* 11 (September 1972): 77-85.

In the wake of the publication of Albert Elsen's book *The Sculpture of Matisse* (1972), the MoMA exhibition of Matisse's sculpture (1972) with catalogue by Alicia Legg, and the Baltimore Museum's show *Matisse as a Draughtsman* (1971) with catalogue by Victor Carlson, Elderfield relates Matisse's sculpture both to his drawing, with which it has much in common, and to his painting, for which it acts as an alternative mode of thinking. Elderfield's usual nuanced and visually acute discussion focuses more on the sculpture than the drawing, see no.188.

272. Elderfield, John. "Drawings at an Exhibition." In *Henri Matisse,* 52-69. Brisbane: Queensland Art Gallery and Art Exhibitions Australia, 1995. Exhibition catalogue.

A very fine discussion of Matisse's drawings after 1920, viewed in the context of Matisse own statements on drawing from that period, and highlighting the importance of the 1948 Philadelphia Retrospective which was, at the artist's behest, especially rich in drawings.

273. Elsen, Albert E. "Rodin's Drawings and the Art of Matisse." *Arts Mag.* 61, 7 (March 1987): 32-39

Author argues that Rodin's drawings, methods of drawing, and attitude toward the model had a considerable influence on

Matisse's drawings, prints, and paintings. This substantial, well-illustrated essay successfully argues for Rodin's influence on the sexual candor of Matisse's nudes.

274. Fourcade, Dominique. "Sur un autoportrait lumineux." In *Matisse, 33 dessins de 1905 à 1950.* Paris: Galerie Dina Vierny, 1982. Exhibition catalogue.

An important essay on Matisse's drawing project, this short introduction by Dominique Fourcade is of especial beauty and insight and includes a tender analysis of a single self-portrait of Matisse in a felt hat from 1945.

275. Fourcade, Dominique. "65 Dessins de Matisse." *Cahiers du Mus. National d'Art Moderne* 13 (1984): 8-17.

An article which enumerates, describes, and sometimes redates the sixty-five drawings that had recently entered the museum's collection-- some through purchase, others through gifts. A meticulous survey with fifteen of the works illustrated.

276. Gasser, Samuel. "Exhibition Posters by Famous Painters (Ausstellungs-Plakate Grosser Meister/ Affiches des Maîtres de l'Ecole de Paris)." *Graphis* 16 (March 1960): 108-19.

Short text; mostly reproductions of posters.

277. Golman, Judith. "The Print's Progress: Problems in a Changing Medium." *Art News* 75, 6 (Summer 1976): 39-46.

In a broad discussion of contemporary prints, current fakes, and bootleg prints are discussed, among them fake Matisse lithographs.

278. Guichard-Meili, Jean. "Matisse et la splendeur des blancs." In *Matisse: l'oeuvre gravé,* 9-18. Paris: Bibliothèque Nationale, 1970.

In the obligatory overview of the prints and illustrated books shown in the exhibition, Guichard-Meili manages to be eloquent about the seriousness, the austerity, and the completeness of expression of Matisse's prints. He notes the

luminous and resounding silences of the artist's whites, coaxed (in great variety of "color") from the black graphic marks that create them.

279. Guichard-Meili, Jean. "Couleurs de blanc, lumières du noir." In *Matisse: Donation Jean Matisse*, 7-15. Paris: Bibliothèque Nationale, 1981.

On the occasion of the gift of one hundred sixty-nine works by Matisse--prints, books, and drawings--by Madame Jean Matisse, the widow of Matisse's elder son, a sculptor. Guichard-Meili elegantly illustrates the reversal signaled in his catalogue introduction's title. He comments on individual works exhibited, while pointing continually to broader characteristics of Matisse's graphic practice.

280. Haftmann, Werner. "Die Zeichnungen von Henri Matisse." *Katalog 3. Internationale du Zeichnung. Sonderausstellung Gustav Klimt--Henri Matisse*, 111-122. Darmstadt: Mathildenhöhe, 1970. Exhibition catalogue.

A sensitive essay on Matisse's drawings in which the author insists upon their importance as autonomous works. Haftmann analyzes Matisse's ability to make the white (paper) of his ground act as both light and space, as well as his ability to derive an abstract play of arabesques from contours that remain faithful to their origin in appearance and sensation. Also sketched is a brief history of Matisse's development as a draughtsman.

281. Hahnloser, Hans R. "Introduction: En visite chez Henri Matisse." In *Henri Matisse, gravures et lithographies de 1900-1929*. Pully: Maison Pullierane and Bern: Kornfeld and Klipstein, 1970. Notes on the graphic work by Margrit Hahnloser-Ingold.

The author recalls visits with his parents to Matisse at Nice in 1927 and 1929, publishing photographs that were taken at those times. An informative and affectionate remembrance which precedes a more esthetic account of the artist's periods of printmaking and the characteristics thereof. A photograph

of Pierre Bonnard posing as an "odalisque" on Matisse's models' platform, surrounded by hanging patterned fabrics, is published here for the first time.

282. Hahnloser-Ingold, Margrit. "Matisse graveur." In *Henri Matisse, gravures et lithographies*, 11-15. Fribourg: Musée d'Art et d'Histoire, 1982.

Concise review of the "interior logic" of Matisse's history as a printmaker, not dependent on his painting or sculpture, though related to them. An intelligent laying out of the most prolific periods of the artist's activity in all media, with emphasis on the series aspects of the work, a method for Matisse to renew his labor again and again on a single theme.

283. Heilmaier, Hans. "Bei Henri Matisse." *Kunst* 65 (April 1932): 206-209.

An interview with Matisse in Montparnasse shortly after his series of international exhibitions in France, Germany, Switzerland, and America. Illustrated with drawings by Matisse.

284. King, A. "Technical and Esthetic Attitudes About the Cleaning of Works on Paper." *Drawing* (November/ December 1986): 80+.

Matisse's *Girl with Tulips* and *The Swimming Pool* are used as examples of the author's general points about the care and conservation of works on paper.

285. Kirker, Anne. "Matisse's Prints and Illustrated Books. A Note." In *Henri Matisse*, 156-161. Brisbane: Queensland Art Gallery and Art Exhibitions Australia, 1995. Exhibition catalogue.

A brief, workmanlike overview of the artist's oeuvre in printmaking and in book design.

286. Kozloff, Max. "Notes on the Psychology of Modern Draftsmanship." *Arts Mag.* 38, 5 (February 1964): 58-63.

A review article for the Guggenheim exhibition, *Twentieth-Century Master Drawings* (1963-64), this essay comments on the importance and autonomy, the abstractness and formal invention, of drawings in their "homeless" state in the twentieth century. In this insightful essay, Kozloff makes general observations and focuses on three masters: Picasso, Matisse and Klee. Matisse's drawings, despite their maintenance of more familiar figuration, display that transparence and continuity of plane, that impression of both abandon and control, of hyper-calculation and absolute spontaneity, that "fruitful ambivalence of discipline and impulse" that the best modern drawing contains. Illustrated with a full-page reproduction of one of Matisse's charcoal self-portraits of 1937.

287. Kueny, Gabrielle, with notices by Germain Viatte. "Dessins du XXe siècle au Musée de Grenoble." *L'Oeil* 96 (December 1962): 67-71.

Story of Jacqueline Marval and Jules Flandrin, students of Moreau and natives of Dauphiné, as was Andry-Farcy, the Musée de Grenoble's director. They influenced him in his early acquisitions of Fauve work for his all-modern museum, which led to the Sembat-Agutte donation that enriched the collection with early Matisse works.

288. Larson, Philip, "The Exotic Ladies of Henri Matisse--Late 1920s, Early 1930s." *Print Collector's Newsletter* 14, 3 (July-August 1983): 77-81.

A printmaker's irreverent, but extremely perceptive, reflections on Matisse's books, prints, and studies for prints in the collection of the Baltimore Museum of Art. Emphasis on processes and the development of the pictorial concept that can be deduced from successive working versions of a theme.

289. Lieberman, William S. "Illustrations by Henri Matisse." *Mag. of Art* 44 (December 1951): 308-14.

A general treatment of Matisse as a book illustrator, with material very similar to that which appeared concurrently in

Barr's *Matisse, His Art and His Public.* A selected bibliography of books, illustrated by Matisse and whose production was closely supervised by the artist, is appended.

290. Lieberman, William. "Henri Matisse 1869-1954." *Print* 10 (August 1956): 17, 18-28.

Short page of text with ten pages of reproductions of prints exhibited in the Museum of Modern Art show of eighty prints by Matisse in 1956.

291. Lieberman, William S., and Riva Castleman. *Matisse in the Collection of the Museum of Modern Art.* New York: The Museum of Modern Art, 1978. Detailed commentaries on Matisse drawings and prints in the collection in a catalogue edited by John Elderfield, no. 78.

A lifelong study of the artist's graphic oeuvre permits Lieberman to review the riches of the spectacular collection of Matisse's drawings at the Museum of Modern Art.

292. Lieberman, William S. "Notes on Matisse as a Draftsman." In *Henri Matisse.* Berkeley and Los Angeles: UCLA Art Museum, 1966. Exhibition catalogue, no. 129.

The author defers to Matisse's own writings on his drawing and quotes a conversation with him in which Matisse referred to drawing as "plastic writing" and as using line to "mold the the light of the empty sheet." Lieberman touches on major drawing groups in the artist's oeuvre, briefly compares him to Picasso, and gives a workmanlike summary of his printmaking and book illustrating activity, about which he had already written in some detail.

293. Micha, René. "La 'Creative Method' de Matisse." *Art Int.* 19 (October 1975): 58-60.

A short article on Matisse's drawing on the occasion of his drawing and sculpture show at the Centre Pompidou in 1975, in which the author draws upon Schneider's and Lebensztejn's insights about Matisse's insistence on the creation of signs

and of the sentiment towards the model which sets the process in motion.

294. Neff, John Hallmark. "Henri Matisse: Notes on his Early Prints." In *Matisse Prints from the Museum of Modern Art,* 17-24. New York: The Fort Worth Art Museum and The Museum of Modern Art, 1986, no. 225.

Remarking on the lack of precise scholarship on the circumstances surrounding the production of particular prints or series, Neff concentrates on two series of etchings from 1913-14: the pair of Matthew Stewart Prichard etchings and the series of transfer lithographs of Germaine Reynal. Using the Isabella Stewart Gardner Archives and the catalogue of Matisse's prints assembled by Félix Fenéon for Bernheim-Jeune's March 1914 issue of their new *Bulletin,* Neff corrects errors of dating and other information on these works, and suggests (*pace* Castleman in the same catalogue) that the *Large Nude* of 1906 is really from 1913. An important article and a model of the kind of detailed sleuthing that still needs to done on Matisse's early work.

295. Olander, William. "Fake, a Meditation on Authenticity." In *Fake.* New York: The New Museum of Contemporary Art, 1987. Exhibition catalogue.

In the catalogue for an exhibition of contemporary work that highlights the questioning of the the concepts of originals, fakes, copies, multiples, and authentic or fraudulent works, a Matisse "forgery" by Elmyr de Hory (a look-alike of one of Matisse's *Theme and Variation* drawings) illustrates the text.

296. Parker, John. "The Prints of Matisse." *Prints* 6 (December 1935): 90-93.

An extended review of Matisse's Brooklyn Museum Prints Exhibition; the author offers a defense of Matisse's inventiveness and daring while not entirely approving of the results.

297. Perl, Jed. "Matisse." *New Criterion* (June 1985): 19-27.

Ruminative essay responding to Pierre Schneider's *Matisse* (1985), John Elderfield's catalogue, *The Drawings of Henri Matisse* , and the exhibition that occasioned it. Perl, an artist, is very perceptive on the artist Matisse; full of fresh observations and judgments, especially good on the 1920s works.

298. Roger-Marx, Claude. "L'Oeuvre Gravé d'Henri Matisse." *Arts et Métiers Graphiques* 34 (1933); Eng. trans. as "The Engraved Work of Henri Matisse." *Print Collector's Quarterly* 20, 2 (April 1933): 138-57.

Roger-Marx notes that, without the dazzling instinctive color that beguiles us in Matisse's paintings, the drypoints and etchings better reveal the domination of Matisse's intelligence and will over his temperament. Concision and elegance are their hallmarks as in the work of Manet, a concision that is the result of "slow research and successive eliminations." Etching forces Matisse to greater vehemence and vigor; his lithographs, unfortunately, often betray "merely a caress on a sensitive epidermis" and risk being a prey to "indolence and insipidity." A penetrating, appreciative though critical, account of Matisse's prints, the best of which, according to the author, avoid the poles of "extreme abridgement and finicking execution."

299. Rudikoff, Sonya. "Words and Pictures." *Arts* 33 (November 1958): 32-35.

General discussion of illustrated books and their qualities, occasioned partly by viewing Matisse's illustrated book on exhibit at the New York Public Library. Matisse as illustrator is compared with Picasso, Miro, Clavé.

300. Russoli, Franco. "I disegni di Matisse." *La Biennale di Venezia* 26 (December 1955): 34-39.

A general appreciation of Matisse's drawings is followed by a summary history of the development of the artist's drawing style. The author denies that Matisse's distortions are

gratuitous or that his abstractions are decorative; they are, rather, always expressive signs.

301. Schultze, Jürgen. "Die Zeichnungen der 'Fauves.'" In *Nabi und Fauves, Zeichnungen, Aquarelle, Pastelle aus Schwiezer Privatbesitz*. Zürich: Kunsthaus, 1982. Exhibition catalogue, no. 1188.

Jürgen Schultze provides a more general essay on "Die Zeichnungen der "Fauves," to introduce the catalogue which features only Matisse, Marquet, Manguin, and Rouault as Fauves, all students of Moreau. Schultze notes that Fauve drawings are too little studied--as Fauvism is deemed chiefly concerned with color. Author emphasizes the "seismographic" immediacy of Fauve drawings, which are the first record of the artist's emotion in front of the motif. This expressivity is what was added in these works to a somewhat standard range of Belle Epoch motifs and subjects. The catalogue includes twenty-six drawings (1901-1947) by Matisse, beautifully reproduced in this handsome catalogue. Following a short general introduction, Margrit Hahnloser-Ingold provides a brief commentary on each Matisse drawing.

302. Solmi, Sergio. "Disegni di Matisse." *Sele Arte* 1, 2 (September-October 1952): 54-57.

A short, well-illustrated article in which Matisse is praised for pure drawing--an operation of learned expressivity, of concrete firmness, and of the flexible potential of each stroke.

303. Volboudt, Pierre. "La Ligne à la recherche de la forme" in *XXe Siècle. Hommage à Henri Matisse*, 97-112. Paris: Cahiers d'Art, 1970.

Profusely illustrated article containing a connoisseur's appreciation of drawing, written in so general a way that it might apply to any modern draughtsman who favors the spare, linear arabesque and not specifically to Matisse.

304. Woimant, Françoise. "Bibliothèque Nationale, Matisse, graveur et peintre du livre." *Rev. du Louvre.* 2 (1970): 97-100.

A general preview of the works to be shown at the centenary exhibition of prints at the Bibliothèque Nationale.

305. Zervos, Christian. "Dessins récents de Henri-Matisse." *Cahiers d'art* 14, 5-7 (1939): 5-7 (text), 9-24 (interleaved charcoal drawings of studies for *Pink Nude, Conservatory,* Rockefeller overmantel, and a mother-and-child composition).

The author discusses the procedures of Matisse's drawing technique. For Matisse, drawing is a complete action, a complex of liberty and discipline, of will and unconsciousness, of general perceptions and precise formulations, of enrichment by elimination. Matisse's concern is to exalt the form, to create surfaces that set into play a complex of sounds and silences, of radiances that summon shadows.

Paper Cut-Outs and Decorative Projects

Books

306. Brauner, Heidi. *"Natürlich ist das Dekoration;" Perspectiven*
 eines Begriffes in der Kunst des 20. Jahrhunderts ausgehend
 von Henri Matisse. Series: Europäische Hochschulschriften,
 176. Frankfurt am Main: Peter Lang, 1992.

The author first discusses the concept of the decorative in the
art historical and critical discourses, especially in the
eighteenth and nineteenth centuries, culminating in its French
usage in Matisse's milieu. She then applies the concept of
Matisse's handling of the motif of the dance in certain of his
decorative easel paintings, the Barnes and Paris murals, his
ballet designs, and cut-outs. Finally, she discusses the
decorative in relation to the contemporary discourses on the
modern and postmodern and the revival of site-specific works
that have decorative implications. The approach remains
conceptually oriented, not favoring the intentions or
statements of Matisse but privileging the theoretical and
philosophical assumptions and ramifications of "discourse
production" that are embodied in particular works.

307. Cowart, Jack, with Jack D. Flam, Dominique Fourcade, and
 John Hallmark Neff. *Henri Matisse, Paper Cut-Outs.* St.
 Louis and Detroit: The St. Louis Art Museum and the Detroit
 Institute of the Arts, 1977.

This catalogue, accompanying a major traveling show of
Matisse paper cut-outs, is the single most important work on
the work of Matisse in this medium. The extensive catalogue
proper, which includes Matisse's early design "precursors" of
1920 through 1934-37, as well as cut-out-derived book,
magazine, and catalogue covers, and posters, fully documents
each work with provenance, exhibition record, and
bibliography. An extensive bibliography of works focusing
on the cut-outs and a list of exhibitions which included cut-
outs is also detailed. One appendix treats the technical matters
pertaining to the cut-outs (materials, procedures, preservation,
and restoration) and another includes unpublished documents in

their original language relating to the cut-outs. Three important essays, John Hallmark Neff's "Matisse, His Cut-Outs and the Ultimate Method," no. 347, Jack Flam's *"Jazz,"* no. 1018, and Dominique Fourcade's "Something Else," no. 326, round out the catalogue's content.

Reviews: Fourcade, Dominique. "Autre chose." *Art Int.* 21 (October-November 1977): 18-25; "Matisse Cut-Outs." *Art News* 76 (December 1977): 66-69; "Paper Cut-Outs: National Gallery of Art, Washington, D. C." *Art Int.* 21 (October-November 1977): 51-53; Baker, Kenneth. "Performing Forms: Notes on Matisse's Cut-Outs." *Artforum* 16 (January 1978): 60-63; Motherwell, Robert. "Review of *Matisse on Art* by Flam and *Henri Matisse, Paper Cut Outs."* *New York Times Book Rev.* (June 4, 1978): 12, 42-43; "Success or Nothing: Matisse: The Cut-Outs, Detroit Institute." *Apollo* 106 (December 1977: 509; Schneider, Pierre. "Puvis de Chavannes: The Alternative." *Art in America* 65 (May 1977): 94-98; Cowart, Jack. "Travailler avec des ciseaux dans ce papier est pour moi une occupation dans laquelle je peux me perdre." *Connaissance arts* 307 (September 1977): 60-67.

308. Duthuit, Georges, and Pierre Reverdy. *Dernières oeuvres de Matisse, 1950-1954.* Special issue of *Verve* 9, 35-36 (July 1958); U. S. edition, 1958. Also published separately as *The Last Works of Henry Matisse, 1950-1954.* New York, Harcourt Brace, 1958.

Plates in *Verve* printed by Mourlot Frères under the direction of Matisse in 1954 and printed by Draeger Frères. Matisse designed a cover expressly for the work. Both essays by men who knew Matisse well are especially insightful; the reproductions brilliant. Duthuit's essay "Le Tailleur de Lumière," and Reverdy's "Matisse dans la lumière et le bonheur," are to be found under their names individually below, nos. 324 and 700.

309. Elderfield, John. *The Cut-Outs of Henri Matisse.* New York: George Braziller, 1978.

A year after the large exhibition of Matisse cut-outs, no. 307, a major Matisse scholar walks the reader through the development of the late works of *découpage*. Elderfield organizes Matisse's odyssey around the artist's desire to integrate the pictorial (image-oriented) role of color with that of its decorative (construction-oriented) role. The author masterfully demonstrates that in the final works of 1952-53, Matisse bonds the figure with decorative panoramas that evoke the lyricism of arcadian pastoral landscapes. *Memories of Oceania* and *The Parakeet and the Mermaid* are his examples.

310. Guichard-Meili, Jean. *Les Gouaches découpés de Henri Matisse*. Paris: Fernand Hazan, 1983. Trans. by David Macey as *Matisse Paper Cutouts*. London and New York: Thames and Hudson, 1984.

Large-format book with drawings curiously positioned in the margins of the summary text (mise-en-page by Marcel Janco) and lavish, lithographed plates, some folding out to four-page spreads. The text by Guichard-Meili is expanded to include Matisse's own words about individual cut-paper works, drawn from interviews with Lejard, Verdet, and from *Jazz*. Of value is the catalogue of *gouaches découpés* in public collections.

311. Neff, John Hallmark. "Matisse and Decoration, 1906-1914: Studies of the Ceramics and the Commissions for Paintings and Stained Glass," Ph. D. dissertation, Harvard University, 1974.

Neff's path-breaking study posits the decorative as fundamental to Matisse's art and educational formation and demonstrates its thesis with a close study--with new data--of three commissions Matisse undertook between 1906 and 1911. These were Matisse's early ceramics, especially the ceramic mural he made for Karl-Ernst Osthaus in Hagen; his decorative panels *Music* and *Dance* for which Neff discovers the original third in this decorative program, *Bathers by a River,* completed in 1916; and an early and unknown commission for stained glass. Neff's study is full of new research and, although never published as a book, its major findings were published in articles in 1975

(see below, nos. 345, 346, 348). An excellent selected bibliography.

312. Néret, Gilles. *Henri Matisse, Cut-outs.* Translated from the German by Chris Miller. Cologne: Benedikt Taschen, 1994.

An intelligent, lively text accompanies good color reproductions of some of Matisse's most important works in cut-paper in this carefully produced book of small format. The author has skillfully juxtaposed sculpture and drawings that relate to the cut-outs, has grouped works that relate to weightlessness (themes of dance, water, flight, acrobatics, etc.), and has altogether made the scope of Matisse's work in this medium accessible to the general reader without oversimplification. Biographical chronology, index of works illustrated, and selected bibliography are appended.

313. Wattenmaker, R. J. *Puvis de Chavannes and the Modern Tradition.* Toronto: Art Gallery of Ontario, 1975. Exhibition catalogue.

An exhibition catalogue essay in which the author argues that, despite the enormous influence of Cézanne and his cubist followers, Puvis de Chavannes' essentially simplified and reductive decorative style became the reigning paradigm of modern painting. In a richly informative and wide-ranging essay on Puvis' work and influence, Wattenmaker uses Matisse as a perfect example of a modern artist who "circled back to [Puvis'] decorative aims through channels opened by Cézanne." From *Joy of Life* (1906) to the Barnes Foundation mural, *Dance* (1933), Matisse finally preferred Puvis's rhythmic scale, restrained and limited palette, lucid and synthetic formal logic to Cezanne's weighty, volumetric solidity of form and density of texture. An indispensable essay on the topic, certainly informed by the prestige of large-scale, decorative color-field painting in 1975.

Articles

314. Baker, Kenneth, "Performing Forms: Notes on Matisse's
 Cutouts." *Artforum* (January 1978): 60-63.

 A very perceptive article which relates the cut-outs of Matisse
 to traditional silhouettes and to portraits, singling out *The
 Dancer* (1949) and its theme of "the observer observed" for
 detailed analysis. Baker comments on both the restraints and
 limitations of the medium and its opportunities for the artist
 to shake off old habits. He notes that the cut-out forms are
 never so abstract as to not signify their nature as signs, if
 sometimes unreadable ones. A discussion of the *Swimming
 Pool* elicits the observation that it is "Matisse's grand
 statement of the pictorial reality of relations as things seen
 rather than as ideas."

315. Bertin, Celia. "Monsieur Matisse." *Le Figaro littéraire*
 (November 13, 1954): 5.

 Delightfully anecdotal reminiscence of an earlier visit to the
 recently deceased artist while he was working on his decorative
 commissions in his later years. The author was the editor of
 Roman, a bi-monthly review published in Vence, for which
 Matisse had designed the cover.

316. Broude, Norma. "Miriam Schapiro and 'Femmage':
 Reflections on the Conflict Between Decoration and
 Abstraction in Twentieth Century Art." In Norma Broude and
 Mary D. Garard, eds. *Feminism and Art History, Questioning
 the Litany*. New York: Harper Row, 1982.

 A feminist discussion of the role of decoration as the avant-
 garde's Other that has marginalized women as well, since
 decoration is gendered as "feminine." In a treatment of the
 contemporary artist Miriam Schapiro's aggressive opposition
 to these stereotypes, Matisse and Kandinsky are presented as
 "authentic" avant-garde artists who worked in decorative
 modes. Matisse is admired for not denigrating his decorative
 works in relation to his easel painting or sculpture.

317. Cassou, Jean. "Matisse va présenter au public ses papiers découpés." *France Illustration* 383 (February 14, 1953): 234-35.

Picture spread on the upcoming exhibition of Matisse's paper cut-outs at the Berggruen galley in Paris; brief text.

318. Childs, Elizabeth C., and John Klein. "Oceanic Escapes: Travel, Memory, and Decoration in the Art of Henri Matisse." In *Henri Matisse,* 122-36. Brisbane: Queensland Art Gallery and Art Exhibitions Australia, 1995. Exhibition catalogue.

The authors give a fresh account of Matisse's voyage to Tahiti with full attention to the implications of the region being a colony of France. They detail the impact of traditional Tahitian ceremonial cloths on Matisse's subsequent decorative cut-paper work carried out in fabric. Also discussed is the gender-reversal that follows from Matisse's use of female assistants in his studio to aid him in turning into high art what was, in Tahiti, the traditional and highly valued production of women alone. An indispensable study on this topic.

319. Courthion, Pierre. "Papiers découpés d'Henri Matisse." *XXe Siècle* 6 (January 1956): 45-47. Special issue on "Le Papier collé du cubisme à nos jours."

A short general treatment of Matisse's deployment of the cut-paper form in mural arrangements, with a slight disparagement of the work as a substitute for painting and as lacking the boldness of his best work.

320. Cowart, Jack. "Matisse's artistic probe: the collage." *Arts Mag.* 39 (May 1975): 53-55.

Using *Beast of the Sea* (1952) as a paradigmatic work, Cowart discusses certain of Matisse's collages that are visually balanced by opposition of vertical bands of color or organized by shapes floating on horizontal color bands. The close formal analysis of this work reveals how eloquent is the artist's use of multiple colors, intensities, shapes, rhythms, and intervals, in

a densely-packed, stacked space, to engage both eye and mind. A very fine analysis.

321. Cowart, Jack. "Travailler avec des ciseaux dans du papier est pour moi une occupation dans laquelle je peux me perdre: Matisse." *Connaissance arts* 307 (September 1977): 60-67.

Broad introduction to the exhibition of which the author was curator, no. 307. Points out the surprising emotional content of certain plates of *Jazz* (three full-page illustrations), the relation of ideas and motifs to recollections of Tahiti, and the importance of masks and masking in the late works.

322. Degand, Leon. "Les Papiers découpés de Matisse." *Art d'aujourd'hui* 2 (1953): 28.

Degand's relatively short review of the Berggruen exhibition of Matisse's paper cut-outs concerns itself with the relation of these works to abstract art. Degand notes that many lament that the artist is sliding (as down a slippery slope) to abstraction; even Tériade, noting that "from color to color, without foreign intervention. . . the composition is formed," cannot bring himself to use the word "abstract." For Degand, that the figurative element is so supressed in the cut-outs that they become abstract, is a real change for Matisse but, for the history of art, an event already forty years old.

323. Diehl, Gaston. "Henri Matisse: contributions à l'art décoratif." *Art and décoration* 6 (Fall 1947): 2-10.

Conceding Matisse's contribution to pictorial art--"translating the essence of our epoch, disengaging its characteristic signs"-- Diehl claims that, even if Matisse had not engaged decorative projects proper, his contribution is universal enough to be utilized in the decorative arts. This contribution comprises: "his ample constructive arabesques, his vigorous color contrasts which render the play of shadows and values useless, his powerful expressive graphism, his audacious rhythmic harmonies, his astonishing suites of assonances and dissonances, his extreme balance of forms and colors, his lines and his vast areas treated with a sure liberty and brutal

frankness"--all convertible to decorative uses. Profusely illustrated with paintings, book designs, ceramics, and silk-screened hangings.

324. Duthuit, Georges. "Le Tailleur de Lumière." In *Dernières Oeuvres de Matisse, 1950-1954,* a special issue of *Verve* 35-36 (July 1958). Eng. trans. as *The Last Works of Henry Matisse, 1950-1954.* New York, Harcourt Brace, 1958, no. 308. Also extracted in *XXe Siècle. Hommage à Matisse,* 75-84. Paris: XXe Siècle, 1970, as "Dernière étape: les papiers découpés."

Are the last works of Matisse the playful diversions of an old man out of touch with the real world or the crystalline epitaphs of the sage who condenses his means to the essential? Duthuit makes a case for the latter, distinguishing the cut-paper work from traditional collage and from Matisse's customary, time-intensive painting methods. Rather, the paper cut-out is an instantaneous sculpting in blocks of color; a surface created in which one substitutes the deep spatial breathing of lungs for the surface expansion/ contraction breathing of gills. Duthuit defends the gravity and mysticism of the late work against the criticisms of detractors; an important article.

325. Forgey, B. "The Matisse Cut-Outs." *Art News* 76, 10 (December 1977): 66-69.

On the occasion of the exhibition of Matisse's paper cut-outs that opened in Washington, D. C., in September 1977, Forgey reviews the sources and techniques used in the works and describes some in detail. A general treatment with no new research.

326. Fourcade, Dominique. "Something Else." In *Henri Matisse, Paper Cut-Outs.* St. Louis and Detroit: The St. Louis Art Museum and The Detroit Institute of Arts, 1977, no. 307.

Fourcade dissents from the majority opinion that Matisse succeeded at last in integrating color and line ("drawing and sculpting with color") in his late paper cut-outs for two

reasons. First, he holds that Matisse had already done so in his paintings of 1905-1917 and 1933-47 and in his drawings, especially those of the late 1930's and of the *Theme and Variations* series. Second, he does not find the cut-paper works altogether successful, despite their adventurousness and their risk-taking break with the artist's traditional practice. The invention of "signs," sheared from their painted environment and placed against a harsh, unpainterly white surface, replaced Matisse's usual working of form-objects within their painterly spatial ambiance, simultaneously creating both the figure and its ground. Though the "something else" that Matisse attempted in the cut-outs is full of contradictions and unresolved problems, according to the author, Matisse left a legacy of fresh perspectives and challenges to the next generation of artists. An important analysis of the artist's artistic probe in the cut-outs.

327. Franzke, Irmela. "Das keramische Frühwerk von Henri Matisse." *Keramos* 110 (October 1985): 67-76.

A broad survey and description of Matisse's ceramics (vases, plates, and the ceramic triptych) done with André Méthey at Asnières in 1907. Well illustrated, with two color plates of less well-known vases, but not an exhaustive survey.

328. Franzke, Irmela. "Matisse und die Keramik: die Zusammenarbeit mit André Méthey im Jahr 1907." *Kunst & Antiquitäten* 1-2 (1992): 38-41.

A close look at the work of one year, that of Matisse's most productive work with Méthey, in the area of ceramic production. Covers the same body of work as the earlier article, no. 327.

329. Goldin, Amy. "Matisse and Decoration: The Late Cut-Outs." *Art in America* 63 (July-August 1975): 49-59.

This is a brave, innovative, and very important discussion of decoration--in itself and without apology for its conceptual blandness--and of the decorations in Matisse's *oeuvre* which include, for Goldin, all of his cut-paper work. A historian of

Islamic art, Goldin discusses decoration in terms of field and frame, grid and pattern, with admirable concision and verve. She discusses with great intelligence Matisse's own transformation of the terms expression and decoration and of his increased desire, toward the end of his life, to produce public and social art, for which the the expanded, intensified spaces of his decorative murals and chapel would provide the ambiance.

330. Goldin, Amy. "Patterns, Grids and Paintings." *Artforum* 14, 1 (September 1975): 50-54.

A thoroughgoing discussion of pattern as a matter of interval and not as a repetition of motifs, Goldin's article refers only once to Matisse but provides much to consider in relation to his work. Goldin relates pattern to drawing, to composition, to iconic meaning, to viewer response, to grids, to temperament, to creativity. A fine, thought-provoking article, a companion to her essay on Matisse, no. 329, though not artist-specific.

331. Goldin, Amy, "The Body Language of Pictures." *Artforum* 16, 7 (March 1978): 54-59.

Responding to Dominique Fourcade's negative evaluation of much of Matisse's late cut-paper work because its method destroys (pictorial) spatiality, Goldin analyzes the unique spatial possibilities inherent in grid structures and the vertical axis of symmetry proper to wall compositions. The viewer's attentive gaze is rendered mobile, multi-positioned, and ongoing; space becomes, not a property of the object or an illusion, but an outcome of specific, actual experience face-to-face with the work. Matisse's work is referenced in this apologia for "another kind of spatial experience" but not dealt with in detail. Fourcade's article "Something Else" is found in the catalogue, *Henri Matisse, Paper Cut-Outs*, St. Louis and Detroit, 1977, no. 307 and see no. 326.

332. Hennessey, Richard. "The Cutouts of Matisse." In *Henri Matisse, Zeichnungen und Gouaches Découpées,* 293-297. Stuttgart: Staatsgalerie Stuttgart, 1993. Exhibition catalogue.

An exaltation of the cutout work that exhibits the very *élan* and the zestful wonder that the author finds in Matisse's late work. Scale, pattern, extension, and compression are phenomenologically examined with extraordinary freshness and with new insights, both formal and thematic. A wonderful discussion.

333. Lassaigne, Jacques. "État de la tapisserie." *Panorama des Arts 1947,* 250-51. Paris: Somogy, 1948.

A two-page summary of the revival of tapestries in contemporary designs, occasioned by an exhibition mounted by Denise Majorel at the Galerie de France. From private patrons to public commissions, according to Lassaigne, new uses are being devised for tapestry projects. The last two sentences mention Matisse's *Polynésie, Le Ciel* and *Le Mer,* the former being given a half-page reproduction.

334. Lassaigne, Jacques. "Les Grandes gouaches découpées d'Henri Matisse; la peinture sans limites." *Les Lettres françaises* (August 6, 1959).

The author emphasizes the revolutionary nature of the revelation of the Kunsthalle (Bern) exhibition, the first to include thirty ambitious, large-scale cut-paper works by Matisse. Twenty-three of these had never before been shown. The author "walks through" the show, singling out representative works in which Matisse handled his new medium in quite different ways--for example, *The Blue Nudes, The Snail, Snow Flowers, The Negress,* and his book, *Jazz.* This is basically a review of the show.

335. Levine, Stephen Z. "Décor/Decorative/Decoration in Claude Monet's Art." *Arts Mag.* 51 (February 1977): 136-39.

Thoroughly applicable to Matisse is Levine's discussion of the terms décor, decorative, and decoration in the writings on

Monet after 1880, when his work was assimilated to symbolist esthetic values. The decorative was newly appreciated as a spectacle for the eye, a manifestation of order and balance created by the thinking artist for the viewer's repose of spirit. The comparative/ successive mode of Monet's serial paintings is also relevant to Matisse's use of seriality in his later work. An indispensable article for the period and the medium.

336. Leymarie, Jean. "Le Jardin du paradis." *Les Lettres françaises* (August 6, 1959); (excerpts of paper given on the occasion of the inauguration of the exhibition of cut-paper work at the Kunsthalle in Bern in 1959). Excerpts also published in *Quadrum* 7 (1959): 103-114+.

A rhetorical exercise in which Matisse's debt to the "East" (especially Persian art) is linked to his themes of the garden and of paradisal joy. The author finds all of these exemplified in the thirty works in cut-paper that are being exhibited in Berne, marveling as well that they are the works of his old age, placing him with Rembrandt, Monet, and Renoir in this late flowering of his gifts, rather than a substitution for media that require greater strength and creativity. Fulfilling the premises of Fauvism, these works are "the exaltation of the flat surface without local color by virtue of combining the arabesque and pure color."

337. Leymarie, Jean. "Les Grandes Gouaches découpées de Matisse à la Kunsthalle de Berne." *Quadrum* 7 (1959): 103-114. From a paper given on the occasion of the inauguration of the exhibition of cut-paper work at the Kunsthalle in Bern in 1959; excerpts also published in *Lettres françaises,* August 6, 1959.

Leymarie praises "these sumptuous and grandiose creations under their apparently fragile and trifling form" that come "from beyond the grave" to make a major impact on modern art. The author distinguishes the work from cubist and surrealist collages and finds it relevant "to the contemporary philosophies of intuition and the immediate, and rejoins the

most penetrating research of contemporary art, based on speed and improvisation, direct contact with the matter, the fusion of painting-sculpting, the decorative demand." He points out Matisse has reversed his painting procedures completely and echoes the exhibition catalogue introduction in claiming that, in experiencing Matisse's large paper cut-out compositions, one enters the "Heavenly Jerusalem" or a garden of paradise.

338. Marchiori, Guiseppe. "Papiers découpés." *La Biennale di Venezia* 26 (December 1955): 26-28.

Short, lyric celebration of the cut-paper work of Matisse and of its Byzantine-like projection of an exact space, the work of a marvelous decorative imagination.

339. Maréchal, Andrea. "Portrait of an Ersari." *Hali* 7, 3 (July-August-September 1985): 10-13.

Author identifies the carpet in Matisse's *Family Portrait* (1911) as a Turkoman Ersari *gülli göl* carpet; she further notes and identifies carpets and fabrics found in other Matisse paintings as prominent vehicles of spatial organization. Against the background of some biographical information, the compositional use of pattern--as found in these carpets-- is examined as a strategy that Matisse discovered and utilized in his move from Western perspectival compositional systems.

340. Marmer, Nancy, "Matisse and the Strategy of Decoration." *Artforum* 4, 7 (March 1966): 28-33.

On the occasion of the UCLA Matisse retrospective, the author relates Matisse's thriving reputation to contemporary color field and "optical" painting. In all of the artist's work-- early to late--decoration functioned structurally as well as expressively, Marmer notes, and the "tough-minded aestheticism" of the French artist is shared by the American "new abstractionists" such as Kelly, Youngerman, Nolan and Held.

341. Marshall, Neil. "Patterning." *Arts Mag.* 55, 1 (September 1980): 120-21.

In a general discussion of the nature of patterning, Matisse's use of pattern--from *Pink Studio* to the last cut-out murals--is analyzed as a particularly inventive and free deployment of patterns for different ends, as the individual work's and the artist's current concerns dictated. The author suggests that as the passion for change-for-its-own-sake wanes in the postmodern period, interest in pattern, though "traditional and conservative," is creating fresh possibilities for new art of quality.

342. Masheck, Joseph. "The Carpet Paradigm: Critical Prolegomena to a Theory of Flatness." *Arts Mag.* 51 (September 1976): 93-110.

A historical tracking of the metaphor of the "Persia carpet" for those qualities of flatness, objectlessness, and formal beauty which can also be found in late nineteenth-century and post-impressionist modernism. A wonderfully rich, inclusive study which acknowledges the role of the applied or decorative arts in the acceptance of non-objective painting but distinguishes the discourses proper to each--though they often seem to overlap in the discussions of decorative and pictorial values. This paradigm of flatness is celebrated by the author as apt until the advent of Cubism and its new paradigm of "pictorially veritable" spatial construction, whereupon the carpet metaphor and its referent seem relegated to the ashbin of superceded plastic ideas. A very learned, important article with many applications to Matisse's theories of painting.

343. Masheck, Joseph. "Embalmed Object: Design at the Modern (with appendix 'Art as Rest and Relaxation')." *Artforum* 13, 6 (February 1975): 49-55

Discusses the history of the idea that art is related to leisure, citing Reynolds, Goethe, Hume, Zola, Baudelaire, Morris, and finally Matisse on his comparison of art for the intellectual worker to an easy chair for the tired laborer. This short work is an appendix to a longer critique of the design collection and its rationale at the Museum of Modern Art, occasioned by an exhibition of its design collection, entitled *Art and Leisure.*

344. Meyer, Franz. "Les Grandes gouaches découpées." In *Henri Matisse, 1950-1954, Les Grandes gouaches découpées*. Bern: Kunsthalle Bern, 1959.

A sensitive, workmanlike review of the history of Matisse's working with cut-paper gouaches and a fine overview of the esthetic problems, challenges, and achievements of the artist in particular works. This is the catalogue introduction to the first large museum exhibition of the cut-paper works, a masterful synthesis of the major formal and iconographical readings that would prevail for the next decades; provides a mini-bibliography of the literature on the medium to that point. An important essay.

345. Neff, John Hallmark. "Matisse and Decoration; an Introduction, part I." *Arts Mag.* 49 (May 1975): 59-61; "Matisse and Decoration, part II," (June 1975): 85.

Two important articles adapted from the author's unpublished dissertation, no. 311, that reposition the decorative as an important aspect of Matisse's early education and life-long aspirations. Fascinating comparisons between Matisse's "Notes of a Painter" (1908) and a standard manual of decorative procedures, Henry Havard's *La Décoration* of 1892, which summarized the nineteenth-century art theories of Charles Blanc and de Superville. Neff also traces the changing views of the value of decoration in the first decade of the twentieth century, often supported by nationalist fervor. Part II discusses the decorative paintings done for the Moscow importer, Shchukin, leading up to the commissions for *Dance* and *Music* and the role of Bernheim-Jeune in those earlier commissions.

346. Neff, John Hallmark. "Matisse and Decoration: the Shchukin Panels." *Art in America* 63 (July-August 1975): 38-48.

An article of the first importance on the ensemble of paintings *Dance, Music* and (the original) *Bathers by a River*. Neff establishes convincingly that the third painting, *Bathers*, was originally intended by Matisse as part of a tri-partite program for Shchukin's staircase. (Neff also clears up the "studio" vs.

"staircase" translation of Charles Estienne's interview with Matisse in 1909 in which Matisse speaks of the total program.)

347. Neff, John Hallmark, "Matisse, His Cut-Outs and the Ultimate Method." In *Henri Matisse, Paper Cut-Outs.* St. Louis and Detroit: St. Louis Art Museum and Detroit Institute of Arts, 1977.

Neff develops the thesis that the cut-outs were not only the synthesis of Matisse's drawing, painting, and sculpture but also of his career as a whole. Drawing on memory, according to Neff, Matisse executed--in the act of cutting a form--a gesture that harmonized his action with his conception. Gestural expression freed him from emotion and at the same time captured the specific yet universal qualities of his subject. Neff also discusses the cut-outs in relation to sculpture and to sources of inspiration in non-Western, especially Islamic, decoration.

348. Neff, John Hallmark. "Matisse's Forgotten Stained Glass Commission." *Burlington Mag.* 114 (December 1972): 867-70.

At the Karl-Ernst-Osthaus Museum archives, Neff discovered the correspondence concerning a stained glass window design requested by Osthaus and Gottfried Heinersdorff, head of the Berlin Werkstatt für Verglasung: Glasmalerei and Glasmosaik, for an exhibition of the executed designs contributed by contemporary painters. Although Matisse's designs were never realized, the history of the conception and the eventual collapse of the project provides an insight into the efforts to revive craft techniques through the intervention of contemporary painter/designers, and the difficulties that attended these efforts. The first (and still only) article on this fascinating page in Matisse's early decorative efforts.

349. Russell, John. "Final Flowering of Henri Matisse, Invincible Artist." *Smithsonian Studies American Art* 8, 6 (1977): 72-79.

Well-illustrated celebration of the preferred technique of Matisse's last years that emphasizes the liberating, youthful and joyous qualities of the last works, particularly *Jazz, Swimming Pool, Women and Monkeys,* and *Large Decoration with Masks.*

350. San Lazzaro, G. "Découpages de Henri Matisse." *XXe Siècle* 4 (January 1954): 73.

On the occasion of the Berggruen Gallery exhibition of Matisse's cut-paper works, the author at this early date is able to recognize their importance as the development of the artist's new system of "signs." This replaces and fulfills the earlier "system" of his painting--at the heart of all of his representations earlier in his career.

351. Schneider, Pierre . "'The Figure in the Carpet,' Matisse und das Dekorative." In *Henri Matisse.* Zürich: Kunsthaus Zürich; Dusseldorf: Städtische Kunsthalle Dusseldorf, 1982. Exhibition catalogue.

Schneider traces the importance of the decorative--as embodied in Persian carpets--throughout the work of Matisse, showing the duality of his Western realism and his Eastern sensitivity to the decorative. The poles are in constant oscillation in his work, each acting to challenge the other. Sometimes the figure (content) is concealed in the carpet and sometimes the carpet (abstract structure) is concealed beneath realistic figuration. An important article whose argument is spelled out in greater depth and detail in Schneider's 1984 book, *Matisse,* no. 157.

352. Schneider, Pierre. "Puvis de Chavannes: The Alternative."*Art in America* 65, 3 (May-June 1977):94-98.

Author details Matisse's debt to the example of Puvis de Chavannes' flat mural style as the alternate possibility to Neo-impressionist "realism," as realized in Matisse's 1904 pointillist panel, *Luxe, calme et volupté.* Schneider incorporates and expands this material in his 1984 book, *Matisse,* no. 157.

353. Sowers, Robert. "Matisse and Chagall as Craftsman." *Craft Horizons* 22 (January 1962): 28-31

A thoughtful comparison of the effectiveness of Matisse's cut paper maquettes, *The Acanthuses* (1953) and *The Vine* (1953), for a ceramic mural and stained glass window respectively, with Marc Chagall's twelve stained glass windows, *The Twelve Tribes of Israel,* for a synagogue in Israel. The author finds Matisse's designs more successful in scale, design, and wholeness of effect, than Chagall's windows. These latter are, ironically, too painterly, in spite of the artist's care in learning technical aspects of the medium.

354. Spies, Werner. "Mit der Schere gezeichnet." In *Das Auge am Tatort. Achtzig Begegnungen mit Kunst und Künstlern,* 90-94. Munich, 1979. Trans. by Luna Carne-Ross and John William Gabriel as *Focus on Art.* New York: Rizzoli, 1982.

An article on Matisse's cut-paper work on the occasion of the *Matisse, Paper Cut-Outs* exhibition of 1977. Compares these works, not with cubist collages but with Picasso's late sculptures constructed as small cardboard maquettes which were then enlarged and fabricated. Spies points to the importance of *Jazz* for the painters of the 1960s and 1970s and rejects the notion that Matisse does cut-paper work because of his poor health. Traces the tradition as a decorative and mural concern which goes back to the 1930 murals and was already used as an aid in constructing paintings such as *Pink Nude* (1935).

355. Spurling, Hilary. "Henri Matisse et les tisseurs de Bohain." In *Tisserands de légende, Chanel et le tissage en Picardie.* Trans. from English by M. J. Gransard. Compiegne: A. S. P. I. V. Éditeur, 1993. Exhibition catalogue.

In the catalogue for an exhibition celebrating the famous weavers and designers of Picardy and particularly of Matisse's home town of Bohain-en-Vermandois, Spurling details the flourishing fabric industry that coincided with the years of Matisse's boyhood there and reveals that the Matisse family had been weavers from before the Revolution until the artist's father broke the tradition by becoming a merchant. The

artisans were known for their subtle and sumptuous color and for their audacity, originality, and experimental ingenuity as designers. The author traces this influence on Matisse's work. A too-brief account that will undoubtedly be developed in the biography of Matisse that the author has in preparation, the first volume of which will be published in 1996 or 1997 by Hamish Hamilton, London, and Knopf, New York.

356. Sutton, G. K. "Papirklip--det er noget [Cut-outs--Quite Something]." *Louisiana Revy* 25, 2 (January 1985): 46-50, 55.

A retelling of the initiation of the cut-paper technique after Matisse's major surgery, his development of themes and motifs, and his manner of working from nature rhythmically in order to capture the essentials of living beings. Stresses the practical nature of the medium for a "handicapped" artist, not its radical nature.

357. Wescher, Herta. "A Glance at Recent Trends in Collage." In *Collage*. Trans. from the German by Robert E. Wolf. New York: Abrams, 1968.

In a general treatment of collage, Matisse's paper cut-outs are given a mini-history that is accurate and treats the works as a major genre of the artist.

358. Wood, William. "Boudoir Scissorhands: Matisse, the Cut-Outs and the Canon." RACAR, *Revue d'Art Canadienne / Canadian Art Review* 18, 1-2 (Spring 1991): 5-17.

The author reviews the "canonical" status of Matisse's paintings and the relation of the reception of Matisse's decorative work--his applied-art multiples of *Polynésie, Océanie, Jazz,* etc.--to the artist's prestige as a painter. He finds that there is confusion in the criticism of the cut-outs on this point, a withdrawal by the artist from commercial ventures with his "multiples," and a recuperation of the cut-paper work under the criteria of painting. Matisse's ambivalence toward the late works is explored, as well as the consuming possessiveness and sublimated eroticism of the late

works like *The Swimming Pool.* Critical issues are examined with perspicacity, balance, and a fresh viewpoint.

359. Zervos, Christian. "Décorations de Henri-Matisse." *Cahiers d'art* 14, 5-6 (1939): 165-178.

Zervos discusses the conflicting aims of easel painting, which is in a healthy state of quality, originality and newness of technical means, and those of mural painting, fallen into disuse and disregard, and which encourage a conventional, restricted approach. Calls for a renewal of mural painting that meets the social needs of the times, and which the "magnetic influence of the masses" in fact stimulates rather than impedes. Zervos cites the Barnes Foundation mural by Matisse and Picasso's *Guernica* as examples of the quality possible in mural painting. The article is profusely illustrated with the in-process photographs of Matisse's overmantel decoration for Nelson Rockefeller's music room and the decorative panel, *Music* (Albright Knox Museum), here simply called *Decoration.*

IV
General Articles

360. Ahlers-Hestermann, F. "Das Atelier Henri Matisse, 1909." In *Pause vor dem III. Akt*, 176-179. Hamburg, 1949.

The reminiscences of one of Matisse's former students on the working conditions in Matisse's school in 1909. Author's subject is the students themselves rather than their teacher.

361. Allard, Roger. "Henri Matisse." *L'Art vivant* 4 (February 15, 1925): 1-3.

A subtle and far-ranging appreciation of Matisse as an "expressionist," but one whose expression is through his plastic means (line and color especially) and through a feeling for "the fantastic reality of life," in Baudelaire's phrase. An essay of the period distinguished by neither elevating the innovative Parisian Matisse of 1905-1916 by diminishing the Niçois Matisse of 1917-1925 nor vice versa.

362. Anazawa, Kazuo. "Matisse." In *Matisse*. Tokyo: The National Museum of Modern Art, 1981. In Japanese. Exhibition catalogue.

Author recalls his first impressions of the 1951 *Matisse Retrospective* in Tokyo and traces the development of Matisse's art with emphasis on those "enlightenments which came [to Matisse] from the East." The essay also stresses the relation of Matisse's art to nature and the necessary subtlety of formal and affective relationships in true works of art. Text in Japanese.

363. Aragon, Louis. "Matisse-en-France." In *Henri Matisse dessins: Thèmes et variations, précédés de "Matisse-en-France."* Paris: M. Fabiani, 1943. Limited edition, 950 copies in portfolio.

Aragon's intimate and leisurely text "Matisse-en-France" is a kind of elegant apology for Matisse--the latter remote, non-political, producing works of a hedonistic esthetic--during the German occupation. Aragon presents Matisse as a timeless French national treasure who maintains a standard of lucidity and excellence that will endure beyond the present dark moment in history. A necessarily guarded or "coded" text, considering the date of its publication. The essay introduces a large, luxury edition of Matisse's "Themes and Variations" drawings of 1941-43, no. 222.

364. Aragon, Louis. "Henri Matisse or the French Painter." In *Henri Matisse Retrospective.* Philadelphia: Philadelphia Museum of Art, 1948. Reprinted in French as "Matisse ou la peintre française." *Arts de France* 23-24 (1949): 11-24, and *Jardin des arts* 106 (September 1963).

A delicate account of Aragon's youthful delight (1919) in the "strangeness" of Matisse's art which has given way to delight in Matisse's Frenchness--his intellectual freshness and sensory joyousness. According to Aragon, Matisse has found a "new way of imitating nature" and, by not servilely copying it, he is allied to all young revolutionaries, political and artistic. With them, he inflames the popular desire for happiness and, hence, for social change.

365. Aragon, Louis. "Au Jardin de Matisse." In *Henri Matisse, chapelle, peintures, dessins, sculptures.* Paris: Maison de la pensée française, 1950. Exhibition catalogue.

A homage to Matisse that lauds his career for its lesson in rupture and its reinvention of the epoch's idea of happiness. An extended garden metaphor is utilized to suggest a materialist utopian promise for the future, social as well as esthetic.

366. Aragon, Louis. "Le Deuxième siècle de Matisse commence."
 Les Lettres françaises 1330, 15-21 (April 1970): 3-9, 25-30.

 Complete issue devoted almost totally to the publishing of
 three chapters of Aragon's soon-to-appear monograph on
 Matisse. The chapters of previously unpublished material are:
 "Prière d'inserer," "Les Signes," and "Un Personnage nommé
 la douleur." Profusely illustrated with Matisse's graphics.

367. Arnold, Matthias. "Das Frühwerk von Henri Matisse, Ein
 Beitrag zu Postimpressionismus und Fauvismus. " *Weltkunst*
 50, 22, Part I: Chronologie (November 15, 1980): 3358-61;
 Part II: Ikonographie und Stil (December 1, 1980): 3530-33.

 This two-part article argues that the work of Matisse from
 1890 to 1903, unfairly neglected in the literature, has not only
 extraordinary value in itself but demonstrates that Matisse
 came to his Fauve style (from Cézanne and Van Gogh
 primarily) earlier than the other "Fauves," thus earning him
 the right to be considered the true originator of the style.
 Author establishes a chronological list of the some 250 works
 from this period. Minor factual errors and an overstatement of
 the neglect of the period do not weaken the major argument
 which is forcefully made.

368. Arnold, Matthias. "Künstler sammeln Kunst." *Kunst &
 Antiquitäten* 2 (1988): 98-105.

 The second half of a two-part article focuses on Picasso's art
 collection; his works by Matisse are given somewhat extended
 treatment.

369. Ashton, Dore. "Matisse and Symbolism." *Arts Mag.* 49 (May
 1975): 70-71.

 A summary review of the symbolist aspects of Matisse's art,
 particularly his affinities to Mallarmé. Richly allusive in a
 very restricted length.

370. Asplund, K. "Henri-Matisse." *Cahiers d'art* 6, 5-6 (1931):
 298-300.

The Swedish critic acknowledges the influence Matisse has had in Nordic countries and especially his own. Reflecting on the 1924 Stockholm exhibit and the current retrospective at Bernheim Jeune, the author argues that Matisse's recent work has maintained the essential characteristics of the "expressionist" and "abstractionist" work of the earlier years, namely, the artist's profound sense of intimate solidarity with the earth, his love for the opulence of his *matière*, and for a complex play of colors. He notes Matisse's personality as complex, refined, and "even disconcerting."

371. Aubrey, P. "Golberg et Matisse." *Gaz. beaux-arts* 6, 66 (December 1965): 339-44.

The author discusses André Rouveyre's claim that Matisse's "Notes of a Painter" was written by or in close collaboration with Mécislas Golberg, the author of *La Morale des Lignes* (1905). Aubrey gives a summary of the career of Golberg-- anarchist, critic, sociologist, playwright, friend of Apollinaire and André Salmon--who died in 1907. He then outlines the ideas common to both texts, but finally finds them too different in overall content and style for the similarities to be the result of anything more than common sources or informal discussions between the authors.

372. Barnes, Albert C. "Matisse." In *The Art in Painting*, 380-85, 535-37. New York: Harcourt, Brace, and Co., 1925, 1928.

A wholly formal analysis of Matisse's break with impressionism by way of Gauguin and, principally, by the continuation of Cézanne's mode of composition through plastic distortion. Matisse's goal is less Cézanne's solidly massed spatial relations, however, than the enhancement of color relations for their own sake. Matisse's line, "without psychological expressiveness," is praised for giving "plastic value to what is contained between the contours of figures and objects." Non-western (Hindu and Persian) influences are noted as well as that of Cubism. Matisse is not classed among the greatest painters of the past, but is the most important painter of the present age because of the personal distinctiveness of his

use of all the plastic means, above all, color. Two paintings are given close analysis: *Joy of Life* (1906) and *The Music Lesson* (1917).

373. Barotte, René. "Henri Matisse, le peintre de bonheur." *Jardin des arts* 2 (December 1954): 109-115.

An admiring reminiscence on the occasion of Matisse's death, spiced with amusing anecdotes that the artist himself told the author.

374. Barr, Alfred H., Jr. "Matisse, Picasso, and the Crisis of 1907." *Mag. of Art* 44 (May 1951): 161-170.

Distillation of two chapters of Barr's monograph, *Matisse, His Art and His Public*, published later the same year. *Bonheur de Vivre* and *Demoiselles d'Avignon* are contrasted as aspects of the style and personality of the two friendly rivals who were both drawing on aspects of Cézanne.

375. Basler, Adolphe. "Die junge französische Malerei." *Cicerone* 12, 20 (October 1920): 748-52.

Basler reviews the exhibitions, *Jeune peinture française,* Cubist painters at the Léonce Rosenberg gallery, and Gimmi and Coubine at Berthe Weill. He raises the question whether Matisse still leads the young or whether, like Vuillard and Bonnard, he is simply a Post-Impressionist. Basler discusses Andre Lhote's recent article on Matisse in the *Nouvelle revue français*, but decides that Matisse's decorative contribution to easel painting puts him more in touch with his epoch than the innovations of Cubism.

376. Basler, Adolphe. "Henri Matisse." *Cicerone* 13, 1 (January 1921): 16-20. Reprinted in *Jahrbuch der jungen Kunst* 2 (1921): 16-20.

Basler distinguishes Matisse's use of Cézanne as a model from the generation before him, Bonnard, Vuillard, and Roussel. The latter took from him, as from Gauguin, only surface patterns and the sparkle of Cézanne's palette. Matisse drew from him an understanding of pictorial structure, of the power

of simplified color, and of use of the whole field--both objects and voids. Matisse creates a symbolic art, an art where every part has a function in the whole. Author comments on the variety of Matisse's non-Western and non-modern sources and criticizes his too-great facility in bringing decorative forms into easel painting.

377. Basler, Adolphe. "Henri Matisse." *Cicerone* 16, 21 (November 1924): 1001-1009. (Reprinted with slight revision in Kunstler, Charles, and Adolphe Basler. *La Peinture indépendante en France*, vol. 2., 1929. Essentially the same text in Adolphe Basler. *Henri Matisse*, Leipzig: Klinkhardt & Biermann, 1924, no. 54. Also published in French under the name Philippe Marcel in *l'Art d'aujourd'hui* (Summer, 1924): 33-47), no. 622. Flam, no. 88, 219-22.

Basler credits Matisse with broadening the influence of Renoir and Cézanne, with being the true interpreter of the latter's art. The Fauves as well, under Matisse, extended the lesson of Gauguin in appreciating qualities of primitive, archaic, Gothic, and non-Western art. Basler also insists on the symbolist heritage of both Fauvism and Cubism and echoes Denis in denouncing an abuse of abstraction which in 1921, happily, Matisse has abandoned for a more naturalistic vision. This vision, unfortunately, results in works of taste and charm, but not greatness.

378. Basler, Adolphe. "Völkerbund der Malerei." *Kunst u. Künstler* 27, 4 (January 1929): 149-154.

Two rather predicatable paragraphs on Matisse (whose prestige is marked nevertheless by commanding four of the five accompanying illustrations) within an article more generally on Paris as an artistic League of Nations, exemplified by Pascin, Modigliani, and Chagall as well as Bonnard and Vuillard.

379. Baynes, Ken. "Art and Industry," *Architectural Rev.* 140 (November 1966): 357-360.

An article that explores the relation between industry, engineering, and mass production on artistic practice, with special attention to the work of David Smith. Smith's self-identifying work ethic and virtuosity with materials is, in the final paragraphs, contrasted with Matisse's praise of the "quality of feeling" inspired by nature. The author values the virtuosity that follows inevitably from honest work, as exemplified by Smith. The exhibition of Matisse's *Parakeet and Mermaid* (1952) at the Tate Gallery and Smith's one-man show there are the occasion of the essay.

380. Bazaine, Jean. "Clarté de Matisse." *Derrière le miroir* 46-47 (May 1952), np.

A large-format folio of quality reproductions of Matisse drawings is accompanied by a mature artist's moving and highly refined text on the clarity of Matisse's fervor, his constructive force, his dominated passion, his lucid and hard-won simplicity. The author sees this as the summit of French force and strength--whose "violent and secret root" is merely masked as measure and limpidity. Were not Matisse an obsessional and profound artist, Bazaine claims, he could not have invented those "profoundly tragic signs," The Stations of the Cross, on the walls of the Chapel at Vence. An extremely moving and intelligent text, beautifully shaped.

381. Bell, Clive. "Matisse and Picasso: the Two Apparent Heirs to Cézanne." *Athenaeum* 4698 (May 14, 1920): 643-44. Reprinted also in *Arts and Decoration* (November 1920) and, slightly revised, in *Since Cézanne*. London: Chatto and Windus, 1922, 83-90. Flam, no. 88, 194-95.

Matisse and Picasso, the primary heirs of Cézanne, are contrasted: Matisse, master of sensibility, a pure artist, the finer painter, but not the head of a school; Picasso, more intellectual, inventive, the richer artist, though occasionally sentimental. Though neither artist comments on life, Picasso manages to comment on art, hence, he is a leader and master of the modern movement.

382. Bell, Clive. "Matisse and Picasso." *Europa* (May-June, 1933). Flam, no. 88, 294-95.

Matisse renders naturally the joy of seeing and feeling, while Picasso renders the beautiful and marvelous or vicious with machine-like precision and hyper-consciousness. Picasso's disgust or despair, willfully cynical, Bell describes as sentimental. Matisse's paintings interest painters; Picasso's reflect the age's interest in popular art, the accidental, industrial scraps, but utilized symbolically.

383. Bell, Clive, "Henri Matisse." *Apollo* 60 (December 1954): 151-56.

Summation, after Matisse's death, of the artist's early "Fauve" contribution to modernism, namely, the subordination of representation and intimate association to the creation of "something moving and beautiful in itself." Author claims that Matisse later developed a system of "equations" or equilibriums of elements that amounted to abstraction.

384. Bell, Quentin. "Meeting Matisse," *The Yale Review* 76 (Spring 1987): 295-99.

A light reminiscence of the author's youth when he was astonished to find, upon meeting Matisse at the home of Simon Bussy during the summer of 1934, that Matisse appeared to be an "amiable philistine," whom the Bussy family believed to be "the greatest living painter, the greatest living egotist, and the greatest living bore." An unflattering portrait of the "social" Matisse.

385. Bendiner, Kenneth. "The Chairs of Matisse." *Gaz. beaux-arts* 106 (November 1985): 179-88.

Examines Matisse's representations of chairs for insights into the artist's ideas. The chair is often a signal of the viewer's meditative position, of the esthetics of participation by seeing. Author offers a subtle reading of paintings where the chair surrogates an absent human presence or where it indicates a state, a civilization, or a social milieu.

386. Bendiner, Kenneth. "Matisse and Surrealism." *Pantheon* (1992): 134-42.

The author argues that the qualitative differences--thematic and stylistic--in the work of the last fourteen years of Matisse's life were significantly influenced by Surrealism. Like the Abstract Expessionists during the same period (1940-1954), Matisse took up aspects of surrealist theory and form and shaped them to his own esthetic and personal ends, effectively infusing fresh vigor into a waning movement. Bendiner traces Matisse's surrealist contacts (Aragon, Breton, Masson, and Miro), his use of Freudian terminology, and his evident knowledge of surrealist attitudes and finally analyzes *Jazz* as an essentially surrealist book.

387. Benjamin, Roger. "Recovering Authors: The Modern Copy, Copy Exhibitions, and Matisse." *Art History* 12, 2 (June 1989): 176-201.

Important discussion (from original research) on the changing role of the copy in French art from 1890-1916, its function in establishing canons of masters and of master works, its commerical manipulation, and its paradoxical role in constructing the copyist as an original author. A fundamental article that builds on the work of Richard Shiff, linking modernist and postmodernist discourses on reproducibility and originality.

388. Benjamin, Roger. "Matisse in Morocco: A Colonizing Esthetic?" *Art in America* 78, 11 (November 1990): 156-165, 211, 213.

A subtle and balanced review of the *Matisse in Morocco* exhibition and catalogue (1990), no. 70. Author analyzes and evaluates the relation between the political and cultural implications of the artist's visit to Tangiers just after French military action there and Matisse's treatment of "orientalist" themes in a modernist (i.e., painterly and abstracting) esthetic. The author suggests that the utopian thematics and modernist style occasioned by his North African subjects cannot detach Matisse's work from French colonial history and its other

attendant cultural manifestations in ethonography, literature, painting and photograpy. An indispensable article on this topic.

389. Benjamin, Roger. "Orientalist Excursions, Matisse in North Africa." In *Henri Matisse,* 71-83. Brisbane: Queensland Art Gallery and Art Exhibitions Australia, 1995. Exhibition catalogue.

Benjamin argues that Matisse's painting trips to Biskra (1906) and Tangier (1912 and 1913) are inextricably involved in the French government's colonisation of these areas, with all the coloniser's arrogance and erasure of the actuality of the indigenous peoples and their cultures. Thoroughly disrupted and spoiled by the colonial structures and industrialization imposed on these areas, North African culture was valued for its picturesque aspects, exploited for tourism. Benjamin analyses the work Matisse produced at these sites to demonstrate that Matisse did not transcend the "cultural tourism" of his times and its myths of exoticism.

390. Benjamin, Roger. "The Vital Sign, an Overview of Matisse's Painting." In *Henri Matisse,* 19-39. Brisbane: Queensland Art Gallery and Art Exhibitions Australia, 1995. Exhibition catalogue.

A historical review of Matisse's career as a painter, divided into the eight chronological segments into which the Australian retrospective exhibition is itself organized. Benjamin, along with Caroline Turner, organized the show and guides the reader through its rationale and sequencing, in this general introductory essay.

391. Berenson, Bernard. "De Gustibus [letter to the editor]," *Nation* 87, 2263 (November 12, 1908): 461. Reprinted in Alfred H. Barr. *Matisse, His Art and His Public,* 114. New York, 1951, no. 53.

A response to a comment on Matisse by the *Nation*'s own reviewer of the 1908 Autumn Salon. Berenson objects to the

assumptions of the review and praises Matisse as one finding himself within tradition rather than seeking to be new for the sake of newness.

392. Berenson, Bernard. "Incontri con Matisse." *La Biennale di Venezia* 26 (December 1955): 9-10. Translated as "Encounters with Matisse" in *Essays in Appreciation*. London: Chapman and Hall, 1958.

A tart reminiscence of Matisse by Berenson, wherein two sovereign egos fail to engage sympathetically.

393. Berger, Klaus. "Henri Matisse" in *Japonisme in Western Painting from Whistler to Matisse*. Cambridge: Cambridge University Press, 1992. Translated by David Britt from the German, *Japonismus in der Westlichen Malerei, 1860-1920*. Munich: Prestel Verlag, 1980.

A brief but highly discerning discussion of Matisse's debt to Japanese prints. The author faults Barr for neglecting this influence and praises Albert Barnes for his discussion of the matter by reproducing in an appendix the section "Matisse and the Japanese Tradition," from Barnes and de Mazia, *The Art of Henri Matisse*, 1933 no. 50.

394. Berger, John. "Henri Matisse, 1869-1954" [Obit]. *New Statesman* (November 13, 1954).

Some perceptive remarks on Matisse's achievements in color and a defense of the goal of pleasure or contentment for art by a prominent critic of the left.

395. Besson, Georges. "Arrivée de Matisse à Nice." *Le Point* 4, 21 (1939): 39-44. Flam, no. 88, 167-68.

A reminiscence of Matisse's early life in Nice, filled with specific dates and details. Indispensable account of Matisse's visits to the elderly Renoir, facilitated by Besson.

396. Bettini, Sergio. "Il Colore di Matisse." *La Biennale di Venezia* 26 (December 1955): 19-24.

Attempts a loose "structural linguistics" approach to Matisse's
use of color which amounts to the reiteration of the claim that
Matisse's color is totally relational, deriving its effectiveness
from the improvised coordination of tone, scale, and placement
of color-areas.

397. Blunt, Anthony. "Matisse's Life and Work." *Burlington
 Mag*. 95 (December 1953): 399-400.

Review of Barr's *Matisse, His Art and His Public* that is
largely admiring but which faults Barr for neither always
giving the reasons for his dating nor indicating when some
dates are doubtful. A close and critical reading of Barr's study
by a distinguished art historian.

398. Board, Marilyn Lincoln. "Constructing Myths and Ideologies
 in Matisse's Odalisques." *Genders* 5 (Summer 1989): 21-49.

Critical feminist analysis of the Odalisques of the 1920's and
1930's which sees them as symptoms of the pervasive
patriarchal dominance, colonialist imperialism, and
psychosexual fantasies of French culture of the period.
Drawing on the writings of Said, Derrida, Eagleton, Jameson,
and Ortner, the author suggests that the necessity for
constructing an inferior Other (who also is a projection of the
lacking Self) seems to have diminished in Matisse's later life
and work, as his cut-paper works manifest a dissolution of
binary oppositions into a more integrated totality of
experience.

399. Bock, Catherine C. "A Question of Quality: a Note on
 Matisse's 'Dark Years.'" *Gaz. beaux-arts* 6, 103 (April 1984):
 169-74.

The author argues that the years 1901-1904, sometimes seen
as a slightly regressive, anti-colorist period in the artist's early
development, were progressive ones in which Matisse
assimilated the discoveries of his first colorist period (1897-
1900) and established himself within a well-understood post-
impressionist tradition. The quality of these works earned for
him the solid reputation among more advanced critics that

permitted the latter to deal with his "fauve" innovations with respect and open-mindedness.

400. Bock, Catherine C. "Henri Matisse Self-Portraits: Presentation and Representation." *Psychoanalytic Perspectives on Art*, 239-65. Vol. 3, edited by Mary Matthews Gedo. Hillsdale, N. J. and London: The Analytic Press, 1988.

Bock discusses as self-portraits two types of Matisse likenesses--1) his hand-drawn or painted self-portraits and 2) published photographs of the artist by various photographers. The former are seen as *vrai* portraits (psychologically penetrating, private) and the latter as *beau* portraits (rhetorically persuasive, public). Bock demonstrates that the two types of images were consciously circulated (or withheld) by Matisse to control his public image as a certain kind of artist: sedate and rational in his person, risk-taking and innovative in his work. Textually, Matisse's interviews functioned as similar "public" portraits, that gave carefully staged access to the "private" man.

401. Bois, Yve-Alain. "Legendes de Matisse." *Critique* 324 (May 1974): 434-66.

Bois explores the "coherence of the 'contradictions'" to be found in Matisse's statements gathered in Fourcade's *Ecrit et propos sur l'Art* (1972). He discusses the tensions between originality and the effect of influences, between the creation of "signs" and the mimetic response to "nature," between autonomy and instinct and observing laws and reason, between the continuity of the artist's project and its discontinuity or ruptures. Matisse's text is seen through the perceptive lens of semiotic discourse and, under the headings Dédale, Limite, Window, Sol/v(i)ol, Structure, Réserve, Retour, Volumen/ Table, and Écriture, Bois opens a rich discussion on painting as language and as silence, as fluid or fixed (transparent) sign, and on the "doubleness" of Matisse's assertions about his art. This early article touches on the themes elaborated in all of Bois' later writings on Matisse.

402. Bois, Yve-Alain, "Matisse and 'Arche-drawing.'" In *Painting as Model*, 3-64. Cambridge, London: MIT Press, 1990.

Bois develops the notion of "arche-drawing" (in Derrida's sense of "arche-writing" as that which precedes the hierarchization of speech and writing) as a proportional, relational division of the plane surface in Matisse's work that governs both painting (color) and drawing (line). Matisse discovers this essential pictorial procedure around 1906, when he becomes aware that relationships are all and that quantitative relations of color produce their quality. Bois explores four related consequences of this primary insight: 1) composition is conceived and realized as a whole and initiates the *all-over* principle of surface; 2) the division of the surface is absolutely related to its framing edges; 3) division of surface is the key to internal scale and hence to space; and 4) saturation and value in color result from the proportional modulation of colored surfaces and, in drawing, color and light-emitting qualities are modulated in the untouched areas of paper created by the placement of line. Bois's very dense and passionately argued study is based on a close textual reading of Matisse's "Modernism and Tradition" (1935) and confirmed in his "Testimonial" of 1951. The author also closely traces the historical development of Matisse in the first decade of the century, when what he terms "Matisse's System" was established.

403. Bois, Yve-Alain. "On Matisse: the Blinding." *October* 68 (Spring 1994): 61-121. First published in Fr. in *Henri Matisse, 1905-1917*. Paris: Centre Georges Pompidou, 1993. Exhibition catalogue.

Bois investigates, in this very rich and suggestive study, two aspects of Matisse's composition: its effect on the viewer's act of perception and the implications of the notion of blindness that the act of viewing entails. The author argues that Matisse's compositions have analogies with the effects of seeing a stone dropped in the water (expansion), of a freely flowing circulatory system (circulation), and of a rhythmic pulsation or inflation by respiration (tension). These analogies

are about a discharge or release of tension that the artist transfers to the finished work. This compositional and colorist mode has for the viewer the force of a "big bang," with hypnotizing silence when particles of color like fireworks spread from the center of impact--explosively fast initially, then slowly spreading out from the center. Matisse's expansive space is cosmic, taking in things not seen, behind, near and far, sounds, odors, in a polysensorial way. This manner of viewing entails not centering the gaze, of "blinding" the viewer's absorbed, focused attention in order to achieve a distracted, peripheral, and diffused attention to work that is surface oriented and architectural.

404. Bonmariage, Sylvain. "Henri Matisse et la Peinture Pure." *Cahiers d'art* 1, 9 (1926): 239-40+.

An elegant review of Paul Guillaume's 1926 exhibition of just two Matisse's, *Piano Lesson* (1916) and *Bathers by the River* (1916), in the midst of the early Nice period. The author recalls a remark made by Matisse about "pure technique" in 1909 before a cubist painting by Picasso, predicting that all advanced painters were moving in that direction. In these 1916 works, Bonmariage concludes, Matisse had arrived there--at the austerity, reductionism, and simplicity that Mallarmé had achieved in poetry; difficult, intellectual, but with the richness of a good burgundy wine, not a dry champagne. A recently published version of Georges Duthuit's opening-reception talk suggests that a third canvas, *Lilac Branch,* was also on display; see no. 77.

405. Bouvier, Marguette. "Henri Matisse chez lui." *Labyrinthe* 1 (October 5, 1944): 1-3.

A look over Matisse's shoulder as he gives drawing "lessons" to a young artist who "fell from the skies." The *maître's* remarks are significant to his own practice: exaggerate the essential forms, he advises his pupil, study the negative spaces *("les vides"),* and position curves in relation to an understood vertical-horizontal structure.

406. Brandi, Cesare. "Matisse nel nostro tempo." *La Biennale di Venezia* 26 (December 1955): 25-27.

Traces Matisse's major contribution to the art "of our times," that is, the reduction of Matisse's color, line, and form in order to render it functional rather than merely descriptive; in this, while building on Post-Impressionism, he remains under the rubric of the truly revolutionary.

407. Branzi, Silvio. "Gli inizi di Matisse." *La Biennale di Venezia* 26 (December 1955): 14-18.

A retelling of Matisse's early years until 1904; no new research.

408. Brassaï, Gyula H. "Conversation with Marguerite Duthuit-Matisse." In *Picasso and Company*, 251-57, and passim. New York: Doubleday, 1967. Translated by Francis Price from the French, *Picasso & Cie*. Paris: 1967.

An interview with Matisse's daughter in 1960 that is full of interesting memories and anecdotes is contained in a book mainly on Picasso. The Spanish painter and his friends, e.g. Kahnweiler, have fascinating asides to make on Matisse throughout the text.

409. Brassaï, Gyula H. "Henri Matisse." In *The Artists of My Life*, 124-139. Translated by Richard Miller from the French, *Les Artistes de ma vie* (Paris: 1982). London: Thames and Hudson; New York: Studio, Viking, 1982.

Valuable reminiscences of Matisse in Nice around 1931 by the photographer who was again "summoned" by the painter for a series of photographs just before the war, in 1939, in Paris, and in 1946 in Vence. These photographs interleave several pages of astute observations and recalled conversations.

410. Brezianu, Barbu, "Matisse et Pallady, leur amitié et leurs rélations artistiques." In *Actes du XXe Congrès International d'histoire de l'art (1969)*, 431-48. Vol. II. Budapest, 1972. Letters also published in *Secolul* 20, 6 (1965) in Romanian.

Essay on the long and intimate relationship between Matisse and Theodore Pallady, the Romanian artist who had studied alongside Matisse in the early years of the century. The essay is followed by fragments of the Matisse-Pallady correspondance, some two dozen letters. Although most are from Pallady to Matisse, an important letter from Matisse (December 7, 1940) describing his works in progress, is given in full.

411. Bryson, Norman. "Signs of the Good Life." *Times Lit. Supp.* (March 27, 1987): 328.

A book review of Jack Flam's *Matisse: the Man and His Art, 1869-1918* that asserts Matisse's work as "deposed and minor" because it is finally simply too decorative and hedonistic to qualify as significantly contributing to the twentieth-century avant-garde. Bryson rehearses the traditional reasons for his judgment, citing T. J. Clark's recent *The Painting of Modern Life* to support the condemnation of subjects of leisure and pleasure as escapist. The author confesses to being intrigued by Flam's alleged thesis that Matisse's use of color, pattern, and reduced forms is in the service of intentionality and feeling. But the artist's preference for unity, calm, and delight ends, for Bryson, in work that is "becalmed and enchanted," slightly "bovine." Finally, Matisse does not show us the modern world--broken, fragmented, conflicted, and dissonant-- through a modern consciousness, as Cubism does; hence, Bryson continues to find Matisse's work fundamentally deficient and marginal.

412. Buchanan, Donald W. "Interview in Montparnasse." *Canadian Art* 8, 2 (Christmas 1950-51): 61-65.

The author, who had interviewed Matisse fifteen years earlier when researching a book on James Wilson Morrice, is received by Matisse at his apartment on the Blvd. Montparnasse. Having seen the chapel recently, as well as the large exhibition at the Maison de la Pensée Française, Buchanan examines work for the still-in-progress chapel and discusses with

Matisse in particular the base of the roof spire which the artist
intends to enlarge.

413. Buettner, Stephen. "The 'Mirrored Interiors' of Henri Matisse."
 Apollo 117 (February 1983): 126-29.

Buettner traces the motif of mirrored interiors, often the artist's
studio, from seventeenth century Dutch usage to its revival in
the nineteenth century by Ingres, Manet, and Degas. Matisse's
use of the ensemble of mirror, window, and door motifs is
examined in a series of the artist's works from 1896 to 1928.
Matisse's themes are explicated by way of traditional meanings
as well as from his specific usages of them in particular
paintings.

414. Burger, Fritz, "Probleme der Mystik in der Kunst von
 Matisse." In *Cézanne und Hodler.* Monaco, 1913; Munich:
 Delphin-Verlag, 1923.

Matisse is included with Hodler, Kandinsky, and others who
seek the infinite, or formless, by means of figuring endless
space. In works like Matisse's *Music,* for example, the
undifferentiated background bespeaks a concern for infinite
space, a site that is not confined by conventional dimensions.

415. Burgess, Gelett. "The Wild Men of Paris." *Architectural
 Record* 27, 5 (May 1910): 400-414. Flam, no. 88, 119-20.

Probably written in November or December 1908, while
Burgess was visiting the studios of young avant-garde painters,
including Picasso, Braque, Derain, Friesz, and Herbin, among
others. Burgess emphasizes Matisse's serious character as an
experimenter seeking expression, someone whose innovations
have inspired madcap variations and misreadings by his
"disciples" (all the other artists visited). Matisse, the older
master, retains a vitality and originality his epigones might
envy. Burgess, whose French was rudimentary, seems to
misquote or misunderstand Matisse in a number of instances.

416. Bussy, Jane Simone. "A Great Man." *Burlington Mag.* 128,
 995 (February 1986): 80-85. Flam, no. 88, 320-24.

An irreverent memoir on Matisse, originally delivered to the Bloomsbury "Memoir Club" in 1947 by the daughter of Matisse's painter friend Simon Bussy and his novelist wife, Dorothy Strachey. Insightful and rather malicious, the author's childhood memories encompass the 1930s, a period personally and professionally eventful, even stressful, for Matisse. Bussy's tart portrait of the mature artist is one of the most intimate that we have of the artist, free as it is of either idolatry or promotion, of indebtedness or self-interest.

417. Cabanne, Pierre. "Mourlot." *Connaissance arts* 278 (April 1975): 49-55.

An account of the printers, Mourlot frères, used by Picasso, Braque, Matisse, and others, richly illustrated with examples of their work; telling anecdote on Matisse's manner of working with the craftsman.

418. *Cahiers d'art* 6, 5-6. Special issue, 1931; English ed. New York: E. Weyhe, with additional plates. Articles by Karel Asplund, Roger Fry, Paul Fierens, Curt Glaser, Will Grohmann, Pierre Guéguen, Henry McBride, Georges Salles, and Christian Zervos are listed individually by author's name.

419. Cantù, Arnaldo. "Henri Matisse." *Critica d'arte* 51, 8 (January-March 1986): 65-74.

Reprint of a 1913 review article on Matisse on the occasion of the first Roman "Secession" exhibition, by Arnaldo Cantù (1885-1915), an early twentieth-century Italian critic. It appeared originally in *Vita d'arte*, 1913. Afterword by C.L. Ragghianti, who gives the context for the original and information on Cantù.

420. Carco, Francis. "Les Fauves.--M. Henri Matisse.--Importance de la figure nue dans son oeuvre." In *Le Nu dans la peinture moderne,* 64-68. Paris: Éditions Crès, 1924. Text written in 1921.

Author claims Matisse owes the very unity of his work to the genre of the studio nude. His work's unity is not to be found

in his temperament, which is restless and changeable, but in his flexibility, his mastery of drawing, and his color sense. Carco discusses *Blue Nude, Italian Girl, The Coiffure, Music,* and *Torso of a Young Girl* of 1918. A *Seated Odalisque* of 1923 is illustrated.

421. Carco, Francis. "Conversation avec Matisse." In *L'Ami des peintres*, 219-38. Paris: NRF, Gallimard, 1953. Originally published in *Die Kunst-Zeitung* [Zürich], 8 (August 1943). Flam, no. 28, 132-41.

This interview, supposedly given in 1941 although there is no mention of Matisse's near-fatal operation of the previous year, is precious testimony of Matisse's state of mind and production during the occupation years. It is full of anecdotes of his early days but accompanied by serious reflections on his current work

422. Carrier, David. "Matisse: The End of Classical Art History and the Fictions of Early Modernism." In *Principles of Art History Writing*, 219-36. University Park, Penn.: Pennsylvania State University Press, 1991.

Carrier, in the overall context of the thesis of his book *Principles of Art History Writing*, which is an emplotment of the implicit rules governing art history writing, takes up Matisse's practice of portraying, in one image, the triad of artist-image-model. (See, especially, Matisse's line drawings of 1936.) Carrier claims that in these works the presentness, the ongoingness, of the act of making the image, which leaves no room for the spectator, correlates with postmodern art historians' critical awareness of the relative, fictional, and self-authorial nature of their art historical interpretations. The author discusses Matisse's self-conscious images in relation to Lacan's and Foucault's theories, insofar as critical self-awareness of the fictitiousness of the plane of representation is an element common to them as post-humanist thinkers.

423. Carter, Malcolm N. "What do Museum Directors and Curators Go To See in New York?" *Art News* 75, 9 (November 1976): 79-82.

Among the favorites are Rembrandt's *Self Portrait* (Frick Collection) and Matisse's *Piano Lesson* (Museum of Modern Art).

424. Cassou, Jean. "La Pensée de Matisse." In *Exhibition of Paintings by Picasso and Matisse.* London: Victoria and Albert Museum, 1945. Exhibition catalogue. Reprinted in French in *Art présent* 2 (1947): 30-34.

Cassou, praising Matisse's active "French" intellect, notes his recent development of symbols or signs--"plastic, elliptic, synthetic and well-balanced"--a deliberate simplification that, neither abstract or schematic, loses nothing of sensuality or intensity. He works in the tradition of Mallarmé who transforms the exterior world into images, arrangements, signs, and equivalences.

425. Cassou, Jean. "La Méthode de Matisse." In *Mélanges offerts à Etienne Souriau,* 39-47. Paris: Nizet, 1952.

Drawing on Quatremère de Quincy's rhetorical figures--hyperbole, ellipsis, metaphor, equivalents, and syncope--by which he characterizes the classical, idealist artist, Cassou applies them to Matisse. They constitute his intellectual "method" for generalizing and epitomizing forms derived from nature but become totally the fruit of his mental processes. Essentially a designer, in the broadest sense, he also designs (emplots) his colors so that, with drawing, they assume the force of volume and expression. The article seems directed against expressionist abstraction, as it places Matisse's distortions under the intellectual device of hyperbole and denies that his perceptions or forms are "bathed in" any cosmic or inchoate field of elementary chaos. A very penetrating discussion of Matisse's intellectual working-process, marred only at the end by reference to an essentialized "Eternal Feminine" and an archetypal "Painter."

426. Cassou, Jean. "Henri Matisse." In *Rétrospective Henri Matisse*. Paris: Musée National d'Art Moderne, 1956. Exhibition catalogue.

Cassou presents Matisse as an intellectual, a Cartesian, whose mental self-awareness precedes and informs every act of artmaking. Like a philosopher he proceeds by purgation, reduction, simplification but is able to bring forth from this process plenitude, totality, and joy. In this important essay from the first French retrospective after the artist's death, Cassou identifies Matisse's oeuvre as one of light and enlightenment, the honor of French genius.

427. Cassou, Jean. "Le Peintre de la justesse." In *XXe Siècle. Hommage à Henri Matisse*, 6-8. Paris: Cahiers d'art, 1979.

Using four works: *Nature Morte sur table de marbre (La diapason)* (1941), *Le Peintre et son modèle* (1916), *Poissons rouge* (1911), and the drawings of Maria Alcaforado (1946), Cassou illustrates that Matisse embodies a single idea in each of these works--harmony, distance, transparency, countenance-- performing an intellectual work of making distinctions, of distillation. Once become precise and single, the idea is made to expand or reverberate throughout the whole work like an errant reverie. This is, according to Cassou, Matisse's two-step process of intellection while creating a work or art.

428. Cauman, John. "Henri Matisse's Letters to Walter Pach." *Archives of American Art Journal* 31, 3 (1991): 2-14.

A commentary on the twelve-year correspondence between Matisse and the American painter-art writer Walter Pach, with the eight letters from Matisse fully cited in translation. The two met in Italy in 1907 through Gertrude and Leo Stein; their correspondence began in 1912 in connection with the Armory Show (for which Pach was adminstrator, publicist, and lecturer), continued during World War I, when Pach acted as a promoter of Matisse's work and as a go-between in dealing pictures, but faded after 1924. The relationship with Pach is instructive for personal insights on the artist and for the spread of Matisse's reputation in the U. S. from 1912-24.

429. Charlot, Jean. "Pinning Butterflies." *Creative Arts* 12, 5
 (May 1933): 354-59.

An extended review of Albert Barnes's book, *The Art of
Matisse*, critical of the book's methodology, its "scientific"
approach. The concentration on purely physical, formal
aspects of the paintings unduly slights the content and the
spiritual impact of the work on the viewer. The emphasis on
"sources," Charlot maintains, neglects Matisse's relation to
nature and direct observation of the motif; Barnes emphasis on
Matisse's "flat" colors underestimates the painter's ability to
create plastic space, not just a two-dimensional surface.

430. Charensol, Georges. "Le Salon des Tuileries." *Amour de l'art*
 6 (June 1926): 204-12.

Exhibition review that features a reproduction of Matisse's
Decorative Nude on an Ornamental Ground (1925-6), noting
that it is one of the two works at the Salon that will be
considered eminent in the oeuvres of their makers (the other
being Chagall's *Double Portrait with Wineglass* of 1917-18).
Charensol notes that this work marks Matisse's "launching
himself once more in new adventures."

431. Chastel, André. "Le visible et l'occulte, Matisse et Klee."
 Medécin de France 61 (1955): 41-42.

An evocative short text that suggests that the two artists used
the visible world--they remained figurative artists--to render the
invisible and to effect "magical" changes in matter. Both
artists transfigured the visible world in their works in order to
effect a spiritual metamorphosis in the viewer.

432. Chevrier, Jean-François. "Matisse et la photo." In *Matisse
 Photgraphies*, 8-18. Cahiers Henri Matisse, 2. Nice: Musée
 des Beaux-Arts, Jules Cheret, 1986. Exhibition catalogue.

A very astute essay on Matisse and photography by a
specialist in the history of the medium. Chevrier places
Matisse's photos and statements on photography in the
context of nineteenth-century photographic practice and

discourse; he relates them to postcards, souvenir images, and professional documentary photography of the time. A very valuable essay in a catalogue richly illustrated with photos of and by Matisse.

433. Chu, Petra Ten-Doesschate. "Unsuspected Pleasures in Artists' Letters." *Apollo* 104, 176 (October 1976): 298-305.

Drawing from the collection of artists' autographs in the Fondation Custodia, founded by Frits Lugt, the author discusses and illustrates the evidence of artists' handwriting and drawings in their letters. Only one letter from Matisse is discussed, to an unnamed patron, for whom the artist sketches a possible canvas for purchase. Unidentified, it appears to be a head of Lorette, his Italian model of 1915-17. Matisse shrewdly intimates that he has refused the painting to other potential collectors [as he would gladly keep such an excellent work for himself] and that the [relatively modest] price is somehow tailored to this buyer. A delightful, informative article, if only peripherally about Matisse.

434. Clair, Jean. "La Tentation de l'Orient." *Nouvelle rev. française* 211 (July 1970): 65-71.

The author contrasts Bonnard's use of the mirror in his interior scenes to Matisse's use of the painting-within-a-painting motif in his oils, as emblematic of painting's relation to the real world. The mirror is metaphoric, Occidental, reflective of the world, mediating the world of the sensible with that of the intelligible. The painting-within-the-painting reflects nothing but itself; it is metonymic, Oriental, self-reflexive, and autonomous. Matisse's canvases are physical realities in real space, leading--like Eastern works--to experience rather than speculation, that is, to sensuous enjoyment, decoration, abstraction. Bonnard makes the painting a window, the end of a tradition; Matisse makes a painting of a depicted window the beginning of the new tradition of Rothko and Newman's color field canvases. A neatly-turned exposition that also deals with color and scale in the works of both painters' approaches.

435. Cocteau, Jean. "Déformation professionelle." In *Le Rappel à l'ordre*. Paris: Librairie Stock, 1926. First published, May 12, 1919. Flam, no. 88, 174-75.

The author laments the loss of Matisse the "discoverer," the "delightful genius" of yore. In his place is one who "doubts, gropes, and hesitates instead of deepening his discovery," one whose current work is without underlying discipline or the "hidden geometrics of Cézanne."

436. Cocteau, Jean, "Matisse et Picasso." *Habitat* 73 (September 1963): 58-60. First published in French in *Le Matin* [Anvers], May 16, 1963.

A brief note that resists opposing the two artists, seeing them rather as partners in the adventure of modern painting. In Portuguese.

437. Codognato, Attilio. "La Serenità come Metafora." In *Henri Matisse, Matisse et l'Italia,* 33-35. Milan: Mondadori, 1987, Exhibition catalogue.

A brief but perceptive meditation on Matisse's use of calm and harmony as a metaphor for intense, existential involvement with life and authentic existence. The painter's very awareness of the discordance and tragedy in human life caused him to struggle to project their opposite.

438. Coellen, Ludwig. [On Matisse]. In *Die Romantik der neuen Malerei*. Munich: E. W. Bonsells, 1912; Flam, no. 88, 131.

A close and perceptive analysis of the dual goals of Matisse's color-forms and Picasso's space-forms, both serving symbolist expression through reliance on the perception of material reality in order to penetrate the "objective sphere of feeling."

439. Cogniat, Raymond. "Henri Matisse." *Goya* 7 (July-August 1955): 28-35.

A straightforward review-summary of Matisse's life, artistic development, and contributions to modern art, published shortly after the artist's death. The essay touches on all media

and portrays Matisse as a great French classical artist, whose
sensibility always served his reason.

440. Cooper, Douglas. "Matisse und Gauguin." In *Matisse, Das
 Goldene Zeitalter*, 91-94. Bielefeld: Bielefeld Kunsthalle,
 1981. Exhibition catalogue.

Cooper reviews the early interest of Matisse in Gauguin (c.
1899 when he acquired Gauguin's *Head of a Young Tahitian
Man)* and his greater readiness for Gauguin's example at the
retrospectives of 1903 and 1906. The last-named exhibition,
with its range of the Gauguin ceramics, sculpture, watercolors,
sketches, lithographs, and woodcuts, had immediate impact on
Matisse's work. The author points to the importance of the
simultaneous influences Cézanne and Gauguin around 1905.
The latter helped Matisse move from impressionist-based
realism to "abstraction" from nature and to the decorative.
Matisse also surrendered to the charm of Gauguin's view of a
life without the constraint of civilization as paradise, the
seduction of the exotic.

441. Coquiot, Gustave. "Matisse." In *Cubistes, Futuristes, et
 Passéistes.* Paris: Ollendorf, 1914; enlarged and revised edition,
 1923.

The author, who has followed Matisse's work since 1901,
emphasizes his role as an intellectual, an experimenter, a
theoretical artist incapable of settling into the formulaic. He
claims that Matisse was able to cite "Kant, Spinoza,
Nietzsche, Maudsley, Chevreul et les Mages" in explaining his
art. Coquiot's addendum in the later (1923) edition of the
book laments the artist's loss of the spirit of inquiry in the
settled charm of the early Nice works.

442. "La Côte: Derain et Matisse." *L'Oeil* 1 (January 1955): 40-41.

A well-documented comparison of the relative prices
commanded by works of Matisse and those of Derain, during
their lifetimes and until recent auctions. The gulf between
them widens, with Matisse's prices consistently higher.

443. Cork, Richard. "A Postmortem on Post-Impressionism." *Art in America* 68, 8 (October 1980): 83-95, 149-53.

On the occasion of the Royal Academy's revisionist *Post-Impressionism* exhibition, the author traces the origins of the definition of the "modern" or "post-impressionist" to Roger Fry's emphasis on abstract form, beginning with his 1910 exhibition *Manet and the Post-Impressionists* in London. Using Matisse's *Young Sailor I* (1906) as an example, Cork analyses Fry's arbitrary foregrounding of non-realistic form over the very vivid subject-matter of an adolescent fisherman and the accessiblity of the canvas's color and touch to viewer engagement. An extended revisionist discussion of the "modern" project.

444. Coulonges, Henri. "Matisse et le paradis." *Connaissance arts* 214 (December 1969): 114-21.

The author groups Matisse with two other sober, intelligent, professorial-looking artists who "veritably invented" modern art: Kandinsky and Mondrian, all three deeply reflective enough to make their own practice the subject of their contemplation and writings. Matisse is the painter of joy, not merely happiness, characterized by an inner harmony and resultant calm, transformations produced by his color and arabesques.

445. Courthion, Pierre. "Le Peintre et son modèle." *Labyrinthe* 8, (May 15, 1945): 6-7.

A visit to Matisse 1939, while the latter in a white smock worked from the model in Mary Callery's studio, causes the author to speculate on Matisse as a doctor, as someone who imposes on his models a kind of death, as he devours them, drains them, absorbs their individuality into his own. Courthion plays with notions of Narcissism, angelism or demonism, Greek severity or archaism, perhaps inspired by Brassai's photos of the sessions which accompany the article.

446. Courthion, Pierre. "Bonnard and Matisse." In *Bonnard, peintre du merveilleux*. Lausanne: Marguerat, 1945.

Author opposes the trembling, insecure hesitancy of Bonnard's signature to the willed order and sureness of Matisse's hand. Analogously, Bonnard is an intuitive, emotive artist of the concrete, a somewhat disorderly searcher; Matisse is consciously rational, abstract, an orderly arranger who constructs in a methodical manner.

447. Courthion, Pierre. "Matisse et la Danse." In *XXe Siècle. Hommage à Henri Matisse*, 44-47. Paris: Cahiers d'art, 1970.

A short reflection on Matisse's fascination with the "whirling and leaping" movement he so often portrayed in the theme of the dance. Courthion suggests a cosmic meaning of universal rhythm which Matisse derived from Eastern, rather than Western, sources.

448. Courthion, Pierre. "La Conquête de la Lumière." In *XXe Siècle. Hommage à Henri Matisse*, 51-55, 62. Paris: Cahiers d'Art, 1970.

Author summarizes the importance of light for Matisse in every stage of his career and of his light always being associated with his use of color. Courthion posits a kind of symbolist significance for the transparent, mysterious world that light makes palpable. Long citations of Matisse's description of light in Tahiti.

449. Cowart, Jack. "Je sens le bois dans les îles: Matisse et Vence." *Art Int.* 22, 6 (October 1978): 24-27.

Cowart identifies the place, Vence, where Matisse retired from the threat of invasion in 1943 and remained for six years, as the site of the "Vence Period," wherein the artist was rejuvenated in the memory of Tahiti and in the exploration of the new techniques of decoupage. *Jazz* was the first fruit of this freshness and depth; Cowart masterfully groups other work of the period in a comprehensible unfolding. Even the paintings of this final period are brought into the analysis of these years as a coherent "period" of experimentation and discovery. An important essay.

450. Cowart, Jack. "A Place of Silvered Light: An Expanded, Illustrated Chronology of Matisse in the South of France, 1916-1932." In *Henri Matisse, the Early Years at Nice*, 14-45. Washington, D.C.: National Gallery of Art, 1986, no. 69.

Richly illustrated, detailed chronology of the artist's life from 1916-1932; an invaluable account with previously unpublished details and corrections of errors in the earlier literature. Invaluable reconstructions of the artist's two Nice apartments at 1, rue Charles-Félix.

451. Craven, Thomas. "Modernism." In *Men of Art*, 498-99. New York: Simon & Schuster, 1931.

Craven, in this brief criticism of Matisse, credits the latter with creating an original style of art by "transferring the ingredients of genre-painting to the field of decoration." Nevertheless, according to Craven, Matisse is "essentially a light talent" with a "faint imagination" whose "taste and tact" must substitute for vigor and knowledge.

452. Craven, Thomas. "Matisse." In *Modern Art, the Men, the Movements, the Meaning*, 143-76. New York: Simon & Schuster, 1935.

An ad hominem attack on Matisse, consistent with the thesis of the entire book that credits the basest commercial motives to the artist's manner of working, his evolving styles, his choice of subjects, and lack of significant content. Matisse is judged to have a dressmaker's or milliner's talent for color and for surface patterning; he permits himself distortions for the sake of formal arrangements but modifies them to remain acceptable to bourgeois tastes. Matisse's main failing, for Craven, is that he has separated art from life, rendering it irrelevent to the larger social realities of the day.

453. Craven, Thomas. "Challenging Matisse." *Art Digest* 7 (March 15, 1933): 1.

A summary of Craven's article on Matisse in the *New York Herald Tribune* that attacks Albert Barnes' monograph on

Matisse for its purely formal approach but allows that Matisse is the perfect subject for such a treatment as he is nothing more than decorative and bland in content.

454. Curtis, John. "The Art *De Luxe* of Henri Matisse." *Studio* 44 (November 1952): 129-35.

A critique of Alfred H. Barr, Jr.'s *Matisse: His Art and His Public* which faults Barr for not drawing the conclusions of his research, for example, the nature of Fauvism's achievement, Matisse's decorative style, the ultimate quality and importance of the Vence chapel and the paper cut-outs. Curtis finds the late works wanting in emotional power, manifesting a fundamental limitation in Matisse's approach to art as a "happy refuge."

455. Dagan, Philippe. "L'Exemple egyptien: Matisse, Derain et Picasso entre fauvisme et cubisme (1905-1908)." *Bull. de la Societé de l'histoire de l'art français* (1984): 289-302.

The author examines the effect of the "Egyptomania" of the early years of the century on the "primitivizing" work of Matisse, Derain, and Picasso from 1905 to 1908. He sees the admiration for Egyptian forms of simplication as a preparation for and prefiguration of the appreciation of African sculpture. Matisse archaicized female heads of c. 1907 and the *Standing Nude, Young Girl* (1906) are singled out for analysis as well as the simplifications of certain painted portraits of family members executed between 1906 and 1913.

456. Daix, Pierre. "Matisse." *Connaissance arts* 492 (February 1993): 24-33.

On the occasion of the *Matisse, 1904-1917* exhibition at the Centre Pompidou in February of 1993, the Picasso scholar Pierre Daix summarizes the achievements of Matisse from 1907 through the 1920s. Especially interesting for its close tracing of the development of Matisse in relation to Picasso's changes of style, the article notes two instances where the contact is significant: in 1913 where Picasso reintroduced color and Matisse reintroduced a more rigourous compositional

structure, and in 1916 where both men reverted to a certain realism with the arrival of new models, Lorette and Olga. Without "returning to order" in the 1920s in a reactionary way, both men preferred to create images of serenity rather than expressionist laments about war-engendered tragedies.

457. Danto, Arthur C. "Memo to Bill--I: Why Not Be the Arts President?" *The Nation* 256, 4 (February 1, 1993): 116-17; with response: "Matisse or Mapplethorpe: Does It Make Any Difference?" *New Criterion* 11 (March 1993): 1-3.

In the issue's series of "Memos to Bill [Clinton]" as to where the president ought to be leading the country, Danto suggests-- using the *Matisse Retrospective* as a point of departure--that Clinton become the Arts President by restoring funding to NEA. He stresses the importance of the art experience for spiritually enriching human life, and includes Mapplethorpe's work as part of that experience, even though it offers other values than that of Matisse's art. In his reply, the editor of *New Criterion* faults Danto for equating the two artists, smoothing over critical esthetic and political differences between their works, and in general ignoring the criteria for "art" that Danto himself has forged in his own previous writings.

458. Däubler, Theodor. "Matisse." In *Der Neue Standpunkt*, 91-100. Dresden: Wolfgang Jess Verlag, 1916. Reprinted in Leipzig: Insel-Verlag, 1919, 108-120.

Däubler insightfully describes the independent status of the color-stroke in modern painting: an absolute, unconditional mark that creates composition, rhythm, space. He compares it to a sentence, complete in itself, standing alone, as in modern poetry. He speaks of the artist's will to style: the absolute search to become the thing-in-itself. The author makes a lengthy survey of the way in which color has become independent, beginning with Etruscan tombs, through Raphael's frescoes, Titian, Tiepolo, Veronese--a long historico-poetic digression. He concludes with the childlike freshness of Matisse's color, its naturalness despite its

intellectual base. Notes Moll and Purrmann as those who best understand the artist's aims; predicts Matisse's long-lasting influence in the future.

459. De Baranano, K. M. "Matisse e Iturrino." *Goya* 205-6 (July-October 1988): 94-98.

Traces the Basque painter Francisco de Iturrino's friendship with Matisse from their days in the Moreau atelier up until the Spaniard's death in 1924. Compares two canvases painted in 1911 in Seville from the same motif: Matisse's *Spanish Still Life* and Iturrino's *Seville Interior*. Also treats their mutual friends, Elie Faure, J. W. Morrice, Henri Evenepoel, and Derain.

460. de Bissy, C. "Femme-fenêtre: une alliance picturale." *Rev. esthétique* 1-2 (1980): 375-80.

Author discusses the significance of placing a female figure or character in relation to a window, whether in paintings such as Matisse's or in novels such as Flaubert's *Madame Bovary*. Although the window can signify a barrier, or a device through which the woman may become the object of a stranger's gaze, it is also a means of the woman's gaining visual purchase on the world beyond her domestic one and, hence, information, insight, reciprocity.

461. Degand, Léon. "Matisse à Paris." *Les Lettres françaises* 76 (October 6, 1945): 1, 4. Flam, no. 28, 159-64; Fourcade, no. 29, 299-309; both extracts.

A very important interview with the artist immediately after the war when Matisse was in Paris for the Autumn Salon in which his wartime work was featured. Degand offers Matisse the opportunity to answer his critics on issues of spontaneity, sincerity, emotion, decorativeness, Frenchness, the human element in art, his contemporaries, and other current esthetic topics.

462. Degand, Léon. "Pour une Révision des valeurs: Matisse, un génie?" *Art d'aujourd'hui* 2, 10 (November 1956): 28-31.

A negative critique of Matisse's lifetime achievement, on the occasion of the artist's 1956 posthumous Paris retrospective. Degand, editor of *Art d'aujourd'hui* and proponent of a hard-edged abstraction, deplores the failure of Matisse to develop, after 1918, the integration of autonomous form with that of autonomous color which the painter helped to propagate (but did not originate) around 1905. He dismisses thirty years of culpably "prudent" work from 1918 to 1947, the year of the publication of *Jazz*, and approves the cut-paper work as the too-long-delayed fruit of the 1911-17 experiments. An important French critical essay of the mid-fifties, enmeshed in the debates between Soviet realism and abstraction.

463. Denis, Maurice. "Salon d'Automne: Painting." *L'Hermitage* (November 15, 1905). Flam, no. 88, 47-50.

Denis' famous criticism of Matisse's work of 1905, in which he warns the artist to give in neither to the "spirit of systems" nor to the tendency toward "painting in itself, the pure act of painting." Reprinted as "De Gauguin, de Whistler, et de l'excès de théories" in *Theories 1890-1910. Du symbolisme et de Gauguin vers un nouvel ordre classique*, 199-210. Paris: Rouart et Watelin, 1920; first ed. 1912. A very perceptive and widely quoted statement of early criticism.

464. Denvir, Bernard. "La Dolce Vita." *Art and Artists* 13, 4 (August 1978): 12-17.

An extended, illustrated review of two exhibits (Marlborough and Lumley Cazalet Galleries) currently on view in London, the article acknowledges the bourgeois nature of Matisse's work, that is, "sense of radiant self-indulgence in the beauty of material things [seen as a] reward for economic achievements." Yet Denvir sensitively analyzes several works which indicate the tension, complexity, and sense of the "uncanny" in many of the most seemingly serene paintings and drawings.

465. De Peslöuan, C. "Matisse Photographe [Narrative by Lisette Clarnète]." *Madame Figaro* (November 25, 1989): 38-42.

An interview (told in the first person, as by Clarnète) of Lisette Clarnète, Matisse's favored model from 1928-1933. Clarnète was a sometime nurse to Mme Matisse who also worked as Matisse's studio assistant on *Dance I,* the newly discovered first study for the Barnes Mural. Ms. Clarnète posed for important works such as *The Yellow Robe* (1929-1931) and gives an intimate description of Matisse's somewhat obsessive behavior with regard to her appearance and costumes. An important testimony to Matisse's relations with his models; important documentary photos accompany the article.

466. De Stefani, Alessandro. "Matisse e il cubismo: per una nuova datazione del *Grand Nu* de Braque [Matisse and cubism: towards a new dating of Braque's *Grand Nu].*" *Paragone* 39, 457 (March 1988): 35-61.

Suggests that Braque's *Large Nude* was painted in 1908 rather than 1907, based on a writing by Matisse. The latter's importance for Cubism argued.

467. Desvallières, Georges. "Preface to [Matisse's] 'Notes of a Painter.'" *La Grand revue* (December 25, 1908). Flam, no.88, 75-76.

A sympathetic introduction to Matisse's important statement of 1908; the term "expressive decoration" is used to describe Matisse's procedure which results in what seems to be gratuitous distortion of the figure. See Roger Benjamin's *Matisse's "Notes of a Painter," Criticism, Theory, and Context, 1891-1908* (1987), no. 55, for a complete analysis of this preface.

468. Diehl, Gaston. "A la recherche d'un art mural: Matisse." *Paris, les arts, les lettres* 20 (April 19, 1946).

A short article in which Diehl notes that attention to the surface and to the compositional rhythm as a whole--proper to mural painting--has always been characteristic even of Matisse's easel painting. Contains extensive quotes by Matisse on how he conceived and carried out his mural for the

Barnes Foundation. The material is essentially contained in Diehl's monograph on Matisse of 1954, no. 73.

469. Diehl, Gaston. "Henri Matisse le méditerranéen nous dit. . . ." *Comoedia* (February 7, 1942): 1, 6.

A brief article on Matisse occasioned by his 1941 exhibition of drawings at the Louis Carré Gallery in Paris. The voluptuous and exotic, yet orderly and disciplined, ambience of Matisse's living quarters at the Hôtel Régina is evoked, along with the incessant warbling of the artist's tropical birds. The author finds this essentially "mediterranean." Matisse is cited on his drawing methods and goals, and he also expresses the desire to work again on a mural scale.

470. Diehl, Gaston. "Avec Matisse le classique." *Comoedia* 3, 102 (June 12, 1943): 6.

A visit to Matisse in his "royal solitude" at the Hôtel Régina. The artist speaks of his purchase of Cézanne's *Bathers* from Vollard around 1899 and of what it meant to him at the time in understanding the role of color and the arabesque.

471. Di Piero, W. S. "Matisse's Broken Circle." *New Criterion* (May 1988): 25-35. Reprinted in *Out of Eden: Essays on Modern Art.* Berkeley and Los Angeles: University of California Press, 1991.

Both a review of the exhibition, *Matisse et l'Italie* (Venice 1987), and a response to Frank Stella's essays in *Working Spaces* (1987), this essay thoughtfully presents the author's own view of Matisse's achievement under a nonhistorical, even formal, argument. The author claims Matisse's effort to unite the contraries of *disegno* and *colorito,* never fully achieved and therefore maintaining a state of unfulfilled desire, constitutes his work's erotic charge as well as its "religious" yearning for unity. A rich, evocative interpretation of Matisse's unfulfilled, yet fulfilling, project.

472. Dittmann, Lorenz. "Anmerkungen zur Farbe bei Matisse." In *Matisse: das Goldene Zeitalter*, 49-64. Bielefeld: Bielefeld Kunsthalle, 1981.

A discussion of Matisse's color through the analysis of eight paintings, from 1910-1947. The author, using many statements by the artist as well as by means of the works themselves, attempts to demonstrate that Matisse, before any other modern painter, was able to create a synthesis out of pure-saturation color and the orchestration of color-surfaces into powerfully expressive harmonies.

473. Dorival, Bernard. "Matisse." *Bull. de la Société des Amis du Musée de Dijon* (1958-60): 69-71.

Author places Matisse's career under the signs of reflection, research, and method, which makes him a quintessentially French artist. Dorival gives a summary of the artist's life (not without factual errors) and development. The cut-outs are passed over; the Chapel at Vence is seen as the artist's culminating masterpiece. The artist's hedonism is translated with reserve, sobriety, economy of means, even asceticism.

474. Dorival, Bernard. "Henri Matisse ou le triomphe de l'intelligence." In *Actes du 22e congrès internationale de l'histoire de l'art*, 43-57. Budapest: Akademiai Kiado, 1972.

Artists dominated by intelligence are often limited by a certain dryness (Valéry) or by a lack of poetry (Gide). In Matisse, Dorival finds an egoism or lack of tenderness for others transferred from the affective plane to the intellectual, where self-love is transformed into passion for his own works. This perceptive article ruminates on several aspects of Matisse's intelligence: his economy of emotion, his reticence, his sobriety, his submission with regard to the laws of his materials and the constraints of scale and purpose--all aspects of a sensuality directed by a lucid consciousness. The Barnes Foundation mural and the chapel at Vence are particularly incisively analysed to illustrate the author's thesis.

475. Dorival, Bernard. "Matisse and Marquet au Musée National d'Art Moderne." *Rev. des arts* 7 (May 1957): 114-20.

Three newly-acquired works are discussed, two reputedly by Matisse (Etude pour le *Nu dans l'Atelier* and *Nu dans l'Atelier*) and one by Marquet of the same title and subject. All are dated early 1905. The Matisse oil, however, has been contested in Cowart (*'Écoliers' to 'Fauves'*, 1972, no. 226); Elderfield (*Fauvism and Its Affinities*, 1976, no. 1176) has suggested that, if it not by Manguin of *Marquet Painting a Nude*, it is of *Manguin Painting a Nude* by Marquet.

476. Duchamp, Marcel. "Matisse and the Physics of Painting," *Yale Literary Magazine* 123 (Fall 1955): 14.

A one-paragraph materialist history of Matisse's stylistic development from 1905 to 1908.

477. Duchein, Paul. "La Région Midi-Pyrénées, source d'inspiration pour les artistes contemporains." *Bull. du Musée d'Ingres* 36 (December 1974): 25-36.

Briefly discusses artists who painted subjects in the region of Toulouse, including Toulouse-Lautrec, Matisse, Redon, Ernst, Magritte, Dufy, and Dali.

478. Duthuit, Georges. "Matisse." *Action* 3 (April 1920): 49-58.

Duthuit's earliest article on Matisse adumbrates all the themes that he would develop in his later writings: the indefinability of art, its instantiation of Bergson's *élan vital*, the role of intuition in experiencing the joy that the art work offers, the creative "completion" of the work by the spectator, the necessity of art to enter one's life as in earlier (i.e., Eastern, Byzantine) cultures, the importance of love for the model to be realized by the artist in the art work, the necessity of purifying and generalizing the individual and sensual inspiration for the work.

479. Duthuit, Georges. "Les Tableaux qui nous entourent ce soir. . . ." In *Georges Duthuit, Écrits sur Matisse.* Paris: École Nationale Supérieure des Beaux-Arts, 1992., no. 77.

An unpublished conference given by the author at the vernissage of an exhibit at Paul Guillaume's gallery on October 8, 1926, in which only *Lilac Branch, The Piano Lesson,* and *Bathers by a River* were shown. Duthuit comments on the problematic of modern art in the mid-20s: its loss of the power to change the culture, to alter people's modes of thinking and acting, to be dangerous. Even those who appreciate modern art seem disappointed finally by what it provides. The best of the new work still causes viewers, if not to approve totally, at least to be unable to appreciate what they had once valued. After the author offers a detailed explication of *Bathers by a River,* he makes a plea for meditating on and discussing art seriously, of placing onself under its influence, of letting it act upon one in its own unique way--its fictions leading to both ecstasy and energetic action.

480. Duthuit, Georges. "Oeuvres récentes de Henri-Matisse." *Cahiers d'art* 1 (1926): 7-8.

This early essay by the artist's son-in-law establishes his esthetic viewpoint, which privileges the moment of viewer response--an increase of vital life through contemplation of the ephemeral transformed (by art) into a moment of real presence. In a style of poetic intensity and play of oppositions, Duthuit relates Matisse's sublimated eroticism to Eastern art, citing a sentence on an Islamic incense-burner: "Within, the fire of the inferno, but without, the suavest aroma."

481. Duthuit, Georges. "Matisse and Byzantine Space." *Transition Forty-Nine* 5 (1949): 20-37.

In response to the post-war call for collective and socially ameliorative art, Duthuit offers Byzantium as an example of an organic society where art was a true product of collective belief and participation, totally integrated with history and the people. He extols, not the isolated esthetic object, but ensembles and environments, in which objects achieve mutual

exaltation and in which participants orchestrate the total experience. Duthuit claims that more than other artists Matisse approximates the integral, non-egoistic unity of space and light one finds in, for example, St. Mark's Cathedral in Venice. Matisse creates a material, all-dimensional space that expresses "the unity of beings and of the light in which they move."

482. Duthuit, Georges. "Preface." In *Matisse*. Knokke-Le Zoute, 1952. Exhibition catalogue.

Duthuit disputes the place of Cubism as the great plastic revolution of our time; it is simply the result of several centuries of classicism, of the reign of abstract intelligence, and of the regulated possession of space by geometry. An art, in short, that leads to the Museum, to the illusion of the unreal, to the suppression of the world in favor of a mental construction of it. Another line of development leads from impressionism to Matisse. The latter does not confront his model but, with the model, achieves a vision that is comparable to the disinterested freshness of mind one has upon waking, before quotidien logic takes over. The model is only the circumstance for the inducement of this state of fluid attention, of availablity, which is then threatened by the actual making of the artwork. Duthuit subtly describes this effort of adequation between the primary sensation and its plastic equivalent which, however, remains open, inviting completion by the spectator.

483. Duthuit, Georges. "Matisse and Courbet." *Ark* 14 (1955): 12-13.

An interview with the artist's son-in-law on the occasion of his visit to the Royal College of Art in March 1955, in which Duthuit speaks of the Chapel at Vence. He also describes Courbet (currently showing in Paris) as a poetic painter--one who can give emotion and luminosity to dull matter and bring out intimate *correspondances* between things.

484. Duthuit, Georges, "Material and Spiritual Worlds of Henri
 Matisse." *Art News* 55 (1956): 22-25.

 Poetic and penetrating essay on the religious nature of
 Matisse's oeuvre on the occasion of the Paris retrospective of
 1956. Duthuit asserts that, like Mozart, Matisse maintains a
 delicate balance between light and dark, the invented and
 described, the imponderable and ponderable, transparency and
 opacity, a balance that provides a "solemn resonance" for the
 viewer-participant that goes beyond esthetic calm, into a sense
 of "the possiblity of harmony with the world." A seminal
 essay that lays out a view of Matisse that is the basis for
 much of Pierre Schneider's subsequent work on the artist.

485. Duthy, Robin. "Matisse: a Twentieth Century Great, Yet
 Still Undervalued." *Connoisseur* 216 (September 1986): 134-
 36.

 Summarizes, from an investor's point of view, the rise of
 Matisse's prices over his lifetime and after. Some extremely
 interesting and surprising statistics are summarized, for
 example, that Matisse's sharpest price rise (500%) was
 between 1960-1975 and that since then his prices have only
 risen another 20%, and that Matisse's work commanded (in
 1986) roughly two-thirds that of Picasso's.

486. Eglinton, Guy. "L'Histoire d'un Fauve." In *Reaching for
 Art,* 37-66. London: Morley and Mitchell; Boston: Kennerley
 and May, 1931.

 A witty and perceptive evaluation of Matisse during the 1920s,
 revealing that the artist never was a revolutionary, a "wild
 one," but rather a painter of the highest quality who initiated
 nothing new, but who "kept the post-impressionist ball a little
 longer in the air." The author offers an interesting perspective
 on Cubism, the lessons of Cézanne, and the fact that all the art
 "revolutions" of the century have "smelt the velvet" of the
 high-priced galleries.

487. Einstein, Carl. "Henri Matisse." In *Die Kunst des 20.
 Jahrhunderts,* 24-32. Berlin: Im Propyläen-Verlag, 1926.

A critical look at Matisse by an apologist for Cubism of the political left. After outlining the crisis in painting bequeathed by Impressionism, Einstein discusses Neo-Impressionism, quoting Signac's *From Eugene Delacroix to Neo-Impressionism*. But he reserves to Van Gogh the role of fathering Fauvism, citing over a page of statements from Van Gogh's letters to demonstrate the affinities between him and the Fauves. Not surprisingly, Einstein ultimately finds fault with Matisse's extreme planarity (poster-like, in his view) and the artist's concern for decorative values rather than those of a "coherent and global representation of space." Also dangerous, for Einstein, is an incipient academicism in Matisse's schematic renderings of figures and objects, where reduction and simplification impoverish rather than enrich the whole. Finally, the author is disappointed with the bourgeois quality of the post-1917 work which carries little of the expressive vitality of color of the Fauve works.

488. Elderfield, John. "Matisse in Morocco, An Interpretive Guide." In *Matisse in Morocco*, 201-239. Washington, D.C. and New York: National Gallery of Art and Harry N. Abrams, 1990. Exhibition catalogue.

Elderfield, drawing on his deep understanding of Matisse's artistic practice and the new documentation on the Moroccan project, takes the reader through the sequential making of the Moroccan works, clearing up problems of dating and sequence. He correlates them to related works and to attitudes about North Africa and travel to foreign lands in general. For the latter the author draws on a range of literary and historical sources. This is a very rich essay, indispensable for understanding how the Moroccan work prepares for the ambitious cubist-like works from 1913-1917 and, paradoxically, for the Nice fantasies of the Orient. Elderfield marks this period as that of a loss of innocence--especially the war years--but not the loss of a reconstructed and mature freshness.

489. Eldridge, Charles. "The Arrival of European Modernism." *Art in America* 61, 4 (July-August 1973): 34-41.

A recounting of the interaction between American artists and French modernism before the famous 1913 Armory Show, with emphasis on the influence of Matisse through his Steiglitz's 291 exhibitions in New York and the sojourns of American artists in Paris, many of whom studied with Matisse.

490. Elliott, Eugene Clinton. "Some Recent Conceptions of Color Theory." *Journal of Aesthetics and Art Criticism* 18 (June 1960): 494-503.

Author discusses "color theory" broadly conceived to include artistic practice as well as theories of painting as a whole. He traces in a summary fashion the color usage of the Impressionists, Neo-Impressionists, Fauves, Cubists, and Orphists (Delaunay). Matisse's and Gris's remarks on color and color practice are treated in greater detail, followed by a section on Kandinsky and the theories of Hilair Hiler. The final analysis is of the work of Hans Hofmann who alone organizes a composition totally by color. Good summary of these artists' views on color.

491. Eluard, Paul. "Le Miroir de Baudelaire." *Minotaure* 1, 1 (1933).

An article on the nineteenth-century poet by a Surrealist; Matisse's portrait of Baudelaire from *Poésies de Stéphane Mallarmé* mentioned in the article. Article is illustrated by a drawing and an engraving by Matisse.

492. Escholier, Raymond. "D'ou vient Matisse?" *Prisme des arts* 4 (1956): 2-4.

In this slight, heavily illustrated, article, Escholier answers his own question by elaborating the influence of Gauguin and Cézanne on Matisse.

493. Escholier, Raymond. "Matisse et le Maroc." *Jardin des arts* 24 (October 1956): 705-12.

In a recirculation of information from his 1956 monograph *Matisse, ce vivant,* Escholier focuses on the work resulting from Matissse's North African trips. Discussing a number of works in some detail, Escholier is the first to concentrate on this period. He confuses the issue somewhat by indicating that Fauvism arose from Matisse's experiences in North Africa in 1906 and again in 1912 and 1913, conflating the two periods. He thus overemphasizes the Moroccan impact so that it can explain the "barbaric" splendor of Matisse's Fauve color from its inception.

494. Esteban, Claude. "Une Limpidité nécessaire." *Nouvelle rev. française* 211 (July 1970): 72-77.

In an epoch famished for images, Matisse's paintings do not provide a simple hedonistic realism. Rather, they evidence a continuity of search conducted with an almost arid intellectual severity. Matisse sought a reconciliation between "palpitation and law"; he refused Cubism as too conceptual, too little savorous of the substance of things. According to Esteban, Matisse regenerates the correspondences between subject and object, finding "intersubjective geometries," and discovering the "divinities immanent in physical things."

495. Faure, Eli. "Opinions." In *Henri Matisse.* Paris: Georges Crès & Cie, 1920. Flam, no. 88, 180-81.

Faure claims that Matisse's development recapitulates that of all true artists: first, a very evident tension in the battle between instinct and intelligence, or between pure emotion and the abstract demands of pure painting; then, a slowly acquired equilibrium between the two in the works of maturity.

496. Faure, Eli. "The Contemporary Genesis." In *L'Art Moderne.* Paris: B. W. Heubsch, 1924. Translated by Walter Pach as *History of Modern Painting.* London: John Lane, The Bodley Head Ltd. and New York: Harper & Brothers, 1924.

An extremely perceptive appreciation of Matisse in the context
of his generation--not the Fauves, but the Nabis. Set off from
Bonnard, Vuillard, and Redon, the decorative Symbolists of the
1890s, Matisse is characterized as more reflective and less
spontaneous than the former, more willful in his formal
invention, less dependent on nature. Faure gives a brilliant
analysis /evocation of Matisse's use of color and says his work
contains the "decorative majesty" of a "grand style" unique to
him because he uses color to evoke the secret meeting at the
frontiers between object and subject. "Music rises from
[Matisse's painting] in absolute silence."

497. Feller, Gerd Udo. "Matisse oder das Angebot der
 Sinnlichkeit." In *Matisse, Das Goldene Zeitalter*, 85-90.
 Bielefeld: Bielefeld Kunsthalle, 1981. Exhibition catalogue.

An extended meditation on the manner in which Matisse's use
of color contributes to the pardisial connotations of his
paintings. That its color breathes, expands, becomes a fluid
environment in which the spectator finds unity and well-being
is central to the author's thesis. He extends this to Matisse's
expansive handling of composition, of line, and of the human
body as subject. He also suggests that color also functions as
a guarantor of the ground of reality, the essence of things, the
unity of being. A subtle and far-ranging treatment of the
artist's use of color.

498. Fels, Florent. "Henri Matisse, 1869." In *L'Art vivant de 1900
 à nos jours*. Geneva: Pierre Cailler, 1950.

A strange patchwork of old interviews and old texts by this
aging critic who is still unable to decide whether art is born of
a temperament or of a "plastic syllogism." He puts Matisse at
the center of every possible vanguard position even when
contradictory, and then claims that Matisse is the greatest of
living painters, in part because his art "varies indefinitely."
Richly and unexpectedly illustrated with infrequently
reproduced drawings of and by Matisse.

499. Fergonzi, Flavio. "Firenze 1910-Venezia 1920: Emilio Cecchi, i Quadri Francesi e le Difficoltà dell'Impressionismo." *Bolletino d'Arte* 79 (May-June 1993): 1-26.

An account of the exhibition history of modern art in Italy from the first show at the Lyceum Club in Florence in 1910 to the Cézanne exhbition in the Venice Biennale in 1920. Emphasis is on the critical reception of these shows, especially that of the poet, essayist and critic, Emilio Cecchi, who wrote for *La voce* and *Il Marzocco*. His own most famous collection of short literary essays, published in 1920, was called--fortuitously, for an admirer of Matisse's painting of the same name shown in Rome in 1913--*Pesci rossi [Goldfish]*.

500. Fermigier, André. "Matisse et son double." *Rev. de l'art* 12 (1977): 100-107.

An important article which, building on Andre Levinson's distinction (1930) between "two Matisse's," discusses the duality of the painter's artistic personality: the "nordic and provincial impressionism" of the early years and its 1920's variant in contrast with the innovative, autonomous, mural-like, iconic works of 1906-1917 and post-1933. In the aftermath of the 1970 Paris retrospective, the author admits that French collectors and critics had been slow to appreciate the Matisse of the most avant-garde, abstract periods, claiming that foreigners appreciated this "other Matisse" and possessed the best works, though unfortunately these were often not available for viewing.

501. Ferrier, Jean-Louis. "1907: 'Immensité intime' et simplication du tableau." In *XXe Siècle. Hommage à Henri Matisse*, 39-42. Paris: Cahiers d'art, 1970.

A thoughtful essay on the simplification and deformations that occurred in Matisse's work around 1907, with sensitive observations but no dominant argument or thesis.

502. Fierens, Paul. "For or Against Henri-Matisse." *Chroniques du jour* (April 1931). Flam, no. 88, 275-76.

Author notes that Matisse's strength is demonstrated to the degree that the young are against his kind of painting. The charge by constructivists, surrealists, abstractionists, etc. is "some lack of humanity, of emotion" in Matisse's work. Fierens observes that Matisse has given enough to the development of painting and remains more free and more true to himself than any modern master.

503. Flam, Jack D. "Matisse in 1911: At the Cross-Roads of Modern Painting." In *Actes du XXIIe congrès international d'histoire de l'art* (1969), 421-30. Vol. 2. Budapest, 1972.

Flam claims that 1911, in spite of the cubist experiments of that year, saw the production by Matisse of the most important works of the period. Matisse's "studio" or "symphonic" paintings of that year, as well as *Goldfish and Sculpture* and *Blue Window,* were to change the artist's concept of pictorial space and have repercussions on later painting in Europe and America. Space is achieved by the structural use of color and by drawing as the delimitation of surface areas. This early essay by Flam on these key works, masterfully analysed, will be enriched and expanded in his later monograph of 1986, no. 89.

504. Flam, Jack D. "Some Observations on Matisse's Self-Portraits." *Arts Mag.* 49 (May 1975): 50-52.

An examination of Matisse's self-portraits--whether by direct self-representations or by surrogate figures or objects in his paintings--for the recurrent themes of alienation, isolation, and anxiety. Paintings used as examples include *Carmelina* (1903), *Music (Sketch)* of 1907, *The Painter's Family* (1911), *Conversation* (1909), *Interior with Violin* (1917-18), *The Artist and His Model* (1919), *Still Life with Phonograph* (1924), and the cut-paper *Sorrows of the King* (1952).

505. Flam, Jack D. "Matisse in Morocco." *Connoisseur* (August 1982): 74-86.

Flam is the first to offer new information on Matisse's trips to Morocco in 1912 and 1913. Retracing the route of the artist's

itinerary, aided by unpublished documentary texts, he details the painter's visits and analyzes both works done in Morocco and those later more abstract works which utilize distilled memories of his trip, *Arab Café* (1913) and *Moroccans* (1916).

506. Flam, Jack. "What Would You Ask Michelangelo? [Art Historians Propose What They Would Ask Their Subjects]." *Art News* 85 (November 1986): 99-100.

Flam would ask Matisse, if he were able, to do a portrait of someone he [Flam] knew well.

507. Flam, Jack. "Image Into Sign." In *Matisse: Image Into Sign,* 5-13. St. Louis: The St. Louis Museum of Art, 1993. Exhibition catalogue.

Using the occasion of a loan exhibition of important works primarily from the 1930s and 1940s, Flam elaborates his theory that Matisse moved from the creation of images to the production of signs. Discussing the prototype work, *Decorative Figure on an Ornamental Ground* (1925-26), Flam really places the advent of the new mode in the post-Barnes Mural work of the 1930s and especially in the paper cut-outs, where, as in poetry, the equivalences take place "in the mind."

508. Flanner, Janet. "King of the Wild Beasts." *The New Yorker* 27 (December 22 and 29, 1951). Reprinted in *Men and Monuments*, 88-133. London: H. Hamilton and New York: Harper Row, 1957. New ed., New York: De Capo Press, 1990, with introduction by Rosamond Bernier.

An immensely readable mini-survey of Matisse's life and career that is written in a zestful journalistic style at once sympathetic, ironic and knowing. Highly accurate in its details and perceptive of the world it views, this essay by Flanner, longtime reporter for *The New Yorker* under the pen name Gênet, has the intimacy of an insider and the detachment of the outside observer.

509. Flint, Ralph. "Interview on the Eve of Sailing." *Art News* 29 (January 3, 1931): 3+.

The author gives no direct citations, but paraphrases Matisse's reactions to the U.S. on the eve of his return to France after his third visit to America. He returns with the Barnes Foundation mural commission.

510. Forbes, Cleaver. "A Sultan and a Prince." *Art News* 89 (May 1990): 41.

A note on the article in *Madame Figaro* by Lisette Clarnète, Matisse's sole model from 1928 to 1933, as told to De Pesloüan.

511. Foster, Joseph Kissel. "Matisse: an Informal Note" [Obit]. *Art Digest* 29 (December 1, 1954): 14-5+.

A note on Matisse's death, the author attempting to see him on the day the painter died; Picasso's reaction.

512. Fourcade, Dominique. "Matisse et Manet?" In *Bonjour Monsieur Manet*, 25-32. Paris: Musée National d'Art Moderne, 1983.

Fourcade traces the "dialogue" that Matisse had with Manet, particularly between 1916 and 1920, when Matisse discovered how to maximize the power of blacks as "luminous," as generators of light. Not limited to this period, however, Fourcade discusses motifs, approaches, techniques common to the two men, and what Matisse added to them to make his homage to the older master totally original. A very rich essay, historically and esthetically.

513. Fourcade, Dominique. "Matisse, An Uninterrupted Story." In *Henri Matisse, the Early Years in Nice, 1916-1930*, 47-57. Washington, D. C.: National Gallery of Art, 1986, no. 69.

Fourcade defends this period as one of strenuous creative effort in which Matisse "refigures" his plastic approach in terms of light (as both subject and structural principle) and of depth, whose "tight and coherent cinematography" can best be seen

when the Nice works are presented in series or "families" of canvases.

514. Frankfurter, Alfred M. "Matisse: Is He the Greatest?" *Art News* 47 (April 1, 1948): 20-28.

Matisse's ultimate importance (quality) is assessed in terms of his self-sustaining individuality, not his influence on others. With Picasso, and complementing him, he is seen as one of the pair of "greats" in French and international painting.

515. Fry, Roger. "Henri-Matisse." *Cahiers d'art* 6, 5-6 (1931): 283-8.

Excerpt from Fry's monograph, *Henri-Matisse*, Paris and New York, 1930 (no. 92); also published in *Creative Art* 9, 6 (December 1931): 458-62.

516. Gaunt, William. "Henri Matisse and the French Spirit in Modern Art." *London Studio 17 (Studio 117)* (February 1939): 52-59.

Situates Matisse squarely in the modernism specific to France, that is, its conservative, tradition-extending wing, staying within the limitations of the medium--stretching, but not defying, painting conventions.

517. Gauthier, Maximilian. "Henry Matisse, Biographie." *L'Art vivant* 6 (May 15, 1930): 409.

A short biographical and bibliographic note on Matisse who, along with others also entered, was exhibiting in the Art Vivant show.

518. Geldzahler, Henry. "World War I and the First Crisis in Vanguard Art." *Art News* 61, 8 (December 1962): 48-51, 63-64.

Why did Matisse, Picasso, and other pre-war vanguardists take up a more calm, less innovative, and more tradition-oriented style after World War I? After reviewing the most frequently cited reasons, the author himself opts for an explanation that

claims for Cubism (and its epoch) an invention comparable to the High Renaissance which, though it ceased to glow with its original vitality, set off "waves of imitation and reaction" that continued to enrich the succeeding decades. The desire for a "combined situation of formal discovery and alienation from the public" seems not to be possible in periods of widespread critical acceptance of the new [such as 1962, when the article was written].

519. George, Waldemar. "Psychanalyse de Matisse: Lettre à Raymond Cogniat." In "Pour ou contre Matisse" issue of *Chroniques du jour* (April 1931): 6-8. Flam, no. 88, 273-275.

The author mounts an attack on Matisse's claim to have broken with Impressionism as a form of naturalism or subservience to nature, Matisse's claim to have facilitated progress in the history of painting. George questions the notion of "nature in itself" as a "vulgar fable," and the notion of "progress" in art as false. There are changes in art practice but not progress. George also argues that the dissociation of color from descriptive forms is a symptom of modern man's alienation from the world of nature, of things. Matisse's "absolute painting," art based on art, results in a sterile autonomy, a divorce of culture from life, human sensation, and the European humanist tradition. The first salvo in what would become a widespread war against modernist values in French mainstream criticism in the 1930s.

520. George, Waldemar. "The Duality of Matisse." *Formes* (June 1931). Flam, no. 88, 276-78.

The critic who, a few months earlier, had used Matisse's work as a sign of the loss of humanist values in modern European painting, uses Matisse's achievements in this article to laud the specifically French qualities in the same body of work. Rather than advance modern art and its utopian dream of painting in itself, Matisse has defeated that dream from within the premises of modern painting by resisting dogmatic theories, rigidity of style, and the renunciation of figures, atmosphere, mood, poetry. Matisse at sixty, "turned to the

present, speaking the vernacular of twentieth-century man, eluded his own generation" by becoming "one of the masters of French painting."

521. Georges-Michel, Michel. "In the Claws of the Fauves: Matisse." In *From Renoir to Picasso, Artists in Action*, 30-38. Boston: Houghton Mifflin, 1957. Fr. ed., Paris: F. Brouty, J. Fayard et Cie, 1954. A condensed version appeared as "Henri Matisse." *La Biennale di Venezia* 26 (December 1955): 11-13.

Informative and amusing anecdotal account of Matisse in London, working on his sets for Diaghilev's *Chants du Rossignol*, and in Nice in the 1920s, as recounted by an artist-friend; illustrated with sketches of each man by the other.

522. Gide, André. "Feullets d'Automne." *Nouvelle rev. française*, 1920. Flam, no. 88, 195-96.

Gide, visiting the artist in his Nice hotel room, describes Matisse's new, detailed drawings which achieve, improbably, an emotional whole. (The painter's current models are Mantegna and Michelangelo.) Matisse asks to be judged on the total curve of his work, but Gide privately opines that that is impossible: artists are judged on individual works. He thinks it rash for Matisse to have stopped producing "paintings," that is, larger, more ambitious compositions.

523. Gilbert-Rolfe, Jeremy. "Matisse the Representational Artist." *Artforum* 17, 4 (December 1978): 48-49.

This article is an elegant and eloquent defense of the mutual functioning of the decorative and representational in Matisse's art, that is, forms of oblique and direct address in which the spectator is trapped, forcing upon him the distance which makes metaphor possible. Representation is necessary for the recognition of objects, in order to marvel at the subsumption of their particular qualities into paint. The elements of displacement and sublimation are key to the way Matisse's canvases work.

524. Gillet, Louis. "Trente ans de peinture au Petit Palais." *Rev Deux Mondes* 107 (July 15, 1937): 330-39 and (August 1, 1937): 562-84.

Reviewing the exhibition of Independent Art at the Petit Palais, Gillet notes that Matisse, in his early career, was responsible for the erroneous model of the artist who must continually reinvent himself and his art in an everchanging succession of novelties. The author admires Matisse's mastery, however, especially favoring the decorative mural painting such as that of the Barnes Foundation and laments that the whole of Matisse, the best of him perhaps, is not to be seen at the Independent show. Matisse remains the master of "the way of organizing the canvas as a feast, as a little machine destined to ravish the senses and calm the spirit, conceived for delectation."

525. Gillet, Louis. "Entretien à Henri Matisse." *Candide* (February 24, 1943).

An eloquent, if somewhat over-written, account of Matisse's state of physical and mental health after his ordeal in Lyons with cancer surgery and a post-operative embolism. Gillet makes much of Matisse's present peace of mind, his joy, and the vigor with which he is undertaking a variety of new projects. He cites the artist's own vivid words about his new appreciation of the beauties of the world and his recollections of the joy of the aged, suffering Renoir who was yet able to work. Matisse's words in Fourcade, no. 29, 289-90.

526. Gilot, Françoise and Carlton Lake. "Part VI" in *Life With Picasso*. New York: McGraw Hill, 1964; Anchor Books, 1989, 261-72 and passim. First published in French, *Vivre Avec Picasso*. Paris: Calmann-Lévy, 1965. London: Penguin Books, 1966; Virago, 1990.

Matisse appears often in this book by Picasso's companion from 1943 to 1955. The stories and observations are priceless first-hand accounts by a sensitive and impartial observer. Gilot would go on to develop these remembrances in her 1990 book, *Matisse and Picasso: A Friendship in Art,* no. 95.

527. Gilot, Françoise. "Henri Matisse at Peace." *Art and Antiques* (October 1986): 92-96.

Author's reminiscences about Matisse on the occasion of the Washington "Matisse: Early Years in Nice" exhibition. The early Nice works, she says, expressed the "feminine side of his nature," while at the same time reflecting a psychological and political retreat from the postwar "roar" of the 1920s.

528. Gilot, Françoise. "Friends and Foes: Pablo Picasso, Henri Matisse and Françoise Gilot and their Duel About the Spiritual in Art." *Arts and Antiques* 7 (October 1990): 122-31, 65.

Recounts memories of Matisse's and Picasso's relationship at the time of the birth of Gilot's second child and the development of Matisse's sketches for the Virgin and Child, St. Dominique, and Stations of the Cross for the Vence Chapel. Brings out Picasso's attitudes toward non-believers making religious art and Matisse's pleasure in arousing the younger artist's latent rivalry with him. A slightly revised version appears as the chapter "The Vence Chapel" in Gilot's *Matisse and Picasso: A Friendship in Art,* no. 95.

529. Girard, Xavier. "Claude Fournet: Picasso, Matisse, roman." *Art Press Int.* 98 (December 1985): 49.

An interview with Claude Fournet, a writer who is also director of the Museums of Nice, on his recent books on Matisse *(Matisse Terre-Lumière)* and Picasso *(Picasso Terre-Soleil)* and a novel *Periplum.* The writer claims a common theme--reflection on the body and words--for all three works and discusses Matisse's transparency and silence in contrast with Picasso's corporality and profusion.

530. Girard, Xavier. "L'émerveillement pour le sud." In *Matisse, Ajaccio-Toulouse 1898-1899: une saison de peinture,* 19-22. Cahiers Henri Matisse, 4. Toulouse and Nice, 1986.

A short essay that details the work that Matisse accomplished in Ajaccio (Corsica) under the spell of light, color,and freedom

that he experienced in his first break with his former Parisian practice.

531. Girard, Xavier. "Matisse Photographies." *Art Press* 110 (January 1987): 32-33.

A brief summary of the material in Girard's catalogue for the *Matisse: Photographies* exhibition held in Nice in 1987; generously illustrated with Matisse's photographs from Tahiti.

532. Girard, Xavier, and Christian Arthaud. "Il Musée Matisse." In *Henri Matisse, Matisse et l'Italie*, 36-42. Milan: Mondadori, 1987. Exhibition catalogue.

On the occasion of an exhibition in Venice of works from the Musée Matisse, its director and curator collaborate on a brief history of the museum and the acquisition of its rich collection.

533. Glaser, Curt. "Henri-Matisse." *Cahiers d'art* (1931): 269-75; Flam, no. 88, 271-273.

Glaser credits Matisse with providing not only a new style but a new form of esthetic perception. He has broken the connection between the law of painting and the laws of reality, for the painting "recreates the world as image, just as a metaphor does." Once admired as a revolutionary, Matisse has become recognized as the keeper of tradition, one that now includes the "Mannerist" works of Matisse's youth. Glaser asserts that Matisse's work, in the manner of Courbet and Renoir, depicts "reality itself." The motif being unimportant, the artist evokes natural light in the works of the 1920s; these works take their place beside nature as a parallel, a new, reality.

534. Golding, John. "Henri Matisse Retrospective." *Burlington Mag.* 134 , 1077 (December 1992): 833-36.

This thoughtful review is replete with startling judgments which one considers respectfully from so sensitive an observer-practitioner. Golding says, for example, that the second

Portrait of Auguste Pellerin (1917) is "arguably the greatest portrait to have been produced in this century," that *Corner of the Artist's Studio* (1911) produces a mystical effect-- "like staring at a mandala," that *Bathers by a River* may have been the first work where Matisse used cut-paper experiments, and that the late 1940s paintings manifest a failure in scale and intimacy. These are highly individual conclusions that stimulate a relooking and rethinking of certain aspects of Matisse's work.

535. Gottlieb, Carla. "The Role of the Window in the Art of Matisse." *Journal of Aesthetics and Art Criticism* 22 (Summer 1964): 393-422.

Part of a larger study entitled, *The Window in Art*, this essay traces chronologically the artist's formal development of the window motif and draws out the psychological inferences from Matisse's particular usage of certain types. The signifying implications of the placement of the female figure in relation to the window and the spectator's viewing position are also considered. The author concludes with an assessment of the window motif in modernist writings (e.g., Mallarmé, Rilke) and in other twentieth century painting, concluding that it is a favorite motif of reflexivity and of ambiguity, connoting both bridge and barrier, inner and outer, personal and social, escape and confinement, surface and depth. It also permits the exploration of what Fry calls the "equivocal nature of painting" as image (in depth) and object (as surface), one of the driving problematics of modern painting.

536. Grafly, Dorothy. "Matisse Speaks." *American Art* 12 (June 1948): 50-51+.

A pastiche of material on the Matisse Retrospective in Philadelphia, general in nature, and ending with the complete text of Matisse's "Letter to Henry Clifford," which appeared in the catalogue of the exhibit.

537. Grautoff, Otto. [On Henri Matisse]. In *Französische Malerei seit 1914*. Munich: Mauritius Verlag, 1921. Flam, no. 88, 190-200.

Author notes a return to the value of the linear, a kind of Ingrism, that was present before the War and continues afterwards, as evidenced in Matisse's post-war mode. The latter's debt is to Courbet and Degas as much as Ingres, Grautoff admits, but the general transformation of style is from "subjective pretensions" to the necessities of the "ideology of race," that is, a self-conscious espousal of French traditions and qualities.

538. Greenberg, Clement. "Matisse in 1966," *Boston Mus. Bull.* 64, 366 (1966): 66-76.

Greenberg's thesis is that quality, rather than the logic of a style or the impulse of continuous originality, is the basis for the continuity of Matisse's work. Matisse's "touch" is at the service of his color, of its pure visibility, not of the substance of the pigment. The activity of Matisse's "thinking eye," according to Greenberg, precedes his "slapdash," instinctive stroke, thus rendering the "issue of spontaneity versus reflection, beside the point."

539. Greenberg, Clement, "Influences of Matisse." In *Henri Matisse*. New York: Acquavella Gallery, Inc., 1973. Exhibition catalogue. Reprinted in *Art Int.* 17, 9 (1973): 28-9.

Greenberg expands his earlier (1966) discussion of Matisse's use of an "aerating" painterly touch, important for Rothko and Avery. He develops the notion of Matisse's "centrifugal" compositions that expanded on the surface and on out beyond the margins, breaking with the "cabinet picture" tightness and centeredness of, for example, Picasso's and Braque's compositions. This was important for Newman and Still and in general gave American painters an example of a surface orientation that kept nothing of the easel picture but the wall on which it hung. An important synthesis of Greenberg's

assessment of Matisse's impact on American painting from the mid-1940s to the mid-1970s.

540. Greene, David B. "Consciousness, Spatiality and Pictorial Space." *Journal of Aesthetics and Art Criticism* 41, 4 (Summer 1983): 375-86.

Perugino's *The Delivery of the Keys* (1482) and Matisse's *Large Interior in Red* (1948) are contrasted as manifesting Newtonian and post-Newtonian conceptions of space, deriving from views of consciousness. Sartre's (and Heidegger's) positions are brought to bear on a close spatial analysis of the works.

541. Grohmann, Will. "Henri-Matisse." *Cahiers d'art* (1931): 276-78.

Grohmann summarizes what the example of Matisse has meant to the German art world, representing as he does one dominant strand of modern art (the other being the intellectual constructivism of Picasso's Cubism). Matisse has legitimized the idea of expression within a French context and has managed to derive a spiritual content from concentration on the sensuous, the concrete, and the physical. Although a new strengthening of forms is seen in the post-1927 work, the paintings of the preceding decade (likened by the author to ancient wall painting) still have a completeness that reflects humanistic values.

542. Grossmann, R. "Matisse et l'Allemagne." *Formes* 4 (April 1930): 4.

On the occasion of the Thannhauser Matisse Retrospective of 1930, this article, translated from the German, recalls the rejection of Matisse's work when Purrmann first arranged an exhibition for him in 1909 at the Cassirer Gallery. Grossmann touts the reformed mentality of the German public which can now accept Matisse as "a model of order and harmony." He recalls Matisse's horror, recounted by Purrmann, at the advertisements for cremations and to his reaction to the witnessing of one. All this barbarism took

place long ago in the Wilhelminian era, the author reassures us. A strange article in light of the banishment of Matisse's art in Germany seven years later and the new barbarisms of the Nazi era.

543. Gruen, John. "Art Notebook: Pierre Matisse, Master Dealer." *Arch. Digest* 43 (April 1986): 100+.

An informative article in which the artist's son, Pierre, speaks of his father; his gallery artists, Miro, Chagall, and Dubuffet; and his career as a gallery owner and dealer.

544. Guéguen, Pierre. "Poésie d'Henri Matisse." *Cahiers d'art* 6, 5-6 (1931): 261-66.

The author recalls naming Marcel Proust's *A l'Ombre des Jeunes Filles en Fleur* as an analogue to Matisse's earlier work, at a time when he had seen only a few Matisse canvases. After much viewing of Matisse, Guéguen is delighted with the justness of the comparison, especially with the Nice work which provides joy through "mystery in full daylight." In spite of hordes of prettifying Matisse look-alikes in the salons, Matisse's vehemence and sense of structure keep his decorative works forceful, yet intimate, and his visions of happiness disciplined yet vivid.

545. Guichard-Meili, Jean. "Les Odalisques." In *XXe Siècle. Hommage à Henri Matisse*, 63-69. Paris: Cahiers d'art, 1970.

Rejecting historical, social, or biographical explanations for the appearance of Orientalizing odalisques in Matisse's work around 1918, Guichard-Meili discusses the motif as an avatar of the universal woman, identified with the line of beauty, the Arabesque. Finally, however, his discussion is formal: Matisse is synthesizing elements of his two modes of working--more realist and more abstract--in the little theatre of exoticism he has erected in his Nice studio. And this period of synthesis is itself only "a moment of exceptional plentitude between two adventures," presumably the pre- and post-Nice works.

546. Hahnloser, Hans. "En Visite Chez Henri Matisse." In *Henri Matisse. Gravures et Lithographies de 1900 à 1929*. Pully: Maison Pulliérane, 1970. Exhibition catalogue.

The son of the Swiss collectors, Arthur and Hedy Hahnloser of Winterthur, and himself a dealer and collector, the author recalls visits he made with his family to Matisse's apartment in Nice in 1927 and 1929. Rich in detailed memories, the account is accompanied by valuable photographs of Matisse and his studio taken at the time. A long discussion of Matisse's graphic oeuvre closes the article, as the Hahnlosers primarily collected Matisse in this medium.

547. Hahnloser, Margrit. "Matisse und seine Sammler." In *Henri Matisse*, 41-63. Zürich and Düsseldorf: Kunsthaus Zürich and Städtische Kunstahalle Düsseldorf, 1982. Exhibition catalogue.

A general summary of Matisse's early collectors, grouped by nationality, with material further developed in the author's contribution to the catalogue: *Henri Matisse: Early Years in Nice*, 1986, 69.

548. Hahnloser-Ingold, Margrit. "Collecting Matisses of the 1920s in the 1920s." In *Henri Matisse: Early Years in Nice, 1916-1930*, 234-74. Washington, D.C., and New York: National Gallery of Art and Abrams, 1986, no. 69.

A full description of the international collectors, discussed in national groups--from the French Paul Guillaume and Alphonse Kann to the Swiss Hahnlosers and the Danish Johannes Rump, among many others--who collected Matisse's contemporary work in the 1920s. A very full account, richly illustrated with documentary photographs.

549. Halvorson, Walther. "Exposition Braque, Laurens, Matisse, Picasso à Oslo, Stockholm, Copenhague." *Cahiers d'art* 12, 6-7 (1937): 218-30.

Author gives anecdotal memories of Braque, Matisse, and Picasso and remarks that great French painters live the most

bourgeois of lives, needing the serenity and lack of engagement elsewhere--political, mercenary, social--as a means to devote themselves to the discoveries of the studio. This article is excerpted from the essay in the catalogue for the exhibition.

550. Hamilton, George Heard, "In Memory of Matisse." *Yale Literary Magazine* 123 (Fall 1955): 17-23.

An essay that develops the idea that Matisse's history is not one that is useful to the history of (modern) art as such nor to the history of art criticism but to the history of taste. Once again the fashionable and popular Matisse is contrasted with the searcher, the experimentalist, the obsessive worker grounded in Cézanne and Symbolism. The author closes with the Chapel of the Rosary as an example of the intuited expresssion that informed the artist's use of even conventional symbols.

551. Händler, Ruth. "Henri Matisse in Marokko, visionen vom irdischen Glück." *Art: das Kunstmagazin* 7 (July 1990): 82-89.

A general treatment of the relation between Matisse's Moroccan paintings and his affinity for Islamic art. Author also notes the disappearance of many of these works into Russian collections.

552. Harris, Frank. "Henri Matisse and Renoir." *Contemporary Portraits*. New York: Brentano's, 1923: 134-42.

An extraordinary interview with Matisse in which, at the beginning of the 1920s, the fifty-year-old painter outlines his fitness regime, tells his life story with interesting asides, insists on the connection of his art with life and "mere beauty." Matisse stresses his debts to Renoir, also an artist heroic in his devotion to the beauty of young women ("God's best works") even unto suffering old age. Both Matisse and Renoir, the author concludes, endeavored to "make loveliness immortal."

553. Heilmaier, Hans. "Bei Henri Matisse." *Kunst* 65 (April 1932): 206-209.

An interview with Matisse by a German who seeks him out in his hotel on the Boulevard Montparnasse. Matisse declines biographical questions but admits his joy in rediscovering his older works in his recent retrospective exhibitions. The function of color remains the same in earlier and later works, Matisse says; only the color range has changed. Matisse speaks of the roles of Cubism and Fauvism in reacting against impressonism and form-types as signs drawn from the inspiration provided by the motif but not imitative of the motif.

554. "Henri Matisse." *Baltimore Mus. News* 18 (December 1954): 6-7.

An obituary notice for the artist, some of whose major works are represented in the museum's collection.

555. "Henri Matisse: 'L'or seul convient pour les cadres.'" (Unsigned.) *Domus* 661 (May 1985): 74-75.

Three columns of quotations taken from Dominique Fourcade's *Henri Matisse, Écrits et propos sur l'art*, no. 29, one in Italian with English translation on the opposite side; in the middle, another column of pithier quotes in French, one of which is the title. This is paired with a full-page illustration in colored pencil by Manuela Bertola entitled, "With Matisse at the Hôtel Regina," showing Matisse working from his bed with charcoal affixed to his long bamboo stick.

556. Heron, Patrick. "Late Matisse." *Modern Painters* 6, 1 (Spring 1993): 10-19.

An extended essay, the fruit of over forty years of meditation on Matisse's work by a painter especially sensitive to color, on the occasion of the *Henri Matisse: a Retrospective* exhibition of 1993. Heron claims that the artist's color strokes, while declaring the requisite flatness of the picture plane, are also his vehicle for providing the sensation of depth

and volume. The late series of paintings of two women at a
table in front of a window is analyzed in exquisite detail to
demonstrate (but not explain) how Matisse's color alludes to
space, atmosphere, and specific ambiances of light.

557. Hess, Thomas B. "Matisse: a Life of Color." *Art News* 47
 (April 1948): 16-19+.

 A broad summary of the artist's life and artistic development,
 based on published sources, on the occasion of the Matisse
 Retrospective at the Philadelphia Museum of Art in 1948.

558. Hess, Thomas B. "Matisse: Hedonist Juggler." *New York
 Mag.* 6, 49 (December 3, 1973): 102-103.

 A defense of Matisse's work against the perjorative label
 "hedonistic."

559. Hilton, Alison. "Matisse in Moscow," *Art Journal* 29, 2
 (Winter 1969-70): 166-73.

 An account of Matisse's trip to Moscow in 1911, based
 primarily on Russian sources, at that time not translated into
 English, especially T. S. Grits and N.I. Khardzhiev, "Matiss v
 Moskve," published later in an anthology, *Matiss*, Moscow,
 1958.

560. Hobhouse, Janet. "Odalisques: What Did These Sensuous
 Images Really Mean to Matisse?" *Connoisseur* 217 (January
 1987): 60-67. A revised version of this article appeared as a
 chapter in *The Bride Stripped Bare, The Artist and the Nude in
 the Twentieth Century.* New York: Weidenfeld & Nicolson,
 1988, no. 561.

 A frank and perceptive appraisal of the content of Matisse's
 paintings of odalisques--the quality of their eroticism, their
 specular/tactile availability and its limits, the melancholy and
 detachment of the models' mood despite their sensual
 complacency, and the nature of the artist's self-projection into
 the female images. A woman's and a novelist's perspective

which, if not strictly feminist, reflects an unmistakably feminine viewpoint.

561. Hobhouse, Janet. "Henri Matisse." In *The Bride Stripped Bare, The Artist and the Nude in the Twentieth Century*. New York: Weidenfeld & Nicolson, 1988.

This is an expanded version of the article on Matisse's odalisques that appeared in *Connoisseur* in 1987 (no. 560). In her book, Hobhouse deals, chronologically, with with a broader selection of Matisse's nudes, beginning with the *Blue Nude, Souvenir of Biskra* of 1908 and including the late paper cut-outs. Also discussed are certain of the artist's sculptures. The approach remains the same as the earlier version and includes much of its text verbatim.

562. Hofmann, Werner. "Das Irdische Paradies." In *Henri Matisse, Das Goldene Zeitalter*, 95-114. Bielefeld: Bielefeld Kunsthalle, 1981. Exhibition catalogue.

Hofmann revisits the ideas in the chapter of the same name from his book, *Das Irdische Paradies. Motive und Ideen des 19. Jahrnunderts* (Munich: 1960 and 1974) in which he discusses the theme of paradise as a place of ease and luxury in the work of artists such as Ingres, Couture, Feuerbach, Manet, Marees, Seurat, Cézanne, Gauguin, and Matisse. He traces its roots in romantic thinking and Saint-Simonism, among other ideas and follows its variations among the artists he discusses. An erudite article on the history and embodiment of an idea that in modern times is partially an escape and partially an answer to certain aspects of social reality.

563. Hohl, Reinhold. "Matisse und Picasso." In *Henri Matisse*, 26-40. Zürich and Düsseldorf: Kunsthaus Zürich and Städtische Kunsthalle Düsseldorf, 1982. Exhibition catalogue.

An extended essay on the mutual influence of Matisse and Picasso on each other but particularly that of Matisse on the younger artist. Hohl skilfully draws on the interactions between the rivals, from biographical and anecdotal sources, to suggest, among other things, that the divergence between

Picasso's structural-cubist mode and Matisse's decorative-colorist mode before the war disappeared during and after World War I. Each artist then freely appropriated each other's discoveries, each developing new ways of working that incorporated all the pre-war strategies. Hohl points especially to Picasso's 1930s paintings of Marie-Thérèse Walter, his sculptures of her, the references to Matisse in 1954 etchings, the Algerian women series of odalisques begun after Matisse's death, and Picasso's flat "Tôles Sculpture" from 1954 as instances of his enrichment from thinking of Matisse. A comprehensive, scholarly, and clever discussion of the admiring competition between the two men.

564. "Homage to Matisse." *Yale Literary Magazine* 123 (Fall 1955). Contributions by Alfred H. Barr, Jr., Marcel Duchamp, George Heard Hamilton, George Kirgo, Jacques Lipshitz, Leonid Massine, Darius Milhaud, Henri Peyre, Alice B. Toklas, and Frank Anderson Trapp. See summaries under individual names.

565. Hoppe, Ragnar. "På Visit Hos Matisse [My Visit with Matisse]." *Städer och Konstnärer Resebrev och Essäer om Konst.* Stockholm: Albert Bonniers Förlag, 1931. (Original interview 1919.) Flam, no. 88, 171-74; Flam, no. 28, 73-77.

An important post-World War I interview with Matisse in which he explains the rationale for his change in style and goals in the works he is currently exhibiting (May 1919) at Bernheim Jeune. The artists speaks of the hygiene of change, of the danger of mannerism in his previous mode, and of a desire for a new synthesis of his acquired technical means.

566. Hoppe, Ragnar. "Fran Matisse till Segonzac." In *Städer och Konstnärer Resebrev och Essäer om Konst,* 200-225. Stockholm: Albert Bonniers Förlag, 1931. Original article 1930.

A general survey of modern French art that includes, besides Matisse, the School of Paris painters Derain, Utrillo, Picasso, Braque, and Leger. Seven works by Matisse reproduced.

567. Hunecker, James B. "Matisse, Picasso, and Others." In *The Pathos of Distance*, 125-56. New York: Scribner & Sons, 1913.

A collection of essays which first appeared as reviews in the *New York Sun*. Hunecker, a music critic, uses analogies with Wagner and Strauss to suggest that fashions change, the shocking becoming familiar and, later, even classic. The review of Matisse's second show at Stieglitz's Little Galleries of the Photo-Secession finds Matisse a powerful, if unconventional, draughtsman; his painting is considered more artificial and sterile. By the time of the 1912 Autumn Salon, Matisse looks more legible than the Cubists, and his sound education stands him in good stead. At the Post-Impressionist Exhibition in London, "Matisse is at his best"--especially in those decorative panels that include his Dancers, either as main event or as background for a still life. *Conversation* is considered, however, grotesque and risible.

568. Hunecker, James B. "The Melancholy of Masterpieces." In *Ivory Apes and Peacocks*, 249-61. New York: Scribner & Sons, 1915.

These occasional pieces for the *New York Sun* include a meditation on masterpieces, their unsurpassability and their life in the past. Matisse is included as a contemporary with the "skill and originality" to paint fresh masterpieces one day, though presently he is too involved in playing magician and "exploding firecrackers on the front stoop of the Institute." Still, he is master of "line, decoration, of alluring rythms"; much is expected of him.

569. Huyghe, René. "Matisse et La Couleur." *Formes* 1 (January 1930): 5-11. Flam, no. 88, 251-54.

The author develops the idea that Matisse uses color as an "instrument of truth, of expression, and of harmony." He posits a middle ground for Matisse, similar to an artist like Ingres, between realist art and the art of pure creation. They draw plastic harmonies from the resources of reality, but, unlike Rembrandt and Delacroix, for example, they do not

force the real to translate a "state of soul, a reality of a different order." Matisse's color genius offers hues that do not retinally fade, irritate, or grow stale; they remain fresh with prolonged viewing and rebound from the canvas surface like a tennis ball off its racket. The essay ends with praise of Matisse's "French" faculties: "a balance of gifts in which French art recognizes itself: subtle sensibility, attentive to the sensations by which reality enriches itself--but always lucid, the control of the mind (esprit) giving to the emotion not a fugitive quality but a surety, a certainty, analogous to those that a definite method would produce."

570. Huyghe, René. "Matisse." *Le Point* 4, 21 (July 1939): 102-103.

A short treatment of Matisse's color which summarizes the points made a decade earlier in his article of 1930 in *Formes*, "Matisse et la Couleur." Although Fauvist color arises from youthful intensity and violence, Matisse's color does not--it maintains "an exquisite and refined impassablity," a matter of intelligence over raw instinct. Matisse partially objects to this judgment in his interview with W. J. Howe in 1949, insisting that passion motivates his work. Huyghe notes that Matisse's surfaces remain planar and reflective (no illusionistic light-absorbing cavity); light bounces brilliantly off the colored surface into the viewer's space, again, like a ball off a racquet. Colors support each other's differences, rather than clash, creating a harmony of oppositions, not a dissonance.

571. Jacobus, John. "An Art of Chamber-Music Proportions." *Art News* 72 (November 1973): 74-76.

Reviewing a mainly "mid-career" exhibition of Matisse paintings at the Acquavella Galleries, Jacobus mounts an early discussion/defense of Matisse's early Nice period works. Situating them knowledgeably in the context of the 1920s Dada/Surrealist vs. Art Deco/School of Paris axes, Jacobus calls these "chamber-music" easel paintings "the necessary complement and indeed completion of his oeuvre" which must

be valued for their own qualities rather than devalued for what
they do not attempt.

572. Jedlicka, Gotthard. "Begegnungen mit Matisse." In
 Begegnungen, Künstlernovellen. Basel: Benno Schwabe &
 Co., 1933. Reprinted in *Begegnungen mit Künstlern der
 Gegenwart*. Erlenbach-Zurich: Eugen Rentsch, 1945. Fr.
 trans. in Dominique Fourcade, "Autres Propos." *Macula* 1
 (1976). Flam, no. 28, 97-103.

 An interview with Matisse in 1931 that provides a valuable
 description of Matisse's working methods, the artist being
 eager to explain the continuity (the "essential substance") in
 his work that remains despite his various styles that are to be
 seen at his current retrospective at the Georges Petit Gallery
 in Paris. Valuable first-person testimony to the artist's own
 view of his work at this critical juncture, just after accepting
 the Barnes Foundation Mural commission and completing his
 trip to Tahiti.

573. Jedlicka, Gotthard. "Max Liebermann über die Malerei von
 Matisse." In *Begegnungen mit Liebermann*, (1928). Reprinted
 in *Begegnungen mit Künstlern der Gegenwart*. 3 Auflage.
 Erlenbach-Zürich: Eugen Rentsch, 1945.

 An anecdote on the elderly Liebermann's fulminations against
 Matisse and Picasso, which he softens when reminded that
 only time will sort the great, the historically important, artists
 from the lesser.

574. Jedlicka, Gotthard. "Matisse - Picasso - Braque." *Werk* 32, 4
 (April 1945): 124-28.

 The author reviews the usual contrasts between Matisse and
 Picasso--that the former is classic, the latter romantic, the
 former an emotive, the latter an intellectual, and so on. But
 Jedlicka complicates the post-war scenario by claiming that
 Picasso has become more Spanish over the years and is no
 competition for Matisse as one who extends *French* painting
 traditions. He also claims Braque as the first Cubist and
 Vlaminck and Derain as the first Fauves. Jedlicka concludes

his remarks by claiming Braque as a real rival to Matisse for epitomizing French traditons, as his work exudes a French calm and self-effacement in front of nature, while Matisse's oeuvre is too troubled and tense to be authentically classical.

575. Jodidio, P. "Special USA [Nous avons rencontré une douzaine de personnes les plus influentes du monde des arts plastiques]: Pierre et Maria Matisse." *Connaissance arts* 420 (February 1987): 62-63.

Profile of the artist's son and his career as an art dealer, especially in the period of hegemony of American painters, that is, in the 1960s and 1970s.

576. Jouffroy, Alain. "Le Rayon Vert de Matisse." *Opus Int.* 33 (March 1977): 14-19.

Sensitive reflection on the collage format of Aragon's *Matisse: Roman* and its lack of closure as an interpretive strategy. Reflects on the "feminine" aspects of Matisse's total oeuvre (and of Breton's and Aragon's incidentally).

577. Jouhandeau, Marcel. "Esquisses." *Nouvelle rev. deux mondes* 5 (1979): 384-93.

A set of short anecdotal reminiscences by the writer about various personalities he has known. The note on Matisse is very short: Couturier reported Matisse's comment when asked if he [Matisse] had the faith. Matisse's indirect reply--on having been exigent with himself all his life--Jouhandeau finds exemplary: to equate the concern for perfection with religion.

578. Kaiserslautern, Pfalzgalerie. *Matisse und seine deutchen Schüler*, 1988. Exhibition catalogue.

A catalogue with entries more on the students than on the teacher, Matisse, but necessarily providing information about the master's pedagogic methods and the attitudes of young Germans to their Parisian experience.

579. Kandinsky, Vasily. [On Matisse]. In *Concerning the Spritual in Art* [1912], 17-18. Eng. trans. New York: Dover, 1977.

A short passage on Matisse which acknowledges Matisse's contribution to the developments in modern art, noting that Matisse "has impressionism in his blood," and that, though "refined, gourmandizing" in the French manner, his work attains transcendance.

580. Katz, Leon. "Matisse, Picasso, and Gertrude Stein." In *Four Americans in Paris, The Collections of Gertrude Stein and her Family,* 50-63. New York: Museum of Modern Art, 1970.

A seminal article on Stein and her two artist-friends by a writer who has studied the American writer's early works in depth and is thoroughly familiar with her notebooks. Stein, of course, relinquished her friendship with Matisse in favor of her identification with and loyalty to Picasso.

581. Kerber, O. "Henri Matisse: Ausbau des Perspektiven Raumes." Vol. II of *Ergebnisse wissenschaftlicher Arbeiten im Bereich der Kunstgeschichte.* Giessen, West Germany: Wilhelm Schmitz, 1982.

The second in a set of paperback volumes on modern art, the first being completely on late nineteenth-century German artists who might be termed Expressionist. The Matisse volume is an overview of Matisse's work, with emphasis on his German connnections; for example, there is significant reference to his German students such as Hans Purrmann and a section dedicated to "Matisse and Rilke." The text, which traces Matisse's use of space, is fairly rudimentary and offers little new but the German perspective of the author. The selection of drawings and prints are good, but the color plates are badly distorted in hue.

582. Kirgo, George. "Me and Matisse." *Yale Literary Magazine* 123 (Fall 1955): 25-27.

A humorous fiction about a young man's discovery of Matisse through his father (who had met the artist after World War I),

his eventual accidental purchase of a Matisse drawing, and its loss to an importunate friend. A slight but amusing essay.

583. Klein, John. "Three New Books on Matisse." [Review Article on Schneider's, Elderfield's, and Monod-Fontaine's 1984 texts on Matisse]. *Art Journal* 45, 4 (Winter 1985): 359-67.

This meticulous review of three major recent (1984) books on Matisse, Schneider's *Matisse* , no. 157, Elderfield's *The Drawings of Matisse*, no. 230, and Monod-Fontaine's *The Sculpture of Matisse*, no. 180, summarizes their major theses, lauds the new scholarship and insights they bring to Matisse studies, and raises appropriate questions on specific isssues. Klein questions Schneider's literal and often uncontextualized use of Matisse's own words to verify the artist's intentions as well as the resolutely ahistorical approach which misses some important factual data that alter interpretations. An assiduous reviewer, Klein points out a number of factual errors and corrects misstatements where necessary.

584. Klein, John. "Matisse et l'autoportrait: Démarche individuelle et relation avec le public." In *Henri Matisse: Autoportraits.* Le Cateau: Musée Matisse, 1988. Exhibition catalogue.

Klein's essay on Matisse's self-portraits accompanies a catalogue rich in previously unpublished drawings. The author is cognizant of the public use to which self-portraits can be put in terms of promotion and self-representation, thus the public use of the works is always noted and analysed. The private drawings, often bordering on the caricatural, are more intimate moments of self-construction or self-confrontation. The author expands on these ideas in his dissertation, "Henri Matisse, Portraits and Self-Portraits" of 1990, no. 119.

585. Kramer, Hilton. "Matisse Triumphant: Who Was the Greatest Painter of the Twentieth Century?" *Art and Antiques* (February 1987): 91, 93.

On the occasion of the exhibition of Matisse's *Early Nice Paintings* at the National Gallery of Art, Kramer uses these often-disparaged paintings to make the claim that they, along

with the artist's more abstract works, demonstrate the career-long quality and exploration of feeling that makes one consider Matisse the greatest painter of the century.

586. Kronsky, Betty. "The Psychology of Art, Traveling as an Artist, Part II." *American Artist* 49, 513 (April 1985): 28-29, 78-79+.

A psychotherapist discusses the anxieties of travel and the concomitant opportunities for creative stimulation as they affect artists. Author uses Paul Klee's and Henri Matisse's travel journals and letters to illustrate her observations. She discusses "loss of ego-boundaries" in unfamiliar sites and the artists' final breakthroughs to "peak [creative] experiences" after their respective North African trips. Somewhat simplistic advice to artists is appended.

587. Kunio, Motoe. "Morocco no Matisse: yuwaku no Tangier-hikari wo toko kara [Matisse in Morocco: Temptation of Tangiers, Light Shines from the East]," *Mizue* 956 (Autumn 1990): 34-50. In Japanese, summary in English.

Traces Matisse's use of limpid blues and the introduction of the goldfish bowl in combination with nudes as a sign of sensuality as commencing with his visits to Morocco.

588. Kuspit, Donald. "Conflicting Logics: Twentieth Century Studies at the Crossroads." *Art Bull.* 69 (March 1987): 117-132.

In a general analysis of current approaches to art history, the author contrasts the informational/objective/closed approach of Golding's "Matisse and Cubism (1978)" to the multidimensional/ experiential/ open approach of Pleynet's "Matisse's System (1984)." This is followed by parallel comparisons: Kermit Champa's approach to Mondrian (*Mondrian Studies,* 1985) with that of Pleynet (*Painting and Cubism,* 1985) and the latter with that of Golding's. Kuspit favors a deconstructionist opening of the interpretive field over "traditional," "positivist," or "perceptual" art history but decries the tendency for all of the new approaches to aspire to

"control of the canon." Kuspit's own favored approach is a psychoanalytic one on the model of Peter Gay's historical studies, arguing that such an approach alone is able to reconcile the new tendencies in the discipline, to preserve the aesthetic dimension of art while giving full attention to the extra-aesthetic, and to investigate the deep structures of creativity and viewer response to art works.

589. Kuspit, Donald. "Duchamp, Matisse, and Psychological Originality: the End of Creative Imagination." *New Art Examiner* 20, 9 (May 1993): 16-19.

The author proposes a psychoanalytic critique of Duchamp's anti-physical, anti-imaginative stance (physical, expressive, imaginative art having been embodied in Matisse's fauvist works). Duchamp's attitude, according to Kuspit, was a reaction of disgust and fear to the bodily, the creative, the expressively meaningful and has resulted in an impoverishment of the value of art and of the world of objects. If Duchamp's famous irony and intellectual detachment are here seen as anxiety, failure and "coldness," his opposite in engagement and originality is Matisse.

590. Kuspit, Donald. "The Process of Idealisation of Women in Matisse's Art." In *Signs of Psyche in Modern and Postmodern Art,* 18-41. Cambridge: Cambridge University Press, 1993.

A thoroughgoing analysis of the psychological implications of Matisse's practice of dematerializing his female figures, stripping them--through generalizing abstraction and flattening--of their bodily materiality and sexual specificity. The defensive actions of Matisse are related by the author to the special place in Matisse's life of his mother, who in giving him color(s) gave him art as a means of escaping the law of the father and of utilizing his own feminine gifts. A most persuasive demonstration of Freudian analysis by an art historian totally at ease in psychoanalytic theory.

591. Landolt, Hanspeter. "Henri Matisse." In *Henri Matisse Retrospective, 1890-1946.* Lucerne: Musée des Beaux-Arts, 1949. Exhibition catalogue.

An essay that balances Matissc's Frenchness with his internationalism, that is, his offer of universal art that is not a "welfare stunt" for "all people" but an accessible "means of grace" that transcends nationalities. Landolt says that Matisse dances on the abyss of sharp contradictions: tradition and innovation, refinement and the elemental, northern and mediterranean, occidental and oriental, intellectual abstraction and sensual figuration. The mediation between these opposites is difficult, but Matisse's solutions respect and preserve both alternatives and maintain the questions and tensions between them. An elegantly rhetorical homage to the artist.

592. Larson, Philip. ""Matisse and the Exotic." *Arts Mag.* 49, 9 (May 1975): 72-73.

Larson sees the "remoteness and artificiality" of Matisse's odalisques and orientalized Nice interiors as an extension of the "romantic-allegorical tradition" of the previous century. Matisse's interest in the Islamic was as much a matter of taste as style: he collected Islamic objects and made use of them in all stylistic periods of his career. More often he utilized the abstractable arabesque patterns of Moorish inspiration rather than a regularized evenly-dispersed pattern, because the former evoked movement and rhythm. A concise article that touches-- without extended development--many key aspects of the topic .

593. "Last of a Master [Obit]." *Life* 37 (December 13, 1954): 42-44.

Photos of Matisse's funeral, color photo of his studio; minimal text.

594. Laude, Jean. "Les 'Ateliers' de Matisse." In *La Sociologie d'art et sa vocation interdisciplinaire,* 1972.

Laude takes up this theme, the studio, with its attendent motifs of the window and French door, in Matisse's work,

where it is often explored in periods of tension, either artistic or personal. As a motif where specifically artistic problems are worked out, it also bespeaks a space that is essentially social, where the artist's whole enterprise in society is legitimated. Laude's very rich article examines how motifs (studio, window) are elaborated problematics about painting itelf--its relation to the model or nature, to space and time, to the painter, etc. The studio is the site of the "painter-at-work"; the painting is the site of "the work of the painting," which is the viewer's work.

595. Lebensztejn, Jean-Claude. "Les Textes du peintre." *Critique* 30, 324 (May 1974): 400-33; reprinted in *Zig zag*. Paris: Flammarion, 1981.

This ambitious and searching essay covers much ground. First, it reviews Jack Flam's *Matisse on Art* (1973), no. 27, and Dominque Fourcade's *Henri Matisse; Ecrits et propos sur l'art* (1972), no. 29; it essays a semiologic-linguistic analysis of Matisse's writings as a whole, pointing to their gaps, contradictions, and distanciations, while doing the same for the paintings themselves. In the latter the distancing is between the object and the artist's sensation of it, between the sensation and the artist's representation of it, between the intimacy of identification and the construction by surface and color. Lebensztejn's central section is on color, grouped under the three new roles given it by Matisse: the auto-referentiality of pure color, which brings in its train the rejection of illusionistic references to real objects; the transpositional value of color in which each hue takes its function only from its relation to others: black, for example, able to function as light in certain works, or the relation of blue to green is able to substitute for that of black to white in particular circumstances. Like a linguistic sign, color signifies syntagmatically. The nature of a color is also conditioned by its amount: quantity determines quality. Third, color is constructive and ultimately merges with "drawing" in the creation of surface, of an expanding, all-over visual field that spills over the limits of the literal canvas. That Matisse's work tests the limits of painting, and the limits of art itself, is

the overriding theme of the essay, too complex in its argument to summarize here. A very important, seminal article.

596. Lebovici, Elizabeth, and Philippe Peltier. "Lithophanies de Matisse." *Cahiers Musée national d'art moderne* 49 (Autumn 1994): 5-37.

An article acutely aware of its methodology in examining the ubiquitous practice of Matisse (especially between 1908 and 1918) of *grattage:* scraping, scratchng, abrading, scumbling, scarring the surface of his paintings. "Lithophany" refers to the translucid effect that results from inequality of thickness of surface covering. The authors turn this practice about, questioning the way it functions as a negation of reading, as punctuation, as merging and distinguishing, as concealing and revealing, as flattening and layering in depth, as adding by subtracting. The psychological implication of irrition, of itching an irritated "skin" of paint or canvas, of scratching to arrousal or to self-effacement, of scarification and incising of the skin: the pathology of this is considered. The non-signature aspect of the gesture is examined as it differs so from one work to another, being without system or consistency. An extremely subtle and extended meditation on this painterly (anti-pictorial) practice of Matisse, occasioned by viewing the Matisse Exhibition at the Centre Pompidou in Spring of 1993.

597. Lejard, André. "Necessité de Matisse." In *Problèmes de la peinture,* edited by Gaston Diehl. Paris: Confluenccs, 1945.

This article strongly opposes the call for historically relevant or readable painting by arguing for the autonomy of art, its intrinsic relation to its epoch that cannot be forced, and the necessity for a periodic purgation of false ends and methods. Matisse, according to Lejard, has been instrumental in this purification, aligning art to the medieval sensibility where color is again independent and illusionistic space absent. Matisse's recent works open up immense possiblities for a new monumental art, marked by a simplicity, force, and clarity that will reverse the divorce between art and the public.

598. Lemassier, J. "Comment peignaient les grandes peintres: Matisse." *Peintures, Pigments, Vernis* (1961): 725-30.

In a series of articles on great painters, the author defines painting as "essentially a surface coloration," whether this color is delivered by oil paint, cut-out paper, pastels, or tempera. Instead of the technical discussion the title promises, however, the author simply assembles brief, undated statements on Matisse's painting by Matisse himself and by various authors (not all favorable).

599. Leroy, Françoise. "Matisse Tout Entier." *Esprit* 2 (February 1986): 25-35.

A meditation of Pierre Schneider's book, *Matisse* (1984), in which the author attempts to analyse and explicate the thesis of Schneider's text: the "sacred" in the artist's work, particularly in his subjects. The latter include that of the Dance, Music, of the Golden Age, of Sacred Conversation, and of light itself as subject which, like medieval artists, Matisse uses to lead the viewer "from the visible to discover there the manifestation of the invisible." The author discusses the dialectic, or dualism, found in Matisse's personality, which is generative in the artist's procedures, and of the role of memory. Leroy, familiar with certain theological concepts, makes quite penetrating observations that enhance and expand the ideas of Schneider.

600. Lévêque, Jean-Jacques. "Matisse." *Le Arti* 7-8 (July-August 1967): 12-33; also in French as "Connaître la peinture: Matisse," *Galerie des Arts* 44 (May 1967) I: 16-25; 45 (June 1967) II: 16-25.

A lavishly illustrated general treatment of the whole of Matisse's career and artistic development, primarily in painting; synoptic in method and utilizing published sources. Text in Italian.

601. Levinson, André. "Les Soixante Ans de Henri Matisse." *L'Art vivant* 6, 121 (January 1930): 24-28.

Levinson, primarily a literature and dance critic, responds to Florent Fels's monograph on Matisse of 1929, which extols Matisse's reputation and talent as manifested in his 1920s work. Levinson forcefully reminds his readers that Matisse's fame rightfully rests on his 1905-1917 formal innovations, and it is these latter which allow one to claim that Matisse has altered the course of twentieth-century art. Matisse's great contribution, according to Levinson, was to free color from its function as descriptive local color and to fuse the abstract and monumental qualities of decorative wall painting with easel painting. The 1920s work, though pleasing, in no way contributes to the transformation of pictorial values as Matisse's earlier works did.

602. Levy, Rudolf. "Matisse," followed by Marcel Sembat's "Henri-Matisse." *Genius* 2 (1920): 186-196.

An affectionate reminiscence of the pre-war days in Paris by a former student of Matisse acts as preface to the German translation of Marcel Sembat's essay that appeared in his monograph, *Henri Matisse et son oeuvre*, Paris, 1920, no. 159.

603. Lewis, Wyndham. "Art Chronicle." *Criterion* 3, 9 (October 1924): 107-13.

Highly critical comments on Matisse ("very circumscribed, thin, gay, chic") and his painting, *La Dame aux Capucines* (sic), within a review of the folio, *Living Art*, printed in Berlin for *The Dial* , Ganymed Press, 1923.

604. Leymarie, Jean. "The Painting of Matisse." In *Henri Matisse Retrospective*, 9-18. Los Angeles: University of California, Los Angeles, 1966. Exhibition catalogue, no. 129.

Leymarie's "The Painting of Matisse" offers a complete summary of the artist's development which acknowledges his debt to Cézanne and Neo-Impressionism, deals judiciously with his relation to Cubism, has some interesting insights on his transformation of "exotic" sources, and gives full analysis to the formal strength of the paintings of the 1940s. "In an era

of confusion and anxiety, which so many artists inevitably echo in their work," Leymarie concludes, "Matisse adopts a compensatory vision of 'balance and purity,' restores the Olympian worship of happiness, . . . the pagan poet of light-without-shade."

605. Leymarie, Jean. "Les Deux horizons d'Henri Matisse." In *XXe Siècle. Hommage à Henri Matisse*, 23-30. Paris: Cahiers d'art, 1970.

An insightful summary of Matisse's efforts between 1913 and 1925. After Matisse dematerialized color (working from 1913 in tandem with Cubism's explorations of space), according to the author, he moved to convert color to light. Leymarie notes that the so-called early Nice period lasted less than a decade, being effectively over by 1925, and was less realist than it is often portrayed.

606. Lhote, André. "Exposition Matisse." *Nouvelle rev. française* 70 (July 1919). Flam, no. 88, 175-79.

A not unappreciative critique of Matisse's new post-war mode in which the artist is faulted nevertheless for too passive a receptivity to nature, too great a reliance on visual perception and sensibility, too much public-pleasing nonchalance. However much a corrective was needed against the pre-war willfulness and conscious overthrow of values, Lhote would like to see the adoption of a balanced technique rather than Matisse's subjective, process-oriented works.

607. Lhote, André. "Notes." *Nouvelle rev. française* (April 1923). Flam, no. 88, 215-16.

An admiring description and evaluation of Matisse's latest works at Bernheim Jeune in which he savors the "light scumbles and sweeping glazes" of the artist's current technique, one which brings out "the mystery in things," as did Rimbaud and, in a different way, Gauguin. Answers the criticism that the works lack the weight of real paintings, by stopping in front of the large canvas *Tea* (1919), noting that it is "more than a sketch, if not quite a painting." It is a

necessary skirmish, Lhote predicts, on the eve of a future battle to produce major work.

608. Lhote, André. "For or Against Henri Matisse." *Chroniques du jour* 9 (April 1931): 3.

A short note in which Lhote makes two points: that Matisse and Bonnard are the two contemporaries who fullly understand color and that Matisse, by bringing intelligence back to painting, is owed much by Cubism.

609. Lhote, André. "Matisse et la pureté" (written in 1939). In *Peinture d'abord*, 74-77. Paris, 1942. Reprinted in *André Lhote. Écrits sur la peinture*. Collection: Témoinages. Paris and Brussels: Aux Éditions Lumière, 1946.

Lhote asserts there is no progress in painting, only the evolution of different manners where good qualities of the past may be left behind in favor of other qualities being developed. Painting acquisitions are not additive; they cannot be accumulated nor synthesized into a new unity. Matisse's work demonstrates that renunciation of acquired techniques is necessary when new objectives are sought. The only progress is to be found in the artist's becoming more and more himself.

610. Liberman, Alexander. "The Fauve Generation: Matisse." In *The Artist in His Studio*, 20-24; photos: plates 21-30. New York: Studio, Viking, 1960.

A photo-essay on Matisse with some telling photographs of the artist in his studio, crammed with interesting accessories. Liberman has an extremely perceptive verbal portrait of the man and artist that accompanies his visual portraits; he compares Matisse to Baudelaire, the "poet of intellectual escape . . . able to transform visions into sensual form."

611. Linker, Kate. "Matisse and the Language of Signs." *Arts Mag.* 49 (May 1975): 76-78.

An important essay that links Matisse's symbolist, Mallarméan references and usage of "signs" to their linguistic

and structuralist counterparts. The author discusses fully the difference between language, with its fixed signs, and the wholly contextual meaning of signs generated by shape, color, and interval. Evocation, analogy, equivalents, rapport, ellipses are the key terms in Linker's subtle discussion of Matisse's developing sophistication and self-awareness in the invention and deployment of signs--signs that dissolve the limits between subject and object, artist and viewer.

612. Linker, Kate. "Meditations on a Goldfish Bowl, Autonomy and Analogy in Matisse." *Artforum* 19, 2 (October 1980): 65-73.

An extraordinary essay on the figuring (in the literary sense) of objects in Matisse's oeuvre. Matisse's usage of the goldfish bowl, windowed and mirrored interiors, curved space, and dancers are examined as metaphors for the self-containment and self-reflexiity of modern art (Proust, Poe, and Mallarmé being the literary counterparts). An important essay.

613. Loring, John. "Notes on a Purity of Means." *Arts Mag.* 49 (May 1975): 64-65.

On Matisse's love, as a printmaker and book illustrator, for the simplest techniques (linocuts, etchings) and most reduced means (unadorned line).

614. "Luxury, Calm and Voluptuousness." *Life* 38 (January 2, 1950): 59.

A single sheet on Matisse, and his reception in the U.S., within a longer article on the Armory Show of 1913.

615. Luzzato, Guido L. "Il Giudizio di Hans Purrmann sui Maestri Francesi." *Commentari* 11 (1960): 284-96.

A review article of the book of Purrmann's collected writings, *Hans Purrmann, An Hand seiner Erzählungen, Schriften und Briefe,* in which the German painter recalls and reiterates his debts to Cézanne and Matisse, his two "teachers." Luzzato acknowledges Purrmann's role in bringing these lessons back

to Germany and giving testimony, by his works and by his writings, to the tradition assimilated in Paris in his youth.

616. Lyman, John. "Matisse as a Teacher." *Studio* 176 (July 1968): 2-3.

A reminiscence by a Canadian painter who attended Matisse's studio in 1909 and maintained contact with him in the 1920s. Some valuable observations on the artist's habits at these times.

617. Lyons, Lisa. "Matisse: Works, 1914-1917." *Arts Mag.* 49 (May 1975): 74-75.

One of the rare attempts to assess Matisse's exploration of "cubist" devices in relation to his friendship with Juan Gris during the First World War.

618. P. M. "Il Film su Matisse." *La Biennale di Venezia* 26 (December 1955): 44-45.

Brief description of the 1946 film on Matisse by François Campaux and the circumstances of its making.

619. MacChesney, Clara T. "A Talk with Matisse, Leader of Post-Impressionism [written in 1912]." *New York Times* (March 9, 1913). Flam, no. 28, 64-69.

A valuable interview with Matisse in his Issy-les-Moulinaux home and studio by an American painter. Matisse patiently discusses his education, his painting methods, his intentions, and his admired models from Western and Eastern art. He ends with the famous plea that the interviewer tell her American audience about the normalcy of his life as a private citizen. An extremely important interview, in spite of the cheerful limitations of the interviewer.

620. Mai, Ekkehard. "Künstlerateliers als Kunstprogramm--Werkstatt heute." *Kunstwerk* 37 (June 1985): 7-44.

An article on artists' ateliers, focusing especially on full-page photographs of contemporary German artists in their studios.

A brief history of artists' workplaces is given, drawn from paintings of artists in their studios. Matisse's studio is described from Alexander Liberman's photographs and praised for the integrated individuality that it demonstrates, in contrast to the more impersonal studios of (successful) contemporary artists who may keep a loft in New York, one in Berlin, a home elsewhere. Often the modern studio is more like a factory, adapted to the use of assistants and heavy work.

621. Mai, Ekkehard. "Alte Künstler--Junge Kunst, zur Avantgarde der 'Späten Jahre'." *Kunstwerk* 39, 2 (April 1986): 6-20.

An article on the late works of older artists in which Matisse is compared to Bonnard; the former initiating new extroverted decorative works, the latter deepening his habitual modes and themes. An essay of general insight on the "problem" of creativity in old age which dissolves as such when one looks at the actual late works of Monet, Cézanne, Picasso, Matisse, Bonnard, Kandinsky, Balthus, or Bacon. Not much focus on Matisse, who is dealt with almost in passing.

622. Marcel, Philippe. "Henri Matisse." *Art d'aujourd'hui* (Spring/ Summer 1924): 33-47.

Pseudonymous essay by Adolphe Basler which appeared again under his own name in *Cicerone*, November 1924, no. 377; in *Henri Matisse* (Leipzig: 1924); "Junge Kunst," 46; and in *La Peinture indépendante en France, 1929*. Vol. 2. Coauthored by Basler and Charles Kunstler.

623. Marchiori, Giuseppe. "Le Retour de Matisse." In *XXe Siècle: Hommage à Henri Matisse*, 3-20. Paris: Cahiers d'art, 1970.

An extended review of Matisse's career at the time of the Centenary Exhibit at the Grand Palais in 1970. Author calls the painter a "revolutionary" leading a normal life that has masked his important contributions to modern art; these may be greater than that of Picasso. No new research.

624. Martin, Jean-Hubert, and Carole Naggar. "Paris-Moscou, artistes et trajets d'avant-garde." In *Paris-Moscou*, 15-39.

Moscow and Paris: Ministry of Culture of the USSR and Centre Georges Pompidou, 1979. Exhibition catalogue.

Although introduced with a rare period photo of Matisse in Shchukin's home with an unidentified child on his lap during his 1911 visit to Russia, this informative general article on French-Russian artistic interrelations before the Revolution of 1917 includes Matisse fairly peripherally. It is, however, rich in period photographs of Shchukin's and Morosov's homes (and their art collections in situ) and provides a rich contextual account of the cultural interchange of which Matisse was a significant part.

625. Martin, Paule. "Il Mio Maestro Henri Matisse." *La Biennale di Venezia* 26 (December 1955): 6-8.

An important reminiscence by the young artist who was Matisse's studio assistant from 1949.

626. Masheck, Joseph. "Albert Ryder, Roger Fry, and Henri Matisse, with Gertrude Stein and Theodore Roosevelt." *Columbia Review* 55, 1 (Winter 1976): 67-70.

Noting a close parallel between certain esthetic formulations in Matisse's "Notes of a Painter" (1908) and Roger Fry's *Burlington Magazine* essay, "The Art of Albert P. Ryder," of the same year, Masheck traces connections between the painter and art writer that might partially account for their parallel views.

627. Masson, André. "Conversations avec Henri Matisse." *Critique* 324 (May 1974): 393-99.

An important collage of recollections by Masson of a period of intimacy with Matisse in 1932, when the older artist befriended him just after he had broken with the Surrealists in Paris, a low point in his career. Masson has vivid memories of particular *aperçus* of Matisse concerning specific artists-- Rodin, Cézanne, Moreau, as well as telling details of their conversations and of Matisse's working methods.

628. "Matisse e I Filosofi." *D'Ars* 101, 24 (April 1983): 34-43.

On the occasion of the major Matisse exhibition in Zürich in 1992, the author reflects on the importance of the concept of time in the work of modern artists, especially of Matisse and Umberto Boccioni. The ideas of Bergson are highlighted with respect to the processes and intentions of these artists.

629. "Matisse Approves." *Art Digest* 4 (April 15, 1930): 26.

An extract from an article by Aline Kistler of the San Francisco *Chronicle* in which Matisse describes his (favorable) reaction to his visit to the California School of Fine Arts.

630. "Matisse on American Art." *Art News* 29 (November 15, 1930): 14.

Several paragraphs on Matisse's recorded comments on American art after his return from the U.S., quoted from the *Herald Tribune* . Painting in the U.S. is still in the formative stage, Matisse is said to believe, but architecture (the skyscraper) is a fully mature American art form.

631. Matisse, Paul. "Letter from Paul Matisse to Thomas Gibson." In *Henri Matisse, Ten Portrait Drawings of Paul Matisse*. London: Thomas Gibson Fine Art Ltd., 1971. Exhibition catalogue.

A two-page letter by the artist's grandson recalling his encounter with Henri Matisse at age thirteen on his first visit to France after the war in 1946. He notes that Matisse's concentration while drawing him gave him an unforgettable experience of "a man living to the fullest immediate extent of his capacity . . . an existence in which quality rather than quantity held the master place."

632. Matisse, Pierre. "Henri Matisse mio Padre." *La Biennale di Venezia* 26 (December 1955): 4-5.

An anecdotal reminiscence by the artist's son; important.

633. Mauny, Jacques. "A Paris Chronicle [Fifty years of French Painting]." *Arts* 8, 2 (August 1925): 105, 109.

A peripatetic review of all the Paris exhibitions held at the time of the Exposition Internationale des Arts Décoratifs et Industriels by a young painter-critic. Matisse exhibited at a surprising number of these, from the most official to less important gallery shows, among others, Fifty Years of French Painting at the Louvre, Twenty-five Contemporaries at Druet, Tri-Nationale Exhibition at Durand-Ruel, Nineteenth- and Twentieth-Century Works at Bernheim Jeune.

634. Mauny, Jacques. "Henri Matisse." *Drawing and Design* 2, 10 (April 1927): 99-102.

For a British journal, the French artist-critic makes a graceful apologia for Matisse that defends the small, charming 1927 odalisques as right for the present moment, in spite of the growing acceptance of abstract art and the greatness of Matisse's earlier large decorative panels done for Shchukin. Earlier and later are done with the same "sense of life," the same deliberation, and the same skills. Author chides the French government for having bought only one of Matisse's "less interesting Turkish ladies" for the Luxembourg. Two interesting points: Mauny compares Matisse's Moroccan works with indigenous North African folk wall painting, suggesting that Matisse knew and was influenced by them, and secondly, he remembers Matisse as enjoying films by "Charlie Chaplin and Fatty [Arbuckle?]."

635. McBride, Henry. "At Matisse's Studio." *The Sun*, November 16, 1913. Reprinted in *The Flow of Art, Essays and Criticisms of Henry McBride*, 73-74. New York: Atheneum, 1975.

Not more than an amusing anecdote about the self-assured, witty Matisse, when confronted with the non-comprehension of one of his admirers but a good insight into the artist's character.

636. McBride, Henry. "Matisse at Montross." *The Sun*, January 15, 1915. Reprinted in *The Flow of Art, Essays and Criticisms of Henry McBride*, 75-80. New York: Atheneum, 1975.

This ostensible review of the Matisse exhibition at the Montross Gallery is really a witty commentary on how and why Matisse's works are accepted in America. Americans still question his "honesty" but are drawn to the "extravagant" painting as something that corresponds to their own experience in an "extravagant age." The author wonders whether, in the future, Matisse's paintings will be considered too refined for post-war tastes, as Watteau and Boucher once were.

637. McBride, Henry. "Matisse and Mestrovic." *The Dial*, January 1925. Reprinted in *The Flow of Art, Essays and Criticisms of Henry McBride*, 203-206. New York: Atheneum, 1975.

At the blue-chip Fearon Gallery, Matisse is considered "safe," but the author still finds the work amazing in attuning its energy to equally amazing delicacy. "He is French, so very French. As French as Chardin. A Chardin up-to-date."

638. McBride, Henry. "Matisse in New York." *New York Sun*, March 8, 1930. Reprinted in *The Flow of Art, Essays and Criticisms of Henry McBride*, 266-268. New York: Atheneum, 1975.

The author, who played host to the artist, testifies to Matisse's enormous enthusiasm for New York. McBride tries to get Matisse to admit that his *Decorative Nude on an Ornamental Ground* was his best recent painting, but the artist will only admit to keeping it in his studio "in order to remind himself of a path he had previously trod." The critic adds: "He did not, however, positively dissent."

639. McBride, Henry. "Matisse in America." *Cahiers d'art* 6, 5-6 (May 1931). Reprinted in *Creative Art* 9 (December 1931): 463-66. Flam, no. 88, 266-268.

Matisse's more adventurous works, McBride notes, have been used as weapons by young American artists to resist their own elders and their art institutions. This youth stayed attached to the artist in their mature years (as they themselves became the establishment), for he justified their taste and their epoch. Hence, the enthusiasm for Matisse on his visit to the U.S. in 1930, his twenty-year-old innovations now being seen as part of the French tradition-- "as French as Chardin." Matisse's *Decorative Nude on an Ornamental Ground,* of 1926 is mentioned as a hoped-for acquisition for an American museum of modern art.

640. McBride, Henry. "Matisse and Miro." *New York Sun,* October 25, 1930. Reprinted in *The Flow of Art, Essays and Criticisms of Henry McBride,* 270-272. New York: Atheneum, 1975.

On the occasion of large exhibition of Miro's work at the Valentine Gallery, the author recalls trying, and failing, to get Matisse to speak of younger emerging artists in Paris. Matisse mentioned Miro's name, nevertheless, and none other.

641. McEwen, John. "The Complete Artist." *Studio Int.* 187, 966 (May 1974): 214.

A note on the influence of the editor Tériade on the work of Braque and Matisse through his magazines, *Minotaure* and *Verve.*

642. McGuire, Penny. "Matisse for Dinner." *Architectural Rev.* 194, 1158 (August 1993): 84-85.

Despite the title, the article is on a renovated restaurant in London (192 Kensington Park Rd., designed by Tchaik Chassay and Malcom Last) which uses broad areas of color to articulate its architectural planes.

643. Meier-Graefe, Julius. "Matisse, das Ende des Impressionismus." *Faust* 6 (1923/ 1924): 1-5. Flam, no. 88, 217-19.

An acerbic essay on the deliquescence of art in the post-Post-Impressionist period. Matisse's art is perfect for the "good European, an intellect cultivated with full academic resources--an intelligent taste." Damned with faint praise, Matisse's two-dimensional art is the "final extraction of modern big-city percepton, a form for people who live with nerves alone."

644. Meier-Graefe, Julius. "Der neue Rationalismus, Matisse und Picasso." In *Die Kunst unserer Tage, von Cézanne bis Heute.* Vol. III of *Entwicklungsgeschichte der Modernen Kunst,* 621-36; plates: 540-44. Munich: Piper & Co., 1927 (2nd ed.).

Book on modern art in which the earlier essay on Matisse in *Faust* from 1923 (no. 643) is repeated in a slightly expanded version. Matisse is again made the perfect example of an art which mirrors the superficial estheticism of the modern era.

645. Melville, Robert. "Matisse." *Architectural Rev.* 144 (October 1968): 292-94.

A brisk, non-reverent review of Matisse's career and the Hayward Gallery retrospective mounted by Lawrence Gowing. Melville comments of the importance of Matisse for young artists wanting to drown in a psychedelic binge of oceanic color, who are taken with the one-color paintings of Matisse. Gowing exaggerates his descriptions, according to Melville, as though they were the size of the late cut-paper murals or of "American environmental painting." Author finds Matisse's popularity related to the current one for Art Nouveau: slippery curves and arabesques and love of bourgeois luxury. In all, Melville finds Matisse's figuration often impoverished (including the late, *Silence Living in Houses* series) and the work uneven and often shallow.

646. Mercereau, André. "Henri Matisse et la peinture contemporaine." *Zolotoye Runo [Toison d'or]* 6, I-III (1909); in Russian and French.

An article on Matisse is the longest illustrated treatment of Matisse's work in any language to that date. The author, a knowledgeable French critic, traces the artist's method from

impressionism but stresses Matisse's intelligence and the conscious will with which he pursues his experiments in line and color. Mercereau alludes to the artist's goals, as outlined in Matisse's "Notes of a Painter" published in the previous year.

647. Milhau, Denis. "Matisse, Picasso, et Braque, 1918-1926, y a-t-il retour à l'ordre?" In *Le Retour à l'ordre dans les arts plastiques et l'architecture, 1919-1925*, 95-142. Travaux 8. Saint-Etienne: University de Saint-Etienne, C.I.E.R.E.C., 1974.

Milhau mounts a long and complex discussion of the post-World War I phenomenon known as "the return to order," focusing particularly on the works of Picasso, Matisse, and Braque that do not in his opinion have the standard characteristics of the reactionary brand of this post-war "ordering." Within a Marxist framework, the author discusses Matisse's practice, as a site of work, of working through, of working for the resolution of contradictions in actual life. There is in Matisse's 1920-25 practice, according to Milhau, the residue of Matisse's more "anarchizing and eschatological utopianism" of his prewar inventions and stylistic ruptures, a residue seen at the very least in *Decorative Figure Against an Ornamental Ground* of 1926, and even in the early Nice works with their multi-perspectival spatial effects which always hold the plane. This major (and perhaps excessively elaborated) argument is an essential one in the study of Matisse's relation to the "return to tradition" by modern painters in the postwar decade.

648. Milhaud, Darius. "Homage." *Yale Literary Magazine* 123 (Fall 1955): 24.

A short recollection of the musician's visit to the Mrs. Allan Stein collection of Matisse paintings and drawings in California.

649. Monnier, Gérard. "Picasso et Matisse, célébration et solitude." In *L'Art en Europe, L'années décisives, 1945-1953*. Geneva:

Skira and Association des Amis du Musée de Saint-Etienne, 1987.

An important essay in an exhibition catalogue that deals exhaustively with post-World War II European art. The author notes that Matisse's last work, dedicated to "decor" and to an art of "utility," was drawn into the discourse on sacred art and architecture of the late 1940s, but that the full scope of both Matisse's cut-paper work and late paintings and the ramifications of the scale of his last, ambitious mural work was not fully recognized until after the artist's death in the late 1950s. A perceptive, if brief, discussion of the significant strategies employed in the chapel at Vence.

650. Monod-Fontaine, Isabelle. "A Black Light: Matisse (1914-1918)." In *Henri Matisse*, 84-95. Brisbane: Queensland Art Gallery and Art Exhibitions Australia, 1995. Exhibition catalogue.

A nuanced examination of the modalities of light and composition--both entailing the unprecedented use of black in Matisse's oeuvre--in his wartime work from 1914-1918. Also included are relations with the artist's dealers and his artist friends and the shift in his approach from the time (end of 1916) that he began to use the professional model, Lorette.

651. Montherlant, Henry de. "En écoutant Matisse." *L'Art et les artistes* 33, 189 (July 1938): 336-39.

Witty and somewhat world-weary, Montherlant draws out from his conversations with Matisse ideas with which he agrees--elaborating them with erudition--or disagrees. He uses the latter to illuminate both their positions, especially on matters pertaining to the creative process. Although Montherlant remains in the foreground of this double portrait, the focus on Matisse is unusually sharp and the shooting angle is fresh.

652. Morris, George L. K. "A Brief Encounter with Matisse." *Life*, August 28, 1970. Flam, no. 88, 263-66.

This marvelous portrait of Matisse is sketched by the author in his 1931 diary when, as a knowledgeable but naive, aspiring twenty-five-year-old artist, he met the French painter on the train from Cherbourg to Paris. The young American takes every opportunity to draw out the famous painter with intelligent questions but is often thwarted, teased, or condescended to. Along with Jane Bussy's essay, "A Great Man," one of the most unvarnished and astute portrayals of Matisse in his informal social contacts.

653. Morse, C. R. "Matisse's Palette." *Art Digest* 7 (February 1933): 26.

An unsigned article consists entirely of excerpts from Morse's essay, published in *Symposium* 4 (Winter 1933): 56-69. The colors of Matisse's palette of 1923 are named, his use of these colors knowledgeably discussed and analysed, some general conclusions drawn. An article of considerable interest for the technical side of Matisse's painting.

654. Morsell, Mary. "Finely Arranged Matisse Exhibit Now on Display." *Art News* 32 (January 27, 1934): 3-4.

Extended review of major show at Pierre Matisse Gallery, with perceptive coverage of individual works. *Woman on High Stool* (1914), *Lorraine Chair* (1919), and *Decorative Figure on an Ornamental Ground* (1926) are chosen to represent quintessential Matisse. A fine early critical review.

655. Mousseigne, Alain. "Une saison de peinture, Matisse à Toulouse." In *Matisse, Ajaccio-Toulouse 1898-1899: une saison de peinture,* 23-29. Cahiers Henri Matisse, 4. Toulouse and Nice, 1986.

A careful study of Matisse's production in the months that he lived in the region of Toulouse, with his wife's family, after returning from Corsica. The work marks an important stage in Matisse's pursuit of color as an independent element and includes his first experiments in pointillism. The author also provides valuable commentary on individual paintings in this important exhibition.

656. Munsterberg, Hugo. "Henri Matisse." In *Twentieth Century Painting*, 24-32. New York: Philosophical Library, 1951.

An accurate general survey of Matisse's career and his importance, especially in emancipating painting from the necessity of illusionistic three-dimensional space by modeling and linear perspective. A reading of the artist's works that is, by that time, widely accepted; no surprises or special insights.

657. Murphy, Richard W. "Matisse's Final Flowering." *Horizon* 12, 1 (Winter 1970): 26-41.

A pleasantly-written general treatment of Matisse's life and oeuvre on the occasion of the Paris Matisse Centenary Exhibition; richly illustrated. There is a slight emphasis in the text on the late work; a handsomely printed portfolio of five cut-paper designs is at the heart of the article and the artist's *The Flowing Hair* is printed in blue on the issue's white cover.

658. Neff, John Hallmark. "The Exhibition in the Age of Mechanical Reproduction." *Artforum* 25, 5 (January 1987): 86-90.

Analysis and evalution of the problems inherent in producing an exhibition catalogue (*Henri Matisse: the Early Years in Nice, 1916-1930* , no. 69, is the occasion for the reflection) that is true to the originals, to the exhibition experienced as a whole, and which utilizes the scholarly opportunity to study the physical state of the works that a large show provides. The administrative mechanics of mounting a large show often work at cross-purposes to the exhibition functioning as an unparalleled intellectual opportunity for scholars and conservators.

659. Neugass, Fritz. "Henri Matisse, 1969-1929." *Deutsche Kunst u. Dekoration* 63 (March 1929): 372-80. Translated into French under the title "Henri Matisse, Pour son soixantième anniversaire." *Cahiers de Belgique* (March 1930).

A critical review in which Neugass refuses, as Matisse has requested, to judge the whole curve of the artist's work, since the curve seems to have come to a full stop in the "tiresome" sameness and vapid luxury of the late works that open no new paths. In spite of his heightening of color and bolder effects, he remains tied to Impressionism and goes little beyond it.

This article is the core text which the author slightly expanded in the versions appearing below in *Kunst für alle* , no. 660, and *L'Art et les artistes*, no. 661.

660. Neugass, Fritz. "Henri Matisse." *Kunst für alle* 61, 1 (October 1929): 12-21. Translated into French in *L'Art et les artistes* 20 (April 1930): 235-40.

A critical description of Matisse's development from Impressionism to his present style, which Neugass admits is simple and limpid, but whose repetitive subjects, sketchy handling, lack of renewing-impulse makes him seem to copy himself. Matisse is a master of color and ornamented surface, but Neugass finds him lacking in a sense of plastic composition both in his sculpture and his painting. He also finds Matisse's ideas, widely promulaged after 1908 throughout Europe, to have been present already in Van Gogh's postition and to be part of a nineteenth-century heritage.

661. Nicolson, Benedict. "Review of *Matisse, His Art and His Public*." *Art Bull.* 34 (September 1952): 246-49.

A perceptive and important review of Barr's book which inaugurates the sharper formalist critiques of Matisse's mid-career work that would dominate the 1960s. Also faulted are Barr's scholarly "puritanism" which holds him close to provable data and does not allow a more imaginative and interpretive speculation on causes and contexts. The author himself indulges in the latter by an intriguing comparison between André Gide's and Matisse's curves of artistic development.

662. Nirdlinger, Virginia. "The Matisse Way, Forty Years in the
 Evolution of an Individualist." *Parnassus* 3 (November
 1931): 4-6.

 A knowledgeable, tart review of the Matisse Retrospective at
 the Museum of Modern Art. The author ranks the 1920s work
 very much lower than the pre-1918 work of Matisse--the Nice
 works seem "like anachronisms, the imperfectly realized effects
 of a less mature mind." A vigorous, opinionated critic,
 Nirdlinger finds the sculpture "experiments more important to
 the painter than to his public." The drawings are highly
 praised; the prints draw a mixed review. Author accuses the
 artist in his later work of flashy Rimsky-Korsakov color:
 abundant, brassy, skillful, and superficial. This is the same
 criticism Matisse himself made in 1945 ("Role and Modality
 of Color") about Bakst's use of color in his decors for
 Diaghilev's ballets!

663. Nochlin, Linda. "'Matisse' and Its Other." *Art in America*
 81, 5 (May 1993): 88-97.

 A critique of the *Matisse: a Retrospective* exhibition at the
 Museum of Modern in comparison with the show of Russian
 art, *The Great Utopia*, at the Guggenheim Museum. Author
 pits a construction of modernism exemplified by Matisse's
 sensuous bourgeois interiors of passive female models against
 that of a populist, communal revolutionary effort in the
 Soviet Union by as many woman artists as men.

664. O'Brian, John , "Greenberg's Matisse and the Problem of
 Avant-Garde Hedonism." In *Reconstructing Modernism, Art in
 New York, Paris, and Montreal 1945-64,* 144-171, edited by
 Serge Guilbaut. Cambridge, London: MIT Press, 1990.

 The author, editor of the collected essays and criticism of
 Clement Greenberg, traces the critic's attitude toward Matisse
 during the period between his important early theoretical
 essays, "Avant-Garde and Kitsch," (1939) and "Towards a New
 Laocoon," (1940), and his mature critical position of the late
 1950s. Greenberg selects Matisse as the greatest living artist,
 it seems, on the basis of his detached hedonism, the sheer

quality of his handling of the medium and his acceptance of its limitations, and his positing of a materialist basis for present happiness as an alternative to the chaos of contemporary culture. This in contrast to, for example, Picasso, whose works, subject dominated, reflect the morbidity and violence of the age or to other propagandistic, utopian, stylistically *retardataire*, or sentimental art that was being offered by contemporaries (in the late 1940s) as being more relevant. O'Brian subtly follows the tacking of Greenberg's judgments as the critic attempts to work out a flexible position from 1944-54, a period of considerable uncertainty and change in both the artworld and society. The author concludes his essay by praising Greenberg's dialectical method by which he keeps both detached and engaged modes of criticism in play, the one as antidote to the other.

665. O'Brian, John. "MoMA's Public Relations, Alfred Barr's Public, and Matisse's American Canonization." *RACAR: Revue d'art canadienne, Canadian Art Review* 18, 1-2 (1991): 18-30.

The author uses Alfred Barr's exhibitions of Matisse's work in 1931 and 1951 to frame and exemplify the museum's policy of massive publicity and education to create a "public" for modern art. The mercenary goals of publicity and the altruistic goals of education are somewhat at odds, as is Barr's view of the two aspects of Matisse's work--the hedonistic and the austerely intellectual. O'Brian offers a critique of culture providers who marshall public relations techniques in the interests of promoting a single reading of modern art, especially one that is divorced from a critical analysis of its own premises and institutional practices. An excellent, incisive study.

666. O'Brian, John. "In Loco Parentis: Art Markets, American Dealers, and Matisse." *Block Points* 1 (1993): no pagination. (Publication of the Block Gallery, Northwestern University, Evanston, Illinois.)

A close look at Matisse's understanding and use of the market possibilities of the dealer system, including his earliest dealer

Bernheim-Jeune, his late 1930s dealer Paul Rosenberg, and his own son Pierre Matisse. Author assembles valuable information on the rise of Matisse's prices, the role of auction sales in his prices, and the artist's cultivation of collectors and dealers. Of special interest is the publication of his Rosenberg contract of 1936 and the relation between Rosenberg and Pierre Matisse. The article provides a good overview of the "protocols and conventions" of the Paris and New York art markets in the first half of the century, as well as Matisse's canny utilization of these vehicles in the achieving his "fame and fortune."

667. Ocampo, Estella. "Henri Matisse: la sedución del Islam (Henri Matisse: the seduction of Islam)." *Kalías* (Spain) 2, 3-4 (October 1990): 72-79.

Traces influence of Arabic art and the Islamic world on Matisse, especially that of Arabic ceramics and tapestry.

668. [Ozenfant, Amadée], "Recherches [Henri Matisse]." *Esprit Nouveau* 22 (1925?):

A retracing of the history of French painting which culminates in the contributions of Matisse. The founders of Purism set out to separate the false "revolutionaries," whose noisy innovations made no lasting contribution to the revitalization of the stagnant lines of development in the arts, from the true. The latter are those whose "revolutions" brought them in line with the long tradition: David, Ingres, Manet, Cézanne, Seurat. Matisse is named as the last of the great nineteenth-century liberators--from servitude to the appearance of nature and to subjects. He prepared the way, according to the authors, by the free opticality of his work, for Cubism. Well illustrated with works from 1906 to 1916, a reminder of Matisse's more abstract, austere style in the midst of the 1920s.

669. Pach, Walter. "Why Matisse?" *Century Mag.* 89 (February 1915): 633-6.

Pach's essay is an apologia for the artist during the latter's Montross Gallery exhibition in New York. Denying the notion of progress in art, Pach speaks of entering more deeply into forgotten or neglected traditions and claims for Matisse only an unusually intense and persistent sensitivity to nature--which is what makes him "modern." The artist's genuineness is stressed as well as the three sources of his art: the masters, nature, and his own individuality. The essay echos Matisse's ideas, gleaned from Pach's talks with the artist in Paris; interesting for its shaping of ideas to contemporary American esthetic values.

670. Pach, Walter. "After Impressionism." In *The Masters of Modern Art*, 64-75, 99-101. New York: Viking Press and B. W. Huebsch, 1925.

Pach, who wrote on Matisse in 1915, here treats Fauvism as a variant of post-impressionism and stresses Matisse's qualities of mastery and measure, rather than his revolutionary contributions to the history of modern art. He cites Matisse's recent work as evidence of his continued excellence, implying no falling off in boldness or quality.

671. Pach, Walter."Henri Matisse, Pablo Picasso, Georges Braque." In *Queer Thing, Painting*. New York: Harper, 1938.

Pach reminisces about his first meeting with Matisse through the Stein family during the painter's first trip to Italy in 1907, how his first article on Matisse, commissioned by Guy Pene du Bois for the Hearst newspapers, was rejected because of the accompanying photo. Author credits Sally (Mrs. Michael) Stein with converting him to Matisse's use of color by comparing them to Byzantine enamels. Pach remembers Matisse stressing the continuity in his work, despite his pursuing different "lines of development" at different times in his life.

672. Palmer, Mildred. "A Note on Henri-Matisse." In *The Arts: Portfolio Series*. New York: *The Arts* Publication, 1927. Series edited by Forbes Watson.

A biographic, critical, and bibliographic note on Matisse, accompanying an album of reproductions.

673. Pancera, M. "Il Pittore del Sole." *Arte* 145, 15 (October 1984): 34-43.

A generously illustrated article, general in nature, in which the author exalts Matisse's oeuvre for its joyful spirit and its exuberant color.

674. Perl, Jed. "Matisse, The Cathedral and the Odalisque." In *Paris Without End, On French Art Since World War I*, 3-18. San Francisco: North Point Press, 1988.

An essay on the enduring traditions of French culture, characterized by moderation and tranquility, that reemerged after World War I and that are especially evident in the paintings by Matisse of that decade. Incorporating a review of the 1986-87 exhibition, *Henri Matisse: the Early Years in Nice*, that appeared in *The New Criterion* in 1987, Perl offers an apologia for the "Silver Age" of French painting from the 1920s. This beautifully written and perspicacious essay, by a New York painter and critic, is one of the best ever written on Matisse's early Nice work--nuanced and wonderfully observed. For a gentle cautionary dissent to Perl's view of the School of Paris, see Arthur Danto's review of *Paris Without End* in *The New Republic*, October 24, 1988.

675. Perl Jed. "Matisse and Picasso: At the Shores of the Mediterranean." In *Paris Without End, On French Art Since World War I*, 52-65. San Francisco: North Point Press, 1988.

Perl begins his essay on art in the South of France with a visit to Matisse's Chapel of the Rosary at Vence and ends with an appreciation of *Large Decoration with Masks* and his cut-paper works. In between, the artist-critic comments on Picasso's work in the Musée Picasso at Antibes, his ceramics and his *War and Peace Chapel* murals at Vallauris. The themes touched on in the essay are the role of decoration in the late work of both artists, the way the Mediterranean coast affected their later work, and the quality of that late work, especially

that of their advanced years. Full of marvelous observations
and critical judgments.

676. Peyre, Henri. "The Lesson of Matisse." *Yale Literary
 Magazine* 123 (Fall 1955): 7-10.

The author praises Matisse, a man of extraordinary
intelligence, for never having fallen prey to literature in his
work or to theories or formulae in his writings. He has
managed to work between the poles of instinct and intellect in
his art, which accounts for the periodic changes in his
approach and style.

677. Phillips, Jonathan. "Matisse: Master of Color." *American
 Artist* 57 (July 1993): 20-27, 68-70.

An extensive and intelligent discussion of Matisse's use of
color by an artist who analyses Matisse's color palette and
shows--in particular works--how the artist achieves the colors
and color-harmonies that he does. One of the best recent
articles to apply real knowledge of artists' oil pigments to a
discussion of Matisse's color usage.

678. Picabia, Francis. "Good Painting." *Little Review* 9, 3
 (Autumn 1922): 61-62.

Picabia holds "good painting" to be original and personal, not
like that of Matisse which is full of the "old tricks" of
painting techniques, is saleable and unadventurous, and
manufactured for the art market. The author also castigates
Signac and the Cubists, excepting the pre-war Cubism of
Picasso and Braque. Picabia is against any system or method
that prescribes "good painting" and hinders a fresh approach,
hence he has no use for the "beaux-arts-Cubists" who edit
L'Esprit nouveau.

679. Piguel, Philippe. "Henri Matisse, un art de la présence:
 rencontre avec Pierre Schneider." *L'Oeil* 449 (March 1993):
 20-23.

An interview, conducted by Philippe Piguel, with Schneider on the occasion of the publication of the revised edition of his 1984 book, *Matisse* (Paris: Flammarion) and the exhibition, *Henri Matisse, 1904-1917*, at the Centre Pompidou. Schneider explains the revisions--new material from the last eight years, the addition of an essay on the newly-discovered first version of the dance, and the reshooting of some forty reproductions for greater fidelity to the originals. He recapitulates the theme of the sacred which for Matisse arose with efforts in abstraction and the decorative.

680. Pissarro, Joachim. "Seeing, Touching, Being Touched by Matisse." *Apollo* 136, 370 (December 1992): 394-96.

An extended review article on the 1992 *Matisse Retrospective* exhibition at the Museum of Modern Art and on its catalogue. Author offers a number of provocative responses--to Elderfield's discussion of metaphor in the catalogue essay, to Matisse's achievement of unity, and to specific works in the show.

681. Pleynet, Marcelin, "Le Système de Matisse." In *L'Enseignement de la peinture*, 25-98. Paris: Éditions du Seuil, 1971. Translated by Sima Godrey as "Matisse's System (Introduction to a Program)." In *Painting and System.* Chicago and London: University of Chicago Press, 1984.

From a structuralist perspective, Pleynet juggles the concepts of sexuality and language in the multidimensional staging of the signs that constitutes Matisse's invention--instinctual drives (castration fantasies) in play with an intelligence thoroughly steeped in the tradition (pictorial language) of Western painting. Pleynet's polarities include: scientific/subjective, active invention/passive copy, subject (self) /model (other), matter/ essence, exposure/repression, law/drives, grammar/preverbal image, painted woman/mother. Negotiating these, the author claims, finally, that Matisse's program is also one that keeps them in creative and critical opposition, a vast tissue of contradictions reflected in his name, MA-tisse.

Review: Devade, Marc. "Painting and Its Double." *Tracks: A Journal of Artists' Writings* 2, 2 (Spring 1976): 50-65.

682. Pleynet, Marcelin. "Matisse et Picasso." In *Les Modernes et la tradition.* Paris: Gallimard, 1990. Reprinted from *Tel Quel* 2 (Spring 1981): 37-49.

An elegantly constructed comparison/ contrast between the Spanish and the French artist (the paper was originally given in Spain in 1980), based on published sources. As "seismographs of their century," the two artists are rhetorically asked what they had made with such urgency after they "unmade" the traditions they had learned? Without directly answering this, Pleynet traces their mutual admiration for and interest in each other's work, each perhaps realizing that they had incited the other to go beyond his limits and the limits of painting itself.

683. Pleynet, Marcelin. "Matisse aujourd'hui: le grand atelier." In *Les Modernes et la tradition,* 191-223. Paris: Gallimard, 1990.

This extended article divides into two parts: the first is on Matisse's *Self-Portrait* of 1906, which the author sees as a "touchstone" for understanding all of Matisse's work. In it Matisse establishes himself as the master of his own special kind of space, his own negotiation of "model" into "subject." In a long associative, rather than logical, argument, Pleynet arrives at the space of the painting in *atelier* canvases, particularly *The Red Studio* (1911) where Matisse is present by entering the space (he "experienced the space behind him" in his paintings), by working the space (literally and otherwise), and by retroactively reflecting on his previous works and projecting those that are in process. From the *Red Studio,* one is led to *Verdure (Faun and Verdure),* and thence to the Chapel of the Rosary at Vence, also a red room because of the afterimage of red from the complementary green/blue in the window. The chapel is also a studio, a self-portrait, a working (liturgical) space, and so on. In spite of some perceptive observations, this exercise in free association sheds little new

light on Matisse and has little of the rigor of Pleynet's earlier
studies on the artist.

684. Poland, R. "Modern Paintings Acquired." *Bull. Detroit Inst.*
 Arts 5, 1 (October 1923): 3-5.

An apologia, based on Matisse's seriousness and character, for
the museums's acquisition of *Interior [The Window]* (1916).
This was the first painting by Matisse acquired by an
American museum.

685. "Portrait of the Artist, No. 100." *Art News and Rev.* 4, 22
 (November 29, 1952): 1.

Unsigned article in a series introducing individual artists,
accompanied by the sheet of self-portrait drawings that
appeared in the Matisse Philadelphia Museum Catalogue of
1948. The commentary praises Matisse for having avoided the
"blind intuitive excursions of Picasso" and bringing back to
modern art the "decorative grandeur and amplitude of which
Cubism deprived it."

686. Purrmann, Hans. "Aus der Werkstatt Henri Matisses." *Kunst*
 u. Künstler 20, 5 (February 1922): 167-76.

An extended essay of anecdotes and remembrances concerning
Matisse as a teacher by the German artist who initiated
Matisse's school and who became a close friend of his teacher.
Matisse's personality is seen in an intimate way, with its
anxieties and hard-won certitudes, and many of his artistic
judgments are relayed in their original context as advice to
young artists, with whom he was immensely sympathetic,
despite the slightly denigrating remarks he made about them in
later life. A valuable portrait.

687. Purrmann, Hans. "Introduction." In *Henri-Matisse*. Berlin:
 Thannhauser Gallery, 1930. Exhibition catalogue.

A slight essay that contrasts Matisse's present fame,
acceptance, and mature style (now manifested internationally in
his retrospective exhibitions in Paris, New York, Zurich, and

Berlin) with the painter's early rejection in Germany due to his revolutionary Fauve innovations in exuberant color.

688. Purrmann, Hans. "Über Henri Matisse." *Werk* 33, 6 (June 1946): 185-92. Reprinted in *Henri Matisse, Farbe und Gleichnis, Gesammelte Schriften. Mit den Erinnerungen von Hans Purrmann,* edited by Hans Purrmann. Zurich, 1955; Frankfurt and Hamburg, 1960, no. 37.

Purrmann reminisces about his arrival in Paris to see the Manet exhibition at the Salon d'Automne and remaining, after being converted by the Fauve works there. Becoming a pupil and friend of Matisse, he has an intimate view of Matisse's aims at this time and recounts many amusing and telling anecdotes about Matisse and the Steins (of whom he most admires Leo and Sarah), about Matisse's studio, and about Matisse's first exhibition in and trip to Germany. Matisse's observations on "modern Germany" betray the Frenchman's amused distaste for its infatuation with technology, coupled with a certain crudeness of custom. Interestingly, Purrmann notes that he and other Berliners were not so favorably disposed to the odalisques and the 1920s style when they were seen in quantity at the 1930 Thannhauser retrospective.

689. Puy, Jean. "Souvenirs," *Le Point* 4, 21 (July 1939): 112-33.

A rich and intimate memoir of a studio mate of Matisse who remained a lifelong friend and confidant. Absolutely indispensable account of the early years in Carrière's studio and of Matisse's studio practice from 1900 to 1904. Describing Matisse's need to explain and justify his work, to push aspects to the extreme for the sake of discovery, Puy confesses that his own preference is for those works that are guided almost solely by Matisse's instincts.

690. Puy, Michel. "Le Dernier état de la peinture." *Mercure de France* (July 16, 1910).

This article is written by a critic with an intimate knowledge of the artist's working method through his brother, Jean Puy, the painter and studio camrade of Matisse. In this second

article (the first was more generally on Fauvism, no. 1258), the critic offers a more considered evaluation of Matisse's role in moving modern painting from the observation of reality to abstraction. He says that Matisse represents the tendency to "decorative speculation" while the Cubists favor a "purely mathematical world." Matisse, he says, is exceptional in producing works of a stunning decorative sumptuosity, which yet stir a profound emotional response in the viewer. An important early review by an "insider."

691. Ragon, Michel, with Tamara Préaud. "L'Anniversaire d'un grand Fauve: Henri Matisse, peintre de la joie de vivre." *Jardin des Arts* 186 (May 1970): 2-21.

Introductory article in an issue of *Jardin des Arts* devoted to Matisse on the occasion of the 1970 Centenary Exhibition at the Grand Palais. Ragon's text is a summary of the artist's life, profusely illustrated, while Préaud contributes, in boxed areas throughout the text, a periodization of his career into twelve parts. Informative and professional; recent sales are appended as is a short bibliography.

692. Rannit, Aleksis. "Ausstellung Henri Matisse 1951." *Kunstwerk* 5, 1 (1951): 53.

A sensitive assessment of Matisse's lifelong development, that marvels, from a Northern point of view, at Matisse's French elegance which, like Braque's and Maillol's, always has something in it of Greek clarity. Rannit mentions the talks that Raymond Cogniat has been giving (as the exhibition travels) in which the art critic reminds his German audiences (who have not seen a major Matisse show since well before the war) of Matisse's historical "firstness" in eliminating traditional perspective and creating a spatial illusion entirely derived from color relationships.

693. Raphael, Max. "Das Erlebnis Matisse." *Kunstblatt* 1 (1917): 145-54.

Raphael defends Matisse against accusations of being too intellectually cold and calculating in his artistic process.

Raphael insists on the residue of sentiment--derived from Matisse's response to nature--that remains in the finished work. The author is sensitive to Matisse's process, in which discoveries, adjustments, and transformations are effected by the necessities of his ongoing experience while painting. Matisse's constant search to surpass himself, to go beyond his immediate experience, may, however, hide a psychic weakness, according to Raphael, in the artist's conception of self or of the limitations of the organic world.

694. Ratcliff, Carter. "Remarks on the Nude." *Art Int.* (March-April 1977): 60-65.

Author takes the occasion of an exhibit at Borgenicht Gallery, *The Nude: Avery and the European Masters,* to discuss Matisse's handling of the nude (in a pencil drawing of 1930) as a response to realism and expressionism, by depicting "worlds alternative to the one we inhabit." That is, he offers in his art a model of the way experience can be controlled and re-invented by a new mode of vision, a new way of seeing the world--with detachment and for pleasure, that is, esthetically.

695. Raymond, Marie. "Matisse contra de Abstracten." *Kronick van Kunst en Kultur,* 1953. First published in Japanese in *Misue* (March 1953). Flam, no. 88, 382-84.

Marie Raymond, an abstract painter and the mother of Yves Klein, attempts to draw Matisse out on the subject of abstract art. Matisse, in turn, denounces abstraction and turns the interview to more concrete matters, to Van Gogh and Cézanne as his models and to his Chapel of the Rosary.

696. R. C. C[ogniat], R[aymond]. "Henri Matisse, la fraîche beauté du monde, les voies secrètes de la peinture." *Jardin des arts* 210 (May 1972): 56-64.

A lavishly illustrated article in which each illustration has its brief accompanying commentary in a poetic style, and a longer, one-page article sets out a general history of and homage to the artist. The texts as a whole insist on Matisse's

Frenchness, his robust love of life, and set him in a lineage of Poussin, Rubens, Fragonard, Ingres, and Renoir.

697. Refsum, Tor. "Møte med Matisse." *Kunst og Kultur* 58 (1975): 65-78.

A general article which discusses Matisse's development, especially in the years from 1908 through 1916 when his work became both more decorative and more abstractly structured. Generously illustrated in black and white, the article treats Matisse's debts to Islamic art and Russian icons in works such as *Still Life with Three Eggplants* and *The Painter's Family.* The 1911 studio canvases are also examined as is Matisse's influence on contemporary painters.

698. Reichardt, Jasia. "Matisse and Subject Matter." *Studio* 172 (July 1966): 2-4.

Despite Matisse's insistence on painting specific objects and sites, the author asserts that these objects are not real subjects for Matisse. They only "act as a vehicle or point of departure for the organization of space, form and color." The author contrasts this attitude with that of Pop artists; and contrasts the expressive intensity of Matisse's *Woman in Blue* (favorably) with de Kooning's 1950 *Woman* .

699. Renshaw, Janet. "A Russian Revelation." *Art and Artists* 239 (August 1969): 19-22.

Describes the conditions and history of the loan, *Impressionist to Early Modern Paintings from the USSR*, which began at the National Gallery in Washington, D.C., and traveled to Los Angeles and New York (Metropolitan Museum). Review of the show and history of Russian collecting of modern art. Matisse's *Conversation, Harmony in Red, Spanish Woman with Tambourine, Goldfish, Standing Riffian, Nasturtiums with "La Dance,"* and *Bouquet on the Veranda* are singled out for comment.

700. Reverdy, Pierre , "Matisse dans la lumière et le bonheur." In
 Dernières oeuvres de Matisse, 1950-1954, a special issue of
 Verve 9, 35-36 (1958). Excerpt in Fourcade, no. 29, 30-33.

 The poet, who had known Matisse since 1912 and comments
 on the ironic and somewhat mocking skepticism of Matisse in
 those earlier years, here remembers the painter as one with a
 congenital gift for happiness, combined with a visceral will
 toward a paradisial existence. Matisse did this by centering his
 will on the axis of art and work and achieved, both in his
 personal life and in his artistic production, the serene "placidity
 in plasticity" towards which he gravitated as a compass points
 North. Reverdy finds Matisse grounded in classical attitudes,
 not in Impressionism, because a critical sense always
 dominates his emotion and sensation. A subtle psychological
 study of the man as much as his paintings, about which
 Reverdy modestly--and falsely--claims insufficient expertise to
 comment.

701. Rihani, Ameen. "Artists in War-Time." *Int. Studio* 68, 269
 (July 1919): III-IX.

 Author emphasizes Paris as a place where the habit of critics
 to analyze the distinctions between "Schools" may work to the
 good of talents and even genius but may also artificially
 foreground the bizarre and grotesque in the name of novelty.
 Having tried to draw out Matisse (during the war) on various
 schools and artists, the author finds Matisse too diplomatic to
 commit himself to one position either in conversation or in
 his work. "He is broad, but not deep, in his vision," the
 author concludes, "his eclecticism often overshadows his art."
 But Rihani must admire Matisse's equanimity in the midst of
 severe wartime shortages and discomforts, his acceptance of
 and "chastened faith" in his fellow man, his ability to manage
 contradictions, even as he regrets the artist's lack of deep
 spirituality and conviction.

702. Rivière, Jacques. "Une Exposition de Henri Matisse [1910]."
 In *Études*. Paris: NRF, 1911. Originally published in 1910 in

La Nouvelle revue française as an extended exhibition review of a Matisse show at Bernheim-Jeune.

A remarkably astute analysis of the artist's conceptual artistic process which, according to Rivière, is too self-conscious, too goal-driven to allow the work to develop with the necessary spontaneity and "blindness" out of which original work arises. The author is very good on Matisse's drawing "system" and mode of composition; one of the first "formal" analyses of the artist's work of any sophistication and insight. A very important essay.

703. Romains, Jules. "Opinions." In *Henri Matisse*. Paris: Georges Crès & Cie, 1920. Flam, no. 88, 181-82.

Matisse has "settled down," not in the weakening of his creative passion, surrender to mediocrity, or renunciation of the boldness of youth, but in the harmony to which he has bought his forces and his domination of himself. He is working "unhastily" toward an eternal "classicism" which is synonymous with "structure."

704. Romanelli, Giandomenico. "Passagi Veneziani." In *Henri Matisse, Matisse et l'Italie*, 43-45. Milan: Mondadori, 1987.

The author sketches a brief exhibition history of Matisse at the Venice Biennales--1920, 1926, 1928, 1950, and 1954. He quotes liberally from and comments on the catalogue essays by Longhi and Cogniat on the Fauves (1950) and by Cogniat again in 1954.

705. Roskill, Marc. "Matisse on His Art and What He Did Not Say." *Arts Mag.* 49 (May 1975): 62-63.

On the publication of Flam's and Fourcade's anthologies of Matisse's writings and interviews, *Matisse on Art* (1973), no. 27, and *Henri Matisse: Ecrits et propos sur l'art* (1972), no. 29, Roskill remarks on what remains unsaid in these extensive collections. He observes that Matisse's remarks are always rather general and unexceptionally framed in reassuring, traditional language; that he is silent from 1912 to 1925--years

of some of his most innovative and most retrenching works; that he does nothing to explain how he reconciles in practice the play of oppositions on which his work is based; and finally, in his last great work, the Chapel at Vence, the author observes that Matisse says nothing about many aspects and details of its design components.

706. Rouveyre, André. "Matisee evoqué." *Rev. des arts* 6, 2 (June 1956): 67-73.

A personal memoire of the author's friend, Matisse, richly illustrated with drawings and decorations that he received on Matisse's letters and envelopes in their nearly daily (1940s) correspondence. Rouveyre's remarks about Matisse's character are perceptive, as he knew him intimately over a long period of time--since they were young art students together at the turn of the century.

707. Rouveyre, André. "Henri Matisse." *Verve* 4, 13 (1945): 35-43.

This long eulogistic article by Matisse's old friend and studio mate covers familiar Matisse ground. Matisse gives the viewer of his work contentment; the artist remains totally himself, retaining the measure of his good sense, in the best and original meaning of the phrase *bon sens*. Matisse's deformations, says the author, are reformations, the creation of a new space. Even while formally or plastically preoccupied, Matisse provides *poetic* work, that is, art that moves, that evokes wonder. Like Nietzsche's "tightrope walker," Matisse balances opposites, providing both "grandiose and intimate plenitude." Several paintings receive commentaries of a very general nature.

708. Rusakov, Yu. A. "Matisse in Russia in the Autumn of 1911." *Burlington Mag.* 17, 866 (May 1975): 284-91.

An important article that traces Matisse's itinerary during his 1911 trip to Russia, documented with excerpts from contemporary letters and journal articles; clarifies problems in

relation to his Russian patrons and to the reception of Matisse in the Russian press.

709. "Safe So Far." *Art Digest* 14 (September 1, 1940): 14.

The first report from Paris after the German invasion of France on the well-being of Matisse, Picasso, and Augustus John, as excerpted from the *Newsweek* art editor's report.

710. Salles, Georges. "Henri-Matisse." *Cahiers d'art* 6, 5-6 (1931): 281-82.

Salles remarks on the coincidence of Matisse's retrospective being shown at the same time as a large exhibition of Byzantine and Coptic art at the Pavillon de Marsan; also, he notes the likeness between a pastel of Matisse's and a fragment of Coptic fabric hanging near it in Salles's apartment. Matisse's researches in color have seen him restore to it a role that predates its illusionistic function in reproducing local color; hence, the likeness of Matisse's art to the Coptic fragment. In both color acts as a calming, a cerebral environment or atmosphere which has its effect without the viewer's conscious attention.

711. Salles, Georges. "Visit to Matisse." *Art News Annual* 21 (1952): 37-39, 79-81.

A rather florid, hagiographic description of Matisse's household surroundings and the effect of the aged artist's personality on the visitor. Richly illustrated with photographs of Matisse in his studio from all periods and of the chapel at Vence.

712. Salto, Axel. "Henri Matisse." *Klingen* (April 1918); excerpted in Monod-Fontaine, I. and D. Fourcade, *Henri Matisse 1904-1917*, 510. Paris: Centre Georges Pompidou, 1993. Translated from the Danish into French.

An article detailing the author's visit in the spring of 1916 to the French painter's studio outside of Paris and his reactions to

the large-scale, cubist-influenced works that were to be seen there.

713. San Lazzaro, G. "L'Idéal feminin d'un grand seigneur." In *XXe Siècle. Hommage à Henri Matisse*, 116-118. Paris: Cahiers d'Art, 1970.

A speculation on Matisse's ideal "type" of female in his mature years: "young, tall, and a little stupid; the girl that bankers and politicians of the thirties liked to entertain luxuriously, a mannequin." In other words, a woman who is a foil for a luxurious environment, one with whom the male is not deeply engaged but by means of whom he manifests his wealth.

714. Schapiro, Meyer. "Matisse and Impressionism." *Androcles* 1, 1 (1932): 21-36. Flam, no. 88, 289-90.

An article of astonishing perspicuity on Matisse's continuing debt to impressionism; not in the least dated although it was written when Schapiro understandably thought (in 1931) that Matisse's career would begin and end in a more "realist-impressionist" style. An essay of major importance, drawing out the consistent formal and iconographic aspects of Impressionism that inform even the artist's work of 1907-1917. While not denying the sharp turn in Matisse's art in 1905 toward an "abstract, decorative" manner and the turn again in 1917 to a design-saturated naturalism, Schapiro tends to stress continuities and progress rather than rupture and reaction.

715. Scheffler, Karl. "Der Sechzigjährige Henri Matisse." *Kunst u. Künstler* 28 (1929-30): 287-90.

The critic values Matisse, on the occasion of his Thannhauser Gallery Retrospective, for the infallible taste, moderation, delicacy of his work, now farther and farther away from the emotiveness of Fauvism. Comparing Matisse with Max Beckmann, he views the former as quintessentially French--imbued with the happy genius of his race: tradition-preserving, cool and balanced. According to the author, Matisse manages

to balance the opposites of realism and decorative charm, plasticity and flatness, lifelikeness with doll-like stasis. An authentic Post-Impressionist in the tradition of Manet, Cézanne, and Renoir, Matisse's talent is not so much that of an individual as of an inheritor of the powerful French cultural tradition.

716. Scheiwiller, Giovanni. "Henri-Matisse." *Cahiers d'art* 6, 5-6 (1931): 302-307.

The Italian critic's article is of interest for what it argues against: current ideas in criticism and the judgments of Matisse's detractors. Of the latter, he admits their claims have not changed over the years; namely, that Matisse is a facile decorator, or a bold colorist and that is all, or that he has become simply fashionable, that he has not the complex emotional life of his forbears, Cézanne, Gauguin, and Van Gogh, that he is superficial, and so on. The author defends the artist against critics who think it important that one prove an artist has added something original to the style of the era, or that he must have an intellectualist foundation to his work, or that he necessarily have innovative "break-through" periods in his career. Matisse has had none, Scheiwiller maintains, and is best studied in and by himself, and his work on its own terms.

717. Schlagheck, Irene. "Der Maler Henri Matisse hatte. . . " *Art: das Kunstmagazin* 9 (September 1988): 72.

Interview with Pierre Matisse who speaks of his father's desire for him to be a musician and the pressure this put on him as a youth.

718. Schneider, Pierre. "La Transparence montrée." In *D'un espace à l'autre: la fenêtre,* 51-53. Saint-Tropez: Musée de l'Annonciade, 1978. Exhibition catalogue.

This essay is an excerpt (pp. 452-55) from a chapter entitled "Goldfish, Studios, Windows," in Schneider's 1984 book, *Matisse.* The author treats the symbolism of the window in two ways: as the traditional sign of the painting itself as a

transparent view onto the represented world of the image and as the sign of the irrevocable-seeming separation between the secular and the sacred. Schneider believes that Matisse uses the window's transparency to dissolve the difference in the latter instance and to overturn a Renaissance convention in the former by his refusal to privilege either the exterior "framed landscape" or the opaque plane of a totally two-dimensional space.

719. Schneider, Pierre. "Die goldene Zeitalter." In *Matisse: Das Goldene Zeitalter*, 25-47. Bielefeld: Kunsthale Bielefeld, 1981. Exhibition catalogue.

An early statement of the theme that Schneider would develop in his 1984 monograph on the artist, *Matisse*, no. 157, namely, that the overarching content of Matiesse's oevre and one of his artistic search as a practicing artist was the reinscription of the conditions of the Golden Age, such as the ancients conceived it. Schneider traces the theme historically, with its artistic predecessors such as Ingres and Puvis, and indicates its presence in a number of major Matisse works. That the longing for the sacred and the blissful continues to haunt the non-religious artists of our century, Schneider affirms, is evident in the works of artists as disparate as Alfred Jarry and Georges Rouault. Matisse is no exception, and the Golden Age theme is a key to Matisse's search for plastic signs that would give an equivalent to the radiant light, limitless space, and ineffable harmony associated with the theme. A shorter version of this essay appears as the introduction to the book, *Tout l'oeuvre peint de Matisse, 1904-1928, Paris: Flammarion, 1982*, no. 132.

720. Schneider, Pierre. "Pierre Schneider, l'art sacré d'Henri Matisse." *Art Press Int.* 87 (1984): 4-8.

An interview of Schneider by Catherine Millet on the occasion of the publication of his *Matisse* (1984), preceded by a keen literary analysis of the book's structure. A very important article in which Schneider lays out the primary ideas behind

his portrait of Matisse, a kind of gloss on the whole text which is very frank and enlightening.

721. Schneider, Pierre. "Une saison décisive." In *Matisse, Ajaccio-Toulouse 1898-1899: une saison de peinture*, 11-18. Cahiers Henri Matisse, 4. Toulouse and Nice: 1986. Exhibition catalogue.

The introductory essay for the catalogue on Matisse's sojourn in Ajaccio and Toulouse during the year after his marriage. Schneider emphasizes the great rupture the work of this period, with its "chromatic anarchy," entailed. Especially valuable is the complete text of the painter Henri Evenepoel's letter in response to seeing Matisse's pochades from Ajaccio; it bears out the sense of shock the works produced among his peers.

722. Schneider, Pierre, with Xavier Girard. "Entretien avec Pierre Schneider." In *Matisse et Tahiti*, 12-27. Cahiers Henri Matisse, 1. Nice: Galerie des Ponchettes, 1986. Exhibition catalogue.

An important interview in which Schneider speaks of the role of the voyages "en vancances" in Matisse's working process, of the way Tahiti became a site or a geographication of his enduring theme of the Golden Age.

723. Schneider, Pierre. "Una 'Belva' tra i Donatello." In *Henri Matisse, Matisse et l'Italie*. Milan: Mondadori, 1987. Exhibition catalogue.

A significant article that traces a number of connections between Matisse and Italy: his use of Italian models, from Bevilaqua to Lorette; his study of Italian masterworks before important undertakings of his own; the echo of specific works by Veronese and Michelangelo in particular Matisse works; and the study of figures in action, such as Pollaiuolo's *Hercules and Anteus*, which enriched a number of works by Matisse throughout his career.

724. Schneider, Pierre. "The Moroccan Hinge." In *Matisse in Morocco*, 17-57. Washington, D.C. and New York: National

Museum of Art and Abrams, 1990. Exhibition catalogue, no. 70.

An absolutely indispensable essay on Matisse's Moroccan trips in 1912 and 1913, on the work he did there, and on the importance of the North African experience as a turning point (hinge) in Matisse's developing esthetic and his artistic practice. Written after the publication of Schneider's comprehensive monograph and with the advantage of new data (collected for and published in the same catalogue), the essay develops and deepens Schneider's earlier insights on Matisse and the Orient. The turn Matisse takes through his Moroccan trips is toward the integration of imagined and experienced light, of floral efflorescence and decoration, and of a natural and invented color. Matisse's three paradisial models, where he experienced an edenic abundance and bliss, were "mythology, Morocco, and Polynesia." According to the author, Matisse's Orientalism after the Moroccan sojourns became an integrated orientality, based on florality and decoration.

725. Schnier, Jacques. "Matisse from a Psychoanalytic Point of View." *College Art Journal* 12, 2 (1953): 110-17.

Accepting the position that art's end is self-expresssion, the portrayal of the inner self, the author--an American sculptor born in Romania--outlines, in layman's language, the nature of the unconscious and its role in both the artist's creative act and in the spectator's act of understanding. Delivered at the *Matisse Retrospective* at the San Francisco Museum of Art in 1952, the essay provides a broad basis for understanding Matisse's approach to artmaking for a general audience.

726. Schrenk, Klaus. "Genauigkeit ist nicht Wahrheit, Ausführungen zur Theorie von Henri Matisse." In *Henri Matisse*, 20-25. Zürich and Düsseldorf: Kunsthaus Zürich and Städtische Kunsthalle Düsseldorf, 1982. Exhibition catalogue.

The author examines the "theory" of Matisse with regard to the pictorial "truth" that it is possible for the artist to achieve or discover about reality. Far from "exactitude," it involves a complex and multi-layered conceptual grasping of the object

through sensuous means and through the filter of the personal expression of a strong individual. Schrenk traces this throughout the major changes in Matisse's style and approach in a sensitive formal analysis of aspects of his work.

727. Schwob, René. "Henri Matisse." *Amour de l'art* 1, 6 (1920): 192-95. Flam, no. 88, 182ff.

An extremely perceptive review of Matisse's earlier achievements, his major corrections of Impressionism, his pursuit of pure color and the two essential dimensions of painting (while others were pursuing the chimera of a 4th dimension), his "imposition of the laws of his mind on the image of the world." A good faith effort is made to appeciate the current post-war work, but the author can only hope that, after a period of excessive docility to nature's appearance, the painter will return to a more intellectual and masterful mode.

728. Seckel, Hélène. "L'Académie Matisse." In *Paris-New York,* 316-33. Paris: Centre Georges Pompidou, 1977, 1991. Exhibition catalogue.

A summary account of the circumstances surrounding the establishment of Matisse's "School" and the nature of its students. A fine gathering of the statements and observations of former pupils and of Matisse himself on the enterprise. This is followed by individual biographical sketches of Americans influenced by Matisse: Max Weber, Arthur B. Carles, Patrick Henry Bruce, Arthur G. Dove, Henry Lyman Saÿen, Alfred Henry Maurer, Samuel Halpert, Morton L. Schamberg, and Charles Sheeler, among others.

729. Sembat, Marcel, "Henri Matisse." *Cahiers d'aujourd'hui* 4 (April 1913): 185-94. Flam, no. 88, 144-50.

A very important early article on Matisse by his friend, the socialist deputy of Montmartre, which wittily answers the charge that Matisse is a charlatan or fool by stressing his talent, seriousness, and general culture. Significant commentary by Matisse is recorded, concerning his painting

Arab Cafe. Matisse considered this the best article written on him to this date.

730. Shenker, Israel. "Maillol's Muse." *Art News* 84 (April 1985): 108-113.

In an article more generally on the famous artists' model and dealer, Dina Vierny, a number of trenchant comments are made about Matisse. Vierny was sent by Maillol to Matisse, who did drawings of her (but never a painting) and remained a lifelong friend. Vierny's observations about Matisse, though brief, are frank and astute.

731. Shiff, Richard. "Matisse and Origins: Impressionism as 'Modernism;' Making and Finding." In *Cézanne and the End of Impressionism*, 55-69. Chicago: University of Chicago Press, 1984.

In a study that examines the interaction between theory and practice in the critical discourses of modern painting, a short chapter is devoted to Matisse. The author sees him as a bridge between Cézanne and the articulated theories of Maurice Denis and Roger Fry, especially with respect to the notion of originality, as spelled out in Matisse's own "Notes of a Painter." Matisse is implicated in a very rich discussion of whether "originality" arises from, has its "origin" in, nature or the artist's temperament or technical skill, and whether originality is a matter of finding (discovery) or making (premeditated construction). Also at issue is whether "original" means authentic (sincere), as well as simply different. An extraordinary book, the whole of which illuminates the context in which Matisse's work was produced and received.

732. Shiff, Richard. "Imitation of Matisse." In *Henri Matisse,* 40-51. Brisbane: Queensland Art Gallery and Art Exhbitions Australia, 1995. Exhibition catalogue.

Distinguishing between copying and imitation, Shiff examines the kind of imitation engaged in by Matisse, its relation to the appreciation for children's art and the art of "primitives."

Author also deals with the formalist theories of Roger Fry and
Clement Greenberg.

733. Silver, Kenneth. "Matisse's Retour à l'Ordre." *Art in America*
 75, 6 (June 1987): 110-23.

In a review of the exhibit *Henri Matisse: The Early Years in
Nice, 1916-1930*, no. 69, Silver objects to what he calls the
"revival" and rehabilitation of the Nice works on esthetic
grounds by Catherine C. Bock and Dominique Fourcade,
especially in the latter's catalogue essay, "An Interrrupted
Story," no. 513. These 1920s works by Matisse are essentially
anti-modern, according to Silver, and pander to a conservative
bourgeois taste that wanted, after World War I, the "return to
order" called for by the right-wing French government. Silver
also implicates Matisse's odalisques in the political mood of
nationalist colonial expansion and exploitation in the interwar
years and contrasts Matisse's prewar male portraits painted in
Morocco with those of the ubiquitous idle females of the
1920s. The works criticized are lavishly illustrated in full
color plates.

734. Skansky, V. "Anri Matiss." *Zhivoe slovo* (October 31,
 1911).

Praising Matisse's gifts as a colorist and a decorator, whose
greatest service is that he popularized the ideas of Cézanne for
a larger public, the critic finally calls him nothing but "a
colored necktie" with no real progeny. His place has been
superceded by Picasso and cubist experimenters.

735. Spurling, Hilary. "How Matisse Became a Painter."
 Burlington Mag. 135, 1084 (July 1993): 463-470.

Spurling, who is preparing a full-scale biography of the artist,
here presents his early years in the light of considerable new
specific data and contextual information. Spurling has much to
say on Matisse's native region, his family genealogy, the
history of the institutions of his early art education, and views
of the young artist by his teachers and peers from the period.
Especially important is the identification of an early influential

teacher, Emmanuel Croizé, and a discussion of his esthetic position and manner of teaching. The narrow provincial world of art teaching and artmaking that Matisse escaped by a combination of talent, determination, and luck is penetratingly detailed. An important contribution to the historical elaboration and/or revisionism that has begun on the traditional hagiographical accounts of the artist. The first volume of Spurling's projected biography of Matisse will be published in 1996 or 1997 by Hamish Hamilton, London, and Knopf, New York.

736. Stein, Gertrude. "Portraits: Matisse" [written in 1909]. *Camera Work* (August 1912). Reprinted in *Portraits and Prayers*. New York: Random House, 1934.

A companion portrait to one of Picasso, writtten when Stein's allegiances were firmly in the Spaniard's "camp," as young painters began to abandon Fauvism for a nascent Cubism. A perceptive, witty, altogether malicious portrait with a great deal of insight and psychological weight, written in Stein's style of repetition and "beginning again and again."

737. Stein, Gertrude. "GMP" [written 1911-1912]. In *Matisse Picasso and Gertrude Stein with Two Shorter Stories*. Paris: Plain Edition, 1933.

A virtually impenetrable piece written in Stein's most abstruse and dense style, as she made her transition from the prose of *The Making of Americans* to the more playful and elliptical style of *Tender Buttons*.

738. Stein, Gertrude. "Storyette H. M." In *Portraits and Prayrers*, 40. New York: Random House, 1934.

A one-paragraph vignette on an incident between Matisse and his wife, which wittily demonstrates the artist's manipulation of his wife's feelings to get his own way.

739. Stein, Gertrude. Chapter 3 and 5: "Gertrude Stein in Paris, 1903-1907" and "1907-1914." In *The Autobiography of Alice B. Toklas*. New York: Harcourt, Brace, 1933.

The American writer's reminiscence of her early years in Paris, when she and her family first purchased Matisse's *Woman with a Hat* from the 1905 Salon d'Automne. Matisse remains a fairly prominent player in the narrative until he is replaced by Picasso as Stein's favored painter-friend. Not to be read for historical accuracy but for the atmosphere of the period and for insightful anecdotes and psychological observations. After some hesitation, Matisse was persuaded to join in a rebuttal of certain aspects of Stein's account, no. 40.

740. Stein, Leo. "Personal Adventures," "More Adventures" and "17 rue de Fleurus." In *Appreciation: Painting, Poetry and Prose*, 139-208. New York: Crown Publishers, 1947.

An astute and well-written account of the author's early years in Paris with his sister, Gertrude, when they were admirers of Cézanne and early patrons of Matisse and Picasso. In analyses and anecdotes about the two painters, the author's Matisse compares favorably with the Spanish painter in theoretical intelligence, clarity of intent, and steadfastness of purpose, though he is not without deficiencies in rhythm. An essential early account to be read along with Gertrude Stein's *Autobiography of Alice B. Toklas.*

741. Taillandier, Yvon. "Matisse et la préhistoire du bonheur." In *XXe Siècle. Hommage à Henri Matisse*, 85-95. Paris: Cahiers d'Art, 1970.

The author discusses the theme of Paradise that so often recurs in the artist's work. The paradise of Matisse-land has a recurrence of rounds of dancers, circling fish, boneless fetal humans of indeterminate sex, often incarcerated in line or color fields and in a restricted spatial plane. The paradise, Taillandier notes, is a pre-natal one and surprisingly vegetal. The plenitude of the scene is given in a difficult or frustrating way; in achieving appreciation of these works, the viewer feels he or she has earned the paradise offered. An important early psychological reading of this theme, not to be developed until Margaret Werth's study of 1990, no. 874.

742. Tériade, E. "Édouard Manet vu par Henri-Matisse."
L'Instransigeant 1932. Reprinted in *Bonjour Monsieur Manet*,
51. Paris: Musée National d'Art Moderne, 1983.

An important interview on the occasion of a Manet
Retrospective when Matisse speaks frankly of Manet's
contribution to modern painting and of his debt to him.
Matisse speaks of the immediacy of Manet's technique,
Manet's reflexive reaction to his sensations that results in
simplication, and the power of direct sensations to liberate the
instinct. Manet developed personal and enduring signs in
painting, according to Matisse, to express his sensation
plastically.

743. Tériade, E. "L'Actualité de Matisse." *Cahiers d'art* 4, 5
(1929): 285-98.

Beyond movements, theories, and tendencies, the work of
"great creators," such as Matisse, give the epoch its
"indivisible unity." Tériade credits Matisse with being, after
the great post-impressionists Cézanne, Seurat, Van Gogh, and
Renoir, one of the important "regulators" of the spontaneity of
impressionist naturalism. The artist maintains pictorial
liberty (Fauvism) and the order of synthesis (in works like *The
Piano Lesson* of 1916). Tériade claims that Matisse's present
work in 1929 manifests an order that does not cry out but that
is "a secret base so natural that one is able to forget it."

744. Tériade, E. "Matisse Speaks." *Art News* 50, 8 (November
1951): 40-71. Reprinted in *Art News Annual* 21 (1951).

A long and comprehensive "interview" with Matisse covering
his whole career that seems to be an elaborated collage of
earlier interviews and recent statements by the artist.
Nevertheless, the article gathers together a remarkable wealth
of material on and by the artist by someone who knew Matisse
well, especially in his later years.

745. Terrasse, Antoine. "A Force de l'instant." *Nouvelle rev.
française* 18, 211 (July 1970): 78-81.

The author offers a comparison of a painting by Matisse to music--for the justness of its single elements within an ordered and successive whole. The analogy is elegantly elaborated: Matisse's work evidences "instants in combination," timbres, orchestration, movement, counterpoint, and so on.

746. Terrasse, Antoine. "Matisse et Bonnard: quarante ans d'amitié," *Rev. de l'art* 64 (1984): 77-84. Reprinted in *Pierre Bonnard.* Zurich: Kunsthaus, 1984. Exhibition catalogue.

A comparison of the two artists in their painterly similarities, in their parallel view of art, in their personal artistic goals. The essay prefaces the first publication of the correspondence between the two artists, no. 26.

747. Thau, Eugène-Victor. "L'Art d'Henri Matisse devant la critique américaine." *Beaux-Arts* (Bruxelles) 551 (December 14, 1951): 4.

Review of MoMA's 1951 Matisse retrospective, which praises the artist as painter and draughtsman but finds his sculpture disappointing. Suggests that nothing new about Matisse is to be learned from the show by a European, although some works may be new to Americans.

748. Thirion, J. "Musées de Nice: l'enrichissement des collections modernes de 1958 à 1964." *Rev. du Louvre* 17, 1 (1967): 55-61.

The author reviews the works given by the Matisse heirs to the city of Nice, recently (1963) installed on the first floor of the seventeenth-century palace which is also a museum of Gallo-Roman antiquities. A fairly thorough inventory is made of the some twenty canvases, one hundred drawings and prints, a complete series of Matisse's illustrated books, and many personal items--pottery and furniture, mostly--that Matisse used again and again in his paintings. Madame Matisse saw to this bequest before her death, and it is an archival resource for the Matisse scholar as much as an exhibition of works, considering the large number of sketches for the Barnes Foundation mural and the Chapel of the Rosary, as well as

other intimate items that the artist left in his studio at the time of his death.

749. Toklas, Alice. "Some Memories." *Yale Literary Magazine* 123 (Fall 1955): 15-16.

A gentle anecdotal remembrance of Matisse in which the usually tart Miss Toklas seems to have mellowed in her judgments.

750. Trapp, Frank. "Matisse and the Spirit of Art Nouveau." *Yale Literary Magazine* 123 (Fall 1955): 29-34. A minimally revised, but fully illustrated, version was published as "Art Nouveau Aspects of Early Matisse." *College Art Journal* 26, 1 (Fall 1966): 2-8.

Trapp posits the importance of the turn-of-the-century modern decorative style known as Art Nouveau on the art of Matisse at a crucial point in his career, namely, during the making of *Joy of Life* (1906). The author reviews the history of Art Nouveau--its self-conscious modernity through abstraction and its relation to Symbolism--and makes a strong case for Matisse's attraction to the style as an alternative to Impressionism. Ultimately, it opened an alternative for Matisse to Cubism as well; *Harmony in Red* (1908) and *Dance* (1910) are analysed as being in the Art Nouveau style and spirit. An important early article on a thesis Trapp would develop in his later writings.

751. Trapp, Frank Anderson. "The Atelier Gustave Moreau." *Art Journal* 22, 2 (Winter 1962-1963): 92-95.

A sympathetic review of Moreau's role as a beloved teacher of Matisse, Rouault, Evenepoel and others, especially in matters of color, of capturing the intimacy of objects and models, and of the role of the imagination in interpreting nature.

752. Vallier, Dora. "Matisse revu, Matisse à revoir." *Nouvelle rev. française* 211 (July 1, 1970): 54-64.

Vallier suggests that Matisse's "Notes of a Painter" and his production from 1908-1914 negotiate a space between nineteenth -century practice, which he repudiates, and Cubism, which he also resists. She suggests that Matisse turned to the abstract nature-forms of Art Nouveau and then to Islamic art as an alternative foundation for his surface-oriented rhythmic compositions, taking up cubist insights only from a position of strength when he was able to investigate them for his own structural needs. An insightful article following upon the 1970 centenary exhibition in Paris.

753. Verdet, André. "Les Heures azuréenes." In *XXe Siécle. Hommage à Henri Matisse*, 113-115. Paris: Cahiers d'Art, 1970.

A reprint of a chapter, "Recontre à Saint-Paul" in the author's *Prestiges de Matisse, Précédé de visite à Matisse, Entretiens avec Matisse*, 113-117. Paris, Éditions Émile-Paul, 1952, no. 166.

754. Vildrac, Charles. "Exposition Henri Matisse." In *Exposition Henri Matisse*. Paris, October 15, 1920. Bernheim-Jeune exhibition catalogue. Flam, no. 88, 198-99.

Author praised the artist's "unity of vision" and "quality of eye," through which he is able to find an equivalent for the dazzling sun-washed brightness of his Nice scenes. Watching Matisse arrange his wet rays [skates] on the beach with the cliffs at Etretat in the distance, he notes that the artist details the cliffs only insofar as they are "a decor and boundary," for it is "in relation to boundaries that we feel the space." Matisse's "freshness" is achieved through reflection, in time, and with great difficulty of realization.

755. Vildrac, Charles. Introduction. In *Seize reproductions d'après les tableaux de Henri-Matisse*. Paris: Bernheim-Jeune, 1921. Flam, no. 88, 202.

A book of half-tone plates of recent paintings is prefaced by Vildrac's essay describing a visit to Matisse's hotel room where it is evident to the writer that the painter's objects have

their true "reality," their enchantment, only in the artist's paintings. They are otherwise commonplace and without soul. Matisse's quality and unity of vision are praised.

756. Vildrac, Charles. "Henri Matisse." *Das Kunstblatt* 7 (July 1921): 214-19.

The author gives a spirited defense and analysis of a few of Matisse's early Nice interiors, with their delicacy of color-tone, lightness of touch, and simultaneous depth-illusion and surface orientation. He counters the accusation that Matisse's work lacks control and deliberation. The spontaneity is illusory, according to Vildrac; all of Matisse's mastery of traditional means and of Cézanne's lessons in color-scale has gone into these works.

757. Warnod, André, "Matisse est de retour." *Arts* 26 (July 27, 1945): 1

A note on Matisse's first extended visit to Paris after the period of German occupation.

758. Watson, Forbes. "Henri Matisse," *Arts* 11 (January 1927): 29-40. Flam, no. 88, 225-28.

Watson defends Matisse on the basis of the artist's intelligence, his painting knowledge, and his eye. One needs to know quite a lot about painting to appreciate Matisse--the eliminations, reductions, complex patternings. Although subject matter has become less important in modern art, Matisse still needs to establish a human connection with models and objects; he is not his best in the wholly abstract. He is always wholly esthetic, however, and wholly French. Matisse's later works, according to the author, though gay and often pretty, are not inferior to his earlier work. Not bowing to the demand for the startlingly new, Matisse had found his natural language, from which emanates calm pleasure.

759. Watson, Forbes. "The Carnegie International." *Arts* 17 (November 1930): 65-72; (December 1930): 167-171+.

An extensive review, in two parts, of the show that Matisse
juried; photo of Matisse with fellow jurors.

760. Watt, Alexander. "Paris Commentary." *Studio* 138 (October
 1949): 125-27.

Review of the Fourth Salon of Mural Art at the Chapel of the
Palace of the Popes in Avignon, Matisse's show at the Musée
Nationale de l'Art Moderne, and Picasso's at the Maison de la
Pensée Française. Watt is critical of Picasso's work--"twisted
fantasies, which are destructive rather than constructive"--but
has high praise for Matisse's 1947-48 paintings and large india
ink brush drawings, as well as some paper cut-outs, which he
feels are a "new beginning."

761. Weber, Max. ["On Matisse's School"], Lecture at the
 Museum of Modern Art, New York, October 22, 1951. Flam,
 no. 88, 98-102.

A detailed reminiscence of the student who, along with Hans
Purrmann and Sally Stein, initiated the Matisse Academy in
January 1908. Perhaps the most extensive description we
have of Matisse as a teacher and mentor. An important first-
hand description of Matisse's pedagogy, his interest in music,
his appreciation of contemporary and of African art, and his
esthetic principles, in these productive years.

762. Weekes, Ann Owens. "Students' Self-Image: Representations
 of Women in 'High' Art and Popular Culture." *Women's Art
 Journal* 13, 2 (Fall 1992 / Winter 1993): 32-38.

The author, an educator and feminist, examines the responses
of her female students to Matisse's *Seated Odalisque with
Arms Raised, Green Striped Chair* (1923) and Suzanne
Valadon's *The Blue Room* (1923) as the occasion for
reflection on the tendency of women to interiorize
representations of themselves in their culture. Weekes draws
on Berger, Mulvey, Chodorow, Modlewski, Janeway, and
others for theoretical support and examines general texts on the
History of Western Art for their inclusion of examples of

works of and by women. There is little analysis of the
Matisse work.

763. Weisner, Ulrich. "Die bildliche Vergegenwärtigung des
Goldenen Zeitalters bei Matisse [The Pictorial Realization of
the Golden Age by Matisse]." In *Henri Matisse, Das Goldene
Zeitalter,* 65-71. Bielefeld: Kunsthalle Bielefeld, 1981.
Exhibition catalogue.

The author deals with Matisse's use of the arabesque from a
formal point of view and from that of content. He argues that
Matisse's deployment of the arabesque, while fully decorative
in the sense of generating an elastic compositional structure
that expands the picture surface as a mural also functions to
preserve the painting from the ornamental, giving it plasticity
and "depth" in every sense. But the arabesque also slows down
the eye of the viewer, inducing a meditative attitude, in which
relationships of fulfilling mutuality are recognized and prized.
As they are also experienced, in the viewing agent's psyche,
they make possible a Golden Age experience of harmony
between things, the self and the world. A subtly argued essay.

764. Werner, Alfred. "The Earthly Paradise of Henri Matisse."
Arts Mag. 40 (January 1966): 30-35.

Written on the occasion of the Los Angeles Matisse
Retrospective of 1966, the author admits that his opinion of
Matisse had changed since seeing the 1948 Retrospective at the
Philadelphia Museum of Art. In a summarizing article on
Matisse's achievement, Werner newly appreciates the artist's
"epicurean" traits, seeing them fully under control of skill and
classical harmony. Matisse is neither a bloodless intellectual
nor a mindless hedonist, as has been charged by critics.

765. Werner, Alfred. "The Life-Enhancing World of Henri
Matisse." *American Artist* 40 (August 1976): 20-25, 62+.

Written on the occasion of the Fauve exhibtion, *The Wild
Beasts: Fauvism and Its Affinities*, at MoMA, this article is of
a more general nature, written by a critic newly enriched by the
reading of Matisse's recently anthologized writings and

Schneider's 1970 Centenary catalogue. An appreciative overview of the artist's life, reputation, and work.

766. Werth, Léon. "Matisse." In *La Peinture et la Mode*, 144-49. Paris: Grasset, 1945.

Provocative thesis (by a critic of impeccable socialist credentials) that Matisse 's career alternates periods of "health" or normalcy with those of "fever," the former producing work of universal accessiblity, the latter, work of strained intellectuality and innovation, of fashion.

767. Whitehall, W. M. "Some Correspondence of Matthew Stewart Prichard and Isabella Stewart Gardner." *Fenway Court* (1974): 10-29.

An informative article on the correspondence of Mrs. Isabella Stewart Gardner and Matisse's English friend, Matthew Stewart Prichard, student of Bergson and of Byzantine art in Paris after he quit the Boston Museum of Fine Arts. Prichard had developed many theories on the role of museums, on art education, and on the relation of art to life. Learned and yet a life-long student, Prichard wrote of his contacts with Matisse in the pre-World War I years and sheds a good deal of light on the Parisian milieu in which Matisse participated at that time.

768. Wight, Frederick S. "Matisse: Fabric vs. Flesh." *Art News* 64, 9 (January 1966): 26-9, 64-5.

On the occasion of the Matisse Retrospective at the University of California in Los Angeles in 1966, the author suggests that Matisse remained as good as he did over a long lifetime because he participated in an "orderly revolution, [perhaps] simply evolution in a hurry." Still, the late work has to be seen as a renewed revolution, in which the body is simply affirmed, and the mind complexly engaged.

769. Wilkin, Karen. "Matisse at MoMA." *Partisan Rev.* 60, 1 (1993): 78-89.

A brisk walk-through of the Matisse Retrospective, with notes that are full of fresh insights and clarifying observation on some of the major works shown. An article for the intelligent layman, written in an engaging and colorful journalistic prose.

770. Wilkin, Karen. "After the Retrospective: Matisse and Picasso." *Hudson Rev.* 46 (Spring 1993): 195-200.

Occasioned by the week-long confrontation of 1907-1916 Matisse canvases with three powerful Picasso works, *Two Nudes* (1906), *Demoiselles d'Avignon* (1908), *Bathers in a Forest* (1908) at MoMA after the *Matisse Retrospective,* this article reflects on the reciprocal influence of the two. Wilkin closely analyzes the monumental bathers of Matisse (for example, *Bathers with a Turtle* and *Bathers by a River)* and reviews their impact on the moderns, though Matisse is, she believes, less imitable than Picasso.

771. Will-Levaillant, Francoise. "Note sur 'L'Affaire' de la Pravda." *Cahier du Musée National d'Art Moderne* 9, (1982): 146-49.

A documentary presentation of the press coverage of a speech by Guerassimov reported in *Pravda* on August 11, 1947, denouncing formalist, bourgeois western art as exemplified by Picasso and Matisse. As a controversy in the French press, it was timely because of Picasso's membership in the French Communist Party, the latter's desire to win over the artistic and cultural establishment, the effects it had on the realism-vs-abstraction debate in Paris, and the manipulation of French nationalism to bring the French into the Soviet camp rather than the American sphere of influence. Of first importance for post-war French history and art history; good bibliography on the affair.

772. Wollen, Peter. "Fashion/ Orientalism/ the Body." *New Formations* 1 (Spring, 1987): 5-33.

A wide-ranging article on the mapping of gender onto theories of production and consumption in capitalism (Veblen, Weber, Sombart) and the manifestation of this in the culture of

modernity. The alternative model to modernity as purity, functionalism, engineering, and abstraction (Western and masculine) is that of sensuality, decoration, exoticism, and excess (Oriental and feminine). The author credits Diaghilev's Ballet Russes for introducing the latter model, Paul Poiret's fashions for popularizing it, and Henri Matisse's art for raising it to High Culture. The "feminized," "orientalized" model bears an excess of the primitive and chaotic along with an excess of artificiality and mannered self-consciousness. Wollen wants to "disentangle and deconstruct" the antimonies of functional/ decorative, machine/body, masculine/feminine, west/east by allowing the "other" (east, feminine) to retextualize her own body and desires.

773. Wollheim, Richard, and Wayne Thiebaud. "Matisse at MoMA: [Richard Wollheim interviews Wayne Thiebaud on the Matisse exhibition]." *Modern Painters* 6, 3 (Autumn 1993): 56-61.

A wonderful exchange between two knowledgeable and sensitive Matisse-watchers that covers issues from Matisse's spatial strategies to his psychological fragility, from Matisse's "slicing, chopping, hacking, severing, sawing, snipping, nipping, cleaving, slashing, truncating, cropping" line that is always sculptural and form-shaping to his "admirable ambition" which risks the less-successful, but still heroic, works in his oeuvre. A most stimulating discussion.

774. Wright, Willard Huntington. "Henri-Matisse." In *Modern Painting: Its Tendency and Meaning*. New York: Dodd, Mead, 1915.

The author, brother of the synchromist painter, Stanton MacDonald Wright, stresses Matisse's debt to Neo-Impressionism in learning to handle color as a force, a source of light, and the major vehicle of his expression. Wright is knowledgable about the issues relating to color harmony and credits Matisse's color with "extending objects in visual depth" through flat, unmodeled color.

775. Yavorskaya, N. "Khudozhestvennaya zhizn' vo Frantsi v 1930-kh godakh i dvizhenie Narodnogo front [Artistic Life in France in the 1930s and the Popular Front Movement]." *Isskustvo* 10 (1973): 52-61.

Author claims to better understand the works of modernists-- Picasso, Matisse, Léger, Lurçat, Braque--in the late twenties (of which she was a witness) as symptoms of the turmoil and crises in Europe which would erupt in the 1930s. The art of the Popular Front is seen as the occasion of a return to realism, which was continued into the post-War decade.

776. Zarate, V. Gonzales de. "Matisse y Rouault frente al mito histórico de la 'Belle Epoque'." *Revista de Ideas Estéticas* (Spain) 31, 123 (July-September 1973): 177-99.

In a revisionist article on the "Belle Epoque" as a period of gaiety and prosperity, the author sees it as a period of tension and anarchism as well. Rouault and Matisse are used as two possible reactions to this situation. The former's view is religious and reformative, the latter's esthetic and escapist.

777. Zerner, Henri. "Matisse and the Colours of Light." *Times Lit. Supp.* 4677 (November 20, 1992): 13-14.

An extended review of the MoMA *Matisse Retrospective*, this essay reviews the installation favorably and calls Elderfield's catalogue essay "heroic" in the comprehensiveness of its aims. Zerner notes the importance of the esthetic break that occurs in Matisse's work with the Barnes mural, the importance of the scale of the cut-outs (not well represented in the show) which is not realized in the easel paintings of the forties, and the romantic elements that still permeate Matisse's aims.

778. Zervos, Christian. "Idéalisme et naturalisme dans la peinture moderne, Part IV: Henri Matisse." *Cahiers d'art* 3, 2 (1928): 158-63.

This essay, richly illustrated with mostly female portraits by Matisse, does not so much as mention the artist. Zervos makes the case for the plastic arts to recognize their relation to

instinct, always allied to the material, and to avoid the attempt to render infinity or the depths of the soul. Art has much to contribute to the spiritual life but must do so by drawing on sensible impressions. The plastic arts, when great, always result from the confrontation with two models, one exterior, the other interior.

779. Zervos, Christian. "L'importance de l'objet dans la peinture d'aujourd'hui." *Cahiers d'art* 5, 3 (1930): 113-120.

While earlier epochs were more concerned with nature in its grander, more cosmic aspects, the search for signs for animals and humans dominated the later ones. After the Renaissance's intense concentration on Man, the object began to be portrayed, especially in the Northern European countries, Flanders, the Low Countries and France, embodying a range of values. With Cézanne, genre divisions have disappeared, either objects, figures, or vistas being treated as plastic vehicles of emotion, real or ideal. Matisse and Picasso, moderns, do not imitate the object but produce in the spectator the effect that the object produced. While praising Matisse's recent work, Zervos states his yet higher regard for the incisive style of 1910-17, with its melodic line and sonorous color. Matisse reproductions from this earlier period.

780. Zervos, Christian. "Notes sur la formation et le developpement de l'oeuvre de Henri-Matisse. " *Cahiers d'art* 6, 5-6 (1931): 229-316. Flam, no.88, 269-71.

The author echos Matisse's belief that his work must be seen in its "organic" evolution, as a whole. His freedom is one of order, continuous volition, solidly supported by his deepest instincts, having a sharp sense of the real, and governed by his lucidity. Zervos places no value on innovation for its own sake; Matisse's shifts of style are based on self-knowledge. Shunning a search for "nervous jolts" of change, Matisse has continued the revolution undertaken by Cézanne; along with the Cubists, whose influences he absorbed, concludes Zervos, Matisse has made "the contemporary Paris school what it is today: the greatest in the world."

V

Individual Works

Painting, Paper Cut-Outs

Académie de l'Homme (Musée Cantini)

781. Cousinou, Olivier. "Un Achat des musées de Marseille: *L'Académie d'homme* (1900-1901) de Henri Matisse." *Rev. du Louvre et des Musées de France* 41, 1 (1991): 119-25.

Analysis of the work, recently acquired by the Musée Cantini, and an account of the artist's close study of Cézanne when the canvas was painted.

Annélies, White Tulips and Anemones (Honolulu Academy of Arts)

782. "Friends give Matisse Painting *Annélies, tulipes blanches, et anémones.*" *Honolulu Academy of Arts News Bull.* 8, 6 (June 1946): 1-2.

Museum News account of the acquisition of the canvas.

Apollo / Paper Cut-Out (Moderna Museet)

783. Ellenius, Allan. "I Apollons tecken." *Konstrevy* 2 (1969): 2, 92-94.

An interpetation of Matisse's *Apollon* with reference to sources in Bernard de Montfaucon's *Supplement au livre de l'antiquité expliquée et representée en figures, Vol. I, Les dieux des grecs et des romains* of 1724, particularly images of the fructifying Sun God, Apollo, on sarcophagus reliefs.

265

784. Cavallius, Gustaf. *Matisses Apollon, Ett collage om
 västerlandet och världen.* Göteborg, Sweden: Konst-
 vetenskapliga Institutionen Göteborgs Universitet, 1984. In
 Swedish.

 The first part of this article investigates the more formal
 elements of the composition; the second pursues a detailed
 iconographical referencing of the motifs of sun, sea, and
 rectangles to mythical figures of Apollo, Daphne, Phaethon,
 Marsyas, and Orpheus, as well as the figure of Christ.

785. Kéry, Bert-Alan. "Apollon och det mytologiska hos Matisse
 (Apollo and the Mythological in Matisse)." *Konsthistorisk
 Tidskrift* 56 (1987): 157-68. In Swedish with English
 summary.

 An interpretation of Matisse's *Apollon* based on the artist's
 habitual usage of mythological materials, for example, Icarus,
 Amphitrite, Venus. Draws on the antique sources identified in
 earlier Swedish literature on the piece. (Cf. Ellenius and
 Cavallius, nos. 783 and 784).

786. Lagerlöf, Margaretha Rossholm. "Bildtolkningen som
 metafor, en teori i ljuset av Matisses *Apollon* (Pictorial
 Integration as Metaphor)." *Konsthistorisk Tidskrift* 53
 (1984): 18-29. In Swedish with English summary.

 A study of divergent readings of Matisse's mural in order to
 explore the methodological problem of the interpretation of
 artistic images. A subtle argument is made for the potential
 integration or interaction of diverse interpretive sources in a
 process comparable to what occurs in metaphor.

787. Linde, Ulf. "Matisses *Apollon.*" *BLM* 26, 9 Stockholm
 (1957); also in *Henri Matisse, das plastische Werk.* Zurich:
 Kunsthaus, 1958. Exhibition catalogue.

 An interpretation of the *Apollon* mural in terms of the Apollo
 and Daphne myth as found in Ovid's *Metamorphoses.*

788. Prendeville, Brendan. "Theatre, Manet, and Matisse, the Nietzschean Sense of Time in Art. " *Artscribe* 14 (October 1978): 26-33.

Using the mural *Apollon* and the Chapel at Vence as examples of the Apollonian and Dionysian poles of Matisse's art, the author relates these works to Manet's theatricality and Nietzsche's notions of time, achieved--for the visual artist-- through dramatic space.

789. Wenneberg, Bo. *"Apollon* and the Aged Matisse." *Konsthistorisk Tidskrift* 58, 1 (1989): 22-23.

A short musing on the elderly Matisse who, with his "luggage packed up," waited for "the last train" and amused himself with new challenges in cut-paper "mélanges." Wenneberg finds these late compositions such as *Apollon,* in Bernard Shaw's phrase, "plays pleasant"-- compositions whose playful anarchy is often held in check by a symmetry that Matisse seldom used in his youth.

Apples (Still Life) (Art Institute of Chicago, ex. Marx)
790. "Double Matisse holiday: two monumental works enter American collections: *Studio [Quai Saint Michel]* acquired by Phillips gallery and *Nature morte [Apples]* acquired by S.A. Marx." *Art News* 39 (December 28, 1940): 6-7+.

Account of the acquisitions of the two works in question.

Arab Café (Hermitage)
791. Noghid, I. "The Restoration of Matisse's Painting Arab Coffeehouse." In *Bulletin of the Central Research Laboratory for Conservation and Restoration,* Moscow, 1970. In Russian.

A technical report on the state of the work and its restoration.

792. Sembat, Marcel. "Henri Matisse." *Cahiers d'aujourd'hui* 4 (April 1913): 185-94.

An important article by the socialist deputy of Montmartre which includes important remarks on the *Café Maure (Arab Café)* by both the author and Matisse.

Asia (Kimball Art Museum)
793. Moncrieff, Elspeth. "Art Market: A Look Back at 1992."
 Apollo 136 (December 1992): 412-13.

An article on the market which records the sale at Sotheby's of
Asia (1946) to Bill Acquavella, bidding on behalf of the
Kimball Art Museum, for $12.1 million.

Balthazar Castiglione (Bagnols-sur-Cèze)
794. Benjamin, Roger. "Une copie par Matisse du *Balthazar
 Castiglione* (Bagnols-sur-Cèze) du Raphael." *Rev. du Louvre
 et des Musées de France* 35, 4 (1985): 275-77.

A detailed historical account of one of the last copies that
Matisse painted (1904) in hopes of a sale to the State--its
actual purchase by the French government and the role played
by this Raphael canvas in the work of young painters of the
period. Author analyzes the influence of this portrait's
expressive arrangement of form on Matisse's subsequent
original portraiture.

Bather (Museum of Modern Art)
795. "Modern Museum to get a Matisse: *Baigneuse, fond bleu.*"
 Art News 34 (January 11, 1936): 14.

A note on the acquisition of the painting by the museum.

Bathers by a River (Art Institute of Chicago)
796. Bock, Catherine C. "Henri Matisse's *Bathers by a River.*"
 The Art Institute of Chicago Mus. Studies 16, 1 (1990): 44-
 55.

An iconographic interpretation of the painting in relation to
the wartime situation in which it was resumed and to artistic
problems relevant to the discourse on the future of Cubism in
1915-16.

797. Carrier, David. "'You, Too, Are in Arcadia': the Place of the
 Spectator in Matisse's *Shchukin Triptych.*" *Word & Image*
 10, 2 (April-June 1994): 119-137.

After reviewing the existing interpretations of *Bathers by the Stream,* the author turns to Leo Steinberg's analysis of Picasso's *Demoiselles d'Avignon* as a model for a new framework in which to consider the Matisse panel(s). That interpretive stategy is to investigate the role of the spectator in establishing the picture's unity and meaning. Carrier suggests that Matisse's *Bathers* presents an Arcadian image but one that is accessible from a spectator's position in the real world, thus presenting the unreachable as still able to be experienced in a bodily perceptual mode. A rich and evocative article.

798. Neff, John Hallmark. "Matisse and Decoration: the Shchukin Panels." *Art in Amer.* 63 (July-August 1975): 38-48.

An article of the first importance on the ensemble of paintings *Dance, Music* and (the original) *Bathers by a River.* Neff establishes convincingly that the third painting, *Bathers,* was originally intended by Matisse as part of a tri-partite program for Shchukin's staircase. (Neff also clears up the "studio" vs. "staircase" translation of Charles Estienne's interview with Matisse in 1909 in which Matisse speaks of the total program.) A very rich and complete treatment of the circumstances surrounding the commission.

799. Trapp, Frank. "Form and Symbol in the Art of Matisse *[Bathers by the River].*" *Arts Mag.* 49 (May 1975): 56-58.

A modified version of the more detailed and elaborate iconographical interpretation of this painting contained in the author's unpublished dissertation, *The Paintings of Henri Matisse, Origins and Early Development, 1890-1917,* no. 165.

Bathers with a Turtle (St. Louis Art Museum)

800. "Recent Acquisitions." *St. Louis Mus. Bull.* 1 (May 1965): 1.

A short note of the work's provenance and acquisition by the St. Louis Museum of Art.

801. [Chetham, Charles.] "Matisse's *Bathers with a Turtle* (City Art Museum, St. Louis)." *Burlington Mag.* 108, 755

(February 1966): 90. First published as Museum Monograph I, City Art Museum, St. Louis.

A note on the history of the painting's importance and its place in Matisse's artistic development.

802. Flam, Jack. *"Bathers with a Turtle."* *Art News* 89 (December 1990): 101-02.

Flam analyzes the work in terms of its powerful, expressive charge that "somehow seem[s] to affect your central nervous system" when viewing the work. He points up the work's unresolved, hence intriguing, formal and iconographic aspects and offers an original interpretation based on "primitivism and notions of becoming," comparing it to Picasso's *Three Women* of the same year.

803. Rousseau, Claudia. "'Une Femme s'honore par son silence;' sources et signification de *Baigneuses à la tortue* de Matisse," *Rev. de l'art* 92 (1991): 76-86.

A careful tracing from classical times of the motif of the woman with a turtle at or under her foot as a symbol of womanly silence, obedience, and passivity. In combination with the gesture of self-silencing in the central figure in *Bathers with a Turtle,* the animal accords with conventional precepts for married women to be silent and submissive, but-- in the early twentieth century--the "new woman" may have looked with dread on this stultifying role. The author makes good use of the possibility that Gauguin's views of women (and the terrifying limitations in their sexual choices) and his symbolic representations of them may have had an impact on Matisse's allegorical portrayals of nude figures from 1907 to 1910. Rousseau plausibly implicates the two versions of *Luxe I* and *II* in her interpretation of this work. An erudite and, on the whole, convincing iconographical interpretation of the work.

Beasts of the Sea (National Gallery of Art)

804. Cowart, Jack. "Matisse's Artistic Probe: The Collage." *Arts Mag.* 49, 9 (May-June, 1975): 53-55.

A careful, mostly formal analysis of the cut-paper composition *Les bêtes de la mer* under the larger context of its collage traditions. Author also relates the cut-paper work to other contemporary projects.

805. Cappadonna, Diana A., and Thomas A. Kane. "Textures of the Spirit: the Arts of Fantasy." *Liturgy* 24:1 (January 1979): 20-25.

Authors relate the joys of artistic experience, particularly in modern art, to a religious perspective of incarnational theology. Matisse's cut-paper work is highlighted, along with works by Miro, Caro, Calder, Arp, Noguchi, and Motherwell, by being reproduced along with an original haiku for each work.

Blue Nude, Souvenir of Biskra (Baltimore Museum of Art)

806. Cone, Edward T. "Aunt Claribel's *Blue Nude* Wasn't Easy to Like." *Art News* 79 (September 1980): 162-63.

An anecdotal memoir by Claribel Cone's nephew, a composer and professor of music at Princeton, of his first introduction to the painting in 1928 when he was eleven years old. His discussion includes a mature appreciation of the work from his present perspective.

807. Hoog, Michel. "*Les Demoiselles d'Avignon* et la peinture à Paris." *Gaz. beaux-arts* 6, 82 (October 1973): 209-16.

In an article on the sources and influences on Picasso's landmark painting, Hoog positions Matisse's *Blue Nude* as a major challenge to Picasso and as an example of a new primitivism of style and content.

808. Williams, William Carlos. "A Matisse." *Contact* (January 1921). Reprinted in *The William Carlos Williams Reader*. New York: New Directions, 1931.

An essay written around 1920 in remembrance of seeing *Blue Nude* at the Exhibition of Modern Art at the Montross Gallery

in New York in 1915. It begins: "On the French grass, in that
room on Fifth Ave., lay that woman who had never seen my
own poor land," thus conflating an experience of the image in
the painting, an American response to it, and the process by
which the meaning of an art work expands experientially.

Blue Nude I , Gouache Découpée (Beyeler Collection)

809. Elderfield, John. "Henri Matisse, *Blue Nude I,* 1952." In
*European Master Paintings from Swiss Collections, Post-
Impressionism to World War II,* 76. New York: Museum of
Modern Art, 1976. Exhibition catalogue.

Catalogue commentary on the work, relating it to the pictorial
framework of painting and the direct carving of sculpture.

810. Cassou, Jean. *Henri Matisse: Carnet de dessins* . 2 vols.
Paris: Huguette Berès and Berggruen & Cie, 1955.

Two slip-cased volumes, one of which is a facsimile of
Matisse's notebook sketches for his first series of *Blue Nudes
I-IV.* The second volume, a long essay on the artist, does not
deal specifically with the works illustrated. See no. 224 for
summary of the text.

Blue Still Life (Barnes Foundation)

811. Flam, Jack. *"Blue Still Life (Nature morte bleue)."* In *Great
French Paintings from the Barnes Foundation,* 240-241. New
York: Knopf and Lincoln University, 1993.

First color reproduction of this painting, with related works
and accompanying catalogue entry.

Blue Window (Museum of Modern Art)

812. Tomás, F. "Para una iconologia de la pintura del siglo XX: la
ventana." *Cimal* (Spain) 19-20 (July 1983): 6-12.

In a larger treatment of the window as a particularly key
iconographic theme in twentieth-century art, the author
discusses Matisse's *Blue Window* and *Woman with a Parasol.*
Other artists discussed are René Magritte, Louis Bou, Angeles

Marco, and Rafael Marti Quinto. The relation of the window to ideas about painting are traced back to the Renaissance.

813. Breton, André, and Philippe Soupault. "La Glace sans tain." *Littérature* 8 (October 1919).

This poetic fragment from *Les Champs magnétiques,* published very early in the proto-Surrealist journal, bears the same name as Matisse's *Blue Window,* known at first by the title *La Glace sans tain.* The work had been commissioned by Jacques Doucet, who then refused it as too difficult for his level of appreciation; Breton was at this time Doucet's secretary.

Boy with a Butterfly Net (Minneapolis Institute of Art)

814. "Institute Purchases: Paintings by Matisse and Kirchner." *Minneapolis Institute Bull.* 42, 6 (February 7, 1953): 26-29.

Currently exhibiting Matisse's *Boy with a Butterfly Net* and Kirchner's *Franzi,* both recently acquired by the Minneapolis Institute of Art, from the *Les Fauves* show, the author links them with the end of Fauvism in 1907 and with the beginning of Cubism. A comparison is made between the artists, the German movement *Die Brücke* and Fauvism, and the formal qualities of each painting. *Franzi* is now, of course, generally accorded a later date.

815. "Institute's New Matisse: *Boy with a Butterfly Net.*" *Minneapolis Instsitute Bull.* 42, 7 (February 14, 1953): 33.

A note suggesting that the importance of the painting as a Fauve work is attested to by its wide exhibition record, especiallly before 1933, and its reproduction in important books and periodicals. A complete provenance is given.

The [Lorraine] Chair with Peaches (Private Collection)

816. Elderfield, John. "Henri Matisse, *The Chair with Peaches,* 1919." In *European Master Paintings from Swiss Collections, Post-Impressionism to World War II,* 74. New York: Museum of Modern Art, 1976. Exhibition catalogue.

Sensitive formal and iconographic interpretation of the painting in the brief format of a catalogue commentary.

La Coiffure (Staatsgalerie, Stuttgart)

817. Jedlicka, Gotthard. *Henri Matisse: La Coiffure.* Series: Werkmonographien zur Bildenden Kunst. Stuttgart: Philipp Reclam, 1965.

A very general treatment of the work in the context of Matisse's overall development, not the usual presentation of possible "sources," preliminary sketches, studies, etc.

818. Rau, Bernd. "Henri Matisse und Auguste Renoir--eine schöpferische Begegnung." In *Studien zur Kunst, Gunther Thiem zum 60. Geburtstag,* 45-50. Stuttgart: Ed. Cantz, 1977.

La Coiffure is compared to Renoir's 1883 painting of the same name, within a more general comparison of the two artists.

Conversation (Hermitage)

819. Schneider, Pierre. "Striped Pajama Icon *[Conversation]."* *Art in America* 63, 4, (July 1975): 76-82; in French, "Le quoi et le comment: *Conversation* d'Henri Matissse." *Tel Quel* 65 (1977): 56-71.

Schneider formally compares the work's color and facture to Byzantine enamels, thus encouraging an interpretation of the work which stresses its sacral character and the harmony of the figures on either side of the theophanic window. Schneider discusses Kandinsky's ideas on the "spiritual in art" relating to Matisse and the problem of the "what" (bourgeois reality) and the "how" (pure painting) of modern art that is brought to a point of tension, and revelation, in *Conversation.* The discussion is elaborated in Schneider, no. 157, 14-24.

820. Flam, Jack. *"Conversation."* In *Matisse, the Man and his Art,* 248-52. Ithaca and London: Cornell University Press, 1986.

An interpretation of the work which references the the *Stele of Hammurabi* of c. 1760 B. C. (Louvre) as a parallel to the

stances of the two figures, indicating a theme of alienation and confrontation between them.

Dance (1) (Museum of Modern Art)

821. "Entering Public Domain: New York," *Art News* 62 (November 1963): 40.

A note on the acquisition and exhibition of Matisse's *Dance I,* previously in the Chrysler Collection and purchased by Nelson Rockefeller to be given to the Museum of Modern Art in honor of Alfred Barr, Jr.

822. "Matisse's *La Dance.*" *Art Digest* 11, 3 (November 1, 1936): 23.

An announcement of the exhibition of the sketch for the Shchukin mural, *Dance I,* at the Pierre Matisse Gallery, along with photographs of *Dance II* installed in the Russian collector's home. In the history of the two works, the article emphasizes the Farandole, a Montmartre nightclub dance, which was reputed to have inspired Matisse's more generalized versions of dancing figures.

823. Davidson, Martha. "Matisse's Allegory of the Dance." *Art News* 35 (November 7, 1936): 13-14.

An article, written on the occasion of the Pierre Matisse Gallery exhibition of Matisse's *Dance I* (not shown since 1912), with related works including *Music (Sketch)* 1907, *Bather* (1909), *Nasturtiums and Dance,* and a drawing of Shchukin, as well of photographs of the latter's rooms with Matisse's work on the walls. With all this related material on view, the author analyses the motif, its sources and the stylistic development that led Matisse to this mural mode of simplification and abstraction. An important and intelligent assessment of Matisse at a crucial moment in American art.

Dance (11) and **Music** (Hermitage)

824. Carrier, David. "'You, Too, Are in Arcadia': the Place of the Spectator in Matisse's *Shchukin Triptych.*" *Word & Image* 10, 2 (April-June 1994): 119-137.

After reviewing the existing interpretations of *Bathers by the Stream,* the author turns to Leo Steinberg's analysis of Picasso's *Demoiselles d'Avignon* as a model for a new framework in which to consider the Matisse panel(s). That interpretive stategy is to investigate the role of the spectator in establishing the picture's unity and meaning. Carrier suggests that Matisse's *Bathers* presents an Arcadian image but one that is accessible from a spectator's position in the real world, thus presenting the unreachable as still able to be experienced in a bodily perceptual mode. A rich and evocative article.

825. Edson, Laurie. "Rimbaud's *Une Saison en enfer* and Matisse's *La Danse." Romanic Review* 74 (November 1983): 461-74.

A literary critic isolates aspects of Rimbaud's project as gleaned from his text, *Une Saison en enfer* and compares these with apparently similar strategies in Matisse's canvas, *Dance.* Rather than seek thematic closure, symbols, or definitive interpretations, the author sees Rimbaud's text as a site of semantic play, a scene of the production of meaning that is ongoing and dynamic. "The text is characterized by dislocation, fragmentation, multiplicity, experimentation, and . . . a powerful and intense language which moves forward, doubles back on itself, watches itself, wanders off, and continually seeks its own threads." The poet role-plays, performs, dances, repetitively falls silent, leaves the spectator to fill the gaps. The author finds Matisse's painting, also a dance where the gap between two of the dancers invites spectator participation, displays the aggressive mobility and the emphasis on the language of painting (pure color, rhythmic line, expressive distortion) that one finds in the poem. Both are open texts that invite participation but frustrate the desire for unequivocal meaning.

826. Farese-Sperken, Christina. *"La Danse* di Matisse e l'arte tedesca." *Arte Illustrata* 53 (May 1973):143-47

An article which discusses *Dance* in relation to other moderns who essayed the same theme: Max Pechstein in an aquatint of 1912, Fernand Hodler in sketches for *Floraison* in 1910-14,

and E. L. Kirchner in a late xylographic print of 1936--all of these strongly linear in character, utilizing this aspect of Matisse's work while ignoring the place of color. Archipenko, in a sculpture called *Dance* of 1912, grasps more of the spatial lesson of Matisse's "ronde."

827. Fourcade, Dominique, and Éric de Chassey. *"La danse II,* fin 1901-1910." In *Henri Matisse 1904-1917,* 461-73. Paris: Centre Georges Pompidou, 1993. Exhibition catalogue.

A collection of comments by Matisse, various critics, and writers on the *Dance* [and *Music]* from 1910 to 1950. A marvelously rich compilation of material.

828. Girard, Xavier. *Matisse, La Dance.* Nice and Cannes: Musée Matisse and La Malmaison, 1993. Cahiers Henri Matisse, 10.

Girard's extended catalogue essay is more broadly on the theme of "Dance" in Matisse's work, beginning with *Luxe, Calme et Volupté* of 1904 and culminating in his late cut-outs--dance as "a dream of respite and magnified intensity." Some ten pages (31-50) are devoted to *Dance* and *Music.* Overall, the author brings out Matisse's musical and theatrical interests, his association of dancers with primitive and pastoral landscapes, and the artist's own décors and costumes for Diaghilev's ballet productions of 1920 and 1937. The essay is illustrated with the dance-related works from the Musée Matisse in Nice that were exhibited in Nice and Cannes in 1993.

829. Hori, Hidehiko. *"Luxury* and *Dance. "Mizue* 913 (April 1981): 58-61. In Japanese.

Author compares *Luxe I* (1907) and *Dance* (1931-32) with bather paintings by Cézanne and with Picasso's *Demoiselles d'Avignon.* Matisse distinguishes himself from Cézanne's search for the essential and Picasso's extreme reductionism.

830. Klimov, Rostislav. "Tanec i muzyka Matissa: koncepcija i mesto v hudozestvennom processe [Matisse's *Dance* and *Music:* Their Conception and Their Place in the Artistic

Process]," *Sovetskoe iskusstvoznanie* 25 (1989): 147-63.
English summary.

A subtle and complex analysis of the change in Matisse's
work around 1910, as exemplified most dramatically in *Dance*
and *Music*. Author claims the artist first reacted strongly to
the pressures of his environment (nature) and projected this
reaction on the screen of the canvas. Across the screen and the
viewer's space a reciprocal relation is generated. Matisse never
loses the sense of the real milieu as a kind of emanation of
himself--the nature / artist link is never completely broken (as
in Cubism). Matisse's work, however, evolves into
something more objective: the canvas surface becomes an
enclosed but flowing system that radiates force through its
own constitutive elements. Thus the canvas becomes, not
only or not so much, the emanation of the artist's expression
but the source of an outflow of energy to the viewer.

831. Kostenevich, Albert. "*La Danse* and *La Musique* by Henri
 Matisse, a New Interpretation." *Apollo* 100, 154 (December
 1974): 504-13.

 Matisse's painting seen in relation to Nietzschean ideas of the
 Apollonian and Dionysian principles, themes which also drew
 other turn-of-the-century symbolist painters. He offers a
 different thesis from Neff (no. 833) on the initial conception of
 the three-painting ensemble of *Dance, Music,* and *Bathers by a
 River* in relation to Shchukin's needs.

832. Kostenevich, Albert. "Matisse and Shchukin: A Collector's
 Choice," *Art Institute of Chicago Mus. Studies* 16, 1 (1990):
 26-43+.

 Author provides a great deal of new biographical material on
 Matisse's Russian patron, along with documentation on his
 purchases from the painter. Author convincingly demonstrates
 that the two--artist and patron--were singularly attuned to one
 another as their lives passed through notable changes just
 before World War I.

833. Neff, John Hallmark. "Matisse and Decoration: the Shchukin
 Panels." *Art in America* 63 (July-August 1975): 38-48.

 An article of the first importance on the ensemble of paintings
 Dance, Music and (the original) *Bathers by a River*. Neff
 establishes convincingly that the third painting, *Bathers*, was
 originally intended by Matisse as part of a tri-partite program
 for Shchukin's staircase. (Neff also clears up the "studio" vs.
 "staircase" translation of Charles Estienne's interview with
 Matisse in 1909 in which Matisse speaks of the total
 program.) A very rich and complete treatment of the
 circumstances surrounding the commission.

834. Ratcliff, Carter. "In Detail: Matisse's *Dance.*" *Portfolio* 3, 4
 (July-August 1981): 38-45.

 Author discusses both version of *The Dance* and *Music* in the
 context of their importance for modern painting and their role
 in Matisse's career. The theme of the Golden Age is also
 analysed along with its modern translators--all preceding
 Matisse's adoption of it, namely, Gauguin, Van Gogh, and
 Puvis de Chavannes.

 The Dinner Table (Private Collection)
835. "Edward G. Robinson acquires Matisse's *La Desserte.*" *Art
 Digest* 14 (May 1, 1940): 16.

 A note on the actor's acquisition of the painting.

836. "Hollywood: Matisse's *La Desserte* for Robinson Collection."
 Art News 38 (April 13, 1940): 17.

 A note on the purchase of the painting by the Hollywood
 collector.

837. Refsum, Tor. "Møte med Matisse [Meeting with Matisse]."
 Kunst og Kultur (Norway) 58, 2 (1975): 65-78.

 A comparison between *The Dinner Table* and *Harmony in Red,*
 works of radically different style though only ten years
 separates their making. Author traces the development of the
 painter's work in that decade.

838. *Mir Iskusstva* 2, 8-9 (1904): 243. Painting reproduced; from
 Matisse's one-man show at Vollard's. First work of Matisse
 to be reproduced in Russia.

Europa and the Bull [Abduction of Europa]
(National Gallery of Art, Australia)

839. Cooke, L. "Henri Matisse: *Europa and the Bull.*" *Art and
 Australia* 20, 1 (Spring 1982): 54-55.

A splendid and complete iconographic and stylistic analysis of
this work in a brief essay. The author relates the pose of the
figure of Europa to other works by Matisse and argues the
importance of this 1929 "turning-point" canvas that, harking
back to the great decorative works of his youth and presaging
the figures in the Barnes Foundation mural, remained in the
artist's studio until his death.

840. Monahan, Laurie J. "Taming Violence: *Europa,* Matisse and
 Myth." In *Henri Matisse.* Eds., Roger Benjamin and Caroline
 Turner. Brisbane: Queensland Art Gallery and Art Exhibitions
 Australia, 1995.

An investigation of the re-appearance of mythic themes in
Matisse's work around 1930, with special emphasis on his
The Abduction of Europa with its theme of potential sexual
violence. The author relates this to the political situation of
the time and the surrealists' response to it. Author traces the
same themes in the work of André Masson, who was in close
contact with Matisse in those years.

841. Moore, Felicity St. John. "New Light on *The Rape of Europa*
 by Henri Matisse." *Art and Australia* 24, 4 (Winter 1987):
 477.

Author suggests that the theme of the abduction of Europa
may have been tied to Matisse's move to a larger, light-
drenched space when he moved into the top floor of his
building in 1927. Since the figure of Europa is derived from
his sculpture of Henriette Darricarrère, *Large Seated Nude,* the

work may also be linked to his feelings when this long-time model left him to get married in the same year.

Festival of Flowers (Cleveland Museum of Art)

842. Francis, H. S. *"Fête des fleurs, Nice,* acquired by the Museum." *Cleveland Museum Bull.* 34 (April 1947): 68-70.

A note on the acquisition of the painting, a short biography of the artist, and an appreciative analysis of the work. The sitters are erroneously named as Mme Matisse and the artist's daughter, Marguerite.

Flowers and Ceramic Plate (Städelsches Kunstinstitut, Frankfurt)

843. "Kirkeby Collection at Auction." *Arts* 33 (November 1958): 32-35.

Full-page color reproduction with short commentary on the painting's history and style.

844. Demski, Eva. "Mein imaginäres Museum oder Exil auf dem Dachboden." *ART: das Kunstmagazin* 3 (March 1990): 48-57.

Author would include this painting by Matisse in her ideal twelve-item personal museum of art works liberated from local galleries and museums in the city of Frankfurt Am Main. A critique of holding works, out of context, in museum collections.

French Window at Nice (Barnes Foundation)

845. Flam, Jack. *"The French Window at Nice (Les persiennes)."* In *Great French Paintings from the Barnes Foundation,* 264-67. New York: Knopf and Lincoln University, 1993.

First color reproduction of this painting, with related works and accompanying catalogue entry that discusses the conservative and national political views of 1920s and the resulting commentaries on the work.

Game of Dominoes

846. "Notable Works of Art Now on the Market." *Burlington Mag.*
 98 (June 1956): supp 3.

 Photo and short commentary on this Marlborough-owned
 canvas of two women playing dominoes of 1919, a not well-
 known work, then for sale.

 Girl Reading (Museum of Modern Art)
847. "Coming Auctions." *Art News* 69, 6 (October 1970): 39.

 Note on forthcoming works to be auctioned at Sotheby's on
 October 14, 1970; Matisse's work, in the Goetz Collection, is
 highlighted.

848. Elderfield, John. "Recent Acquisitions: Museum of Modern
 Art, New York." *Artforum* 9 (June 1971): 78.

 Girl Reading is highlighted in a general treatment of the
 acquisitions.

 Goldfish (Pushkin Museum)
849. Perrone, Jeff. "Hokyo (Jewelled Mirror) Samadhi
 (Meditation)." *Arts Mag.* 59, 3 (November 1984): 84-89.

 A highly poetic collage of texts on the place of the goldfish in
 Chinese life and art, followed by a zen-like examination of the
 subtle meanings that can be read from Matisse's 1911-12
 painting, *Goldfish.*

 Goldfish and Sculpture (Museum of Modern Art)
850. "A Life Round Table of Modern Art." *Life* 25 (October 11,
 1948): 60-61, 69.

 In *Life* magazine's "symposium" on the nature and value of
 modern art, Matisse's work is illustrated in color and briefly
 discussed by Georges Duthuit in terms of its formal elements.
 Later, it is heralded by the English critic Raymond Mortimer
 for its intense affirmation of the richness of life and of sensible
 pleasure.

851. Reff, Theodore. "Matisse: Meditations on a Statuette and
 Goldfish." *Arts Mag.* 51, 3 (November 1976): 109-15.

A detailed discussion of the motifs of goldfish, the sculpture of
a reclining nude, and the open doorway or window in a number
of Matisse paintings, primarily those in the Museum of
Modern Art collection. Far-ranging and erudite in its
references, Reff's article entails both iconographic and formal
interpretation and relates these motifs to classical arcadian
themes, to the art of and experience in the Middle and Far East,
and to their precedents in Cézanne's oeuvre. An article of the
first importance for all works using these motifs.

Harmony in Red (Hermitage)
852. Gowing, Lawrence. "Henri Matisse, *Harmony in Red*."
Washington, D. C.: National Gallery of Art, 1986. Pamphlet
published in conjunction with the exhibition *Impressionist to
Early Modern Paintings from the U.S.S.R.: Works from the
Hermitage Museum, Leningrad, and the Pushkin Museum of
Fine Arts, Moscow*, 1986.

An elegant iconographic and historic treatment of this
important work in which the author gives, for the first time in
print, the name of Matisse's common-law wife, Caroline
Joblaud, the mother of Marguerite Matisse. He links this
work to the earlier *La Desserte* of 1897, in which Joblaud was
the actual model, according to Gowing, positing a nostalgic
sentiment in the later work which constitutes an aspect of its
expressivity.

853. Refsum, T. "Møte med Matisse [Meeting with Matisse]."
Kunst og Kultur (Norway) 58, 2 (1975): 65-78.

A comparison between *The Dinner Table* and *Harmony in Red*,
works of radically different style though only ten years
separates their making. Author traces the development of the
painter's work in that decade.

Harmony in Yellow
854. Moncrieff, Elspeth. "Art Market: a look back at 1992."
Apollo 136 (December 1992): 412-13.

An article on the market which records the sale of at Sotheby's
of *Harmony in Yellow* (1927-28) for $14. 5 million.

855. Findlay, Michael. *"L'Harmonie jaune* by Matisse." *Christie's Review of the Season [1992 auctions]* (1993): 86-87.

An account of the painting and its record sale.

856. "The New Reality," *Art News* 92 (January 1993): 89-91.

In an article more generally on the disappointing auction prices of recent years, Matisse's *Harmony in Yellow* in pictured in color with its sale price of $14.5 million as an exception to the trend.

The Hindu Pose
857. Vogel, Carol. "Art Auction Stakes Rise Again," *New York Times*, 1995.

Author notes the sale of *The Hindu Pose* from the Stralem Collection for $14. 8 million, a record for Nice period works.

The Idol (Koerfer Collection, Bern)
858. Elderfield, John. "Henri Matisse, *The Idol (Portrait of Madame Matisse),* 1906." In *European Master Paintings from Swiss Collections, Post-Impressionism to World War II,* 72. New York: Museum of Modern Art, 1976. Exhibition catalogue.

Mostly formal discussion of the work in a catalogue commentary that positions its style in relation to evolving Fauve techniques.

Interior at Nice (St. Louis Art Museum)
859. "St. Louis buys *Interior at Nice." Art Digest* 20 (December 15, 1945): 6.

A note on the details of the canvas's acquisition.

860. *"Interior at Nice,* by Henri Matisse Recently Purchased by the City Art Museum of St. Louis." In *Pictures on Exhibit* 8 (January 1946): 1.

A short notice on the acquisition and display of this work.

Interior with Black Notebook (Private Collection, Switzerland)

861. Hahnloser, Hans R. "Werke aus der Sammlung Hahnloser." *Du* 16 (November 1956): 23-24.

A personal commentary on this work by collectors who were friends of Matisse.

Interior with Eggplants (Musée de Grenoble)

862. Fourcade, Dominique. "Rêver à trois aubergines." *Critique* 30, 324 (1974): 467-89.

An exhaustive and important treatment of this painting as to its provenence, its physical state and the circumstances of the removal of its decorative frame, its place in the artist's decorative oeuvre, and the iconography of the work's style. Fourcade argues that the composition's expansiveness, lack of center (or omni-centeredness), its equality of emphasis and incident, its multiple internal framings, all convey an experience of unhierarchized and mobile freedom and openness- - both of the spectator's gaze and of the fabricated picture-object itself. The picture is both an example and an image of unalienated production and its happiness.

Interior with Egyptian Curtain (Phillips Gallery)

863. *"Interieur au Rideau Egyptien* 1948: Henri Matisse in mostra a Roma a Villa Medici." *Domus* 592 (March 1979): 48.

A short commentary on the flat, highly-colored, formally rigorous style of this work, not on the specifics of the painting. In Italian, French and English.

Interior with Etruscan Vase (Cleveland Museum of Art)

864. Ballou, M. G. *"Interior with Etruscan Vase* by Matisse." *Cleveland Museum Bull.* 39 (December 1952): 239-40.

A fine short description of the work, setting it into its historical context--during the "phony war" of 1939-40, just before the occupation of France--and its stylistic context in terms of the artist's Nice oeuvre.

Interior with Goldfish (Barnes Foundation)

865. Flam, Jack. *"Interior with Goldfish (Poissons rouge: Intérieur)."* In *Great French Paintings from the Barnes Foundation,* 242-45. New York: Knopf and Lincoln University Press, 1993.

First color reproductions of this painting, with accompanying catalogue entry that discusses the theme and style in relation to other works in the artist's oeuvre.

Joy of Life (Barnes Foundation)

866. Barnes, Albert C. "Matisse." In *The Art in Painting,* 535-36. New York: Harcourt Brace, 1925, 1928.

A totally formal assessment of the plastic relations of this work which, while admirably "flat" and "highly decorative," transcends "mere decoration" by its "structural elements of plastic form," that is, its suggestion of modeling, deeper space, and rhythmic complexity.

867. Barr, Alfred H., Jr. "Matisse, Picasso, and the Crisis of 1907." *Mag. of Art* 44 (May 1951): 161-170.

Distillation of two chapters of Barr's monograph, *Matisse, His Art and His Public*, published later the same year. *Bonheur de Vivre* and *Demoiselles d'Avignon* are contrasted as aspects of the style and personality of the two friendly rivals who were both drawing on aspects of Cézanne.

868. Cuno, James B. "Matisse and Agostino Carracci: A Source for the *Bonheur de Vivre.*" *Burlington Mag.* 122 (July 1980): 503-505.

Reviews the sources for *Bonheur de Vivre (Joy of Life)* suggested in the literature and offers Agostino Carracci's reproductive engraving *Reciprico Amore* (dated between 1589 and 1595) as a possible source for Matisse's painting. It and its pendant, *Love in the Golden Age*, are images in reverse after paintings attributed to Paolo Fiammingo.

869. Dagen, Philippe. "L'Age d'or: Derain, Matisse et *Le Bain Turc.*" *Bull. du Musée Ingres* 53 (1984): 43-54.

Matisse's *Joy of Life* and Derain's *Golden Age* are discussed in terms of the influence of Ingres's *Turkish Bath* on their style and iconography around 1905-1906. Matisse's painting is respectful of Ingres's work, using it to go beyond *Luxe, Calme, et Volupté* in artificial style, while achieving a greater classicism in its arcadian subject matter. The author reads Derain's canvas, however, as a critique of both Ingres and Matisse; it ironically pits a foreground of torment against the "golden age" middle ground, of weepers against dancers, of Ingres-figures against Chéret-poster look-alikes.

870. Flam, Jack. *"Le Bonheur de Vivre (The Joy of Life)."* In *Great French Paintings from the Barnes Foundation,* 226-35. New York: Knopf and Lincoln University Press, 1993.

An extended catalogue essay that presents the most recent scholarship on the work, illustrates the painting in color for the first time along with all related sketches and studies, and touches (necessarily briefly) on interpretations of this major work and the problematics of its style.

871. Giry, Marcel. "Ingres and Fauvism," In *Actes du Colloque international Ingres et son influence* (1980): 55-60.

Traces the influence of Ingres on Fauvism via the exhibition of sixty-eight of his works at the Salon d'Automne. A drawing for the *Golden Age* was undoubtedly seen by Matisse who was beginning his *Joy of Life*.

872. Gottlieb, Carla, *"The Joy of Life:* Matisse, Picasso, and Cézanne." *College Art Journal* 18 (Winter 1959): 106-116.

The author examines the formal and iconographic aspects of Matisse's painting under the aegis of the lessons learned from Cézanne and of a rivalry between him and Picasso (who produced his *Demoiselles d'Avignon* shortly after seeing *The Joy of Life*). Cézanne's desire to indicate depth yet retain a homogeneous surface in which space is made tactile, his use of

color to modulate volume, his desire to realize sensation and
perception were influential on both Matisse and Picasso from
1906 through 1910. While Matisse retained fluidity and depth
through his outlines and colored surfaces, Picasso maintained
the structure of objects and was faithful to his intellectual
perception of them, thus mounting a criticism of Matisse's
"use" of Cézanne's lessons. In terms of subject matter, too,
Picasso cynically turns Matisse's idyllic *Joy of Life* into a
harsh portrait of "filles de joie," prostitutes. An ambitious and
insightful study.

873. Puttfarken, Thomas. "Mutual Love and Golden Age: Matisse
 and 'gli Amori de Carracci'." *Burlington Mag.* 124, 949
 (April 1982): 203-208.

A learned gloss on the four engravings (and their source
paintings in Vienna) from which Matisse may have taken his
composition for his *Joy of Life.* Puttfarken accepts Cuno's
earlier suggestion (no. 868) that the first of the four
engravings, *Reciprico Amore,* was Matisse's visual source, but
retitles it as *Love in the Golden Age,* on the basis of the
quatrains inscribed below the engravings and on the traditional
cycles of Love in successively Golden, Silver, Bronze and Iron
Ages, derived from literary sources.

874. Werth, Margaret. "Engendering Imaginary Modernism: Henri
 Matisse's *Bonheur de Vivre.*" *Genders* 9 (Fall 1990): 49-74.

The author examines Matisse's engagement with Western
traditions of the utopic, the pastoral, and the Golden Age in
terms of the complex ways this mode embodies ideas of repose
and erotic pleasure, and the tension between these and
contemporary social and psychic realities. In Matisse's work
the tension arises from the shifting boundaries of the pastoral
mode itself and Matisse's modern appropriation of it, his
figuration of sexuality and gender, and the consequent
destabilization of the viewer's (gendered) relation to the image.
Werth convincingly reads the lack of unity in style, tone, and
figuration (in this theme that proposes a myth of unity and
harmony) as representing bisexual figures of desire, open

ciphers on which the viewer is invited to project his or her own desire. The merging couple at the lower right, in particular, are read as a primal intrauterine fantasy of unity, combining issues of maternal seduction, castration, and the primal scene. Werth posits Matisse's unsettling conjoining of traditional meanings and a thoroughly modern psychic self-consciousness, as "an unembarrassed apology for infantile satisfactions and Dionysian joys." An important, ground-breaking study.

Landscape: Broom (Haas Collection)

875. Bishop, Janet. "Highlights from the collection: *Paysage: les Genêts.*" In *Matisse and other Modern Masters, the Elise S. Haas Collection.* Eds., John Lane and Janet Bishop. San Francisco: San Francisco Museum of Modern Art, 1993. Exhibition catalogue.

A short, astute commentary on the painting with a fine color reproduction.

Large Red Interior (Musee National d'Art Moderne)

876. Gouk, Alan. "Essay on Painting," *Studio* 180 (October 1970): 145-49.

The debt of several "colorist" painters (Jackson Pollock, Hans Hofmann, Mark Rothko, Clyfford Still, Morris Louis, Kenneth Noland, and Jules Olitski) to Matisse is detailed in a fine analysis that, while it challenges certain American interpretations of the new color painters, is in its way dependent on the analysis of figure-ground, drawing-color, volume-planarity, abstraction-image problems that surfaced in American criticism around 1970. Matisse's work, such as *Large Red Interior,* is the boldest and most successful of all, having the "hieratic chromatic splendor, barbarism, and fierce impulse" that much contemporary work lacks. The contemporary Americans solve some problems by suppressing others; Matisse's painting, on the other hand, keeps them all edgily in play.

877. Greene, David B. "Consciousness, Spatiality and Pictorial
 Space." *Journal of Aesthetics and Art Criticism* 41, 4
 (Summer 1983): 375-86.

 Matisse's *Large Interior in Red* (1948) and Perugino's *The
 Delivery of the Keys* (1482) are contrasted as examples of
 Newtonian and post-Newtonian conceptions of space, deriving
 from views of consciousness. Sartre's (and Heidegger's)
 positions are brought to bear on a close spatial analysis of the
 works.

878. Nakahara, Y. "Approaching Walls, Retreating Paintings."
 Mizue 913 (April 1981): 51-8. In Japanese.

 With the late *Large Red Interior* (1948) as his starting-point,
 the author examines other major "studio" works in which wall,
 windows, and paintings on walls exchange functions as the
 space is experienced by the viewer. Matisse's own statements
 are utilized, and comparisons made with other artists such as
 Léger, Gris, Chagall, Picasso, and others.

 Lorette in Turban and Yellow Vest (National Gallery
 of Art, Washington, D.C.)

879. Cooke, H. L. "Henri Matisse's *Lorette* acquired by the
 National Gallery of Art, Washington, D.C.," *Burlington Mag.*
 107 (September 1965): 488.

 A note on the acquisition of the work by the National Gallery.

 Lorette with Long Locks of Hair (Norton Gallery and
 School of Art)

880. Flam, Jack D. "A Comment on the Matisse Paintings in the
 Norton Gallery and School of Art." *Norton Galleries Studies*
 2 (Art Museum of Palm Beach), 1973.

 A full discussion of the work in a broad formal, iconographic
 and historical context.

 Luxe, Calme et Volupté (Musée Nationale d'Art
 Moderne)

881. Bock, Catherine C. "Matisse, Signac, and Cross in 1904." In *Henri Matisse and Neo-Impressionism, 1898-1908,* 63-84. Ann Arbor: UMI Research Press, 1981, no. 61.

Within a larger study of the effect of Neo-Impressionism on Matisse's theory and practice, the author closely examines the situation surrounding the painting of *Luxe, Calme et Volupté* --technically and iconographically.

882. Herbert, Robert. *Neo-Impressionism,* 23-25, 215-18. New York: The Solomon Guggenheim Foundation, 1968. Exhibition catalogue.

In a splendid study of the new phase of divisionism after Seurat's death, Herbert is the first to place Matisse's "conversion" to the technique in the wider historical framework of pointillism's reincarnation in the early twentieth century under Signac's leadership.

Luxe I (Musée Nationale d'Art Moderne)
Luxe II (Statens Museum for Kunst)

883. Hori, Kôsai. *"Luxury* and *Dance." Mizue* 913 (April 1981) 58-61. In Japanese.

The author, a painter inspired by Matisse, compares *Luxe I* (1907) and the Paris *Dance* (1931-32) with bather paintings by Cézanne and with Picasso's *Demoiselles d'Avignon.* Matisse distinguishes himself from Cézanne's search for the essential and Picasso's extreme reductionism. Unlike Cézanne, Matisse is a finder rather than a continual searcher; unlike Picasso, who reduces to graphic formulas, Matisse is concerned with wholeness or totality--an ideal no longer operative for today's young artists.

884. Naesgaard, Ole. "Matisse's *Luxe [II]." Aarstiderne, Tidsskrift for Kunst* 9, 3 (August 1952): 65-68.

A purely descriptive account of the Copenhagen painting, prompted by the publication of Barr's monograph on Matisse of 1951. Briefly mentions the relationship of the Copenhagen work to the Paris version.

885. Reiff, Robert. "Matisse and Torii Kiyonaga." *Arts Mag.* 55
 (February 1981): 164-67.

 Reviewing the general influence of Japanese woodblock prints
 on the development of Matisse's modernist style, the author
 proposes a tripart woodblock print, *Visitors to Enoshima*
 (Museum of Fine Arts, Boston), by Torii Kiyonaga, as having
 an "aesthetic affinity" to Matisse's *Luxe II,* both in the flat
 paint handling and in the position of the "boneless," crouching
 servant-figures in each. Reiff admits that there is no evidence
 that Matisse knew the print and that the painter generally
 evolved figure-positions in a highly personal way over time,
 but seems to reject the possiblity that the similarity may be
 simply "happy coincidence."

886. Valloton, Félix. "Le Salon d'Automne." *La Grande Revue*
 (October 25, 1907): 920.

 A contemporary review of the 1907 Autumn Salon by the
 Nabi "realist," Félix Valloton, who was also an occasional
 critic. He gives an incisive description of the work, describes
 the spectator's impression of far and near viewing of it, and
 finally concedes Matisse's sincerity and skill in this large
 panel because he is a "craftsman of real probity" and a serious
 artist.

 The Moorish Screen (Philadelphia Museum of Art)
887. *"The Moorish Screen.* Collection of Robert Treat Pain II,
 Boston." *Coronet* 6 (September 1939): 64-65.

 Facing color reproductions of a sixteenth-century Persian
 miniature (from the Fogg Art Museum) and Matisse's
 Moorish Screen. An art-appreciation caption is appended
 which signals the common use of patterns in different scales,
 although Matisse's "Western" play of movement and some
 spatial depth is also noted.

 Moroccan Garden (Periwinkles)
888. Haglund, E. "Gront [Green]." *Paletten* (Sweden) 1 (1982):
 40-41.

Within a broader discussion of the psychological effects of the color green, Matisse's painting is discussed, along with a particular scene dominated by the color green in Werner Herzog's film *Woyzek*.

Music (1939) (Albright-Knox Gallery)

889. "Mr. Matisse Paints a Picture: three weeks work in 18 views." *Art News* 40 (September 1941): 8.

Page of eighteen photographs of *Music* in progress from March 18 to April 8, 1939.

Music Lesson (Barnes Foundation)

890. Barnes, Albert C. "Matisse." In *The Art in Painting,* 536-37. New York: Harcourt Brace, 1925, 1928.

A formal analysis which assesses the canvas's strength in the "compactness of its composition" and its "rhythm . . . felt primarily as one of color." Its greater complexity causes it to be ranked by the author as superior to *Joy of Life*.

891. Flam, Jack D. "Matisse in two keys *[Piano Lesson]* and *[Music Lesson]." Art in America* 63 (July-August 1975): 83-86.

Comparison of two parallel works with emphasis on iconography, composition, rendering, and personal symbolism. The earlier (1916) *Piano Lesson* is interpreted as an allegory about the nature of art; the later (1917) *Music Lesson* is revealed as a more personal, autobiographical statement. *Violinist at the Window* (early 1917) is examined as a stylistically and psychologically transitional work between the other two. Important insights into Matisse's position just before his move to Nice in 1917-18.

892. Flam, Jack. *"The Music Lesson (La leçon de musique)."* In *Great French Paintings from the Barnes Foundation,* 258-61. New York, Knopf and Lincoln University Press, 1993.

An extended catalogue essay that presents the most recent scholarship on the work, illustrates the painting in color for

the first time along with all related sketches and studies, and touches (necessarily briefly) on commentary on the work and the problematics of its style.

My Room at the Beau Rivage

893. "My Room at the Beau Rivage, 1917-18." *Cimaise* 40 (November-December 1993): 54.

Reproduction of the work only.

Nasturtiums with "The Dance" (I) (Metropolitan Museum)

894. Braune, Heinz. "Zu einem Gemälde von Henri Matisse." *Genius* 2 (1920): 197-98.

A short, but full, appreciative analysis of Matisse's first version of *Nasturtiums and "The Dance,"* formerly in the Oscar Moll collection. The formal analysis is used to explicate Matisse's concerns for the rhythm of the whole, for holding the decorative planarity of the surface, and for a freedom of color invention.

Nasturtiums with "The Dance" (II) (Pushkin Museum)

895. Hines, Jack. "Composition: In the Mood." *Southwest Art* 22 (February 1993): 42-45.

A very general article on the creative process in which Matisse's *Nasturtiums and The Dancers* is used briefly as an example of a centrifugal composition which creates a spin, a dance, around the fulcrum of the vase at the center.

896. Cassou, Jean. "Henri Matisse, *Coin d'Atelier (Les Capucines à La Danse)"* in "Fifty Years of Modern Art." *Quadrum* 5 (1958): 59-94.

A perceptive, one-page analysis of the painting in Cassou's elegaic literary style.

897. Roskill, Marc. "Looking Across to Literary Criticism." *Arts Mag.* 45 (Summer 1971): 16-19.

Author examines four instances of parallelism between figures proper to both literary criticism and art criticism, namely, metaphor, enactment, dramatization of aspects of contrast in a whole work, and quotation. The last of these he illustrates by means of Matisse's *Nasturtiums and the Dance,* where Matisse "cites" himself by integrating the image of an earlier work, *The Dance,* into a studio still life. A well-turned analysis of this phenomenon in interpreting Matisse's canvas.

Notre Dame in the Late Afternoon (Albright-Knox Gallery)

898. *"Notre Dame in the Late Afternoon* [Analysis of Buffalo canvas]." *Art News* 35 (October 3, 1936): 18-19.

A review that describes in detail a pedagogical exhibit of one painting, *Notre Dame in the Late Afternoon,* by means of photographs of the motif, pictorial analysis of the painting, other painters' treatments of the motif, stylistic influences (Persian ceramics, miniatures, Japanese prints; European forebears such as Manet , Gauguin, Cézanne), and follow-up works that show how the artist's style developed after the making of this work. The analysis of composition and sources follows the example of Barnes and De Mazia in their book, *Henri Matisse.* The author praises the educational benefits of such a didactic exhibition.

Odalisque in Red (Museo de Arte Contemporaneo, Caracas)

899. Wagner, Anni. "Museo de Art Contemporaneo in Caracas." *Kunst* 7-8 (July-August 1986): 550-57.

In a larger report on the expanded space of the contemporary museum in Caracas and on its permanent collection, Matisse's *Odalisque in Red* is compared with Picasso's *Portrait of Dora Maar* as an example of an important work in each man's oeuvre.

Odalisque with a Tambourine (Private Collection)

900. Clark, E. "Milestones in Modern Art: *Odalisque with a Tambourine." Studio* 155 (May 1958): 138-39.

A mostly formal analysis of the work, emphasizing the structural balance of colored forms.

Open Window, Collioure (Musée National d'Art Moderne)

901. Monod-Fontaine, Isabelle. "Matisse: *Porte-Fenêtre à Collioure.*" *Cahiers du Musée National d'Art Moderne* 13 (1984): 17-25.

A sensitive and full account of this canvas, painted at the end of Summer 1914, kept in the artist's studio, and exhibited for the first time only after his death in 1966. If the window (like the goldfish bowl) was charged with the theme of continuity and exchange between the interior and exterior, in this case the canvas manifests, in the words of Proust, "vertical distances being assimilated to horizontal distances." Author notes that the window's rectangle is identical to the canvas's rectangle; the black surface may signify a closure or a possible new beginning over the marks occluded by the black layer. The work is contextualized thematically in relation to other window-motif canvases of the period, especially its "true pendant" *The Yellow Curtain,* also of 1914.

902. Laude, Jean. "Autour de la *Porte-Fenêtre à Collioure* de Matisse." In *D'un espace à un autre: la fenêtre.* St. Tropez: Musée de l'Annonciade, 1978. Exhibition catalogue.

A structuralist analysis of the painting which signals Matisse's acute awareness of the fundamental modernist problem of the painting as a framed surface covered with lines and colors abstractly understood. This focus on one work is situated in a general discussion of the readability of Matisse's "theory" only in a study of his series of works--windows, studios, painter-and-models, etc. Matisse's "obsessional" use of the window theme was not so much psychological as it was intellectual, a rethinking of the pictorial Albertian law of the picture plane conceived as a transparent window before the painter, through which he is presumed to see the world he will represent. It signals a radical redirection of the pictorial project, the progressive repression of the signified by the

signifier. An article of the first importance in a semiotic understanding of painting and Matisse's role in our awareness of that possibility.

Open Window, Tangiers (Private Collection)

903. Wollheim, Richard. "The Work of Art as Object." *Studio Int.* 180, 928 (December 1970): 231-35. Revised as Chapter 6 in *On Art and the Mind.* Cambridge: Harvard University Press, 1974.

A brief discussion of Matisse's painting, along with ones by Morris Louis and Mark Rothko, in a more general exposition of the attention to surface as part of the trend to see the canvas as an object rather than mirror or window.

The Painter in his Studio (Musée National d'Art Moderne)

904. Baticle, Jeannine. "L'Atelier du peintre." *Rev. du Louvre et des Musées de France* 26, 3 (1976): 225.

An account of the exhibition *L'Atelier du peintre,* organized within the framework of Dossiers of the Department of Painting of the Louvre to reflect the social function, evolution, and symbolism of the artist's studio from the medieval to modern periods. A small number of "studio paintings" were displayed with accompanying documentation, among them Matisse's *The Painter and His Model* of 1916.

905. Laude, Jean. "Les 'Ateliers' de Matisse." *Coloquio Artes* (Portugal) 16, 18 (June 1974): 16-25.

A fine discussion of the role of the studio as a social site and its use in Western painting. The empty studio and the one in which model and/or artist are present are both treated but with special emphasis on a reading of Matisse's 1916 *The Painter and His Model* to explore the nature of the painter's practice.

906. Fourcade, Dominique. "Crise du cadre: à propos d'un tableau de Matisse, *Le Peintre Dans son Atelier.*" *Cahiers du Musée National d'Art Moderne* 17/18 (1986): 68-83.

Fourcade eloquently discusses the role of the frame in traditional painting and declares the crisis of the frame for modern art since Beaudelaire, since Monet's *Nymphéas,* when modern painting became unframable. Modern painting from Monet to Pollock and beyond presents a world without borders, over the edge, a world coextensive with the world. Fourcade traces the history of attempts to frame Matisse's *The Painter in His Studio* individually, and within the context of presentation on the museum wall and within museum exhibitions. The work is now in a frame--narrow, pale gold and flush with the picture-surface--which the author terms "frame zero, the least virulent and most respectful" toward the painting itself. The work has been rehung in the permanent collection nine times since it was acquired in 1945; all are evaluated by the author. An important essay on the artwork's apparition/insertion into the world, richly illustrated with period photographs of various installations of this work and others.

The Painting Lesson (Scottish National Gallery of Modern Art)

907. Hall, D. "Matisse's *La Leçon [Scéance] de Peinture* (Scottish National Gallery of Modern Art)." *Burlington Mag.* 108 (May 1966): 261.

An elegant formal analysis of the way Matisse mingles objective and fictive spaces in this work. Its history is also sketched.

The Parakeet and The Mermaid (Stedelijk Museum, Amsterdam)

908. "Museum Notes, 1984." *Rhode Island School of Design Museum Notes* 71 (1984): 34.

In an extended article on current museum news, Matisse's paper cut-out is discussed briefly.

Piano Lesson (Museum of Modern Art)

909. Flam, Jack D. "Matisse in two keys *[Piano Lesson]* and *[Music Lesson]*." *Art in America* 63 (July-August 1975): 83-86.

Comparison of two parallel works with emphasis on iconography, composition, rendering, and personal symbolism. The earlier (1916) *Piano Lesson* is interpreted as an allegory about the nature of art; the later (1917) *Music Lesson* is revealed as a more personal, autobiographical statement. *Violinist at the Window* (early 1917) is examined as a stylistically and psychologically transitional work between the other two. Important insights into Matisse's position just before his move to Nice in 1917-18.

910. Leigh, D. M. "Pictorial Perpetual Motion Machines." *De Arte* 23 (April 1979): 12-18.

A general treatment of how composition generates complexity of meaning with an analysis of three paintings in particular: Raphael's *School of Athens,* Delacroix's *Entry of the Crusaders into Constantinople,* and Matisse's *Piano Lesson.*

Pink Shrimp (ex. Everhart Museum)
911. Vogel, Carol. "Matisse or Money: Everhart Museum in Scranton, Penn., wants to sell its most valuable painting, H. M.'s *Pink Shrimp.*" *New York Times* 142 (October 9, 1992): B6, C30.

A news item on the quandry of the Everson museum which must contemplate selling its most notable work in order to pay for other museum expenses in difficult economic times.

Pink Tablecloth (Lewisohn Collection)
912. Frost, Rosamond. "Collectors Come Out of Privacy: Lewisohn Matisse: *Pink Tablecloth,* lent to Museum of Modern Art." *Art News* 45 (July 1946):17.

Note on the painting's history and its collector's acquisition of it in a longer article on the Museum of Modern Art's exhibition of Summer 1946.

Portrait of André Derain (Tate Gallery)

913. Farr, Dennis. "Modern Art and the M.A.-C.F." *Apollo* 80
(December 1954): 510-15.

The circumstances of the Tate's acquisition of Matisse's *André Derain* are detailed in a longer article about recent acquisitions.

Portrait of the Antique Dealer Demotte (Musée de Beaux-Arts de Lyon)

914. Brachlianoff, Dominique. "Le Portrait de l'antiquaire Demotte." In *Matisse: L'Art du livre*, 9-12. Milan: Mondadori, 1987. Catalogue for the exhibition, Matisse: *L'Art du livre, Matisse dans les collections du Musée de Beaux-Arts de Lyon*.

Fascinating account of the life and hard times of the sitter, the circumstances of the portrait commission, and Matisse's relation to the antique dealer.

Portrait of a Face in Pink and Blue (Montréal Musée d'Art Contemporain)

915. Gagnon, P. "Notes sur le *Portrait au Visage Rose et Bleue* de Matisse."*Ateliers* (Canada) 6, 1 (June 15-August 7, 1977): 4.

Note on the painting's acquisition by the Musée d'Art Contemporain in Montréal from the Waddington Gallery, which had purchased it from Georges Duthuit. There is also an extended and intelligent analysis of the work and its role in the artist's investigation of the problem of "drawing with color." Author also makes an interesting contrast with *The Green Stripe* of 1905.

Portrait of Greta Moll (National Gallery, London)

916. Levey, Michael. "French Acquisitions of Recent Years at the National Gallery." *Apollo* 123 (June 1986): 378-85.

Among other works discussed, Matisse's portrait of his pupil, Greta Moll, is treated briefly.

917. Moll, Margarete. "Errinerungen an Henri Matisse." *Neue Deutsche Hefte* (February 1956).

Reminiscences by a former student of Matisse who was also the subject of this portrait; she speaks of the stages of the portrait's fabrication.

918. Fourcade, Dominique, and Éric de Chassey. In *Henri Matisse 1904-1917*, 448-9. Exhibition catalogue.

Testimony by the sitter, from a letter to Alfred Barr and a late article by Moll, on Matisse's method while painting the portrait. Also an excerpt from Hans Purrmann on the making of the portrait.

Portrait of Greta Prozor (Musée National d'Art Moderne)
919. Fourcade, Dominique. "Henri Matisse: *Greta Prozor.*" *Cahiers du Musée National d'Art Moderne* 11 (1983): 101-108.

MNAM has begun to fulfill its mission to elevate taste, as American museums have done so well, according to the author, by purchasing significant, highest-quality masterworks of artists already represented in their collections--hence, the recent acquisition of *Portrait of Greta Prozor*. Richly documented, with all preparatory drawings reproduced. Fourcade's article illuminates Matisse's working method in portraiture, gives evidence of the painting's neglect until mid-century, and of Matisse's high regard for it.

Portrait of Yvonne Landsberg (Philadelphia Museum of Art)
920. Weiss, Peg. "Florence Koehler and Mary Elizabeth Sharpe: An American Saga of Art and Patronage." *Arts Mag.* 4 (December 1978): 108-17.

An American artist, Koehler, and her patron Mrs. Sharpe are privy to the events surrounding the painting of Yvonne Landsberg. Primarily on the two woman, their milieu and careers.

921. Fourcade, Dominique, and Éric de Chassey. In *Henri Matisse 1904-1917*, 499-500. Paris: Centre Georges Pompidou, 1993. Exhibition catalogue.

An unusual compilation of commentary on the work by a number of witnesses and critics.

Reclining Nude (Barnes Foundation)

922. Flam, Jack. *"Reclining Nude (Nu couché)."* In *Great French Paintings from the Barnes Foundation*, 272-73. New York: Knopf and Lincoln University, 1993.

First color reproductions of this painting, with related works and accompanying catalogue entry, relating it to the criticism of the day which favorably regarded the work in French "classical" tradition.

Red Madras Headdress (Mme Matisse: Madras rouge) (Barnes Foundation)

923. Flam, Jack. *"The Red Madras Headdress (Mme Matisse: Madras rouge)."* In *Great French Paintings from the Barnes Foundation*, 238-39. New York: Knopf and Lincoln University, 1993.

Flam discusses briefly the reception of the work, dates it firmly to early summer of 1907, and indicates the influences that were brought to bear on its decorative qualities.

924. Barnes, Albert, and Violette de Mazia. In *Henri Matisse*, 379-82. New York: Scribner, 1933, no. 50.

Compositional analysis of the work.

The Red Studio (Museum of Modern Art)

925. Heron, Patrick. "Matisse; The Changing Jug." *The Listener* (January 25, 1951).

A version of the radio talk of the same title in which Heron first lays out his understanding and appreciation of how Matisse makes his color create the objects in his interiors and, at the same time, create their measurable spatial intervals. *The Red Studio* is used as an example and appears on the cover of the journal.

926. Hollander, John. "Words on Pictures: Ekphrasis." *Art and Antiques* (March 1984): 80-91.

A brief history of the practice of writing poems about painting is followed by modern examples. W. D. Snodgrass's poem on Matisse's *Red Studio* is included.

927. Jacobus, John. "Matisse's *Red Studio*." *Art News* 71 (September 1972): 30-34.

Jacobus sees this work as the most important anti-Cubist, anti-Cézanne statement in early twentieth century art, rivaling Picasso's *Demoiselles d'Avignon* in importance. It is a Salon-scaled *machine,* in ambition, size, and theme; Jacobus contrasts it with Courbet's *Atelier* and Corot's, Gérome's, and Bazille's treatments of the "artist's studio" subject. He also points out its importance to contemporary color-field painters such as Rothko and Newman.

928. Nochlin, Linda. "The Telling Detail." *House and Garden* 155, 1 (January 1983): 136-43.

Using paintings of rooms by Hockney, Hogarth, Van Gogh, and Matisse *(Red Studio),* Nochlin reads the works for emotional clues to the artist and his meanings. Matisse's work is interpreted as both an avant-garde statement and an indicator of Matisse's attitude toward the female body.

929. Reiff, Robert F. "Matisse and *The Red Studio.*" *Art Journal* 30 (Winter 1970/71): 144-47.

A sensitive formal reading of the work, which is contrasted with *The Pink Studio* of the same year, 1911. The context of viewing the works is the 1970 Paris Centenary show, also evaluated.

930. Snodgrass, W. D. "Matisse: the *Red Studio.*" *Portfolio and Art News Annual* 3 (1960): 90-91.

Snodgrass's poem on the painting is printed on a two-page spread of the painting in color, along with numerous selected details of the work.

**The Repose of the Models on an Ornamental
Background with Checkerboard** (Philadelphia Museum
of Art)

931. H. G. G. *"Le Repos des modèles,* 1928." *Bull. Philadelphia
Museum of Art* 283-284 (Fall 1964): 9.

The page-long description/analysis of this oil relates it to
Matisse's trip to Italy in 1925 and the turn taken in his work
with *Decorative Nude on an Ornamental Background.*

The Road to Clamart (Musée National d'Art Moderne)

932. Dorival, Bernard. *"La Route de Clamart,* acquisition au Musée
National d'Art Moderne." *Rev. des Arts* 6 (March 1956): 54.

A very fine, if brief, treatment of this canvas recently acquired
by the Museum. which had no work by Matisse of either this
genre or period. Dorival sets the work in the context of the
post-1917 work of Matisse and skillfully summarizes its
characteristics: "cursive contours, marked forms, clear planar
recession, restricted palette, thin paint application, decisive and
rapid facture, so sure of itself that, in the sky especially, it can
leave vast stretches of virgin canvas without the painting
appearing empty, hasty, or unfinished."

The Rose (Norton Museum and School of Art)

933. Flam, Jack D. "A Comment on the Matisse Paintings in the
Norton Gallery and School of Art." *Norton Galleries Studies*
2 (Art Museum of Palm Beach), 1973.

A full discussion of the work in a broad formal, iconographic
and historical context.

The Rose [Pink] Marble Table (Museum of Modern
Art)

934. "Painting and Sculpture Acquisitions." *Museum of Modern
Art Bull.* 24, 4 (Summer 1957): 8-9.

A note on the Museum's acquisition of *Back II, The Serf,
Jeannette II,* and *The Pink Marble Table.*

Sailor II (Gelman Collection)

935. Schneider, Pierre. *"Sailor II."* In *Twentieth Century Modern Masters: The Jacques and Natasha Gelman Collection.* New York: The Metropolitan Museum of Art and Abrams, 1989. Exhibition catalogue.

A fine article that places the work in the context of Matisse's fauve style of 1906 and, and among other things, identifies the boy who posed for the picture in Collioure.

Seated Odalisque (ex. Clark collection)

936. Crowninshield, Frank "Seated Odalisque." *Vogue* (December 15, 1937): 53, 92.

A full-page color reproduction of the work (formerly in the Stephen C. Clark collection) is accompanied by an essay which strongly defends Matisse on a point-by-point basis. One of these points is that he is not a modern in the sense of Picasso and others, that he has more in common with the problem-solving of Chinese, Persian, Byzantine, and medieval artisans. *Seated Odalisque*'s color is analyzed to refute the charge that Matisse's color is crude and uncontrolled; rather it shows "impeccable elegance and taste."

Seated Odalisque with Raised Knee (Barnes Foundation)

937. Flam, Jack. *"Seated Odalisque (Le Genou Levé)."* In *Great French Paintings from the Barnes Foundation*, 268-71. New York: Knopf and Lincoln University, 1993.

First color reproductions of this painting with related works, and accompanying catalogue entry that discusses the theme of the odalisque more generally.

Seated Riffian (Barnes Foundation)

938. Flam, Jack. *"Seated Riffian (Le Rifain assis)."* In *Great French Paintings from the Barnes Foundation*, 246-49. New York: Knopf and Lincoln University, 1993.

First color reproductions of this painting with related works, and documentary photo and accompanying catalogue entry.

The Snail (Tate Gallery)
939. Roddon, Guy. *"L'Escargot."* *Artist* (UK) 98, 7 (July 1983): 166-67.

A mostly formal discussion of the large cut-paper work.

940. Fairbrass, Sheila. "Henri Matisse's *The Snail.*" In *Completing the Picture: Materials and Techniques of Twenty-Six Paintings in the Tate Gallery.* London: Tate Gallery, 1982.

A discussion of the materials and technique used in the production of the paper cut-out.

Spanish Still Life (Hermitage)
Seville Still Life (Hermitage)
941. De Baranano, Kosme M. "Matisse e Iturrino." *Goya* 205-206 (July-October 1988): 94-98.

Author discusses the work of Francisco de Iturrino (1864-1924) who was associated with Picasso around 1901, with Matisse around 1911, and with Soutine in the early twenties. Matisse was joined by Iturrino in Seville in 1910-11 and the author discusses work by both men from the same motif and perhaps the same model--Joaquina.

Still Life (George Booth Collection, Detroit)
942. "Booth's Matisse." *Art Digest* 4 (January 15, 1930): 19.

A note and photograph of a still life (late 20s) just purchased by Booth from the Reinhardt Galleries of New York.

Still Life [pineapple, compote, fruits, anemones] on a Table (Philadelphia Museum of Art)
943. H.G.G. *"Still Life on a Table, 1925."* *Bull. Philadelphia Museum of Art,* 283-284 (Fall 1964): 7.

An analysis/description of this newly-acquired work which relates it to still lifes with the same motifs.

Still Life with Goldfish

944. Daniels, A. "Looking and Learning." *Artist* (UK) 86, 2 (October 1973): 43-46.

A lesson in understanding the structure of pictorial composition, using a work each by Cézanne, Matisse, and Nicholson, all of whom moved from the depiction of nature to abstract construction.

Still Life with a Plaster Bust (Barnes Foundation)

945. Flam, Jack. *"Still Life with a Plaster Bust (Nature morte aux coloquintes)."* In *Great French Paintings from the Barnes Foundation*, 250-51. New York: Knopf and Lincoln University, 1993.

First color reproduction of this painting with related works, and accompanying catalogue entry which reiterates Flam's dating of the canvas to late spring, 1916, rather than the long-held date of 1912.

Still Life with Statuette [Plaster Figure] (Yale Art Gallery)

946. Carlson, Eric Gustav. *"Still Life with Statuette* by Henri Matisse." *Yale Univ. Art Gallery Bull.* 31 (Spring 1967): 4-13.

Carlson dates the work to 1906, identifies the objects and artworks depicted, and assesses its importance to the development of Matisse's style and to international Expressionism.

Studio, Quai Saint-Michel (Phillips Collection)

947. "Double Matisse holiday: two monumental works enter American collections: *Studio [Quai Saint Michel]* acquired by Phillips gallery and *Nature morte* acquired by S. A. Marx." *Art News* 39 (December 28, 1940): 6-7+.

Account of the acquisitions of the two works in question.

948. Schwartz, Paul W. "The Hidden Muse: Finding the Divine Spark in the Details of Old Masters." *Connoisseur* 218, 916 (May 1988): 104-13.

A reading of brilliant and intimate details in the work of nine master paintings, one of which is Matisse's *Studio, Quai St. Michel.*

Swimming Pool (Museum of Modern Art)

949. "Le Museé d'Art Moderne de New York vient d'acquerir *La Piscine.*" *Connaissance arts* 292 (June 1976): 11.

On the acquisition of *La Piscine [Swiming Pool]* by the Museum of Modern Art and the loss of another part of the French patrimony.

950. Glueck, Grace. "Modern Gets Huge Matisse Cut-Out for 1 Million Trade." *New York Times* (March 10, 1976).

An account of the acquisition of this major paper cut-out by the Museum of Modern Art through the trade of undisclosed other works in the collection.

Tea (Los Angeles Museum of Art)

951. Livingston, Jane. "Matisse's *Tea.*" *Los Angeles County Museum Bull.* 20, 2 (1974): 47-57.

In this superb study of an important, large post-war panel that critics termed "illustrational" and "anti-rhetorical," the author consciously questions the standard wisdom of the Matisse literature that stresses progressiveness and innovation as the hallmark of modernity. Unusually thorough and insightful; the model is incorrectly identified as Henriette.

952. "Important New Museum Installations and Acquisitions *[Tea* of 1919]." *Connoisseur* 189 (May 1975): 72.

A note on the acquisition of this major work for a Los Angeles museum.

Thousand and One Nights (Carnegie Institute)

953. "Frieze by Matisse for the Carnegie Institute." *Burlington Mag.* 114 (July 1972): 509.

An informative note on the acquisition of this work for the Carnegie Institute.

954. Failing, Patricia. "The Objects of Their Affection." *Art News* 81, 9 (November 1982): 122-31.

Author discusses the favorite pieces (by visitors' responses) in each of ten museums, giving historical and anecdotal details on each work and some information on iconography and technique. From Carnegie Institute Museum of Art, Matisse's *Thousand and One Nights* is selected for discussion.

Three Bathers (Minneapolis Museum of Art)
955. Lucas, John. "The Twins Come of Age." *Arts Mag.* 36 (March 1962): 60.

Mentions, among other works, Matisse's *Three Bathers [Collioure]* as an important work in the collection.

The Three Sisters Triptych (Barnes Foundation)
956. Flam, Jack. *"The Three Sisters Triptych (Les trois soeurs, triptyque)."* In *Great French Paintings from the Barnes Foundation*, 252-57. New York: Knopf and Lincoln University, 1993.

First color reproductions of this painting, with sketches and related works and accompanying catalogue entry which establishes the details of its acquisition by Barnes.

Two Girls in a Yellow and Red Interior (Barnes Foundation)
957. Flam, Jack. *"Two Girls in a Yellow and Red Interior (Deux fillettes, fond jaune et rouge)."* In *Great French Paintings from the Barnes Foundation*, 292-93. New York: Knopf and Lincoln University, 1993.

First color reproduction of this painting, with related work and accompanying catalogue entry.

Two Rays (Norton Gallery and School of Art)
958. Flam, Jack D. "A Comment on the Matisse Paintings in the Norton Gallery and School of Art." *Norton Galleries Studies* 2 (Art Museum of Palm Beach), 1973.

A full discussion of the work in a broad formal, iconographic, and historical context.

Variation on a Still Life by de Heem (Museum of Modern Art)

959. Beal, Jack. "Sight and Sense, Studying Pictorial Composition." *American Artist* 50 (February 1986): 54-61, 92-97.

Using methods of compositional analysis learned as a student at the School of the Art Institute from Isobel Steele McKinnon (former student of Hans Hofmann) and Kathleen Blackshear (former student of Helen Gardner), the painter Jack Beal discusses pictorial composition by examining a number of eighteenth-, nineteenth-, and twentieth-century still lifes. Constrasting Matisse's *Variation on a Still Life by de Heem* (1916) with the original canvas by de Heem, he finds that, for all its modernist flatness, Matisse's work exhibits a certain conservatism in stablizing the composition into a frontal, static grid, simplifying the objects in number, and imposing strong contours. Matisse thus rids de Heem's composition of its complex and multivalent rhythms and intricate organization of space.

Vase of Flowers (Toledo Museum of Art)

960. "Our painting by Matisse: *Vase of Flowers." Toledo Museum Newsletter* 88 (December 1939): 10-12.

A very fine formal anlaysis of this work, acquired by the Museum in 1935, which has an unusual (for Matisse) dominant color scheme around blue and yellow. The painting of a woman in the background, behind the flowers, is barely noted in the descriptive analysis that minimizes the extent of 'human significance" the work evokes.

View of Collioure with Church (ex. Kate Steichen Collection)

961. Robinson, W. "MoMA Surrenders Contested Matisse." *Art in America* 78 (October 1990): 47.

A well-researched notice on the details of the lawsuit between the Steichen heirs and the Museum of Modern Art on the contested work, and a discussion of the status of "old loans" (long-term promised loans for which the terms are not clear or the parties have lost contact) in general and their resolution.

962. "My Little Matisse (MOMA and members of the family of Edward Steichen have reached a settlement over the ownership of a painting by Matisse)." *Art News* 89 (October 1990): 76.

A full account of the falling out between Kate Steichen and the Museum of Modern Art over the small landscape, *View of Collioure with Church,* bequeathed or loaned to the museum in 1973. Given by Matisse to Edward Steichen in 1908, the latter, who headed MoMA's photography department from 1947-1962, gave it to his daughter on her birthday in 1962. The work's absence from the museum's collection was compensated by the gift from Mrs. Bertram Smith of a more important landscape of the same year, 1905, *Landscape at Collioure.*

View of Notre Dame, Spring (Museum of Modern Art)
963. Siegel, Jeanne. "Henri Matisse's *View of Notre Dame, Spring,* 1914." *Arts Mag.* 54 (January 1980): 158-161.

A nuanced discussion of this painting in relation to eight others with the same motif and in relation to Matisse's response to Cubism.

View of the Sea, Collioure (Barnes Foundation)
964. Flam, Jack. *"View of the sea, Colloiure (La mer vue à Collioure)."* In *Great French Paintings from the Barnes Foundation,* 236-37. New York: Knopf and Lincoln University, 1993.

First color reproduction of this painting with related works and accompanying catalogue entry that establishes date of early summer 1907.

White Plumes (Minneapolis Institute of Arts)

965. "Institute Acquires a Famous Matisse, *The White Plumes.*"
 Minneapolis Institute Bull. 37 (February 7, 1948): 25-31.

 An extended discussion of the painting recently acquired by the
 Institute, comparing it with the Chester Dale version of the
 same subject and to the drawing which most closely resembles
 it (Newberry Collection). More comprehensive than
 insightful.

966. Salinger, Marguerite. *"White Plumes* with Variations."
 Parnassus 4 (December 1932): 9-10.

 A fine, appreciative analysis of the eleven drawings related to
 the painting, *White Plumes* (1919) that challenges the claim
 by Charles Vildrac that the drawings are only "preliminary
 studies" for the oil(s). Salinger's discussion stresses the
 drawings' completeness, variety, and sensitivity to the sitter's
 moods.

967. *"White Plumes* acquired by Minneapolis." *Art News* 47
 (September 1948): 36-37.

 Full color, full-page reproduction of the painting with
 accompanying brief commentary.

 The Window (Detroit Institute of the Arts)
968. *"Interior* Purchased by the Museum." *Detroit Institute of Arts
 Bull.* 5 (October 1923): 4-5.

 An account of the purchase--the first by any American
 museum--of Matisse's 1915 painting now known as *The
 Window.* The short article insists, for its readers, on Matisse's
 wholesomeness and rationality.

 The Wine Press (Private Collection)
969. *"La Vis [The Wine Press]."* Art News* 92 (October 1993): 22.

 Handsome colored full-page reproduction in an announcement
 of the work's imminent sale at Sotheby's.

970. *"La Vis [The Wine Press]." Architectural Digest* 50
 (November 1993): A 13.

Notice on the work's availablity for sale at Sotheby's auction.

Woman and Goldfish Bowl (Barnes Foundation)
971. "Femme à la bowl des poissons." *Cahiers d'art* 6-7 (June 1937).

Black and white reproduction only.

972. Bock, Catherine C. *"Woman Before an Aquarium* and *Woman on a Rose Divan;* Matisse in the Helen Birch Bartlett Memorial Collection."* Art Inst. of Chicago Museum Studies* 12, 2 (1986): 200-21.

In the discussion of the motif of the woman with goldfish bowl in the later, more finished version of this work (Art Institute of Chicago), the author deals with the character and dating of the earlier (Barnes Foundation) painting. See longer summary below, no. 973.

Woman Before an Aquarium (Art Institute of Chicago)
973. Bock, Catherine C. *"Woman Before an Aquarium* and *Woman on a Rose Divan;* Matisse in the Helen Birch Bartlett Memorial Collection."* Art Inst. of Chicago Museum Studies* 12, 2 (1986): 200-21.

Author treats the two 1920s Matissè canvases as aspects of the "new" women whose appearance is often marked by melancholy and anxiety or as fictitious "odalisques" from an artificial and bankrupt nineteenth- century Orientalist tradition. Both works are given detailed formal, iconographic, and historical analyses which support a claim to qualitative excellence for the decade in question.

974. Brettell, Richard R. "The Bartletts and the *Grande Jatte:* Collecting Modern Painting in the 1920s." *Art Inst. of Chicago Museum Studies* 12, 2 (1986): 102-113.

Places the acquisition of *Woman Before an Aquarium* in the context of the Bartletts' collecting patterns of the 1920s. Author indcates that, along with Van Gogh's *Madame Roulin*

Rocking the Cradle, the Matisse is the most significant painting purchased before Seurat's *Grande Jatte.*

975. Hampl, Patricia. "On Henri Matisse, *Woman Before an Aquarium.*" In *Transforming Vision, Writers on Art.,* 46-7. Ed., Edward Hirsch. Boston; Little, Brown and Company, and Chicago: The Art Institute of Chicago, 1994. A Bullfinch Press book.

In a book of writers' responses to works in the Art Institute of Chicago, Patricia Hampl's 1978 poem on Matisse's 1920's painting is reproduced across from its full-page color reproduction. Hampl is the author of *Virgin Time, In Search of the Contemplative Life* (1992).

976. Linker, Kate. "Meditations on a Goldfish Bowl, Autonomy and Analogy in Matisse." *Artforum* 19, 2 (October 1980): 65-73.

An extraordinary essay on the figuring (in the rhetorical sense) of objects in Matisse's oeuvre. Matisse's usage of the goldfish bowl, windowed and mirrored interiors, curved space, and dancers are examined as metaphors for the self-containment and self-reflexiity of modern art (Proust, Poe, and Mallarmé being the literary counterparts). An important essay.

977. Reff, Theodore. "Matisse: Meditations on a Statuette and Goldfish." *Arts Mag.* 51, 3 (November 1976): 109-15.

A detailed discussion of the motifs of the sculpture of a reclining nude, goldfish, and open doorway or window in a number of Matisse paintings, primarily those in the Museum of Modern Art collection. Far-ranging and erudite in its references, Reff's article entails both iconographic and formal interpretation, and relates these motifs to classical arcadian themes, to the art and experience of the Middle and Far East, and to their precedents in Cézanne's oeuvre. An important article for all works using these motifs.

Woman in Blue Dress (Philadelphia Museum of Art)

978. *"[Blue Robe]:* Evolution of a Painting." *Mag. of Art* 32, 7 (July 1939): 414-15.

Ten photographs of progressive stages of Matisse's *Blue Robe* are reproduced along with the final version. The anonymous commentator notes that the first version is as stylish as a fashion illustration in *Harper's Bazaar.* Although he admits that the work moves from "stylishness" to "style," the writer characterizes all of the work of these years as that of Matisse's "fashionable maturity."

Woman in Blue Gandurah

979. Szymusiak, Dominique. "Acquisitions: Le Cateau-Cambrésis." *Revue du Louvre* 42 (December 1992): 111-12.

A short article on the painting *Femme à la gandourah bleue,* one of the artist's last oil paintings (1952), which has just come into the museum's collection.

Woman on a Rose Divan (Art Institute of Chicago)

980. Bock, Catherine C. *"Woman Before an Aquarium* and *Woman on a Rose Divan;* Matisse in the Helen Birch Bartlett Memorial Collection." *Art Institute of Chicago Mus. Studies* 12, 2 (1986): 200-21.

Author treats the two 1920s Matisse canvases as aspects of the painter's portrayals of women in the early Nice period: as contemporary "new" women whose appearance is often marked by melancholy and anxiety or as fictitious "odalisques" from an artificial and bankrupt nineteenth-century Orientalist tradition. Both works are given detailed formal, iconographic, and historical analyses which support a claim to qualitative excellence for the decade in question.

Woman Reading at a Dressing Table (Barnes Foundation)

981. Flam, Jack. *"Woman Reading at a Dressing Table (Intérieur, Nice)."* In *Great French Paintings from the Barnes Foundation,* 262-63. New York: Knopf and Lincoln University, 1993.

First color reproduction of this painting, presented with related works and accompanying catalogue entry.

[Woman] Reader on a Black Background (Musée National d'Art Moderne)

982. Cogniat, Raymond. "The French Comeback, *Reader* Acquired by Musée d'Art Moderne." *Art News* 46 (June 1947): 35, 54.

A short report from Paris touting its post-war cultural "comeback" including an account of the reopening of the Musée d'Art Moderne with new acquisitions, including the donation by the artist of ten Picasso paintings and of Matisse's 1939 *Reader [on a Black Background]*.

Woman Seated by a Window

983. "Notable Works now on the Market." *Burlington Mag.* 97 (December 1956): supp. 12.

Photo and historical commentary on this little-known variant of a well-known theme (1918-19), formerly owned by Marlborough Fine Art, and for sale at this time.

Woman with the Hat (San Francisco Museum of Modern Art)

984. Klein, John. "When Worlds Collide, Matisse's *Femme au Chapeau* and the Politics of the Portrait." In *Matisse and Other Modern Masters, The Elise S. Haas Collection,* 7-18. San Francisco: The San Francisco Museum of Modern Art, 1993.

The author's subtly argued theme is that of the contradictions in Matisse's desire to use the new (Fauve) stylistic freedom that was developed in landscape painting to create a portrait, a genre demanding more "consistency and finish." To compound the problem, the portrait's subject is the artist's wife, an intimate subject with its own conventional demands. The transgression of the portrait, therefore, according to Klein, lies not only in the fluidity of its non-naturalistic color and facture, but in the tension and near hostility of the portrayal of Mme Matisse and the further denial of the class prestige that a hand-painted portrait was meant to embody and disclose. Klein

suggests that the negative criticism of the work somehow recognized all these transgressive features of the work.

Yellow and Blue Interior (Musée National d'Art Moderne)

985. Boudou, Dominique. "Après le chaos, les années 50 de Bernard Ceysson; Entretien." *Beaux-Arts Mag.* 1 1 7 (November 1993): 64.

Interview with the curator of an exhibit, *Entre la sérénité et l'inquiétude*, at the Musée d'art Moderne de Saint-Etienne. A detail of Matisse's work is given a full-page color reproduction but not specifically discussed. General remarks on the period, however, are pertinent.

Sculpture

Backs 0, I, II, III, IV

986. Flam, Jack. "Matisse *Backs* and the Development of his
 Paintings." *Art Journal* 30, 4 (Summer 1971): 352-61.

A fine study of the *Backs* in relation, not so much to one
another in a linear development as in relation to other
sculptures and paintings that were being made at the same
time. Written after Albert Elsen's article on the *Backs,* "The
Sculpture of Henri Matisse: IV," had appeared, Flam's study
enriches our understanding of the works by placing them in
this wider context of Matisse's ongoing stylistic development
in all media. In his sculpture, as in his painting, from 1909
to 1929 he moved from plastic to non-plastic space, from
acute attention to details to a search for totality in the balance
between figure and ground.

987. Szymusiak, Dominique, and Isabelle Monod-Fontaine.
 Matisse: Les Plâtres originaux des bas reliefs Dos I, II, III, IV.
 Le Cateau-Cambrésis: Musée Matisse, 1990.

A small, beautifully produced catalogue published on the
occasion of the gift of the four original plaster casts of the
Backs to the Musée Matisse in Le Cateau-Cambrésis. Each
plaster is completely documented with bibliography and
commentary drawn mainly from the catalogue of *Matisse in
the Collection of the Musée National d'Art Moderne* by
Isabelle Monod-Fontaine. The short, informative introduction
is by Dominque Szymusiak, the curator of the museum.

988. "Painting and Sculpture Acquisitions." *Museum of Modern
 Art Bull.* 24, 4 (Summer 1957): 8-9.

A note on the Museum's acquisition of *Back II, The Serf,
Jeannette II,* and *The Pink Marble Table.*

989. Bothner, Roland. Chapter V of *Grund und Figur: die
 Geschichte des Reliefs un Auguste Rodins Hollentor.*
 Munich: Wilhelm Fink, 1993.

In a general study of the modern problem of the sculptural relief that takes Rodin's *Gates of Hell* as its main example, the author discusses the sculptural relief work of Matisse and Picasso in the context of the dissolution of form.

Jeannette I-V

990. "Five Heads of Jeannette by Matisse." *Los Angeles Museum of Art Bull.* 19, 1 (1968-69): 20-21.

A short analytic description (illustrated) of the five versions of the head of Jeannette (1910-1916), donated by the Art Museum Council as a memorial to Mrs. Elmer C. Rigby.

991. "Painting and Sculpture Acquisitions." *Museum of Modern Art Bull.* 24, 4 (Summer 1957): 8-9.

A note on the Museum's acquisition of *Back II, The Serf, Jeannette II,* and *The Pink Marble Table.*

Large Seated Nude

992. "Notable Works Now on the Market." *Burlington Mag.* 102 (December 1969), supp. 7.

Discusses Matisse's 1925-26 bronze along with other works.

Reclining Figure with Chemise (Baltimore Museum of Art)

993. Rosenthal, Gertrude. "Matisse's Reclining Figures: A Theme and Its Variations." *Baltimore Museum News* 19 (February 1956): 10-15.

Discusses the motif of the reclining nude in Matisse's scupture and painting on the occasion of the gift of the bronze *Reclining Figure with Chemise* (1905) to the museum.

994. "Three Sculptures in the Cone Collection: *Reclining Nude, Slave, Venus in a Shell.*" *Baltimore Museum News* 20, 3 (February 1957): 10-11.

The three works are reproduced along with other major paintings in an issue devoted to the opening of the Cone Wing

at the Baltimore Museum of Art in 1957. No specific commentary.

Reclining Nude I (Albright-Knox Gallery)

995. *"Reclining Nude I,* acquired by the Museum." *Buffalo Gallery Notes* 11 (July 1946): 19, 24-25.

A brief note on the acquisition of the sculpture for the museum.

The Serf

996. "Painting and Sculpture Acquisitions." *Museum of Modern Art Bull.* 24, 4 (Summer 1957): 8-9.

A note on the Museum's acquisition of *Back II, The Serf, Jeannette II,* and *The Pink Marble Table.*

Two Negresses

997. Hobhouse, Janet. "Looking at Art: Matisse's *Two Negresses.*" *Art News* 86, 10 (December 1987): 81-82.

A sensitive study of the sculpture analysing how Matisse de-eroticized the bronze in working from a trite colonialist photograph of two Tuareg women. In building an astonishing construction from the two nearly-identical/ significantly different figures, Matisse finds the gravity and grandeur of the human figure and perhaps sublimates its eroticism.

998. " Notable Works on the Market *(Two Negresses),"* *Burlington Mag.* 99 (December 1957): supp. 7.

A short but rich note on the bronze, a cast of which was for sale from the Dr. and Mrs. Harry Bakwin Collection.

Drawing, Graphics, Book Design

Circus (Plate II from *Jazz)*
999. Olsen, Valerie Loupe. *"Jazz." Arts Quarterly* 9, 1 (January-March 1987): 9.

Discusses the individual plate *Circus* from *Jazz,* a print of which has just entered the collection of the New Orleans Museum of Art.

Dancer Resting in an Armchair (National Gallery of Toronto)
1000. Taylor, M. "Recent Acquisitions: The National Gallery Department of Prints and Drawings." *Arts Canada* 26 (February 1969): 19-20.

A note on the acquisition of the 1939 drawing which was a study for the Toledo Art Museum's *Seated Dancer.*

The Dream, Poster
1001. Breeskin, Adelaid D. "A Poster by Matisse: *Le rêve."* *Print Collector's Quarterly* 24 (December 1937): 441-42.

Matisse's poster, one of those used to announce the Independent Art Exhibition of 1937 in Paris, is compared favorably to those of Steinlen and Toulouse-Lautrec in the nineteenth century and is considered a "collectable" by print lovers. The museum is adding it to its collection of prints.

Girl with Tulips (Museum of Modern Art)
1002. King, Antoinette. "Technical and Esthetic Attitudes About the Cleaning of Works of Art on Paper." *Drawing* 8 (November-December, 1986): 79-84.

The author, director of conservation at the Museum of Modern Art, discusses damage problems of specific works on paper, including this charcoal drawing of Jeanne Vaderin and Matisse's cut-paper mural *The Swimming Pool.*

Female Nude (Location unknown)
1003. Geldzahler, Henry, "Two Early Matisse Drawings." *Gaz. beaux-arts* 6, 60 (November 1962): 497-505.

A close analysis of this pen and ink drawing with a connoisseur's appreciation of quality and technique. This reclining nude (known only from being illustrated in Marcel Sembat's 1920 monograph on Matisse) is compared to a Van Gogh painting, *Female Nude* (Barnes Foundation, formerly Vollard Collection), and a related drawing which Matisse could not have seen. The comparison is not entirely convincing. Another drawing of the period, *Male Nude*, no. 1030, is also discussed.

Five Drawings, Two Etchings (Gardner Museum)
1004. Haas, Karen E. "Henri Matisse; 'A Magnificent Draughtsman.'" *Fenway Court* (1985): 36-49.

The five figure drawings and two portrait etchings by Matisse owned by the museum (courtesy of Thomas Whittemore, Matthew Prichard, and Sarah Sears) are reproduced and discussed. Earlier literature (R. van N. Hadley, *Drawings/ Isabella Stewart Gardner Museum*, Boston, 1968) is corrected.

Une Fête de Cimmérie (book)
1005. Riopelle, Jean, and Pierre Schneider. *"Une Fête de Cimmérie ou les Esquimaux vus par Matisse."* *Ateliers* (Canada) 3, 5 (1974): 8.

Excerpts from catalogue accompanying an exhibition of drawings inspired by Eskimo masks which Georges Duthuit had in his studio. The Canadian Cultural Center in Paris was the site of the exhibition in 1970-71; the book, with text by Duthuit, had been published in 1963.

1006. *Matisse, the Inuit Face (Le Visage Inuit).* London: Cultural Center, Canadian High Commission, 1993. Exhibition catalogue. Foreword by Michael Regan, curator, who was assisted by Patricia Anderson; introductory text by Claude Duthuit. English and French.

Catalogue for the exhibition of all the known drawings and prints--charcoal, pencil, aquatints, lithographs--that Matisse made from a collection of Inuit masks belonging to Georges Duthuit; from the Henri Matisse archives and loans from Jean-

Paul Riopelle. A fine essay, "Surrealism, Structuralism, and the French Collecting of American Ethnography," by J. C. H. King of the Musée d'Homme is the major catalogue text.

Les Fleurs du mal by Baudelaire (book)

1007. Eichhorn, Linda. "Matisse and *Les Fleurs du mal.*" *Library Chronicle of the University of Texas at Austin* 27 (1984):47-59.

The author demonstrates Matisse's total involvement in the production of the books he illustrated by examining twenty unpublished letters to printer and book designer Jean-Gabriel Daragnes concerning an unrealized edition of *Les Fleurs du mal.*

1008. Smith, Elaine. "Matisse and Rouault Illustrate Baudelaire." *Baltimore Museum News* 19, 1 (October 1955): 1-9.

Matisse's illustrations for *Les Fleurs du mal* are judged less in keeping with the spirit of Baudelaire's text than the more expressive and tragic images of Rouault. A careful analysis of both artists' illustrations.

Florilège des Amours de Pierre Ronsard [book]

1009. Aragon, Louis. "Ronsard ou le quatre-vingt printemps." *Les Lettres françaises*, December 30, 1948; also in *Henri Matisse: a Novel*, vol. II; 159-64, no. 49.

A short poetic comment on Matisse's *Ronsard* in which Aragon remembers Matisse already reading the poet in 1941. Matisse finally only dealt with the poet's *amours* and nothing but his loves. Matisse, Aragon concludes, takes from each poet (Mallarmé, Baudelaire, etc.) only what he pleases, what he needs, athough he were telling his own life story.

1010. Bouvier, Marguette. "Henri Matisse illustre Ronsard." *Comoedia* 80 (January 9, 1943): 1, 6.

An article on the Ronsard project which includes statements by Matisse on the illustrations.

1011. "Matisse: Illustrations to the *Amours of Pierre Ronsard* [Atkinson Art Gallery, Southport, England; traveling exhibit]." *Art & Artists* 213 (June 1984): 29.

A review of selected drawings from the *Florilège des amours* of Ronsard, with two illustrated. The extended English itinerary of the exhibit is given at the end of the review.

1012. Mitchell, Breon. "Florilège des amours de Ronsard [Review article of reproduction of the original book by Dieter Grauer Design, in 1986]." *Fine Print* 13 (October 1987): 187-88.

After a description of the original book designed by Matisse and published by Skira in 1948, the author notes that the reprise, printed in half the size of the original under the name *Les Amours de Cassandre*, makes no note of the original colophon, leading the uninformed reader to believe that this is a first printing of Matisse's design. Besides, only nineteen poems of the original, and fifty-two of the 126 original illustrations are used. Although a close comparison of the reproduction with the original results in a criticism of the former, the author nevertheless says that the new book is carefully printed and attractive in its own right and places at least this reduced version in the hands of those who might never see or handle one of the original volumes.

1013. "Ronsard's Love Poems Illustrated with 126 lithographs." *Art News* 48 (June 1949): 12.

A note on the publication of Matisse's illustrated book, *Florilège des amours de Pierre Ronsard.*

Jazz (Unbound Book))
1014. "À Propos d'un livre de Matisse *[Jazz]." Arts* (January 2, 1948): 2.

A short note on the book's appearance as a major artistic event.

1015. Auchincloss, Eve. "Cut to the Quick." *Connoisseur* 213 (November 1983): 18.

A note on Matisse's technique in the production of his book, *Jazz*, on the occasion of its facsimile edition published by Braziller in 1983. Colored reproduction of *The Nightmare of the White Elephant.*

1016. Arikha, Avigdor. "Matisse et *l'Apocalypse de Saint-Sever:* Beatus et *Jazz.*" In *Peinture et regard, Écrits sur l'art 1965-1990,* 193-205. Paris: Hermann, 1991. Originally published as a pamphlet in English for the Los Angeles County Museum of Art, 1972, and reprinted in *Connaisance arts* 468 (February 1991): 26-39.

A learned essay on the eleventh-century illuminated manuscript, the *Apocalyse of Saint-Sever,* and on the possibility that it was seen by Matisse when he began to work with cut-paper as a new medium. On exhibit at the Bibliothèque Nationale in 1937, individual pages were reproduced in *Documents* 2 (1929) and *Verve* 2 (1937-38), and published in a facsimile edition in 1943 by Matisse's printers, Mourlot, just as Matisse began *Jazz.* The vividly contrasting zones of pure color in a non-naturalistic rendering of figures and grounds are common to both narratives, both books of Revelation.

1017. Delectorskaya, Lydia. "Commentaire sur les images de *Jazz.*" Written on the presentation of the album offered to the Musée National d'Art Moderne, 1964. Published in Cowart, et al. *Henri Matisse, Paper Cut-Outs,* 103-113. St. Louis and Detroit, 1977, no. 307.

This invaluable commentary succinctly summarizes Matisse's subject matter in each plate of *Jazz,* as recalled by his secretary-companion of that time.

1018. Flam, Jack D. "Jazz." In *Henri Matisse, Paper Cut-Outs,* 37-47. St. Louis and Detroit: The St. Louis Mueum of Art and the Detroit Insititute of the Arts, 1977. Exhibtion catalogue, no. 307.

This text sets the process of cut-out paper design in the context of Matisse's historical struggle to reconcile line and color, surface and space, immediacy and synthesis in his oils as well as in other media. Flam sees the plates as "text" and the written words of *Jazz* as the "illustrations" of the text. Together they form a kind of credo, manifesto, and autobiography in which the artist offers himself as an example to young artists and at the same time sets out a program for his subsequent work in the medium. Flam details his ideas on Matisse's development of a system of signs for things and concepts rather than the images--however distilled--that he had previously used. Author uses *Jazz* to discuss larger issues on the changes in Matisse's project at this time, as the specific history and iconography of *Jazz* is treated in the commentary later on in the catalogue, 101-115. An article of the first importance.

1019. Flam, Jack D. *"Jazz* [book review]." *Artforum* 22 (February 1984): 72-73.

This review is critical of the Braziller 1983 reproduction of Matisse's *Jazz* in nearly the same size with an introduction by Riva Castleman. Flam objects to the book as claiming to be faithful to or approaching the quality of the original, since the colors in the reproduction are "dull and lifeless" and the paper so thin that the design of the next page shows through.

1020. Glenn, Constance. "For Collectors: The Ingenious *Livre d'Artiste."* *Architectural Digest* 41 (March 1984): 62, 66+.

A general explanation of the *livre d'artiste* is followed by a demonstration of the artists' total conception in Matisse's *Jazz* and Jim Dine's *Apocalypse: the Revelation of Saint John the Divine.*

1021. Hadler, Mona. *"Jazz* and the Visual Arts." *Arts* 57 (June 1983): 93-94.

The author includes Matisse's book *Jazz* in a discussion of African-American jazz music and its aesthetic on modern

visual artists, including Picasso, Léger, Delauney-Terk, Picabia, Dubuffet, Davis, and others.

1022. Holland, Nicolle M. "Henri Matisse and *The Imitation of Christ.*" *Print Collector's Newsletter* 9, 4 (1978): 108-109.

Author details Matisse's use of a portion of *The Imitation of Christ*, a pious fifteenth-century book of devotion ascribed to Thomas à Kempis, as the entire eleventh section of of his handwritten text in *Jazz*.

1023. "*Jazz* [book]." *Art News* 82 (October 1983): 72-77.

A promotional excerpt from the Braziller reproduction of *Jazz* published in 1983. Generously illustrated in color, it reprints the English translation of the text by Sophie Hawks.

1024. "*Jazz.*" *Aarstiderne, Tidsskrift for Kunst* 6, 4 (1948): 127.

A one-page notice of the book's publication.

1025. Lassaigne, Jacques. "Matisse." *Panorama des Arts 1947*, 17-18. Paris: Somogy, 1948.

On the occasion of the Pierre Berès Gallery's exhibition of Matisse's original cut-paper maquettes for his book, *Jazz*, Lassaigne says the works have a hallucinatory force and recover a "primitive" purity and intensity that is indisputably authentic.

1026. Leinz, Gottlieb. "*Jazz* von Henri Matisse." *Pantheon* 44 (1986): 141-57.

A plate-by-plate discussion of the iconography of the twenty stencil prints in Matisse's book; draws heavily on earlier studies.

1027. Olsen, Valerie Loupe. "*Jazz.*" *New Orleans Mus. of Arts Quarterly* 9, 1 (January-March 1987): 9.

Discusses "Circus" from *Jazz*, 1947, a paper cut-out in the New Orleans Museum of Art.

1028. Stolzenburg, Andreas. "Henri Matisse: Das Buch *Jazz* und der Beginn der Gouaches Découpées." In *Henri Matisse, Zeichnungen und Gouaches Découpées.* Stuttgart: Staatsgalerie Stuttgart, 1993. Exhibition catalogue.

A general treatment from all known sources with complete text of *Jazz* with the comments by Lydia Delectorskaya published earlier in Cowart, et al, *Matisse, the Paper Cut-Outs,* 1977. Comprehensive and well researched.

Nightmare of the White Elephant (Print IV from Jazz)
1029. Urbanelli, Lora S., Deborah J. Johnson, and Lisa Norris. "Department of Prints, Drawings and Photographs." *Rhode Island School of Design Museum Notes* 75 (October 1988): 36-44.

A brief discussion of the stencil from *Jazz* on pages 41-2.

Male Nude (Thannhauser Collection)
1030. Geldzahler, Henry, "Two Early Matisse Drawings." *Gaz. beaux-arts* 6, 60 (November 1962): 497-505.

A close analysis of the drawing with a connoisseur's appreciation of quality and technique. The drawing is related to Matisse's sculpture *Serf* and to Rodin's *Walking Man,* (exhibited in 1900) all based on Rodin's model Bevilaqua who was posing for Matisse at the time the drawing (and related paintings) was produced. Another drawing of the period, *Female Nude* (no. 1003) is also discussed.

Moroccan Sketchbook and Drawings
1031. Cowart, Jack. "Matisse's Moroccan Sketchbooks and Drawings: Self-discovery through Various Motifs." In *Matisse in Morocco,* 113-54. Washington, D.C., and New York: National Gallery of Art and Abrams, 1990. Exhibition catalogue, no. 70.

An important detailed study of the some sixty documented drawings and two drawings on canvas that Matisse made while in Morocco on his two trips. Studies from Delacroix's sketchbooks of the same sites, photographs of the period,

postcard views sent by Matisse and other visual material are used as comparative documents. The drawings, analysed in themselves, often throw light on paintings for which they are the original sketch. A sensitive and illuminating study.

Motorcar

1032. Crawford, J. *"Motorcar, a Pen Drawing."* Art News 61 (Summer 1962): 6.

A letter to the editor of the magazine by the young Canadian woman who shared a train compartment in 1934 with Matisse and his niece and was drawn by Matisse in the ink drawing in question. A fresh, eyewitness account.

Pasiphaë par Henri de Montherlant (book)

1033. Comtesse, Alfred. "Le Troisième grand livre d'Henri Matisse." *Stultifera Navis* 7 (1955): 87-90.

A descriptive account of the commission and designing of the book by Montherlant.

1034. Diehl, Gaston. "Matisse, illustrateur et maître d'oeuvre," *Comoedia* 132 (January 22, 1944): 1, 6.

Article on Matisse which includes some statements of the artist on the Pasiphaë illustrations.

1035. *Henri Matisse: Gravures originales sur le thème de Pasiphaë, Chant de Minos (Les Crétois).* 2 vols. Paris: Les Héritiers de L'Artiste, 1981; Eng. ed. as *Original Engravings on the Theme of Pasiphaë,* 1981.

All of Matisse's original engravings for the published version of Montherlant's *Pasiphaë, Chant de Minos,* published in a two-volume set of 125 (100 numbered).

Poèmes de Charles d'Orléans (Book)

1036. Pernoud, Regine. "Nous manquions d'un portrait de Charles d'Orléans . . . Henri Matisse vient d'en composer un." *Figaro littéraire* (October 4, 1950).

A history and "review" of the recently-published Charles
d'Orléans book of poems,

Poésies de Stéphane Mallarmé (Book)
1037. Breeskin, A. D. "Swans by Matisse." *Mag. of Art* 28
(October 1935): 622-28.

Describes Matisse's working method of transforming early
realistic sketches from the model into simplifed, abstracted
etchings, using the maquettes for *Poésies de Mallarmé*
recently acquired by the Baltimore Museum of Art. Included
are photos of Matisse sketching swans in the Jardin des
Plantes in Paris and reproductions of the resultant drawings of
swans.

1038. Eluard, Paul. "Le Miroir de Baudelaire." *Minotaure* 1, 1
(February 1933).

Matisse's drawing and etching of Baudelaire (the latter having
appeared in *Poésies de Stephane Mallarmé)* are accompanied by
a commentary of Eluard's.

Portraits of Mary Hutchinson (Private Collection,
London)
1039. Shone, Richard. "Matisse in England and two English
Sitters." *Burlington Mag.* 135, 1084 (July 1993): 479-484.

Fully documented account of Matisse's commissions for
charcoal portraits of Mary Hutchinson and Maud Russell,
well-placed patronesses of modern art and members of the Bell
and Fry social set. A fascinating look at Matisse's English
reception between the wars, documents his visits and activities
there, and liberally quotes from letters in private collections
that testify to the impression he made. An important article.

Portraits of Mrs. Gilbert (Maud) Russell (Private
Collection, London)
1040. Shone, Richard. "Matisse in England and two English
Sitters." *Burlington Mag.* 35, 1084 (July 1993): 479-484.

Fully documented account of Matisse's commissions for charcoal portraits of Mary Hutchinson and and Maud Russell, well-placed patronesses of modern art and members of the Bell and Fry social set. A fascinating look at Matisse's reception in England between the wars, documents his visits and activities there, and liberally quotes from letters in private collections that testify to the impression he made. An important article.

Drawings for Romanian Blouse (Bucharest Museum)

1041. Costesco, Eleonora. "Trois dessins de Matisse." *Art Rep. Pop. Roumaine* 14 (1957): 67-70.

Seated Nude with Arms Raised

1042. Eckstrom, Kevin. "Matisse: *Seated Nude with Arms Raised.*" *Indiana University Art Museum Bull.* 1, 2 (1978): 78-83.

Compares the lithograph with other works, an oil and a bronze, using the same motif.

Standing Nude with Black Fern (Musée National d'Art Moderne)

1043. Monnier, Geneviève. "Henri Matisse: *Nu Debout et fougère noire.*" *Art Press* 14 (May 1987): 84-85.

A connoisseur's short analysis of this large brush drawing in india ink of 1948 that is closely related to two paintings, *Interior with Figure* of 1947 and *Interior with Black Fern* of 1948.

Still Life with Fruit and Flowers (Detroit Institute of Art)

1044. Newberry, John S., Jr. "Matisse drawing: *Still Life with Fruit and Flowers.*" *Detroit Institute Bull.* 31, 1 (1951-52): 21-23.

A sensitive extended descriptive analysis of the 1947 brush and ink drawing, recently donated to the museum by Robert H. Tannahill.

Themes and Variations

1045. Delectorskaya, Lydia. *"Thèmes et variations,* Album didactique de Henri Matisse." In *Henri Matisse, Zeichnungen und Gouaches Découpées,* 135-136. Stuttgart: Staatsgalerie Stuttgart, 1993. Exhibition catalogue. In French and German.

A brief but extremely astute discussion of the *Thèmes et variations* drawings by Matisse's assistant and confidante during the time of their fabrication. The author emphasizes Matisse's desire to publish the groups in series before their dispersion because of their being a touchstone of his method, which he wanted to share with his viewers.

1046. Flam, Jack. "Les Sujets de Matisse: Thèmes et variations." In *Matisse aujourd'hui,* 97-116. Cahiers Henri Matisse, 5. Nice: Musée Matisse, 1992, no. 98.

Flam, in this rich meditation on the series, *Themes and Variations,* suggests that the subjects of this series are the Bergsonian ones of time, occurance, memory, and the relativity of experience. Also discussed is the use of the arabesque, symbol of belief, duration, and becoming, in relation to Matisse's process in elaborating his themes. Many of these ideas, first given as a paper in 1987, are developed in a 1993 catalogue essay in *Henri Matisse, Zeichnungen und Gouaches Découpées,* no. 1047.

1047. Flam, Jack. "Matisse's *Thèmes et variations,* a Book and a Method." In *Henri Matisse, Zeichnungen und Gouaches Découpées,* 121-132. Stuttgart: Staatsgalerie Stuttgart, 1993. Exhibition catalogue. In English and German.

A comprehensive essay on the salient features of the *Thèmes et variations d*rawings--thematic recurrance, Bergsonian relativity of experience in time, metaphoric resemblances, the flowering of unconscious impulse, the invention of signs, and the work as a trace of its "formative history." Flam also considers how these underlying methods inform Matisse's working process as a whole. An important study.

1048. Girard, Xavier. "Henri Matisse: Thèmes et variations." In *Henri Matisse, Zeichnungen und Gouaches Découpées,* 215-

16. Stuttgart: Staatsgalerie Stuttgart, 1993. Exhibition catalogue.

An elegant and perceptive meditation on the musical analogy of *Thèmes et variations* in Matisse's series of drawings. The sensitivity of Matisse is as much to situations as to objects depicted or even to the rapport between them; it is a situation that evokes accords.

Ulysses [book]

1049. Kenner, Hugh. *"Ulysses* de luxe [Matisse's etchings for Joyce's modern classic]." *Art & Antiques* (January 1987): 100.

Reprise of the history of the book's commission and execution. Puts to rest the possibility of securing a book signed by Matisse alone (due to Joyce's supposed disgust with the illustrations--a baseless legend).

1050. Moore, Thurston. "The Fortunes of Polyphemus." *Register of the Spencer Museum of Art* 5, 9 (Fall 1981): 36-57.

An article on the themes of the *Odyssey* particularly the tale of the blinding of Polyphemus, and its various representations in the visual arts. Among the latter are Matisse's illustrations for James Joyce's *Ulysses*, which are fairly briefly treated. Rich in literary and artistic references, the article is only peripherally enlightening on Matisse's specific work.

Decorative Commissions (Architecture, Murals, Theatre, Applied Arts)

Abby Aldrich Rockefeller Memorial Window (Rosace) (Pocantico Hills, New York)

1051. *The Abby Aldrich Rockefeller Memorial Window.* New York, 1956.

Publication on the occasion of the dedication of the Memorial Window in Union Church, Pocantico Hills, New York, in 1956. The text gives details of the commission, Mrs. Rockefeller's long history with the Union Church, site of the window, citations from relevant correspondence about the window, and the artist's fortuitous completion of the window two days before his death.

1052. Barr, Alfred H. "When Matisse died. . . ." *Yale Literary Magazine* 123 (Fall 1955): 40.

A brief account of Barr's last dealings with Matisse concerning the stained glass window for the Abby Aldrich Rockefeller Memorial Window at Pocantico Hills, New York, the designs for which Matisse had completed two days before his death on November 3, 1954.

Apollo / Ceramic Mural (Toledo Museum of Art)

1053. "Matisse's *Apollo* [Toledo Museum of Art]." *Ceramics Monthly* 32 (April 1984): 55.

A page-long note on the history of the mural's fabrication and its acquisition by the museum. See also entries under *Apollo / Paper cut-out* in this section, above, no. 783-789.

Arbre en Fleur (Mural-Scroll)

1054. Soby, James Thrall. "Calder, Henri Matisse, Miro, Matta: silkscreen mural-scrolls from original designs." *Arts & Architecture* 66 (April 1949): 26-28.

A short article on the first four artists to offer designs to be silk-screened on canvas in editions of two hundred by Katzenbach and Warren, Inc. Illustrated in black and white, the

designs are characteristic of the work of the artists. Matisse's design is of two leaf-fronds flanking a rectangle of a bordered leafy form. Matisse's scrolls were actually printed in an edition of only thirty. Soby's article justifies such projects in the interest of interior design of high quality and accessible price.

Chant de Rossignol (The Chinese Nightingale)
(Ballet Russes decor)

1055. Barsky, Vivianne. "Matisse at the Ballet: Le Chant du Rossignol." In *Matisse at the Ballet: Le Chant du Rossignol.* Jeursalem: The Israel Museum, 1991. Exhibition catalogue. In English and Hebrew.

Comprehensive essay on Matisse's collaboration with Diaghilev for the ballet, *Le Chant du Rossignol.* Gathers all available scholarship on the work; richly illustrated.

1056. Cogniat, Raymond. "Henri Matisse et le théatre." *Le Point* 21 (July 1939): 140-42.

Despite Matisse's plastic sense, the richness of his color, and the power of his arabesques, his theatre decors have disconcerted the public (in 1919, *Rossignol,* in 1939, *Rouge et Noir).* As someone who works in two dimensions, for a theatre that is wholly three-dimensional, Matisse's solutions have been ingenious. In *Rossignol,* for instance, mediating the exigencies of the 2nd and 3rd dimensions, he placed the emperor's bed on an inclined plane. Matisse grouped his dancers in vertical formations, pyramids, etc. In both decors, Matisse's emphasis on two-dimensionality helped abstract the dance movement and depersonalized the dancers so that a new and unexpected effect was produced

1057. Favelin, Corine. "Matisse decorateur de théatre: Essai de reconstitution d'une conception scénographique." *Ecrit-Voir* 11 (1988): 51-61.

Describes closely the scenic design and costumes for the ballet, *Chant de Rossignol* (1919), stressing the similarity of its principles to those of the later ballet, *Rouge et Noir* (1939). Although the former was praised as a return to "French good

taste" by contemporary critics, the ballet must be compared to the previous scenographic treatment of the ballet by Benois (1914) as well as the modernist geometries of an aborted version by Fortunato Depero (c. 1916). Matisse's version falls more surely within a striking modernist simplification and abstract disposition of color groupings, than the Ballet Russes décors of the first phase, though not as radical in its geometricizations as Picasso's *Parade* or Depero's version.

1058. Goerg, Charles. "Un Manteau de Matisse pour *Le Chant de Rossignol.*" *Musées de Genève* 264 (April 1986): 6-9.

A note on a gift to the museum, "Coutume d'un pleureur (1920):" a white felt robe with appliquéd designs in deep blue velvet. Author includes related documentation and sketches.

1059. McQuillan, Melissa Ann. "Henri Matisse: Le Chant de Rossignol." In *Painters and the Ballet, 1917-1926*, 477-92. Ph.D. dissertation, New York University, 1979.

Until the Israel Museum catalogue of 1991, this chapter of the author's study is the most complete treatment of Matisse's 1920 ballet decor and costumes, drawn from relevant reviews, memoirs, and dance studies.

1060. Schouvaloff, Alexander. "Stravinsky sur scene." *Connaissance arts* 365/366 (July-August 1982): 64-71.

In an article as much on various ballets as on Stravinsky himself, one page is devoted to photos and sketches from *Rossignol* with a brief informative text.

Reviews of the ballet: Laloy, Louis. "Le Chant du Rossignol." *Comoedia* (February 4, 1920); Marnold, Jean. "Revue de la Quinzaine." *Rev. des lettres modernes* (November 1, 1920); Prunières, Henri. "Les Nouveaux Ballets Russes." *La Rev. critique* 160 (March 10, 1920); Bernier, Jean. "Les Ballets Russes à l'Opera." *Comoedia illustré* (February 15, 1920).

General studies in which Matisse's ballet is mentioned: Brillant, Maurice. "Influence multiforme des Ballets Russes."

La Rev. musicale (December 1930); Cogniat, Raymond. *Les Décorateurs de théatre*. Paris: La Librairie Théatrale, 1955; Georges Michel, Michel. *Histoire anecdotique des Ballets Russes*. Paris: Edition du Nouveau Monde, 1923; Masson, André. *Le Rebelle du Surréalisme*. Paris: Hermann, 1976; Michaut, Pierre. *Le Ballet contemporain*. Paris: Plon, 1950; Moussinac, Léon. *La Décoration théatrale*. Paris: F. Rieder, 1922; Baer, Nancy Van Norman. *The Art of Enchantment: Diaghilev's Ballets Russes*. San Francisco: Fine Art Museums of San Francisco, 1989; Warnod, André. "Les Peintres et les Ballets Russes," *La Revue musicale* (December 1930).

Chapel of the Rosary (Vence)

Books

1061. Billot, Marcel. *La Chapelle de Vence, journal d'une création*. Paris: Menil Fondation, Archives Courturier, 1993.

This is a carefully annotated and wonderfully rich compilation of documents from the three-way contact between: Frère Rayssiguier, the young Dominican who acted as project-consultant in the development of Matisse's Chapel at Vence; Père Couturier, promoter of religious art by gifted contemporary artists; and Matisse. The documents assembled are: the journal of Rayssiguier, correspondence between Rayssiguier and Matisse, extracts of the journal of Père Couturier, and the correspondence between Couturier and Matisse. An invaluable source of information on the development of Matisse's ideas concerning the chapel, its decorations and appointments, and of the problems and issues that surfaced in the construction of the chapel. Matisse's observations on artists, writers, and art movements are interspersed throughout and provide a rich source of new information on his views.

1062. Bourniquel, Camille, and Jean Guichard-Meili. *Les Créateurs et le sacré*. Paris: Editions du Cerf, 1956.

Subtitled *Textes et témoinages de Delacroix à nos jours*, the text includes an unsigned introduction of idealist and nonspecific claims for a return to "grandeur and a rediscovery of the past" in modern art and sets out short quotations that concern religion or ideas of the sacred by thirty-four French artists. The Matisse selections (pp. 173-77) are fairly predictable ones made in connection with his work on the Chapel of the Rosary at Vence.

1063. Calmels, Norbert. *Matisse: La Chapelle du Rosaire des Dominicaines de Vence et de l'espoire.* Mane: Morel Éditeur, 1975.

Study of the chapel by a religious who portrays the orgins of the project as an act of gratitude for the artist's recovery after surgery in 1941. Withdrawn from sale.

1064. Couturier, M.-A., M. R. Capillades, L.-B. Rayssiguier, and A. M. Cocagnac. *Les Chapelles du Rosaire à Vence et de Notre-Dame-du-Haut à Ronchamp*, 1-56. Paris: Éditions du Cerf, 1955.

The introduction to this book of mainly plates is comprised of extracts of texts already published in *L'Art Sacré*, nos. 11-12, 1951.

1065. Couturier, M.-A. *Propos de Matisse: propos notés par le Père Couturier*. Paris: P A B, September 1956. Edition of 35 copies.

A miniature (c. 2 1/2 x 2 1/2") paper-cover book in which two statements by Matisse are printed over five pages without further text. The texts are: "J'ai dit à Picasso: oui, je fais ma prière, /et vous aussi, et vous le savez très bien: quand tout va mal, nous nous jetons dans la prière pour retrouver le climat/ de nôtre première communion. Et vous le faites, vous aussi. Il n'a pas dit non." Mars 1949 / "On est conduit. On ne conduit pas. Je ne suis qu'en serviteur." "La mort n'est pas la fin de tout, c'est une porte qui s'ouvre." Mars 1952.

1066. Couturier, M.-A. *Se Garder Libre* [Journal 1947-1954]. Paris: Éditions du Cerf, 1962.

Posthumously published journals of the Dominican artist-monk who worked intensively with Matisse during the planning and construction of the chapel. The journal reveals Couturier's close contact with, besides Matisse, Braque, Chagall, Derain, Rouault, Léger, Gide, the Duthuits, and many others during this period. Very valuable commentary on Matisse's process and direct quotes from Matisse on the project.

1067. Couturier, M.-A. *Art Sacré*. Nice: Menil Fondation, 1983. With a contribution from Dominique de Menil. Trans. by Granger Ryan as *Sacred Art*. With a contribution by Pie Duployé. Austin: University of Texas Press, 1989.

The collected and edited writings of Marie-Alain Couturier which includes previously published works on Matisse's Vence Chapel of the Rosary as well as on Léger's windows at Audincourt and Le Corbusier's church at Ronchamp.

1068. David, Christoph W., ed., with Raymond Escholier. *Moderne Kirchen: Matisse, Vence; Fernand Léger, Audincourt; Le Corbusier, Ronchamp*. Series: Horizont. Zürich: Die Arche, 1957, 1962.

An anthology of texts and statements by artists and others connected with the design and building of these three churches, including Père Couturier, Matisse, Léger, Bazaine, Le Corbusier. Brief bibliography and some plates.

1069. Finsen, Hanne, and Mikael Wivel. *Matisse. Kapellet i Vence /Matisse: Chapelle du Rosaire des Dominicaines de Vence*. Copenhagen: Ordrupgaard Museum, 1993. Exhibition catalogue.

Richly illustrated catalogue of sketches, maquettes, letters, and sketchbooks by Matisse as studies for the chapel and its decoration. Finsen's 1951 essay [*Aarstiderne* 9, 2 (December 1951), no. 1093] is reprinted within her larger catalog essay,

which scrupulously narrates the initiation and flowering of the
project for the chapel based on primary documentation. Over
one hundred items, many from the Musée Matisse but others
from private collections and other museums are reproduced and
documented.

Review: Fonsmark, Anne B. "Matisse in Denmark, The
Chapel at Vence," *Apollo* 138 (October 1993): 258.

1070. Girard, Xavier. *Matisse. La Chapelle du Rosaire, 1948-1951*.
Cahiers Henri Matisse, 8. Paris: Réunion des Musées
Nationaux, 1992.

Handsomely designed book produced by the Musée Matisse,
which holds the largest collection of materials related to the
Chapel of the Rosary. An extensive catalogue essay by the
director, Xavier Girard, is immensely informative about the
construction and history of the chapel, the artist's artistic
process and his final achievement, and the political and critical
controversies that have swirled about the meaning and value of
the work. Much collateral historical material is brought to
bear on the making of the chapel, further enriching this
meticulous and sensitive study. An indispensable resource.

1071. Jacques-Marie, Soeur [Monique Bourgeois]. *Henri Matisse, La
Chapelle de Vence*. Paris: Gregoire Gardette, 1993.

A reminiscence about the friendship between Matisse and
Monique Bourgeois, who served as his nurse, model, and
studio assistant before entering the Dominican order and
becoming Soeur Jacques-Marie. Stationed at Vence, she was
responsible for involving the artist initially in the projected
Dominican chapel. An affectionate and informative account of
a rather remarkable relationship and its remarkable
consequence.

1072. Jedlicka, Gotthard. *Die Henri Matisse Kapelle in Vence:
Rosenkranzkapelle der Dominikanerinnen*. Frankfurt am
Main: Suhrkamp, 1955.

A workmanlike overview of the commissioning of the Chapel of the Rosary at Vence and an analytic description of the building, its windows, wall murals and furnishings, based on previously published documentation, e.g., of Couturier, Rayssiguier, Barr and Matisse himself. Of greatest interest and value is a long interview with Matisse from March 19, 1952, in which he speaks freely of his chapel, clears up misconceptions, discusses his cut-paper work, and reflects on the life he has lived after his close encounter with death more than a decade past. (This important interview was translated into French in "Autres Propos de Henri Matisse," *Macula* 1 (1976), no. 30.) The black and white photographs of the chapel are well chosen and clearly present all aspects of the chapel proper but not the altar furnishings nor the vestments.

1073. Matisse, Henri. "La Chapelle du Rosaire." In *Chapelle du Rosaire des Dominicaines de Vence*. Vence: La Chapelle du Rosaire, 1951; printed by Mourlet Frères; other eds. 1955, 1956, 1958, 1963.

Short text by Matisse on the chapel as the culmination of his life-long artistic effort, preceding excellent halftone reproductions of the chapel, its decoration, its vestments; drawings and studies for the Madonna, St. Dominic, Stations and crucifix. Lithographed cover with blue cut-leaf form against a yellow ground. Flam, no. 28, and Fourcade, no. 29.

1074. Matisse, Henri. "Chapelle du Rosaire des Dominicaines de Vence par Henri Matisse." *France Illustration* 320 (December 1, 1951): 561-70. Reprinted as "La Chapelle de Vence, aboutissement d'une vie." *XXe Siècle, Hommage à Henri Matisse*, 71-73. Paris: Cahiers d'Art, 1970. Flam, no. 28, 197-98; Fourcade, no. 29, 259-60.

A detailed statement of the artist's intention in adjusting the colors of the stained glass windows in relation to the murals on tile, which together orchestrate the spiritual expression of the whole decor.

1075. Percheron, René. *Vence et la Chapelle du Rosaire*, 33-47. Paris: Dessain et Tolra, 1974.

A general treatment of the chapel and its decor; illustrated.

Articles

1076. Barker, Michael. "Stained Glass in France in the 1950's."
 Journal of the Decorative Arts Society 1850 to the Present 15
 (1991): 5-13.

 A well-illustrated general survey of the production and use of
 stained glass as an art form in France includes Matisse's
 windows from the Chapel of the Rosary in Vence.

1077. Barry, Joseph A. "The Chapel of Henri Matisse." In *Left
 Bank, Right Bank, Paris and Parisiens*, 129-136. New York:
 W. W. Norton, 1951.

 Author recounts a visit to Matisse at Vence while he was
 working on the Chapel; anecdotal but with close observations
 of the work-in-progress.

1078. Bernier, Rosamond. "Matisse Designs a New Church."
 Vogue 112 (February 15, 1949): 131-32.

 An extensive and vivid description of the projected chapel
 before its building by an author who had access to the artist
 and his sketches and maquettes. Two full-page color
 photographs of Matisse at work on the chapel in his bedroom
 at Vence accompany the article.

1079. Bertin, Célia. "A Vence Henri Matisse décore une chapelle."
 Arts Plastiques 5-6 (1959): 209-214.

 Eyewitness account of Matisse's activity in designing the
 chapel at Vence by a writer and magazine editor who lived in
 Vence.

1080. Billot, Marcel. "Le Père Couturier et l'Art Sacré." In *Paris-
 Paris 1937-1957*, 197-200. Paris: Centre Georges Pompidou,
 1981. Exhibition catalogue.

 General treatment of the role of the Dominican priest, Marie-
 Alain Couturier, in the invitation to modern artists to

participate in the renewal of liturgical art that began before World War II and saw actual production at Assy, Vence, and Audincourt in 1950-51. Matisse's Chapel is placed in this historical context; the call for a renewal of religious art had its beginnings in the work of Maurice Denis at the beginning of the century.

1081. Bordley, R. "Matisse's chapel at Vence." *Art Digest* 25 (September 15, 1951): 9+.

A general two-page description of the chapel interspersed with quotations from Courturier and Matisse; illustrated with black and white photographs.

1082. Buchanan, Donald W. "Interview in Montparnasse." *Canadian Art* 8, 2 (Christmas 1950-51): 61-65.

Having seen the chapel recently, Buchanan examines work for the chapel in the artist's apartment on the Blvd. Montparnasse and discusses with Matisse particularly the roof-spire base which the latter intends to enlarge.

1083. "Capella di Matisse." *Emporium* 111 (April 1950): 182-83.

A note describing the chapel, particularly the effect of the colored windows against the black-and-white ceramic murals. A full-page reproduction of a preliminary sketch for the *Madonna and Child* mural is appended.

1084. "Chapel at Vence." *Liturgical Arts* 20 (February 1952): 43, 53.

An editorial on the initiatives in modern church construction; a page of photographs and a plan of the chapel put out by the Museum of Modern Art.

1085. "La Chapelle de Vence." *L'Illustration* (Christmas, 1951).

Extensive photographic picture-story of the inauguration of the chapel.

1086. "Chapelle du Rosaire des Dominicains de Vence par Henri Matisse." *France illustration* 7 (Noël 1951): 565-72; includes Matisse's statement, "La Chapelle de Vence, aboutissement d'une vie;" reprinted as *XXe Siècle*, special no. (1970): 70-73.

1087. Couturier, M.-A. "La Chapelle de Matisse." *France illustration* 5 (December 24, 1949): 704-08.

Five pages of photographs of the artist working in this studio on the Virgin and Child with a long charcoal-tipped stick, reading a sacred text, etc. along with studio shots of the maquette of the chapel and in-progress sketches. The page of text reiterates the origin of the commission, a glowing description of the effects of the windows on the white walls, and praise of Matisse's increasing purity of design and purpose, as the chapel is the "fulfillment of his life's artistic search."

1088. Couturier, M.-A. "Church Full of Joy." *Vogue* 118 (December 1951): 128-32.

Illustrated picture-story on the chapel.

1089. Couturier, M.-A. "L'Église d'Assy et la Chapelle de Vence." *L'Art Sacré* 5-6 (May-June 1948): 109-110.

A progress report on the two churches along with an enthusiastic description of works in progress. The author gives the circumstances of the two church's initiations in order to dispel errors that are circulating about their histories.

1090. Couturier, M.-A. "Religious Art and the Modern Artist." *Mag. of Art* 44, 7 (November 1951): 268-72.

Author offers his rationale for attempting to revivify Christian art by commissioning religious art from the greatest living artists, whether or not they are practicing or believing Christians. Father Couturier was consultant for the programs of churches at Assy, Agincourt, and the Dominican Chapel of the Rosary at Vence. An important *apologia* or the post-war phenomenon in church building commissions.

1091. Delectorskaya, Lydia. "La Veritable histoire de la Chapelle de Vence." In *Henri Matisse: roman*, 183-227. Vol. 2. Paris, 1971, no. 49.

Matisse's secretary and companion, eyewitness to the events she recounts, sets the record straight on the artist's relationship to his nurse and sometime model, Monique Bourgeois (Soeur Jacques-Marie), and on just how the commission to design the chapel came about. A frank, generous, and apparently accurate account of this special friendship and its outcome.

1092. Douaire, Richard J. with response by M.-A. Couturier. "Pilgrimage to Assy--an Appraisal." *Liturgical Arts* 19, 2 (February 1951): 28-31.

An on-site description and evaluation of the chapel at Assy and a defense of Couturier's intentions in commissioning work from great, if not necessarily believing, artists. He agrees that the "immanent habit of art" in these men would manifest itself in sincerely religious work. Matisse's image of St. Dominic on a side altar is praised: "its boldness of expression is restrained by its happy poverty of means." Couturier's response, solicited and augmented by the editors, merely assures the reader that the works have the approval of the Holy See and are in full concordance with episcopal authority as to liturgical laws.

1093. Finsen, Hanne. "Kapellet i Vence." *Aarstiderne, Tidsskrift for Kunst* 9, 2 (1951): 58-64. Reprinted in Finsen and Wivel. *Matisse. Kapellet i Vence*. Copenhagen, 1993, no. 1069.

An account of a Danish student's visit to Matisse and to his chapel just before its dediction; an unusually well-observed and well-written eyewitness description, with some interesting observations by Matisse.

1094. Girard, Xavier. "The Chapel of the Rosary at Vence." In *Henri Matisse*, 136-143. Brisbane: Queensland Art Gallery and Art Exhibitions Australia, 1995. Exhibition catalogue.

A full, if succinct, introduction to the chapel by an author who has written on it more extensively, no. 1070. In this essay Girard emphasizes the metaphor of flower, sunlit glade, and atmospheric space for song that the Chapel provides for those within it, similes that Matisse himself acknowledged.

1095. Hammarén, Carl-Erik. "Kapellet i Vence." *Paletten* 2 (1956): 42.

Brief description of the chapel, its design, and the history of its commission.

1096. Harbison, Robert. "Modern Art and the Riviera." *C Magazine* (Canada) 20 (December 1988): 62-5.

A general tour of the Riviera with its museums and churches (including Matisse's chapel at Vence) and the Fondation Maeght. Author reminisces about the area before its popularity as a tourist attraction.

1097. Hasegawa, Saburo. "Matisse through Japanese Eyes." *Art News* 53 (April 1954): 27-29+.

A severe critique by a contemporary Japanese artist of Matisse's late work, especially the line drawings for the Chapel at Vence, as work of declining quality, of too great leisure and failure of tension, of the disengagment of a space that (since 1920) is too "camera-eye" and not sufficiently spatially and emotionally involving. An important and rare criticism.

1098. "Henri Matisse, a Small Chapel in France and a Monumental Art Exhibit at the Museum of Modern Art." *Life* 31 (November 26, 1951): 108-16.

A thumb-nail (one-page) biography of the artist accompanies full-color illustrations of Matisse in his chapel and reproductions of notable paintings and prints, on the occasion of the 1951 Matisse Retrospective at MoMA in New York and the near-completion of the chapel at Vence.

1099. "Henri Matisse, La Cappella del Rosario delle Domenicane di
 Vence." *La Biennale di Venezia* 26 (December 1955): 39-40.

 Photographs of the chapel with some of Matisse's statements
 about it.

1100. Hoctin, Luce. "The Renaissance of Church Art in France."
 Graphis 13 (May 1957): 224-29. Text in English, German,
 and French.

 A longer article on the revival of religious art through the
 work of France's finest artists in the post-World War II
 building and rebuilding of some 4000 churches. Matisse's
 chapel at Vence is dealt with briefly and given high praise;
 illustrations of it include inside and exterior views, a close-up
 of the sacristy crucifix, four views of vestments, the holy
 water font, and the altar's tabernacle and ciborium.

1101. Holm, Arne E. "Matisse's Kapell i Vence." *Kunsten idag*
 (Norway) 20, 14 (1951): 32-48, 58-61.

 Author describes the setting of Vence, tells the story of how
 the chapel came about, and provides a good overall description
 of the design, materials, and experiential effects of the chapel
 on the viewer. Concludes with reflections on Matisse's own
 religious beliefs.

1102. Italiaander, Rolf. "Henri Matisse baut eine Kirche." *Kunstwerk*
 5, 1 (1951): 52-53.

 Author tells of his visit (accidentally as he was seeking out
 Chagall at the time) to Matisse's chapel, which he found
 beautiful, but which did not inspire "spiritual," to say nothing
 of religious, thoughts or feelings. In a later visit to Matisse,
 surrounded by his sketches and maquettes for the chapel,
 Italiaander says the artist spoke of wanting to work in other,
 more enduring, materials such as sculpture, ceramics, and
 architecture, if that were possible.

1103. Justema, William. "Activities of Matisse at Vence."
 Liturgical Arts 20 (May 1952): 100.

A letter to the magazine's editor from a Benedictine monk and sometime writer on religious art that is critical of the chapel on both esthetic and religious grounds. The designs are weak; the content without depth, despite Matisse's sincere efforts. These judgments are made from photographs.

1104. Lacaze, André, and Walter Carone. "Matisse Sacrifie 800 Millions pour Soeur Jacques dominicaine." *Paris-Match* 59 (May 6, 1950): 15-17.

A well-illustrated piece of journalistic sensationalism which seeks to imply a concealed romantic attachment of Matisse to his former nurse and model.

1105. Lane, John W. "Matisse: Painter into Architect, His Venture at Vence." *Liturgical Arts* 20 (February 1952): 61-62.

Lane appreciates the chapel for the "delicate and deep originality of the design and decoration." The only reservation the author has is the success of the Stations of the Cross but excuses the unevenness of so ambitious a project.

1106. Langdon, Gabrielle. "A Spiritual Space: Matisse's Chapel of the Dominicans at Vence." *Zeitschrift fur Kunstgeschichte* 51, 4 (1988): 542-73

This article discusses the liturgical rites for which the chapel was the setting and the specifically religious ends to which Matisse had to submit his decorative scheme. The religious iconography of the chapel, its images, and its furniture are fully explored within the Dominican traditions of the order which commissioned it. Matisse's relations with Couturier and Rayssiguier are treated as well as those with Soeur Jacques-Marie in this important and well-researched essay.

1107. Lemaître, Henri. "A Masterpiece of Modern Art: Religious Art by Henri Matisse." *Blackfriars* 31 (1950): 35-39.

A visit to Matisse by the author reveals the artist preoccupied with nothing but his design for the chapel in which his vocation as an artist will be fulfilled. A straightforward and

sensitive description of the project follows. Lemaître stresses the purity of the work, its richness, its note of joyousness and hope, as fitting for a house of prayer but does not impute the truly "religious" attitudes to Matisse. Matisse, he notes, struggles with an esthetic problem: how to "give utterance harmoniously and simultaneously . . . to line and color."

1108. "Masterpiece Completed: Mural for Chapel in Provence." *Art Digest* 25 (August 1951): 13.

Notes the dedication of the completed Chapel of the Rosary, while Matisse lay "on a sickbed," too incapacitated, it is implied, to attend the ceremony. Erroneously notes the chapel having been done for "Franciscan" (sic) nuns.

1109. "Matisse Chapel." *Interiors* 111 (January 1952): 10.

On the occasion of the Matisse Retrospective at the Museum of Modern Art in 1951, the author of this short review concentrates on the ensemble of designs and maquettes of the Chapel at Vence and its furnishings, that is, the crucifix, vestments,and confessional door, which he finds remarkable and moving.

1110. "Matisse Chapel." *Architectural Forum* 96, 5 (May 1952): 148-53.

A short, admiring description of the chapel accompanies ten stunning photographic reproductions (three in color) of the interior and exterior of the chapel, the altar, confessional door, the floor plan and of the artist himself, working on an earlier version of the rondel of the Virgin and Child from his wheelchair.

1111. "Matisse Chapel Designs at Modern." *Art Digest* 26 (January 1, 1952): 24.

A paragraph-long notice of the delayed opening of that part of the Matisse Restrospective at the Museum of Modern Art that included photographs of the chapel as well as "designs for stained glass window and wall murals."

1112. "Matisse et ses derniers jours, ses derniers oeuvres." *Paris-Match* 294 (November 13-20, 1954): 30-35.

Photo essay on Matisse in the chapel, at the first celebration of Mass, with Henriette Darricarrère and her adult daughter, Claude Plent; Henriette in her mature years looking very much like the third sculptured head of her, *Henriette III.*

1113. "Die Matisse-Kapelle in Vence." *Werk* 40 (June 1953): 200-04.

A short description of the chapel, with more attention than usual to the liturgical functions that the chapel construction facilitates, is illustrated with three pages of fine quality black and white photographs of the chapel in use and under differing light conditions, also of charcoal sketches for the Stations of the Cross, and some altar furnishings.

1114. Monnier, Gérard. "Picasso et Matisse, célébration et solitude." In *L'Art en Europe, l'années décisives, 1945-1953*, 248-251. Geneva: Skira and Association des Amis du Musée de Saint-Etienne, 1987.

The author notes that Matisse's last work, dedicated to "decor" and to an art of "utility," was drawn into the discourse on sacred art and architecture of the late 1940s, but that the full scope of Matisse's cut-paper work and late paintings and the ramifications of the scale of his last ambitious mural work were not fully realized until after the artist's death, in the late 1950s. A perceptive, if brief, discussion of the significant strategies employed in the chapel at Vence.

1115. Murcia, M. H. "Homage to Henry Matisse." *Marg* 8, 3 (June 1955): 91-94.

The author compares Matisse's aims, realized in the Chapel of the Rosary, with the purity, economy of means, and intellectual austerity of Mallarmé's poetry. Matisse's works are judged to be more universally human, more direct, than the symbolist poet's.

1116. "Un Nouveau projet d'Henri Matisse: La Chapelle de Vence."
 Les Amis de l'art 1 (1948).

 An early notice on the project then just underway.

1117. "Painter Turns Architect: Designs Chapel for an Orphanage at
 Vence." *Architectural Forum* 90 (April 1949): 210.

 A photo of Matisse with the maquette for his chapel and other
 in-process photos accompany a short description of the project,
 then still at an early stage.

1118. Parnotte, Henri. "A Vence: l'achévement de la chapelle de
 Matisse." *France illustration* 7 (June 30, 1951): 691-4.

 Four pages of photos of the nearly-completed chapel with
 construction rubble still visible and workmen putting on the
 finishing touches. A brief informational note and picture
 captions are the only texts; a large-type opener states that "a
 team animated by the faith of the cathedral builders works for
 the completion of the chapel of Matisse."

1119. Perl, Jed. "The Chapel of the Rosary, Vence, France." *New
 Criterion* 5 (September 1986): 52-53.

 Perl begins his essay on art in the South of France with a visit
 to Matisse's Chapel of the Rosary at Vence and ends with an
 appreciation of *Large Decoration with Masks* and his cut-
 paper works. The themes touched on are the role of decoration
 in the late work of both Picasso and Matisse, the way the
 Mediterranean coast affected their later work, and the quality of
 that late work, especially that of their advanced years. Full of
 marvelous observations and critical judgments.

1120. Pernoud, Regine. "The Chapel of the Rosary." *San Francisco
 Museum Quarterly* 1-2 (1952): 13-20.

 An article of considerable interest and accuracy of detail by
 Mme Pernoud, then curator of the Musée de l'Histoire de
 France of the National Archives who had been teaching at the
 University of Aix-en-Provence when the chapel was being
 built and was privy to Matisse's developing ideas. She was

asked by the artist to write the first article on the chapel released to the press.

1121. Pleynet, Marcelin. "Henri Matisse: La Chapelle du Rosaire à Vence." *Art Press* 102 (April 1986): 80-81.

A rather brief essay by Pleynet in which he tells the story of the chapel's making, stresses the artist's religious engagement, especially in the making of the Stations of the Cross, and claims that the chapel is an example of an "art of creation by light (luminism) and an art of displacement and movement of forms (cinétisme)."

1122. Prendeville, Brendan. "Theatre, Manet, and Matisse, the Nietzschean Sense of Time in Art." *Artscribe* 14 (October 1978): 26-33.

Using the mural *Apollon* and the Chapel at Vence as examples of the Apollonian and Dionysian poles of Matisse's art, the author relates these works to Manet's theatricality and Nietzsche's notions of time, achieved--for the visual artist-- through dramatic space.

1123. Proulx, Alfred C. "The Matisse Chapel." *Yale Literary Magazine* 123 (Fall, 1955): 37, with illustrations.

A brief appreciation of the chapel as the "complete single expression" of Matisse's entire life's work, a rare opportunity even for major artists.

1124. Saint-Bris, Gonzague. "Matisse dans l'hiver de Dieu." *Décoration internationale* 77 (December 1984-January 1985): 110-17.

The author insists on the totally religious nature of the chapel and on the religious motivation of the artist in building it. Although he often quotes Matisse's own statements, he interprets them in ways that would seem to distort their patent meaning if one takes into account the testimony of others close to Matisse at the time. A tendentious article that presents a pious Matisse, fervently seeking God. The title

derives from Matisse's simple observation that the chapel looks its best in winter light.

1125. Salles, Georges. "Visit to Matisse." *Art News Annual* 21 (1951): 34-39, 79-81.

Well-illustrated article on a visit to Matisse and the chapel, with remarks centered on artistic development leading to the chapel.

1126. Seguin, Jean-Pierre. "Matisse à Vence." *Arts Mag.* (April 12, 1949): 46.

A note on the commencement of the chapel and early progress report.

1127. Slivka, Rose. "Matisse Chasubles Designed for the Vence Chapel." *Craft Horizon* (January 1956): 22-25.

A detailed account of the making of the chasubles: of some twenty designs, five were executed for the chapel, five for the Museum of Modern Art. How the Museum procured the second set is also narrated in detail. The chasubles are all described and illustrated.

1128. Thibaud, Paul. "Un Christianisme littéraire, dans les murs et hors les murs." *L'Esprit* 113-14, 4-5 (April-May 1986): 219-33.

In a far-ranging exploration of the possibility of faith, of Christianity, in the modern world, the author discusses Charles Peguy and Georges Bernanos as examples of writers who have replaced priests as ministers of the faith. Matissse is treated briefly as an agnostic, paradigmatic of those for whom the symbols and teaching of Christianity can still be bearers of a kind of human and Christian experience. Citing Schneider on the pagan religious exaltation that Matisse experienced in artmaking, the author points to the participation of the viewer in that transporting experience in the artist's late works. By means of Christian symbols in the chapel, Matisse used the traditional signs of faith to refer to both suffering and

happiness. A thoughtful reflection on the modern artist and his capacity for belief.

1129. Vaa, Thora. "Matisses Kapell i Vence." *Kunst og Kultur* 41 (1958): 17-24.

An article, well illustrated with black and white photos, which gives an overview of the chapel, its physical setting, its windows and wall murals. In Norwegian.

1130. "Vence Chapel: illustrations." *London News* 219 (July 7, 1951): 28.

Page of photographs of the completed chapel.

1131. "Vestments Designed by Matisse for the Vence Chapel: Illustrations." *Arts & Architecture* 73 (May 1956): 35.

A page of photos in black and white of the five vestments owned by the Museum of Modern that are replicas of those designed by Matisse and used in the Chapel of the Rosary at Vence. The maquette for the red chasuble is also pictured; there is a short text with minimal necessary information.

1132. "Vestments for Vence." *Time* 59 (April 7, 1952): 75.

A short description of the vestment project undertaken by the artist for his chapel.

1133. Vignorelli, Valerio, O.P. "La Lezione di Vence." *Arte Cristiana* (1954): 33-38.

A vigorous defense of the chapel against detractors within the church who were critical of the chapel on religious, rather than esthetic, grounds.

1134. "What I Want To Say: Work on the Dominican Chapel at Vence." *Time* 54 (October 24, 1949): 70.

A short, two-column note on Matisse's chapel, but the reviewer secures a few fresh quotes from the artist, who

expresses sincerity and satisfaction with the results of his immense effort.

1135. Welch, M. L. "Matisse and His Masterpiece." *American Society Legion of Honor Magazine* 28 (1957): 29-42.

An extended article on Matisse which gives a careful description of the Chapel and the story of its commission and completion. The author stresses the spiritual, even religious, motivation of the artist and gives his whole narration a rather edifying cast. Following this section, Welch offers a straightforward summary of Matisse's career, accurately told. Concluding remarks again inspirationally stress Matisse's offering to God the "fruit of his talents" in his "masterpiece," the chapel at Vence.

1136. Wind, Edgar. "Traditional Religion and Modern Art." *Art News* 52 (May 1953): 18-22, 60-63.

Lecture given (April 1953) on the occasion of a Georges Rouault Exhibition at the Museum of Modern Art. Wind concludes that Rouault, the intolerant, obsessed Catholic, and Matisse, the tolerant, disengaged pagan, both produced religious art that is "unsacramental," that is, not theologically compelling but moving for personal piety. An important reflection on contemporary religious expression.

Dance (Barnes Foundation Mural)
Dance (Musée d'Art Moderne de la Ville de Paris)
Unfinished **Dance** (Pierre Matisse Estate, Musée d'Art Moderne de la Ville de Paris)

1137. *Autour d'un chef-d'oeuvre de Matisse: Les Trois versions de La Danse Barnes (1930-1930).* Paris: Musée de l'Art Moderne de la Ville de Paris, 1993. Exhibition Catalogue.

Handsome exhibition catalogue of the three versions of the Barnes Foundation mural, including that removed for the traveling show from the Barnes Foundation itself. Excellent illustrations of studies and sketches for the three versions with pull-out reproductions. An introduction by Suzanne Pagé precedes the essay by Jack Flam which also appeared in the National Gallery of Art (Washington) catalogue, no. 1143. Pierre Schneider contributes "Vivants piliers" an essay which reprises something of what he has already laid out in the revised version of his monograph *Matisse* (1993) and his introduction to the *Matisse et l'Italie* catalogue. Xavier Girard's essay "La Danse, la peinture à l'oeuvre," and Laurence Louppe's "Matisse et la danse du futur," complete the substantive essays in the catalogue. A conservation report on the most recently discovered first version by Dominique Gagneux and a short account of its finding on April 1992, by the artist's granddaughter, Jackie Monnier, completes the rich collection of texts in this catalogue.

1138. Bois, Yve-Alain. "The Shift." In *Henri Matisse.* Eds., Roger Benjamin and Caroline Turner. Brisbane: Queensland Art Gallery and Art Exhibitions Australia, 1995.

A close reading of Matisse's three versions of the Barnes *Dance* mural, in a framework of theories about the relationship of line to color and the pictorial problem of an architectural context.

1139. "Matisse's 40-foot Mural." *Art Digest* 6 (February 15, 1932): 8.

A note on the projected mural.

1140. Danto, Ginger. "The Missing Matisse." *Art News*
 (September 1992): 37.

 A column on the recently rediscovered first version of
 Matisse's mural for the Barnes Foundation project, *Dance*.
 Good historical account of the circumstances surrounding the
 discovery.

1141. Dudley, Dorothy, "Notes on Art: The Matisse Fresco in
 Merion." *Hound and Horn* 7, 2 (January-March, 1934): 298-
 303. Flam, no. 28, 107-12; Fourcade, no, 29, 39-43.

 A first-hand account of great importance of the author's visit
 to the studio where Matisse was completing his mural and of
 her interview with him upon his return to France after
 installing it in Merion. Rich in extended quotations by
 Matisse about his intentions and processes with respect to the
 mural, the article also contains material on the artist's
 reactions to the United States, its painters, its culture.

1142. Flam, Jack. *"The Dance (Merion Dance Mural) (La Danse)."*
 In *Great French Paintings from the Barnes Foundation*, 274-
 291. New York: Knopf and Lincoln University, 1993, no.
 1278

 A superb visual recapitulation of all the versions of the Dance
 Mural including the recently discovered (1992) earliest version.
 Along with the first color reproduction of the Barnes
 Foundation mural are included in-progress photographs,
 sketches, and gouache studies from the Barnes archives. The
 catalogue entry details the history of the commission,
 correcting previously held versions. Indispensable article on
 this work.

1143. Flam, Jack. *Matisse, The Dance.* Washington, D. C.: The
 National Gallery of Art, 1993.

 This slender book, published on the occasion of the opening of
 the exhibition *Great French Paintings from the Barnes
 Foundation* at the National Gallery, is the single most
 important work on the commission which produced three

works: the unfinished first version of the Barnes Commission
(discovered in 1992); the Paris version (Musée d'Art Moderne
de la Ville de Paris), begun as the second version but which, in
actuality, was completed last; and the installed Barnes
Foundation Mural that has recently been removed and included
in the Barnes Foundation traveling exhibition. Using the full
resources of the Barnes Foundation archives and photos, as
well as the sketches and studies from the Musée Matisse in
Nice, Flam has elaborated and enlarged his essay on the
complete story of the three versions that appeared in the Barnes
Exhibition's text (no. 1142). Flam's usual impeccable
scholarship, fresh and readable prose, and discerning eye are all
at work in this definitive and handsomely designed text. Text
in French in *Autour d'un chef-d'oeuvre de Matisse, Les Trois
versions de la Danse Barnes (1930-1933)*, 1993, no. 1137.

Review: Bois, Yve-Alain. "Clearing Up the Mysteries," *Art
News* 93 (January 1994): 107.

1144. Gillet, Louis. "*La Danse* d'Henri Matisse à Pittsburg (sic)."
 Beaux-Arts (May 26, 1933): 1, 6.

Admitting to having seen the work only in photograph (which
is reproduced in black and white), Gillet offers a brilliant
analysis of the composition, discusses the color from a
description by Simon Bussy, relates it to earlier work *(Bathers
with a Turtle, Bathers by a River)*, treats the theme as both
"demoniac" and geometrically related to the architecture, and
generally offers high praise to the work in a prominent and
perceptive review.

Response by Despujols, Dupas, and Pougheon, "Une
Reponse? Un Manifeste?" Followed by a "Letter" from P.
Ettinger, *Beaux-Arts* (June 16, 1933): 2.

The three successful Art Deco mural painters deplore the
review of such an unrealized work in Gillet's extravagant
critical language which must supply what the work itself is
missing. These men find the "impotence, the fear of
completely realized works, a kind of artistic defeatism that is
only one of numerous moral defeatisms. From which arises

the repudiation of knowledge, fear of the craftsmanship, indifference to execution, stagnation in the merest indication of possiblities--open door to literary ramblings in which art historians and critics have inundated us for twenty years." They issue a plea for the recognition of the permanence of nature's elements and of the artistic language with which to express it.

The note from Ettinger, the journal's Moscow correspondent, calls to Gillet's attention the panel *Dance* (1910)--then on exhibit at the Museum of Modern Art in Moscow--as a precursor of the Barnes mural. Gillet was apparently unaware of this work.

1145. Girard, Xavier. *Matisse, La Dance*. Nice and Cannes: Musée Matisse and La Malmaison, 1993. Cahiers Henri Matisse, 10.

Girard's extended catalogue essay is more broadly on the theme of "Dance" in Matisse's work, beginning with *Luxe, Calme et Volupté* of 1904 and culminating in his late cut-outs--dance as "a dream of respite and magnified intensity." Overall, the author brings out Matisse's musical and theatrical interests, his association of dancers with primitive and pastoral landscapes, and the artist's own décors and costumes for Diaghilev's ballet productions of 1920 and 1939. The essay is illustrated with the dance-related works from the Musée Matisse in Nice that were exhibited in Nice and Cannes 1993; these are particularly rich in studies for the Barnes Foundation Mural.

Ivy in Flower Stained Glass (Muséc du XXe Siècle de Vienne)

1146. Bony, Paul. "Le Vitrail de Matisse pour le Musée du XXe Siècle de Vienne." *Cahiers de la Céramique, du Verre et des Arts du Feu* 26 (1962): 145-60.

A fairly technical reminiscence by the ceramicist/glass artist who worked with Matisse on his major stained glass commissions, including that of the Chapel of the Rosary in Vence. Matisse's perfectionism is recalled as well as his insistence that the material, the quality of the glass, be not too rich in itself, that it serve only as a conveyer of colored light.

A well-illustrated article with one stunning hand-tipped colored plate of a detail of the window, *Le Lierre,* which was never incidentally installed for the mausoleum of Albert Lasker as originally intended.

Leda and the Swan (Door Panel)

1147. Barr, Alfred H. "Vence." In *Matisse, His Art and His Public,* 269-70, 493. New York, 1951.

A short account of the commission by Barr. More valuable are the two illustrations of earlier (1944 and 1945) versions: one, a preliminary sketch, the other, a state of the doors which Matisse had at one time considered the definitive version.

1148. Matisse, Henri. "Letter" on *Leda and the Swan* doors to the patron who commissioned them. *Derrière le miroir* (1958): 14-16, 18.

The artist expresses his satisfaction to Mme Enchorrina, the wife of the Argentine diplomat who commissioned the doors, with the way the doors have turned out, justifying their delay in delivery.

1149. Aragon, Louis. *Apologie du luxe.* Geneva: Albert Skira, 1946, no. 48.

This essay includes a lyric and amusing section on this work which was in Matisse's studio when the author did his initial interviews earlier that year.

Nymph and Satyr / Ceramic Triptych (Osthaus Museum)

1150. Neff, John Hallmark. "An Early Ceramic Triptych by Henri Matisse." *Burlington Mag.* 114 (December 1972): 848-53.

The author establishes, in this first important article on the all-but-forgotten work, the history of its commission and that of its making. Commissioned for the home of Karl-Ernst Osthaus in Hagen which Henry van de Velde designed, the work is related by Neff to Matisse's style of 1907-08 and other works of the period. The site for which the triptych was made was intended by Osthaus to become an artists' colony and

contained works by Vuillard, Maillol, and Hodler. Of first importance for information on Matisse's early German patrons and his decorative commissions.

1151. Windsor, A. "Hohenhagen." *Architectural Review* (UK) 170, 1015 (September 1981): 169-75.

A detailed description of Hohenhagen, a garden suburb of Hagen, Germany, where the dealer and collector Karl-Ernst Osthaus established his home and museum, the nucleus for an artists' colony. Among the artworks that adorned the buildings, Matisse's ceramic triptych is discussed.

Oceania, the Sky and **Oceania, the Sea** (Ascher Panels)

1152. Reed, Judith Kaye. "Modern Decoration: Ascher panels and bronzes at Buchholz." *Art Digest* 23, 16 (May 15, 1949): 9.

A review of the exhibition of Ascher panels by Matisse and Henry Moore as well as of bronze sculptures and drawings by both artists. Matisse's drawings for his Ronsard *Amours* book illustrations were shown. Léger and Miro were represented by small panel paintings, but these are not commented on by the reviewer.

1153. Kavanagh, Liv. "Fine Art and Textiles: the Ascher Head Squares and Wall Panels." *Apollo* 125, 303 (May 1987): 332-37.

On the occasion of an exhibition of the forty-five years of textile work by Zika Ascher at the Victoria and Albert Museum, the author summarizes the history of Ascher's textile production, his esthetic, and his contacts with important fine artists who designed head scarves for the company. Among the latter, Matisse did one scarf design and the double panels, *Océanie-le- Ciel* and *Océanie-la-Mer,* two silk-screened panels on tan linen which were signed in a limited edition of thirty pairs. The correspondence between the Aschers and Matisse is included at the end of the article.

1154. Matisse, Henri. "Oceanie: Teinture Mural." *Labyrinthe* 22 (1946): 3. Flam, 1973, 109-110.

Statement by Matisse on the memory of the light of Tahiti, its flora and fauna, that inspired the panels.

1155. "Une tapisserie de Matisse: *Le ciel."* *Arts* (October 24, 1947): 1.

A note on this tapestry which was exhibited for the first time in New York.

Polynesia, The Sky and **Polynesia, the Sea** (Musée National d'Art Moderne)

1156. "Une tapisserie de Matisse." *Art & Décoration* 8 (1948): 55.

A note on the commissioning of the tapestry design from Matisse 1947 by Georges Fontaine, active director of the Mobilier National, and executed at Gobelins. A description and short appreciation follow; illustrated in black and white.

1157. Lassaigne, Jacques. "État de la Tapisserie." *Panorama des Arts 1947.* Paris: Somogy, 1948: 250-51.

A two-page summary of the revival of tapestries in contemporary designs, occasioned by an exhibition mounted by Denise Majorel at the Galerie de France. From private patrons to public commissions, according to Lassaigne, new uses are being devised for tapestry projects. The last two sentences mention Matisse's *Polynésie, Le Ciel* and *Le Mer,* the former being given a half-page reproduction. See also William Wood, no. 358, for another view of the reception of Matisse's "commercial" ventures in the decortive arts.

Rouge et Noir [L'Étrange farandole] (Ballet)

1158. "Henri Matisse: Designs for the Monte Carlo Ballet's *Rouge et Noir."* *Theatre Arts Monthly* 23 (October 1939): 753.

Portrait drawing of Lubov Roudenko, one of the dancers from the ballet, with a note on the production.

1159. Massine, Leonid. "A Recollection." *Yale Literary Magazine* 123 (Fall 1955): 24.

A recollection of the relation of Matisse's Barnes Foundation mural, *Dance,* and the 1939 ballet, *Rouge et Noir.* Mention is made of another ballet, *Diana,* for which Matisse was to design the costumes and decor but which was aborted by the outbreak of the war.

1160. "Matisse's Own Sketch of Monumental Dancing Figures for the Backdrop of *La Farandole [Rouge et Noir]."* *Vogue* 91 (June 15, 1938): 28-32.

A beautiful full-color, double-page spread of a late (1938) watercolor reprise of the Dance motif, evidently made in preparation for the sets of the ballet. This is followed by photographs of Matisse in his aviary by Schall and a brief description of the artist's projects laid out in his studio, among them, maquettes for the ballet.

1161. Michaut, Pierre. "Matisse and the Ballet." *La Biennale de Venezia* 26 (1955): 43-45.

A general article on Matisse's costumes and set designs for both Diaghilev ballets, *Le Chant de Rossignol* (1920) and *Rouge et Noir* (1939). The illustrations are of the latter ballet.

1162. "Dans un atelier de la Rue Désiré de Niel à Nice, le célebre peintre Henri Matisse et le chorégraphe Léonide Massine ont conçu un ballet abstrait." *L'Eclaireur de Nice et du Sud-Est* (May 11, 1939).

A news story on the development of the ballet.

The Sheaf Ceramic Mural (Brody Collection)

1163. "Matisse's Last Mural Installed in California: Tile Wall *(La Gerbe)* in the Brody home, Los Angeles." *Art News* 55 (June 1956): 30-31+.

A complete documentation of the process of making the tile mural (the maquette being then on exhibit at the Museum of Modern Art) with first-hand commentary by Mrs. Brody of Los

Angeles. Photo of the work in place and a diagram of the divisions of tiles devised by Matisse for for shipping and installation.

Song (The Rockefeller Mansion Overmantel Mural)

1164. Wakabayashi, Isamu. "Henri Matisse's Overmantel Decoration of the Rockefeller Family." *Misue* 886 (January 1979): 56-63. In Japanese.

Discussion of the overmantel, now in a Japanese collection, relating it to works similar in time and theme, also stressing the importance of the original decor of the room in the Rockefeller apartment. Author also compares the spatial effects of the lower (forward) figures in the overmantel to those of the Vence Chapel, and relates the drawings in the Chapel to those of prehistoric cave paintings.

1165. Zervos, Christian. "Decorations de Henri-Matisse." *Cahiers d'art* 14, 5-10 (1939): 165-78.

An article more generally on the advantages and dangers of the current call for collective and public mural painting, illustrated by photographs of seven versions of the overmantel in progress, along with nine versions of the decorative panel, *Music* (1939).

Stations of the Cross, Ceramic mural (Chapel of the Rosary, Vence)

1166. Arrouye, Jean. "Les enseignments du Chemin de Croix." In *Matisse aujourd'hui,* 125-46. Cahiers Henri Matisse, 5. Nice: Musée Matisse, 1992, no. 98.

The author undertakes an exhaustive analysis of the structure of the Stations, not a narrative in time, but a synthetic tabular simultaneity, designed for meditation. He discusses the work as a medieval allegory, with its literal, tropologic, and anagogic levels of meaning.

VI

Fauvism

Books and Catalogues

1167. Apollonio, Umberto. *Fauves et Cubistes*. Paris: Flammarion, 1959. Eng. and U. S. eds., *Fauves and Cubists*. London: Batsford, and New York: Crown Publishers, 1960; Ger. and Ital. eds., *Fauves und Kubisten* and *Fauves e cubisti*. Bergamo: Istituto Italiano d'Arti Grafiche, 1960.

Comprehensive and well-illustrated book with eighty-four tipped-in plates of good quality for the time. The text stresses the continuity between the two pre-World War I movements, Fauvism establishing the autonomy of the canvas, the use of color for its own sake, the influence on color intensity by form-areas and vice versa, and the greater reliance on individual feeling and the unconscious. Cubism builds on this, aided by the examples of Cézanne and African sculpture. The author is perhaps too prone to rely on Apollinaire's accounts of the movements which leads him to overvalue the importance of Vlaminck in the formation of the Fauve "style." Quoting Apollinaire, Apollonio sees Fauvism as "a sort of preface to Cubism."

Review: *Connoisseur* 147 (May 1961): 101; Lynton, N. *Burlington Mag.* 104 (May 1962): 220.

1168. Chassé, Charles. *Les Fauves et leurs temps*. Lausanne-Paris: La Bibliothèque des Arts, 1963.

A curious, well-researched book which means to vindicate all those neglected French "colorists" who do not have the fame of the Moreau students who were to be called Fauves. Chassé objects to the histories that credit Gustave Moreau alone with laying the groundwork for the intense color of the new trend. The provinces, not Paris, were the breeding grounds for the new colorism: René Seyssaud, Adolphe Monticelli, Georges Desvallières, Diaz de la Pena, Félix Ziem, Jean Lemordant, among others, were all colorists from the provinces and all receive generous chapters in this text. The essential characteristics of Chassé's Fauvism is heightened color (nature based and still local) and a passionate, urgent facture of evident brushwork and considerable impasto. Van Gogh is the model--isolated, eccentric, expressionist. It is hardly surprising that Chassé gives Derain, Vlaminck, and Van Dongen no more extended treatment than Auguste Chabaud and Louis Valtat. Claims to Matisse's leadership, superiority, and importance are treated with great skepticism, as though his longevity and self-promotion through his writings have falsely given him this position in the histories of Fauvism. Finally, it appears that Matisse's temperament--cautious, cold-blooded, rational, deliberative, according to the author--prevents him from being a true Fauve. By Chassé's description, a Fauve is a passionate, intuitive, and spontaneous colorist, whatever his affiliations to the historical movement called Fauvism.

1169. Clement, Russell T. *Fauves: A Sourcebook.* Series: Art Reference Collection, 17. Westport, Conn., London: Greenwood Press, 1994.

A bibliography of the literature on Fauvism which, after a short section on general works, consists mainly of bibliographies of the major "Fauves." Artists included are: Dufy, Rouault, Vlaminck, Derain, Van Dongen, Marquet, Friesz, Camoin, Manguin, Puy, and Valtat.

1170. Crespelle, Jean-Paul. *Les Fauves.* Series: Les Grands Mouvements. Neuchâtel: Ides et Calendes, 1962. Trans. by Anita Brookner as *The Fauves.* London: Oldbourne Press, and Greenwich, Conn.: New York Graphic Society, 1962.

Handsome monograph, lavishly illustrated with one hundred full-page color reproductions of good quality. The main text is warmly anecdotal and full of period color, while a documentary text, set in smaller type and printed in the margins, provides collateral information: contemporary events abroad, artistic events, biographies, direct citations from artists' writings or statements. After chapters on "The Studio of Moreau," "The School of Chatou," and "The Painters from Le Havre," the author picks up the stories of Rouault, Van Dongen, Valtat, Manguin, Camoin, Puy, and Flandrin in a catchall essay, entitled "Fauves and More Fauves." A short chapter, "Death and Resurrection of Fauvism," treats German Expressionism as a later manifestation of the French movement and the final essay (Chapter VIII) "The World of the Fauves" details some of the critics, dealers, and collectors who supported Fauvism. The last chapter lists current (c. 1960) prices for Fauve paintings. A highly readable account of the movement, chockfull of documentary information.

Review: Habasque, G. *Oeil* 96 (December 1962): 85.

1171. Denvir, Bernard. *Fauvism and Expressionism.* London: Thames and Hudson, 1975; U. S. ed., Woodbury, N. Y.: Barron's, 1978.

This pocket book account of European Expressionism devotes only nine of its fifty-seven pages of text to French Fauvism. Expressionism, according to Denvir, as an anti-rational impulse felt throughout Europe from the late 1880s to the 1950s (De Kooning's *Woman and Bicycle* of 1952 is reproduced) and expressed in literature, music, film, and theatre as much as in painting. The latter was rendered expressive by an "ecstatic use of color and emotive distortion of form, reducing . . . or dispensing with . . . dependence on objective reality" in favor of personal vision and the projection of the artist's interior experiences. Matisse's "lyrical" interior experiences are a small part of the story; the "aggressive, mystical, or anguished" quality of Northern European artists dominates. Color plates are of only fair quality and, in one case, the titles of two are transposed.

1172. Diehl, Gaston. *Les Fauves*. Paris: Nouvelles Éditions Françaises, 1971. Eng. ed., *The Fauves*. New York: Harry N. Abrams, Inc., 1975.

A handsomely produced book with tipped-in plates of fair quality, each work illustrated with a page-long commentary by the author. The comprehensive and inclusive introductory text treats first the "Prelude to Fauvism [1900-04]," its "Maturity [1905-07]," and its "Denoument [1908-10]." The following chapter "Life and Survival of a Myth" takes up the "Dômier" students of Matisse, his American followers, and Fauve-influenced artists in Czechoslovakia, Hungary, Russia, and Scandinavia. A later chapter treats "Drawing, Watercolors, and Prints" as well as some decorated plates and sketches. The author, who has written a scholarly book on Matisse, is on sure ground in his narrative. The wide scope of the book may be judged, however, by the fact that works by Matthew Smith, Hans Purrmann, and Piet Mondrian are reproduced as influenced by Fauvism. Seven well-chosen works by Matisse are reproduced.

1173. Diehl, Gaston. *Les Fauves. Oeuvres de Braque, Derain, Dufy, Friesz, Marquet, Matisse, Van Dongen, Vlaminck*. Paris: Éditions du Chêne, 1943.

Large-format album of twelve plates preceded by a four-page general introduction by Diehl. The plates are tipped-in and surprisingly good for the period and wartime conditions. Text has a faint Vichy echo of deploring the decadence of modern art (Symbolism in the nineteenh century and Surrealism in the twentieth) against which Fauvism rebels, bringing a "witness of plenitude and health."

1174. Duthuit, Georges. *Les Fauves: Braque, Derain, van Dongen, Dufy, Friesz, Marquet, Matisse, Puy, Vlaminck*. Geneva: Éditions des Trois Collines, 1949. Trans. by Ralph Mannheim as *The Fauvist Painters*, with introduction by Robert Motherwell. New York: Wittenborn, Schultz, 1950; Swed. ed., Stockholm: Galerie d'Art Latin.

A brilliant, wordy, self-indulgent, and absolutely indispensable text on Fauvism's "most illustrious representative," Matisse, by his son-in-law, the Byzantine art historian and *homme de lettres*, Georges Duthuit. The author disposes of most of the other putative Fauves with a good deal of sarcasm and wit, Vlaminck being the most mercilessly skewered. In a matrix of philosophical and literary opinions, digressions, and feints, the author eulogizes Matisse and, in the process, provides a good bit of solid information and direct quotations from his protagonists, whom the author has recently interviewed. Duthuit's Matisse is someone who never ceases to attend to, to (literally) focus on, the real world while creating a marvelous painted world as its equivalent. At his most successful, Matisse succeeds in transcending Bergson's durational time by providing epiphanic flashes of transcendent experience for the viewer, in which the latter tears free of the constraints of both time and materiality.

This is a greatly "reworked and amplified" version of the five-part article, "Le Fauvisme," I *Cahiers d'Art* 4, 5 (1929): 177-92; II *Cahiers d'Art* 4, 6 (1929): 258-68; III *Cahiers d'Art* 4, 10 (1929): 429-34; IV *Cahiers d'Art* 5, 3 (1930): 129-35; V *Cahiers d'Art* 6, 2 (1931): 78-82. These have been reprinted in their original form in *Georges Duthuit, Répresentation et présence. Premiers écrits et travaux*, 95-235. Paris: Flammarion, 1974, no. 77.

Review: *Canadian Art* 82 (1950): 87; *Mag. of Art* 44 (December 1951): 337-8; *Art Bull.* 34 (December 1952): 328.

1175. Duthuit, Georges. *Matisse période fauve.* Series: Petite Encyclopédie de l'Art. Paris: Fernand Hazan, 1956. Eng. ed. *Matisse, Fauve Period.* New York: Tudor Publishing, 1956.

Livre de poche format with plates preceded by an introductory text. Duthuit's essay is a subtle, but substantive, discussion of the movement in which he distills his twenty years of thinking on the topic into a text accessible to a wider audience.

1176. Elderfield, John. *The "Wild Beasts," Fauvism and its Affinities.* New York: Museum of Modern Art, 1976. Exhibition catalogue.

Elderfield's is an important essay which distinguishes the Fauve movement, Fauve style(s), and the Fauve group. The latter comprised three distinct circles, in which Matisse was the common linchpin: the Moreau and Carrière students (Matisse, Marquet, Manguin, Camoin, Puy and Rouault); the artists from Chatou (Derain and Vlaminck); and the latecomers from Le Havre (Friesz, Dufy, and Braque). Van Dongen belonged to none of these. The fauvist style manifested itself at the 1905 Salon des Indépendants as a high-color Post-Impressionism (mostly Neo-Impressionism), was followed by what the author calls a mixed style (broken color and some areas of flat infilling, influenced by Seurat and Van Gogh), and developed into the flat-color style (influenced by Gauguin, Ingres, and non-Western sources). Fauvism as a movement, over after the 1907 Salon des Indépendants, was largely the result of the public's and critics' response to the paintings. Its demise partly came from increased influence of Cézanne's work, which was to lead to Cubism and the natural disintegration of a not-very-united group of maturing young painters. The author sensitively analyzes the changes in the painters' styles; he also pays attention to the themes of Fauvism--its pastoral and Mediterranean paganism, youthful even primitive ardor in response to nature, and its idealism.

In setting these thematic concerns in a wider cultural and historical context, Elderfield draws on Ellen Oppler's earlier study (1969), no. 1191, of the political, cultural, and artistic milieu which nurtured early twentieth century art movements in all media. Scrupulously documented and researched, this is a key text on Fauvism, the most important until *The Fauve Landscape* exhibition (1990), no. 1179, and Herbert's reinterpretation of the cultural politics of the movement in *Fauve Painting, The Making of Cultural Politics* (1992), no. 1181.

Reviews: Baldwin, Carl R. "The Fauves: Reflections on an Exhibition, A Catalogue, and a History," *Arts Mag.* 50 (June

1976): 99-102; Bremmer, Nina. Review. *Pantheon* 34, 3 (July-September 1976): 265; Dorra, Henri. *"The 'Wild Beasts': Fauvism and Its Affinities*, at the Museum of Modern Art." *Art Journal* 36 (Fall 1976): 50-54; Goldin, Amy. "Forever Wild, a Pride of Fauves. Fauvism and Its Affinities," *Art in America* 64, 3 (May-June 1976): 90-95; Hobhouse, Janet. "Fauve Years: A Case of Derailments," *Art News* 75, 6 (Summer 1976): 47-50; Kramer, Hilton. Review. *New York Times* (April 4, 1976): 29; Lampert, C. "Wild Beasts: Museum of Modern Art, New York," *Studio* 192 (July 1976): 78-79; Russell, John. Review. *New York Times* (March 26, 1976): 20.

1177. *Fauvism and Modern Japanese Painting [Fōvisumu to nihon kindai yōga]*. Eds., Yori Saito and Kotaro Takamura, with essays by R. Pickvance, I. Monod-Fontaine, T. Asano. Tokyo: Shinbun, 1992. Exhibition catalogue. In Japanese and English.

An exhibition catalogue on the influence of French modernism, especially Fauvism, on twentieth-century Japanese art, for an exhibition in which 182 works were displayed. The following essays were included: Roland Pickvance, "Post-Impressionism, Van Gogh, and Fauvism"; Isabelle Monod-Fontaine, "Matisse's Fauvist Paintings," and Toru Asano, "Fauvism and Modern Japanese Painting--The Roles Played by Yori Saito and Kotaro Takamura." The Monod-Fontaine essay presents familiar material on Matisse but the essay by Asano offers fascinating new material on the waves of European modernism that affected Japanese artists who were familiar specifically with Matisse's work. Amazingly, Matisse's "Notes of a Painter" was published in Japanese as early as 1909, admittedly in an imperfect translation. Generously illustrated and fully documented.

1178. Ferrier, Jean-Louis. *Fauves, règne de la couleur. Matisse, Derain, Vlaminck, Marquet, Camoin, Manguin, Van Dongen, Friesz, Braque, Dufy.* Paris: Pierre Terrail, 1992; Eng. ed. in the luxury series, The Glorious World of Art, as *The Fauves,*

The Reign of Color. Norwalk, Connecticut: The Easton Press, 1995.

A big, lavishly illustrated text with all the old-favorite 1905-06 paintings by the major Fauves in saturated color.This has also a workmanlike text that does not offer much new by way of documentation or point of view but is written by a knowledgeable and elegant writer on art. Since a number of other general Fauve histories are out of print, perhaps such a book fills a need in the 1990s but the format seems somewhat anachronistic.

1179. Freeman, Judi, with contributions by Roger Benjamin, James D. Herbert, John Klein, Alvin Martin. *The Fauve Landscape.* Los Angeles and New York: Los Angeles County Museum of Art and Abbeville Press, 1990. Exhibition catalogue.

This exhibition catalogue deals only with what it deems the dominant motifs of the movement--"seascape, riverscape, townscape, cityscape, sometimes populated, sometimes not." The catalogue essays examine the "geography of Fauvism," much as the 1984-85 exhibition *A Day in the Country: Impressionism and French Landscape* exhaustively analysed the geography of that earlier movement. The catalogue is sumptuously produced, with fine reproductions and profuse documentary illustrations and a detailed "Documentary Chronology, 1904-1908" by the curator, Judi Freeman, as well as an excellent selected bibliography.

Freeman's essay, "Surveying the Terrain, the Fauves and Landscape," gives a general overview of the exhibition's rationale, touching on themes of the similar nature of Fauve landscape subjects to those of Impressionism, itself indebted to the conventions of the picturesque overlaid with a vacationer's viewpoint. She shows how the Fauves, in their landscapes with nudes, combined this practice with that of an arcadian tradition in French "classical" landscapes. John Klein's essay, "New Lessons from the School of Chatou, Derain and Vlaminck in the Paris Suburbs," pursues these ideas in relation to Derain's and Vlaminck's suburban and urban landscapes, specifically in Chatou and Le Pecq and in London.

Although both chose views that were frequently reproduced on postcards, Derain's compositions are more altered, his style more inventive. He more than Vlaminck--whose sites were always close to home--ventured to new locations and new experiments with his pictorial elements.

Freeman's essay, "Far from the Earth of France, The Fauves Abroad," investigates the work produced by Derain in London and Friesz and Braque in Antwerp, sites to which they brought a tourist's imagination as well as an artist's eye. Even Matisse's trips to Algeria and Morocco favored Europeanized cities that had long been tourist magnets; revealing letters from Matisse to Manguin while in Algeria are cited extensively. Freeman argues, from evidence, that Derain's first London trip was in the Fall of 1905, after his summer with Matisse in Collioure, not in Spring of that year. Only Derain was able to paint a powerful body of work while abroad; for the others, the foreign experience fueled later work painted on home territory.

Alvin Martin and Judi Freeman's essay, "The Distant Cousins in Normandy, Braque, Dufy and Friesz," looks closely at the works of these Le Havre artists along their own Atlantic coast as well as Mediterranean towns in the shadow of Marseille, l'Estaque, and La Ciotat. Authors discuss as well the artistic networks outside of Paris that nurtured the three and aided their careers. Herbert's "Painters and Tourists, Matisse and Derain on the Mediterranean Shore," develops the thematic core of the exhibition and Benjamin's "Fauves in the Landscape of Criticism, Metaphor and Scandal at the Salon" takes up the critical discourse in which the movement was assessed. Both of these last named essays are summarized separately under Fauve Articles, nos. 1200 and 1236.

Review: Flam, Jack. "Taming the Beasts," *New York Review* (April 25, 1991): 40-42; Thomson, Richard. "Young Men's Painting," *Times Lit. Supp.* (June 28, 1991): 16.

1180. Giry, Marcel. *Le Fauvisme: ses origines, son évolution.* Neuchâtel: Ides et Calendes, 1981. Trans. by Helga Harrison as *Fauvism: Origins and Development.* New York: Alpine Fine

Arts, 1981; Ger. ed., *Der Fauvismus; Ursprünge und Entwicklung*. Würzburg: Popp, 1982.

An ambitious rethinking of Fauvism in terms of the movement's subjective lyricism, poetry, and expressionism (these terms used synonymously); its rejection of mimetic realism in favor of an autonomous work in harmony with the artist's inner life, rather than the objective world; and its achievement of "color-space" in place of light-space or traditional perspective. Relating Fauvism to an anarchist (Nietzsche) and vitalist (Bergson) world-view, the author rejects the simple notion that spontaneity and high-saturation color identify fauvist painting. The artists he treats are Matisse, Marquet, Derain, Van Dongen, Dufy, Friesz, and Braque, discussing the development of each from 1900 to 1907 in careful detail. Only their painting is discussed; sculpture and drawing are not included. Giry is especially respectful toward and insightful on Marquet, Dufy, and Van Dongen, artists often slighted or omitted in Fauve histories. Matisse is not given more space than the others.

Giry claims considerable conscious rebellion (against Impressionism as well as academic art) on the part of Fauve artists, and a total volitional awareness about their stylistic decisions from 1904-1907. Although he claims to refute some older notions of Fauvism, his final narrative adheres largely to the traditional French reading of the movement. Giry retains the older ideas of progressive stylistic development, authorial awareness and control, and the core of "poetical lyricism" that distinguishes authentic art from mere realism. Though the text is lavishly illustrated with fine color plates and numerous black and white reproductions, too often works which are not illustrated are discussed in some detail . Published in 1981, the text seems ten years older, as Elderfield's and Oppler's important texts, published in the 1970s, are not overtly alluded to, though Oppler's findings are liberally used. Fine bibliography, both general and on the individual artists.

1181. Herbert, James Daniel. *Fauve Painting: The Making of Cultural Politics*. New Haven and London: Yale University Press, 1992.

Author reviews Fauvism under the aegis of the "New Art History," that is, as grounded in social history and constructed through a variety of pre-1914 cultural discourses. First, he demonstrates that the 1905 manner of Fauve painting, by Matisse, Derain, and Vlaminck, constitutes a kind of neo-realism, positioning itself between the idealistic, painter-referencing approach of Symbolism and the reformist images of city and suburb found in contemporary photographs and cartoons. Fauvism's "neo-realism" effected a material similitude between the facticity of the painting medium and that of the scene portrayed, a conflation of materialities that escaped representation by a matching physicality. In dealing with Matisse's representation of the nude (*Carmelina* and *Marquet Painting a Nude in Manguin's Studio*) in Chapter 2, Herbert draws heavily on gender studies on the gaze and the positioning of women as spectacle (Mulvey, Gallop, Doane, Silverman, Duncan, T. J. Clark). The third chapter deals with the relation between possession of a site/sight by touristic viewing and by artistic representation--both possessions metaphorized in contemporary literature as the possession of a passive, female "nature," but a nature that has been already structured as "classical." From a discussion of the Mediterranean, arcadian landscape, the author moves to the French nationalism of the early twentieth century which was easily aligned with a Latinized French culture in the *grande tradition* of Poussin and the seventeenth century. Other topics considered in the text are the implications of colonial attitudes toward non-European peoples and the use of African sculpture by the Fauve artists, and the Fauves' visual play between similarity--between European [art] and African [art]--and inescapable difference. Thus, for example, Matisse uses the African fetish to work out approaches to the fetishized female body, conflating national, racial, and gender differences. Herbert's study uses the Fauve body of paintings to play out his own critical agenda against the nationalism, imperialism,

colonialism, and gender chauvinism to which "neutral" or autonomous art history seems blind.

Review: Cottington, David. "Matisse: Myth and History." *Art History* 17 (June 1994): 278-84; Humble, Paul. Review. *Brit. Journal of Aesth.* 34 (April 1994): 190-2; Whitfield, Sarah. "Review of *Fauve Painting: The Making of Cultural Politics.*" *Burlington Mag.* 135, 1081 (April 1993): 280.

1182. Jedlicka, Gotthard. *Der Fauvismus.* Zürich: Büchergilde Gutenberg, 1961.

In this richly illustrated book (ninety-six plates of which twenty-three are in color), Jedlicka gives a full treatment of the sources of Fauvism, its history, the development of Matisse in some detail, and individual treatments of the artists of the "Schools" of Chatou and Le Havre, as well as a chapter each on the "Society" Fauve: Van Dongen, the "Outsider" Fauve: Rouault, and those "on the margins" of Fauvism: Valtat, Manguin, Camoin, and Puy. Jedlicka, though understanding the deliberate and synthetic quality of Matisse's art, nevertheless frames Fauvism in expressionist terms that stress individual temperament, youthful anarchism, instinctual spontaneity, a certain violence and force of facture and color-choice, and makes Van Gogh the father figure of the movement. The terms are almost those of German Expressionism in the broadest characterization of that movement. Good bibliography.

1183. Laude, Jean. *La Peinture française (1905-1914) et "L'Art nègre,"* 2 vols. Series: Collection d'esthétique. Paris: Éditions Klincksieck, 1968.

A book of the very first order on the topic of Parisian painting (Fauvism and Cubism) and the absorption of "lessons" from African Art, called indiscriminately during this period (1905-1914) "Colonial Art." The section on Fauvism is pathbreaking both for its meticulous historical documentation and for its extremely subtle analysis of Matisse's "project" during the period, which involved investigation of color, line

and volume in all three media (painting, graphics, and sculpture). Using African sculpture (as he used archaic Greek, Egyptian, Oceanic, and Cambodian art) only for its ability to help him solve plastic problems in his own work, Matisse did not succumb to the exoticism or the "cult-power" of African art as some others did. Laude brilliantly dissects the specific plastic problems Matisse addressed in 1905-07 for which he entered into a dialogue with "negro art." The study as a whole is basic to our understanding of the reception and formation of the concept "primitive" in modern European culture, and its assimilation by particular artists and movements.

1184. Leymarie, Jean. *Le Fauvisme.* Series: Le Goût de nôtre temps. Geneva: Skira, 1957, 1959. Trans. by James Emmons as *Fauvism; Biographical and Critical Study.* Paris: Skira, 1959; revised ed., *Fauves and Fauvism.* New York: Skira/ Rizzoli, 1987.

Small-format, beautifully produced book with superb quality tipped-in plates, many paired to facilitate comparisons. The author conceives Fauvism broadly as the excited handling of color, drastic simplification of line, and subjective possession of the picture surface. In a fluent and accurate narrative of the history of Fauvism, Leymarie perhaps gives too much credit for priority and quality to Vlaminck but is among the first to recognize the importance of Signac's and Cross's studies and watercolors for Matisse's free use of pointillism in 1904-05. The text includes a full chapter on German Expressionism, dominated by "psychic force" rather than the French "plastic form." Although Van Gogh, Gauguin, and non-Western sources are common to both French and German artists, the North Europeans were also affected by Munch, Jugendstil, and by the traditions of Gothic art and the German woodcut. An altogether balanced, excellent study.

Review: Werner, A. *Arts Mag.* 33 (June 1959): 14; Grenier, J. *Oeil* 55-56 (July-August 1959): 70; Melquiot, J. *Apollo* 71 (June 1960): 211.

1185. Marussi, Garibaldo. *I Fauves*. Venice: Edizioni del Cavallino, 1950. Exhibition catalogue.

A general treatment of Fauvism published on the occasion of the Fauve exhibition at the 1950 Venice Biennale.

1186. Mathews, Denis. *Fauvism*. London: Metheun, 1956. Ger. ed., *Fauvismus*. Vienna, 1956.

A slim volume of plates with an intelligent general introduction to the Fauve movement and its major participants.

1187. Muller, Joseph-Émile. *Le Fauvisme*. Series: Aldine des Arts, 35 (1956). Paris: Fernand Hazan, 1956, 1966. Trans. by Shirley E. Jones as *Fauvism*. London: Thames & Hudson, and New York: Praeger Paperback, 1967.

Small-format book with fairly good color plates for its price and an excellent text of unusual depth and range for its relatively early date. Muller organizes his discussion around the formation of the movement, the development of individuals' styles, the broad contributions of Fauvism up to 1907, the reasons for the movement's dissolution, and its survival after 1908 in the work of Matisse and Dufy. Also of interest is the author's inclusion of a chapter entitled "Influences and Parallel Trends" which treats in some detail the story of German expressionism from the Brücke to the Blaue Reiter group, carefully distinguishing what was common to both groups from direct influences. Besides the color plates, many drawing and prints are included in black and white reproduction, which highlight facets of the movement not dominated by color.

1188. *Nabi und Fauves, Zeichnungen, Aquarelle, Pastelle aus Schweizer Privatbesitz*. Zürich: Kunsthaus, 1982. Exhibition catalogue.

This exhibition catalogue includes twenty-six drawings (1901-1947) by Matisse and an autograph letter from Matisse to the Swiss collectors, the Hahnlosers, dated 1945. Following a

short general introduction, Margrit Hahnloser-Ingold provides a brief commentary on each drawing; they are beautifully reproduced in this handsome catalogue. Jürgen Schultze provides a more general essay on "Die Zeichnungen der Fauves," no. 301, to introduce the catalogue which features only Matisse, Marquet, Manguin, and Rouault as Fauves, all students of Moreau. Schultze notes that Fauve drawings are too little studied--as Fauvism is deemed chiefly concerned with color--and emphasizes the "seismographic" immediacy of Fauve drawings, which are the first record of the artist's emotion in front of the motif. This expressivity is what is added in these works to a somewhat standard range of Belle Epoque motifs and subjects.

1189. Negri, Renata. *Matisse e i Fauves.* Series: Mensili d'arte, 27. Milan: Fabbri, 1969. Trans. by Himilce Novas as *Matisse and the Fauves.* New York: Jupiter Art Library, 1970.

A book of sixty plates of mediocre quality is preceded by an introductory overview essay on the "movement" and followed by brief biographical notes on the artists who are termed "Fauves." The latter list is inclusive, rather than selective, but Matisse's contribution and leadership is given pride of place. Good on the "origins and components" of Fauvism, the author sees the movement as a "step toward freeing the creative imagination from any obligation to imitate nature," a movement toward "pure painting."

1190. Neumayer, Hans. *Fauvisme (Zeit und Farbe).* Vienna: Verlag Brüder Rosenbaum, 1956.

A slim pocket-book of colored plates (of indifferent quality) is preceded by a short text of a general nature. The text and plates (which include Gauguin and Van Gogh) cast the movement in a broad context, as a more general colorist impulse from the nineteenth century and spreading throughout Europe, rather than a Parisian phenomenon of short duration and few "true" practitioners. The Matisse works illustrated are

from the 1930s, rather than from the c. 1906 period of his development.

1191. Oppler, Ellen Charlotte. *Fauvism Reexamined*. New York: Garland Publishing, 1976. Series: Outstanding Dissertations in the Fine Arts. (Ph.D. dissertation, Columbia University, 1969.)

A reprint of her Ph.D. dissertation, Oppler's study is a major work on the history of Fauvism. For the first time, the movement is set within a serious discussion of its relation to Impressionism, neo-symbolism, resurgent classicism, naturism, and other cultural and artistic trends as well as its relation to literary movements in Paris. Extensive original research is coupled with a broad grasp of modern French cultural history to produce a comprehensive context in which to reexamine the myths about the movement, the claims of its participants, the nature of its originality, and the extent of its influence. Matisse's work is given its full due, but not unduly emphasized, since the author believes him to be exceptional, rather than typical, of the movement due to his age, talent, perseverence in more disciplined researches, and independent course of development. Written in an effortless and clear style which disguises its erudition, the study also contains an outstanding comprehensive bibliography.

Review: Baldwin, Carl. *Art Bull.* 60 (March 1978): 187-88.

1192. Payró, Julio E. *Qué es el 'fauvismo.' Un arte feliz: la pintura de las fieras*. Series: Colección Esquemas. Buenos Aires: Columba, 1955.

A modestly produced volume in a series for a general audience; good general text.

1193. Salmon, André. *Le Fauvisme*. Series: Tendances de la peinture moderne. Paris: Somogy, 1956.

Salmon reviews the history of Fauvism in an unusual way, speaking only of Vlaminck and Derain at first, primarily to deny the former's coloristic spontaneity as essential to the

definition of his topic. Moving to Matisse, whom he had mocked in their youth as inferior to Picasso and as having only a dressmaker's talent, Salmon suggests that Matisse's considered construction by "colored volumes" was the heart of the movement's innovation, an innovation without which there would have been no Cubism, Futurism, nor most of the subsequent innovations in painting even to the present post-World War II painting. This short and eccentricly organized essay accompanies twenty-four colored plates by artists as varied as Van Gogh, Franz Marc, Dufy, and Schmidt-Rottluff, each with its own page-long commentary. The four works by Matisse are well chosen, but date from 1926 (*Decorative Nude Against an Ornamental Background*) to 1948 *(Large Red Interior).*

1194. Sotriffer, Kristian. *Expressionismus und Fauvismus.* Vienna: Anton Schroll and Co., 1972. Eng. ed., *Modern Graphics: Expressionism and Fauvism.* New York: distributed by McGraw-Hill, 1972.

This study, which deals only with the print medium, sees Expressionism as a time-specific movement "crystallized in a pure and unmistakable form" that is confined to Germany. It is therefore not surprising that French "Fauvism" receives very little attention. One Matisse lithograph is illustrated, *Nude with Footstool* (1906), and the author admits that since French expressionism remained bound to tradition and used color as its main element it does not fit his description of a rebellious, even hysterical, movement that favored the lapidary, brutal style encouraged by woodcuts. More substantially treated among the French are Rouault, Van Dongen, and Vlaminck.

1195. Vauxcelles, Louis. *Le Fauvisme.* Series: Peintres et sculpteurs d'hier et d'aujourd'hui, 51. Geneva: Pierre Cailler, 1958.

A text originally published as various articles in 1939 is updated with a handsomely designed format and numerous tipped-in plates of good quality for the period. Vauxcelles

greatly aggrandizes the role of Vlaminck and, secondarily, Derain in the formation and continuation of Fauvism. In a book of some one hundred twenty-five pages, the Chatou artists are given the first sixty-five, while Matisse is accorded a scant eight pages thereafter. Vauxcelles's style is anecdotal, journalistic, and amusing; he makes ample use of the artists' own accounts of their role in the movement, without weighing the possible self-interest of their statements. The second half of the text is given over to secondary figures such as Marquet, Friesz, Puy, Manguin, Camoin, Flandrin, Rouault, Desvallières, and Van Dongen. Matisse is seen as too rationalist to be a true Fauve, although the movement served as a springboard for his liberation from realism.

1196. Wattenmaker, Richard J. *The Fauves.* Toronto: Art Galleries of Ontario, 1975. Exhibition catalogue.

A short intelligent introduction to an exhibition of painters connected with Fauvism. Author weaves a coherent narrative around the painters and paintings in the show, establishing the almost ad hoc development of the Fauve "style" by young artists responding to and building on the great Post-Impressionists, Gauguin, Van Gogh, Cézanne, and Seurat and Co. There are five varied works of Matisse in the show, including *Boy with a Butterfly Net* and two 1906 horizontal-format oil sketches on cardboard, one of which is a study for the pointillist, *Port d'Abaill [Avall]*.

1197. Wentinck, Charles. *Modern Art and Primitive Art*, 16-17. London: Phaidon, Oxford, 1979. Published in the Netherlands as *Moderne und Primitive Kunst*, 1974.

A book with startling visual comparisons between modern and "primitive" art but with a text that blurs differences, sometimes carelessly uses primary sources, and generally tends to value the "primitive" works to the extent that either they embody the values of modern art or helped to clarify those values. Short section on Matisse places his discovery and appreciation of African sculpture with respect to Vlaminck's in an ambiguous light.

1198. Werenskiold, Marit. *The Concept of Expressionism, Origin and Metamorphosis.* Oslo and Bergen: Universitetsforlaget, 1984. Trans. by Ronald Walford from the original Norwegian.

Werenskiold traces, with exhaustive scholarship and sound methodology, the usage of the term "expressionism" in early twentieth-century art and its changing conceptual content. She traces expressionism's origins from Matisse's "Notes of a Painter," via Roger Fry's post-impressionist exhibitions of 1910 and 1912, to its use in Scandinavia and Germany, at first to label all (Fauve and Cubist) new French painting. She then tracks its acceptance in Germany as a national style (*German* Expressionism) especially from 1918 until the 1937 "Entartete Kunst" exhibition under the Nazi government. Returning to France, she follows the term's usage there (and its rejection by the French as applicable to French artists) in the inter-war years. This extremely informative and comprehensive study concludes by examining the term and concept in Scandinavia, where the presence of Matisse's former pupils allowed it to retain something of its original signification. A useful historical treatment of this much-used and often abused term.

1199. Whitfield, Sara. *Fauvism.* Series: World of Art. London: Thames & Hudson, 1988, 1991.

A well-written, workmanlike historical narrative of the formation and recognition of the Fauves as a group with a developing style. Richly illustrated, but with many more reproductions (86 %) in black and white than in color. As a rival to the inexpensive Muller paperback survey, this study provides more context by way of exhibition and marketing practices in Paris and, of course, incorporates more recent scholarship. In a chapter entitled, "Dreams of Other Spaces," the author skillfully weaves a discussion of modern exotic dancing, the influence of African sculpture and Gauguin's carving, and the theme of the Golden Age into a satisfying discussion of Matisse's and Derain's *Joy of Life* and *Golden Age* paintings and their sculpture. For Whitfield, Fauvism rendered painting autonomous; that is, in Matisse's words, it made painting "do what only painting can do."

Articles

1200. Benjamin, Roger. "Fauves in a Landscape of Criticism,
Metaphor and Scandal at the Salon." *The Fauve Landscape*,
241-66. Edited by Judi Freeman. Los Angeles and New
York: Los Angeles County Museum of Art and Abbeville
Press, 1990, no. 1179.

This is an astute assessment of the critical discourse in which
Fauvism was received--that of personal style and artistic
filiation (remnant of the guild system), that of "decorative
landscape" in which style change was more readily accepted,
that of distinguishing and naming "movements" in order to
delimit smaller entities in mass Salon exhibitions with an eye
to dealers and the market. Benjamin notes that, after the 1907
Independents Salon, the criticism of Fauve works remained
largely negative, while the attraction of the new work to the
general viewing public and the sales to dealers and collectors
increased markedly. The author also examines how political
and social views were allied to being for or against the new art.
An important study of Fauve reception, building on
Benjamin's far-reaching study of *Matisse's "Notes of a
Painter,"* no. 55.

1201. Benjamin, Roger. "The Decorative Landscape, Fauvism, and
the Arabesque of Observation." *Art Bull.* 75, 2 (June 1993):
295-316.

Benjamin, objecting to the recent Fauve scholarship that
concentrates on the sites represented, discusses the historical
artificiality of the painted landscape, its constructed nature, and
more particularly the relation of landscape to the decorative in
the late nineteenth century in mural painting and stage
decoration. In easel painting, the Fauves further structured the
landscape by means of the arabesque, a well-known motif
utilized in both East and West. In fact, the arabesque becomes
figure in Fauve landscapes, composed as they were with color
in direct observation of the vegetal motifs and rhythms of land-
formations. These landscapes--composed, abstract, femininely
embodied-- have direct links to the pastoral and utopian

landscapes of tradition. A complex and erudite study of great importance.

1202. Burgess, Gelett. "The Wild Men of Paris." *Architectural Record* 27, 5 (May 1910): 400-14. Reprinted, ibid., 140 (July 1966): 237-50; Flam, no. 88, 119-20.

Probably written in November or December,1908, while Burgess was visiting the studios of young avant-garde painters, including Picasso, Braque, Derain, Friesz, and Herbin, among others. Burgess emphasizes Matisse's serious character as an experimenter seeking expression, someone whose innovations have inspired madcap variations and misreadings by his "disciples" (all the other artists visited). Matisse, the older master, retains a vitality and originality his epigones might envy. Burgess, whose French was rudimentary, seems to misquote or misunderstand Matisse in a number of instances.

1203. Carco, Francis. "Le nu dans la peinture moderne: les Fauves." *Nouvelles littéraires* (May 1924). Reprinted in idem, *Le Nu dans la peinture moderne*, 64-76. Paris: G. Crès, 1924.

Not really a discussion of the Fauve use of the figure, the article is just a way to talk about individual artists known as "Fauves": Marquet, Van Dongen, Derain, Vlaminck, and, especially, Matisse. For the last named, see this material summarized in the General Articles section, no. 420.

1204. Carmean, E. A. "Morris Louis and the Modern Tradition: I. Abstract Expressionism; II. Cubism; III. Impressionism; IV. Fauvism; V. Later Matisse; VI. Principles of Abstraction." *Arts Mag.* 51, 1, 2, 3, 4 (September, October, November, December, 1976): 70-75, 112-117, 122-126, 116-119.

Discusses what Louis took from the example of Matisse's work. From the style of Fauvism , Morris learned the power of multiple, separate, and boldly colored interactive elements and, from Matisse's late works, the concept of drawing in colored shapes and arranging them on a surface.

1205. Cartier, Jean-Albert. "Gustave Moreau, Professeur à l'Ecole des Beaux-Arts." *Gaz. beaux-arts* (May 1963): 347-58.

An article written on the occasion of the exhibit, *Gustave Moreau et ses élèves,* by the show's curator. Cartier stresses Moreau's availability to his students, his sharing with them of a more general culture and his personal values, his stress on an "imagined" color, and an appreciation for the decorative. Many direct citations by Moreau's students which testify to the reasons for their gratitude toward their teacher.

1206. Chassé, Charles. "L'Histoire du Fauvisme revue et corrigée." *Connaiss. arts* (October 1962): 54-59.

Author refutes several claims by Vlaminck on the origins of Fauvism. For example, the famous train derailment which literally threw Vlaminck and Derain together is in part Vlaminck's fabrication, altered as to gravity and time for dramatic effect. Vlaminck's claim to have introduced Derain and Matisse is also refuted, as well as Vlaminck's claim to have been working in heightened color from before 1900. Well illustrated, with new documentation and information on current sale prices of Fauve works.

1207. Cunne, Karl. "Fauvisme och Kubismen i Frankrike." *Ord och Bild* (1927): 655-70.

An early overview of French modernism through a discussion of the two major movements that had been identified as crucial to its development.

1208. Dagen, Philippe. "'L'Example égyptien': Matisse, Derain et Picasso entre fauvisme et cubisme (1905-1908)." *Bull. de la Societé de l'Histoire de l'Art Français* (1984): 289-302.

The author examines the effect of the "Egyptomania" of the early years of the century on the "primitivizing" work of Matisse, Derain, and Picasso from 1905 to 1908. He sees the admiration for Egyptian forms of simplification as a preparation for and prefiguration of the appreciation of African sculpture. Matisse's archaicized female heads of c. 1907 and the *Standing*

Nude, Young Girl (1906) are singled out for analysis, as well as the simplifications of certain painted portraits of family members executed between 1906 and 1913.

1209. Donne, J. B. "African Art and Paris Studios, 1905-1920." In *Art and Society, Studies in Style, Culture, and Aesthetics.* Edited by Michael Greenhalgh and Vincent Megaw. New York: St. Martin's Press, 1978.

A preliminary investigation of the styles of African art that could be seen in Paris in 1905-20, as derived from early published collections--that of Markov, Guillaume, Apollinaire, and Clouzot, and Level. A careful historical study, especially tracing possible African influences on Picasso, that challenges the juxtaposition of "cubist" works and African sculpture that is based on purely formal similarities.

1210. Dorgelès, Raymond. "Le Prince des Fauves." *Fantasio* (December 1, 1910). Flam, no. 88, 124-26.

A slashing, satirical attack on Matisse's work, including the ad hominem accusation of his purveying novelties for the sake of notoriety and monetary gain. Mean-spirited and even racist, the author pretends to lament Matisse's native gifts, now so manipulated as to dupe the (ignorant) public. Vitriol under the guise of humor.

1211. Dorival, Bernard. "Fauvism." In *Les Étapes de la peinture française contemporaine,* vol. II, 71-194. Paris: Gallimard, 1944.

In this early, war-time text on Fauvism, of which nineteen pages are devoted exclusively to Matisse, Dorival sets forth the characteristics of the movement: arbitrary and intense color, deformation of (naturalistic) form, and a strong decorative impulse. Above all, Fauvism aims at sensation-- immediate sensation delivered with maximum shock. Dorival relates this spirit, this "will to power," to that of the twentieth century with its nationalisms, its extreme political and social movements, its taste for easily grasped slogans over reasoned rhetoric. If Rouault is the Claudel of the movement, the author

says, Matisse is its Valéry. There is nothing more "authentically French" than Matisse's work, characterized as it is by "sensibility, intelligence, and will." Matisse's work is treated in its entirety, not just the Fauve years, but Dorival does not attempt to reconcile his characterization of Fauvism with the cool deliberateness and intellectuality of Matisse's total oeuvre.

1212. Dorival, Bernard. "Fauves: The Wild Beasts Tamed." *Art News Annual* (1952-53): 98-129, 174-76.

An extensive, profusely illustrated article on the occasion of the Museum of Modern Art's Fauve exhibition with the color plates from the latter's catalogue bound into the article. There are, besides, under the rubrics, "The Fauves after Fauvism," "Extending into Expressionism," and "Influences in America" a curious assortment of "side-bar" paintings dating from 1925 to 1940 that stretch any concept of Fauvism. The thoughtful essay by Dorival, however, sees 1905 as the moment of a seven-year-old colorist movement's reaching the "age of reason" in a mature manifestation of its style. Seen as the product of a collective "climate" of experimentation arising from the example and challenge of post-impressionism, the author posits Fauvism as a "necessity," a stage in the long historical revolution of pictorial art. Based on a need for individualistic self-expression and the simplification of pictorial means, Fauvism joins Cubism as the twin pillar of an arch through which all moderns have past. In 1953, Dorival sees the French painters--Bazaine, Lapique, Estève, Pignon, Gischia, Manessier, Singier--as the culmination of Fauvism rather than the emerging French or American *tachistes.*

1213. Dorival, Bernard. "L'Art de la Brücke et le Fauvisme." *Art de France* (1961): 381-85.

Reviewing the exhibit, *Triumph der Farbe*, at the Orangerie of Charlottenburg in 1959, Dorival objects to the general impression given by the exhibit and its catalogue that German Expressionism and French Fauvism were parallel movements

in which the German painters were not aware of the emerging style of their French counterparts. Dorival cites the work of Lothar Buchheim (1956), Peter Selz (1957), and Bernard Myers (1956) in which evidence is given of the German painters having seen Fauve work in shows in Germany. Dorival indicates works by Kirchner, Pechstein, and Nolde which are clearly indebted to Matisse and to Vlaminck. He also reiterates the unreliability of Kirchner's personal testimony as he is known to have backdated paintings. He does not mean to undermine the claim to originality and quality of the German painters but to set the historical record straight about the precedent example of the French Fauves.

1214. Dorival, Bernard. "Preface." In *Le Fauvisme français et les débuts de l'expressionnisme allemand.* Paris and Munich: Musée National d'Art Moderne and Haus der Kunst, 1966. Exhibition catalogue. A condensed version in English as *Fauves and Expressionists.* New York: Leonard Hutton Galleries, 1968. Exhibition catalogue.

Dorival's succinct but mature evaluation of the nature of Fauvism is a significant example of the state of Fauvism studies at this time. Seeing Fauvism as the development of "bright chromatism of Impressionism, the divided touch of Neo-Impressionism, and the concern for a decorative style of the Nabis," he lists Cézanne's contribution as well: the accentuating and simplfying of forms, the constructive use of color, the idea of painting as an autonomous architecture. The author stresses the immediate influence of Gauguin and the Neo-Impressionists *(Luxe, calme et volupté* was exhibited), and minimizes that of Van Gogh--except for Vlaminck. What the Fauves offered that was new was: the clear interest in non-Western art (African, Islamic); recognition of color sensation as a bridge between the artist and spectator, between the objective world and the subjective experience of it; a pursuit of intensity through reductivism (less yielding more, multiplication by subtraction); and a spirit of syncopation, dissonance, vitally clashing oppositions--the spirit of an age of jazz and speed.

1215. Dorra, Henri. "The Wild Beasts: Fauvism and Its Affinities at the Museum of Modern Art." *Art Journal* 34, 1 (Fall 1976): 50-54.

An extended review of Elderfield's catalogue and the exhibit at MoMA in 1976. Dorra mostly applauds the richness of the show and the analytic thoroughness of the catalogue essay but finds fine points about which to debate or quibble. According to the reviewer, not enough credit is given to the influence of Neo-Impressionism or of Van Gogh; Japanese prints are slighted as a source for some of Derain's port scenes of 1905-06; and the symbolist themes, encouraged by Gauguin's example, are not treated in sufficient depth.

1216. Duthy, Robin. "Buy Fauves (If You Can)." *Connoisseur* 210 (May 1982): 126-7.

An intelligent summary of Fauvism followed by an assessment of the market value of Fauve works. Still not as expensive as impressionist paintings of comparable stature, prices are steadily rising as the importance of this movement of the first decade of the century is recognized as is the rarity of good 1905-07 works.

1217. Elderfield, John. "The Garden and the City: Allegorical Painting and Early Modernism." *Museum of Fine Arts Houston, Bulletin* 7, 1 (1979-80): 3-20.

Rich reflection on the passage of the pastoral idyll or allegory of happiness from country scenes of the Fauves (and even Cubists) before World War I to scenes of newly-constructed metropolises as allegories of social progress. The utopia of the garden, Elderfield demonstrates, was replaced by the utopia of the modern industrial city.

1218. "Fauves and Post-Impressionists." *Minneapolis Institute Bull.* 42, 4 (January 24, 1953): 17-18.

A two-page notice on the Fauve exhibition that had traveled from the Museum of Modern Art in New York for its venue in Minneapolis, January 22-February 22, 1953. Summarizes

Rewald's catalogue essay and points to the availablity of the catalogue and of George Duthuit's *Fauvist Painters* in the museum store.

1219. Feuerring, Maximilian. "Henri Matisse und die Fauvisten." *Prisma* 1, 1 (November 1946): 15-17.

This well-illustrated article appearing in German shortly after the Second World War is a tribute to Matisse and the tradition of Post-Impressionism forty years after the 1905 Salon d'Automne. Author gives a knowledgeable analysis of the fauve formal characteristics and some history of Matisse's entire career. Matisse himself is quoted at some length and saluted in his 76th year as a colorist and classicist.

1220. Fierens, Paul. "Matisse e il fauvisme." *Emporium* 88 (October 1938): 195-208.

Substantial essay on Fauvism, concluding that Matisse has remained faithful to the fundamental impulses of the movement: brilliance of color, eloquence of the arabesque, and independence from the perceived motif. Draws on Fry and Sembat for insights into Matisse's project.

1221. Flam, Jack D. "The Spell of the Primitive; in Africa and Oceania Artists Found a New Vocabulary." *Connoisseur* 214 (September 1984): 124-31.

Author sketches the concept "primitive" at the turn of the century as a catch-all idea containing elements of a return to nature, revulsion against industrialism, urbanism, and social constraints, a desire to return to basic principles and to giving free rein to the instincts. Since African art "history" was unknown, the work seemed timeless, symbolic, and universal to Matisse's and Picasso's generation. The occasion of the article is the *'Primitivism' in 20th Century Art* exhibition at MoMA and the loan of works from the Musée d'Homme, Paris, to the Center for African Art, New York.

1222. Flam, Jack D. "Matisse and the Fauves." In *'Primitivism' in 20th century Art: Affinity of the Tribal and the Modern*, 211-240. Vol. I. New York: Museum of Modern Art, 1984.

Flam's account of the relation of African and Oceanic works to the development of Matisse's style in sculpture and in painting from 1905-1908 builds on and clarifies (and sometimes corrects) the earlier pioneering work on the topic by Fraser, Goldwater, Oppler, Wilkenson, and Laude. Although the author also deals with Vlaminck and Derain, Matisse is the focus of the article; Flam clarifies the relation of *Jeannette V* to the Bambara sculpture Matisse had recently acquired. Also discussed are paintings such as *Portrait of Mme Matisse* of 1913 and *Seated Woman* of 1915. The author also deals with the relation beween the late paper cut-outs and Oceanic motifs. The indispensable article on this topic.

1223. Fraser, Douglas. "The Discovery of Primitive Art." *Arts Yearbook* 1 (1957): 119-33.

Wide-ranging discussion of the history of the reception of "primitive" or "barbarian" artifacts in the West. The author posits the ability to "read" universal psychological elements from both European and non-European art and, although he coins the term "avant-garde-retardataire" for Worringer's ideas of 1908, seems unaware of his own 1950s Western biases. The comments on Matisse (a minor part of the essay) are perceptive in some instances (e. g., on *Music, Sketch* of 1907) but based on dated research; the Bambara sculpture that Matisse once owned is pictured and used as an example of a type of African art but apparently without awareness that Matisse owned it in 1916. While historically rich, the essay is esthetically universalist and formalist.

1224. Garvey, Eleanor M. "Cubist and Fauve Illustrated Books." *Gaz. beaux-arts* 63 (January 1964): 7-50.

Primarily on cubist books published by Henri Kahnweiler. Derain's woodcut illustrations for Apollinaire's *L'enchanteur pourrissant* (1909) and Dufy's illustrations for the same

writer's *Le Bestiare* are discussed. Matisse does not feature at all in the treatment of these early book illustrations.

1225. Gassier, Pierre. "Les Fauves." In *Manguin parmi les Fauves.* Martigny: Fondation Gianadda, 1983. Exhibition catalogue.

An essay valuable for Matisse scholars due to its wealth of citations from letters to Manguin from Matisse around 1904-06.

1226. George, Waldemar. "Le Mouvement Fauve." *L'Art vivant* 54 (March 15, 1927): 206-208.

George sees the Fauve movement as the crossroad of modern painting, where optical painting is sacrificed to plastic expression and a way cleared for "neo-Romanticism" and the domain of the imagination. The author describes Fauvism as the springboard for all of Matisse's later work and even terms the proto-Fauve male nudes of c. 1901 the precursors of Cubism.

1227. Gide, André. "Promenade au Salon d'Automne." *Gaz. beaux-arts* (December 1905): 475-85.

A review strongly dependent on Maurice Denis's extended comments on Matisse , no. 463, in which the latter is accused of being too theoretical and is warned to heed his instinctive gifts.

1228. Gillet, Louis. "L'Atelier de Gustave Moreau: M. Henri Matisse." In a longer series on "Trente ans de peinture au Petit Palais," *Revue des Deux Mondes* 107 (July 15, 1937): 330-337. Reprinted in *Essais sur l'art français,* 475-85. Paris: Flammarion, 1938.

Reviewing the current exhibition at the Petit Palais, Gillet comments on Fauvism as a whole and on Matisse in particular. Fauvism is viewed as a bit of theatre or sport played out by artists in the role of *enfants terribles* in reaction to Impressionism. The best of them used it as a spring board to a classicism that was neither of the École nor the Académie.

Matisse's constant reinvention of his techniques, his self-renovation, is praised in a highly laudatory review of Matisse's fifty-work mini-retrospective then on view. The author is familiar with the work of the austere period, 1908-1918 (and the Barnes Mural), which he prizes and admits are not well represented in the current show. Gillet uses some perceptive metaphors: Matisse draws on his canvases by scratching lines "like graffiti in chalk on a wall," he organises his canvas "like a festival, like a little machine destined to ravish the senses and calm the mind." If Gillet finds Matisse somewhat lacking in emotion, tenderness, human sympathy, it is because the artist's personal drama is entirely as an artist engaged in artistic problems. As such, however, it has produced a lifetime of art works worthy of the Louvre.

1229. Giry, Marcel. "Le Salon d'Automne 1905." *L'Information d'histoire de l'art* (January-February 1968): 16-25. Summaries in English and German.

A carefully researched article which gives precise information on the circumstances surrounding the constitution of the Salon d'Automne jury of 1905, an account of the artists on view, and a very complete survey of the reviews of the exhibition. A long and valuable footnote comprises a complete history of the references to the origin of the designation "fauve"--a history definitively corrected only in 1957 with Jean Leymarie's statement in *Le Fauvisme* [p. 13], no. 1184, that Vauxcelles named them as such in print in *Gil Blas* , October 17, 1905. Giry demonstrates that the 1905 Salon d'Indépendants identified the "colorists" to one another, the 1905 Salon d'Automne identified them to the public as a tendency but that it wasn't until 1906 that Fauvism became a movement.

1230. Giry, Marcel. "Le Style géometrique dans la peinture vers 1907, contribution au problème du fauvisme comme source du cubisme." In *Le Cubisme,* Travaux IV, 29-34. Saint-Etienne: University of Saint-Etienne, C.I. E. R. E. C., 1973.

Finding it difficult to accept the position that Cubism, born of the influences of Cézanne and African sculpture, owes nothing

to Fauvism, Giry points to a geometricizing tendency among the Fauves already in 1907 and earlier. But this geometric tendency favored circles, ellipses, and spirals in a two-dimensional planarity, as in Matisse's work. Derain experimented with more triangular and trapezoidal shapes as early as 1906. Giry summons all the two-dimensional simplification and synthesis of form found in fauve work as evidence of a proto-Cubist impulse in Fauvism--in French painting more generally--that helps to acount for the early plastic concerns of *Les Demoiselles d'Avignon,* for example. Fauve simplifications look back to Art Nouveau while Cubist analysis looks forward to African influences, of course, but both arise from (in Levi-Strauss's words) "the weakening of the representational function of the work of art."

1231. Giry, Marcel. "Matisse et la naissance du fauvisme." *Gaz. beaux-arts* 75, 112 (May 1970): 331-34.

Giry's seminal article on the development of Matisse's work-- hence, the development of the fundamental characteristics of Fauvism--from 1904 to 1906. A close visual analysis of the works known to Giry supported by the knowledge of the immediate stimuli present through Paris exhibitions and friendships. Neo-Impressionism, according to Giry, helped Matisse discover pure, autonomous color and the examples of Ingres (sinuous line and rhythm) and Gauguin (flat, dense color areas and the exotic) led him to invent his own manner of creating space by the contrast of color planes synthesized with elliptical drawing. This essay is found expanded in the author's treatment of Matisse and the technique of Fauvism in his 1981 study, *Le Fauvism, son origines, son évolution,* no. 1180.

1232. Giry, Marcel. "Le Salon des Indépendants de 1905." *L'Information d'histoire de l'art* (May-June 1970): 110-14 .

A detailed and carefully researched account of the committees, members and exhibitors involved in the Société des Indépendants 1905 Salon. Giry gives an account of the artists on view and a very complete survey of the reviews of the

exhibition. Giry concludes that conservative critics saw the show as the proof of the degeneration and anarchy of modern art and that more progressive critics saw too great a diversity and lack of direction in the work of the young--some lamenting the cacaphony, others predicting a new era to arise from it. Neo-Impressionism's influence was noted, but with regret, as too dry and rational; no incipient "colorist [Fauve]" trend is remarked.

1233. Giry, Marcel. "Ingres and Fauvism." In *Actes du Colloque international Ingres et son influence*, 55-60. Montauban, 1980.

Traces the influence of Ingres on Fauvism via the exhibition of sixty-eight of his works at the Salon d'Automne. A drawing for the *Golden Age* was undoubtedly seen by Matisse who was beginning his *Joy of Life*.

1234. Golding, John. "Fauvism and the School of Chatou: Post-Impressionism in Crisis." *British Academy Proceedings* 66 (1980): 85-102. First read as a paper in *Aspects of Art* series, February 7, 1980.

Richly contextual study of the development of Fauvism in the work of Vlaminck and Derain.

1235. Goldwater, Robert. "The Primitivism of the Fauves." In *Primitivism in Modern Art*. Cambridge, Mass. and London: Belknap Press, Harvard University, 1986, 86-103. Enlarged and revised ed. of *Primitivism in Modern Painting*, 1938; revised as *Primitivism in Modern Art*, 1966. Reprinted in *Major European Art Movements, 1900-1945*, 42-90. Edited by Patricia E. Kaplan and Susan Manso. New York: E. P. Dutton, 1977.

Unchanged from the 1938 edition, Robert Goldwater's pioneer study classifies French Fauvism under the rubric Romantic Primitivism (as opposed to the Emotional [German Expressionism], Intellectual [Picasso, Cubism and Constructivism], and Subconscious [Dada and Surrealism, Child-cult artists such as Klee, Miro, and Dubuffet] forms of

the modern "Primitive"). Placed under the heading with Gauguin's Pont Aven "school," Fauvism is as much nineteenth century as it is twentieth. Author posits that the Fauves admired African art for its childish or crude qualities (signs of authenticity and sincerity) and its mysterious or undecipherable qualities (signs of its symbolic power or charge), attributes derived from late nineteenth-century aesthetic desiderata rather than the African works themselves on their own terms. The Fauve retention of romantic elements of the paradoxical themes of remoteness/intensity, cosmological/ personal are common to the figure-in-nature works of Gauguin, Hodler, and Munch. The Fauves, however, have a new approach to color, facture, and degree of simplification. An important, foundational assessment, still timely after fifty years.

1236. Herbert, James D. "Painters and Tourists, Matisse and Derain on the Mediterrranean Shore." In *The Fauve Landscape*, 152-174. Edited by Judi Freeman. New York and Los Angeles: Los Angeles County Museum of Art and Abbeville Press, 1990. Exhibition catalogue, no. 1179.

Author details the importance of the mediterranean coastal towns such as St. Tropez and Collioure as tourist sites at the turn of the century and the new, more natural, manner of enjoying these towns (or villages). Landscape views which merge village and surrounding countryside, native laborers and urban visitors, blur the differences between them. The Fauve painters, developing a "rustic," direct, unmediated style, suggested an unmediated relationship with nature, no culture intervening. Differing from symbolist or impressionist approaches where the artist's individuality is projected onto the scene, Fauve works imply that signs of expression are the very product of the rustic scenes portrayed. Herbert also discusses the Kantian idea of the sublime--nature controlled by the thinking mind--in opposition to that of Burke--the mind in awe of ungraspable nature. Also analyzed are the concepts of the picturesque and the *grande tradition* of French landscape, both functioning in service of a rhetoric of nationalism of the period. An important, comprehensive treatment of the theme

of the exhbition: that Fauve landscapes are not merely signs of plastic experimentation, but that they are richly signifying in political and social terms.

1237. Honeyman, T. J., "Les Fauves, Some Personal Reminscences." *Scottish Art Review* 12, 1 (1969): 17-20.

On the occasion of a Derain retrospective at the 1967 Edinburgh Festival of the arts, Honeyman reminisces about his acquisition of the Glasgow Art Gallery's *Blackfriars Bridge, London* of 1906 in Derain's fauvist style. A delightful, anecdotal essay with unusual information, such as the fact that Matisse's *Head of a Young Girl [Antoinette]* of 1919 was purchased for sixty pounds; fauve works before World War II could be had for one hundred fifty pounds.

1238. Hoog, Michel. "La Direction des Beaux-Arts et les Fauves, 1903-1905." *Arts de France* III (1963): 363-66.

New documentary information on the State's policy on purchasing the work of living artists from Salon and gallery exhibitions, particularly as it changed in 1905 when Roger Marx could influence decisions, that is, at the time of the first notoriety of the Fauves.

1239. Hoog, Michel. "Fauves." Album No. 7 de la Collection Pierre Lévy. Paris: Mourlot, 1972. Reprinted in Pierre Lévy, *Des Artistes et un collectionneur*, 29-34. Paris: 1976.

Hoog states that even after sixty years, Fauvism remains a shocking and disturbing kind of painting that is not accounted for in the usual narrow histories of French art as that of good taste and measured discipline. Without a theory, Fauvism marks the maturity of plastic research begun years earlier in the studio of Gustave Moreau and subsequently stimulated by the Neo-Impressionists. The list of fauve-type painters will always remain in dispute but not the heritage of painting by colored planes. Author suggests the influence of non-realist, visionary landscape painting and non-French sources such as Munch and Ensor on the movement, as well as Gauguin and Cézanne. The pagan hedonism and joy expressed by means of

commonplace subjects and sites will remain a lasting Fauve strain in European painting. A nuanced and balanced assessment of Fauvism which places it in a European context.

1240. Humbert, Agnes. "Les Fauves et le Fauvisme." *Jardin des arts* 12 (October 1955): 713-20.

On the occasion of the Matisse Retrospective at the 1955 Salon d'Automne and the fiftieth anniversary of Fauvism, Humbert offers a historical overview of the fauve movement in a fresh and unsentimental account. She balances the innovations of the movement against all the techniques and attitudes it maintained from its post-impressionist forbears. A general section is followed by a short treatment of each major Fauve: Braque, Derain, Dufy, Friesz, Marquet, Matisse, van Dongen, and Vlaminck. She suggests that the example of this very French, sunlit style is still warm enough after fifty years to ripen the works of young French artists of 1955.

1241. Huyghe, René. "Le Fauvisme: les coloristes" (97-102), "Le Fauvisme: les peintres pathetiques" (129-132); and "Le Fauvisme: le réveil des traditions" (153-156). In René Huyghe and Germain Bazin, *Histoire de l'art contemporaine*. Paris: Felix Alcan, 1935. Parts of chapters 1V, V, and VI; originally published in *L'Amour de l'art* 7 (1933).

Huyghe introduces three chapters on Fauvism in this modern survey. He distinguishes three aspects of Fauvism: the first is the original, French version of Matisse, Derain, and Vlaminck which concentrates on color as a major expressive means of purifying and clearing away bourgeois values in art. A youthful movement, it returned to elementary "givens" of painting and succeeded in its revolutionary aims. Matisse's continued use of color is rational, charming, and calculated, not truly personal or expressive. The second chapter deals with the expressive Fauves, Vlaminck and Rouault, and with Jewish artists for whom Fauvism offered a means to express the emotionality and melancholy of their racial experience. The last chapter sees Derain leading the former Fauves to new interest in structure, composition, and synthesis, a balance

between attention to the real and a return to moderation and instinct. Matisse has in common with these latter artists-- Bonnard, Guérin, Laprade, d'Espagnat, Asselin--that he retains an essentially bourgeois sensibility, although intellectualised and purified.

1242. Jedlicka, Gotthard. "Le Fauvisme." In *XXe siècle. Hommage à Henri Matisse*, 35-39. Paris: Cahiers d'Art, 1970; an extract from *Chronique du Jour*, 1929.

An intelligent analysis of Fauvism from the point of view of its debts to and divergences from Neo-Impressionism (system of analysis) on the one hand, and Symbolism (system of synthesis) on the other. A balanced view which avoids the excessive aggrandisement of the movement which, in some French writers, is more a function of chauvinism than historical judgment.

1243. Lassaigne, Jacques. "Les Origines du Fauvisme." In *Panorama des Arts 1947*, 60-65. Paris: Somogy, 1948.

On the occasion of a Gallery Bing exhibition on the "School of Chatou," Lassaigne asks whether Fauvism arises more from the "calculations and reasoning of Matisse and his friends" or the "violent and instinctive explosions of Vlaminck and Derain?" Although the latter two Chatou natives originally worked with a Fauve vision that was more unified and intense, they both abandoned the mode within a matter of years. Matisse, Dufy, Marquet, and Frieze, on the other hand, used the mode as part of a conscious evolution in their work, a point of departure toward a more abstract creation.

1244. Lassus, Jean de. "Les Fauves." *L'Amour de l'art* 6 (June 1927): 209-11.

Author briefly summarizes Fauvism ("a passage, not a school," having Van Gogh and Cézanne as its romantic and classic forebears) before reviewing the Fauve exhibit at the Galerie Bing. Lassus writes briefly but with great insight on the works on view by individual Fauves. Of Matisse the author readily admits that his best Fauve work was in Moscow

but comments on *The Gypsy, Tulips, Young Girl Reading,* among others. He points out that Matisse's gift is to be entirely concerned with relationships (of color, form, and line) and to make flat areas of color create the sensation of depth. Since Seurat, he is the most astonishing colorist modernism has produced. Fauvism, de Lassus claims, was concerned with "construction, the object [painting] in itself," and thus led to Cubism.

1245. Lebensztejn, Jean-Claude. "Sol." *Scolies, Cahiers de recherches de l'Ecole Normal Supérieure* (Paris: P.U.F., 1971), vol. 1, 95-122; vol. 2, 89-114.

Lebensztejn uses the art historical literature on Fauvism and German Expresssionism to point up the inadequacy of an art history praxis that is concerned exclusively with classifications of "movements" (schools, tendencies, styles) and that is blighted by nationalism, loose psychological interpretations, biography, and other contradictory and vague methodologies. He proposes rather to examine the systems that artworks deploy and to place these system-transformations in a synchronic framework. For Fauvism and German Expessionism the chronological framework is 1905-1910 and concerns the emergence of a new system that rejects representation for non-objectivity or abstraction. Calling for a more rigorous structuralist methodology in art history and condemning the present "taxonomic" methods of art historians, Lebensztejn accuses art history of atomizing the history of twentieth-century art into separate and unconnected "-isms" in order to minimize the scandal, the true revolution, wrought by the advent of abstraction around 1910. Abstract art questions both the entire principle of representation and, by that, painting itself. Lebensztejn, in this comprehensive critique of the ground ("sol") of art historical method, offers as well a brilliant analysis of how Matisse (and, to a lesser extent, his colorist peers) moved painting into the pre-stage of abstraction, procuring its conditions, while drawing back from its ultimate consequences. An important, influential article.

1246. Lehmann, Leon. "L'Art vécu, souvenirs du temps des
 Fauves." *Beaux-arts* 134 (July 1926): 2; 135 (August 2,
 1935): 2.

 A reminiscence with special emphasis on Matisse and
 Rouault.

1247. Leymarie, Jean. "Il Fauvismo." In *L'Arte Moderna,* 201-20.
 3 vols. Milan: Fratelli Fabbri, 1967-68-69.

 A balanced summary of ideas and historical narrative already
 developed in Leymarie's 1957 book, *Le Fauvisme.*

1248. Linnebach, Gabrielle. "La Brücke et le Fauvisme, une querelle
 dépassée." In *Paris-Berlin,* 70-77. Paris: Centre Georges
 Pompidou, 1978. Exhibition catalogue.

 An essay that attempts to put the quarrel between the mutual
 influences of young French and German expressionists to rest
 by finding a position between the idea of complete French
 dominance and influence and that of little or no influence of
 Fauves upon the Brücke artists. Admitting a certain priority
 to the French, the author gives a more nuanced analysis of the
 way the Germans developed, in which the fauve example is
 merely one of many possibilities integrated by the Germans
 into their highly individual styles.

1249. Longhi, R. "Preface." In *I Fauves.* Venice: Twenty-Fifth
 Biennale, 1950. Exhibition catalogue.

 A brief, but vividly written, introduction to the Fauve
 paintings in the Biennale exhibition, in which the writer
 accords the short-lived movement a firmly revolutionary
 character in relation to late nineteenth-century trends and even
 when compared to Cubism. Dominating the first decade of the
 century, its brilliance was a clarion call to the changes that
 followed.

1250. Meyer, Franz. "Introduction." In *Henri Matisse, Twenty
 Important Paintings.* Zurich: Marlborough Fine Arts, 1971.
 Exhibition Catalogue.

Meyer interprets Matisse's Fauve painting as the beginning of the functioning of color and form as vehicles for a wholly visual experience-- one of perceptual scanning that provides the pulsebeat of an active experience. The optical spatiality of Matisse's work is consistent throughout his work and particularly influential on contemporary artists such as Kelly and Stella. The "twenty important paintings" in the show are each briefly discussed in the light of the author's thesis.

1251. Mullaly, Terence. "The Fauves." *Apollo* 64 (December 1956): 184-89.

Workmanlike discussion of Fauve artists; unfortunately confuses Matisse's *Luxe I* and *II* of 1907 with the pointillist *Luxe, calme et volupté* of 1904, a common misunderstanding before Barr straightened it out in 1951.

1252. Myers, Bernard. "Matisse and the Fauves." *American Artist* 15, 7 (December 1951): 70-72+.

On the occasion of the Matisse Retrospective at the Museum of Modern Art in New York, the author provides an accessible general explanation of Fauvism for a broad public, explaining its sources in Van Gogh, Cézanne, Gauguin. In the case of Matisse, a pronounced leaning on Oriental sources is noted in the use of outlines, bold color, and flatness of form. Myers finds Matisse's *Bathers with a Turtle* more brutal and less anecdotal than Gauguin's Tahitian scenes; some discussion of Rouault, Van Dongen, and Derain.

1253. Nakayama, Kimio. "The Dawn of Modern Painting: Fauvism and its Affinities." *Mizue* 855 (June 1976): 21-9. In Japanese, English summary.

On the occasion of the Museum of Modern Art's *Fauvism and Its Affinities* show, the author traces the arrival of Fauve influences into Japan in the 1920s, along with the introduction more generally of French modern painting into the country. Article is preceded by fifteen pages of illustrations of Fauve paintings from the exhibition.

1254. Ozenfant, Amédée [Vauvrecy]. "Les Fauves, 1900-1907." *L'Esprit Nouveau* 16 (1920): 1871-2.

In a series on the history of modern painting, Fauvism is inserted between Impressionism and Cubism as characterized by "romanticism, taste for vivid and contrasting color, truculence, turbulence, aggressivity, exasperation, emancipation, off-the-mark, red flag, anarchist, sensuality of color and of touch," in a word, the youthful style of every gifted painter. Those for whom it is a lifelong manner are Matisse, Van Dongen, Rouault, Vlaminck, Friesz, and Le Fauconnier. Early Cézanne and Van Gogh are named fathers of the movement; Gauguin's "pale exoticism" is discounted as an "unmerited fad." An article devoted to Matisse followed in the next issue.

1255. Pancera, M. Bertello. "Note sull'arte de Henri Matisse." *Arte* 1 (September 1930): 477-89.

A general treatment of Matisse's work under the label "Fauve," drawing freely from Matisse's own comments in "Notes of a Painter" (1908).

1256. Perry, Gill. "The Decorative and the 'culte de la vie': Matisse and Fauvism." In *Primitivism, Cubism, and Abstraction, The Early Twentieth Century,* 46-82. Edited by Charles Harrison, Francis Frascina, and Gill Perry. New Haven and London: Yale University Press and Open University, 1993.

Perry discusses Fauvism as an aspect of the discourse on the "primitive," the "decorative," and the "expressive" in which German Expressionism also participated. Challenged are the origins of Fauvism in 1905 and the allegedly totally negative response to Fauve works that the later literature posits as a sign of their revolutionary nature. Author discusses in a balanced way the relation of the "impetuosity" of the style (and its related attitudes) to a position of social or political radicalism and also to the colonialist attitudes inherent in the exoticised view of African culture. The tension between the decorative / abstract and the figurative / meaningful--even to

Greenberg's formulation in the 1950s--is also explored. Comparison is made with German Expressionism.

1257. Platte, Hans. "Introduction." In *Matisse und Seine Freunde-- Les Fauves.* Hamburg: Kunstverein in Hamburg, 1966. Exhibition catalogue.

A fine summary of the history of Fauvism with all of its difficulties of definition and characterization. The author gives a nuanced historical account of the tendencies that led up to the coming together of a group and an exhibition that allowed the tendency to be named. Author notes that Vauxcelles called the group "Marquet and Company" at first, underscoring the point that line as well as color were involved from the beginning. Platte concludes that the Fauves were able to sharpen--through their use of self-sufficient color and line--the latent expression that underlies the appearance of things.

1258. Puy, Michel. "Les Fauves." *La Phalange* (November 15, 1907): 450-59. Reprinted in *L'Effort des Peintres Modernes,* 61-78. Paris: Messein, 1933.

An early review of the Fauves by the brother of one of them, Jean Puy. A first-hand account by a sensitive observer. Knowing Matisse's temperament, he fortifies the notion of Fauve vehemence in expression by noting that Matisse is driven by an "internal force that he knows poorly," but which impelled him to seek in his painting the psychological calm that a resolved work of art can provide to anxiety-prone moderns.

1259. Reidemeister, Leopold. "Preface." In *Le Fauvisme français et les débuts de l'expressionnisme allemand.* Paris and Munich: Musée National d'Art Moderne and Haus der Kunst, 1966. Exhibition catalogue. A condensed version in English in *Fauves and Expressionists.* New York: Leonard Hutton Galleries, 1968. Exhibition catalogue.

In an essay parallel to that of Bernard Dorival's on the Fauves in the same catalogue, Reidemeister stresses the self-taught

nature of the Brücke members' works, their romantic desire to form a community of artists, their conscious defiance of tradition. After treating the independents, Christian Rohlfs and Paula Modersohn-Becker, the author briefly sketches the activities of the Blue Rider artists from Munich. Reidemeister hopes young artists are now mature enough not to deny national differences between schools of artists by denying the fecund diversity of early modernism.

1260. Rewald, John. "An Introduction to the Fauve Movement." In *Les Fauves*. New York: Museum of Modern Art, distributed by Simon and Schuster, 1953. Exhibition catalogue.

A sober and careful treatment of the development of Fauvism from its impressionist and post-impressionist roots by an eminent scholar of these two latter movements. Dated in some details and emphases, it is still a solid history which makes good use of Barr's monograph on Matisse published two years earlier.

1261. Rosset, David. "Les Fauves dans les collections suisses." *La Galerie des arts* 16 (May 1964): 22-6.

On the occasion of an exhibition in Lausanne of masterworks from Swiss collections, the author selects the Fauve works as the occasion to instruct his readers on the movement. Dating it from 1900-1907, Rosset claims Fauvism is less the result of the influence of absolutely new ideas than the repudiation of certain traditions: classical perspective, drawing, and modeled local color. The artists involved around 1906, the apogee of the movement, changed and diverged in their mature styles so that the art critic, like a card player, must reshuffle the deck to account for their place in the history of art in later years. Rosset also discusses the reason for such high-quality Fauve works in such great quantity in Swiss collections. Article is well illustrated with works that have individual side-bar information.

1262. Rouault, Georges. "Evocations." *In Chroniques du Jour* (April 1931): 8-9; reprinted in *XXe Siècle. Hommage à Henri*

Matisse, 5. Edited by G. di San Lazzaro. Paris: XXe Siècle, 1970.

A poetic and playful evocation of the art situation around 1900 in which not much is said of Fauvism nor of Matisse, though the author praises the latter's Moroccan paintings and his respect for the masters of the Louvre.

1263. Salmon André. "Les Fauves." In *La Jeune Peinture Française,* 9-40. Paris: Société des Trente, Albert Messein, 1912.

In this mostly scornful account, Picasso's admirer Salmon credits Matisse with some audacity around 1900 in having researched light by way of color but finally condemns him for sacrificing line to color, for being incoherent in the development of his style, for repeating himself, and finally for having merely "skill, quick assimilation, an easily acquired but limited science, feminine gifts." He has a minor taste, that of a "modiste, his love for color amounts to a love of dress samples *[chiffons].*" His students are foreigners of second rank, most of whom have returned home to give French painting a vaudeville turn in Berlin, Moscow or Scandinavia. Though he has something in him of the great painter, Salmon admits, Matisse is now an isolate--sterile, and of no consequence.

1264. Salmon, André. "Vingtième siècle." In *L'Art vivant.* Paris: Crès & Cie, 1920.

For all Matisse's questioning of Impressionism's weaknesses, for all his researches into color, for all his discoveries, the author judges that Matisse has never been freed from the chains of the decorative, from approaching the dressmaker's door. To his credit, Matisse first recognized the countersigns of those who would oppose his approach to art-by-sensibility. Salmon admits that he had combatted Matisse in the pre-War years because he saw him, until the triumph of Picasso's superior gifts, as a dangerous master for the young.

1265. Salmon, André. "Les Fauves et le fauvisme." *Art vivant* (May 1, 1927): 321-24.

A picaresque reminiscence of the "time of Fauvism" rather than an essay on the movement, which, Salmon claims, had no common doctrine but consisted of friends with a common taste for vehemence, destruction, and rawness. Matisse, "theoretician of Colored Volumes," is barely mentioned, except as one who in those days (before Cubism) was considered the leader of all free modern painting.

1266. Salmon, André. "Naissance du Fauvisme." *L'Amour de l'art* (May 1933). Reprinted in René Huyghe, ed., *Histoire de l'art contemporain: la peinture*, 103-05. Paris: Alcan, 1935.

Salmon colorfully evokes the pre-war period and ruefully submits to the notion of a fauve group, although he broadens it to include artists as diverse as Girieud, Chabaud, Verhoeven, Tobeen, Lhote, and Delaunay in the list. He also privileges Matisse's students as messengers of Fauvism to Central Europe and founders of the School of Paris. He dates the movement from 1903 to 1908, when Cubism--which owes something to Fauvism--was born. Revolutionary in some sense, Fauves finally wanted to return painting to its classical traditions. Salmon's vivid summary of the Belle Epoque, itself retrospectively colored in the gay hues of Fauvism, is followed by a more factual history of the movement compiled by Germain Bazin.

1267. Sutton, Denys. "Aspects of the Venice Biennale: The Fauves." *Burlington Mag.* (September 1950): 263-65.

In a review of the Fauves' exhibit at the Venice Biennale, Sutton characterizes the commonality of a diverse group by their youth and enthusiasm, their determination to "evolve a new and vital manner of painting," their reliance on intuition, and their eclecticism (drawing from diverse sources, both European and eastern). He points out their attitude as a continuation of the symbolist tradition of poetic abstraction. Also noted is both Matisse's and Marquet's early dependence on Vuillard. Each artist is commented upon in turn, and Sutton acknowledges the international impact of Fauvism

which was perhaps more important and longer-lasting outside France than in Paris.

1268. Vauxcelles, Louis. "Le Salon des Indépendants." *Gil Blas* (March 20, 1906).

Vauxcelles responds to Matisse's *Joy of Life* painting at the Independents by accusing him, in Denis's terms, of being too theoretical in his attempt to attain the "highest synthesis," that is, of falling prey to the dangers of "simplification and inadequacy, schematism, and emptiness."

1269. Vauxcelles, Louis. "Les Fauves, A Propos de L'exposition de la *Gazette des beaux-arts.*" *Gaz. beaux-arts* 12 (1934): 273-82.

Vauxcelles recounts the origins of the tags "Fauvism" and "Cubism"--both connected to Matisse--while disparaging the importance of such labels. Defining Fauvism as a reaction against Impressionism by painting in pure flat areas of color, with simple and expressive shapes that are outlined and unmodeled, he then proceeds artist by artist in a colorful, anecdotal analysis of each one's qualities. (Rouault, distinguished from the others, is termed the leader of French Expressionism.) Vauxcelles implies that many of the former Fauves have sold out their heroism, bowed to public taste, and are no longer as honest and intense as they once were.

1270. Vauxcelles, Louis. "Le Fauvisme à Chatou." *Art-Documents*, Geneva (July-August 1951): 4-6.

Author claims Matisse as the Prince of the Fauves, but not their Father. The whole thesis of this essay is to claim Vlaminck as the *premier et fons* of the movement. The author quotes extensively from Vlaminck's own published claims to this priority, and from another manuscript that the artist reads aloud to him. The message is that Vlaminck, more than any other of the Fauves, is one by temperament and continues to be so in spite of the loss of a high-colored palette. This article is substantially the first chapter of Vauxcelles's 1958 book, *Le Fauvisme*, no. 1195.

1271. Viazzi, Glauco. "Fauvismo." *Domus* 203 (November 1944): 419-22.

An article consisting mostly of illustrations of the major Fauves with a general overview text drawn from available sources.

1272. Vlaminck, Maurice. "Avec Derain, nous avons crée le Fauvisme." *Jardin les arts* (June 1955): 473.

An article in which Vlaminck attempt to rewrite or at least distort history in order to place himself and Derain as central and originating agents of the new movement, independent of Matisse. An excerpt from his book, *Portraits avant déces* (Paris: Flammarion, 1943).

1273. Whitfield, Sarah. "Fauvism" (1967). In *Concepts of Modern Art*, 14-32. Edited by Tony Richardson and Nikos Stangos. Harmondsworth, England: Penguin, 1974, and New York: Harper and Row, Icon Editions, 1974.

A wise and remarkably complete overview of a moment (1904-07) that was, for all but Matisse, a transitional stage in the careers of a handful of painters. Limiting herself to Matisse, Derain, and Vlaminck, with some attention paid to Rouault and Braque, the author disengages the movement from the hyperbole of exaggerated claims without slighting its real contribution to the post-impressionist development of independent painting.

1274. Zervos, Christian. "Le fauvisme." In *Histoire de l'art contemporain*, 113-38. Paris: Cahiers d'Art, 1933.

Zervos' summary of this movement in the context of a larger survey of major twentieth-century movements.

VII

Collections and Collectors

1275. Coulonges, Henri. "Les Premiers collectionneurs de Matisse." *Jardin des arts* 186 (May 1970): 22-31.

A well-illustrated account of Matisse's earliest collectors-- Sembat, the Steins, Shchukin and Morosov, Quinn, Tetzen- Lund and Sagen, and Barnes, to whom the author attributes a certain kind of "genius" to have appreciated these bold works so early in the century.

1276. Vincent, Helène. *La collection Agutte-Sembat du Musée de Grenoble, historique et catalogue.* Lyon: Maîtrise d'histoire d'art, Université de Lyon, 1975.

A careful account of the history of the collection and a scholarly catalogue of the collection.

1277. Kuh, Katherine, and Daniel Catton Rich, eds. *Twentieth Century Art, Arensberg Collection.* Chicago: The Art Institute of Chicago, 1949. Exhibition catalogue.

Elegantly designed small catalogue of the first public showing of nearly all of the famous Louise and Walter Arensberg collection; short essays by Kuh and Rich.

1278. *Great French Paintings from the Barnes Foundation, Impressionist, Post-impressionist, and Early Modern.* New York: Knopf and Lincoln University Press, 1993. Exhibition catalogue.

Luxury catalogue to accompany selections from the Barnes Foundation collection on its first traveling tour. Of note are the essays: "Dr. Barnes and the Barnes Foundation" by Richard J. Wattenmaker, "Dr. Barnes in Paris" by Anne Distel, and the entries on the fourteen important Matisse paintings that include *Joy of Life,* the *Three Sisters Triptych,* and the mural, *Dance.* A longer entry can be found in Exh.Cat.: Washington, D.C. 1993.

1279. Greenfeld, Howard. *The Devil and Dr. **Barnes**: Portrait of an American Art Collector.* New York, London: Viking Penguin, 1987; London: Boyars, 1989.

The most complete and accurate biographical account of the collector's life and career as a defender of modern art and founder of his own Barnes Foundation. Corrects previous tendentious accounts and is especially accurate with respect to the history of Barnes's relation to Matisse and the mural commission.

1280. Hart, Henry. *Dr. **Barnes** of Merion, An Appreciation.* New York: 1963.

A not-disinterested account of Dr. Barnes's life and achievements by a man who ended up as an editor at Scribner's but started out as a local reporter who met Barnes at the age of twenty-three and remained his life-long friend.

1281. Schack, William. *Art and Argyrol, The Life and Career of Dr. Albert C. **Barnes**.* New York and London, 1960.

One of the earliest biographies of Albert Barnes, with a chapter, "Pertaining to Matisse Mostly," that is replete with errors. Most are corrected in Greenfeld's book, no. 1279.

1282. Donnell, Courtney Graham. "Frederic Clay and Helen Birch **Bartlett**: The Collectors." *The Art Institute of Chicago Museum Studies* 12, 2 (1986): 85-102.

In an issue of this journal devoted entirely to the Helen Birch Bartlett Collection at the Art Institute of Chicago, the author provides a general overview of the couple's collecting pattern

and history of their relation to the Art Institute. The issue also includes Catherine C. Bock's article on the two Matisse works in the collection, *"Woman before an Aquarium* and *Woman on a Rose Divan;* Matisse in the Helen Birch **Bartlett** Collection." See the summary of the article under Individual Works, no. 973.

1283. Lee, Thomas P. *The Collection of John A. and Audrey Jones Beck: Impressionist and Post-Impressionist Paintings.* Houston: Museum of Fine Arts, 1975.

An exhibition catalogue with scholarly apparatus on the works in this collection.

1284. Tinterow, Gary. "Heinz **Berggruen** collectionneur." *Collection Berggruen.* Genève: Fondation GenèvArt, 1988. Exhibition catalogue.

A long catalogue essay on the career of the German-born collector-dealer, Heinz Berggruen. A naturalized American citizen, he worked at the San Francisco Museum of Art and, after World War II, at Unesco in Paris and finally as a dealer in rare books and art works. In 1953, his gallery, Berggruen & Cie., was responsible for making Matisse's cut-paper work more well known through a major exhibition of them in that year. He regularly showed works by Matisse and produced unusually handsome catalogues to accompany them.

1285. Alexandre, Arsène. "La Collection **Canonne.**" *La Renaissance de l'art français* 13, 4 (April 1930): 85-108.

An article which muses on the affinities between works in a single collection. Matisse's *Still Life: Les Pensées de Pascal* was in the Canonne Collection and is illustrated.

1286. Lipman, Jean H. "Matisse Paintings in the Stephen C. **Clark** Collection." *Art in America* 22 (October 1934): 134-44.

A descriptive analysis of the artist's style leading up to the Nice manner (1917-25), the period of most of the works in

Clark's collection. Each of the latter is given a brief analytic commentary; they include: *Goldfish and Sculpture* (1911), *Interior with Victrola* (1924), *Still Life with Shrimps* (1921), and *White Plumes* (1919).

1287. *The **Cone** Collection of Baltimore-Maryland; Catalogue of Paintings-Drawings-Sculpture of the Nineteenth and Twentieth Centuries.* Lucerne: Siegfried Rosengart, 1934.

An early checklist with black and white illustrations of works in the collection published by Etta Cone with the assistance of her relative, the dealer Siegfried Rosengart.

1288. *The **Cone** Collection.* Baltimore: The Baltimore Museum of Art, 1967. Revised edition of *The Handbook of the **Cone** Collection.* Baltimore, 1955. Preface by Charles Parkhurst, Director; Foreword by George Boas; the essays "Paintings, Watercolors and Pastels" and "Sculpture" by Gertrude Rosenthal, Chief Curator; and "Drawings and Prints" by Adelyn D. Breeskin.

Boas's essay tells discreetly something of the lives lived by the genteel Cone sisters and their brother Ferdinand, although he concentrates on the boldness of their foray into collecting modern art long before other conventional American collectors did so. Author points to the spirit of questioning that was abroad in science, politics, and the arts in the pre-World War I period and, minimizing the influence of the Steins on the Cones's taste, asserts that the Cones maintained this open and questioning attitude until their deaths. The Rosenthal and Breeskin essays are running commentaries on the respective works and the history of their acquisition. These are updated in the 1967 edition; otherwise the articles are reproduced from the 1955 *Handbook.*

1289. Richardson, Brenda. *Dr. Claribel and Miss Etta: The **Cone** Collection of the Baltimore Museum of Art.* Baltimore: The Baltimore Museum of Art, 1985. Foreward by Arnold L. Lehman, "Two Women" by Gertrude Stein, "Dr. Caribel and Miss Etta" by Brenda Richardson; also an Annotated

Chronology of the Cone Acquisitions and a List of the Matisse Painting and Sculpture in the Cone Collection.

This catalogue, richly illustrated and beautifully designed, is as much about the remarkable Cone sisters themselves as their collection. The latter, donated in 1950 and dedicated in its new wing in 1957, not only includes master work of French modernism, but textiles, ivories, African Art, Japanese prints, oriental rugs, and much more. Of great importance are the Cone Archives--correspondence, diaries, clippings, and so on-- which round out the bequest. The Foreword by Lehman details this history of their collecting habits and acquisitions. The fascinating account by Richardson benefits from new archival material and, among other things, recounts in detail the purchases by the Cones, the role of Michael Stein in negotiating purchases from the Gertrude Stein collection, gives an accurate list of such treasures as the Mallarmé material from Matisse's book, *Poésies de Stephan Mallarmé*. The personal lives and customs of these vivid women are brought to life in Richardson's brilliant essay, with a wealth of social and psychological insight on their intimate lives as well as their attitudes toward their possessions.

1290. Cone, Edward T. "The Miss Etta **Cones,** the Steins, and M'sieu Matisse." *The American Scholar* 42, 3 (Summer 1973): 441-60.

An affectionate reminiscence by a fond nephew of his aunts, the Cone sisters, Claribel and Etta, the Steins, Michael, Sarah and Leo, and the artist whose work they collected, Henri Matisse. Charmingly anecdotal, but with perceptive insights and telling quotes.

1291. Werner, Alfred. "Osthaus and the **Folkwang** Museum." *Arts Mag.* 38, 5 (February 1964): 35-41.

A history of the Hagen and Essen museums that does not stress Matisse's early connections with Osthaus but is illustrated by the former's *Still Life with Asphodels.*

1292. George, Waldemar. "La Collection **Fukushima**." *La Renaissance de l'art français* 13, 3 (March 1930): 102-108.

A survey of the collection of French moderns by Fukushima who owned works from the early Nice period, including *Still Life with Plaster Bust, Girl with Mandolin, Woman Reading in a Landscape* which are illustrated. George has a superficial line or two about these works in a survey which touts the taste and focus of the collection.

1293. *Museum of Living Art, A. E. Gallatin Collection.* New York: New York University, 1940.

A catalogue of this collection of modern art which moved from its New York University site to the Philadelphia Museum of Art in 1943. Gallatin writes of his collection in the introduction; James Johnson Sweeney has a brief essay on the paintings. There are but three prints and one Matisse painting in the collection.

1294. Lieberman, William S., ed. *Twentieth-Century Modern Masters: The Jacques and Natasha Gelman Collection.* New York: The Metropolitan Museum of Art and Abrams, 1989.

An elegantly produced catalogue of this collection with scholarly catalogue by Sabine Rewald and contributions by specialists in the field. An especially fine commentary on *Sailor II* (1906), no. 935, by Pierre Schneider is included as well as his more general essay, "The Gelmans and the Fauves."

1295. Dorival, Bernard. "Musée National d'Art Moderne: Le Legs **Gourgaud**." *Rev. du Louvre* 17, 2 (1967): 93-102.

An earlier article on the Picasso paintings (*Revue du Louvre*, 1966) in the Gourgaud collection, and a still earlier note on Matisse's *Portrait of Mme Gourgaud* (*Bulletin des Musées de France*, April 1947), that had been bequeathed to the national Musée National d'Art Moderne, left only Matisse's *Interior with a Goldfish Bowl* of 1914 to be dealt with in this article on the work of Bonnard, Matisse, Braque, and Léger recently

donated by Baroness Gourgaud to the French Museum of Modern Art.

1296. Picard, Denis, with Arnaud Carpentier. "Grenoble, Un musée toujours pionnier." *Connaissance arts* 502 (January 1994): 36-49.

An extended article, well illustrated, on the new addition to the **Musée de Grenoble**; included is a history of the museum and its collections--including that of the **Sembats**, rich in Matisses. The direction of the museum's programs and acquisitions under Serge Lemoine is detailed.

1297. Klein, John, and Janet Bishop. *Matisse and Other Modern Masters, The Elise S. Haas Collection.* San Francisco: San Francisco Museum of Modern Art, 1993. Exhibition Catalogue. Introduction by John Lane; "When Worlds Collide, Matisse's *Femme au Chapeau* and the Politics of the Portrait" by John Klein; and "Highlights of the Collection" by Janet Bishop.

There is an illustrated checklist of the collection including four important Fauve period oils by Matisse that were once in the Sarah and Michael Stein Collection: *Woman with the Hat, Landscape: Broom,* final oil sketch for *Joy of Life, and Portrait of Sarah Stein.* Also in the collection are three early sculptures, three drawings, and an etching. The commentary on certain important paintings by Bishop is full and sensitive; Klein's important essay on *Woman with Hat* is detailed under no. 984.

1298. Braun, Emily, with Julie Blaut and others. *The Hillman Family Collection: Manet to Matisse.* New York: Hillman Family Collection, distributed by Seattle: University of Washington Press, 1994.

Well-documented and illustrated scholarly catalogue on the collection; there are only two Matisse drawings and one painting, *The Pineapple* of 1948, presently in the collection. Works once owned by the Hillmans are also pictured and documented, including two Matisse works.

1299. Young, Mahonri Sharp. "Ferdinand **Howald:** The Art of the
 Collector (Letter from Columbus, Ohio)." *Apollo* 90
 (October 1969): 340-43.

 A complete account of Howald's career as a collector, the
 prices of his acquisitions, and the demonstration of his taste
 which included many Americans (for example, twenty-eight
 John Marin and twenty-eight Charles Demuth paintings) and
 significant French artists (five Matisses, five Picassos, seven
 Derains).

1300. "The **Juviler** and Erickson Collections at Auction." *Arts
 Mag.* 36 (October 1961): 54-55.

 Notes the Parke-Bernet auctions of these collections in October
 and November; illustrates Matisse's *Deux Femmes sur une
 Terrasse* (1925) in the collection of Mr. and Mrs. Adolphe A.
 Juviler of New York and Palm Beach to be auctioned.

1301. Woods, Willis F. "The **Kamperman** Collection." *Bull.
 Detroit Art Inst.* 44, 1 (1965): 7-18.

 A survey of a collection of mostly School of Paris paintings
 and works by Michigan artists given by the Kampermans to
 the Detroit Institute; Matisse's *Black Ribbon* of the early
 1920s is illustrated as well as a lithograph *Dancer Seated.*

1302. Frankfurter, Alfred, ed. *The Albert D. **Lasker** Collection,
 Renoir to Matisse.* New York: Simon and Schuster, 1957.

 Catalogue of the collection with introduction by Frankfurter
 and individual commentary on the works by Wallace
 Brockway.

1303. du Plessix, Francine. "The Albert **Lasker** Collection," *Art
 in America* 56, 2 (March-April, 1968): 52-59.

 A lavish photographic spread in color of Albert and Mary
 Lasker's New York apartment, which houses their notable
 collection of modern art. The minimal text contains a good
 deal of information, much supplied by Mary Lasker in a recent

interview. Matisse's work is highlighted, both in the photos and text.

1304. "Modern Art and Modern Taste: The Albert D. **Lasker** Collection." *Art News Annual* 27 (1958): 35-36.

An article which "samples" several works from the Lasker collection, reproducing them in a new seven-color offset process done in Europe, and accompanying them with short statements by the artist. Matisse's *Interior with Phonograph, Selfportrait* (1923), and *Flowering Ivy* (1941) are reproduced with a short excerpt from the 1936 interview with Tériade entitled "Constance du Fauvisme."

1305. Kelder, Diane. *Masters of the Modern Tradition: Selections from the Collection of Samuel J. and Ethel LeFrak*. New York: LeFrak Organization, 1988.

Primarily a collection of post-impressionists and modern French artists, a group of major works from the LeFrak Collection is highlighted in this catalogue with scholarly documentation.

1306. Lévy, Pierre. "Henry Matisse." In *Des Artistes et un Collectionneur*. Paris: Flammarion, 1976.

The history of the purchase of two Matisse paintings (and the loss of one of them) by the collector, Pierre **Lévy**, who also collected primarily the work of Fauve painters, of Maurice Marinot, and of Roger de la Fresnaye. Includes an account of a short visit to Matisse in 1942 and a brief biography of the artist.

1307. Piexotto, Mary H. "Famous Art Collections: The **Lewisohn** Collection." *Studio* 117 (March 1939): 95-107.

Richly illustrated (in black and white) with works from the Lewisohn collection, this article has a running narrative and quotes from Lewisohn's book *Painters and Personality* (New York: Harper & Brothers, 1939) used as commentary to the paintings.

1308. Chatelet, Albert. "**Musée des Beaux-Arts de Lille**: Quatre années d'acquisitions d'oeuvres contemporaines." *Rev. du Louvre* 18, 6 (1968): 423-30.

Recounts the attempts by an association of the Friends of Contemporary Art to increase the museum's modern holdings. Although Matisse was from the region, the museum owns only a drawing, *Etude de femme devant une draperie* of c.1909 (illustrated), a 1940s charcoal drawing of a woman's face, and a copy of the artist's book *Jazz*.

1309. Dorival, Bernard. "Musée National d'Art Moderne, La Donation **Lung**." *Rev. du Louvre* 11, 3 (1961): 148-52.

Details the recent donation of Mme Frédéric Lung to the museum, of which Matisse's *Intérieur à Nice, la Sieste* of 1921-22 is reproduced. Dorival gives its provenance history and a brief descriptive analysis of the work.

1310. August, Marilyn. "House of **Maeght**." *Art News* 85 (Summer 1986): 93-97.

Reminiscences of Adrien Maeght, son of Aimé and Marguerite Maeght, founders of the Maeght Foundation. The article contains memories about Matisse and reproduces the latter's line drawing of Marguerite.

1311. Bernier, Rosamond. "La **Musée Matisse** à Nice." *L'Oeil* 105 (September 1963): 20-29.

Workmanlike history and tour of the newly-opened second floor of the Musée des Arènes at Nice as a Musée Matisse. Matisse's personal still life objects and the preliminary studies for the Chapel at Vence are among the items displayed in this well-illustrated article.

1312. Dorival, Bernard. "Musées de Nice, Le Legs **Matisse**." *Rev. du Louvre* 17, 1 (1967): 55-61.

An account of the donation of the Matisse family of the major holdings of the museum, not so much the site of major works as a center of documentation on his methods, his early works,

his working processes. Author walks through the relatively recently installed collection commenting on some important works in it.

1313. Girard, Xavier. "The **Musée Matisse** at Nice, The Renaissance of a Museum." *Apollo* 136, 370 (December 1992): 362.

An update on the state of the enlarged Musée Matisse, opening in 1993 after four years closure for the renovation. Author also outlines the other Matisse exhibitions to be held during 1993 in Grasse, Vence, and Nice in honor of the new visibility of Matisse in the region, enriched by donations from the Matisse family.

1314. Jeudwine, W. R. "Modern Paintings from the Collection of W. Somerset **Maugham**, II." *Apollo* 64 (November 1956): 137-141.

Matisse's *Girl with Sunshade* (1921) and *The Yellow Chair* (1940) are discussed in the context of Maugham's other modern works and his overall taste as a collector.

1315. Dorr III, G. H. "Putnam Dana **McMillan** Collection." *Minneapolis Institute Bull.* 50 (December 1961): 12-13, 24-25.

Note on the acquistion of three Matisse canvases, *Music Lesson, Three Bathers,* and *Collioure,* of the McMillan collection for the Minneapolis Institute.

1316. Lucas, John. "Twins Come of Age {**McMillan** bequests]." *Arts Mag.* 36 (March 1962): 60.

A note on the acquisition of the McMillan bequests in Minneapolis and St. Paul.

1317. Becker, John. "The **Museum of Modern Western Painting** in Moscow--Part II." *Creative Art* 10, 3 April 1932): 278-83.

The second of a two-part article on the Museum of Modern Western Art in Moscow (which the author has recently visited), in which twentieth-century work is discussed in some detail. The somewhat quirky commentary is mostly descriptive. The author, who has also seen the Matisse retrospectives in Paris and New York in 1931, ventures the judgment that "Matisse the painter and Matisse the decorator had said and resaid everything that he had to say before the end of the war."

1318. Ettinger, Paul. "Die modernen Franzosen in den **Kunstsammlungen Moskaus**." *Cicerone* 8, 4 (February 1926): 111-21.

In an article which works its way in two parts through the Moscow museums, Matisse is treated before Derain and Picasso in the most modern collections. Author remarks that the tradition of Russian religious icons and of folk art prepared collectors to appreciate the strong color, simplifications, and decorative quality of Matisse's work. Traces Matisse's use of color from Cézanne-influenced work to the bold decoration of the later paintings.

1319. Brettell, Richard, and Stephen Nash, eds. *A Century of Modern Sculpture: The Patsy and Raymond Nasher Collection.* New York: Rizzoli, 1987. Ital. ed. *Un Secolo di Scultura Moderna dalla Collezione Patsy e Raymond Nasher.* Florence, 1987. Florence, Washington, Dallas: Forte di Belvedere, National Gallery of Art, Dallas Museum of Art: 1987. Exhibition Catalogue.

Exhibition catalogue for the Patsy and Raymond Nasher sculpture collection, which contains several Matisse sculptures: *Madeleine I* (1901); *Woman with Necklace* (1907); *Reclining Nude I* (1907); *Decorative Figure Seated* (1908); *Two Negresses* (1908); *Large Nude* (1923-25); and *Tiari* (1930). A general essay by Stephen Nash, no. 207, places Matisse's work in the modern figurative tradition of Rodin, Rosso, and Maillol; individual works are completely documented.

1320. Arnold, Matthias. "Künstler sammeln Kunst." *Kunst &*
 Antiquitäten 2 (1988): 98-105.

 The second half of a two-part article focuses on **Picasso's** art
 collection; his Matisse's are given somewhat extended
 treatment.

1321. Chetham, Charles Scott, ed. *Modern Painting, Drawing, and*
 Sculpture Collected by Emily and Joseph **Pulitzer.** Vol. 1.
 New York: Knoedler and Company, and Cambridge, Mass.:
 Fogg Art Museum, 1957. Exhibition catalogue.

 Catalogue to the Pulitzer Collection in the form of an
 exhibition catalogue, with all works shown fully documented
 and a commentary on each. Matisse's *Bathers with a Turtle,*
 Conservatory, and 1925 sculpture, *Seated Nude,* are
 accompanied by relevant passages on the works from Alfred H.
 Barr, Jr.'s *Matisse, His Art and His Public* (New York: 1951).

1322. *John* **Quinn** *Collection of Paintings, Watercolors, Drawings*
 and Sculpture. Huntington, New York: Pigeon Hill Press,
 1926. Distributed by the Joseph L. Brummer and E. Weyhe
 Galleries.

 A substantive catalogue of Quinn's collection, prepared at the
 time of the sale of his work by the American Art Association.

1323. Lieberman, William S., ed. *Twentieth Century Art from The*
 Nelson Aldrich **Rockefeller** *Collection.* New York:
 Museum of Modern Art, distributed by the New York Graphic
 Society, 1969. Exhibition catalogue.

 Well-documented catalogue of the collection with a Foreword
 by Monroe Wheeler, preface by Nelson A. Rockefeller, and
 Lieberman's essay, "The Nelson Aldrich Rockefeller
 Collection," chronicles the Rockefeller's dealings with Matisse
 and their donations to The Museum of Modern Art. Matisse's
 work illustrated.

1324. *The Nelson* **Rockefeller** *Collection.* New York, 1978.

A promotional pamphlet for the selling of reproductions of works in the Rockefeller collection. Contains a good color photograph of Matisse's overmantel, *Song* (1938), and *Italian Woman* (1916) in place in the living room.

1325. *Von Matisse bis Picasso: Hommage an Siegfried **Rosengart**.* Stuttgart: Verlag Gerd Hatje, 1988.

A gallery director more than collector, Rosengart first worked at the Thannhauser gallery when it held the Matisse Retrospective in 1930. Thereafter, in his own gallery in Switzerland, he advised and acted as dealer for Etta Cone of Baltimore, whose Matisse collection became renowned. This is a handsome, well-documented catalogue of an "imaginary exhibit" in the dealer's honor with essays by Martin Kunz, Werner Schmalenbach, Ellen B. Hirschland, Franz Meyer, David Douglas Duncan, Pierre Daix, and others.

1326. Soby, James Thrall, and Lippard, Lucy R. *The School of Paris: Paintings from the Florence May **Schoenborn** and Samuel A. **Marx** Collection.* New York: Museum of Modern Art, 1965, 1978. Exhibition catalogue.

Handsome publication that functions as a catalogue to the collection; introduction by James Thrall Soby, notes by Lucy R. Lippard; second ed., 1978.

1327. Akinsha, Konstantin. "Irina **Shchukina** versus Vladimir Lenin." *Art News* 93 (Summer 1993): 71-2.

A complete account of the efforts of Shchukin's daughter, Irina, to have her father's collection reassembled in a separate venue, preferably his former home, the old Trubetskoy palace. A detailed description of the legal issues involved in copyright disputes for reproduction royalties and the vexed problem of works expropriated from private owners by governments that incorporated them into national collections. An important article on these issues.

1328. de Chassy, Éric. "L'Affaire **Chtchoukine**." *Beaux-Arts Mag.* 119 (January 1994): 50-65.

A complete account of the state of the suit brought by the heirs of Serge Shchukin to have their claim on their father's collection in the Russian State Museums recognized. The players are pictured, the issues outlined; the whole story is told again in this well-illustrated and informative article.

1329. Ginsburg, Michael. "Art Collectors of Old Russia: The **Morosovs** and the **Shchukins**." *Apollo* 98 (December 1973): 470-86.

An extended, well-researched article, with many documentary photographs, on the major collectors of modern art in late nineteenth- century and early twentieth-century prerevolutionary Russia. Comprehensive and informative.

1330. Ettinger, Paul. "Französische Handzeichnungen in Moskau [**Shchukine and Morosov**]." *Monatshefte für Bücherfreude u. Graphiksammler* (1925): 1.

A notice on the graphic works by French artists in Moscow collections.

1331. Osborn, Max. "Die Junge Kunst in den russischen Museen und Sammlungen." *Cicerone* 16, 19 (September 1924): 899-908.

Grateful that the reported destruction of artworks during the Russian Revolution has proved untrue, Osborn tours the now-nationalized Soviet museums, walks through the former mansions of **Shchukin** and **Morosov** and glowingly pronounces modern art alive and well in the new Socialist Republic. Matisse is mentioned without emphasis; ten Gauguin works are reproduced because less well known in the west.

1332. Fauchereau, Serge. "Henri Matisse dans les Collections russes [**Shchukine and Morosov**]." *Beaux-Arts Mag.* 49 (November 1986): 44-51.

Lavishly illustrated article with short but informative text on the two Russian collectors whose daring and taste made the Pushkin and Hermitage holdings possible.

1333. Kean, Beverly Whitney. *All the Empty Palaces: The Merchant Patrons of Modern Art in Pre-Revolutionary Russia.* New York: Universe Books, 1983.

Details the lives and collection-history of the **Shchukin** and **Morosov** collections in pre-revolutionary Russia. Author also describes the fate of the works after 1918 and appends a checklist of the collection, and the texts of Shchukin's letters to Matisse.

1334. Kostenevich, Albert G. "Matisse and **Shchukin**: A Collector's Choice." *The Art Institute of Chicago Museum Studies* 16, 1 (1990): 26-43, 91-2.

Much new material on the personal life of Shchukin and his relationship to Matisse, resulting in new insights on the interaction of the patron and artist and how that affected the course of the work made for Shchukin.

1335. Kostenevich, Albert G. "The Russian Collectors and Henri Matisse," *Matisse in Morocco.* Washington, D. C. and New York: National Gallery of Art and Abrams, 1990. Exhibition catalogue, no. 70.

A retellling of the story of Matisse and his Russian patrons, **Shchukin** and **Morosov**, this time with emphasis on their purchase of the works painted in Morocco. Pertinent letters are appended in the catalogue.

1336. Tancock, John. "Nineteenth and Twentieth Century Sculpture [from the **Norton Simon** Museum of Art in Pasadena]." *Connoisseur* 193, 177 (November 1976): 238-40.

A general survey of Simon's holdings which include Matisse's *Backs I, II, III and IV.* No discussion of them.

1337. Eliel, Carol S. *Degas to Picasso: Modern Masters from the Smooke Collection.* Los Angeles: Los Angeles County Museum of Art, 1987.

Attractive, well-documented catalogue on the collection, edited by Carol Eliel.

1338. Kimball, Fiske, "Matisse: Recognition, Patronage, Collecting." *Philadelphia Mus. Bull.* 43 (March 1948): 33-37.

Reminiscences of Sarah **Stein** as a friend and collector of Matisse; an overview of other early buyers of Matisse, e.g., Etta Cone and George Of, Albert C. Barnes and John Quinn.

1339. Kimball, Fiske. "Discovery from America." *Art News* 47 (April 1948): 29-31, 54.

An expanded version of the article in the Philadelphia Museum Bulletin of March 1948. The **Stein** recollections are fuller and richer, and the story of **Stieglitz**'s and **Barnes's** acquisitions are added to those in the earlier, shorter article.

1340. Potter, Margaret, ed. *Four Americans in Paris: The Collections of Gertrude Stein and Her Family.* New York: Museum of Modern Art, 1970. Exhibition catalogue.

A handsome, simulated-leather-bound catalogue of the Stein collections, completely illustrated and documented. On the Stein collections are the essays: "A World Beyond the World: The Discovery of Leo Stein" by Irene Gordon, "The Michael Steins of San Francisco: Art Patrons and Collectors," and "More Adventures" [reprinted] by Leo Stein. Of special importance are the reprint of Gertrude Stein's "Portraits: Henri Matisse" and an important essay,"Matisse, Picasso, and Gertrude Stein," by Leon Katz, no. 580. A series of period photographs show the Stein living quarters at varying times, showing (and identifying) the works in the collections at different periods.

1341. Seckel, Hélène. "27, Rue de Fleurus, 58, rue Madame: les **Stein** à Paris." *Paris-New York*, 278-305. Paris: Centre Pompidou, 1977, Gallimard, 1991. Exhibition catalogue.

A summary, but complete, review of the hospitality of the branches of the Stein family in Paris to Matisse and Picasso and the young Americans who benefited from these contacts. This account is followed by brief biographical sketches of Marie Laurencin, Paul Cézanne, Matisse, and Picasso and the works by these artists in the Stein collections.

1342. Hamilton, George Heard. "The Alfred **Stieglitz** Collection." *Metropolitan Mus. Journ.* 3 (1970): 371-92.

This essay comprises a history Alfred Stieglitz' s career as a gallery owner (291 and An American Place) and a survey of the works that he left to the Metropolitan Museum in 1949. Among the latter are two watercolors by Matisse which had been exhibited at 291 in 1908 (Matisse's earliest American show) and five drawings that had been shown in 1910. Two other drawings by Matisse from this exhibition were purchased for the museum's collection by Mrs. George Blumenthal. A major article, though touching on Matisse only briefly (pp. 375, 378-9).

1343. George, Waldemar. *La Grande Peinture Contemporaine à la Collection Paul Guillaume*. Paris: Éditions des "Arts à Paris," 1929.

The completely reproduced collection of Guillaume, with an elegaic but penetrating foreword on the collector, contains a section on Matisse in which George judges Matisse to be an optical and cerebral artist who never really emphasizes his materials but works by the language of signs, that is, of colors and lines, that refer finally to themselves. Each work by Matisse in the Guillaume collection is given a brief commentary.

1344. de Forges, M. T., and G. Allemand. "Orangerie des Tuileries, La Collection **Jean Walter-Paul Guillaume**." *Revue du Louvre* 16, 1 (1966): 55-64.

An account of this collection on the occasion of its permanent installation at the Orangerie. Matisse's *Trois Soeurs* of 1917 is mentioned in the article and his *Nu Drapé étendu* is reproduced.

1345. Hoog, Michel, with Hélène Guicharnaud and Colette Giraudon. *Catalogue de la Collection **Jean Walter et Paul Guillaume**.* Paris: Réunion des Musées Nationaux, Musée de l'Orangerie, 1984.

A beautifully produced volume on the occasion of the collection's permanent installation in the Orangerie in Paris, with an introduction by Michel Hoog on the two who formed the collection and on its growth after Guillaume's relatively early death in 1934. Each work has its own commentary and scholarly documentation--provenance, bibliography, exhibition history, and is reproduced with a good quality color plate. Matisse has ten significant early Nice period works (1917-1927), including the earliest, *Three Sisters.*

1346. *Collection **Jean Walter-Paul Guillaume**.* Paris: [Orangerie des Tuileries]: 1966. Exhibition Catalogue.

A modest catalogue on the collection at the time of its first showing in Paris after being donated to the State by Mme Walter. Exhibition and catalogue organized by Mme H. Adhémar.

1347. O'Brian, John. *Degas to Matisse, The Maurice **Wertheim** Collection.* New York and Cambridge: Abrams and the Fogg Art Museum, 1988. Japanese ed. *The Maurice Wertheim Collection and Selected Impressionist and Post-Impressionist Paintings and Drawings in the Fogg Museum.* Tokyo: The Tokyo Shimbun, 1990. In Japanese.

Handsome scholarly catalogue on Wertheim and his collection (which subsequently was bequeathed to the Fogg Art Museum of Harvard University) with a fine introduction by his daughters, Barbara Wertheim Tuchman and Anne Wertheim Werner. An excellent general essay by John O'Brian deals in part with Matisse. The works in the collection, *Geraniums*

(1915), *Still Life with Apples* (1916), a suite of drawings of *Mlle Luba Roudenko* (1939), and a drawing *Nude Leaning on her Left Elbow* (1935-39) are given full documentation and commentary, pp. 117-125. Bibliography and a valuable section with "Technical Information on the Collection."

1348. Gardner, Henry G. "The Samuel and Vera **White** Collection." *Philadelphia Mus. Art Bull.* 63, 296-97 (January-March, April-June 1968): 74-88.

A double issue devoted to the collectors and the collection. Seven canvases of importance bought from Bignou, Quinn, Rosenberg, or Bernheim-Jeune are reproduced and documented.

1349. Bulliet, C. J. "**Winterbotham** Collection United in Chicago." *Art Digest* 21, 18 (July 1, 1947): 9+.

Informative early article on the unified hanging of the Winterbotham collection at the Art Institute of Chicago. Recounts the forcing of Matisse's *By the Window* (1919) into the museum's collection in 1921 as the first work by the artist in the museum's collection and the first work to be purchased by Winterbotham. (It has been since sold.)

1350. *The Joseph* **Winterbotham** *Collection at the Art Institute of Chicago.* A special issue of *The Art Institute of Chicago. Museum Studies* 20, 2 (1994): 134-35.

A special issue on the collection, with an introduction, "A Living Tradition: The Winterbothams and Their Legacy" by Lyn Delliquadri, and commentary on Matisse's *The Geranium*(1906) by Margherita Andreotti.

VIII

Matisse and Other Artists

1351. *After Matisse.* New York: Independant Curators Inc., 1986. Exhibition catalogue. Introduction by Susan Sollins, "After Matisse" by Tiffany Bell, "Matisse: The Olympian Example" by Dore Ashton, and "Expression Through Color" by Irving Sandler.

A broad-ranging exhibition that demonstrates the influence of Matisse's work in America from the 1940s through the 1970s. Handsome, well-documented catalogue with fine illustrations and thoughtful essays by art historians of the period. Artists included range from Hans Hofmann to Sean Scully.

1352. Arnason, H. H. "Motherwell: the Window and the Wall." *Art News* 68 (Summer 1969): 50.

Compares Motherwell's use of the window motif with Matisse's, especially *Open Window, Collioure.*

1353. Barron, Stephanie, and Larry Rosing. "Matisse and Contemporary Art, 1950-1970 and 1970-1975." *Arts Mag.* 49 (May 1975): 66-69.

Traces Matisse's influence on hard-edged painters (e.g., Youngerman, Kelly, Zox), certain colorists (e.g., Frankenthaler, Motherwell, Stella) and figurative artists (e.g., Avery, Wesselman). Rosing discusses Lichtenstein's pastiches of Matisse and Diebenkorn.

1354. Bioulès, Vincent. "Les Matisse 'Americains.'" *Art Press Int.* 30 (July 1970): 18-19.

An extremely perceptive meditation, by a French painter, on the works by Matisse in the Museum of Modern Art in New York and the influence that they have had on American abstract painting--in their frank materiality, their process-oriented method of construction, and in the interest in a kind of "musical" control of colored surfaces.

1355. Bouisset, Maïten. "Entretien Viallat, la couleur et ses supports." *Beaux-Arts Mag.* 59 (July-August 1988): 28-33.

An important interview with this "matissean" artist who founded the group "Support-surface" in the late 1960s to subvert the traditions of easel painting by creating unstretched, unprimed, color-impregnated works on a variety of fabric supports. Viallat speaks of Matisse's paper cut-out work *La Vague,* in which the figure and ground, positive and empty areas, are reversible as an important prototype for works in which he designed by voids or gaps, rather than positive forms.

1356. Broude, Norma F. "Miriam Schapiro and 'Femmage': Reflections on the Conflict Between Decoration and Abstraction in Twentieth-Century Art." *Arts Mag.* 54, 6 (February 1980): 83-87. Reprinted in *Feminism and Art History, Questioning the Litany,* 315-29. New York: Harper & Row, 1982.

Discusses the "feminization" of the collage by artists such as Miriam Schapiro (who invents the term "femmage"), who render it in non-high art materials of a blatantly decorative nature. Broude argues however that this mode might as well be considered a new mode of abstraction, and points to predecessors such as Matisse and Kandinsky who acknowledged the role played by decoration in their development toward abstraction.

1357. Buck, Robert T. "Richard Diebenkorn: The Ocean Park Paintings." *Art Int.* 22, 5 (Summer 1978): 29-34, 60.

Author traces and analyzes the influence on Diebenkorn's nearly abstract series by the 1912-17 works of Matisse.

1358. Carmean, E. A. "Morris Louis and the Modern Tradition: I. Abstract Expressionism; II. Cubism; III. Impressionism; IV. Fauvism; V. Later Matisse; VI. Principles of Abstraction." *Arts Mag.* 51, 1, 2, 3, 4 (September, October, November, December, 1976): 70-75, 112-117, 22-126, 116-119.

Discusses what Louis learned from the example Matisse's work: of Fauvist features, the multiplicity of separate and boldly colored interactive elements; and in the late works, drawing in color shapes and arranging them on a surface.

1359. Cassidy, Donna M. "John Marin's Dancing Nudes by the Seashore: Images of the New Eve." *Smithsonian Stud. American Art* 4, 1 (Winter 1990): 71-91.

A study of the iconographic sources for a series of nudes by the seashore that Marin commenced around 1930, when he had seen reproductions of Matisse's Barnes Foundation Mural. Author traces the American sources for the image of the nude female as a symbol of anti-puritanism, freedom, and wholesome sensuality. Marin's formal influences were French--Matisse, Cézanne, Rodin, Picasso--but his ideas were fashioned in his American milieu.

1360. Clair, Jean. "L'Influence de Matisse aux Etats-Unis (with English summary)." *XXe Siècle* 35 (December 1970): 157-60.

Author recapitulates the influence of Matisse in America in the first decades through Gertrude Stein and Alfred Stieglitz; also follows with brief discussion of Avery and Davis, the New York School of the post-war period, Hofmann and Kelly, and Pop Artists such as Wesselman and Kruchenik.

1361. Collins, Amy Fine. "Sequined Simulacra." *Art in America* 76, 7 (July 1988): 51-53.

A critical discussion of the use, by fashion designers Yves Saint Laurent and Bill Blass, of paintings by Van Gogh and Matisse in beaded copies on the jackets of their latest outfits. A full discussion including the reasons for the union of art and

fashion in the late 80s, when prices for Van Goghs had recently reached unheard-of prices at auction. Matisse's design was an early Nice interior, when Matisse was at his most luxurious and marketable.

1362. Dagen, Philippe. "Serge Fauchier, peintre 'américain'." *Art Press Int.* 128 (September 1988): 35.

A younger member of the "Support / surface" group who were influenced by Matisse and by American colorfield painters, Fauchier continues to work in vivid monochrome fields inflected by undulating marks that constitute "figures" or "drawing" that do not interrupt the field.

1363. Davvetas, Demosthenes. "Inside the Tomato Jungle, Interview with André Masson." *Artforum* 26 (October 1987): 91-95.

An interview with the elderly Masson, primarily on his classical themes and on his eroticism, but which contains comments on Matisse whom Masson found interesting as a thinker on topics other than painting.

1364. de Chassey, Éric. "Kelly et Matisse, une filiation inavouée." *Cahiers Musée national d'art moderne* 49 (Autumn 1994): 41-57.

The author traces the rapport between the work of the American Ellworth Kelly and Henri Matisse, often barely acknowledged by the former. Although Kelly spent the years 1949 to 1956 in France, when several large Matisse exhibitions of late cut-paper work were mounted, the younger artist has not always admitted the importance of these works for him. Chassey nevertheless draws out the common elements and approaches in the work of the two artists and, while respecting Kelly's differences, plausibly demonstrates the numerous filiations between the younger and older artist. A subtle and convincing essay.

1365. Elderfield, John. "Morris Louis and Twentieth Century Painting." *Art Int.* 21, 3 (May-June 1977): 24-32.

Matisse's influence on Louis's *Unfurled* and *Stripe* paintings, which are seen as combining the pastoral joyousness of Matisse's work with a certain epic and classical quality.

1366. Elderfield, John. "Language of Pre-Abstract Art: Three Good Museum Shows Illuminate the Problems of an Art on the Threshold of Abstraction." *Artforum* 9 (February 1971): 46-51.

Elderfield combines reviews of three shows, two of which involve Matisse, under the theme of the "language" of "pre-abstract" art. The *Four Americans in Paris* show at MoMA, although containing the Stein families' famous Fauve Matisse's, is discussed by the author only in terms of its Picasso works. *From Naturalism to Abstraction: Three Series*, also at MoMA, features Matisse's *Heads of Jeannette,* which are discussed by the author, along with two series of increasingly abstract paintngs by Van Doesburg.

1367. Elderfield, John. "Diebenkorn at Ocean Park." *Art Int.* 16, 2 (February 1972): 20-25.

Compares Diebenkorn's art of "surfaces and of light," of edge-bounded forms, to Matisse's in the second decade, i.e., during the latter's Cubism-exploring years.

1368. Elderfield, John. "High Modern: An Introduction to Post-Pollock Painting in American Art." *Studio Int.* 188 (July 1974): 4-7.

A subtle discussion of the role of emotion in post-Pollock, that is, post-expressionist, painting, exemplified by Morris Louis. Citing Michael Fried, who brings Pollock, Louis, and Matisse together, Elderfield speaks of Matisse's non-psychological, abstract "feeling" that is the "self-engrossment" of someone for whom painting is all. His feeling is for the maintaining of art and its place in the world as self-contained and independent of human presence. Elderfield's argument is richer than this summary suggests and very much tied to the defense of "post-painterly abstraction."

1369. *Fernand Léger: des Figürliche Werk.* Cologne: Kunsthalle, 1978. Exhibition Catalogue.

Catalogue essays by Christopher Green and Siegfried Gohr, who curated the show which ran from April 12-June 4, 1978. Text includes comparative material on Léger and Matisse.

1370. Forge, Andrew, Howard Hodgkin, and Phillip King. "Relevance of Matisse: a Discussion." *Studio* 176 (July 1968): 9-17.

A discussion on the artist's importance on the occasion of the Matisse Retrospective exhibition at the Tate Gallery. There is general agreement that Matisse has not been a key figure in American painting between 1948-68, although Matisse's influence will be felt in the next twenty years (1970-90). His gift essentially relates to his handling of the figure, in which continual invention prevented him from falling into any kind of system or intellectual formulae. After a wide-ranging discussion of color, the group concludes that Matisse may challenge the notion of avant-garde outrageousness by his affirmation of painting as a reasonable profession that does not need to justify itself by continually severing itself from tradition.

1371. Glueck, Grace. "The Twentieth Century Artists Most Admired by Other Artists." *Art News* 76, 9 (November 1977): 78-105.

Nearly one hundred (mostly American) artists were asked: what specific work(s) or artist(s) of the past seventy-five years have you admired or been influenced by the most? Picasso came out first, with Matisse, Pollock, and Brancusi as runners-up, in that order; Cézanne was fifth. Matisse's *Bathers by a River, Red Studio, La Musique,* and various papiers découpés were mentioned most often by artists as influential.

1372. Goodman, Jonathan. "Larry Rivers at the Marlborough." *Art News* 93 (Summer 1993): 168.

A review of Rivers' show entitled, *Art and the Artist,* which featured portraits of famous artists such as Matisse, Léger, and

Picasso at work in their studios, each painted in a style compatible with the artist portrayed. A reproduction of one of the Matisse paintings accompanies the review.

1373. Gordon, Donald E. "Kirchner in Dresden." *Art Bull.* 48 (September- December 1966): 335-66.

An important article that establishes through documentary evidence, despite the retrospective testimony of E. L. Kirchner himself, the influence of Matisse's work on his first characteristically "Brücke" distortions.

1374. Gouk, Alan. "Principle, Appearance, Style." *Studio* 187 (June 1974): 292-5.

A discussion of new American painting with reference to Matisse's and Hans Hofmann's ability to use their color both for plasticity and sheer opticality.

1375. Gran, Henning. "Henrik Sørensen og Matisse. Tre brev fra 1908-12." *Kunst og Kultur* 53 (1970): 39-51. In Norwegian.

Well-illustrated article on the Norwegian painter Henrik Sørensen, a student of Matisse and habitué of the Café Dôme. First attracted by Cézanne, Sørensen studied in Amsterdam before coming to Paris. Author includes extended citations from Sørensen's letters to his friend, Wold-Torne, from the period.

1376. Herrera, Hayden. "Gorky's Self-Portraits: the Artist by Himself." *Art in America* 64, 2 (March-April 1976): 56-64.

Cézanne, Picasso, and Matisse are discussed as influences on Gorky's style.

1377. Hoog, Michel. "A propos de *l'Automne* de Michel Larianov." *Rev. du Louvre* 22, 1 (1972): 25-30.

L'Automne, one of four paintings on the seasons, is compared with Cézanne's *Automne* (Musée du Petit Palais) and Matisse's *Nymph and Satyr* (Hermitage).

1378. Kenedy, R. C. "Günter Haese." *Art Int.* 18 (April 1974): 30-31+.

In his introduction to this article on Haese, a contemporary German sculptor, the author claims that Matisse and Duchamp are the two major directions or "routes" for contemporary art (in the early 1970s). The tradition of Constructivism and Mondrian has remained minor, although Haese's work is in that tradition and also owes much to the esthetic of Paul Klee.

1379. Landau, Ellen G. "The French Sources for Hans Hofmann's Ideas on the Dynamics of Color-Created Space." *Arts Mag.* 51, 2 (October 1976): 76-81.

Influence of Matisse, Cézanne, Kandinsky, and Delaunay on Hofmann's ideas on color while he was in Paris between 1904-1914.

1380. Lane, John R. "The Sources of Max Weber's Cubism." *College Art Journal* 24, 3 (Spring 1976): 231-36.

An account of Weber's discovery of Cubism, after his primary introduction to modern art through the teaching of Matisse and a study of Cézanne's work under Matisse's guidance. The Matisse material is incidental to the major theme of Weber and Cubism.

1381. Larson, Philip. "Brücke Primitivism: the Early Figurative Woodcuts." *Print Collectors's Newsletter* 6, 6 (January-February 1976): 158-60.

In a broad discussion of influences on early Brücke woodcuts, Matisse is discussed as an influence and his work contrasted with the German artists.

1382. Lebensztejn, Jean-Claude. "Eight Statements: Roy Lichtenstein, Paul Sharits, Tom Wesselmann, Carl Andre, Frank Stella, Brice Marden, Donald Judd, Andy Warhol." *Arts Mag.* 63, 4 (July-August 1975): 67-75.

Interviews with American artists (painters, a filmmaker, two sculptors) whose first mature work appears in the 1960s.

Questioned about Matisse and his influence on their work, many admit to the "law of the grandfather" by which they were able to use the flat, surface-oriented figurative work of the French painter to bypass their immediate predecessors, the abstract expressionists. In spite of diversity in responses, all join in their great admiration for Matisse. An important document of the period.

1383. Levin, Gail. "Patrick Henry Bruce and Arthur Burdett Frost, Jr.: from the Henri Class to the Avant-Garde." *Arts Mag.* 53, 8 (April 1979): 102-6.

Details the effect that becoming pupils of Matisse had on Bruce and Frost in turning them toward a more abstract mode of representation and the use of pure color.

1384. Lévy, Bernard-Henri. "Yves Saint Laurent und die Erfindung der Eleganz." *Du* 10 (1986): 20-35, 58-9.

An elegant essay (in German and English) on the quality of elegance in the designs of Yves Saint Laurent, who is shown to be a collector of modern art, owning a Matisse oil and paper cut-out from 1937. The article is lavishly illustrated with drawings, graphic designs, and clothing by Laurent--some of which are unmistakably inspired by Matisse.

1385. Levy, Thomas, and Carl-Jürgen Tohmfor. *Das Café du Dôme und die Académie Matisse.* Schwetzingen: K. F. Schimper-Verlag, 1988. In German with summaries in Eng., Fr., Ital., and Span.

A well-illustrated and informative book, published in connection with an exhibition on the same theme at the Galerien Herold und Levy in Hamburg in January 1989. The (mostly) German artists who frequented the Café and some of whom studied with Matisse are: Friedrich Ahlers-Hestermann (1883-1973), Bela Czobel (1883-1976), Rudolph Grossmann (1882-1941), George Kars [Karpeles] (1882-1942), Rudolf Levy (1875-1942), Oscar (1974-1947) and Greta (1884-1977) Moll, Franz Mölken (1884-1918) and Hans Purrmann (1880-1966).

1386. "Matisse: A Symposium." With contributions by Robert
 Rosenblum, Peter Schjeldahl, Brook Adams, Lynne Tillman,
 Francis M. Naumann, Jeff Perrone, Kenneth Silver, Richard
 Hennessey, et al. *Art in America* 81, 5 (May 1993): 74-87.

 A collection of responses by critics, art historians, and artists
 to the Matisse Retrospective exhibition at the Museum of
 Modern Art that range from the positive (Ellsworth Kelly,
 Francis M. Naumann, Jeff Perrone, Richard Hennessey,
 Robert Kushner) to the gender based or politically critical
 (Nancy Spero and Jo Anna Isaak, Kenneth Silver), from the
 impressionsitic (Jennifer Bartlett, Lynne Tillman, Gary
 Indiana) to the soberly art historical (Robert Rosenblum, Peter
 Schjeldahl, Charles Stuckey). Responses vary considerably in
 length.

1387. Meyer, Franz. "Matisse und die Amerikaner." *Henri Matisse*.
 Zurich: Kunsthalle, 1982. Exhibition catalogue.

 Drawing from sources published in English during the
 previous decade, Meyer recounts--for a European audience--the
 influence of Matisse on American artists from Motherwell and
 Diebenkorn to Stella and Wesselman. Quoting from
 Greenberg, Meyer notes that ideas of the all-over, centrifugal
 composition, the space-defining use of color, the sharp
 abstraction from nature in the paper cut-out, the "making
 powerful" of the decorative, and use of black as both color and
 light--all are derived by the Americans from the example of
 Matisse. A good summary of this material with convincing
 illustrations.

1388. Millard, Charles E. "A look at Edward Weston." *Print
 Collector's Newsetter* 6, 3 (July-August 1975), 68-70.

 In broader discussion of Weston's artistic development, his
 Nude (1925) is compared with Matisse's lithograph, *Seated
 Nude, Back Turned* (1914).

1389. Monnier, Geneviève. "Brève histoire du bleu." *Artstudio* 16
 (Spring 1990): 36-45.

Traces the color blue as a motif from the monochrome painting by Alexander Rodchenko in 1925, through Matisse's use of it, to moderns such as Yves Klein, Ellsworth Kelly, James Turrell, and Anish Kapoor.

1390. *New Decorative Works from the Collection of Norma and William Roth.* Florida: Loch Haven Art Center and Jacksonville Art Museum, 1983. Exhibition catalogue.

Exhibition catalogue with essays by John Perreault, Jeff Perrone, Carter Ratcliff, and Carrie Rickey; a general defense of decoration--both its timelessness and its modernity--is mounted, with Matisse as patron saint.

1391. O'Brien, John. "Greenberg's Matisse and the Problem of Avant-Garde Hedonism." In Serge Guilbaut, ed. *Reconstructing Modernism, Art in New York, Paris, and Montreal 1945-64*, 144-171. Cambridge, Mass. and London: MIT Press, 1990.

A close look at Greenberg's criticism shows how much Matisse's example of sheer quality helped to shape Greenberg's mature critical opinion on the characteristics and future of the avant-garde in painting. See Articles no. 664 for a fuller account.

1392. Perreault, John. "The Cultivated Canvas." *Art in America* 70, 3 (March 1982): 96-101.

An evaluation of Robert Zakanitch's oeuvre which, in its decorative, all-over lushness of surface, shows its debt to Monet and Matisse as well as its sources in minimalism and pop art.

1393. Poulain, Gaston. "L'Influence de Matisse au-delà des frontières." *Art présent* 2 (1947): 15-16.

Author muses on the lack of consistent or widespread influence of artists such as Matisse and Bonnard; he concludes that these artists are too French to be transplanted, too sincerely individual to belong to a movement or style. Poulain briefly

discusses artists in Scandinavia, Germany, England, and the United States who manifests some Matisse influence. In America, after mentioning Max Weber and John Marin, he notes only Milton Avery, Stuart Davis, and Audrey Skaling, a Canadian working in New York.

1394. Renard, Delphine. "Claude Viallat, entre matière et symbole." *Art Press Int.* 78 (February 1984): 24-5.

An interview with Claude Viallat on the occasion of his retrospective at the Centre Pompidou (1982-83) in which the artist's turn from referencing the work of Matisse to that of Picasso is discussed. The recent work is not as much involved with color and surface but with found objects and sculpture.

1395. Schoenfeld, Ann. "Grace Hartigan in the Early 1950s: Some Sources, Influences, and the Avant-Garde." *Arts Mag.* 60, 1 (September 1985): 83-88.

In a special section devoted to the "heroic decades, the 1950s and the 1980s," Grace Hartigan's debt to Matisse in the early 1950s is treated. She was influenced especially by *Bather by a River* and *Variation on a Still Life by de Heem,* which she saw in the 1951 Museum of Modern Art retrospective and saw in Barr's 1951 monograph.

1396. Thorstenson, Inger Johanne. "André Lhote om den syntetiske kubismen." *Konsthistorisk Tidskrift* 54, 1 (1985): 27-32; summary in English.

The author calls attention to the influence of Matisse on Lhote around 1916 when the artists of the vanguard were separated by military service. The author argues that Matisse's lessons--on color-usage in flat planes that are not bound by the contours of objects--were incorporated by Lhote and others and helped them develop a version of synthetic cubism. Picasso and his work were also available to these young painters, however, and a combination of influences were exploited by the young men who became theorists of the 1920s.

1397. Thorud, Svein. "En Norsk Malerinne i Paris: Magnhild Haavardsholms dagbok fra 1909." *Kunst og Kultur* 61, 4 (1978): 33-44.

A Norwegian student of Matisse offers her imprcssions in a diary kept in 1909, of her teacher and fellow students, as well as other current cultural events taking place in Paris at this time.

1398. Werenskiold, Marit. "Sigrid Hjertén som ekspresjonist, En analyse av *Självporträtt* 1914." *Konsthistorisk Tidskrift* 52, 1 (1983): 31-43. In Norwegian, summary in English.

An analysis of an expressionist self-portrait by one of Matisse's favorite pupils, Sigrid Hjertén, a young Swedish woman who would marry another of Matisse's students, Isaac Grünewald. The article details her professional and private life as aspiring painter, mother, leader of the Swedish avant-garde with her husband from 1914-18, and her gradual decline into mental illness, for which she was ultimately institutionalized. A sketch by fellow-student, Arvid Fougstedt, showing a suave Matisse giving special instruction to the fashionable Ms. Hjertén in front of a group of gaping male students, is reproduced in this well-illustrated article.

1399. Werenskiold, Marit. "Matisse og Skandinavia." *Louisiana Revy* 25, 2 (January 1985): 42-5.

Author details the influence of Matisse on Skandinavian artists. Although few Danish studied with him, there were important exhibits of Matisse and his students in Denmark. Sigrid Hjertén was said to be Matisse's favorite student; Henrik Sørensen and Jean Heiberg among his most conventional.

IX

Books on Matisse for Children

1400. Amzallag-Augé, Elizabeth. *Henri Matisse, la tristesse du roi.*
 Series: Atelier des enfants. Paris: Éd. Centre Pompidou,
 1990.

 A colorful interpretation of the paper cut-out for children;
 attractively illustrated in color reproductions.

1401. Baillet, Yolande, with illustrations by Bernadette Theulet.
 Matisse, le peintre de l'essential. Tournai: Casterman, 1992.
 Series: Le Jardin des Peintres.

 Under the fiction of a girl finding her great-grandmother's diary
 in an attic trunk, the story unfolds of an art-minded young
 bride who arrives in Paris in 1900, meets the young Matisse,
 and follows his career throughout her married life. The decades
 are colorfully sketched and illustrated with period photographs;
 the first-person journal is supplemented by the grandmother's
 answers to the heroine's questions and by third-person side-bars
 with reproductions of Matisse's paintings. Despite the
 elaborate artifice of the book's structure, the young reader will
 learn a good bit of accurate information on Matisse and his
 times.

1402. Buchholz, Cornelia. *Henri Matisse, Papiers découpés, zur
 analyse eines Mediums.* Frankfurt am Maine, , Berne, New
 York: Peter Lang, 1985. Series: Europaische
 Hochschulschriften Studieren nos. 28 and 44.

A historical, technical, and formal discussion of Matisse's practice within the paper cut-out technique, simply told for a young adult audience. The text sees the cut-paper technique as a culmination of and solution to his earlier painting, drawing, and sculpture problems. Traces the development of the technique and his varied usage of the medium. Attractively produced, accurate in its details.

1403. Coleno, Nadine, and Karine Marinacée. *Petites tâches au pays de Matisse*. Paris: Regards.

A slight tale for children with Matisse's work as the major point of reference.

1404. Haas, Patrick. *Le Dessin contemporaine 2*. Paris: Centre National de Documentaion Pédagogique, 1981. Twenty-four slides, with accompanying booklet.

Introduction to and commentary on slides that, besides Matisse's cut-paper work, includes automatic drawings by Masson, found-object work by Broodthaers, Sol Le Witt's wall drawings , and Smithson's *Spiral Jetty*. A broad approach to drawing/design, obviously.

1405. Munthe, Nelly. *Meet Matisse*. London: Walker Books Ltd., 1983. French ed. *Découper avec Matisse*. Paris: Éditions des Centurion, 1983. Series: Centurion Jeunesse.

A book that informs the 10 to 15-year-old reader about Matisse's ideas on color, cutting with a scissors as sculpture, and the role of nature in art in simple language. The author then sends the reader to art activities that follow Matisse's leads. Projects include painting sheets of paper, cutting shapes from them; positioning, arranging, and patterning the forms; examining the structures of forms in nature; decorating a folded screen, a "field," with shapes and colors, and costume design. An attractive pedagogical book, well written and illustrated, with intelligent design activities oriented to clear esthetic goals.

1406. Raboff, Ernst Lloyd. *Henri Matisse*. Series: Art for Children. New York: Lippincott, 1988.

A brief biography of the French artist in simple language; accompanied by reproductions of and commentaries upon several major Matisse works.

1407. Robinson, Anette. *Matisse.* Paris: Scala.

Small book on Matisse and his work for children.

1408. Rodari, Florian. *Un Dimanche avec Henri Matisse.* Geneva: Skira, 1993. Text and design by Rodari.

Simply told in the first person, the narrator (Matisse) flies into Nice, welcomes a visitor at the Hotel Regina, and explains his working methods and his esthetic principles. The text closely paraphrases for the young reader Matisse's own words, giving an accurate and unsentimentalized overview of the artist's project. The photographs and reproductions are well chosen, the layout attractive. A list of museums where Matisse's original works can be found is appended at the end.

X

Exhibitions and Catalogues

One-person and selected group shows

Paris 1896
Salon des Cent
Paris: Hall des Cent [Galeries de *La Plume*], April 1896.

Review: Degron, Henri. "Salon des Cent, vingtième exposition." *La Plume* 169 (May 1, 1896): 305-09 [Matisse not mentioned]; Saunier, Charles. "Petites Expositions." *Rev. encylopédique* (July 11, 1896): 481-82.

Salon de la Société Nationale des Beaux-Arts
Paris: Champs-de-Mars, April 25-May 1896.
Illustrated catalogue.

Review: Flat, Paul. "Les Salons de 1896." *Rev. bleue politique et littéraire* 4, 5 (June 6, 1896): 722-26; Marx, Roger. "Le Salon du Champs-de-Mars." *Rev. encyclopédique* 6 (April 25, 1896): 277-86.

Paris 1897
Salon de la Societé Nationale des Beaux-Arts
Paris: Champs-de-Mars, April 24-May 1897.
Illustrated catalogue.

Review: Bouyer, Raymond. *L'Art et la beauté aux Salons de 1898.* Paris: L'Artiste, 1898, 36, 73; Fontainas, André. "La Revue du mois: Art." *Mercure de France* 22 (June 1897): 590-97; Marx, Roger. "Gustave Moreau, seine Vorlaeufer--seine Schule--seine Schueler." *Pan* (May-October 1897): 61-64 [review of Gustave Moreau's atelier; first mention of Matisse in German periodical]; Michel, André. "Le Tour du Salon. Champs-de-Mars." *Le Journal des débats politiques et littéraires* (April 23, 1897); Santillane, J. "Le Salon du Champs-de-Mars (deuxième article)." *Gil Blas* 26 (April 26, 1897).

Paris 1899
Salon de la Societé Nationale des Beaux-Arts
Paris: Champs-de-Mars, May 1, 1899.
Illustrated catalogue.

Review: Bouyer, Raymond. "Un Salonnier aux Salons de 1899." *L'Artiste* 3 (1899): 97-192; Marx, Roger. "Les Salons de 1899." *Rev.*

encyclopédique 9 (July 15, 1899): 541-60; Saunier, Charles. "Petite gazette d'art." *La Revue blanche* 19 (May 15, 1899): 136-40.

Paris 1901
Salon de la Société des Artistes Indépendants
Paris: Grandes Serres de l'Expositon Universelle, April 20-May 21, 1901. (Ten works.)

Review: Gustave Coquiot. "Le Salon des Indépendants." *Gil Blas,* April 20, 1901; Marx, Roger. "Petites Expositions." *Chronique des arts et de la curiosité* (May 1901):138-39; Marx, Roger. "La Saison d'Art (de janvier à juillet 1901)." *Rev. encyclopédique* 1 (July 13, 1901): 649-52.

Paris 1902
Group Show (Moreau students)
Paris: Berthe Weill Gallery, February 1902.

Review: Charles, François [Charles Guérin]. "Les Arts." *L'Ermitage* 24 (March 1902): 238.

Salon de la Société des Artistes Indépendants
Paris: Grandes Serres de la Ville de Paris, March 28-May 5, 1902. (Six paintings.)

Review: Charles, François [Charles Guérin]. "Les Arts. L'Exposition des Artistes Indépendants." *L'Ermitage* 24 (May 1902): 400; Fontainas, André. "Art moderne." *Mercure de France* 42 (May 1902): 526-31.

Paris 1903
Salon de la Société des Artistes Indépendants
Paris: Grandes Serres de la Ville de Paris, March 20-April 25, 1903. (Seven paintings and one drawing.)

Review: Fagus, Félician [Georges-Eugène Hayet]. "Les Indépendants." *La Revue blanche* 30 (April 30, 1903): 541-42; Marx, Roger. "Le Salon des Indépendants." *Chronique des arts et de la curiosité* (March 20, 1903): 102-04; Morice, Charles. "Le XIX Salon des Indépendants." *Mercure de France* 46 (June 1903): 389-405.

Group Show
Paris: Berthe Weill Gallery, May 4-31, 1903. (Two paintings.)

Salon d'Automne
Paris: Petit Palais des Champs-Elysées, October 31-December 6, 1903.
(Two paintings.)
Illustrated catalogue.

Review: Marx, Roger. "Le Salon d'Automne." *Chronique des arts et de
la curiosité* (November 2, 1903): 283-84.

Paris 1904
Salon de la Société des Artistes Indépendants
Paris: Grandes Serres de la Ville de Paris, February 21-March 24, 1904.
(Six paintings.)

Review: Marx, Roger. "Le Salon des Artistes Indépendants."
Chroniques des arts et de la curiosité (February 27, 1904): 70-72.

*Exposition de peintures, pastels et dessins par MM. Camoin, Manguin,
Marquet, de Mathan, Matisse, Puy*
Paris: Berthe Weill Gallery, April 2-30, 1904.
Catalogue with preface by Roger Marx.

Review: Marx, Roger. "Petites Expositions." *Chroniques des arts et de
la curiosité* (April 9,1904):119; Saunier, Charles. "Les Petites
Expositions." *Rev. universelle* 4 (1904): 214; Vauxcelles, Louis.
"Notes d'art, MM. Manguin, Marquet, Henri Matisse." *Gil Blas* (May
5, 1904).

Exposition des oeuvres du peintre Henri Matisse
Paris: Galerie Vollard, June 1-18, 1904. (Forty-five paintings, one
drawing.)
Catalogue with preface by Roger Marx.

Review: Marx, Roger. "Petites expositions." *Chronique des arts et de
la curiosité* (June 18, 1904); Morice, Charles. "Art moderne." *Mercure
de France* 51 (August 1904): 530-34; Saunier, Charles. "Les Petites
expositions," *Rev. universelle* 4 (1904): 535-38; Vauxcelles, Louis.
"Notes d'art, Exposition Henri Matisse." *Gil Blas* (June 14, 1904).

Salon d'Automne
Paris: Grand Palais des Champs-Elysées, October 15-November 15,
1904. (Fourteen paintings, two plaster sculptures.)

Review: Blanche, Jacques-Emile. "Notes sur le Salon d'Automne."
Mercure de France 42 (December 1904): 672-90; Marx, Roger. "Le
Salon d'Automne." *Gaz. beaux-arts* 3rd per, 32 (December 1, 1904):
458-74; Marx, Roger. "Le Salon d'Automne, 15 octobre-14 novembre
1904." *Rev. universelle* 4 (1904): 641-46; Thibeault-Sisson, François.
"Le Salon d'Automne au Grand Palais." *Le Petit temps* (October 14,
1904); Vauxcelles, Louis. "Le Salon d'Automne." *Gil Blas* (October
17, 1904).

Paris 1905
Intimistes, 1er Exposition (Matisse, Bonnard, Vuillard, Laprade)
Paris: Galeries Henry Graves, February 10-25, 1905.

Review: Marx, Roger. "Petites expositions." *Rev. universelle* 5
(1905): 43.

Salon de la Société des Artistes Indépendants
Paris: Grandes Serres de la Ville de Paris, March 24-April 30, 1905.
(Eight works including *Luxe, calme et volupté*). Retrospectives of
Seurat, Van Gogh.

Review: Denis, Maurice. "La Réaction nationaliste." *L'Ermitage* (May
15, 1905); Girieud, Maxime. "Au Salon des Indépendants." *Le Soir*
(April 11, 1905); Marx, Roger. "Le Salon des Indépendants." *Chronique
des arts et de la curiosité* (April 1, 1905): 99-102; Monod, François.
"Le Salon d'Automne." *Art et décoration* 18 (1905): 198-210; Morice,
Charles. "Le XXI Salon des Indépendants." *Mercure de France* 54
(April 15, 1905): 542-43; Louis Vauxcelles. "Le Salon des
Indépendants." *Gil Blas* (March 23, 1905); "Le Salon d'Automne."
L'Illustration 63, 327 (November 4, 1905): 294-5.

Exposition, Matisse, Camoin, Manguin, Marquet
Paris: Berthe Weill Gallery, April 6-29, 1905.

*Artistes Impressionistes, Matisse, Luce, Guérin, Schuffenecker, and
others*
Paris: Prath and Magnier, June 1905.

Review: Vauxcelles, Louis . "La Vie artistique." *Gil Blas* (June 14, 1905).

Salon d'Automne
Paris: Grand Palais des Champs-Elysées, October 18-November 25, 1905. (Ten works.) Retrospectives of Ingres, Manet, and Renoir.

Review: Maurice Denis, "La Peinture, Le Salon d'Automne de 1905 [De Gauguin, de Whistler et de l'excès des théories]." *L'Ermitage* (November 15, 1905); Geffroy, Gustave. "Le Salon d'Automne." *Le Journal* (1905); André Gide, "Promenade au Salon d'Automne." *Gaz. beaux-arts* 34, 582 (December 1, 1905): 483-84; Hepp, Pierre. "Sur le choix des maîtres." *L'Occident* (December 1905): 263-5; Marx, Roger. "Le Vernissage du Salon d'Automne." *Chronique des arts et de la curiosité* (October 21, 1905): 267-68 [Matisse not mentioned; advocates dropping "Moreau group" label]; Monod, François. "Le Salon d'Automne." *Art et décoration* 28 (1905): 198; Morice, Charles. "Le Salon d'Automne." *Mercure de France* 57 (December 1, 1905): 376-93; Nicolle, R. Review. *Journal de Rouen* (November 20, 1905); Vauxcelles, Louis. "Le Salon d'Automne." *Gil Blas* (October 17, 1905); [Unsigned]. Review. *Petit caporal* (October 1905).

Exposition de peintures par MM. Camoin, Derain, Dufy, Manguin, Marquet, Matisse, Vlaminck
Paris: Berthe Weill Gallery, October 21-November 20, 1905.

Review: Morice, Charles. "Art moderne." *Mercure de France* 57 (December 1, 1905): 451-52; Vauxcelles, Louis. "La Vie artistique." *Gil Blas* (October 26, 1905).

Exposition de peintures de MM. Camoin, Guérin, Friesz, Manguin, Marquet, Matisse, Vlaminck
Paris: Prath and Magnier, December 1-31, 1905.

Brussels 1906
Exposition La Libre Esthétique
Brussels: February 22-March 25, 1906. (Seven works.)
Catalogue with preface by Octave Maus.

Le Havre 1906

Exposition Au Cercle de l'Art Moderne
Le Havre: May 26-June 30, 1906. (Two Collioure landscapes.)

Paris 1906
Salon de la Société des Artistes Indépendants
Paris: Grandes Serres de la Ville de Paris, March 20-April 30, 1906.
(One work: *Bonheur de vivre.*)

Review: Boisard, A. "Salon des Indépendants." *Le Monde illustré*
(March 31, 1906); Crucy, François. "Le Salon des Indépendants."
L'Aurore (March 22, 1906); Denis, Maurice. "Le Renoncement de
Carrière, la superstition du talent." *L'Ermitage* (June 15, 1906);
Estienne, Charles. "Le Salon des Indépendants." *La Liberté* (March 21,
1906); Maus, Octave. "Salon des Indépendants." *L'Art moderne* (April
29, 1906); Morice, Charles. "Le XXII Salon des Indépendants."
Mercure de France 54 (April 15, 1906): 534-44; Review. *Le Matin
d'Anvers* (March 23, 1906); Jean Tavernier. "Le Salon des
Indépendants." *Grande revue* 38 (April 1, 1906):101-106; Vauxcelles,
Louis. "Le Salon des Indépendants." *Gil Blas* (March 20, 1906): 1-2.

Exposition Henri Matisse
Paris: Galerie Druet, March 19-April 7, 1906. (Fifty-five paintings,
three sculptures; watercolors, drawings, lithos, woodcuts.)
Small catalogue with check-list of works exhibited; no text, two
reproductions *(Collioure, Vue de ma fenêtre* and *Sketch for Bonheur de
vivre, nude with arms behind head)* and brush and ink drawing on back
cover.

Review: Rosenthal, Léon. "Petits expositions." *Chroniques des arts et
de la curiosité* (March 31, 1906): 99-100.

Salon d'Automne
Paris: Grand Palais des Champs-Elysées, October 6-November 15,
1906. (Five paintings.) Retrospectives of Carrière, Courbet, and
Gauguin; Russian Art Exhibition organized by Diaghilev.

Review: Denis, Maurice. "Le Soleil." *L'Ermitage* (December 15,
1906); Fontainas, André. "Le Salon d'Automne." *L'Art moderne* 42
(October 21, 1906): 332; Holl, J.-C. "Salon d'Automne." *Cahiers d'art
et de littérature* 5 (October 1906): 67-114; Jamot, Paul. "Le Salon
d'Automne." *Gaz. beaux-arts* 3, 36 (December 1, 1906): 456-84; Kahn,

Gustave. "Lettre à un exposant du Salon d'Automne." *La Phalange* (October 15, 1906): 113-16; Marx, Roger. "Le Vernissage du Salon d'Automne." *Chronique des arts et de la curiosité* (October 6, 1906): 262-63; Mauclair, Camille. "La Crise de la laideur en peinture." *La Trois crises de la peinture actuelle*, Paris: Fasquelle, 1907, 296-97; Morice, Charles. "La IVe exposition du Salon d'Automne." *Mercure de France* 64 (December 1, 1906): 34-48; Vauxcelles, Louis. "Au Grand Palais: Le Salon d'Automne." *Gil Blas [supplement]* (October 5, 1906): 1; "Au Vernissage du Salon d'Automne." *Gil Blas* (October 6, 1906); [Unsigned.] Review. *Petit Dauphinois* (October 1906).

Group Exposition [Fauves]
Paris: Berthe Weill Gallery, November 1906.

Review: Jamot, Paul. "Petites expositions." *Chronique des arts et de la curiosité* 24 (November 24, 1906): 316-17; Vauxcelles, Louis. "La Vie artistique."*Gil Blas* (November 18, 1906).

Berlin 1907
Vierzehnte Ausstellung der Berliner Secession, Zeichnende Kunst
Berlin: December 1907. (Eight drawings by Matisse.)

Budapest 1907
Tavaszi Kiállitás--Gauguin Cézanne Stb. Müvei
Budapest: Nemzeti Szalon, May 1907. (Drawings by Matisse.)

Hagen 1907
Nature mortes
Hagen: Folkwang Museum, November 1907. (Seven works by Matisse.)

Le Havre 1907
2e Exposition Au Cercle d'Art Moderne
Le Havre: May-June 1907. (Two works by Matisse.)

Paris 1907
Salon de la Société des Artistes Indépendants
Paris: Grandes Serres du Cours la Reine, March 20-April 30, 1907.
(One painting, *Blue nude, souvenir de Biskra,* drawings, and woodcuts.)

Review: Desvallières, Georges. "A Propos des Indépendants." *Grande revue* 42 (April 10, 1907): 117-24; and "Aux Serres du Cours-la-Reine." (April 10, 1907): 139-47; Kahn, Gustave. "Review." *L'Aurore* (1907); Malpel, Charles. "Le Salon des Indépendants," *Le Télégramme* (Spring 1907); Marx, Roger. "Le Vernissage du Salon des Artistes Indépendants." *Chronique des arts et de la curiosité* (March 23, 1907): 94-97; Morice, Charles. "Art moderne." *Mercure de France* 66 (April 15, 1907): 752-54; Pératé, André. "Les Salons de 1907." *Gaz. beaux-arts* 37 (May 1, 1907): 356; Thibault-Sisson, François. "Le Salon des Indépendants." *Le Petit temps* (March 21, 1907); Vauxcelles, Louis. "Le Salon des Indépendants." *Gil Blas* (March 20, 1907): 1.

Dessins, croquis, pastels et aquarelles de Camoin, Derain, Dufy, Friesz, Manguin, Marquet, Matisse, Puy
Paris: Berthe Weill Gallery, March 30-April 15, 1907.

Review: Marx, Roger. "Petites expositions." *Chronique des arts et de la curiositee* (March 30, 1907).

Salon d'Automne
Paris: Grand Palais des Champs-Elysées, October 1-22, 1907.
(Paintings including *Music* [Oil Sketch], and *Luxe I.*) Cézanne Retrospective.

Review: Apollinaire, Guillaume. "Le Salon d'Automne." *Je dis tout* (October 12, 1907); Estienne, Charles. "Le Salon des 'Fauves'--dissensions intérieures." *La Liberté* (November 28, 1907); Desvallières, Georges. "Au Salon D'Automne." *Grande revue* 44 (October 10, 1907): 740-42; Jean-Aubry, Georges. "La peinture au Salon d'Automne." *L'Art moderne* 43 (October 27, 1907); Kahn, Gustave. Review. *L'Aurore* (Spring 1907); Malpel, Charles. "Le Salon des Indépendants." *Le Télégramme* (Automne 1907); Marx, Roger. "Le Vernissage du Salon d'Automne." *Chroniques des arts et de la curiosité* (October 10, 1908): 323-28; Morice, Charles. "Art moderne." *Mercure de France* 71 (November 1, 1907): 161-68; Pératé, André. "Salons de 1907." *Gaz. beaux-arts* (1907); Puy, Michel. "Les Fauves." *La Phalange* (November 15, 1907): 450-59, reprinted in *L'Effort des peintres modernes,* Paris: Messein, 1933; Rouart, Louis. "Réflexions sur le Salon d'Automne, suivies d'une courte promenade au dit Salon." *L'Occident* 12 (November 1907): 230-41; Thibault-Sisson, François.

"Le Salon d'Automne." *Le Petit Temps* (October 1, 1907); Valloton Félix . "Le Salon d'Automne." *Grande revue* (October 25, 1907): 916-24; Vauxcelles, Louis. "Le Salon d'Automne." *Gil Blas* (September 30, 1907): 3.

Exposition Camoin, Derain, Manguin, Marquet, Matisse, Van Dongen, De Vlaminck
Paris: Berthe Weill Gallery, November 1907.

Review: Hepp, Pierre. Review. *Chroniques des arts et de la curiosité* 35 (November 16, 1907): 332.

Fleurs et natures mortes
Paris: Galerie Bernheim-Jeune, November 14-30, 1907. (Two works by Matisse.)

Review: Hepp, Pierre. Review. *Chronique des arts de la curiosité* 37 (November 30, 1907): 348; J.-F. Schnerb. "Fleurs et natures mortes; chez MM. Bernhiem-Jeune." *Grand revue* 46 (December 10, 1907): 581-84.

Group Exhibition
Paris: Galerie Eugène Blot, December 1907. (Two paintings.)

Portraits d'hommes
Paris: Galerie Bernheim-Jeune, December 16, 1907-January 4, 1908. (Matisse's *Self-Portrait.)*

Review: Hepp, Pierre. "Exposition portraits d'homme." *Chronique des Arts et de la curiosité* 1 (January 6, 1908): 3.

Vienna 1907
Paul Gauguin et les autres [Signac, Puy, Matisse, Marquet]
Vienna: Galerie Miethke, March-April 1907.

Berlin 1908-09
Henri Matisse Exhibition (with others)
Berlin: Paul Cassirer, December 1908-January 1909.

Review: M[ax] O[sborn]. "Matisse Ausstellung." *Kunstchronik* 20 (February 5, 1909): 238-39.

Le Havre 1908
Exposition Au Cercle d'Art Moderne
Le Havre: Hotel de Ville du Havre, May-June 1908.
Catalogue with preface by Guillaume Apollinaire.

London 1908
Group Exhibition of the International Society of Painters, Sculptors and Engravers
London: New Gallery, January 1908.

Moscow 1908
Le Salon de la Toison d'or [Braque, Derain, Manguin, Marquet, Matisse, Puy]
Moscow: Offices of the Toison d'or, April 11-May 24, 1908. (Three to five works by Matisse.)

Review: *Zolotoye Runo [Toison d'or]* (April 1908); Matisse works in exhibition reproduced; article by Charles Morice, "Nouvelles tendances de l'art français."

New York 1908
An Exhibition of Drawings, Lithographs, Water Colors and Etchings by M. Henri Matisse
New York: The Little Galleries of the Photo Secession, April 6-25, 1908.

Review: Cary, Elizabeth Luther. *New York Times;* Chamberlain, J. Edgar. *New York Evening Mail* (1908), reprinted in *Camera Work* (July 1908); Huneker, James. "On the Photo-Secession Exhibition." *New York Sun* (July 1908), reprinted in *Camera Work* (July 1908); Kerfoot, J. B. "Henri Matisse, a Retrospect." *Camera Work* 25 (January 1909): 45-46; *The Scrip* (June 1908).

Paris 1908
Salon de la Société des Artistes Indépendants
Paris: Grandes Serres de la Ville de Paris, March 20-May 2, 1908. (Matisse not exhibiting.)

Review: Denis, Maurice. "Liberté épuisante et stérile." *Grande revue* April 10, 1908 [Comments negatively on Matisse's qualities, evident in the work of his followers]; Marx, Roger. "Le Salon des Artistes Indépendants." *Chronique des arts et de la curiosité* 13 (March 28,

1908): 116 [admits that "Fauve" experiments in distortion and arbitrary color leave the critic only with a question of their "good faith," critical judgment having been rendered useless]; Vauxcelles, Louis. "Le Salon des Indépendants." *Gil Blas* (March 20, 1908).

Salon d'Automne
Paris: Grand Palais des Champs-Elysées, October 1-November 8, 1908.
(Eleven paintings, thirteen bronzes and works in plaster; six drawings; thirty works in all by Matisse.)

Reviews: Bovy, Adrien. "Le Salon D'Automne." *Grand revue* 51 (October 10, 1908): 558-69; Estienne, Charles. "Le Salon d'Automne II." *La Liberté* (October 1, 1908); Hepp, Pierre. "Les Expositions." *Grande revue* 52 (December 25, 1908): 603-07, and "Les Expositions." ibid., 57 (January 10, 1909): 191-95; Hepp, Pierre. "Le Salon d'Automne." *Gaz. beaux-arts* 3, 40 (November 1, 1908): 381-401; Jean-Aubry, Georges. "Le Salon d'Automne." *L'Art Moderne* 43 (November 1, 1908): 34; Marx, Roger. "Le Vernissage du Salon d'Automne." *Chroniques des arts et de la curiosité* 32 (October 10, 1908): 323-28; Morice, Charles. "Art moderne." *Mercure de France* 76 (November 1, 1908): 155-66; Péladan, M. J. "Le Salon d'Automne et ses retrospectives--Greco et Monticelli." *Rev. hebdomadaire* 42 (October 17, 1908) 360-61; Thibault-Sisson, François. "Le Salon d'Automne." *Le Petit temps* (September 30, 1908); [Review of Autumn Salon.] *The Nation* (October 29, 1908); with response by Berenson, Bernard. "Letter to the Editor." *The Nation* (November 12, 1908); Vauxcelles, Louis. "Le Salon d'Automne," *Gil Blas* (September 30, 1908): 1.

Exposition d'aquarelles, dessins et croquis [Lebasque, Lehmann, Manguin, Marquet, de Mathan, Matisse, Puy]
Paris: Berthe Weill Gallery, December 11-31, 1908.

Hagen 1909
Sonderausstellung
Hagen: Folkwang Museum, August 4-September 16, 1909.

Moscow 1909
2e Salon de la Toison d'Or

Moscow: La Toison d'or [Zolotoye Runo] Offices, January 24-February 28, 1909. (Nine drawings and four paintings by Matisse.)

Review: Mercereau, Alexandre. "Henri Matisse et la peinture contemporaine." *Zolotoye Runo* [*Toison d'or*] 6 (1909): illus: 3-14, text: I-X. Russian translation of Matisse's "Notes of a Painter."

Odessa, Kiev, St. Petersburg, Riga 1909-10
Salon Izdebsky: First International Exhibition of Paintings, Sculptures, Graphic Art and Drawings
Odessa: December 17, 1909-February 6, 1910; Kiev; St. Petersburg: Late April, 1910; Riga: until July 7, 1910.
Catalogue: *Salon. Katalog internatsional'noi vystavki Kartin, Skul'ptury, Graviury i risunkov. 1909-1910.*

Reviews: Khardzhiev, N. "Maiakovskii i zhivopis." *Apollon* (1910) I, 237, II: 31; "O Salone Izdebskago." *Zolotoye Runo [Toison d'or]* 11/12 (1909): 95; Rostislavov, A. "Khudozhestvennaia zhizn' Peterburga." *Apollon* 8 (1910): 47; Tugenhold, I. "Le Nu dans l'art français." *Apollon* (October-November 1910): 17-29.

Paris 1909
Salon de la Société des Artistes Indépendants
Paris: Temporary Barracks, Jardin des Tuileries, March 25-May 2, 1909. (Two paintings and two studies by Matisse.)

Review: Denis, Maurice. "De Gauguin et Van Gogh au classicisme." *L'Occident* (May 1909); Malpel, Charles. "Le Salon des Indépendants." *Le Télégramme* (Spring 1909); Marx, Roger. "Le Vernissage du Vingt-cinquième Indépendants." *Chronique des arts et de la curiosité* 13 (March 27, 1909): 99-101; Morice, Charles. "Le Salon des Indépendants." *Mercure de France* (April 16, 1909); Salmon, Andre. "Le Salon des Indépendants." *L'Intransigeant* (March 26 and 27, 1909); Vauxcelles, Louis. "Le Salon des Indépendants." *Gil Blas* (March 25, 1909).

Salon d'Automne
Paris: Grand Palais des Champs-Elysées, October 1-November 8, 1909. (Two paintings.) Von Marées Retrospective.

Review: Malpel, Charles. "Le Salon d'Automne à Paris." *Le Télégramme* (January 1909); Marx, Roger. "Le Vernissage du Salon

d'Automne."*Chronique des arts et de la curiosité* 32 (October 9, 1909): 255-57.

Group Exhibition
Paris: Galerie Eugène Blot, November 13, 1909. (Two paintings by Matisse.)

Vienna 1909
International Secession Exhibition
Vienna: May-October, 1909. (Two works by Matisse.)

Berlin 1910
Berlin Secession Ausstellung
Berlin: Spring, 1910. (Two portraits by Matisse.)

Brighton 1910
Modern French Artists
Brighton: Public Art Galleries, June 1910. (Two still lifes by Matisse.)
Catalogue of the Work of Modern French Artists, preface by Robert Dell, Roger Fry's secretary.

Brussels 1910
Exposition Le Libre Esthétique: l'evolution du paysage
Brussels: March 12-April 17, 1910. (Two paintings by Matisse.)

Budapest 1910
Exposition Impressioniste
Budapest: Novaszhaz, April-May 1910. (Two paintings by Matisse.)

Dusseldorf 1910
Sonderbund Ausstellung
Dusseldorf: Kunstpalast, July 16-October 9, 1910. (One painting, *Bathers with a Turtle,* exhibited by Matisse.)

Review: Niemaeyer, Oskar. "Henri Matisse, Der Architektonische Rythmus." *Sonderbund 1910 Denkschrift.*

Florence 1910

Prima mostra italiana dell'impressionismo
Florence: Lyceum Club, under auspices of *La voce*, April 20-May 5,
1910. (One landscape by Matisse, owned by Bernard Berenson, loaned
to exhibit.)

Review: Soffici, Ardengo. "L'Impressionismo a Firenze," *La voce*
(May 12, 1910).

Leipzig 1910
Exposition d'art français XVIIIe, XIXe, XXe siècle
Leipzig: Kunstverein, October-November 1910. (Two paintings by
Matisse.)

London 1910-11
Manet and the Post-Impressionists
London: Grafton Galleries, November 8, 1910-January 15, 1911. (Three
paintings, eight bronzes, twelve drawings, and a vase.)
Catalogue with preface by Desmond McCarthy and notes by Roger Fry.

Review: Fry, Roger. "Art, the Post-Impressionists, II." *The Nation*
(December 3, 1910): 403, idem, "Post-Impressionism." *Fortnightly
Rev.* 89 (May 1, 1911); Holmes, C. J. *Notes on the Post-
Impressionist Painters: Grafton Galleries, 1910-11.* London: Philip
Lee Warner, 1910; Konody, P. G. "Grafton Gallery Exhibition."
Observer (November 13, 1910).

New York 1910
*An exhibition of Drawings, Painting [one], and Photographs of Works
by Henri Matisse*
New York: The Little Galleries of the Photo Seccession, February 27-
March 20, 1910. (At least twenty-four drawings.)

Review: Cary, Elizabeth Luther. *New York Times;* Chamberlain, J.
Edgar. *Evening Mail;* Harrington, J. *New York Herald;* Hoeber,
Arthur. *The Globe;* Huneker, James G. *New York Sun;* Mather, Frank
Jewett. *Evening Post;* Stephenson, B.P. *Evening Post.* These are
summarized in two issues of *Camera Work* 30 (April 10, 1910): 47-
53 and 31 (July 1910): 46-7.

Paris 1910

Exposition Henri Matisse
Paris: Galerie Bernheim-Jeune et Cie, February 14-22, 1910. Actually
ran from February 14 -March 5. (Sixty-five paintings, twenty-six
drawings.)
Small catalogue with check-list of works; five reproductions, one a
drawing of a seated boy for *Game of Bowls.*

Reviews: Morice, Charles. "A qui la couronne?" *Le Temps* (February
22, 1910); Rivière, Jacques. "Une Exposition de Henri Matisse."
Nouvelle rev. française 16 (April 1910): 531-34, reprinted in *Études*,
42-46. Paris: NRF, 1911; Salmon, André. "Henri Matisse." *Paris-
Journal* (February 15, 1910); Schnerb, J. F. "Exposition Henri Matisse
(Galerie Bernheim Jeune)." *Chroniques des arts et de la curiosité* 8
(1910): 59.

Salon de la Société des Artistes Indépendants
Paris: Temporary Rooms, Cours la Reine, March 18-May 1, 1910.
(One painting by Matisse, *Girl with Tulips [Jeanne Vaderin].)*

Reviews: Apollinaire, Guillaume. "Prenez garde à la peinture! Le Salon
des Indépendants." *L'Intransigeant* (March 18, 1910); Bidou, Henri. "Le
Salons 1910." *Gaz. beaux-arts* 52 (May 1910): 361-78, (June 1910):
470-98, (July 1910): 26-50; Puy, Michel. "Le Dernier état de la
peinture." [1910], reprinted in *L'Effort des peintres modernes,* 103-04.
Paris: Messein, 1933; Vauxcelles, Louis. "A travers les salons:
promenades aux 'Indépendants'." *Gil Blas* (March 18, 1910).

D'Après les maîtres [First modern commercial exhibition of copies.]
Paris: Bernheim-Jeune, April 18-30, 1910. (Matisse showed a drawing
after Delacroix.)

Nus (Group show)
Paris: Galerie Bernheim-Jeune, May 17-28, 1910. (Four drawings.)

Salon d'Automne
Paris: Grand Palais des Champs-Elysées, October 1-November 8, 1910.
(Dance II and *Music* exhibited.)

Reviews: Apollinaire, Guillaume. "The Opening of the Salon
d'Automne." *L'Intransigeant* (October 1, 1910); Apollinaire,
Guillaume. "Le Salon d'Automne." *Poésie* (Autumn 1910); Benois,

Alexandre. "Lettres sur l'art; impressions moskovites." *Retch* (February 17, 1911), [As much a commentary on the Shchukine collection, as the Salon]; Dorgelès, P.c.c.R. , "Le Prince des Fauves." *Fantasio* 5, 105 (December 1, 1910): 299-300; F. M. "Le Salon d'Automne." *L'Art et les artistes* 68 (November 1910); Fontainas, André. "Le Salon d'Automne." *L'Art moderne* (October 15, 1910): 329-30; Fry, Roger. "The Autumn Salon." *The Nation* (October 29, 1910), idem, "Le Salon d'automne." *Gaz. beaux-arts* (November 1910); Morice, Charles. "Le Salon d'Automne." *Mercure de France* (November 1, 1910); Mourey, Gabriel. "Le leçon du Salon d'Automne." *Paris-Journal* (November 13, 1910); Rude, Léopold. "Le Salon d'Automne." *Gil Blas* (September 30, 1910); "Le Salon d'Automne." *Gaz. beaux-arts* (November 1910): 370; Skrotsky, "Iz Parija [From Paris: Le Salon d'Automne]. " *Odesskii Listok* 267 (November 20, 1910); Tugenhold, Yakov. "Osenny salon [Salon d'Automne]." *Apollon* 12 (1910); "Le Salon d'Automne." *Gaz. beaux-arts* (November 1910): 370; [Unidentified.] "Le Salon d'Automne." *Gaz. beaux-arts* (November 1910).

Exposition des élèves de Gustave Moreau
Paris: Galerie Hessèle, November 1910.

Review: "Les Élèves de Gustave Moreau (chez Hessèle)." *Bull. de l'art ancien et moderne* 490 (November 26, 1910): 286-87.

Prague 1910
Société des artistes Manès: Les Indépendants
Prague: Manès Gallery, February-March, 1919. (Six drawings and four sculptures.)

Review: Utitz, Emil. Review. *Die Kunst für alle* (April 1919): 334.

Saint Petersburg 1910
Exposition de dessins, lithographies et aquarelles des artistes français contemporains
Saint Petersburg: Offices of Apollon, February-March 1910.

Berlin 1911
XXII Berliner Secession
Berlin: April 1911. [French group around Matisse called expressionists.]

Paris 1911

Salon de la Société des Artistes Indépendants
Paris: Quai d'Orsay, April 21-June 13, 1911. (Two paintings, a portrait and *Manila Shawl [l'Espagnole],* which is replaced by *The Pink Studio* before the show ended.)

Reviews: Allard, Roger. "Salon des Independants." *La Rue* (May 5, 1911); Apollinaire, Guillaume. "Salon des Indépendants." *L'Intransigeant* (April 20, 1911), and "Artistes d'aujourd'hui et les nouvelles disciplines." ibid., (April 21, 1911); Frappier, Georges. "L'Exposition des Indépendants." *La République* (April 22, 1911); Guilbeaux, Henri. "Les Indépendants." *Hommes du jour* (April 29, 1911); Guillaume-Janneau, Charles. "Les Indépendants." *Gil Blas* (April 20, 1911); Lecomte, Georges. "Le Salon des Indépendants." *Le Matin* (April 20, 1911); Marx, Roger. "Le Vernissage du Salon des Indépendants." *Chroniques des arts et de la curiosité* 2 (January 14, 1911): 123-26; Richard, Frantz. "Le Salon des Indépendants, deux kilomètres entre les Fauves." *Gil Blas* (April 21, 1911): 2; Review. *Fantasio* (May 1, 1911); Salmon, André. "Le 27e Salon des Indépendants." *Paris-Journal* (April 20, 1911): 5; Salmon, André (La Palette). "Courrier des ateliers." *Paris-Journal* (April 25, 1911): 4; "Courrier des ateliers." ibid., (April 27, 1911): 5; Vauxcelles, Louis. "Salon des Indépendants." *L'Aero* (April 23, 1911); [Unsigned.] "Independent artists in Paris." *The Times* (April 24, 1911); [Unsigned.] "Le Salon des Indépendants." *La Vie artistique* (April 1911); [Unsigned.] "Une Promenade au Salon des Indépendants." *Petit journal* (April 27, 1911); "Independent Artists in Paris." *Times* (April 24, 1911).

Exposition de l'eau
Paris: Bernheim-Jeune, June 26-July 18, 1911. (Two paintings by Matisse.)

Review: Bidou, Henry. "Exposition de l'eau." *Chroniques des arts et de la curiosité* 24 (July 1, 1911): 190.

Salon d'Automne
Paris: Grand Palais des Champs-Elysées, October 1-November 8, 1911. (Two paintings one of which was *Interior with Eggplants.)*

Reviews: Apollinaire, Guillaume. "Le Salon d'Automne."
L'Intransigeant (October 12, 1911) and *Mercure de France* (October 16,
1911); Des Gaschons, Jacques. "La Peinture d'après demain." *Je sais
tout* (April 15, 1912); Goldschmidt, Ernst. "Strejtog i Kunsten, Henri
Matisse." *Politiken* (November 24, 1911); Jean-Aubry, Georges. "Le
Salon d'Automne, III." *L'Art moderne* 43 (October 22, 1911); Marx,
Roger. "Le Vernissage du Salon d'Automne." *Chronique des arts* 31
(October 7, 1911) : 242-44; Salmon, André. "Review." *Paris-Journal*
(September 30, 1911); Vauxcelles, Louis. "Au Grand Palais: Le Salon
d'Automne." *Gil Blas* (September 30, 1911):1.

Cologne 1912
Sonderbund Internationale Kunstausstelllung
Cologne: Städtische Ausstellungshalle, May 25-September 30, 1912.
(Five paintings.)

Review: Fortlage, Arnold. "Die Internationale Ausstellung des
Sonderbunds in Köln." *Kunst u. Künstler* (November 1912): 84-93.

Leipzig 1912
Leipziger Jahresausstellung 1912
Leipzig: April 7-end of June 1912. (Two paintings.)

London 1912
Second Post-Impressionist Exhibition
London: Grafton Galleries, October 5-December 31, 1912. (Nineteen
paintings, eight sculptures, eleven drawings, and some prints.)
Catalogue with essay by Roger Fry; frontispiece of Matisse's *Girl with
Black Cat* in color and six of the other thirty-nine reproductions are of
Matisse works.

Review: "Post-Impressionist Exhibition, Matisse and Picasso." *London
Times* (October 4, 1912); Fry, Roger. "The Grafton Gallery: An
Apologia." *The Nation* (November 9, 1912): 250-51; Hind, C. Lewis.
"Ideals of Post Impressionism: Matisse Who Discards All Tradition:
Joyous Works." *Daily Chronicle* (October 5, 1912); Konody, P. G.
"The Comic Cubists: Laughable Pictures at the Grafton Galleries."
Daily Mail (October 5, 1912); idem, "More Post-Impressionism at the
Grafton: the Frenchmen." *Observer* (October 6, 1912); Sée, R.R.M.
"Les Arts: L'exposition post-impressionniste à la Grafton Gallery de

Londres." *Gil Blas* (October 4, 1912); [Unsigned.] "The Post-Impressionsts: An Interesting Exhibition." *The Morning Advertiser* (October 4, 1912.

Moscow 1912
Jack of Diamonds [Valet de carreau]
Moscow: January-February 1912 (Three drawings.)

Munich 1912
Neue Kunst, Erste Gesamtausstellung
Munich: Gallery Hans Goltz, October 1912. (Two paintings.)

New York 1912
An Exhibition of Sculpture (first in America) and Recent Drawings by Henri Matisse
New York: Gallery "291," March 14-April 6, 1912. (Six bronzes, five works in plaster, one terra cotta; twelve drawings.)

Reviews: Hoeber, Arthur. *New York Globe;* Hunecker, James. *New York Sun*;; Lloyd, David. *New York Evening Post;* de Kay, Charles. "Matisse-Sculpture? 'Mazette!'" *American Art News* 10, 24 (March 23, 1912): 8; Hartmann, Sadakichi. "One More Matisse." *Camera Work* 39 (July 1912): 23, 33; these are summarized in *Camera Work* 38 (April 1912).

Paris 1912
Salon de la Triennale
Paris: Salle de Jeu de Paume, June, 1912. (One painting by Matisse, according to Apollinaire [*L'Intransigeant*, June 30, 1912].)

Salon d'Automne
Paris: Grand Palais des Champs Elysées, October 10-November 8, 1912. (Two works.)

Reviews: Apollinaire, Guillaume. "Le Salon d'Automne." *L'Intransigeant* (October 2, 1912); idem, "L'Art et la curiosité, origines de cubisme." *Le Temps* (October 14, 1912); Hunecker, James. "Decade of the New Art Moves Toward Big Changes." *New York Sun* (November 1912); Jean-Aubry, Georges. "Le Salon d'Automne, II." *L'Art moderne* 41 (October 13, 1912); Kahn, Gustave. "Art [Salon

d'Automne]." *Mercure de France* (October 1912): 881; Marx, Roger. "Le Vernissage du Salon d'Automne." *Chronique des arts et de la curiosité* 31 (October 5, 1912): 247-54; Vauxcelles, Louis. "Le Salon d'Automne." *Gil Blas* (September 30, 1912).

Zurich 1912
Moderner Bund
Zurich: Kunsthaus, July 7-31, 1913. (Four paintings by Matisse; also exhibiting: Arp, Delaunay, Kandinsky, Klee, and Marc.)

Berlin 1913
Berliner Secession Ausstellung
Berlin, April- May 1913. (Four paintings including *Dance I.)*

Review: Elias, Julius. "Französische Kunst, 1913." *Kunst u. Künstler* (February 1914): 292-93; Scheffler, K. "Die Jüngsten." *Kunst u. Künstler* (May 1913): 391-409; Vollert, Konrad. "Die XXVI Ausstellung der Berliner Seccession." *Deutsche Kunst u. Dekoration* (July 1913): 239-45; Waldmann, Emil. "Die Berliner Secession." *Kunst u. Künstler* (July 1913): 501-14.

Henri Matisse, Moroccan Paintings
Berlin: Kunstsalon Fritz Gurlitt, May 1-10, 1913.

Review: [Unsigned.] *Kunstchronik* 33 (1913): 177.

Kollektionen: Henri Matisse, Franz Heckendorf, E. L. Kirchner, George Leschnitzer
Berlin: Kunstsalon Fritz Gurlitt, November 1913. (Twelve paintings, drawings and lithographs.)

Budapest 1913
Exhibition
Budapest: Möveszhaz, April-May 1913. (One landscape.)

London 1913-1914
Post-Impressionists and Futurists
London: Doré Galleries, October 12-January 15, 1914. (Two paintings and five lithographs.)

Exhibition organized by Frank Rutter, curator of the Leeds City Art Gallery.

Munich 1913
II. Gesamtausstellung
Munich: Gallery Hans Goltz, August-September 1913. (Two paintings, one sculpture.)

New York 1913
The International Exhibition of Modern Art
New York: Armory of the Sixty-Ninth Infantry, February 15-March 15, 1913. (Seventeen works: thirteen paintings, three drawings, one sculpture.)
Smaller versions of the show: Chicago: The Art Institute of Chicago, March 24-April 16, 1913; Boston: Copley Hall, April 28-May 19, 1913.

Reviews: Cortissoz, Royal. "The Post-Impressionist Illusion." *Century Magazine* 85, 6 (April 1913): 812; Cox, Kenyon. Review. *Harper's Weekly* (March 15, 1913); idem, "The New Art: On Cubism and Futurism." *New York Sunday Times* (March 16, 1913); Mather, Frank Jewett. "Old and New Art." *The Nation* (March 1913); idem, "Newest Tendencies in Art." *The Independent* (March 6, 1913); Pach, Walter. "L'Art aux États-Unis." *La Vie* (September 6, 1913); Philpot, A. J. "Marvels of Modernity in the Name of Art," *Boston Globe* (April 28, 1913); Street, Julian. "Why I Became a Cubist." *Everybody's Magazine* (June 1913): 818-19; W. H. D. "Art That Merely Amuses." *Boston Evening Transcript* (April 28, 1913); [Unsigned.] "The 'Ism' Exhibition." *New York Tribune* (February 17, 1913).

Paris 1913
Exposition Henri Matisse, Tableaux du Moroc et Sculpture
Paris: Galerie Bernheim-Jeune, April 14-19, 1913. (Fourteen paintings, at least six drawings, and a survey of his sculpture.)
Small catalogue with six line drawings reproduced; no text.

Reviews: Apollinaire, Guillaume. "Henri Matisse." *L'Intransigeant* (April 17, 1913), and "Henri Matisse." ibid., (April 28, 1913); "Ausstellung," *Kunstchronik: Wochenschrift für Kunst und Kunstgewerbe* 24, 33 (May 16, 1913): 482; Jean, René. "Exposition

Henri Matisse." *Chronique des Arts et de la curiosité* 16 (April 19, 1913): 125; Sembat, Marcel, "Henri Matisse." *Les Cahiers d'aujourd'hui* 4 (April 1913): 185-94; Vauxcelles, Louis. "Les Arts: Exposition Louis Charlot et Matisse." *Gil Blas* (April 20, 1913).

Salon d'Automne
Paris: Grand Palais des Champs-Elysées, November 15, 1913-January 5, 1914. (One painting, *Portrait of Mme Matisse.*)

Reviews: Apollinaire, Guillaume. "Le Salon d'Automne: Henri Matisse." *Les Soirées de Paris* (November 15, 1913): 16; idem, "M. Bérard Inaugurates the Salon d'Automne." *L'Intransigeant* (November 14, 1913); Benn, Joachim. "Der Pariser Herbstsalon [1913]." *Die Rheinlande* (June 1914): 37-38; Dreyfus, Albert. "Der Pariser Herbstsalon [1913]." *Kunstchronik* (January 16, 1914): 219-23; Fargue, Léon-Paul. "Au Salon d'Automne." *Nouvelle rev. français* (January 1, 1914; Goldschmitt, Lucien. "Strejtog i Kunsten." *Politiken* (December 5, 1913, includes interview of 1912); Jean-Aubry, Georges. "Le Salon d'Automne, II: peinture-sculpture." *L'Art moderne* 49 (December 7, 1913); Salmon, André. "Le Salon." *Montjoie!* 1 (November-December, 1913): 4; Sillart. "Salon d'Automne [Ossennii Salon]." *Apollon* 1-2 (1914): 47-63; Thibault-Sisson, François. "Le Salon d'Automne: La Peinture." *Temps* (November 16, 1913); de Thubert, Emmanuel. "Au Salon d'Automne." *L'Art de France* (December 1913): 473-87; Vauxcelles, Louis. "Le Salon d'Automne." *Gil Blas* (November 7, 1913; special supp.).

Exposition d'affiches originales
Paris: Galerie Druet, November 1913.

Review: Hautecoeur, Louis. "Exposition d'affiches originales." *Chroniques des arts et de la curiosité* 34 (November 8, 1913): 268.

Rome 1913
Rome Secession Exhibit
Rome: Summer, 1913.

Review: Cantù, Arnoldo. "La Secessione Romana." *Vita d'Arte* (July-August 1913): 44-60 [cites Matisse and other young French artists as the most interesting; singles out Matisse's *Poissons Rouges* for discussion]; Cecchi, Emilio. "Esposizione romane. Impressionisti

francesi." *Il Marzocco* (April 20, 1913); Nebbia, Ugo. "Sul movimento pittorico contemporaneo." *Emporium* (December 1913): 421-38.

Vienna 1913
Die Neue Kunst [Impressionist, Expressionist, Cubist, etc.]
Vienna: Galerie Miethke, January-February 1913. (One painting.) Catalogue with preface by Adolphe Basler. Works by Monet, Van Gogh, Cézanne, Marchand, Matisse, Picasso, Rappaport, and Melzer shown.

Review: Fischel, Hartwig. "Aus dem viener Kunstleben." *Kunst u. Kunsthandwerk* 2 (1913): 135-37.

Berlin 1914
Henri Matisse, Sammlung des Herrn Michel Stein in Paris
Berlin: Gurlitt Gallery, Mid-July-August 1, 1914. (Nineteen paintings, seized at the outbreak of World War I.)

Brussels 1914
Salon Triennial
Brussels: May 1914. (Matisse sent *Bonheur de vivre*)

Review: Apollinaire, Guillaume. "French Exhibitions Abroad." *Paris-Journal* (May 15, 1914); Review. *Bulletin [de la Galerie Bernheim-Jeune]* 7 (May 14, 1914).

Düsseldorf 1914
Exhibition (collective)
Düsseldorf: Gallery Flechtheim, Late December 1913-January 1914. (One painting, probably *The Red Studio.*) Traveled to Cologne: Deutscher Werkbund, March-October 1914.

Munich 1914
Neue Kunst
Munich: Gallery Hans Goltz, Summer 1914. (Three paintings.)

Paris 1914
Matisse not in Salon des Indépendants nor Salon d'Automne.

General Salon Reviews: André Salmon. Review. *Montjoie!* (March 1914): 25; Levinson, André. "Expositions des Quatorze, jeunes disciples de Cézanne." *Apollon* 6-7 (1914): 39-45; Schnerb, J.-F. "Les Salons de 1914: Salon des Indepéndants (1)." *Gaz. beaux-arts* (April 1914): 297-308; idem, "Société Nationale des Beaux Arts (2)." (May 1914): 405-24; idem, "Société des Artistes français (3)." (June 1914): 491-501; idem, 4 (July 1915): 67-80.

"La Peau de l'ours" Collection vente
Paris: Hotel Drouot, March 2, 1914. (Ten early Matisse paintings sold.)

Review: *Comoedia* (March 3, 1914); Delcourt. "Avant l'invasion." *Paris-Midi* (March 3, 1914).

Dessins
Paris: Cercle Carré, March 23-early April, 1914.

Le Paysage du Midi
Paris: Bernheim-Jeune, June 8-16, 1914. (Two paintings by Matisse.)

Rome 1914
2nd Esposizione internazionale d'arte "della Secessione"
Rome: Spring 1914. [Canvases by Constantini, Oppo, Matisse, Cézanne, etc.; sculpture by de Melli.]

Review: Cantù, Arnoldo. "La Seconda Secessione romana." *Vita d'arte* (May 1914): 108-15; Cecchi, Emilio. "Note retrospettive de esposizione." *Il Marzocco* (July 19, 1914); Review. *Le Bulletin [de la Galerie Bernheim-Jeune]* 1 (January 29, 1914).

New York 1915
Henri Matisse Exhibition, Paintings, Drawings, Etchings, Lithographs and Sculpture
New York: Montross Gallery, January 20-February 27, 1915. (Fourteen paintings, eleven sculptures, five drawings, twenty-four etchings, nineteen lithos.)
Catalogue with no text but well illustrated with thirteen half-tone reproductions and *Goldfish* in color and Steichen's photo portrait of Matisse.

Review: "Art Notes." *New York Evening Post* (January 23, 1915); Pach, Walter. "Why Matisse?" *Century Mag.* 89 (February 6, 1915): 633-36; "Matisse at Montross." *American Art News* (January 23, 1915); *American Art News* (February 13, 1915).

New York 1916
Exhibition of Modern Art Arranged by a Group of European and American Artists
New York: Bourgeois Galleries, April 1916. (Matisse showed two paintings, three drawings, seven monotypes.)

Oslo 1916
Den Franske Udstilling (Modern French Art)
Oslo: Kunstnerforbundet, November 18-December 10, 1916. (Five paintings, ten drawings, ten etchings by Matisse; four paintings and six drawings by Marguerite Matisse.)
Catalogue with texts by Jean Cocteau, Apollinaire, and André Salmon; exhibit organized by Walther Halvorson who, with his wife Greta Prozor, was a student of Matisse.

Paris 1916
La Triennale
Paris: Jeu de Paume, March 2-April 15, 1916. (Two drawings by Matisse.)

Review: Kahn, Gustave. "Arts." *Mercure de France* (March 1916): 321-22; Vernay, Jacques. "La Triennale, exposition de l'art français." *Arts* (April 1916): 25-28.

Group Exhibition
Paris: Galerie des Indépendants, June 13, 1916. (Derain, Dufy, Matisse, and others).

Exposition de Peinture Série C
Paris: Bernheim-Jeune, June 19-30, 1916. (Three paintings by Matisse.)

L'Art moderne en France (Salon d'Antin)
Paris: Barbazanges Gallery (Studio Paul Poiret), July 16-31, 1916. (Two paintings and several drawings by Matisse in show organized by

André Salmon; Picasso's *Demoiselles d'Avignon* in first public showing.)

Review: Bissière, Roger. "Beaux-Arts et curiosité, la logique des expositions." *L'Opinion* (July 22, 1916): 95-96.

"Lyre et Palette" Exposition (organized by Salmon)
Paris: Salle Huygens (Studio of Émile Lejeune), November 19-December 5, 1916.

Exhibition, Blanc et Noir
Paris: Bongard exhibition space, Winter 1915-1916.

Philadelphia 1916
Advanced Modern Art
Philadelphia: McClees Galleries, May 17-June 15, 1916. (Two paintings.)

Winterthur 1916
Exposition d'art français
Winterthur: Kunstverein, October 29-November 26, 1916; traveled to Basel: Kunsthalle, January 10-February 4, 1917. (Three works.)
Catalogue with text by Théodore Duret.

Basel 1917
Exhibition d'art français
Basel: Kunsthalle Basel, January 10-February 4, 1917.

Frankfort 1917
Die Neue Kunst aus Frankfurter Privatbesitz
Frankfort: Kunstverein, 1917

Review: Müller-Wulkow, W. "Die Ausstellung der vereinigung für Neue Kunst in Frankfurt a. Main." *Das Kunstblatt* (1917).

New York 1917
Group Show
New York: Bourgeois Galleries, February 10-May 10, 1917.

Exhibition of the Society of Independent Artists
New York: Grand Central Palace, March 1917.

Group Show
New York: Bourgeois Galleries, November 11-December 11, 1917.

Paris 1917
Exposition d'un groupe d'artistes indépendants
Paris: Galerie Goupil, April-June 1917. (One painting, drawings.)

Exposition de Peinture Série D
Paris: Bernheim-Jeune, May 1-11, 1917. (Two paintings by Matisse.)

Exposition de peinture moderne
Paris: Bernheim-Jeune, June 14-23, 1917. (One painting by Matisse.)

Exposition Matisse
Paris: Galerie Paul Guillaume, December 1917.

Review: *L'Eventail*, December 15, 1917.

Oslo 1918
Den Franske Udstilling (Corot à Matisse)
Oslo: Kunstnerforbundet, January 18-late February, 1918; traveled to
Helsinki: Franska Konstutställningen; Stockholm: Exhibition of
French Art; Copenhagen: Danske Kunsthandel, January 16-February 2,
1919. (Eleven paintings, five drawings, and five monotypes by
Matisse.)
Catalog with texts by Matisse on Renoir and Cézanne, by Théodore
Duret, and by Walther Halvorsen.

Paris 1918
Oeuvres de Matisse et de Picasso
Paris: Galeric Paul Guillaume, January 23-February 15, 1918. (Twelve
paintings and several watercolors and drawings by Matisse.)
Catalogue with essays by Guilluame Apollinaire.

Reviews: Bissière, Roger. "Exposition Picasso-Matisse." *Paris-Midi;*
Chinet. Review. *L'Éventail*, March 15, 1918; Leblond, Marius-Ary.
"Les Derniers Matisse." *La Vie* 7 (January 1918): 32; Vauxcelles,
Louis. "Matisse et Picasso." *Le Pays* (1918).

Exposition au profit des oeuvres de guerre
Paris: Petit Palais, May-June 1918.

Review: Elias, Julius. "Nach der heroischen Zeit." *Kunst u. Künstler* (December 19, 1918): 83-97; Mille, P. "Le Salon de 1918." *Gaz. beaux-arts* (April-June 1918): 198-220.

London 1919
Modern French Art: Picasso, Matisse, Derain, Modigliani, Vlaminck
London: Mansard Gallery, August 1-September 1919.
Catalogue preface by Arnold Bennett; show organized by Osbert and Sacheverell Sitwell with Léopold Zborowski.

Pictures by Henri Matisse and Sculpture by Maillol
London: The Leicester Galleries, November-December, 1919. (Fifty-one works, including prints, three drawings, mostly recent.)
Catalogue with 1913 text by Apollinaire.

Review: "Exposition de l'oeuvre de Henri Matisse aux Leicester Galleries." *Burlington Mag.* (December 1919): 281; 1 plate; M.S.P. "Modern French Art." *Burlington Mag.* (September 1919): 120-125; two illus.

New York 1919
Exhibition of Paintings by Courbet, Manet, Degas, Renoir, Cézanne, Seurat, Matisse
New York: Marius De Zayas Gallery, November 17-December 6, 1919.

Paris 1919
Oeuvres récentes de Henri-Matisse
Paris: Galerie Bernheim-Jeune, May 2-16, 1919.
Small catalogue with thirty-six paintings listed; ten reproductions, no text.

Review: Cocteau, Jean. "Déformation professionelle." *Le Rappel à l'ordre* (May 12, 1919), reprinted in *Rappel á l'order, 1918-1926*, Paris: Stock, 1926; Hoppe, Ragnar. "My Visit with Matisse [June 1919]." *Städer och Konstnärrer* (1920); Lhote, André. "Une Exposition Matisse." *Nouvelle rev. française* 70 (July 1919).

La Triennale, exposition d'art français
Paris: Ecole des Beaux-Arts, May 5-June 30, 1919.

Review: Bouyer, R. "Les Salons de 1919." *Gaz. beaux-arts* (April-June 1919): 144-176; de Félice, Roger. "La Peinture au Grand Palais: la Triennale." *Arts et décoration* (July-August 1919): 65-75, [Matisse

among thirteen works illustrated]; Hamel, Maurice. "Les Salons de 1919." *Les Arts* 175 (1919): 2-16; 26 [plates].

Salon d'Automne
Paris: Grand Palais des Champs-Elysées, November 1-December 10, 1919.

Review: Allard, Roger. "Le Salon d'Automne: La Peinture." *Nouveau spectateur* 1, 11-12 (October 25/ November 10, 1919): 5; Bouyer, R. "Les Salons de 1919: le Salon d'Automne." *Gaz. beaux-arts* (October-December 1919): 407-427; Hamel, Maurice. "Le Salon d'Automne." *Art et décoration* (1919): 1-15; Sédeyn, Emile. "Le Salon d'Automne II: la peinture et la sculpture." *Art et décoration* 36 (Fall 1919): 161-172; [Unsigned.] *Comoedia illustré* (December 5, 1919).

Zurich 1919
Eröffnungsausstellung
Zurich: Galerie Bernheim-Jeune & Cie, June 25-August 20, 1919.

Anvers 1920
La Triennale d'Anvers
Anvers: Summer 1920.

Review: "Henri Matisse et la Triennale d'Anvers." *Bull. de la vie artistique* (July 15, 1920): 462-64.

Barcelona 1920
Exposicio d'art francès d'avanguarda
Barcelona: Galerie Dalmau, October 26-November 15, 1920.

Copenhagen 1920
Matisse in the Tetzen-Lund and Sagen Collection
Copenhagen: Tetzen-Lund Apartment, early October (two days), 1920. Before dividing the twenty works between the two collectors (originally from the Sarah and Michael Stein collection).

Review: Petersen, Car V. "Henri Matisse--Den Steinske Samling hos Tetzen-Lund." *Politiken* (October 2, 1920), in Danish.

London 1920
Paintings by Matisse
London: Carfax and Patterson, 1920.

New York 1920
Fourth Annual Exhibition of the Society of Independent Artists
New York: Waldorf Astoria, April 1-11, 1920.

Paintings by Matisse
New York: Marius De Zayas Gallery, December 6-25, 1920

Paris 1920
Exposition Henri Matisse
Paris: Galerie Bernheim-Jeune , October 15-November 6, 1920.
Invitation-catalogue with check-list of fifty-eight works, eighteen of
them reproduced; preface by C. Vildrac, "Exposition Henri Matisse,"
no. 754. Matisse's *Mon Deuxième Tableau [Still Life with Books]* as
frontispiece.
Vildrac also wrote the introduction for Matisse's *Henri Matisse,
Cinquante Dessins*, 1920, privately published on the occasion of this
exhibition and displayed in the book section of the Salon d'Automne of
1920, no. 257.
Review: Basler, Adolphe. "Die Junge Französische Malerei." *Cicerone*
12, 20 (October 1920): 740-752.

Salon d'Automne
Paris: Grand Palais, November 1920.

Review: Briçon, Etienne, "Salon d'Automne." *Gaz. beaux-arts* 62
(November 1920): 317-37; Grautoff, Oskar. "Von Hôtel de Bîron nach
Issy und Marly le Roi. Die französische Kunst seits 1914." *Kunst u.
Künstler* 19, 2 (November 1919): 43-59; Scheffler, K. "Wir und die
Französischen." *Kunst u. Künstler* 19, 4 (January 1921): 121-23;
Serruys, Yvonne. "Le Salon d'Automne ou l'école de discipline." *La
Rev. Rhénane, Rheinische Blätter* (December 1920): 112-115; [7
illus].

Venice 1920
XII Esposizione internazionale d'arte della Cittá di Venezia
Venice: May 8- October 31, 1920 (Two paintings by Matisse.)

Kurashiki 1921
The First Exhibition of French Contemporary Painting
Kurashiki, Japan, 1921.

New York 1921
Paintings by Modern French Masters
New York: Brooklyn Museum, February-April 1921.

Loan Exhibition of Impressionist and Post-Impressionist Paintings
New York: Metropolitan Museum of Art, May 3-September 15, 1921.

Paris 1921
Salon d'Automne
Paris: Grand Palais, 1921

Review: Escholier, Raymond. "Le Salon d'Automne." *Art et décoration* (December 1921): 161-81.

Berlin 1922
Exhibition (works by Matisse, Pechstein, Camoin, Kokoschka, Beckmann)
Berlin, 1922.

Review: Glaser, Curt. "Berliner Ausstellungen." *Kunstchronik u. Kunstmarkt* (January 6, 1922): 239-242.

Kurashiki 1922
The Second Exhibition of Contemporary French Painting
Kurashiki, Japan, 1922.

New York 1922
Exhibition of Contemporary French Art
New York: The Sculptor's Gallery, 1922.

Kelekian Collection Auction and Sale
New York, January 1922
Catalogue with foreword by Arsène Alexandre.

Review: *The Arts* (January 1922): 247.

Paris 1922
Exposition Henri-Matisse
Paris: Galerie Bernheim-Jeune, February 23-March 15, 1922.
Accompanied by Charles Vildrac, *Nice 1921--Seize réproductions*

d'après les tableaux de Henri-Matisse, Paris: Éditions Bernheim-Jeune, 1922, no. 755.

Review: Levinson, André. "Le Mouvement artistique." *L'Amour de l'art* (March 1922): 85-88; Sentenac, Paul. "Les Arts." *Paris-Journal* (March 12, 1922).

Salon d'Automne
Paris: Grand Palais, October-November 1922.

Reviews: George, Waldemar. "Salon d'Automne I." *L'Amour de l'art* (October 1922): 305-317; Mériam, Jean. "A Travers le Salon d'Automne." *Art et les artistes* (December 1922): 115-118 [Matisse illus.]; Schneeberger, A. "Le Salon d'Automne." *La Rev. de l'epoque* (December 1922): 84.

Paris 1923
Henri Matisse (Barnes Collection, recent purchases)
Paris: Paul Guillaume Gallery, January-February 1923.

Exposition Henri-Matisse
Paris: Galerie Bernheim-Jeune, April 16-30, 1923.

Review: Lhote, André. "Notes." *Nouvelle rev. française* (April, 1923); Feuillet, Maurice. Review. *Le Figaro artistique* 8 (November 1923): 3.

Exposition d'oeuvres d'art des XVIIIe, XIXe, et XXe siècles
Paris: Chambre Syndicale de la Curiosité et des Beaux-Arts, 1923.

Philadelphia 1923
Exhibition of Contemporary Paintings and Sculpture (from Barnes Collection)
Philadelphia: The Pennsylvania Academy of the Fine Arts, April 11-May 9, 1923.

Copenhagen 1924
Henri Matisse Retrospective
Copenhagen: Ny-Carlsberg Glyptotek, September-November 1924; traveled to Stockholm and Oslo.
Modest catalogue with thirteen reproductions; complete check-list of

works (eighty-seven paintings) shown, including Tetzen-Lund collection. Introduction by Leo Swane to this largest exhibition of Matisse's work to this date.

Review: Danneskiold-Samsoe, S. "Matisseutställningen i Köpenhamn." *Kunstbladet* (1923-34): 135+; Petersen, Carl V. "Matisseutställningen i Köpenhamn." *Tilskueren* 40, 2 (1924): 271+; idem, "Hvad er et Maleri av Matisse vaerdt?" *Dagbladet* (December 6, 1924), in Norwegian.

Glasgow 1924
Works of Some of the Most Eminent French Painters of Today
Glasgow: The Galleries of Mr. Alex Reid, October 1924.

Leipzig 1924
Henri Matisse (or French painting)
Leipzig: Flechtheim Galerie, 1924.

London 1924
The CAS: Loan Exhibition of Modern Foreign Painting
London: Colnaghi's Galleries, June-July 1924.

New York 1924
Exhibition of Works by Henri Matisse
New York: Joseph Brummer, February 25-March 22, 1924.
Largest solo show by Matisse in New York since 1915 Montross Gallery exhibition; catalogue preface by Joseph Brummer, former student of Matisse. (Fourteen paintings, six drawings, three etchings.)

Review: "Exhibition Review." *The Arts* (March 1924): 169.

Henri Matisse [works chosen by the artist himself]
New York: Fearon Galleries, December, 1924.

Review: "Exhibition Review." *The Arts* (December 1924): 330; McBride, Henry. "Matisse and Mestrovic." *The Dial*, January 25, 1925.

Paris 1924
Collection Henri Aubry
Paris: Hotel Drouot, April 7 (exhibition and sale), 1924.

Exposition Henri Matisse
Paris: Galerie Bernheim-Jeune, May 6-20,1924
Small invitation-catalogue with check-list of 39 paintings, (drawings
indicated but not listed); six reproductions, no text.

Salon des Tuileries
Paris: Palais du Bois, Summer 1924.

Review: Fosca, François. Le Salon des Tuileries." *Gaz. beaux-arts* 66
(July-August, 1924): 87-102.

Exposition and Auction for Monument to Apollinaire
Paris: Paul Guillaume Gallery, June 16-21, 1924. (Over sixty artists
contribute.)

*Première exposition des collectionneurs, organisée au profit de la
Société des Amis du Luxembourg*
Paris: Chambre Syndicale de l'Antiquité et des Beaux-Arts, 1924.

Baltimore 1925
An Exhibition of Modern French Art
Baltimore: Baltimore Museum of Art, January 9-February 1, 1925

New York 1925
Modern French Paintings
New York: Dudensing Galleries, June 1925.

Review: "Exhibition of Modern French Paintings at the Dudensing
Galleries," *The Arts* (June 1925): 341.

Matisse Graphics
New York: Weyhe Galleries, 1925.

Paris 1925
Dessins d'Henri Matisse et aquarelles de P. Signac and d'H. E. Cross
Paris: Galerie Bernheim-Jeune, January 1-20, 1925.

*Fifty Years of French Painting, Exposition internationale des arts
décoratifs et industriels modernes*
Paris: Pavillon de Marsan, Louvre, April 1925.

Revue: Mauny, Jacques. "A Paris Chronicle." *Arts* 8, 2 (August 1925): 109-13.

La Triennale
Paris: Durand-Ruel Gallery, Summer 1925.

Vingt-Cinq Contemporains
Paris: Galerie Druet, Summer, 1925.

Exposition
Paris: Pavillon-Studio des Éditions Berheim-Jeune, April-mid-October 1925.

Salon d'Automne
Paris: Tuileries (Terrasse du bord de l'eau), September 26-November 2, 1925 (One work by Matisse.)

Review: Mauny, Jacques. "The Autumn Salon." *The Arts* 8, (November 1925): 286-88, no. 633.

Henri Matisse, dessins
Paris: Galerie Quatre Chemins, November 13-28, 1925.
On the occasion of the publication of a book of Matisse's drawings with essay by Waldemar George, no. 233.

Zurich 1925
Gemälde und Handzeichnungen
Zurich: G. and L. Bollag, March 31-April 3, 1925. (Exhibition and sale.)

Internationale Kunstausstellung
Zurich: Kunsthaus Zurich, August 8-September 23, 1925.

London 1926
Opening Exhibition of the Modern Foreign Gallery
London: National Gallery Millbank, June-October 1926.

New York 1926
The John Quinn Collection
New York: Art Center, January 1926.

Catalogue: *The John Quinn Collection of Paintings, Watercolors, Drawings and Sculpture*, New York: Pidgeon Hill Press, 1926.

Paris 1926
Trente ans d'Art Independant, 1884-1914, rétrospective de la Société des Artistes Indépendants
Paris: Grand Palais, February 20-March 21,1926.

Tableaux modernes, aquarelles, pastels, gravures et dessins
Paris: Hotel Drouot, May 6-7, 1916.
Catalogue of exhibition and sale of the Auguste Pellerin collection.

IVe Salon des Tuileries
Paris: Palais de Bois, Summer 1926.

Review: Bouyer, Raymond. "Le IVe Salon Tuileries au Palais du Bois." *Rev. de l'art* 278 (July-August 1926): 121-28; Charensol, George. "Le Salon des Tuileries." *L'Amour de l'art* 6 (June 1926): 204-212; Foçillon, Henri. "Salons de 1926." *Gaz. beaux-arts* 68 (May 1926): 257-80; Rey, Robert. "Les Salons." *Art et décoration* (July 1926): 44.

Deux Toiles de Henri Matisse (Piano Lesson and *Bathers by a River)*
Paris: Paul Guillaume Gallery, October 8-14, 1926.

Review: Blanche, Jacques E. Review. *Les Arts plastiques* (1931): 247. Bonmarriage, Sylvan. "Henri Matisse et la peinture pure." *Cahiers d'art* 1, 9 (1926): 239-40+; Kahn, Gustave. Review. *Le Quotidien* (Automne 1926); [Unsigned.] Review. *Le Journal des débats* (1926); Warnod, André. Review. *Comeodia* (Autumn 1926); *Les Arts à Paris* (1927): 19-22 (carried summary of reviews on Matisse).

Exhibition and Auction John Quinn Collection
Paris: October 18, 1926.

Salon d'Automne
Paris: November 5-December 19, 1926. (One painting, *Odalisque with Tambourine.)*

Glasgow 1927

A Century of French Painting
Glasgow: McLellan Galleries, May 1927.

Hamburg 1927
Europäische Kunst der Gegenwart
Hamburg: Kunsthalle Hamburg, 1927.

Kyoto 1927
Exhibition of Western Paintings
Kyoto: Kyoto National Museum, 1927.

London 1927
Exhibition of Works by Henry Matisse
London: Alex Reid and Lefevre, June 1927

New York (and Chicago) 1927
*Retrospective Exhibition of Paintings by Henri Matisse, the First
Painting 1890, the Latest Painting 1925*
New York: Valentine Dudensing Gallery, January 3-31; Chicago: The
Arts Club of Chicago, February 17-27, 1927.

Review: Watson, Forbes. "Henri Matisse." *The Arts* (January
1927): 29-40.

Exhibition of French Art of the Last Fifty Years
New York: M. Knoedler and Co., January 17-29, 1927.

Exhibition of Modern French Paintings, Watercolors and Drawings
New York: C. W. Kraushaar Galleries, October 8-22, 1927.

Paris 1927
Exposition Henri Matisse--dessins et lithographies
Paris: Galerie Bernheim-Jeune, January 24-February 4, 1927.

Review: Mauny, Jacques. "Henri Matisse." *Drawing and Design* 2, 10
(April 1927): 99-102, no. 634.

Les Fauves, 1904-1908
Paris: Galerie Bing, April 15-30, 1927
Catalogue with preface by Waldemar George, no. 1226.

Review: George, Waldemar. "Le Mouvement fauve." *L'Art vivant* 54 (March 15, 1927): 206-208 (same text as catalogue, no. 1226); Salmon, André. "Les Fauves et le fauvisme." *L'Art vivant* 3 (May 1, 1927): 321-24, no. 1265.

Salon d'Automne
Paris: Grand Palais des Champs-Elysées, November 4-December 16, 1927.

Collection d'un amateur, tableaux modernes
Paris: Hotel Drouot, December 16-17, 1927.

Pittsburgh 1927
Twenty-sixth International Exhibition of Paintings
Pittsburgh: Carnegie Institute Museum, October 13-December 4, 1927. (Matisse wins first prize.)

Washington 1927
Leaders of French Art Today
Washington, D. C.: Phillips Memorial Galley, December 1927-January 1928.

London 1928
Drawings, Etchings and Lithographs by Henri Matisse
London: The Leicester Galleries, January 1928. (One hundred works, including sixteen drawings.)

Second Loan Exhibition of Foreign Paintings
London: M. Knoedler and Co., February 1928.

New York 1928
Loan Exhibition of Modern French Art from the Chester Dale Collection
New York: Wildenstein and Co., October 1928.

100 Years of French Portraits
New York: Museum of French Art, 1928.

Exhibition of Modern French Paintings, Watercolors and Drawings
New York: C.W. Kraushaar Galleries, October 1-18, 1928.

A Century of French Painting
New York: M. Knoedler and Co., November 12-December 8, 1928.

Paris 1928
Collection du Docteur Soubies
Paris: Hotel Drouot, June 13-14, 1928 (Exhibition and sale).

Maîtres de l'art moderne
Paris: Galerie Danthon, Fall 1928.
Exhibition organized by André Salmon.

L'École de Paris
Paris: Salle Pleyel, Fall 1928.

Tableaux modernes provenant de la villa "Sauge pourprée" à Deauville
Paris: Hotel Drouot, December 7-8, 1928. [Exhibition and sale of the
Jean Laroche collection.]

Salon d'Automne
Paris: Grand Palais des Champs-Elysées, November 4-December 16,
1928. (Matisse exhibits *Still Life on Green Sideboard.*)

Philadelphia 1928
The Inaugural Exhibition, Works from Samuel S. White III Collection
Philadelphia: The Philadelphia Museum of Art, March 1928.
No catalogue.

Tokyo 1928
Exhibition of Western Paintings
Tokyo: Tokyo Metropolitan Art Museum, 1928.

Venice 1928
XVI Biennale di Venezia, 1928
Venice: 1928. (Fourteen paintings, six bronzes, thirteen prints.)

Washington 1928
Tri-Unit Exhibition of Paintings and Sculpture
Washington, D.C.: Phillips Memorial Gallery, February-May 1928.

Cambridge 1929
French Painting of the 19th and 20th Centuries
Cambridge, Mass: Fogg Art Museum, March 6-April 6, 1929.

André Derain, Henri Matisse, Picasso, Charles Despiau
Cambridge: The Harvard Society for Contemporary Art, November 7-22, 1929.
(Matisse represented by eight oils, one drawing, three lithos mostly borrowed from New York galleries.)
Small fold-out catalogue with works listed and brief artists' biographies by Alfred Barr, Jr.

Cleveland 1929
French Art Since 1800
Cleveland: Cleveland Museum of Art, 1929.

Lucerne 1929
Peintures de l'école Impressionniste et Neo-Impressionniste
Lucerne, 1929.

New York 1929
Exhibition of Modern French Paintings, Water Colors and Drawings
New York: C. W. Kraushaar Galleries, October 5-28, 1929.

Henri Matisse, 1927-1929
New York: Valentine Gallery, December 9, 1929-January 4, 1930.
(Seventeen works.)

Reviews: "Valentine Gallery Shows Late Work by Matisse." *Art News* 28 (December 14, 1929): 3 [remarks change in Matisse's work from 1927 exhibit of *Odalisque (Decorative Nude on Ornamental Ground); a* new boldness and plasticity as seen in *Woman with Veil];* Marion, Pierre. "A New York, Matisse, Galerie Valentine." *Beaux-arts* 227, 2 (February 20, 1930): 20.

Paris 1929
La Grande Peinture Contemporaine à la collection Paul Guillaume
Paris: Galerie Bernheim-Jeune, May 25-June 7, 1929. (Sixteen paintings, two sculptures by Matisse.)
Catalogue and book by Waldemar George, *La grande peinture*

contemporaine à la collection Paul Guillaume, Paris: Editions des Arts à Paris, n.d.(1929?), no. 1343.

Henri Matisse, Quarante lithographies originales
Paris: Galerie Bernheim-Jeune, June 1929.
No catalogue.

Exposition de peintures et dessins de Henri Matisse
Paris: Galerie Le Portique, November 7-25, 1929.

Baltimore 1930
Cone Collection of Modern Paintings and Sculpture
Baltimore: Baltimore Museum of Art, April 1930.

Berlin 1930
Henri Matisse
Berlin: Galerie Thannhauser, February 15-March 19, 1930. (Eighty-three paintings, nineteen bronzes, fifty-four drawings.)
Catalogue with preface by Hans Purrmann; sixty-four of the 265 works illus., no. 687.

Review: "Exposition." *Cahiers d'art* 5, 2 (1930): 107 [photos of installation]; "Ausstellung, Berlin," *Deutsche Kunst u. Dekoration* 66 (May 1930): 116; [FTD]. Review of Thannhauser Exhibit. *Art News* 28 (March 8, 1930): 6; Grossmann, R. "Matisse and Germany." *Formes* 4 (April 1930): 4; Neugass, F. "Henri-Matisse." *Art et artiste* 20 (April 1930): 235-40; Neugass, F. "Henri-Matisse, for His Sixtieth Birthday." *Cahiers de Belgique* (March 1930); Neugass, F. "Henri-Matisse." *L'Amour de l'art* 24, 106 (April 1930): 240; Scheffler, K. "Der sechzigjährige Henri Matisse in der Galerie Thannhauser, Berlin." *Kunst u. Künstler* 28 (April 1930): 287-90; Terkel-Deri, Flora. "Exhibition, Thannhauser Galerie." *Art News* 28 (March 8, 1930): 6; Wolfradt, W. "Henri Matisse: zur Ausstellung in der Galerie Thannhauser, Berlin [with English summary]." *Cicerone* 22, 5 (March 1930): 129-32, supp. 18.

Matisse, Braque, Picasso. 60 Werke aus Deutschen Besitz
Berlin: Galerie Flechtheim, September 21-mid-October 1930.

Notice: *Cahiers d'art* 5,7 (1930): 387.

Bristol 1930
Contemporary French Painting, Sculpture, and Tapestries
Bristol: Association française d'expansion et d'echanges artistiques and
the Alliance française, June 1930.

Review: Wilenski, R. H. "Letter from England." *Formes* 7 (July
1930): 25.

Brussels 1930
Trente Ans de peinture française
Brussels: Galerie "Le Centaure" with George Petit Gallery, 1930.
Catalogue with preface by Paul Fierens.

Notice: *Cahiers d'art* 5, 5 (1930): 275-76.

London 1930
Modern French Masters
London: Arthur Tooth and Sons, April 2-May 3, 1930.

New York 1930
Painting in Paris from American Collections
New York: The Museum of Modern Art, January 19-February 16,
1930.
Catalogue with text by Alfred H. Barr, Jr.

La Nature Morte from Chardin to the Abstract
New York: Wildenstein and Co., 1930.

Summer Exhibition: Painting and Sculpture
New York: The Museum of Modern Art, June 15-September 28, 1930

Matisse, Picasso, Derain, Dufy, Segonzac, and others
New York: Valentine Gallery, August, 1930.

Paris 1930
Exposition de L'Art vivant
Paris: Galerie Pigalle, May 1930.

De Delacroix à nos jours
Paris: Galerie Georges Petit, 1930.

Review: Zervos, C. "De Delacroix à nos jours, une exposition-programme à la Galerie George Petit." *Cahiers d'art* 5, 5 (1930): 251-58.

Exposition de peintures et de sculptures de Henri Matisse
Paris: Galerie Pierre Loeb, 1930. (At least sixteen sculptures.)
No catalogue.

Review: "Sculptures de Matisse." *Cahiers d'art* 5, 5 (1930): 275-76; George, W. "Chronicles." *Formes* 7 (July 1930): 18, 19; Poulain, Gaston. "Sculpture d'Henri Matisse." Formes 9 (November 1930): 9-10, no. 210.

Pittsburgh 1930
29th International Exhibition of Painting
Pittsburgh: Carnegie Institute Museum, October 16-December 7, 1930. (Matisse was a juror; three Matisse works in show.)

Review: "Carnegie Juror on Return." *Art News* 28 (March 8, 1939): 12, [note that Matisse will stop in New York [Ritz Carlton, March 4] on way to Tahiti); "Philpot of London and Storrer of Austria to Serve on Carnegie Jury." *Art Digest* 4 (September 1930): 7, [Matisse photo]; "Matisse Is Coming." *Art Digest* 4 (January 15, 1930): 18; Watson, Forbes. "The Carnegie International." *Arts* 17: 1 (November 1930): 65-72; idem, 2 (December 1939): 167-71+; *Art News* 28 (January 25): 6, [note on Matisse's participation on Carnegie Jury; response by Matisse to rumors that his "students" were returning to tradition, no. 759].

Basel 1931
Henri-Matisse, Retrospective
Basel: Kunsthalle Basel, August 9-September 15,1931. (111 oils, sixteen sculptures, twenty-eight drawings, thirty-four lithos.)
Substantial catalogue: sixteen halftones, complete list of works shown; text with passages from Matisse's "Notes of a Painter" (1908).

Boston 1931
The Collection of John T. Spaulding
Boston: Museum of Fine Arts, May 1931-October 1932.

Columbus 1931
Inaugural Exhibition
Columbus, Ohio: Columbus Gallery of Fine Arts, January-February, 1931.

New York 1931
Portraits of Women, Romanticism to Surrealism
New York: Museum of French Art, January 1931.

Sculpture by Henri Matisse
New York: Brummer Gallery, January 5-February 7, 1931. (Forty-six sculptures.) Chicago: The Arts Club of Chicago, March 13-28, 1931. (Twenty-five works.)

Reviews: "Bronzes at the Brummer Gallery." *Art Digest* 5 (January 15, 1931): 14; "Exhibition of Sculpture in Bronze, Brummer Galleries." *Parnassus* 3 (January 1931): 4; Flint, R. "Exhibition of Sculptures, Brummer Galleries." *Art News* 29 (January 10, 1931): 9, no. 192; Goodrich, Lloyd. "Exhibition of Sculpture, Brummer Galleries." *Arts* 17 (February 1931): 353-55, no. 195; Herdle, G. "Sculpture by Henri Matisse." *Rochester Mus. Bull.* 3 (March 1931): 6;

Pictures of People 1870-1930
New York: M. Knoedler and Co., April 6-18, 1931.

Memorial Exhibition: The Collection of Miss Lillie P. Bliss
New York: The Museum of Modern Art, May 17-September 27, 1931; Andover, Mass: Addison Gallery of American Art, October 17-December 15, 1931.

Henri Matisse, Retrospective
New York: The Museum of Modern Art, November 3-December 6, 1931. (162 works, includng eleven bronzes, thirty-seven drawings.) Catalogue with text by Alfred H. Barr, Jr.

Reviews: Berthelot, P. "Exposition Matisse à New York." *Beaux-arts* 9 (December 1931): 4; Brown, J. N. "Matisse Exhibition." *School of Design Bull.* 20 (January 1930): 3-5; Cortissoz, Royal. "The Ideas and Art of Henri Matisse." *New York Herald Tribune* (November 8, 1931);

Flint, R. "Matisse Exhibit Opens Season at Modern Museum." *Art News* 30 (November 7, 1931): 5-6; Mase, C. C. "Scorn for Matisse." *Art Digest* 6 (December 1931): 7; McBride, Henry. "The Museum of Modern Art Gives a Matisse Exhibition." *New York Sun* (November 7, 1931); "Painter of the Modern French School." *Pencil* 12 (December 1931): 872; "World's Greatest Exhibition of Matisse's Art Is Held Here." *Art Digest* 6 (November 15, 1931): 5.

Renoir and His Tradition
New York: The Museum of French Art, November-December 1931.

Since Cézanne
New York: Valentine Gallery, December 28-January 16, 1932.

Review: "Here Is an Answer to the American Attack on French Modernism." *Art Digest* 6 (January 1, 1932): 7.

Paris 1931
Henri-Matisse, Exposition organisée au profit de l'orphelinat des Arts
Paris: Galerie Georges Petit, June 16-July 25, 1931.
An elaborate book-sized catalogue with twenty-four quality halftones of paintings and sculpture, embossed signature of artist on cover; intro. by George Petit. Matisse exhibited 141 paintings, one sculpture; drawings and prints not listed individually in catalogue.

Reviews: Berthelot, P. "Exposition." *Beaux-Arts* 9 (July 1931): 22-23; Cheronnet, Louis. Chronique. *Art et Décoration* 60 (August 1931): supp. 3: 111; Cogniat, Raymond, ed. *Matisse, Pour ou Contre?* Paris: Chronique du jour, 1931, articles by Fierens, George, Lhote, and others; Fierens, P. "Exhibition, Georges Petit Galleries." *Art News* 29 (August 15, 1931): 20; "Matisse in Review at Georges Petit Gallery." *Art Digest* 5 (August 1, 1931): 17; McBride, H. "Matisse in America." *Art News* 29 (August 15, 1931): 6, same art. in *Creative Art* 9 (December 1931): 463-66 and *Cahiers d'art* 6, 5-6 (1931): 291-6; McBride, H. "The Palette Knife." *Creative Art* 9 (October 1931): 269-70; Nirdlinger, Virginia. "The Matisse Way." *Parnassus* 3 (November 1931): 4-6; Salmon, André. "Letter from Paris." *Apollo* 14 (August 1931): 110-13; "Matisse Exhibit, Paris." *Art News* 29 (July 11, 1931): 8.

Pittsburgh 1931
Exhibition of Twentieth Century Paintings from the Chester Dale Collection
Pittsburgh: Carnegie Institute, May-June 1931.

Providence 1931
Henri Matisse
Providence, R. I.: Rhode Island School of Design, 1931.

Stockholm 1931
Fransk Genombrottskonst Fran Nittonhundratalet
Stockholm: March 1931; traveled to Oslo, Goteborg, Copenhagen until June 1931.

Amsterdam 1932
École de Paris
Amsterdam: Stedelijk Museum, April 9-May 2, 1932.

Indianapolis 1932
Modern Masters from the Collection of Miss Lillie P. Bliss
Indianapolis: John Herron Art Institute, January 1-31, 1932.

New York 1932
French Paintings
New York: Marie Harriman Galleries, 1932.

Summer Exhibition, Paintings and Sculptures
New York: The Museum of Modern Art, Summer 1932.

Henri Matisse, Exhibition of Fifty Drawings
Paris: Pierre Matisse Gallery, November 22-December 17, 1932.
(Forty-nine drawings, actually.) Exhibition of the drawings originally reproduced in 1920, *Cinquante Dessins*.

Reviews: "Drawings, Pierre Matisse Gallery." *Parnassus* 4 (November 1932): 9; "Exhibit, Pierre Matisse Gallery." *Art News* 31 (November 26, 1932): 5; "Fifty Drawings by Matisse Shown for the First Time." *Art Digest* 7 (December 1, 1932): 13; "How an Artist Transmutes Poetry into Line." *Art Digest* 7 (December 1, 1932): 27.

Poésies de Stéphane Mallarmé, with thirty original etchings by Henri Matisse
New York: Marie Harriman Gallery, December 3-30, 1932. Shown in Paris, Pierre Colle Gallery, February 3-10, 1933; London; Baltimore, April 1933. (Preparatory studies included).

Review: "Matisse Etchings, Marie Harriman Galleries." *Art Digest* 7 (December 1, 1932): 5; Breeskin, Adelyn D. "Miss Cone Presents Matisse Etchings." *Baltimore Mus. News* 4 (January 1933): 2.

Stephen C. Clark Collection
New York, 1932.

Review: "S. C. Clark's Matisse Collection Shown to Aid Hope Farm." *Art News* 31 (November 12, 1932): 4.

Exhibition
New York: The Art Association, 1932.

Exhibition
New York: Reinhardt Gallery, January 1932.

Northampton 1932
Special Exhibition of Three Paintings
Northampton, Mass: Smith College Museum of Art, Winter 1932-33.

Paris 1932
Collection Charles Pacquement
Paris: Hotel Drouot, December 10-12, 1932. (Exhibition and sale.)

Barnes Mural (announced but not held)
Paris: George Petit Galley, April 1932.

Notice: "Matisse's Forty-Foot Mural." *Art Digest* 6 (February 15, 1932): 8.

Chicago 1933
A Century of Progress: Exhibition of Paintings and Sculpture
Chicago: The Art Institute of Chicago, November 20-January 20, 1933.

Reviews: "Matisse, Picasso in One Gallery at the Century of Progess Art Exhibition." *Art Digest* 7 (May 15, 1933): 24; Rich, Daniel Cotton. "Exhibition of French Art, Art Institute of Chicago." *Formes* 33 (1933): 381-85.

London 1933
Henry Matisse
London: Arthur Tooth and Sons, June 22-July 8, 1933.

New York 1933
International Exhibition
New York: Rockefeller Center, 1933.

Paris 1933
Collection Eugène Blot
Paris: Hotel Drouot, June 1-2, 1933. (Exhibition and sale.)

Collection G. B. . . première vente
Paris: Hotel Drouot, June 8-9, 1933. (Exhibition and sale of collection of Georges Bénard.)

Review: "Fine Groups by Matisse and Bonnard Feature Auction of 'G. B.' Collection at Hotel Drouot in Paris on June 9." *Art News* 31 (June 3, 1933): 3+.

Tableaux modernes offerts par l'association des Amis des Artistes vivants
Paris: Galerie Bernheim-Jeune, 1933.

Exposition d'estampes originales de H. Matisse et Raoul Dufy
Paris: Galerie Marcel Guiot, October 25-November 10, 1933.
Catalogue-invitation with works listed; litho of *Odalisque les bras levés derrière la tête* on cover; Dufy etching on back.

Seurat et Ses Amis; la suite de l'impressionisme
Paris: Expos. de "Beaux-Arts et de la Gazette des Beaux-Arts," December 1933-January 1934.
Catalogue with preface by Paul Signac.

Philadelphia 1933

The White Collection
Philadelphia: The Philadelphia Museum of Art, 1933.

The Ingersoll Collection
Philadelphia: Philadelphia Museum of Art, 1933.

Baltimore 1934
Henri Matisse
Baltimore: Baltimore Museum of Art, Fall, 1934
On the occasion of the publication of *The Cone Collection Catalogue--
Paintings, Drawings, Sculptures of the nNneteenth and Twentieth
Centuries*, published by Etta Cone, no. 1287.

Review: "Baltimore Sees Fifty-Two Works by Henri Matisse." *Art
Digest* 8 (September 1934): 20.

New York 1934
Henri Matisse, Paintings
New York: The Pierre Matisse Gallery, January 23-February 24, 1934.

Reviews: Morsell. M. "Finely Arranged Matisse Exhibit Now on
Display." *Art News* 32 (January 27, 1934): 3-4; "Music in Matisse:
exhibition Pierre Matisse Gallery." *Art Digest* 8 (February 15, 1934):
14; "Twenty-six Pictures Reveal Matisse's Simple Design." *Art Digest*
8 (February 1, 1934): 14; Wellman, R. "Exhibition, Pierre Matisse
Gallery." *Parnassus* 6 (February 1934): 10.

Modern Works of Art: Fifth Anniversary Exhibition
New York: The Museum of Modern Art, May 14-September 12, 1934.
Catalogue by Alfred H. Barr, Jr.

The Lillie P. Bliss Collection
New York: The Museum of Modern Art, June 1-November 1, 1933.

Paris 1934
Braque, Matisse, Picasso
Paris: Durand-Ruel Galleries, Spring 1934.
Catalogue.

Review: Eglington, L. Review. *Art News* 32 (March 17, 1934): 3-6.

Les Fauves, L'atelier de Gustave Moreau
Paris: Exposition de la Gazette des beaux-arts, November-December
1934.
Catalogue by R. Cogniat, preface by L. Vauxcelles.

Review: "Au temps des Fauves." *Beaux-Arts* (November 16, 1934): 1;
Baschet, Jacques. "Au temps des Fauves," *L'Illustration* 93: 4801
(March 3, 1935): 281-4; Guenne, Jacques. "Les Fauves au musée."
L'Art vivent 192 (April 1935): 3; Vauxcelles, Louis. "Les Fauves, à
propos de l'exposition de la Gazette des Beaux-Arts." *Gaz. des beaux-
arts* 76, 86 (December 1934): 273-82, no. 1269.

San Francisco 1934
*Exhibition of French Painting, from the Fifteenth Century to the
Present Day*
San Francisco: California Palace of the Legion of Honor, June 8-July
8, 1934.

Brussels 1935
Exposition internationale d'art moderne
Brussels, 1935.

London 1935
Silver Jubilee Exhibition of Some of the Works Acquired by the CAS
London: The Tate Gallery, July-August 1935.

New York 1935
Twelve Paintings by Six French Artists
New York: Durand-Ruel Galleries, 1935.

Henri Matisse Prints
New York: Brooklyn Museum of Art, Fall, 1935.
Organized by Carl O. Schniewind.

Review: Parker, John. "The Prints of Matisse." *Prints* 6 (December
1935): 90-93; "Prints of Henri Matisse." *Brooklyn Mus. Quart.* 23
(January 1936): 34-35.

Paris 1935

Hommage du Musée Grenoble à Paul Guillaume
Paris: Petit Palais, February-April 1935.

Les Chefs d'oeuvre du Musée de Grenoble
Paris: Petit Palais, February-April 1935.
Catalogue by G. Barnaud, preface by J. Robiquet.

Matisse, dessins et sculpture
Paris: Renou et Colle Galerie, late November-early December 1935.

Saint Louis 1935
Twenty-four Paintings from the Bliss Collection [organized by the Museum of Modern Art]
Saint Louis, Missouri: City Art Museum, February 4-March 4; Pittsburgh, Carnegie Institute, March 13-April 10; Northampton: Smith College Museum, April 18-May 19, 1935.

San Diego 1935
California Pacific International Exposition
San Diego: Fine Arts Gallery of San Diego, May 29-November 11, 1935.

Zurich 1935
Sammlung 1919-1935
Zurich: Kunsthaus Zürich, May 26-August 11, 1935.

Belgrade 1936
Exposition de la peinture moderne française
Belgrade: Musée du Prince Paul, 1936.

Buffalo 1936
Matisse's Notre Dame in the Late Afternoon
Buffalo: Albright-Knox Gallery, October 1936.

Review: "Buffalo: the Analysis of a Matisse Canvas," *Art News* 35 (October 3, 1936): 18-19, no. 898.

Cleveland 1936
Cleveland Museum of Art Anniversary Exhibit
Cleveland: Cleveland Museum of Art, 1936.

The Hague 1936
Hedendaagsche Fransche Kunst
The Hague: Gemeentemuseum, February 15-March 15, 1936.

London 1936
Drawings and Lithographs by Henri Matisse
London: Leicester Gallery, February 1936. (Fifty-two drawings.)

Review: Duthuit, Georges. "The Vitality of Henri Matisse," *Listener* 15, 371 (February 19, 1936): 342-4.

Mr. Walter Taylor Collection
London: The Mayor Gallery, September-October 1936.

Exhibition of Masterpieces by Braque, Matisse, Picasso
London: Rosenberg and Helft, October 5-Mid-November, 1936.
Small catalogue with annotated (exhibition and literature record) checklist of works shown; one black and white reproduction by each artist; nine paintings by Matisse.

Reviews: "Recent Works at Rosenberg and Helft's," *Apollo* 10 (August 1937): 109.

New York 1936
French Masters of the Twentieth Century
New York: Valentine Gallery, January 1936.

Review: Morsell, M. "French Masters of XXe Siécle," *Art News* 34 (January 11, 1936): 6-7.

Matisse
New York: Marie Harrimann Gallery, February 1936.

Review: Frankfurter, A. M. "Informal Work at the Marie Harrimann Gallery." *Art News* 34 (February 22, 1936): 5+.

Modern French Tapestries by Braque, Dufy, Léger, Lurçat, Henri-Matisse, Picasso, Rouault
New York: Bignou Gallery, 1936.
Catalogue of works from the collection of Madame Paul Cuttoli, with preface by Edouard Herriot.

Review: "France with Modernistic Tapestries Points Another Way to Serve Art." *Art Digest* 10 (May 1936): 8.

Modern Painters and Sculptors as Illustrators
New York: Museum of Modern Art, April 17-September, 1936; traveled.

The Joseph Stransky Collection
New York: Wildenstein and Co., July 1936.

Matisse; Dance and Other Works on the Theme by Matisse and Others
New York: Pierre Matisse Gallery, late October 27-November 21, 1936.

Reviews: Breuning, M. "Exhibition, Pierre Matisse Gallery." *Parnassus* 8 (November 1936): 24-26; *Art Digest* 11, 3 (November 1, 1936): 23; Davidson, Martha. "Matisse's Allegory of the *Dance.*" *Art News* 35 November 7, 1936): 13-14.

Twenty-one Paintings by Henri Matisse, 1912-1936
New York: Valentine Gallery, November 23-December 19, 1936.

Reviews: "20 Paintings by Matisse Create a Sea of Decorative Color, Valentine Gallery." *Art Digest* 11 (December 1, 1936): 7; Davidson, M. "Magic Color of Matisse." *Art News* 35 (December 5, 1936): 14+, no. 823.

Paris 1936
Cent Ans de Théatre Music-Hall et Cirque
Paris: Galerie Bernheim-Jeune, 1936.

Exposition d'Oeuvres Récentes de Henri Matisse
Paris: Paul Rosenberg, May 2-30, 1936. (Twenty-seven recent works including *Nymph and Faun.*)

San Francisco 1936
Henri-Matisse, Paintings, Drawings, Sculpture
San Francisco: The San Francisco Museum of Art, January 11-February 24, 1936. (Thirty paintings, four sculptures, one pastel, drawings, and prints.)

Reviews: Morley, G. L. M. "Museum Events: Exhibition San
Francisco Museum of Art." *Parnassus* 8 (March 1936): 17; "Premier
West Coast Exhibition of Matisse." *Art News* 34 (February 1, 1936):
34.

Chicago 1937
Modern Painters and Sculptors
Chicago: The Arts Club, March 30-April 19, 1937.

London 1937
Recent Works of Henri Matisse
London: Rosenberg and Helft, Ltd., July 5-31, 1937.
Catalogue with check-list of works; three reproductions, no text.

Los Angeles 1937
Loan Exhibition of International Art
Los Angeles: Los Angeles Art Association, October-December 1937.

Lucerne 1937
Henri Matisse
Lucerne: Galerie Rosengart, 1937. (Recent paintings, thirty-four
drawings.)

Paris 1937
Les Maîtres de l'art indépendant 1895-1937
Paris: Petit Palais, June 17-November 10, 1937.
Catalogue with preface by Raymond Escholier and text by A. Sarraut;
Matisse shows sixty-one paintings.

Reviews: Arland, Marcel. "Premier Regard sur l'exposition des Maîtres
de l'Art Indépendant." *Nouvelle rev. française* (1937): 350-53;
Florisoone, M. Review. *Beaux-arts* (July 2, 1937): 8; Gillet, Louis.
"Trente ans de peinture au Petit Palais." *Rev. deux mondes* 107 (July
15, 1937): 330-339; (August 1, 1937): 562-584, no. 524.; Vauxcelles,
L. "Les Maîtres de l'art independant au Petit Palais." *Beaux-arts* (July
2, 1937): 2.

Origines et développement de l'art international indépendant
Paris: Musée du Jeu de Paume, July 30-October 31, 1937. (Matisse
shows six paintings; also works from his collection including African

sculpture.)
Exhibition organized by Tériade, Zervos, and Kandinsky; catalogue.

Oeuvres récentes de Henri Matisse
Paris: Paul Rosenberg, June 1-29, 1937.
Small catalogue with three reproductions in black and white; complete
checklist of works shown: twenty-one works from 1936-37.

Review: Lhote, André. "James Ensor [Galerie de l'Elysées]-Henri
Matisse [Rosenberg]." *Nouvelle rev. française* (1937), reprinted in
Écrits sur la peinture, Paris and Brussels, 1946; Lo Duca, G. H.
"Mostra, Galleria de Paul Rosenberg." *Emporium* 86 (August 1937):
446-47.

Valenciennes 1937
Exposition d'art moderne
Valenciennes: Palais des Beaux Arts, April 8-May 9, 1937.

Winterthur 1937
Werke aus der Sammlung Dr. Arthur Hahnloser
Winterthur: Kunstmuseum, April 18-May 30, 1937.

Boston 1938
Picasso--Matisse
Boston: Boston Museum of Modern Art, October 19-November 11,
1938. (Twenty-four works by Picasso, fifteen by Matisse.)

Chicago 1938
*Loan Exhibition of Modern Paintings and Drawings from Private
Collections in Chicago*
Chicago: The Arts Club of Chicago, November 2-25, 1938.

Cleveland 1938
Twenty Oils by Matisse
Cleveland: Cleveland Museum of Art, November 10-December 18,
1938.

Reviews: Francis, H. S. "Twenty Oils by Henri Matisse." *Cleveland
Mus. Bull.* 25 (December 1938): 178.

London 1938

Bonnard, Braque, Henri-Matisse, Picasso, Rouault
London: Rosenberg and Helft, Ltd., March 16-April 14, 1938. (Three 1937 paintings by Matisse.)
Catalogue with check-list of works; no text.

Review: "Recent Works at Rosenberg and Helft's." *Apollo* 26 (August 1937): 109.

New York 1938

Henri Matisse, Paintings and Drawings of 1918 to 1938
New York: Pierre Matisse Gallery, November 15-December 10, 1938. (Nine drawings.)
Catalogue with checklist, no text or illustrations.

Review: "Exhibition, Pierre Matisse Gallery." *Art Digest* 1 (December 1, 1938): 9; Davidson, M. "Recent Matisse Anthology at the Pierre Matisse Gallery." *Art News* 37 (November 19, 1938): 12+; Sweeney, James J. "Exhibition at the Pierre Matisse Galleries." *Parnassus* 10 (December 1938): 14.

Important Works by French Masters of the XX Century
New York: Bignou Gallery, Autumn 1938

Oslo 1938

Matisse, Picasso, Braque, Laurens
Oslo: Kunstnernes Hus, January 10-February 2, 1938; traveled to Copenhagen: Statens Museum for Kunst; Stockholm: Liljevach Konsthall. (Thirty-one paintings from 1896 to 1937.)
Catalogue with preface by Walther Halvorson, no. 549; essay on Matisse by Leo Swane.

Reviews: Blomberg, Erik. "Matisse med anledning av den stora skandinaviska utställningen." *Konstrevy* (1938): 2+; Halvorsen, Walther. "Exposition Braque, Laurens, Matisse, Picasso à Oslo, Stockholm, Copenhague." *Cahiers d'art* 12, 6-7 (1937): 218-30; excerpts from Halvorsen's catalogue preface; "Henri Matisse." *Tidskrift for Kunst-industry* 11 (October 1938): 182, no. 549; Matisse-Duthuit, Marguerite. "The School of Paris at Oslo." *XXe Siècle* 4 (Christmas 1938): no page numbers.

Paris 1938
Exposition Henri-Matisse
Paris: Paul Rosenberg, October 24-November 12, 1938.
Invitation-catalogue with checklist of thirty works.

Review: "Exposition, Galerie Paul Rosenberg." *Renaissance* 21 (January 1939): 44, [four reproductions] *Cahiers d'art* 14, 1-4 (1938): 76-78.

Toledo 1938
Influences in Development of Contemporary Painting
Toledo, Ohio: Toledo Mueum of Art, November 5-December 11, 1938.

Amsterdam 1939
Parijsche Schilders
Amsterdam: Stedelijk Museum, February 25-April 10, 1939.

Boston 1939
The Sources of Modern Painting
Boston: Museum of Fine Arts, March 2-April 9, 1939.

Buenos Aires 1939
Pintura Francesa
Buenos Aires, 1939; Montevideo and Rio de Janeiro, 1940.

Review: Huyghe, René et Michel Faré. "L'Exposition de peinture françaises au XIXe et au XXe siècle au Musée Nationale de Buenos Ayres." *Promethée* (1939), special number: 1-60; 68 illus.; Huyghe René. "L'Exposition d'art français organisée à Buenos Aires." *Beaux-arts* (1939) 344: 3, and 347: 1, [5 illus].

Chicago 1939
Exhibition of Paintings by Henri Matisse
Chicago: The Arts Club of Chicago, March 13-April 18, 1939.

London 1939
Modern Paintings and Drawings, the Property of Walter Taylor, Esq.
London: Christie's, March 3, 1939. (Exhibition and sale.)

Lucerne 1939

Gemälde und Plastiken Moderner Meister aus Deutschen Museen
Lucerne: Galerie Fischer, 1939.
Catalogue of modern works confiscated by the Nazis and sold at
international auction in June 1939.

Melbourne 1939
Melbourne Herald Exhibition
Melbourne, October 1939.

Moscow 1939
French Landscape, 19th and 20th Centuries
Moscow: Museum of Western Art, 1939.
Catalogue.

New York 1939
Art in Our Time
New York: The Museum of Modern Art, 1939.

Twentieth Century French Painters and Picasso
New York: Bignou Gallery, April 17-May 13, 1939.

Copenhagen 1940
Moderne Franske Illustrerede Böger, Kobberstiksamlingen
Copenhagen: Kongelige Kobberstiksamling, Statens Museum for
Kunst, 1940.

Review: Rubow, Jorn. Review. *Kunstmuseets Aarsskrifs* (1940): 102-
129.

London 1940
The Montague Shearman Collection
London: The Redfern Gallery, April-May 1940.

*The Eumorfopoulos and Harcourt Johnstone Collections, Catalogue of
Old and Modern Oils Paintings, etc.*
London: Sotheby's, June 10-12, 1940. (Exhibition and Sale of the
collection.)

New York 1940

Landmarks in Modern Art
New York: Pierre Matisse Gallery, December 30, 1940-January 25, 1941.

Paris 1940
La Guerre de 1914-1918 par quelques artistes: Segonzac, Moreau, Forain, La Fresnaye, Naudin, George-Victor Hugo
Paris: Musée des Art Décoratif, 1940.

San Francisco 1940
Golden Gate International Exposition
San Francisco: May-September 1940.

The Painting of France since the French Revolution
San Francisco: M. H. de Young Memorial Museum, December 1940-January 1941.

Baltimore 1941
A Century of Baltimore Collecting
Baltimore: Baltimore Museum of Art, 1941.

Chicago 1941
Masterpieces of French Art, Lent by the Museums and Collectors of France
Chicago: The Art Institute of Chicago, April 10-May 20, 1941.

Los Angeles 1941
From Cézanne to Picasso
Los Angeles: Los Angeles County Museum of Art, January 15-March 2, 1941.

New York 1941
Masterpieces of Modern Painting and Sculpture
New York: Pierre Matisse Gallery, January 5-30, 1941.

Drawings by Matisse. Small Pictures by French Painters
New York: Pierre Matisse Gallery, April 15-May 3, 1941. (Twelve drawings.)

Les Fauves
New York: Marie Harrimann Gallery, October 20-November 22, 1941.
Catalogue with preface by R. Lebel; six works by Matisse.

Review: "Fauves reunited in a provocative New York Exhibit." *Art Digest* 16 (November 1, 1941): 9.

Paris 1941
Henri Matisse. Dessins à l'encre de chine, fusains (oeuvres récents)
Paris: Galerie Louis Carré, November 10-30, 1941. (At least thirty-three drawings.)
Small four-page invitation-catalogue with reproductions of works from the show; unsigned three-page introduction; no list of works.

The occasion for edition of a luxury volume of 30 reproductions published by the gallery: *Dessins par Matisse*; statements by Matisse, five hundred exemplars.

Review: Bazaine, J. "Dessins de Matisse et Duby." *Nouvelle rev. française*, February 1942.

Portland 1941
Masterpieces of French Painting
Portland, Oregon: The Portland Museum of Art, 1941.

Washington 1941
The Functions of Color in Painting
Washington, D.C.: Phillips Memorial Gallery, February 16-March 23, 1941.

Baltimore 1942
Prints and Drawings by Matisse and Picasso from the Cone Collection
Baltimore: Baltimore Museum Print Alcoves, January 12-February 8, 1942.

Review: "Prints and Drawings by Matisse and Picasso." *Baltimore Mus. News* 4 (January 1942): 8.

Eighteen Bronzes from the Cone Collection
Baltimore: Members' Room for Modern Art, October 13-November 20,

1942.
Selected maquettes from *Poésies de Stéphane Mallarmé* also shown.

Review: "Sculpture by a Painter's Hand." *Baltimore Mus. News* 5
(November 1942): 8.

London 1942
The Tate Gallery's Wartime Acquisitions
London: National Gallery, April-May, 1942.

Lyon 1942
Dessins français contemporains
Lyon: Jeune France, January 1942.

New York 1942
Figure Pieces in Modern Painting
New York: Pierre Matisse Gallery, January 20-February 14, 1942.

Paris 1942
Les Fauves, Peintures de 1903 à 1908
Paris: Galerie de France, June 13-July 11, 1942.

Inauguration provisoire du Musée National d'Art Moderne
Paris: Musée National d'Art Moderne, August 7, 1942.

Group show
Paris: Beaux-Arts, August 20, 1942.

Saratoga Springs 1942
Exhibition of Modern French Painting
Saratoga Springs: Skidmore College, February 8-25, 1942.

Cannes 1943
Matisse, Bonnard, Picabia
Cannes: Galerie Serguy, April 10-30, 1943.

Chicago 1943
Twentieth Century French Paintings from the Chester Dale Collection
Chicago: The Art Insittute of Chicago, 1943.

Glasgow 1943
Spirit of France
Glasgow: Glasgow Art Gallery and Museum, 1943.

New York 1943
Ancient Chinese and Modern European Paintings
New York: Bignou Gallery, May-June 1943.

Henri Matisse, Retrospective Exhibition of Paintings, 1898-1939
New York York: Pierre Matisse Gallery, February 9-27, 1943.

Reviews: "Exhibition Pierre Matisse Galleries." *Art News* 42 (February 15, 1943): 23; "His Son Presents 41 Years of Henri Matisse." *Art Digest* 17 (February 15, 1943): 10.

Paris 1943
Salon d'Automne
Paris: Palais des Beaux-Arts de la Ville de Paris, September 25-October 31, 1943. (Exhibits four works.)

Albany 1944
Beauty and Is It Art?
Albany, New York: Albany Institute of History and Art, November 1-30, 1944.

Buffalo 1944-45
French Paintings of the Twentieth Century
Buffalo: Albright Art Gallery, December 1-31, 1944; Cincinnati Art Museum, January 18-February 18, 1945; Saint Louis: The City Art Museum, March 8-April 17, 1945.

Edinburgh 1944
A Century of French Art
Edinburgh: National Gallery of Scotland, 1944.

New York 1944
Modern Drawings
New York: Museum of Modern Art, February 1944. (Seventeen drawings.)

Color and Space in Modern Art since 1900
New York: Mortimer Brandt, February 19-March 18, 1944.

Manet to Picasso, Still Life
New York: Durand-Ruel Galleries, March 8-31, 1944.

Notable Modern Paintings and Sculpture. . . Property of the Museum of Modern Art
New York: Parke-Bernet Galleries, May 11, 1944. (Exhibition and sale.)

Odalisques
New York: Kleemann Gallery, October 1944.

Review: "Odalisques at Kleeman Gallery." *Art Digest* 19 (October 15, 1944): 16; "Exhibition, Kleeman Galleries." *Art News* 43 (October 15, 1944): 26.

Paris 1944
Matisse, Bonnard
Paris: May 26, 1944. (Exhibition and auction.)

Exposition: Thèmes et variations (for benefit of Swiss Red Cross)
Paris: November 25-30, 1944.

Dayton 1945
The Little Show
Dayton, Ohio: Dayton Art Institute, March 2-31, 1945.

Glasgow 1945
The McInnes Collection
Glasgow: Glasgow Art Gallery and Museum, 1945.

Limoges 1945-46
Peintures du Musée National d'Art Moderne
Limoges: October-November 1945; Saint-Etienne: December 1945-January 1946; Perpignan: February 1946; Toulouse: March-April 1946; Bordeaux: May-June 1946; Amiens: July-August 1946; Lille: September-October 1946.

London 1945
Exhibition of Paintings by Picasso and Matisse
London: Victoria and Albert Museum, December, 1945; traveled in
1946 to Birmingham, Glasgow, Amsterdam, and Brussels.
Brief catalogue essays by Christian Zervos, "Picasso," and Jean Cassou,
"La Pensée de Matisse," no. 424. The essays contrast Picasso's
Spanishness, his ability to image suffering and universalize it through
personal understanding with Matisse's French clarity of thought and
lucidity of line and color. (Thirty works by Matisse shown.)

Reviews: Cooper, Douglas. "Exhibition of Paintings at Victoria and
Albert Museum." *Phoebus* 1, 1 (1946): 45-46; "Picasso-Matisse Furor
at the Victoria and Albert Museum." *Art News* 45 (March 1946): 59;
"Exhibition, Victoria and Albert Museum." *Museum Journal* 45
(February 1946): 198.

New York 1945
Eleven Nudes by XX Century Artists
New York: Pierre Matisse Gallery, April 10-28, 1945.

Henri Matisse Recent Drawings
New York: Pierre Matisse Gallery, October 30-November 17, 1945.
(Twenty-two drawings.)

Reviews: "Drawings at Matisse Gallery." *Art News* 44 (November 15,
1945): 26; "Exhibition of Drawings at Pierre Matisse Galleries." *Art
Digest* 20 (November 1, 1945): 16.

Paris 1945
Portraits français
Paris: Galerie Charpentier, 1945.

Salon d'Automne, Matisse Retrospective
Paris: Palais des Beaux-Arts de la Ville de Paris, September 28-October
29, 1945. (Thirty-seven paintings.)

Review: Parrot, Louis. "Matisse au Salon d'Automne." *Labyrinthe* 2,
13 (October 15, 1945): 1-4.

Henri Matisse, peintures--dessins--sculptures
Paris: Galerie Maeght, December 7-29, 1945. (Twenty-six drawings,

two sculptures, six paintings with photographs of paintings-in-progress.)

Nice: Palais de la Méditerranée, February 19-March 10, 1946. (Sixteen drawings removed and one painting, *Atelier de Gustave Moreau* [1897] added in Nice.)

Catalogue with checklist of works shown. The paintings were: *La France* (eight "study" photos), *La Blouse Paysanne* (thirteen photos), *Dormeuse sur la table violette* (twelve photos), *Nature Morte Coquillage* (three photos), *Nature Morte au Magnolia* (three photos), and *Jeune Fille à la pelisse.*

Stockholm 1945
Grace og Philip Sandbloms Samling
Stockholm: Stockholm Foreningen for Nutida Konst, 1945.

Baden-Baden and Berlin 1946
Moderne Französische Malerei
Baden-Baden: Kurhaus, September 1946; Berlin: Chateau Impérial, October 22-November 6, 1946; Innsbruck, 1946; Konstanz, 1946; Mainz, 1946.

Brussels 1946
Vingt-quatre oeuvres de Henri Matisse
Brussels: Palais des Beaux-Arts, May 1946.
Catalogue with preface by Jean Cassou; series: Collection des Petits Monographies d'Art Moderne, 6.

Cambridge 1946
French Painting Since 1870, Lent by Maurice Wertheim, Class of 1906
Cambridge: Fogg Art Museum, June 1-September 7, 1946.

Lille 1946
Peintures de Musée National d'Art Moderne
Lille: Galerie Michon, September-October 1946.

London 1946
Acquisitions of the CAS
London: The Tate Gallery, September-October, 1946.

New York 1946
Paintings from New York Private Collections
New York: Museum of Modern Art, Summer 1946.

Review: Frost, Rosamond. "Collectors Come out of Privacy." *Art News* 45 (July 1946): 14-20.

Six from the School of Paris [Matisse, Bonnard, Rouault, Picasso, Dubuffet, and Marchand]
New York: Pierre Matisse Galley, 1946.

Review: Louchheim, Aline B. "First from France at the Pierre Matisse Gallery." *Art News* 45 (June 1946): 17-18+; Greenberg, Clement. "Review of an Exhibition of the School of Paris." *The Nation* (June 29, 1946).

Paris 1946
Cent Chefs d'oeuvres des peintres de l'École de Paris
Paris: Galerie Charpentier, February 27-March 24, 1946.

Review: "Exposition de peinture contemporaine: Ecole de Paris." *Labyrinthe* (December 15, 1946): 5.

Les Chefs d'oeuvres des collections françaises retrouvés en Allemagne par la Commission de Récupération Artistique
Paris: Orangerie des Tuileries, June-August 1946.

Salon d'Automne
Paris: Musée des Beaux-Arts de la Ville de Paris, October 4-November 10, 1946. (Three paintings.)

Review: Parrot, Louis. "Matisse au Salon d'Automne." *Labyrinthe* 13 (October 15, 1945): 1-4, [many reproductions].

Sainte Catherine (organized by the journal *Ce Soir* for the profit of the Maison de la Midinette)
Paris: Palais de Chaillot, November 25, 1946.
Beautifully produced catalogue/book with original lithograph by Matisse ; also Laurencin, Picasso, Christian Bérard, Mourlot Frères; texts by Elsa Triolet, Aragon, Eluard.

Prague 1946
French Modern Masters
Prague, 1946.

Amsterdam 1947
Picasso in the Stedelijk Museum; Matisse in the Stedelijk Museum
Amsterdam: Stedelijk Museum de la Ville, 1947. (Twenty-four works by Picasso, eighteen by Matisse.)
Small illustrated catalogue with checklist of works and illustrations; no text.

Avignon 1947
Deuxième exposition de peintures et sculptures contemporaines
Avignon: Chapelle, Palais des Papes, June 27-Deptember 30, 1947. (Twelve works by Matisse.)

Review: La Bastie, A. "Picasso et Matisse: exposition dans la chapelle du Palais des Papes d'Avignon." *Arts* (July 11, 1947): 1; and "Avignon: l'exposition d'art contemporain du Palais des Papes." *Arts de France* 17-18 (1947): 116-18.

Bern 1947
Quelques oeuvres des collections de la Ville de Paris
Bern: Kunstmuseum Bern, March 29-April 14; La Chaux de Fonds: Musée des Beaux-Arts, April 16-24; Geneva: Musée Rath, April 26-May 4; Basel: Kunsthalle Basel, May 6-28, 1947; Zurich: Kunsthaus Zurich, June 9-August 31, 1947.

25 Jahre Kunstpflege der Stadt Bern
Bern: Kunsthalle Bern, 1947.

Freiburg im Breisgau 1947
Die Meister französischer Malerei der Gegenwart
Freiburg im Breisgau: October 20-November 23, 1947.

Liège 1947
Henri Matisse, dessins
Paris: A.P.I.A.W., 1947. (Forty-nine drawings)
Catalogue with some works illustrated; Matisse's text, "L'Exactitude n'est pas la verité" is published for the first time.

New York 1947
A 20th Century Selection, Paintings and Sculpture
New York: Bignou Gallery, March 4-29, 1947.

Ascher Squares Designed by Matisse, Moore, Derain, Sutherland,
Hutchins, Hodgkins, Laurencin, Cocteau, and others
New York: The American British Art Center, October 20-November 1,
1947.
First showing of Ascher Squares.

Review: Lassaigne, J. "État de la tapisserie." *Panorama des Arts* 1947,
250-51. Paris: Somogy, 1948.

Paris 1947
Beautés de Provence
Paris: Galerie Charpentier, 1947.

L'Influence de Cézanne, oeuvres de 1903 à 1914
Paris: Galerie de France, January 14-February 15, 1947.

Inaugural Exhibition, Musée d'Art Moderne
Paris: Musée d'Art Moderne, June 1947.

Review: Lassaigne, Jacques. "Le Musée d'Art Moderne." *Panorama*
des Arts 1947. Paris: Somogy, 1948.

Salon d'Automne
Paris: October-November, 1947. (Four recent paintings by Matisse.)

Review: Cassou, Jean. "Matisse at the Salon." *Art News* 46
(November 1947): 50.

Jazz, Tériade édition
Paris: Librairie Pierre Berès, December 3-20, 1947.
Twenty stencil-printed plates based on original cut-outs.

Review: Lassaigne, Jacques. "Matisse." *Panorama des Arts 1947*, 17-
18. Paris: Somogy, 1948.

Philadelphia 1947
Masterpieces of Philadelphia Private Collections
Philadelphia: Philadelphia Museum of Art, 1947.

Rio de Janeiro 1947
Exposicao do novo libro de Henri Matisse, Jazz, editado per Tériade
Rio de Janeiro: Galerie Europa, Arte Antiga e Moderna Ltd., December
3-20, 1947.

Saint Louis 1947
A Saint Louis Private Collection [Joseph Pulitzer, Jr.]
Saint Louis: City Museum of Art, Summer-Autumn 1947.

Vienna 1947
Meister der Modernen Französischen Malerei
Vienna: Kunstgewerbemuseum, 1947.

Amherst 1948
An Exhibition at Amherst College
Amherst: May 16-29, 1948.

Avignon 1948
Troisième exposition - Murales
Avignon: Palais des Papes, 1948.
Matisse's Petit Palais *Dance* mural shown for the first time since
purchased.

London 1948
Ascher Panels Designed by Henri Matisse-Henry Moore
London: Lefebvre Galery, Fall 1948.
First showing of *Océania, le ciel; Océania, la mer.*

Louisville 1948
Matisse Drawings
Louisville: J.B. Speed Art Museum, June 10-30; also shown in Beverly
Hills: Modern Institute of Arts, July 15-August 5, 1948; San Francisco
Museum of Art, August 12-September 2, 1948; Minneapolis,
September 15-October 6, 1948; Washington, D. C.: Philips Gallery,
October 17- November 7, 1948; Chicago: Art Institute of Chicago,
November 21-December 12, 1948; Cincinnati: Modern Art Society,
December 20-1948-January 10, 1949; Baltimore, January 23-February
13, 1949; Dayton, February 25-March 18, 1949; Cleveland, March 29-
April 24, 1949; and Cambridge, Mass., May 10-31, 1949. (Sixty

drawings selected from the Philadelphia show by American Federation
of Arts for traveling.)

New York 1948
Henri Matisse, Three Decades, 1900-1930
New York: Bignou Gallery, January 27-February 28, 1948.

Reviews: "Exhibition Bignou." *Art News* 46 (February 1948): 42;
"Exhibition Bignou," *Art Digest* 22 (February 15, 1948); Greenberg,
Clement. "Henri Matisse, Eugène Boudin, John Piper, Misha
Reznikoff." *The Nation* (February 21, 1948).

Henri Matisse-Jazz, Tériade editor
New York: Pierre Berès, January 20-February 3, 1948.

A Selection of Paintings from the Durand-Ruel Galleries (no.2)
New York: Durand-Ruel Galleries, 1948.

A Selection of Paintings from the Durand-Ruel Galleries (no.3)
New York: Durand-Ruel Galleries, 1948.

Henri Matisse, Jazz, Gift of the Artist
New York: Museum of Modern Art, October 1-31, 1948.

Paris 1948
La Femme 1800-1930
Paris: Galerie Bernheim-Jeune, April-June, 1948.

*Livres illustrés français publiés par les Éditions George Macy, New
York*
Paris: Bibliothèque Nationale, April 10-May 8, 1948.

Dance et divertissements
Paris: Galerie Charpentier, December 1 948-January 1949.
Matisse's *Deux femmes assises avec un violin* shown.

Philadelphia 1948
*Henri Matisse, Retrospective Exhibition of Paintings, Drawings, and
Sculpture Organized in Collaboration with the Artist*
Philadelphia: Philadelphia Museum of Art, April 3-May 9, 1948.

(Ninety-three paintings, nineteen sculptures, eighty-six drawings, prints, and illustrated books.)
Catalogue with foreword by Henry Clifford, curator, and essay by Louis Aragon, "Henri Matisse or the French Painter" no. 364; Matisse's "Letter to Henry Clifford;" and "Exactitude Is Not the Truth" are published.

Review: Caspers, F. "Philadelphia Honors Matisse with Impressive Retrospective." *Art Digest* 22 (April 15, 1948): 9+; Fremantle, C. E. "Matisse in Philadelphia." *Studio* 136 (September 1948): 94-95; Kimball. F. "Matisse: Recognition, Patronage, Collecting." *Philadelphia Mus. Bull* 43 (March 1948): 33-47; "M. Clifford, Conservateur du Musée de Philadelphie prépare une Rétrospective Matisse." *Arts* (January 24, 1947): 3; "Matisse Retrospective." *Baltimore Mus. News* 11 (May 1948): 2-4; "Matisse Show at Philadelphia Museum Delayed." *Art Digest* 21 (March 15, 1947): 12. See *Articles* under their respective names, the writers who responded to the show in the special issue of *Art News* 47 (April 1948): 16-54; namely Thomas Hess, no. 557, Alfred M. Frankfurter, no. 514, and Fiske Kimball, no. 1338.

Arles 1949
Dessins et aquarelles du XXième siècle
Arles: Musée Aéattu, April 15-August 31, 1949.

Avignon 1949
Quatrième exposition - Murals
Avignon: Chapel, Palais des Papes, Summer through October 1949.

Review: Watt, Alexander. "Paris Commentary." *Studio* 138 (October 1949): 125-27, no. 760.

Baltimore 1949
Selections from the Cone Collection
Baltimore: Baltimore Museum of Art, October 1949
Thirty-two page catalogue with illustrations; special number of *Baltimore Mus. News* 13, 1 (October 1949): 1-32. Texts by d'Arcy Paul, George Boas, Adelyn D. Breeskin.

Cambridge 1949

Paintings from the Spaulding Collection
Cambridge: Fogg Art Museum, February 1-September 15, 1949.

Chicago 1949
20th Century Art from the Louise and Walter Arensberg Collection
Chicago: Art Institute of Chicago, October 20-December 18, 1949.

Dayton 1949
An Exhibition of Works by Matisse
Dayton, Ohio: Dayton Art Institute, February 24-March 16, 1949.

Detroit 1949
Masterpieces of Paintings from Detroit Private Collections
Detroit: The Detroit Institute of Arts, April 23-May 22, 1949.

Lucerne 1949
Henri Matisse Retrospective 1890-1946; Zehn Jahrhunderte
französischer Buch-Kunst
Lucerne: Musée des Beaux-Arts, July 3-October 2, 1949. (Thirty-eight
bronzes, sixty drawings.)
Catalogue introduction by Jean Cassou, essay by Hanspeter Landolt,
no. 591. Twenty-four of the 308 works in the exhibit illustrated; no
color.

Review: "Ausstellung, Kunstmuseum, Luzern." *Werk* 36 (September
1949): supp. 125.

Montreal 1949
Manet to Matisse
Montreal: The Montreal Museum of Fine Arts, May 27-June 26, 1949.

New York 1949
Henri Matisse, Paintings, Papiers Découpés, Drawings, 1946-1948
New York: Pierre Matisse Gallery, February 1949. (Ten cut-outs; first
public showing of paper cut-outs.)

Reviews: "Exhibition, Pierre Matisse Gallery." *Art News* 47 (February
1949): 44-45; "Exhibition of Paintings and Drawings at Pierre Matisse
Gallery." *Art Digest* 23 (February 15, 1949): 14; Greenberg, C.

"Review of an Exhibition of Henri Matisse." *The Nation* (March 5, 1949).

Léger, Matisse, Miro, Moore: Paintings and Sculpture, Recent Lithographs of Matisse
New York: Buchholz Gallery, May 4-28, 1949.

Review: Reed, Judith K. "Modern Decoration: Ascher Panels and Bronzes at Buchholz Gallery," *Art Digest* 23, 16 (May 15, 1949): 9.

Braque, Matisse and Picasso
New York: Hugo Gallery, May 16-31, 1949.

Review: "Exhibition of Works Seen in America for the First Time, Hugo." *Art News* 48 (May 1949): 46; "Big Three Duplicate: Braque, Matisse and Picasso Exhibitions at Rosenberg and Hugo Galleries." *Art Digest* 24 (November 1, 1949): 9.

The French Art of the Book
New York: Cultural Division of the French Embassy, May 11-June 5, 1945. Traveled to Hamburg, June 3-16, 1949; Frankfurt am Main, September 1949; and Le Mans: Les Amis de l'Art, 1949.

Braque, Matisse and Picasso
New York: Paul Rosenberg, October-November 1949.

Reviews: "Big Three Duplicate: Braque, Matisse and Picasso Exhibitions at Rosenberg and Hugo Galleries." *Art Digest* 24 (November 1, 1949): 9; "Braque, Matisse, and Picasso; Joint Exhibitions at Rosenberg Gallery." *Art News* 48 (November 1949): 51.

Osaka 1949
Exhibition of Western Paintings
Osaka: Osaka Municipal Museum of Art, 1949.

Ottawa 1949
Forty-One Paintings from the Montreal Museum of Fine Arts Collection
Ottawa: National Gallery of Canada, October 7-November 12, 1949.

Paris 1949
Henri Matisse, oeuvres récentes, 1947-1948.
Paris: Musée National d'Art Moderne, June-September 1949.
(Thirteen oils, twenty-two brush drawings, twenty-one decoupages, two
printed fabrics, two tapestries, two illustrated books.) First showing of
découpages and *Oceania* panels in France, and first of *Polynesia*
tapestries anywhere.
Catalogue with preface by Jean Cassou, checklist of the works, black
and white reproductions, extracts from *Jazz,* "Letter to Henry Clifford"
by Matisse; pochoir cover in color of cut-paper designs.

Review: "Ausstellung, Musée d'Art Moderne, Paris." *Werk* 36
(August 1949): 12-13; "Exhibition of Work, 1947-1948." *Studio* 138
(October 1949): 125-27; "Latest Works at the Musée d'Art Moderne,
Paris." *Art News* 48 (June 1949): 19; "Les Oeuvres récentes,
Exposition du Musée d'Art Moderne." *Art & Décoration* 3 (1949): 55;
Watt, Alexander. "Paris Commentary." *Studio* 138 (October 1949):
125-27; Zervos, C. "A Propos de l'exposition Matisse au Musée d'Art
Moderne de Paris." *Cahiers d'art* 24 (1949): 159-70.

Pasadena 1949
French Painters' Show
Pasadena: Pasadena Art Institute, Autumn, 1949.

Rio de Janeiro 1949-50
Exposicion de Pintura Francesa Contemporanea
Rio de Janeiro: October 1949; Caracas: January 1950; Santiago: Museo
Nacional de Bellas Artes, May 1950.

Winterthur 1949
Winterthurer Privatbesitz II
Winterthur: Kunstmuseum, August 28-November 28, 1949.

Baltimore 1950
Cone Memorial Exhibition
Baltimore: Baltimore Museum of Art, January 13-March 5, 1950.

Bern 1950

Die Fauves und die Zeitgenossen
Bern: Kunsthalle, April 29-May 29, 1950.
Catalogue with preface by A. Rudlinger.

Geneva 1950
Henri Matisse: eaux-forts
Geneva: Athénée, 1950.

Review: *Werk* 37, Supp. 91 (July 1950).

Milan 1950
Mostra di Matisse
Milan: Commune di Milano, November 1-21, 1950. (Thirty-four paintings, eight lithographs.)
Small catalogue with introduction by Raymond Cogniat.

New York 1950
A Collector's Exhibition
New York: M. Knoedler and Co., February 6-25, 1950.

An Exhibition of Paintings
New York: Metropolitan Museum of Art, 1950.

Nice 1950
Matisse à Nice, peintures, dessins, sculptures, tapisseries
Nice: Galerie des Ponchettes, January 26-March 19, 1950. (Thirty-eight paintings, twenty-three drawings, five sculptures, two tapestries.)
Catalogue with texts by Georges Salles ("Matisse à Nice") and J. Cassarini.

Paris 1950
Salon de Mai
Paris: May 9-31, 1950.
Papier découpé *Zulma* exhibited.

Henri Matisse, chapelle, peintures, dessins, sculptures
Paris: Maison de la Pensée Française, July 5-September 24, 1950. (Fifty-one bronzes, thirty-two drawings; one hundred fifteen works in all.)

Catalogue with introduction by Louis Aragon, "Au Jardin de Matisse,"
no. 365; cover by Matisse.

Reviews: "Exposition à la Maison de la Pensée Française." *Cahiers d'art*
25, 2 (1950): 387-88; La Côte, René. "Henri Matisse, La Maison de la
Pensée Française." *Arts de France* 31 (October 1950): 46-48.

Salon des Tuileries
Paris: October 1950.
Matisse's *Deux femmes assises avec un violin* shown.

Philadelphia 1950
S. White, 3rd, Collection
Philadelphia: Philadelphia Museum of Art, 1950.

Diamond Jubilee Exhibition, Masterpieces of Painting
Philadelphia: Philadelphia Museum of Art, November 4, 1950-February
11, 1951.

Pomona 1950
Masters of Art from 1790-1950
Pomona: Los Angeles County Fair, September 15-October 1, 1950.

Venice 1950
XXV Biennale di Venezia
Venice, June 8-October 15, 1950.
Matisse in Fauve Salon (thirty-two works), in French Salon (thirty-
nine works). He receives highest award of the Biennale.
Catalogue with intro. by Raymond Cogniat; preface by Roberto
Longhi, no. 1249.

Review: Dorival, Bernard. "Bonnard, Matisse, Utrillo." *La Biennale
di Venezia* 1 (July 1950): 18-21; Sutton, Denys. "Aspects of the
Venice Bienale, the Fauves." *Burlington Mag.* (September 1950): 263-
65, no. 1267.

Birmingham (N.Y.) 1951
Inaugural Exhibition
Birmingham, N.Y.: Birmingham Museum of Art, 1951.

Chapel Hill 1951
XXth Century Paintings
Chapel Hill: Person Hall Art Gallery, Univ. of North Carolina, 1951.

Cincinnati 1951
History of an American, Alfred Stieglitz, 291 and After
Cincinnati: The Taft Museum, January 31-March 18, 1951.

Hamburg 1951
Henri Matisse, Gemälde, Skulpturen, Handzeichnungen, Graphik
Hamburg: Kunsthalle, to February 1951; traveled to Düsseldorf, April 14-May 6, 1951; Munich.

Review: Rannit, Aleksis. "Ausstellung Henri Matisse, 1951." *Kunstwerk* 5, 1 (1951): 53.

London 1951
L'École de Paris 1900-1950
London: Royal Academy of Arts, 1951.

Marseilles 1951
Henri Matisse
Marseilles: Galerie Mouillot, December 7-29, 1951. (Twenty-eight drawings.)
Small, eight-page catalogue with checklist and some high-quality plates.

New Haven 1951
Pictures for a Picture of Gertrude Stein as a Collector and Writer on Art and Artists
New Haven: Yale University Art Gallery, February 11-March 11, 1951; travels to Baltimore: Baltimore Museum of Art, 1951

New York 1951
Impressionist and Post-Impressionist Paintings (mostly from the Albert D. Lasker collection)
New York: Knoedler Galleries, January 8-28, 1951. (Sponsored by Elizabeth Arden for New York Heart Association.)

Note: "Collectors Lend for Benefit." *Art Digest* 25, 7 (January 1, 1951): 1.

New York Private Collections
New York: Museum of Modern Art, June 26-September 12, 1951.

Sculpture by Painters
New York: Curt Valentin Gallery, November 20-December 15, 1951.
(Twelve sculptures by Matisse.)

The Lewisohn Collection
New York: Metropolitan Museum of Art, November 2-December 2, 1951.

Duchamp to Brancusi
New York: Sidney Janis Gallery, 1951.

Henri Matisse Retrospective
New York: Museum of Modern Art, November 13, 1951-January 13, 1952; Cleveland Museum of Art, February 5-March 16, 1952; Art Institute of Chicago, April 1-May 4, 1952; San Francisco Museum of Art, May 22-July 6, 1952 (with supplementary works); Los Angeles and Portland (partial shows). (Seventy-four paintings, thirty-two sculptures, twenty-seven drawings, watercolors and prints, and studies for the Vence chapel, six chasuble designs (nine cut-outs in all), and a version of the altar crucifix in bronze.)
Catalogue with a Matisse chronology. Alfred H. Barr, Jr.'s book *Henri Matisse, His Art and His Public* publication coincides with the exhibition.

Reviews: "Henri Matisse: a Small Chapel in France and a Monumental Art Exhibition at Museum of Modern Art." *Life* (November 26, 1951): 108-16; Fitzsimmons, J. "Henri Matisse: the Conflict and Resolution of Opposed Tendencies, Exhibition at Museum of Modern Art." *Art Digest* 26 (December 1, 1951): 9; "Matisse at His Best; Exhibition at the Museum of Modern Art." *Art News* 50 (December 1951): 40-41+; Soby, James T. "Matisse Reconsidered." *Saturday Review* 35 (January 5, 1952): 34-35; "Retrospective at Museum of Modern Art." *Art News* 50 (November 1951): 46; Thau, Eugène-Victor. "L'Art d'Henri Matisse devant la critique Américaine." *Beaux-arts* (Bruxelles) 551 (December

14, 1951): 4. (Chicago showing) Sweet, F. A. "Henri Matisse, Exhibition at the Institute." *Chicago Art Inst .Quart.* 46 (April 1952): 30-35. (San Francisco showing) "Exhibition at the San Francisco Museum of Art." *Art News* 51 (June 1952): 92; Ballard, L. "Matisse Show at the San Francisco Museum." *Arts & Arch.* 69 (July 1952): 7-9; Morley, Grace L. McCann. "The Matisse Exhibition and Works by Henri Matisse in the San Francisco Region." *San Francisco Mus. Quart.* 2nd ser. 1-2 (1952): 13-20.

Paris 1951
Salon des Artistes témoins de leur temps
Paris: Musée d'Art Moderne de la Ville de Paris, February 2-March 4, 1951.

Oeuvres choisies du XXe siècle
Paris: Max Kaganovitch, May 25-July 20, 1951.

Le Fauvisme
Paris: Musée National d'Art Moderne, June-September, 1951
Catalogue by G. Vienne, with preface by Jean Cassou.

Jubilé, École des Arts Décoratifs
Paris: Pavillon de Marsan, October 19-November 18, 1951.

Sur Quatre Murs
Paris: Galerie Maeght, 1951.

Stockholm 1951-52
Henri Matisse, Thèmes et variations, Le Rêve, La Chapelle
Stockholm: Konstsalongen Samlaren, December 31, 1951-January 31, 1952. (Thirty-two drawings.)
Catalogue with cut-out of *Boxeur nègre* on the cover.

Strasbourg 1951
Dessins français
Strasbourg, April 1951.

Tokyo 1951

Rétrospective Henri Matisse
Tokyo: National Museum, March 3-June 6, 1951; traveled to Kyoto
and Osaka: Municipal Museum.
Complemented by the album, *Henri Matisse*. Tokyo: Le Journal
Yomiuri, 1951. This catalogue has a preface ("Le Texte") by Henri
Matisse in French and Japanese and another essay in Japanese by
Asano. Cover in color designed by Matisse, three illustrations in color,
twenty-one black and white; carefully, if modestly, produced.

Albi 1952
De Toulouse-Lautrec à Picasso
Albi: Palais de la Berbie, July 5-September 30, 1952.

Amsterdam 1952
*Honderd Meesterwerken, uit het National Museum voor Moderne Kunst
de Parijs/100 Chefs-d'oeuvre de Musée Nationale d'Art Moderne de
Paris*
Amsterdam: Stedelijk Museum, February 25-April 10, 1952;
Rotterdam: Museum Boymans van Beuningen, April 18-May 26, 1952;
Brussels: Palais du Beaux-Arts, May 31-July 14, 1952.

Baltimore 1952
Matisse Drawings (known only through article below)
Baltimore: Baltimore Museum of Art, 1952.

Review: "Accolade to Henri Matisse." *Baltimore Mus.News* 15 (June
1952): 1-3. "The large collection of over fifty of his drawings which
were on view last month"

Berlin 1952
Werke französischen Meister der Gegenwart
Berlin: Hochschule für Bildende Künste, September 11-October 12,
1952.

Beverly Hills 1952
*Henri Matisse, Loan Exhibition from Southern California Museums
and Collectors*
Beverly Hills, Cal.: Frank Perls Gallery, May 22-June 30, 1952.

Review: "Exhibition, Perls Gallery, Los Angeles." *Art News* 51 (June 1952): 87.

Dallas 1952
Some Businessmen Collect Contemporary Art
Dallas: Dallas Museum of Art, April 6-28, 1952.

East Hampton 1952
19th Century Influences in French Painting
East Hampton: Guild Hall, August 14-September 8, 1952.

Geneva 1952
Livres illustrés, estampes, sculptures
Geneva: Gérald Cramer, November 1952.

Knokke-Le Zoute 1952
Matisse
Knokke-Le Zoute: /Albert Plage, Grande Salle des expositions de la réserve, July 12-August 31, 1952. (Thirty paintings, ten sculptures, seven drawings, five prints, two printed fabrics.)
Catalogue with preface by George Duthuit, no. 482; rich in black and white reproductions of early works, three-color cover of a *Masque* by Matisse.

Los Angeles 1952
Henri Matisse, Selection from the Museum of Modern Art Retrospective
Los Angeles: Municipal Department of Art, July 21-August 17, 1952; Portland, Oregon: Portland Art Museum.

Review: Millier, A. "Exhibition to be Held in Los Angeles." *Art Digest* 26 (August 1952): 14; "Matisse Exhibition." *Portland Mus. Bull.* 14 (September 1952):1.

New York 1952
19th and 20th Century French Paintings
New York: Paul Rosenberg and Co., April, 1952.

Les Fauves
New York: Museum of Modern Art, October 8, 1952-January 4, 1953;

travels in 1953; Minneapolis: Minneapolis Institute of Arts, January
21-February 22,1953; San Francisco: San Francisco Museum of Art,
March 13-April 12, 1953; Toronto: Art Gallery of Toronto, May 1-31,
1953.
Catalogue with text by Andrew Carduff Ritchie; show organized by
John Rewald, wrote the major catalogue essay, no. 1260.

Reviews: Dorival, Bernard. "Fauves; the Wild Beasts Tamed."*Art News
Annual* 22 (1952): 98-129, no. 1212; Flanner, Janet. "King of the Wild
Beasts." *New Yorker* 27 (December 22 and 29, 1951): 30-32+ and 26-
28+, no. 508 ; Myers, Bernard. "Matisse and the Fauves." *American
Artist* 15 (December 1951): 70-72+, no. 1252.

Ostende 1952
La Femme dans l'art français
Ostende: Kursaal, July 12-August 31, 1952.

Paris 1952
Peintres de portraits
Paris: Bernheim-Jeune, 1952.

*La Civilization du livre, les richeses de la librairie française des origines
à nos jours*
Paris: Gelerie Royale, March 14-April 15, 1952.

Dessins récents de Henri Matisse
Paris: Galerie Maeght, May, 1952. (Sixty-two drawings.)

Reviews: "Dessins récents dans l'exposition à la Galerie Maeght; douze
illustrations." *Cahiers d'art* 27, 1 (1952): 55-66.

Salon de Mai
Paris: Palais de New York, May 9-29, 1952.

Henri Matisse, gravures récentes, dessins
Paris: Galerie Berggruen, June 19-July 12, 1952.
Small elegant catalogue with all thirty works--lithographs, etchings,
lino cuts, and aquatints--illustrated; two-color lithographed cover.

Symbolistes, Divisionnistes, Fauves; hommage à Gustave Moreau
Paris: Galerie Nina Dausset, November 7-29, 1952.

Cinquante ans de peinture française dans les collections particulières de Cézanne à Matisse
Paris: Musée des Arts Décoratifs, 1952.

Affiches d'expositions réalisés depuis vingt-cinq ans par l'Imprimerie Mourlot et présentées à l'occasion de son centenaire
Paris: Galerie Kléber, December 5, 1952-January 1953.

Rabat 1952
Salon d'art français au Maroc
Rabat: February 25-April 5, 1952; traveled to Casablanca.

Raleigh 1952
Matisse, lithographs, etchings, bronzes
Raleigh, North Carolina: Raleigh State Art Gallery, February 10-March 2, 1952

Rennes 1952
Le Fauvisme
Rennes: Musée des Beaux-Arts, April-May 1952.

Stockholm 1952
Henri Matisse
Stockholm: Galerie Blanche, September-October, 1952.
Small invitation-catalogue with checklist of works, all prints; self-portrait of Matisse on cover.

Toulon 1952
Chefs-d'oeuvre des illustrateurs français contemporains
Toulohn: Salle des Expositions du Musée-Bibliothèque, November 2-23, 1952.

Washington 1952-53
Twentieth Century French Paintings from the Chester Dale Collection
Washington: National Gallery of Art, November 22, 1952-December, 1953.

Annecy 1953-54
De Bonnard à Picasso
Annecy: August 1-September 1, 1953; traveled to Mâcon, September 5-
October 5; Valence, October 11-November 11; Marseille, November
15-December 15; Cannes, December 20, 1953-January 31, 1954;
Nîmes, February 6-25; Sète, March 7-27; Montauban, March 31-April
28; Limoges, April 30-May 30; Orléans, June 2-25; Bourges, June 27-
July 29; Blois, July 20-August 15; Boulogne, August 22-September
20; Rabat, November 4-13; Casablanca, November 21-30, 1954.

Basel 1953
Tableaux français: Bonnard, Degas, Gauguin, Matisse, Monet, Picasso,
Redon, Soutine, Utrillo, Vlaminck, and others.
Basel: Galerie Chateau d'Art, E. Beyeler, March 10-April 30, 1953.
Small catalogue with documentation, black and white illustrations.

Bern 1953
Europäische Kunst aus Berner Privatbesitz
Bern: Kunsthalle Bern, July 31-September 20, 1953.

Biel 1953-54
Meisterwerke des 19. und 20. Jahrhunderts
Biel: Stadtische Galerie Biel, 1953-54.

Brussels 1953
La Femme dans l'art français
Brussels, March 15-June 1, 1953

Copenhagen 1953
Henri Matisse: Sculpturer, Malerier, Farveklip
Copenhagen: Ny Carlsberg Glyptotek, November 6-December 6, 1953;
travels to Oslo: Kunsternes Hus, February 20-March 7, 1954;
Rotterdam: Museum Boymans van Beuningen, April 16-June 8,1954;
Ottawa: National Gallery of Canada, 1954; and Houston: Museum of
Fine Arts, September 18-October 16, 1955. (Includes forty-five
sculptures, one hundred twenty-two drawings.)
Slim catalogue with checklist of works; preface by Haarvard Rostrup
and brief introduction by Jean Cassou. Common format but slight
differences in catalogues at each venue. *Still Life with Shell* (1940)

shown with eleven studies and two in-progress photos; *The Dream* with seven studies and thirteen photos, *Red Still Life with Magnolia* with sixty-eight studies and five photos.

Denver 1953
Origins and Trends of Contemporary Art
Denver: Denver Art Museum, January 11-February 15, 1953.

Fontainbleau 1953
Le Livre illustré en France au XXe siècle
Fontainbleau: Musée Nationale, June 20-July 31, 1953.

London 1953
An Exhibition of the Sculpture of Matisse and 3 Paintings with Studies
London: Tate Gallery, January 9-February 22, 1953. (Forty-eight bronzes.)
Catalogue with preface by Philip James and introduction by Jean Cassou, no. 186.

Reviews: "Exhibition of Sculpture and Drawings at the Tate." *Apollo* 57 (February, 1953): 35; "Exhibition of Sculpture at the Tate." *Arch. Rev.* 113 (March, 1953): 204; "Exhibition of Sculpture at the Tate Gallery." *Art News* 52 (March 1953): 43+; "Matisse Sculpture at the Tate Gallery." *Studio* 145 (April 1953): 141; "Painter with a Knife: Exhibit of Sculpture at Tate gallery." *Time* 61 (January 16, 1953): 64; Sylvester, David. "The Sculpture of Matisse." *The Listener* (January 19, 1953), no. 216.

Minneapolis 1953
Klee Drawings, Matisse Bronzes
Minneapolis: Minneapolis Institute of the Arts, July 7-September 7, 1953.

Review: "Klee Drawings and Matisse Bronzes Shown at the Institute." *Minneapolis Inst. Bull.* 42 (May 30, 1953): 107.

New York 1953
The Sculpture of Henri Matisse
New York: Curt Valentin Gallery, February 10-28, 1953. (Thirty-eight sculptures, twenty-four drawings.)

Small elegant catalogue, all works reproduced, text reproduced from Barr (1951) chapters on sculpture; cover in color of drawing of 1942.

Reviews: "Matisse Bronzes at Curt Valentin Gallery." *Art News* 52 (March 1953): 40; "Matisse, sculptor; Exhibition at Valentin Gallery." *Art Digest* 27 (February 15, 1953): 16.

Collector's Choice
New York: Paul Rosenberg and Co., March 17-April 18, 1953.

Henri Matisse: lithographs, linoleum cuts, aquatints, 1925-1953
New York: Galerie Chalette, 1953.
Small catalogue with all works reproduced.

Osaka 1953
Exhibition of Western Paintings of the Ohara Collection
Osaka: Osaka Municipal Museum of Art, March 30-June 25, 1953; traveled to Tokyo and Okagama.

Palm Beach 1953
The Art of Henri Matisse
Palm Beach: Society of the Four Arts, February 6-March 1, 1953.
(Twenty-four paintings, seven drawings, fifteen prints, four sculptures.)
Small black and white catalogue with complete checklist of works and seven illustrations.

Paris 1953
Les Peintres témoins de leur temps: Le Dimanche
Paris: Musée d'Art Moderne de la Ville de Paris, January 30-March 1, 1953.

Un Siècle d'art français 1850-1950
Paris: Petit Palais, 1953.

Henri Matisse, papiers découpés
Paris: Berggruen et Cie., February 27-March 28, 1953.
Catalogue with intro. by E. Tériade; cover by Matisse. (First exhibition concerned only with cutouts.)

Review: R. W. H. "Events in Paris." *Apollo* 57 (April 1953): 114; Cassou, Jean. "Matisse va présenter au public ses papiers découpés." *France-Illus.* 383 (February 14, 1953): 234-5; Degand, Léon. "Les Papiers découpés de Matisse." *Art d'aujourd'hui* 2 (1953): 28, no. 322; San Lazzaro, G. "Découpages de Henri Matisse." *XXe Siècle* 4 (January 1954): 73, no. 350.

Salon de Mai
Paris: Palais de New York, May 1953.

Figures nues d'école français
Paris: Galerie Charpentier, 1953.

Richmond 1953
The Cone Collection
Richmond: The Virginia Museum of Fine Arts, 1953.

Chicago 1954
Twentieth Century Art Loaned by the Members
Chicago: Arts Club of Chicago, October 1-30, 1954.
Matisse's *The Conservatory* of 1938 shown.

Denver 1954
Ten Directions by Ten Artists
Denver: Denver Art Museum, January 7-February 14, 1954.

Edinburgh 1954
The Diaghilev Exhibition, An Exhibition Organized by the Arts Council of Scotland
Edinburgh: College of Art, 1954; traveled to London: Forbes House.

Geneva 1954
Trésors des Collections Romandes
Geneva: Musée Rath, 1954.

Oeuvres de Matisse et Picasso
Geneva: Galerie Cramer, July 1954

Lausanne 1954

Lithographies de Matisse
Lausanne: Maurice Bridel and Nane Cailler, March 8-27, 1954.

Le Locle 1954
Chefs-d'oeuvre illustrés de la littérature universelle d'Homère à Baudelaire
Le Locle, Switzerland: Musée des Beaux-Arts, September 11-17, 1954.

London 1954
Masterpieces from the Sao Paulo Museum of Art
London: The Tate Gallery, June 19-August 15, 1954.

Minneapoplis 1954
Matisse in Minneapolis

Minneapolis: Minn. Institute of Arts, November 16-December 5, 1954. (Twenty-six works, ten bronzes.)

New York 1954
Henri Matisse, Loan Exhibition of Paintings
New York: Paul Rosenberg & Co. April 5-May 1, 1954.
Catalogue with all eighteen works in exhibit reproduced; no color.

Review: "Dream of Matisse; Exhibition of 18 Canvases Representing Major Phases of his Art at Rosenberg Gallery." *Art Digest* 28 (April 15, 1954): 10; Hasegawa, Sabro. "Matisse Through Japanese Eyes." *Art News* 53 (April 1954): 17-29+, no. 1097.

Magic of Flowers in Paintings
New York: Wildenstein and Co., April 13-May 15, 1954.

25th Anniversary Exhibition: Paintings
New York: Museum of Modern Art, October 19, 1954-January 23, 1955.

Matisse: Aquatints, Lithographs and Linoleum Cuts, 1925-1953
New York: Chalette Gallery, December 1, 1954-January 3, 1955.

Reviews: "Exhibition of Aquatints, Lithographs and Linoleum Cuts at Chalette Gallery." *Art News* 53 (December 1954): 49; "Exhibition of Prints at Chalette Galerie." *Art Digest* 29 (December 1, 1954): 29.

Paris 1954
Xe Salon de Mai
Paris: Musée Municipal d'Art Moderne, May 7-30, 1954.
Modest sixteen-page catalogue with Matisse's *La Gerbe* (1953) on the cover (first showing of the work); short texts by Bernard Dorival and Gaston Diehl and check list of works.

Book Design and Advertising
Paris: Galerie Maeght, 1954.

Review: "Galerie Maeght, Paris: Book Design and Advertising; Three Illustrations." *Graphis* 10, 56 (1954); 14-16.

Henri Matisse, Lithographies rares
Paris: Berggruen et Cie, October 15-November 27, 1954.
Small elegant catalogue with quality reproductions, lithographed cover in color; important text by Marguerite Duthuit-Matisse, no. 270.

Philadelphia 1954
Gallatin Collection
Philadelphia: Philadelphia Museum of Art, 1954.

Rotterdam 1954
Vier Euwen Stilleben in Frankrijk/ La Nature morte français du XVIIê siècle à nos jours
Rotterdam: Museum Boymans van Beuningen, July 10-September 20, 1954.

San Francisco 1954
Paintings from the Collection of Mrs. Albert D. Lasker
San Francisco: California Palace of the Legion of Honor, April 4-May 17, 1954.

Stockholm 1954

Modern Utlandsk Konst, Ur Svenska Privatsamlingar
Stockholm: Nationalmuseum, 1954. (Twenty-two bronzes, one
painting, sixty-eight prints.)

La revue Verve, Tériade éditeur
Stockholm: Galerie Samlaren, March 30-April 30, 1954.

Cézanne till Picasso
Stockholm: Liljevalchs Konsthall, September 1954. (Seventeen
sculptures.)

Foreign Pictures from Swedish Private Collections
Stockholm: Nationalmuseum, November 1954.

Tokyo 1954
Exhibition of Western Paintings in the Ohara Collection
Tokyo, 1954.

Aix-en-Provence 1955
Le Livre français
Aix-en-Provence, July 9-July 21, 1955.

Atlanta 1955
Painting School of France
Atlanta: Atlanta Art Assoc. Galleries; Birmingham Museum of Art,
1955.

Boston 1955
Matisse Bronzes and Drawings
Boston: Museum of Fine Arts, November 1-30, 1955. (Forty-six
sculptures, one hundred thirty-one drawings.)

Cambridge 1955
The Arts of Matisse: a Museum Course Exhibition
Cambridge, Mass.: Busch-Reisinger Museum, May 9-June 8, 1955.

Edinburgh 1955
French Paintings of the 19th and 20th Centuries
Edinburgh: Arts Council of Scotland, 1955.

Houston 1955
Matisse Sculptures, Paintings and Drawings
Houston: Houston Museum of Fine Arts, September 18-October 16, 1955.

Jerusalem 1955
Collection Ayala and Sam Zacks, Twentieth Century French Art
Jerusalem: Bezalel National Museum, 1955; travels in 1956.

Marseille 1955
Premières étapes de la peinture moderne
Marseille: Musée Cantini, March-May 1955.

Moscow 1955
French Art, Fifteenth to Twentieth Centuries
Moscow: Pushkin Museum of Fine Arts, 1955; traveled to Leningrad: Hermitage Museum, 1956.

New York 1955
The Cone Collection New York: M. Knoedler and Co., January-February 1955. (Nine drawings.)

Reviews: Mellow, James, "Gertrude Stein and the Cone Collection." *Arts Digest* 29 (January 15, 1955): 6-7+; "Henri Matisse." *Baltimore Mus. News* 18 (December 1954): 6-7; "Matisse, a Rare Collection Record; Cone Collection." *Vogue* 125 (March 1, 1955): 132-35.

Matisse, Etchings
New York: Museum of Modern Art, May 4-May 31, 1955.
Catalogue with text by William Lieberman.

Reviews: "Graphics: Exhibition at the Museum of Modern Art," *Arts* 30 (August 1956): 27; S. B. "Exhibition of Etchings and Dry Points at the Museum of Modern Art," *Art Digest* 29 (May 15, 1955): 29.

An Exhibition of Paintings
New York: E. and A. Silberman Galleries, October 12-November 1, 1955.

Matisse's Chasubles
New York: Museum of Modern Art, December 20, 1955-January 15, 1956.

Paris 1955
Salon d'Automne (Rétrospective Henri Matisse)
Paris: Grand Palais, November 1955.

Review: Alazard, Jean. "Deux peintres: Henri Matisse." *Rev. Méditerranéan* 15 (1955): 405-09.

Les Peintres témoins de leur temps-IV: Le Bonheur
Paris: Musée Galliera, March 1-May 31, 1955.

Saint-Étienne 1955
Natures mortes de Géricault à nos jours
Saint-Étienne: Musée d'Art et d'Industrie, April 24-May 30, 1955.

Vienna 1955
Europäische Kunst--Gestern und Heute
Vienna: Oesterreichisches Museum für Angewandte Kunst, June 6-July 6, 1955.

Basel 1956
Maîtres de l'art moderne
Basel: Galerie Beyeler, August-October, 1956.

Berlin 1956-57
120 Meisterwerke des Musée National d'Art Moderne
Berlin: Akademie der Künste, August 12-October 2, 1956; Frankfurt: Städelsches Kunstinstitut, October 20-November 25, 1956; Luxembourg: Musée de l'État, December 15, 1956-January 13, 1957; Cardiff: National Museum of Wales, March 9-April 4, 1957; London: R. B. A. Galleries, April 13-May 18, 1957.

Brussels 1956
De Toulouse-Lautrec à Chagall
Brussels: Palais des Beaux-Arts, March 3-April 22, 1956.

Livres illustrés et estampes de Manet à Dufy
Brussels: Bibliothèque Royale, May 25-June 16, 1952.

Cavaillon 1956
Les Chefs-d'oeuvre d'art moderne--Les peintres contemporains--Les artistes régionaux amateurs
Cavaillon: Musée, November 10-18, 1956.

Cleveland 1956
The International Language
Cleveland: Cleveland Museum of Art, 1956.

Colorado Springs 1956
Garden Clubs of America Exhibition
Colorado Springs: Colorado Springs Fine Arts Center, 1956.

Grenoble 1956
Dix ans de peinture française, 1945-1955
Grenoble: Musee de Grenoble, July 1-September 23, 1956.

Limoges 1956
La Peinture française de l'impressionnisme à nos jours
Limoges: Musée Municipal, January 15-March 15, 1956.

London 1956
The Bronze Reliefs Nu de dos by Matisse
London: Tate Gallery, 1956.

Mexico City 1956
Arte Francés contemporáneo
Mexico City: Museo Nacional de Artes Plásticas, October -November, 1956.

Milwaukee 1956
Still Life Exhibition
Milwaukee: Milwaukee Art Institute; traveled to Cincinnati: Cincinnati Art Museum, 1956.

Moutier 1956

Peintres français et suisses de XXe siècle
Moutier, France: École Secondaire, September-October 1956.

New Haven 1956
Pictures Collected by Yale Alumni
New Haven: Yale University Art Gallery, May 8-June 18, 1956.

New York 1956
Matisse, Lithographs, Drawings, Etchings, Lino Cuts
New York: Deitsch Gallery, March 2-April 7, 1956. (Seventy-five
works.)
Photocopy catalogue with checklist and prices.

Review: *Arts* 30 (April 1956): 49; *Art News* 55 (April 1956): 81.

The Prints of Henri Matisse
New York: Museum of Modern Art, June 27-October 14, 1956.

Recent European Acquisitions
New York: The Museum of Modern Art, November 28, 1956-January
20, 1957.

International Collage Exhibition
New York: Rose Fried Gallery, December 1956-January 1957.

Paris 1956
Henri Matisse, exposition rétrospective
Paris: Musée National d'Art Moderne, July 28-November 18, 1956.
Catalogue with short introduction by Jean Cassou, "Henri Matisse,"
no. 426; black and white reproductions, but with the 106 works fully
documented with bibliography and exhibition record. Mourlot Frères
lithographed cut-out design by Matisse on the covers.

Reviews: Degand, Léon. "Matisse, un Génie?" *Art d'aujourd'hui* 2,
10 (November 1956): 28-31; "Deux grandes retrospectives à Paris:
Fernand Léger et Henri Matisse." *XXe Siècle* 8 (January 1957): 77;
Duthuit, Georges. "Material and Spiritual Worlds of Henri Matisse;
Retrospective at the Musée d'Art Moderne." *Art News* 55 (October
1956), no. 484: 22-25+; Gross, J. "Matisse Retrospective in Paris."
Burlington Mag. 98 (October 1956): 387; Humbert, Agnes. "Painter

of Happiness, Henri Matisse 1869-1954." *Studio* 151 (June 1956): 170-73; Watt, A. "Paris Commentary: Retrospective Exhibition at the Museum of Modern Art." *Studio* 152 (November 1956): 154-55.

Portland 1956
Paintings from the Collection of Walter P. Chrysler, Jr.
Portland: Portland Art Museum; Seattle Art Museum; San Francisco: California Palace of the Legion of Honor; Los Angeles County Museum of Art; The Minneapolis Institute of Arts; City Art Museum of Saint Louis; Kansas City: Willam Rockhill Nelson Gallery of Art; Detroit Institute of Arts; Boston: Museum of Fine Arts.

Prague 1956
Francouske umeni od Delacroix po soucasnot
Prague: Narodní Galerie, January 20-end February 1956.

Toronto 1956
The Ayala and Sam Zacks Collection
Toronto: The Art Gallery of Toronto, September 11-October 18, 1956; Ottawa: The National Gallery of Canada; Winnipeg: The Winnipeg Art Gallery; Minneapolis: The Walker Art Center; Vancouver: The Vancouver Art Gallery.

Tournai 1956
Maîtres de l'art contemporain
Tournai: Musée des Beaux Arts, 1956.

Valenciennes 1956
Cinquante chefs-d'oeuvre du Musée national d'art moderne
Valenciennes, April 14-June 1; Dijon, July 2-August 25; Besançon, September 1-October 1; Strasbourg, October 10-November 25; Reims, December 1, 1956-January 15, 1957.

Yverdon 1956
100 sculptures de peintres, de Daumier à Picasso
Yverdon: Hôtel-de-ville, August 4-September 17, 1956; traveled to Zurich: Kunsthaus, October 26-end November 1956.

Amsterdam 1957

Europa-1907
Amsterdam: Stedelijk Museum, July 8-September 30, 1957.

Baltimore 1957
Cone Collection
Baltimore: Baltimore Museum of Art, February 23, 1957. (Opening of new wing of museum.)

Review: Opening of the Cone Wing. *Baltimore Mus. News* 20, 3 (February, 1957): 1-18. (Twelve pages of reproductions of the collection.)

Boston 1957
Twentieth Anniversary Exhibition
Boston: Institute of Contemporary Art, January 9-February 10, 1957.

Casablanca 1957
Salon d'Automne marocain
Casablanca: November 14-December 20, 1957.

Geneva 1957
Art et travail
Geneva: Musée d'Art et d'Histoire, June 14-September 22, 1957.

Marseille 1957
Chefs-d'oeuvre contemporains, de Bonnard à N. de Stael
Marseille: Musée Cantini, June 21-July 21, 1957.

New York 1957
Paintings and Sculpture from the Minneapolis Institute of Arts, a Loan Exhibition
New York: M. Knoedler and Co., 1957.

Modern Painting, Drawing and Sculpture collected by Louise and Joseph Pulitzer
New York: M. Knoedler and Co., April 9-May 4, 1957; Cambridge: Fogg Art Museum, May 16-September 15, 1957.
Catalogue edited by Charles Chatham with reproduction of the works in the exhibition and commentary on each, no. 1321.

Paintings from the São Paulo Museum
New York: Metropolitan Museum of Art, March 21-May 5, 1957.

The Albert D. Lasker Collection, Renoir to Matisse
New York: Simon and Schuster, 1957.
Catalogue with introduction by Alfred Frankfurter and commentary by
Wallace Brockway.

The George Lurcy Collection, French Modern Paintings and Drawings
New York: Parke-Bernet Galleries, November 2-7, 1957. (Exhibition
and sale.)

Paris 1957
Depuis Bonnard
Paris: Musée National d'Art Moderne, March 23-April 1957.

Collection Lehman de New York
Paris: Musée de l'Orangerie, Summer 1957.

Henri Matisse: papiers découpés
Paris: Berggruen & Cie, 1957.
Small, elegant catalogue with Matisse four-color design on the cover;
reproductions in brilliant color, pochoir technique. Two-page
introduction by E. Tériade in which he denies that the cut-paper designs
were a diversion for the aging artist, but a capital development in his
work.

Pau 1957
Dessins de maîtres modernes--Choix de dessins, aquarelles, gouaches
Pau: Musée des Beaux-Arts, June 21-September 1, 1957.

Recklinghausen 1957
Verkannte Kunst
Recklinghausen: Kunsthalle, Ruhrfestspiele, June 16-July 31, 1957.

Salisbury 1957
Panorama of European Painting, Rembrandt to Picasso
Salisbury, Southern Rhodesia: Rhodes National Gallery, July 16-
September 1, 1957.

Stockholm 1957
Henri Matisse, Apollon, Collection Theodor Ahrenberg; forty-three bronzes.
Stockholm: Nationalmuseum, organized in collaboration with the Association of Medical Students of Stockholm, September 4-23, 1957; traveled to Lund: Skanska Museet, 1957; Helsinki: Helssingin Taidehall, December 10, 1957-January 6, 1958; Liège: Musée des Beaux-Arts, May 3-July 31, 1958; Zurich: Kunsthaus Zurich (with supplements from private collections) and Gothenburg: Kunsthallen, March 16-April 10, 1960; Copenhagen: Raadhus, Fredrickberg, March 18-April 9, 1961. (Forty-three bronzes, twenty-four drawings.) Soft-cover catalogue with color lithograph of *Apollon* on cover introduction by Bo Wennberg; text in Swedish and French. Sculptures numbered in parentheses to correspond with same works--from Matisse's studio in Cimiez--exhibited at the Maison de la Pensée Française in Paris, 1950.
Review: "Ur Matisse Anteckningar." *Paletten* 19, 2 (1958): 40-44.

Henri Matisse, sculptures, dessins, lithographies, ouvrages illustrés Stockholm: Galerie Samlaren, 1957.

Tours 1957
50 oeuvres d'artistes du XXe siècle
Tours: Musée des Beaux-Arts, July-September 1957.

Arnhem 1957
Internatioonale Beeldententoostelling in de open lucht, soonsbeek '58 Arnhem: Staadtpark Soonsbeek, May 1958.

Basel 1958
Kunst & Naturform
Basel: Kunsthalle, September 20-October 19, 1958.

Belgrade 1958
Savremeno Francesko Slikarstvo
Belgrade: January; Zagreb, March 1958.

Brussels 1958

Cinquante Ans d'art moderne
Brussels: Exposition Universelle et Internationale, Palais International
des Beaux-Arts, April 17-July 17, 1958. (Russian Matisse's shown in
West for first time since 1917: *Portrait of Mme Matisse, Nasturtiums
and Dance, Still Life with Goldfish, Red Studio, Spanish Still Life I .*)

Geneva 1958
Henri Matisse, estampes, dessins, livres illustrés, sculptures
Geneva: Galerie Cramer, February 18-March 18, 1958.

Houston 1958
The Human Image
Houston: The Museum of Fine Arts of Houston, 1958.

Collage Internationale from Paris to the Present
Houston: The Museum of Fine Arts of Houston, 1958.

Liège 1958
Léger-Matisse
Liège: Musée d'Art Wallon, July-September 1958.

Luxemburg 1958
Du néo-impressionnisme à nos jours
Luxemburg: Musée de l'État, November 15-December 14, 1958.

Metz 1958
Peinture en France, 1905-1914
Metz: Musée, June-July 1958.

New York 1958
Kirkeby Collection
New York: Parke-Bernet, November 19, 1958. (Auction.)

Henri Matisse, Sculpture, Drawings
New York: Fine Art Associates, Otto M. Gerson, November 25-
December 20, 1958.

Catalogue with four-page introduction by Jean Cassou; twenty good
half-tone reproductions of the twenty-one sculptures exhibited; drawings

neither listed nor reproduced, no. 185.

Reviews: M[unsterberg, H[ugo]. "Sculptures at Fine Arts Associates."
Arts 33 (January 1959): 56; Porter, Fairfield. "Matisse Sculpture and
Drawings [at Matisse Gallery]." *Art News* 57 (January 1959): 11.

Matisse, Drawings and Sculpture
New York: Pierre Matisse Gallery, December 2-27 1958. (Twenty-six
drawings.)

Review: *Arts* 33 (January 1959): 63.

Paris 1958
*Chefs d'oeuvre de Henri Matisse (au profit de l'entr'aide des travailleurs
intellectuels)*
Paris: Galerie Bernheim-Jeune, May 9-July, 1958. (Eighteen drawings.)
Catalogue with introduction by J. and H. Dauberville, interview with
Matisse, "Une Visite à Matisse en 1942." All contracts with
Bernheim-Jeune published here.

Reviews: "Matisse at the Galerie Bernheim-Jeune Dauberville." *Apollo*
68 (August 1958): 58; "Matisse Exhibitions at Bernheim-Jeune and
Berggruen." *Arts Mag.* 33 (November 1958): 15.

Les Affiches originales des maîtres de l'École de Paris
Paris: Maison de la Pensée Française, Summer 1958.
A book of the same name based on the exhibit was published in Paris,
A. Sauret, 1959.

Review: Gasser, Samuel. "Ausstellungs-Plakate grosser Meister/
Affiches des maîtres de l'École de Paris," *Graphis* 16 (March 1960):
108-19.

Henri Matisse, dessins et sculptures inédites
Paris: Galerie Berggruen, June 20-July 1958 (Fifteen drawings, four
sculptures.)
Small elegant catalogue with quality plates; no text. Four unpublished
sculptures given good reproductions.

Review: "Drawings and Sculptures by Matisse at the Galerie Berggruen
and Hanover Gallery." *Apollo* 68 (August 1958): 58-9; "Matisse

Exhibitions at Bernheim-Jeune and Berggruen."*Arts Mag.* 33 (November 1958): 15.

Recklinghausen 1958
Schönheit aus der Hand, Schönheit durch die Maschine
Recklinghausen: Kunsthalle, Ruhrfestspiele, June 14-July 27, 1958.

Reims 1958
Exposition de dessins contemporains
Reims, 1958; traveled to Bar-le-Duc; Brive-la-Gaillarde.

Rotterdam 1958
Van Clouet tot Matisse: Tentoonstelling van Franse Tekeningen uit amerikanse collecties [De Clouet à Matisse; dessins français des collections américains]
Rotterdam: Boymans Museum, July-September 1958; Paris: Musée de l'Orangerie, October 1958-January 1959; New York: Metropolitan Museum of Art, February 3-March 15, 1959.
Catalogue with introduction by Agnes Mongan.

Zurich 1958
Sammlung Emil G. Bührle
Zurich: Kunsthaus Zurich, June 7-September 30, 1958; Berlin: Nationalgalerie, Schlosses Charlottenburg, October 5-November 23, 1958. (Only one Matisse oil, an early view of *Pont St.-Michel,* in the collection.)

Atlanta 1959
Collector's First
Atlanta: Atlanta Art Association, February 18-March 1, 1959.

Bern 1959 / Amsterdam 1960
Henri Matisse, 1950-1954: Les Grandes gouaches découpés
Bern: Kunsthalle, July 25-September 20, 1959; traveled to Amsterdam, Stedilijk Museum, April 29-June 20, 1969. (Thirty gouaches découpées, eight drawings, two books.)
Catalogue with major essay by Franz Meyer, no. 374; separate catalogue in Dutch.

Review: Althaus, P. F. "Bern: Gouaches Découpées in der Kunsthalle."
Werk 46 (September 1959): supp. 190; Kuenzi, André. "Henri
Matisse." *Gaz. de Lausanne* (August 8/9, 1959); Lassaigne, Jacques.
"Les Grandes gouaches découpés de Matisse." *Lettres françaises*
(August 6, 1959), no. 336; Leymarie, J. "Les Grandes gouaches
découpées de Matisse à la Kunsthalle de Berne (with English
summary)." *Quadrum* 7 (1959): 103-114, 192 [substantially same
article in "Le Jardin du paradis." *Lettres françaises* (August 6, 1959),
no. 337]; "Les Grandes gouaches découpées d'Henri Matisse." *Tribune
de Genève* (August 6, 1959).

Charleroi 1959
De Maillol à nos jours
Charleroi: Palais des Beaux-Arts, 1959; traveled to Ixelles: Musées des
Beaux-Arts; Tournai: Musée des Beaux-Arts; Luxemburg: Musée des
Beaux-Arts.

Cincinnati 1959
The Lehman Collection
Cincinnati: Cincinnati Art Museum, May 8-July 5, 1959.

Copenhagen 1959
Grace og Philip Sandbloms Samling
Copenhagen: Ny Carlsberg Glyptotek, 1959.

Delaware 1959
Selections from the Columbus Gallery of Fine Arts
Delaware, Ohio: Ohio Wesleyan Unversity, November 13-December
13, 1959.

Geneva 1959
Le Livre illustré par Henri Matisse: dessins, documents
Geneva: Galerie Gérald Cramer, December 4, 1959-January 29, 1960.
(Twenty drawings.)
Small catalogue of an exhibition in the Gérald Cramer Gallery of
illustrated books and unusual prints from them, carefully documented
and reproduced in an edition of 1250.

Hamburg 1959

Französische Zeichnungen des XX Jahrhunderts
Hamburg: Kunsthalle, September 3-November 15, 1959; traveled
during 1960. (Twenty-seven drawings.)

Kassel 1959
International Ausstellung: Documenta II
Kassel, July 11-October 11, 1959.

Leningrad 1959
*Western European Landscape Painting, Sixteenth to Twentieth
Centuries*
Leningrad: Hermitage Museum, 1959.
Catalogue in Russian.

London (Ontario) 1959
French Paintings from the Impressionists to the Present
London, Ontario: London Public Library and Art Museum, February 6-
March 13, 1959.

Minneapolis 1959
Modern Illustrated Books from the Collection of Louis E. Stern
Minneapolis: Minneapolis Institute of Arts, April 1-May 3, 1959.

Miami 1959
Paintings and Sculpture from the Norton Gallery Collection
Miami, Fla.: Playhouse Gallery, January 12-24, 1959.

New York 1959
Matisse, Villon: Prints
New York: New Arts Center, January 9-31, 1959.

Review: "Matisse, Villon, Prints." *Art News* 57 (January 1959): 15.

Henri Matisse, Drawings and Lithographs, 1905-1945
New York: Bayer Gallery, March 9-April 11, 1959.

A Family Exhibit
New York: Knoedler Galleries, April 6-23, 1959.

Paris 1959

De Géricault à Matisse, chefs d'oeuvre français des collections suisses
Paris: Petit Palais, March-May, 1959.

Pau 1959
Le Dessin français de Signac aux abstraits
Pau: Musée des Beaux-Arts, 1959.

Recklinghausen 1959
Die Handschrift des Künstlers
Recklinghausen: Kusthalle, Ruhrfestspiele, May 23-July 5, 1958.

Schaffhausen and Berlin 1959
Triumph der Farbe, die europäischen Fauves
Schaffhausen: Museum der Allerheiligen; traveled to Berlin:
Nationagalerie der ehemals Staatlichen Museen, 1959.

Zurich 1959
Henri Matisse, Das Plastiche Werk (Theodore Ahrenberg Collection)
Zurich: Kunsthaus Zurich, July 14-August 12, 1959. (Sixty-seven
bronzes, one wood sculpture, fifty-one drawings; one hundred ninety-
three works in all.)
Catalogue (separate from Swedish catalogue of 1957) with introduction
by Eduard Hüttinger, "Henri Matisse als Plastiker," no. 201, and essay
by Ulfe Linde, *"Apollon,"* no. 787.

Reviews: "Das Plastische Werk, Ausstellung im Kunsthaus Zurich."
Werk 46 (September 1959): supp.193; "Das Kunsthalle Zurich Stellte
das Gesamte Plastische Werk von Matisse." *Kunstwerk* 13 (August
1959): 69.

Aix-en-Provence 1960
Matisse
Aix-en-Provence: Pavillon de Vendome, July 9-August 31, 1960.
(Twenty drawings, five bronzes, two tapestries, fifteen books, eight
gouaches decoupées from Jean Matisse collection, twenty-seven
paintings.)
Small catalogue with check list of works, short preface by J.-G.
Martial-Salme.

Amsterdam 1960
Dix Artistes, trois étapes [Rodin, Monet, Van Gogh, Kandinsky, Nolde, Bonnard, Matisse, Mondrian, Malevitch, Klee]
Amsterdam: Stedelijk Museum, Spring, 1960; traveled to Otterlo: Rijksmuseum Kröller-Müller, June 30-September 19, 1960.

Review: Sandberg, W. "Dix Artistes, trois étapes." *Oeil* 69 (September 1960): 42-51.

Bern 1960-61
Tériade éditeur, Revue Verve
Bern: Kornfeld und Klipstein, February 6-March 12, 1960.

Henri Matisse, Das Illustrierte Werk, Zeichnungen und Druckgraphik
Bern: Kornfeld und Klipstein, December 15, 1960-January 31, 1961.
(Twenty-seven drawings, one découpage.)
Well-documented catalogue; text by Matisse, "Comment j'ai fait mes livres."

Baltimore 1960
French Illustrated Books of the 19th and 20th Century
Baltimore: Baltimore Museum of Art, October 15, 1960-January 14, 1961.

Chicago 1960
Inaugural Exhibition
Chicago: The Art Gallery, November 18-December 23, 1960.

Dayton 1960
French Paintings 1789-1929 from the Collection of Walter P. Chrysler, Jr.
Dayton: Dayton Art Institute, March 25-May 22, 1960.

Düsseldorf 1960-61
Sammlung G. David Thompson, Pittsburgh/USA
Düsseldorf: Kunstmuseum Düsseldorf, December 14, 1960-January 29, 1961; The Hague: Gemeentemuseum, February 17-April 9, 1961.

Göteborg 1960

Henri Matisse ur Theodore Ahrenbergs Samling
Göteborg: Kunsthallen, March 16-April 10, 1960.
Catalogue with preface by Jean Cassou.

London 1960
*Forty-nine Bronzes by Matisse--Property of Mr. and Mrs. Theodor
Ahrenberg of Stockholm*
London: Sotheby and Co., July 4-6, 1960. (Exhibition and sale.)
Catalogue of sale, July 7, 1960.

*Important Impressionist and Post-Impressionist Pictures, Drawings, and
Bronzes*
London: Christie's, May 20, 1960. (Exhibition and sale.)

Nagoya 1960
Exhibition of Western Paintings of the Ohara Collection
Nagoya, 1969.

New York 1960
*Modern Paintings, Sculptures, Drawings, Collected by the Late
Baroness Gourgaud*
New York: Parke-Bernet Galleries, March 12-16, 1960. (Exhibition and
sale.)

The Colin Collection
New York: M. Knoedler and Co., April 12-May 14, 1960.

*Important Impressionist and Post-Impressionist Pictures, Drawings, and
Bronzes*
New York: Christie's, May 17-20, 1960. (Exhibition and sale.)

Jazz by Henri Matisse
New York: Museum of Modern Art, June 17-September 19, 1960.

Nice 1960
Peintres à Nice et sur la Côte d'Azur, 1860-1960
Nice: Palais de la Méditerranée, July-September, 1960.

Paris 1960

Cent Tableaux de collections privées de Bonnard à de Staël
Paris: Galerie Charpentier, 1960.

Les Sources du XXe siècle: les arts en Europe de 1884 à 1914
Paris: Musée National d'Art Moderne, November 4, 1960-January 23,
1961.
Catalogue by J. Cassou and A. Chatelet; texts by J. Cassou, G. C.
Argan, and Nicolas Pevsner.

Quimper 1960
Le Dessin français de Signac aux abstraits
Quimper, June 1, 1960; travels to Pau, Rennes, Bourges, and Dijon.

Rotterdam 1960
Beeldententoonstelling floriade
Rotterdam: Musée Boymans van Beuningen, March 25-September 25,
1960.

Zurich 1960
*G. David Thompson Collection: Aus einer ameriknanischen
Privatsammlung, Pittsburgh*
Zurich: Kunstmuseum Zurich, October 15-November 27, 1960.

Review: *Werk* 49 (September 1962): 331-33 [note on the acquisition
two years later of the *Backs I-IV* shown in the exhibit].

Albi 1961
*Exposition Henri Matisse, peintures, dessins, gouaches, sculpteurs,
gravures.*
Albi, France: Musée Toulouse-Lautrec, Palais de la Berbie, July 11-
Sepember 15, 1961. (Sixty-three bronzes, seventy-seven drawings, ten
cut-outs from Jean Matisse collection.)
Catalogue text by Jacques Lassaigne and twelve good photogravure
reproductions. Paintings and sculptures mainly from French museums
and the collection of Jean Matisse.

Birmingham (N.Y.) 1961
10th Anniversary Exhibition
Birmingham, N.Y. : Birmingham Museum of Art, 1961.

Bruges 1961
Meesterwerken van het Museum voor Moderne Kunst in Brussel
Bruges, 1961.

Kansas City 1961
The Logic of Modern Art
Kansas City: Nelson Gallery and Atkins Museum, 1961.

New York 1961
Masterpieces; a Memorial Exhibition for Adele R. Levy
New York: Wildenstein and Co., April 6-May 7, 1961.

Modern Paintings and Sculptures from the Collection of Mr. and Mrs.
Adolphe A. Juviler
New York: Parke-Bernet Galleries, October 21-25, 1961. (Exhibit and
sale.)

The Last Works of Henri Matisse, Large Cut Gouaches
New York: Museum of Modern Art, October 17-December 3, 1961;
The Art Institute of Chicago, January 10-February 13, 1962; San
Francisco Museum of Art, March 12-April 22, 1962.
Modest catalogue with a workmanlike, informational essay by Monroe
Wheeler.

Review: Preston, S. "Papiers collés at the Museum of Modern Art."
Burlington Mag. 103 (December 1961): 526; Sidney Tillim, "New
York Exhibitions." *Arts* 36 (January 1962): 29-30.

Paris 1961
Henri Matisse, les grands gouaches découpés.
Paris: Musée des Arts Décoratifs, March 22-May 25, 1961.
Catalogue beautifully lithographed (Mourlot Fréres), each of the forty-
six works is accompanied by any statement or text of Matisse on that
individual work and annotated (by François Mathey) with bibliography
and exhibition history. Introduction, "La Peinture sans limites," by
Jacques Lassaigne, no. 332.; high-quality photos of Matisse's studio
with cut-paper works in process.

Reviews: Frigerio, S. "Les grandes gouaches découpés d'Henri
Matisse." *Aujourd'hui* 5 (May 1961): 36; Mellquist, J. "Paris:

Advances in Sculpture and Painting: Papiers Coupés at the Musée des Arts Décoratifs." *Apollo* 74 (May 1961): 151; Morand, K. "Les grandes gouaches découpées de Henri Matisse [Musée des Arts Décoratifs]." *Burlington Mag.* 103 (May 1961): 200; Schneider, Pierre. "Matisse's Papiers découpés at the Musée des Arts décoratifs." *Art News* 60 (May 1961): 44; Watt, A. "Les Grandes Gouaches Découpés, Exhibition at the Musée des Arts Décoratifs." *Studio* 162 (July 1961): 22-23.

Tokyo and Kyoto 1961-62
Exposition d'art français 1840-1940
Tokyo: Musée National des Beaux Arts, November 3, 1961-January 15, 1962; Kyoto: Musée Municipal, January 25-March 15, 1962.

Wolfsburg 1961
Französische Malerei von Delacroix bis Picasso
Wolfsburg: Wolksvagenwerke, 1961.

Grenoble 1962
Dessins de vingtième siècle
Grenoble: Musée de Grenoble, Fall 1962.

Review: Kueny, G. "Dessins du XXe siècle au Musée de Grenoble." *Oeil* 96 (December 1962): 67-68.

London 1962
Matisse and Modigliani Drawings
London: Hannover Gallery, March 21-April 19, 1962.
Small elegant catalogue with six Matisse works reproduced; no text.

Primitives to Picasso
London: Royal Academy of Arts, Winter, 1962.

Marseille 1962
Gustave Moreau et ses élèves
Marseille: Musée Cantini, June 26-September 1, 1962. (Eight drawings, one cutout).
Catalogue with preface by Jean Cassou.

Mexico City 1962

Cien Años de Pintura en Francia/100 Años de Dibujo Frances, 1850-1950
Mexico City: Palace of the Fine Arts and the University, October -November 1962; traveled to Caracas.

New York 1962
Modern French Paintings
New York: Wildenstein and Co., Rose Art Museum, Brandeis University, 1962.

Masters of Seven Centuries
New York: Wildenstein and Co, March 1-31, 1962.

Modern Sculpture from the Joseph H. Hirshhorn Collection
New York: Solomon R. Guggenheim Museum, October 3, 1962- January 6, 1963.

Exhibition
New York: Finch College, 1962.

Matisse Etchings 1929
New York: Deitsch Gallery, April 10-28, 1962.

Review: "Etchings at Deitsch." *Art News* 61 (May 1962): 15.

Ottawa 1962
European Paintings in Canadian Collections
Ottawa: National Gallery of Canada, February 9-March 4, 1962.

Paris 1962
Les Fauves
Paris: Galerie Charpentier, March 7-May 31, 1962.
Catalogue with short promotional preface by Raymond Nocenta; many of the one hundred fifty works in the exhibit illustrated in black and white; thirteen works by Matisse, including *Luxe, calme et volupté.*

Review: Lesore, H. "Paris Letter." *Apollo* 76 (May 1962): 526; Veronese, Giulia. "I Fauves," *Emporium* 136 (July 1962): 196; Brookner, Anita. "Les Fauves." *Burlington Mag.* 54 (May 1962): 221.

Minotaure
Paris: Galerie l'Oeil, May-June 1962.

Henri Matisse, Aquarelles, Dessins
Paris: Jacques Dubourg, June 6-29, 1962.
Beautifully lithographed catalogue with color reproductions of rare
Matisse watercolors; text by Matisse, "Notes sur la couleur,"
previously published in G. Diehl, *Les Problémes de la peinture*, 1945,
237-40; Fourcade (1972), 205-207.

San Francisco 1962
Stein Collection
San Francisco: San Francisco Museum of Art, March 1962.

The Collection of Henry P. McIlhenny
San Francisco: California Palace of the Legion of Honor, June 15-July
31, 1962.

Stockholm 1962
Dessins de Henri Matisse
Stockholm: Konstsalongen Samlaren, 1962.

Venice 1962
XXXI Venice Biennale Internationale d'Arte
Venice: June 16-November 7, 1962.

Vienna 1962
Kunst von 1900 bis heute
Vienna: Museum des XX. Jahrhunderts, September 21-November 4,
1962.

Warsaw 1962
Francuskie rysinki i tkaniny
Warsaw: Muzeum Narodowe, March 20; traveled to Cracow, May 1962.

Bombay 1963
Exhibition of Tapestries and Contemporary French Decorative Arts
Bombay: October 1, 1963; New Delhi: Lalit Kala Akadei; Calcutta;
Madras; Hyderabad: April 9, 1964.

Caen 1963
Exposition inaugurale
Caen: Maison de la Culture, 1963.

Miami 1963
Matisse ?
Miami: Lowe Art Gallery, February 8-March 10, 1963.

Montreal 1963
La Peinture française contemporaine
Montreal: Musée des Beaux-Arts, October 3-November 3, 1963;
Quebec: Musée de la Province, November 18-December 15, 1963.

New York 1963
Reader's Digest Collection
New York: M. Knoedler and Co., May 15-June 8, 1963.

Twentieth Century Master Drawing
New York: Solomon Guggenheim Museum, November 1962-January
1963; travels to Minneapolis: Univers. of Minn. Art Gallery, February
3-March 15, 1963; Cambridge: Fogg Museum of Art, April 6-May 24,
1963.
Catalogue with essay by Sidney Simon.

Review: Kozloff, Max. "Notes on the Psychology of Modern Draughts-
manship." *Arts Mag.* 38, 5 (February 1964): 58-63, 286.

Nice 1963
Dation Matisse (inauguration of the museum)
Nice: Villa des Arènes, January 5, 1963.
Invitation with cut-paper lithographed on cover.

Review: Cooper, Douglas. "Matisse Museum." *New Statesman &
Nation* 65 (February 1963): 162.

Paris 1963
Deux cents aquarelles et dessins de Renoir à Picasso
Paris: Galerie Romanet, November, 1963.
Catalogue with text by A. Romanet.

Philadelphia 1963
A World of Flowers
Philadelphia: Philadelphia Museum of Art, May 2-June 9, 1963.

Pittsburgh 1963
Works of Art from the Collection of The Museum of Modern Art
Pittsburgh: Museum of Art, Carnegie Institute, December 17, 1963-February 1964.

Rotterdam 1963
Franse landschappen van Cézanne tot heden
Rotterdam: Museum Boymans van Beuningen, October 4-November 17, 1963.

Strasbourg 1963
La Grande aventure de l'art du XXe siècle
Strasbourg: Chateau des Rohan, June 8-September 15, 1963.

Stockholm 1963
Fran Bonnard till vara dagar
Stockholm: Riksfobundet for bildande Konst, August-November 1963; traveled to Humlebaek: Louisiana Museum, January 24-April 1964.

Washington 1963
Paintings from the Museum of Modern Art, New York
Washington, D.C.: National Gallery of Art, December 16, 1963-March 1, 1964 (extended to March 22).

Baltimore 1964
Art of the year 1914 at the Baltimore Museum of Art
Baltimore: Baltimore Museum of Art, Fall 1964.

Review: Lanes, J. "Survey of Art in the Year 1914 at Baltimore Museum of Art." *Burlington Mag.* 106 (November 1964): 528.

Basel 1964
Bilanz--Internationale Malerei seit 1959
Basel: Kunsthalle, June 20-August 23, 1964. (One cut-out.)

Beverly Hills 1964

Matisse / Picasso, drawings and graphic work
Beverly Hills: Frank Perls Gallery, November 20-December 20, 1964.
(Forty lithographs and etchings.)

Bordeaux 1964
La Femme à l'artiste, de Bellini à Picasso
Bordeaux: Musée des Beaux-Arts, May 22-September 20, 1964.

Ghent 1964
Figuratie-Defiguratie. De Menselijke figuur sedert Picasso
Ghent: Museum voor Schoone Kunsten, July-September, 1964.

Kassel 1964
Documenta III
Kassel: Alte Galerie, Museum Fredericianum und Orangerie, June 27-
October 5, 1964. (Two Matisse cut-outs.)

Lausanne 1964
Chefs-d'oeuvre des collections suisses de Manet à Picasso
Lausanne: Palais de Beaulieu, May 1-October 25, 1964.

London 1964
[19]54 / [19]64 Painting and Sculpture of a Decade
London: Tate Gallery, April 20-June 28, 1964. (One cut-out.)

New York 1964
Important European Paintings from Texas Private Collections
New York: Marlborough-Gerson Gallery, November-December 1964.

Nice 1964
Le Midi des peintres
Nice: Palais de la Méditerranée, February-March 1964.

Paris 1964
Oeuvres choisies de 1900 à nos jours
Paris: Galerie Max Kaganovitch, 1964.

Henri Matisse, Gravures
Paris: Galerie Adrien Maeght, June 9-July 1964
Invitation; no checklist, one reproduction.

Collection Georges et Adèle Besson
Paris: Musée du Louvre, December 11, 1964-February 8, 1965.
Catalogue with preface by J. Cassou.

Saint-Etienne 1964
Cinquante ans de collage, papiers collés, assemblages; collages du cubism à nos jours
Saint-Etienne: Musée d'Art et d'Industrie, June 23- September 13, 1964. (One Matisse cut-out.)

Saint-Quentin 1964
Les élèves de l'École La Tour
Saint-Quentin: Chambre de Commerce, 1964. (Sixteen drawings.)

Vancouver 1964
The Nude in Art
Vancouver: Vancouver Art Gallery, November 3-29, 1964. (Two oils, *Carmelina* (1903) and *Nude in Interior* (1951), and a lithograph, *Odalisque with Bowl of Fruit*, were exhibited.)

Review: Emery, Tony. "The Nude in Art." *Canadian Art* 95 (January/February 1965): 39-47.

Berlin 1965
Von Delacroix bis Picasso, Ein Jahrhundert französischen Malerei Austellung
Berlin: National Galerie, 1965.
Catalogue in German.

Beverly Hills 1965
Matisse Drawings
Beverly Hills: P. N. Matisse Gallery, April-May 1965. (Eighteen drawings.)

Brussels 1965

Un demi-siècle d'amitiés littéraires et artistiques franco-belges
Brussels: Palais des Beaux-Arts, January 5-24; Mons, February 1-28;
Liège, March 12-April 4, 1965; Namur, May 6-29, 1965.

Detroit 1965
The John S. Newberry Collection
Detroit: Detroit Institute of Arts, October 13-November 14, 1965.

Duisburg 1965
*Pariser Begegnungen, 1904-1914: Café du Dôme. Académie Matisse,
Lehmbrucks Freundeskreis*
Duisburg: Wilhelm-Lehmbrück-Museum der Stadt Duisburg, October
16-November 28, 1965.

Helsinki 1965
Henri Matisse, grafik, teckningar, plakat
Helsinki: Amos Andersonin Taidemuseo, April 25-May 16, 1965.
((Drawings, prints, poster.)
Small catalogue in Finnish and Danish, introduction by Hans Eklund.

Lisbon 1965
Un Siècle de peinture française, 1850-1950
Lisbon: Fondation Gulbenkian, 1965.

London 1965
XIX and XX Century French Paintings
London: Lefevre Gallery, October 14-November 13, 1965.

Montreal 1965
J. W. Morrice
Montreal: Montreal Museum of Fine Arts, September 30-October 31;
Ottawa: National Gallery of Canada, November 12-December 5, 1966.

New York 1965
*The School of Paris: Paintings from the Florence May Schoenborn and
Samuel A. Marx Collection*
New York: Museum of Modern Art, November 2, 1965-January 2,
1966.
Handsome catalogue that functions as a catalogue to the collection;

introduction by James Thrall Soby, notes by Lucy R. Lippard; second ed., 1978, no. 1326.

Palm Beach 1965
Feature of the Month
Palm Beach: Society of the Four Arts, February-March, 1965.

Paris 1965
La Cage aux Fauves du Salon d'Automne 1905
Paris: Galerie de Paris, October 12-November 6, 1965.
Catalogue preface by J. Cassou, text by Pierre Cabanne.

Chefs-d'oeuvre de la peinture française dans les Musées de Leningrad et de Moscou
Paris: Musée du Louvre, September 1965-January 1966; traveled to Bordeaux in 1966.
Review: Champa, K. "From Russia with Love." *Arts Mag.* 39 (September 1965): 56.

Quarante tableaux d'une collection privée [Pierre Lévy, Troyes]
Paris: Galerie M. Knoedler & Cie, 1965.
Catalogue with text by Waldemar George.

Philadelphia 1965
Peale Club Collectors Show
Philadelphia: Peale House Galleries, September 23-October 31, 1965.

Pittsburgh 1965
The Seashore, Paintings of the 19th and 20th Centuries
Pittsburgh: Museum of Art, Carnegie Institute, October 22-December 5, 1965.

Rio de Janiero 1965
Pintura Francesca Contemporanea
Rio de Janeiro: Museum of Modern Art, June 3-July 4, 1965;
Montevideo: National Museum of Fine Arts, August-September, 1965;
Santiago: Museum of Chile, late November-Late December 1965.

Tokyo 1965

Les Fauves
Tokyo: Takashimaya, September 7-26, 1965; Osaka: Takashimaya,
October 5-17, 1965; Fukuoka: Iwataya, October 26-31, 1965.

Bordeaux 1966
La Peinture française, collections américaines
Bordeaux: Musée des Beaux Arts, 1966.

Brussels 1966
Art français contemporain
Brussels: Palais des Beaux-Arts, September 16-November 13, 1966.

Cleveland 1966
Fifty Years of Modern Art, 1916-1966
Cleveland: Cleveland Museum of Art, 1966.

Hamburg 1966
Matisse und seine Freunde, Les Fauves
Hamburg: Hamburg Kunstverein, May 25-July 10, 1966; show from
Paris and Munich, with changes. (Twenty-one paintings by Matisse.)
Catalogue with introduction by Hans Platte, no. 1257.

Review: Whitfield, S. "Matisse and the Fauves at Hamburg."
Burlington Mag. 108 (August 1966): 439.

London 1966
Henri Matisse Lithographs
London: Redfern Gallery, January 1966.

Los Angeles 1966
Henri Matisse Retrospective
Los Angeles: UCLA Art Gallery, January 5-February 27, 1966; travels
to Chicago: Art Institute of Chicago, March 11-April 24; Boston:
Museum of Fine Arts, May 11-June 26, 1966 (Boston venue has its
own catalogue). (Paintings and prints, forty-seven bronzes, eighty-three
drawings.)
Major scholarly catalogue with essays by Jean Leymarie, no. 604;
Herbert Read, no. 209; and William Lieberman, no. 290. See no. 129
for a more complete description of the catalogue.

Reviews: Greenberg, Clement, "Matisse in 1966." *Bull. Boston Mus. Fine Arts* 64, 336 (1966): 48-76, no. 538; [Chicago site] "Henri Matisse Retrospective." *Chicago Art Inst. Cal.endar* 60 (January 1966): 6-7 and 60 (March 1966): 1-5; [Boston site] Kramer, Hilton. "Matisse as a Sculptor." *Bull. Boston Mus. Fine Arts* 64, 336 (1966): 49-44, no. 203; Marmer, Nancy. "Matisse and the Strategy of Decoration." *Artforum* 4, 7 (March 1966): 28-33, no. 340; Seldis, Henry. "Exhibition Preview: Matisse in Los Angeles." *Art in America* 53 (December 1965-January 1966): 76-9; Seldis, Henry. "Magic of Matisse." *Apollo* 83 (April 1966): 244-55; [Review of catalogue] Review. *Art Quarterly* 30 (1967): 97, 99; Werner, Alfred. [Review of Catalogue.] "The Earthly Paradise of Henri Matisse," *Arts Mag.* 40 (January 1966): 30-35, no. 764; Wight, Frederick. "Matisse: Fabric vs. Flesh." *Art News* 64, 9 (January 1966): 26-9, 64-65, no. 768.

Munich 1966
Der Französische Fauvismus und der Deutsche Frühexpressionismus
Munich: Haus der Kunst, March 26-May 15, 1966.

New York 1966
Henri Matisse, 64 Paintings
New York: Museum of Modern Art, 1966.
Catalogue with seminal essay, "Matisse: the Harmony of Light," by Lawrence Gowing, no. 99.

Gauguin and the Decorative Style
New York: The Solomon R. Guggenheim Museum, 1966.
Handsome small catalogue with general introduction by Lawrence Alloway and a short section on Matisse, among others, by Rose-Carol Washton.

Paris 1966
Henri Matisse, dessins
Paris: Galerie Dina Vierny, January 25-February 25, 1966.

Le Fauvisme français et les débuts de l'expressionnisme allemand
Paris: Musée National d'Art Moderne, January 15-March 6, 1966; Munich: Haus der Kunst, March 26-May 15, 1966; Hamburg: Kunsthalle, May 24-July 10, 1966 (with different names and catalogues

at each venue).
Well-illustrated, solid catalogue by Michel Hoog, with prefaces by
Bernard Dorival, no. 1214, and L. Reidemeister, no. 1259.

Collection Jean Walter-Paul Guillaume
Paris: Orangerie des Tuileries, 1966.
Catalogue with commentary on Matisse works by Geneviève Allemand.

Review: De Forges, M.T. and G. Allemand, " Orangerie des Tuileries,
La Collection Jean Walter-Paul Guillaume." *Rev. du Louvre* 16 (1966):
57.

Soixante maîtres de Montmartre à Montparnasse de Renoir à Chagall
(Modern Art Foundation Oscar Ghez, Geneva)
Paris: Musée Galliéra, 1966.
Catalogue by O. Ghez, F. Daulte, and E. Gribaudo.

Cent dessins et aquarelles de Renoir à Picasso
Paris: La Palette Bleue, Romanet-Rive Gauche, 1966.

Sarasota 1966
Masterpieces from Montreal
Sarasota: The John and Mabel Ringling Museum of Art, January 10-
February 13, 1966; travels to Buffalo, Rochester, Raleigh,
Philadelphia, Columbus, Pittsburgh to April 30, 1966.

Thonon-les-Bains 1966
Chefs d'oeuvre du Musée National d'Art Moderne
Thonon-les-Bains: Maison de la Culture, June 4-19, 1966.

Tokyo 1966-67
Masterpieces of Modern Painting from the USSR National Museum of
Western Art
Tokyo: National Museum of Art, 1966; traveled to Kyoto, 1967.
Catalogue.

Baltimore 1967
French Illustrated Books of the Nineteenth and Twentieth Centuries
Baltimore: Baltimore Museum of Art, October 15, 1967-January 14,
1968.

Bucharest 1967

Exposition de dessins et d'aquarelles en France depuis Matisse
Bucharest: March, 1967; traveled to Dublin: The Municipal Gallery,
June 3-21; Prague: Palac Kinskych, July 4-August 6; Bratislava:
Vystavna sien SSVU, August 15-end September; Budapest: Palais des
Expositions, September 30-October 22, 1967.

Chicago 1967

Matisse Drawings
Chicago: Holland Gallery, November, 1967.

Columbus 1967

Selections from The Baltimore Museum of Art Collection
Columbus: The Columbus Gallery of Fine Arts, November 10-
December 3, 1967.

Copenhagen 1967

*Hommage de l'art français, de Courbet à Soulages, dessins français du
Musée du Louvre et du Cabinet des Estampes et du Musée National
d'Art Moderne, Paris.*
Copenhagen: Kongelige Kobberstiksamling, Statens Museum for
Kunst, June 3-July 30, 1967.

London 1967

Henri Matisse, Drawings
London: Victor Waddington, April 21-May 27, 1967. (Thirty-seven
drawings.)
Catalogue, carefully produced with all works illustrated, with Matisse's
"A Painter's Notes on his Drawings," from *Le Point* 4, 21 (July 1939),
reprinted in French and English.

Reviews: Brett, Guy. "Matisse Drawings of Last Ten Years." *London
Times* (May 1, 1967); Gordon, A. "Exhibitions in London."
Connoisseur 165 (July 1967): 186; Lucie-Smith, E. "Matisse drawings
at Victor Waddington." *Studio* 173 (May 1967): 252; Mullaly,
Terence. "Union of Heart and Hand in Matisse." *Telegraph* (April 24,
1967); Mullins, Edwin. "Passion for Drawing." *Sunday Telegraph*
(April 23, 1967); Russell, John. "London, Matisse Drawings." *Art
News* 66 (Summer 1967): 60; idem, "Black and White Colorist."

London Sunday Times (April 23, 1967); Sutton, Denys. "Matisse the Draughtman." *Financial Times* (April 26, 1967).

Henri Matisse, Graphic Work
London: Lumley Cazalet Gallery, June 1-July 7, 1967.

Review: Gordon, A. *Connoisseur* 165 (July 1967): 186.

Moscow 1967
Masterpieces of French Painting, 19th and early 20th Centuries, from the Collections of the Pushkin Museum of Fine Art
Moscow: Pushkin Museum, 1967; traveled to Kharkov in 1968.

New York 1967
Selections from the Collection of Dr. and Mrs T. Edward Hanley, Bradford, Pennsylvania
New York: Gallery of Modern Art, January 3-March 12; Philadelphia Museum of Art, April 6-May 28, 1967.

Drawings from the Alfred Stieglitz Collection
New York: Metropolitan Museum of Art, September 9-November 12, 1967. (Six drawings by Matisse.)

Matisse Drawings
New York: Albert Loeb and Krugier Gallery, November 1967.
Small elegant folio-type catalogue, with Matisse's "Notes of a Painter on His Drawing" in English and French.

Review: *Art News* 66 (January 1968): 15.

First Showing of Paintings, Sculpture, Drawings
New York: Pierre Matisse Gallery, December 19, 1967-January 25, 1968.

Paris 1967
Chefs-d'oeuvre des collections suisses de Manet à Picasso
Paris: Orangerie des Tuileries, 1967.
Catalogue by F. Daulte, texts by J. Chatelain, F. Daulte, and H. Adhémar.

Recklinghausen 1967
Zauber des Lichtes
Recklinghausen: Kunsthalle, Ruhrfestspiele, June 7-July 30, 1967.

Washington 1967
100 European Paintings and Drawings from the Collection of Mr. and Mrs. Leigh B. Block
Washington: National Gallery of Art, May 4-June 11, 1967; Los Angeles: Los Angeles County Museum of Art, September 21-November 2, 1967.

Wellesley 1967
Nineteenth and Twentieth Century Paintings in the Collection of Doctor and Mrs. Harry Bakwin
Wellesley: Wellesley College Art Museum, 1967.

Baltimore 1968
From El Greco to Pollock: Early and Late Works
Baltimore: Museum of Art, 1968.

Beverly Hills 1968
Frank Perls Presents: Six Sculptures by Henri Matisse
Beverly Hills: Frank Perls Art Dealer, January 15-February 15, 1968.
Catalogue with text by Alfred Barr (excerpt from his book, *Matisse, His Art and His Public*, 1951).

London 1968
Matisse, 1869-1954, A Retrospective Exhibition.
London: Hayward Gallery, July 11-September 8, 1968. (Eight sculptures, ten cut-outs, paintings, and graphics.)
Catalogue by Lawrence Gowing, expanding the essay of the 1966 MoMA exhibition, no. 100.

Reviews: Burr, J. "Hymn of Hedonism: Art Council's Retrospective." *Apollo* 88 (July 1968): 62; Gordon, A. "Hayward Gallery Opens with a Large Retrospective of Matisse." *Connoisseur* 168 (July 1968): 186-88; Gouk, A. "Apropos Some Recent Exhibits in London." *Studio* 176 (October 1968): 125; Melville, R. "Matisse." *Arch. Rev.* 144 (October 1968): 292-94, no. 645; Roberts, K. "Exhibit at New Hayward Gallery." *Burlington Mag.* 110 (August 1968): 476; Russell,

J. "Exhibit at Hayward Gallery." *Art News* 67 (September 1968): 21; Schneider, Pierre. "Dans la lumière de Matisse." *Express* (August 12, 1968).

Thirty-four Recently Acquired Lithographs and Aquatints by Henri Matisse
London: Lumley Cazalet, Ltd., July 10-August 30, 1968.
Catalogue with two-page introduction by Susan Lambert; all works illustrated in black and white.

Sotheby Exhbition and Sale of Diaghilev Costumes, Curtains, Sketches
London: Scala Theatre, July 17 and 18, 1968.
Well-illustrated catalogue with introduction by Richard Buckle. Matisse's pencil-sketch costume design for one of the Warriors in *Le Chant du Rossignol* was sold for 2,200 pounds.

Review: G. W. "Dance and Drama in the Sale-Room." *Apollo* 90 (October 1969): 356-59.

Matisse Prints / Posters by Mourlot
London: Lumley Cazalet Gallery, August-December 1968.

Review: Burr, J. "Matisse Lithographs and Aquatints." *Apollo* 88 (August 1968): 138; "On Exhibition." *Studio* 176 (December 1968): 270.

New York 1968
Fauves and Expressionists
New York: Leonard Hutton Galleries, April 18-June 12, 1968.
Handsome catalogue with many color plates; essays by Bernard Dorival and Leopold Reidemeister, condensed from the catalogue, *Le Fauvisme français et les débuts de l'expressionnisme allemand,* Paris and Munich, 1966, nos. 1214 and 1259.

Review: Rosennstein, H. "French Beasts and Tormented Teutons." *Art News* 67 (May 1968): 46-47.

Primitive to Picasso
New York: M. Knoedler and Co., December 2-21, 1968.

Stockholm 1968
Henri Matisse, "Apollon;" Pablo Picasso "Femme nu au rocking-chair" (on exhibit before auction on January 31, 1968).
Stockholm: Svensk-Franska Konstgalleriet, January 1967.

Strasbourg 1968
L'Art en Europe autour de 1918
Strasbourg: A l'Ancienne Douane, May 8-September 15, 1968.

Washington 1968
Painting in France, 1900-1967
Washington: National Gallery of Art; Boston: Museum of Fine Arts;
The Art Institute of Chicago, San Francisco: M. H. de Young
Memorial Museum.

Yerevan (Armenia) 1968
French Twentieth Century Painting
Yerevon: Art Gallery of Armenia, 1968.

Basel 1969
Die Fauves
Basel: Galerie Beyeler, 1969.

Beverly Hills 1969
Matisse: Thirty-four Recently Acquired Lithographs and Aquatints
Beverly Hills, California: Frank Perls Gallery, January 13-February 17,
1969.

Buffalo 1969
Works from the Hanley Collection at Canisius College
Buffalo: Canisius College, November 23-December 23, 1969;
Columbus: Columbus Gallery of Fine Arts, November 7-December 15,
1968.

Cairo 1969
La Peinture française du XXe siècle
Cairo: February; Teheran, March 15-April 15, 1969; Athens: Gal. d'Art
de l'Hotel Hilton, May 9-June 6; Ankara, Istanbul.

Geneva 1969
An Exhibition and Sale of Impressionist and Modern Art
Geneva: Christie's, November 6, 1969.

London 1969
Henri Matisse--Sculpture
London: Victor Waddington , June 12-July 12, 1969 (Sixteen bronzes
and eleven lithographs--*The Dance,* put on stone in 1931/32, printed in
1967.)
Small, elegant catalogue on good stock with substantial essay by
William Tucker, no. 217; checklist and reproduction of all works
shown.

Forty-nine Bronzes by Henri Matisse (Sale of Arensberg collection)
London: Sotheby and Co.: July 1969.
Catalogue, *Forty-nine Bronzes by Matisse,* edited and introduced by
Monroe Wheeler.

Malines 1969
Fauvismus in de Europese Kunst
Malines: Cultureel Centrum Burgmeester Antoon Spinoy, 1969.
Catalogue with preface by J. Leymarie, Em. Lanui, and D. Van Dalle.

Montreal 1969
Portraits et figures de France
Montreal: Musée des Beaux-Arts, December 1969-February 1970;
Québec: Musée, March-April, 1970.

Moscow 1969
*Matisse: Peintures Sculpture, Oeuvre Graphique, Lettres [Matiss.
Zhivopis, sku'ptura, grafika, pisma (Albom)]*
Moscow: Pushkin State Museum of Fine Arts, March-June, 1969;
Leningrad: Hermitage, September-October, 1969. (Painting, sculpture,
prints, fifty-one drawings.) Anniversary exhibition of the artist's birth
in 1969.
An excellent well-illustrated catalogue by M. Alpatov, no. 47, in
Russian that includes twenty letters in French from Matisse to
Alexander Romm (1934-36) and to Morosov (1911-13), to
Tcherniowsky (1934), and the director of the Museum of Modern Art in

Moscow (1935). Leningrad: Sovetskij khudoznik, 1969. Essay on illustrated books by Yuri Russakov, on sculpture by N. K. Kosareva, on paintings by A. N. Izergina, and on drawings by E. C. Levitin.

Review: Kaptereva, T. "Crónica de Moscú." *Goya* 93 (November 1969): 175.

New York 1969
Matisse and Braque
New York: Borgenicht Gallery, Summer 1969.

Review: "Hommage to Matisse and Braque." *Arts Mag.* 43 (Summer 1969): 68; Mellow, J. "New York Letter." *Art Int.* 13 (Summer 1969): 48.

Twentieth Century Art from the Nelson Aldrich Rockefeller Collection
New York: Museum of Modern Art, May 26-September 1, 1969.
(Seven works by Matisse.)
Catalogue with preface by Monroe Wheeler, introduction by Nelson Rockefeller, and essay on the collection by William Lieberman.

Review: Mellow, J. "New York Letter." *Art Int.* 13 (Summer 1969): 48.

Paris 1969
Cent ans de peinture française
Paris: Galerie Schmit, May 7-June 7, 1967.

Art et travail
Paris: Musée Galliéra, October 25-November 30, 1969.

Prague 1969-70
Matisse [Ze sbírek sovetskych muzeí]
Prague: National Gallery of Prague, Sternbersky Palace, December 1969-February 1970.
Small catalogue in black and white; short text.

Reviews: "Expoción Matisse en la Galeria Nacional de Praga." *Goya* 94 (January 1970): 263.

Saint-Paul-de-Vence 1969

A la Rencontre de Matisse
Saint-Paul-de-Vence: Fondation Maeght, July-September, 1969 (sixty-four drawings' six cutouts).
Important, beautifully produced catalogue with text by Aragon.

Review: Peppiatt, M. "South of France: exhibitions." *Art Int.* 13 (October 1969): 73+.

Peintres illustrateurs; Le livre illustré moderne depuis Manet
Saint-Paul-de-Vence: Fondation Maeght, July-September 1969.

Strasbourg 1969
Les Ballets Russes de Serge Diaghilev, 1909-1929
Strasbourg: Ancienne Douane, May 15-September 15, 1969.

Toronto 1969
Henri Matisse Drawings
Toronto: The Gerald Morris Gallery, April 12-30, 1969.

Youngstown 1969
From the Collection of Ferdinand Howald
Youngstown: Butler Institue of American Art, March 2-30, 1969;
Columbus: Columbus Gallery of Fine Arts, October 10-December 31, 1969.

Review: Young, M. S. "Letter from Columbus, Ohio; Ferdinand Howald, Art of the Collector." *Apollo* 90 (October 1969): 343.

Basel 1970
Collection Marie Cuttoli-Henri Laugier, Paris
Basel: Galerie Beyeler, October-November 1970.
Catalogue.

Bordeaux 1970
Hommage à Henri Matisse
Bordeaux: Musée des Beaux Arts, May 2-September 1, 1970. (Seven drawings.)

Buffalo 1970

Color and Field
Buffalo: Albright Knox Gallery, September 15-November 1, 1970; traveled to Dayton and Cleveland in 1971.

Chatillon 1970
Le Jardin de Matisse
Chatillon: Salle des Fêtes, October 1970.
Simple catalogue with preface by Jean Moulin, poem by Aragon: "Le Nouveau crève-coeur" (1947), with pullout print on coated stock of *Venus*.

Copenhagen 1970
Matisse. En Retrospektiv udstilling / Henri Matisse Plakaten
Copenhagen: Statens Museum for Kunst, October 10-November 29, 1970. (Twenty-one sculptures, sixteen drawings.)
Catalogue with introduction by Hanne Finsen, texts by Denys Sutton and Pierre Soulages.

Darmstadt 1970
III. Internationale der Zeichnung, Sonderausstellung Gustav Klimt-Henri Matisse
Darmstadt: Mathildenhöhe, August 15-November 11, 1970. (Eighty-two drawings.)
Substantial catalogue with text on Matisse's drawings by Werner Haftmann, no. 280.

Düsseldorf 1970
Buchgrafik des XX. Jahrhunderts
Düsseldorf: Kunstmuseum, February- April, 1970.

Geneva 1970
Henri Matisse, trente-huit lithographies, aquatints et eaux-fortes
Geneva: Galerie Georges Moos, February 19-March 25, 1970.
Small, elegant, fully illustrated catalogue with introductory essay by Rainer Michael Mason.

London 1970
Henri Matisse, Forty Lithographs, Etchings and Aquatints
London: Lumley Cazalet, Ltd., April 23-May 30, 1970.

Small catalogue with all works reproduced, no text; a fine drypoint of an odalisque on the front cover, a lithograph of Marguerite Matisse on the back.

Review: Burr, J. "Exhibitions in London." *Apollo* 91 (May 1970): 394; Thomas, R. "Graphics: Lumley Cazalet Gallery, London." *Art & Artists* 5 (June 1970): 70.

French Drawings and Modern Painting
London: Lefevre Gallery, December 1970.

Review: Dunlop, T. "Exhibitions in London." *Apollo* 92 (December 1970): 480-81.

Munich 1970
L'Expressionnisme européen
Munich: Haus der Kunst, March 7-May 10; Paris: Musée National d'Art Moderne, May 26-July 27, 1970.
Catalogue with texts by J. Leymarie, P. Vogt, and L. J. F. Wijsenbeck.

Review: Descargues, P. "Matisse parmi les expressionistes." *Connaissance arts* 220 (June 1970): 100-7.

New York 1970
Four Americans in Paris, The Collections of Gertrude Stein and Her Family
New York: Museum of Modern Art, January -March 1, 1970; modified version of the exhibit shown later in Baltimore, San Francisco, and Ottawa. (Thirty-four paintings, nine sculptures, fourteen prints, seventeen drawings.)
Uniquely designed catalogue with cut-out faux-leather cover, well-illustrated with period photographs and reproductions of works in the show. Texts include an introduction by the curator, Margaret Potter; "Matisse, Picasso and Gertrude Stein" by Leon Katz, no. 580; "More Adventures" by Leo Stein, no. 740; and "Portraits: Henri Matisse, Pablo Picasso" by Gertrude Stein, no. 736. Important essays on the Steins and Cones as collectors.

Reviews: Elderfield, John. "The Language of Pre-Abstract Art." *Artforum* 9 (February 1971): 46-51; Hughes, Robert. "Patrons and

Roped Climber." *Time* (December 14, 1970): 34-39; Mellow, J. R. "Exhibition Preview: Four Americans in Paris: the Collections of Gertrude Stein and Her Family." *Art in America* 58 (November 1970): 84-91; Prideaux, Tom. "Four Patron Saints in One Great Act." *Life* (January, 1971): 56-65; Ratcliff, Carter. "Four Americans in Paris: Museum of Modern Art, New York; Exhibit." *Art Int.* 15 (March 1971): 50; Young, M. S. "Springtime in Paris: *Four Americans in Paris* at the Museum of Modern Art, New York." *Apollo* 93 (February 1971): 135-40.

Impressionist and Modern Paintings
New York: Parke-Bernet, February 25, 1970. (Exhibition and sale.)

Henri Matisse, Drawings and Graphics
New York: La Boétie, Inc., April 21-May 16, 1970.
Small but handsome catalogue; ten illustrations of some twenty-six drawings and other other graphics.

Reviews: "Exhibit at La Boetie Gallery." *Art News* 69 (May 1970): 70; "Matisse at La Boetie Gallery." *Arts* 44 (May 1970): 61.

The Ferdinand Howald Collection
New York: Wildenstein and Co., May 19-July 3, 1970.

Les Fauves
New York: Sidney Janis Gallery, November 13-December 23, 1970.
Catalogue by Georges Duthuit and Robert Lebel.

Paris 1970
Chefs-d'oeuvre de Henri Matisse à l'occasion de son centenaire (au profit de la Fondation des Journalistes)
Paris: Galerie Bernheim-Jeune, February 10-March 10, 1970. (Ten drawings, among other works.)

Review: Dauriac, J. P. "Galerie Bernheim-Jeune, Paris: chefs-d'oeuvre de Matisse à l'occasion de son centenaire." *Pantheon* 28 (May 1970): 252.

Matisse
Paris: Galerie Dina Vierny, April 23-June 1, 1970. (Twenty-one

drawings.)

A luxury catalogue with excellent reproductions; letters to Dina Vierny from Matisse reproduced; short introduction by Pierre Schneider.

Henri Matisse, exposition du centenaire
Paris: Grand Palais, April -September 1970. (Twenty-eight bronzes, eighteen drawings.)
Catalogue well illustrated and documented; important essay by Pierre Schneider (see no. 154). Accompanied by portfolio of colored plates (no color in catalogue).

Reviews: Cabanne, Pierre. "Matisse une oeuvre magnifique et une exposition ratée." *Combat* (April 27, 1970); Chantelon, "Les Matisse dispersés de 1951 à 1970." *Le Monde* (November 4, 1970); Drweski, A. "Grand Palais, Paris; Exhibit." *Art and Artists* 5 (September 1970):45; Flanner, Janet [Genet]. Review. *New Yorker* (May 30, 1970): 86; Gállego, J. "Cronica de París: Apoteosis de Matisse." *Goya* 96 (May 1970): 360-62; Hahn, O. "Paris." *Arts Mag.* 45 (September 1970): 54; Herzogenberg, J. "Aus der Arbeit der Museen: CSSR; Matisse Ausstellung." *Pantheon* 28 (May 1970): 247; Hess, Thomas B. "The Most Beautiful Exhibition in the World: Matisse at the Grand Palais." *Art News* 69 (Summer 1970): 28-31+; "Hommage à Matisse: Grand Palais; Bibliothèque Nationale, Galerie Dina Vierny." *Pantheon* 28 (July 1970): 335-36; "Hommage à Matisse: Grand Palais, Paris; exposition." *Connaissance arts* 218 (April 1970): 17+; Lipsi, J. "Matisse-retrospektive, Grand Palais, Paris." *Werk* 57 (July 1970): 488; Marchiori, G. "Le Retour de Matisse: Grand Palais, Paris; exposition." *XXe Siècle* 35 (December 1970): 3-18; "Matisse-en-France." *Oeil* 184 (April 1970); Mellow, James R. "New York Letter." *Art Int.* 13 (Summer 1969): 48; Millard, Charles. "Matisse in Paris."*Hudson Rev.* 23 (Fall 1970): 540-45; Moffat, K. "Matisse in Paris: the Master's Centenary Is Royally Celebrated." *Artforum* 9 (October 1970): 69-71; Morris, George L. K. "Matisse Exhibition in Paris Celebrates 100th Birthday." idem, "A Brief Encounter with Matisse." *Life* 69 (August 28, 1970): 30-44, 47; Murphy, Richard W. "Matisse's Final Flowering." *Horizon* 12 (1970): 26-41; Pavel, Amelia. "Henri Matisse zum 100. Geburtstag." *Rev. Roumaine d'histoire de l'art* 6 (1970):107-13; Pleynet, Marcel. "Grand Palais, Paris; exhibit." *Art Int.* 14 (December 1970): 55; Préaud, Tamara. "Pour mieux comprendre l'exposition Matisse." *Jardin des Arts* 186

(May 1970); "Pour la 100e anniversaire de sa naissance, exposition au Grand Palais et à la Bibliothèque Nationale, Paris." *Gaz. Beaux-Arts* 6, 76 (December 1970): supp. 9; Restany, Pierre. "Au Grand Palais, la Mostra per il Centenario." *Domus* 491 (October 1970): 56; Russell, John. "Paris: Unrolling the Red Carpet." *Art in America* 58 (May 1970): 114; Russell, John. "Matisse en France." *Oeil* 184 (April 1970): 16-25; Schneider, Pierre. "Galeries nationales du Grand Palais: Henri Matisse." *Rev. du Louvre* 20, 2 (1970): 87-96 [lavishly illustrated promotional preview]; Schurr, G. "Paris: a Tribute to Matisse at the Grand Palais." *Connoisseur* 174 (July 1970): 202; Sutton, Denys. "The Mozart of Painting." *Apollo* 105 (November 1970): 358-65; idem, "Matisse Magic Again." *Financial Times* (June, 1970); "Hommage à Matisse: Grand Palais." *Conaissance arts* 218 (April 1970): 17+. A large clippings dossier of exhibition reviews is at the Bibliothèque National, Réserve, Paris.

Matisse, l'oeuvre gravé
Paris: Bibliothèque Nationale, April 30-Summer 1970.
Catalogue by F. Woimant (estampes) and J. Guichard-Meili (livres illustrés); essay, "Matisse et la splendeur des blancs," by Guichard-Meili, no. 278.

Review: Woimant, F. "Bibliothèque Nationale: Matisse Graveur et Peintre du Livre." *Rev. du Louvre* 20, 2 (1970): 97-100 [lavishly illustrated promotional preview]; "Hommage à Matisse: Grand Palais; Bibliothèque Nationale, Galerie Dina Vierny." *Pantheon* 28 (July 1970): 335-36.

Une Fête en cimmérie, les esquimaux vus par Henri Matisse
Paris: Centre Culturel Canadien, November 19, 1970-January 15, 1971.
Catalogue with texts by Pierre Schneider and Jean-Paul Riopelle, no. 1005.

Pully 1970
Henri Matisse, gravures et lithographies de 1900 à 1929
Pully: Maison Pullièrane, September 3-October 4, 1970.
Catalogue with introduction by Hans Hahnloser, "En visite chez Henri Matisse," nos. 281 and 546, and an afterword by the curator-editor, Margrit Hahnloser-Ingold, "Notes sur l'oeuvre graphique de Henri Matisse," no. 281.

Saint-Paul-de-Vence 1970
A la rencontre de Pierre Reverdy et ses amis
Saint-Paul-de-Vence: Fondation Maeght, 1970.

Strasbourg 1970
L'Art en Europe en 1925
Strasbourg: Ancienne Douane, May 14-September 15, 1970.

Baltimore 1971
Matisse as a Draughtsman
Baltimore: Baltimore Museum of Art, January 12-February 21, 1971;
San Francisco: California Palace of the Legion of Honor, March 20-
May 9, 1971; Chicago: The Art Institute of Chicago, May 26-July 10,
1971. (Eighty drawings.)
Catalogue with quality reproductions and excellent text and
documentation by Victor Carlson; new edition, New York: Hacker Art
Books, 1982.

Reviews: Butler, J. T. "Matisse as a Draughtsman at the Baltimore
Museum of Art." *Connoisseur* 176 (April 1971): 289; Davis, F.
"Elegant Pen of Matisse." *Country Life* 150 (November 4, 1971):
1206; "Matisse as a Draughtsman at the Baltimore Museum of Art;
Exhibit." *Art News* 69 (January 1971): 8; "Matisse as a Draughtsman,
at the Baltimore Museum." *Apollo* 93 (February 1971): 141-42;
Werner, A. "Baltimore Museum of Art: Exhibition; Henri Matisse."
Pantheon 29 (May 1971): 252; Review. *Arts Mag.* 45 (February
1971): 50.

Beyreuth 1971
Henri Matisse
Beyreuth: Centre d'Art, May 1971.

Céret 1971
Hommage à Aragon
Céret: Musée d'Art Moderne de Céret, July-September 1971.

Jerusalem 1971
Henri Matisse. Prints and Drawings from a Swiss Private Collection
Jerusalem: The Israel Museum, Barbara and Isidore M. Cohen Gallery,
Autumn 1971. (Seven drawings.)

London 1971
Henri Matisse, Ten Portrait Drawings of Paul Matisse
London: Thomas Gibson Fine Art Ltd, April 14-May 22, 1971.
Small catalogue with all portraits reproduced; letter from Paul Matisse describing the session and how he had been influenced by his grandfather, no. 631.

Paris 1971
Delacroix at le fauvisme
Paris: Musée Delacroix, May-November, 1970.

Saint-Paul-de-Vence 1971
Exposition de René Char
Saint-Paul-de-Vence: Fondation Maeght, 1971; Paris: Musée d'Art Moderne de la Ville de Paris, 1971.

Tel Aviv 1971
Grands maîtres français du XXième siècle
Tel Aviv: Tel Aviv Museum, April 19-July 1, 1971.

Tokyo 1971
One Hundred Masterpieces from the USSR Museums
Tokyo, 1971; traveled to Kyoto.
Catalogue.

Zurich 1971
Henri Matisse, Twenty Important Paintings
Zurich: Marlborough Galerie, September-October 1971.
Catalogue with introduction by Franz Meyer, no. 1250; inauguration of Marlborough Gallery in Zurich.

Review: Daval, J. L. "Marlborough et Matisse conquèrent la Suisse." *Art Int.* 15 (October 1971): 49-51; Moholy, L. Review. *Burlington Mag.* 113 (November 1971): 682.

Chicago 1972
Henri Matisse, Master of Graphic Art, Woodcuts and Lithographs, 1904-29
Chicago: R. S. Johnson International Galleries, Fall 1972.
Catalogue with short introduction by Johnson; forty-six illustrations.

Jerusalem 1972
Henri Matisse: Prints and Drawings
Jerusalem: Israel Museum, 1972.
Illustrated catalogue; many works from private collections.

Leningrad 1972
Art of the Portrait
Leningrad: Hermitage Museum, 1972.
Catalogue entitled *Art of the Portrait: Ancient Egypt, Classical
Antiquities, The Orient, Western Europe.* Leningrad, 1972. In Russian.

London 1972
Henri Matisse, Drawings 1919-1952
London: Victor Waddington, July 6-29, 1972. (Nineteen drawings.)
Small catalogue with all drawings reproduced.

Henri Matisse, Lithographs and Aquatints (1942-1953)
London: Hester Van Royan Gallery, July 6-August 5, 1972.

Henri Matisse Lithographs
London: Victoria and Albert Museum and Bethnal Green Museum, June
12-July 6, 1972.
Catalogue and essay by Susan Lambert, no. 239; new ed., New York:
Universe Books, 1982. Fifty of the ninety works exhibited handsomely
reproduced.

Los Angeles 1972
Jazz and the Apocalypse du Saint-Sever: Beatus et Jazz
Los Angeles: Los Angeles County Museum of Art, April 11-May 28,
1972.
Catalogue with essay by Avigdor Arikha, no. 1010.

Munich 1972
Les Cultures du monde et l'art moderne
Munich: Haus der Kunst, June 15-September 30, 1972.

New York 1972
The Sculpture of Matisse
New York: Museum of Modern Art, February 24-May 8, 1972; traveled

to Minneapolis: Walker Art Center, June 20-August 6, 1972, and Berkeley: University Art Museum, September 18-October 29, 1972. (Sixty-nine sculptures, nineteen drawings.)
Catalogue with text by Alicia Legg, covering all sixty-nine known bronzes of Matisse with related sketches, no. 177. Complete list of sculpture exhibitions from 1904 to 1970.

Reviews: Butler, J. T. "American Way with Art; The Sculpture of Matisse." *Connoisseur* 180 (August 1972): 296+; Donadio, E. "Matisse Sculpture at the Museum of Modern Art." *Arts Mag.* 46 (April 1972): 62-63; Goldwater, Robert. "Sculpture of Matisse." *Art in America* 60 (March 1972): 40-45, no. 194; "Museum of Modern Art, New York; Exhibit." *Art Int.* 16 (May 1972): 50.

Matisse Graphics
New York: Reiss-Cohen Gallery, September 1972.

Review: Hancock, M. "Reviews." *Arts Mag.* 42 (November 1972): 79.

Otterlo 1972
Van Gogh tot Picasso (From Van Gogh to Picasso: 19th and 20th c. paintings and drawings from the Pushkin Museum in Moscow and the Hermitage Museum in Leningrad)
Otterlo, Netherlands: Rijksmuseum Kröller-Müller, April 30-July, 16, 1972.
Catalogue with entries by E. B. Georgievskaya, Anna Barskaya, K. I. Panis.

Paris 1972
LXXXIIIe exposition de la Société des artistes indépendants / Fauves et cubistes
Paris: Grand Palais, April 6-16, 1972. (Matisse represented by his program for *Les Mamelles des Tirésias* by Apollinaire of June 24, 1917; the linocut *Grand Nu assis* of 1906 is the illustration.)
Catalogue well illustrated with black and white reproductions; short preface by Claude Roger-Marx.

Elsa Triolet
Paris: Bibliothèque Nationale, 1972.

Prague 1972
From Poussin to Picasso, from the Pushkin Museum
Prague: National Gallery, 1972.
Catalogue in Czech.

Strasbourg 1972
Occident-Orient: l'art moderne et l'art islamique
Strasbourg: L'Ancienne Douane, May-September 1972.
Catalogue with texts by N. Berk, Michel Hoog, and Joseph-Émile
Muller.

Review: del Castillo, A. "Aduana de Estrasburgo [Occidente-Oriente]."
Goya 109 (July 1972): 27-8.

Toulouse 1972
*Sculptures, dessins, gouaches, lithographies de Henri Matisse; Art
esquimau contemporain du Canada.*
Toulouse: Musée des Augustins, November 17-December 15, 1972.
Catalogue with introduction by Denis Milhau.

Wolfenbüttel 1972
Henri Matisse
Wolfenbüttel: Herzog-August-Bibliothek, July 19-September 24, 1972.
Small illustrated catalogue.

Belgrade 1973-74
Exposition de peinture moderne française
Belgrade: Galerie de l'Art Moderne, 1973; Sarajevo: Musée; Ljubljana:
Galerie d'Art Moderne; Zagreb: Galerie d'Art Moderne, 1974.

Chapel Hill 1973
Matisse, His Sources and His Contemporaries; Prints and Sculptures
Chapel Hill, North Carolina: Ackland Art Center, Univ. of North
Carolina, October 7-28, 1973.
Ambitious, informative, inexpensively produced catalogue with essay
by Mary Martha Ward. "Sources" include Cézanne, Puvis de
Chavannes, Rodin, Degas, Gauguin, Lautrec, Cross; "contemporaries,"
Bonnard, Vuillard, Dufy, Derain, Picasso, Braque, Marcoussis, Miro,
etc.

Chicago 1973
Twentieth Century Drawings from Chicago Collections
Chicago: Museum of Contemporary Art, September 15-November 11, 1973. (Five drawings by Matisse.)

College Park 1973
Twentieth Century Masterpieces from the Musée de Grenoble
College Park: University of Maryland Art Gallery, November 7-December 21, 1973; exhibit traveled to Louisville: J. B. Speed Art Museum, and Austin: University of Texas Art Museum. (Eighteen drawings.)

Geneva 1973
Un dessin, une peinture - un dessin, une sculpture
Geneva: Marie-Louise Jeanneret-Art Moderne, June 21-September 20, 1973.

L'Art du XXe siècle
Geneva: Musée d'Art et d'Histoire, 1973.

Hempstead 1973
The Book Stripped Bare: A Survey of books by 20th c. Artists and Writers
Hempstead, New York: September 17-October 21, 1973.

London 1973
Ferdinand Howald, Avant-Garde Collector
London: Wildenstein and Co., June 20-July 21, 1973.

Pioneers of Modern Sculpture
London: Hayward Gallery, 1972

Review: Melville, R. Review. *Arch. Rev.* 154 (November 1973): 327-30.

New York 1973
Twelve Years of Collecting from the Carnegie Institute
New York: Wildenstein Gallery, November 1973; traveled as "A French Way of Seeing" to Atlanta: The High Museum of Art, 1973.

Henri Matisse
New York: Acquavella Galleries, November 2-December 1, 1973.

Review: Jacobus, John. "An Art of Chamber-Music Proportion." *Art News* 72 (November 1973): 74-76; Review. *Art and Artists* 8 (September 1973): 31; Review. *Arts Mag.* 48 (November 1973) 68; Review. *Arts Canada* 30 (December 1973): 204; Review. *Apollo* 99 (January 1974): 67; Review. *Art Int.* 17 (November 1973): 31.

Paris 1973
Tableaux de maîtres français 1900-1955
Paris: Galerie Schmit, May 16-June 16, 1973.

Sculptures de peintres
Paris: Musée Rodin, 1973.

Hommage à Tériade
Paris: Grand Palais, May 16-September 3, 1973.
First and only exhibition of original cut-outs for *Jazz.*

Dessins français du Metropolitan Museum of Art, New York, de David à Picasso
Paris: Musée du Louvre, Cabinet des Dessins, October 25, 1973-Janurary 7, 1974.

Théodor Pallady 1871-1956
Paris: Musée d'Art Moderne de la Ville de Paris, December 1973-January 1974.

Tokyo 1973
Paris and Japan in the History of Modern Japanese Art
Tokyo: National Museum of Modern Art, September 15-November 4, 1973; traveled to Kyoto: National Museum of Modern Art, November 5-December 31.

Lavish, fully documented catalogue on artists influenced by the School of Paris; not so specifically on Matisse.

Masters of Modern Sculpture
Tokyo: Gallery Seibu, November 8-20, 1973.

Warsaw 1973

Maiarstwo Francuskie XVII-XX wiékowze zbiorow Ermitazu
[Exposition des maîtres français, Hermitage]
Warsaw: Palais Zachentu, April 4-28; Katowice, Musée Municipale,
May 3-15, 1973.

Winterthur 1973

Künstlerfreunde um Arthur und Hedy Hahnloser-Bühler
Winterthur: Kunstmuseum, September 23-November 11, 1974.

Zurich 1973

Henri Matisse, Graphik
Zurich: Galerie Kornfeld, March 16-May 11, 1973.
Small well-produced catalogue with fifty-four individual prints
reproduced; a suite of *Dancers* (6) and *Sirènes* (6) and a book not
reproduced. No text.

Albuquerque 1974

Florilège des Amours de Ronsard
Albuquerque: University of New Mexico Art Museum, 1974.
Catalogue is *Bulletin of the University of New Mexico Art Museum*,
no. 8, with essay by Garo Z. Antreasian.

Houston 1974

*The collection of John A. and Audrey Jones Beck; Impressionist and
Post-Impressionist Paintings*
Houston, Texas: Houston Museum of Fine Arts, 1974.
Catalogue by Thomas P. Lee for the first public showing of the Beck
collection.

Leningrad 1974

Anri Matiss, Novie Knigi [Henri Matisse, Livres Nouveaux]
Leningrad: Hermitage, April 18-May 16, 1974.
Small catalogue of seventy-two works, presented to the Hermitage by
Madames M. Duthuit and L. Delectorskaya, with extended text by Yu.
Russakov; completely documented check list of works, including *Une
Fête en Cimmerie, Poèsies Antillaises.*

London 1974

Henri Matisse, Graphic Work
London: Lumley Cazalet, May 9-June 7, 1974.
Catalogue with texts by John Russell and J. Frank Perls.

Review: Gilmour, P. *Arts Rev.* 26 (May 17, 1974): 296; *Apollo* 99 (May 1974): 373.

Impressionist and Modern Paintings and Sculpture
London: Sotheby's, December 4, 1974. (Exhibition and sale.)

Los Angeles 1974
Twenty Years of Acquisition: Evolution of a University Study Collection
Los Angeles: Grunwald Center for the Graphic Arts, April 9-June 2, 1974.
Catalogue with foreword by Charles Young, introduction by E. Maurice Bloch; Matisse well represented.

Marseille 1974
130 Dessins de Matisse
Marseille: Musée Cantini, June 15-September 15, 1974.
Compact, fully illustrated and documented catalogue; includes Matisse's text, "Exactitude n'est pas la verité."

Review: Peppiat, M. "Images of Delight and Fertility: Musée Cantini." *Art News* 73 (November 1974): 66+; Rigden, Geoff. "130 Drawings of Matisse." *One* (UK) 6 (May-June 1975): 14-17; Review. *Connoisseur* 187 (September 1974): 62.

Montreal 1974
Henri Matisse, lithographs, aquatints, linoleum cuts
Montreal: Waddington Galleries, September 25, 1974.

New York 1974
Cone Collection
New York: Wildenstein and Co., March-May, 1974.

Review: Cone, J. H. "The Cone Collection at the Wildenstein." *Arts Mag.* 48, 7 (April 1974): 56-58.

Important 19th and 20th Century Paintings and Sculpture
New York: Sotheby Parke-Bernet, May 2, 1974. (Exhibition and sale.)

Seurat to Matisse: Drawing in France; Selections from the Collection of the Museum of Modern Art.
New York: Museum of Modern Art, June 13-September 8, 1974.

Review: Ashton, Dore. "Seurat to Matisse, Drawing in France." *Art News* 73 (September 1974): 99, no. 261.

Nice 1974
Henri Matisse-sculptures
Nice: Musée Matisse, July 19-September 29, 1974. (Sixty-eight sculptures.)
Well-illustrated and documented catalogue with short preface by Jean Leymarie; other commentary by Colett Audibert and Henri Bernardi.

Okayama 1974
Gustave Moreau et ses élèves
Okayama: Magasin Teyaman, February 15-March 6, 1974; Hiroshima: Magasin Teyaman, March 15-30; Tokyo: Magasin Tobu, April 6-23, 1974.

Osaka 1974
Exposition Les Fauves
Osaka: Galeries Seibu Takatsuki, November 15-December 8, 1974; traveled to Tokyo and Kanazawa.
Catalogue Includes artists' biographies, a chronology, and a short essay on Fauvism by Jean Mélas Kyriazi. Introduction and scholarly notes by François Daulte in French and Japanese; all other textual material in Japanese only. An article, "Reflections," by Matisse is simply a series of quotations from the Apollinaire interview of 1908 and the Tériade interview of 1929. Published by Yomiuri Shimbun Sha, which organized the exhibition for the seventieth anniversary of the Salon d'Automne of 1905.

Paris 1974
Dessins du Musée National d'Art Moderne, 1890-1945
Paris: Musée National d'Art Moderne, November 22, 1974-January 20, 1975. (Seven drawings.)

Catalogue by Pierre Georgel, Maria-José Stern, Marielle Tabart; account of Matisse's gifts to the museum.

Maîtres-graveurs contemporains
Paris: Galerie Berggruen et Cie., 1974.

Stockholm 1974
Henri Matisse
Stockholm: Moderna Museet, November 3, 1974-January 6, 1975
Catalogue by Nina Ohman; introduction by Ulf Linde.

Toronto 1974
Henri Matisse, An Exposition of Drawing and Sculpture
Toronto: David Mirvish Gallery, November 16-December 4, 1974. (Ten drawings.)

Washington, D. C. 1974-75
Sculptors and Their Drawings; Selections from the Hirshorn museum and Sculpture Gaarden.
Washington, D. C.: Smithsonian Institute, Joseph H. Hirshorn Museum, and Austin: Lyndon Baines Johnson Library, October 4, 1974-January 1975. Traveled to Middletown, Connecticut: Center for the Arts Gallery, January 23-February 29 1975.
Small catalogue by Cynthia Jaffee McCabe, organiser of the show; one sculpture and one related drawing by twelve artists.

Chicago 1975
Raiment for the Lord's Service: A Thousand Years of Western Vestments
Chicago: Art Institute of Chicago, November 15, 1975-January 18, 1976.

Grenoble 1975
Matisse au Musée de Grenoble
Grenoble: Musée de Peinture et de Sculpture, 1975.
Important scholarly catalogue by Dominique Fourcade, no. 89.

Hartford 1975

Selections from the Joseph L. Shulman Collection
Hartford, Connecticut: Wadsworth Atheneum, March 5-April 13, 1975.
Catalogue with texts by James Elliott, Joseph L. Shulman, and Mark
Rosenthal.

Kobe 1975
Collections des Musées de Nice et de la Côte d'Azur: Renoir, Matisse, Dufy
Kobe: Musée d'Art Moderne de Hyôgo [Kobe Shimbunsha], April 12-
May 11, 1975; traveled to Utsunomiya: Musée des Beaux-Arts de
Tochigi; Sapporo: Galerie Tokyu; Nagoya: Oriental Nakamura;
Takamatsu: Centre Culturel de la Préfecture de Kagawa; Nara: Musée
des Beaux-Arts.
Catalogue (157 pages) with both black and white and color plates. Text
in French and Japanese.

London 1975
Matisse, Light and Colour in Line Drawing
London: Thomas Gibson Fine Art, Ltd., March 24-April 25, 1975.

Review: Forsyth, Susan. "Matisse." *Arts Rev.* 17, 13 (June 27,
1975): 375; *Arch. Rev.* 157 (June 1975): 361.

Review: Burr, James. "The Select Few." *Apollo* 101 (June 1975): 479-
80; Forsyth, Susan. "Matisse." *Arts Rev.* 17, 13 (June 27, 1975):
375.

Hommage à Tériade
London: Royal Academy of the Arts, August 9-October 12, 1975.
Catalogue by Michel Anthonioz; mostly illustrations from the editor's
Grands livres.

Paris 1975
Matisse, Dessins et Sculpture / tekeningen en sculpturen
Paris: Musée National d'Art Moderne, May 20-September 7, 1975;
Brussels: Palais des Beaux-Arts, September 27-October 26, 1975
(Sixty-nine sculptures.)
Important catalogue with introduction by Dominique Bozo and
important text by Dominque Fourcade, "'Je crois qu'en dessin j'ai pu
dire quelque chose. . .'", no. 230; with works fully documented and

reproduced by Isabelle Monod-Fontaine and Nicole Barbiek, bibliography, and list of exhibitions. Separate catalogue, *Tekeningen en sculpturen*, in French and Dutch for the Brussels show; quality reproductions with descriptive captions; introduction by Dominique Bozo, no other text.

Review: Brenson, Michael. *Art in America* 63, 4 (July-August 1975): 50-54; Descargues, Pierre. "Matisse en noir et blanc." *Plaisir de France* 41, 430 (June 1975): 50-54; "Dibujos y esculturas de Matisse, Brussels." *Goya* 129 (November 1975): 187; Micha, René. "The 'Creative Method' of Matisse." *Art Int.* 19 (October 1975): 58-60; Winter, P. *Kunstwerk* 28, 5 (September 1975): 47-48.

James Joyce et Paris
Paris: Centre Pompidou, Bibliothèque d'information, July 16-July 13, 1975.

Providence 1975
French Watercolors and Drawings from the Museum's Collections, 1800-1910
Providence, Rhode Island: Rhode Island School of Design, 1975.
Catalogue by Kermit Champa, published in *Rhode Island School of Design Museum Notes* 61, 5 (April 1975): 9-176.

Recklinghausen 1975
Der Einzelne und die Masse
Recklinghausen: Kunsthalle, Ruhrfestspiele, May 22-July 10, 1975.

San Francisco 1975
Henri Matisse: an Exhibition of Selected Drawings in Homage to Frank Perls
San Francisco: John Berggruen Gallery, Fall 1975; traveled to Los Angeles, Margo Leavin Gallery, November 1975.
Catalogue; forty-three drawings, three prints.

Santa Cruz 1975
Les Visages, Arnovich collection
Santa Cruz, California: Cowel College Gallery, January 19-February 15, 1975; traveled to New York: Eloise Pickard Smith Gallery, 1975.
Sixty-eight lithographs by Matisse from the Jane and Peter G.

Arnovich Collection; catalogue with introduction by Gene von Hartmann.

Sochaux 1975
Trente-trois dessins du Musée National d'Art Moderne
Sochaux: Maison des Arts et Loisirs, May 22-June 22, 1975.

Sydney 1975
Modern Masters: Manet to Matisse
Sydney: Art Gallery of South Wales, April 11-May 11, 1975; Melbourne: National Gallery of Victoria, May 26-June 23, 1975; New York, Museum of Modern Art, August 4-September 1, 1975. Well-illustrated, substantial catalogue edited by William Lieberman.

Review: (In New York) Russell, John. *New York Times* (August 4, 1975): 15; Canaday, John. *New York Times* (August 17, 1975): sec. 2: 1, 21.

Toronto 1975
The Fauves
Toronto: Art Gallery of Toronto, April 11-May 11, 1975.
Documented catalogue with text by Richard J. Wattenmaker, no. 1188.

Basel 1976
Autres Dimensions, collages, assemblages, réliefs. . .
Basel: Galerie Beyeler, June-September 1976.
Handsome catalogue with text by Andreas Franzke; excellent color reproductions. In French and German.

Dresden 1976
Monet, Cézanne, Gauguin, Picasso und Matisse; Meisterwerken aus dem Puschkin Museum, Moskau.
Dresden: Gemälde Galerie, 1976.
Catalogue.

Grand Couronne 1976
Hommage à Henri Matisse
Grand Couronne and Saint Etienne du Rouvray: May 15-June 4, 1976.
Small catalogue with short essay by Raoul-Jean Moulin. The exhibition contained ten prints by Matisse and the work of eight

contemporary painters: Bellegarde, Lybinka, Messagier, Mihaïlovich, P. Humbert, Risos, Tabuchi and Viseux. (Thirty-five works in all.)

London 1976
Master Drawings and Prints
London: Agnew Gallery, Summer 1976. (Drawing: *Coupe de raisin* by Matisse).

Review: Melville, Robert. "Gallery, Possibly Decadent." *Arch. Rev.* 159 (June 1976): 377-78.

Henri Matisse, Paintings, Drawings, Color Crayons
London: Victor Waddington Gallery, June 9-July 10, 1976.

Review: *Burlington Mag.* 118 (August 1976): 608.

Los Angeles 1976
Matisse Prints
Los Angeles: Margo Leavin Gallery, January 1976.

Review: "Margo Leavin Gallery." *Art News* 75 (January 1976): 67-8.

Montreal 1976
Master Paintings from the Hermitage and the State Russian Museum
Montreal: Museum of Fine Arts, December 1976-January 1977.

Review: Bates, C. *Artmagazine* 8, 30 (December 1976-January 1977): 11-13.

New York 1976
The "Wild Beasts": Fauvism and Its Affinities
New York: Museum of Modern Art, March 26-June 1, 1976; traveled to San Francisco: Museum of Modern Art, June 29-August 15, 1976; Fort Worth: Kimball Art Museum, September 11-October 31, 1976. Important, well-illustrated, and documented catalogue by John Elderfield, no. 1168.

Review: Dorra, Henri. "Wild Beasts--Fauvism and Its Affinities at the Museum of Modern Art." *Art Journal* 36, 1 ((Fall 1976): 50-54; Goldin, Amy. "Forever Wild: a Pride of Fauves." *Art in America* 64, 3 (May-June 1976): 90-95; Hobhouse, Janet, "Fauve Years: a Case of Derailments." *Art News* 75 (Summer 1976): 47-50; Lampert, C. "Wild

Beasts, Museum of Modern Art." *Studio* 192 (July 1976): 78-9; [San Francisco venue] Werner, A. "The Life-Enhancing Work of Henri Matisse." *American Artist* 40 (August 1976): 20-25+, no. 765.

Matisse - Gaudi: Ecclesiastical Design
New York: Museum of Modern Art, November 15, 1976-January 9, 1977.

Directed by J. Stewart Johnson.

Between World Wars: Drawings and Paintings in Europe
New York: Museum of Modern Art, August 20-November 19, 1976.
Organized by William Lieberman.

European Master Paintings from Swiss Collections: Post-Impressonism to World War II
New York: Museum of Modern Art, December 17, 1976-March 1, 1977.
Catalogue by John Elderfield, foreword by William Rubin.

Review: Russell, John. *New York Times* (January 9, 1977): D23.

Nice 1976
Collections des Musées de Nice et de la Côte d'Azur
Nice: Musée des Beaux-Arts Jules Chéret, Spring 1976.

Paris 1976
Techniques de la peinture, l'atelier du peintre
Paris: Musée du Louvre, June 3-November 8, 1977.
Catalogue with text by Pierre Georgel and Jeanne Baticle.

Review: Baticle, Jeannine. "L'Atelier du Peintre." *Rev. du Louvre* 26, 3 (1976): 225.

Matisse, Léger, Picasso.
Paris: Musée National d'Art Moderne, July 13-September 13, 1976.

Berlin 1977
Tendenzen der Zwanzigerjahre, Neue Wirkichkeit: Surrealismus und Neue Sachlichkeit
Berlin: Orangerie, Schloss Charlottenburg, August 14-October 16,

1977; traveled elsewhere.
Substantial catalogue by W. Schmied and M. Eberle.

Buffalo 1977
The School of Paris: Drawing in France (from the Museum of Modern Art)
Buffalo: Albright-Knox Gallery, April 29-May 5, 1977; Saint Louis: Art Museum, June 30-August 21, 1977; Seattle: Art Museum, September 25- November 26, 1977.
Catalogue with introduction by William Lieberman; selection from collection of MoMA drawings, 1904 to 1954.

Claremont 1977
Works on Paper 1900-1960: From Southern California Collections
Claremont, California: Montgomery Art Gallery, Pomona College, September 18-November 3, 1977; traveled to San Francisco: M. H. de Young Memorial Museum, November 11-December 31, 1977.
Catalogue by Frederick S. Wight.

Review: Stofflet-Santiago, M. *Artweek* 8, 44 (December 24, 1977): 1, 16.

Düsseldorf 1977
Vom Licht zur Farbe: Nachimpressionistische Malerei zwischen 1886 und 1912.
Düsseldorf: Städtische Kunsthalle, May 27-July 10, 1977.
Substantial catalogue by J. Harten, Robert L. Herbert, and J. Mathieson; an essay by Harten attempts to order and clarify the "isms" included under the broad category of Post-Impressionism.

Leningrad 1977
New Acquisitions of the Hermitage 1966-77
Leningrad: Hermitage, 1977.
Catalogue in Russian.

London 1977-79
19th and 20th Century Drawings and Prints from the Courtauld Collection
London: Arts Council of Great Britain, traveled to various British

venues from late 1977 to March 1979.
Catalogue with essay on Samuel Courtauld by Michael Harrison.

Moscow and Leningrad 1977-78
Onze Tableaux au Fonds du Centre National d'Art Moderne et Centre Georges Pompidou
Moscow: Pushkin Museum, August 1977-January 1978; itinerary included Leningrad: Hermitage, and Paris: Centre Georges Pompidou.
Catalogue in Russian and French by Marina A. Bessonova.

Munich 1977
Exempla 77: le culte et ses objets / Handwerk messe.
Munich: March-April l 1977; Paris: Chapelle de la Sorbonne, May 10-August 31, 1977.

Impressionismus, Pont-Aven, Nabis, Fauves: Skizzen und Bilder à l'hommage de A. W. Heymel
Munich: Kunsthandel Sabine Helms, November 17-December 31, 1977.
Catalogue with thirty-eight page supplement, "Alfred Walter Heymel, 1878-1914, Geschichte einer Sammlung."

New York 1977
Painting and Sculpture in the Museum of Modern Art, 1929-1967
New York: Museum of Modern Art, 1977.
Catalogue with text of Alfred H. Barr, Jr.

Matisse: The Swimming Pool
New York: Museum of Modern Art, March 11-August 1, 1977
Installation by Alica Legg.

The Nude: Avery and the European Masters
New York: Borgenicht Gallery, Spring 1977.

Review: Ratcliff, Carter. "Remarks on the Nude." *Art Int.* 21 (March-April 1977): 60-65, no. 694.

Nothing but Nudes
New York: Whitney Museum of American Art, 1977.

Review: Ratcliff, Carter. "Remarks on the Nude." *Art Int*. 21 (March-April 1977): 60-65.

Twentieth Century Paintings and Sculpture, Matisse to de Kooning
New York: Xavier Fourcade Inc., March 29-April 30, 1977.
Small catalogue.

Impressionist and Modern Paintings
New York: Christie's, May 10-16, 1977. (Exhibition and sale.)

Paris 1977
*Musée National d'Art Moderne--Acquisitions du Cabinet d'Art
Graphique, 1971-1976*
Paris: Musée National d'Art Moderne, January 31-March 28, 1977.

Apollinaire aujourd'hui
Paris: Musée National d'Art Moderne, February 1977.

Paris-New York
Paris: Musée National d'Art Moderne, June 1-September 19, 1977, repr.
1991.
Important, lavishly produced scholarly catalogue; includes two essays
by Hélène Seckel: "27, rue de Fluerus, 58, rue Madame: Les Stein à
Paris," no. 1341, and "L'Academie Matisse," no. 728.

Washington 1977-78
The Paper Cut-Outs of Henri Matisse
Washington D. C.: National Gallery of Art, September 10-October 23,
1977; Detroit: Detroit Institute of Art, November 23-January 8, 1978;
Saint Louis: Saint Louis Art Museum, January 29-March 12, 1978.
Exceptional catalogue with essays by Jack Cowart, John Hallmark
Neff, Jack Flam, Dominique Fourcade; each exhibited work reproduced
with scholarly entries (bibliography, history, etc.), no. 307.

Review: Baker, Kenneth. *Artforum* 16, 5 (January 1978): 60-3;
Cowart, J. *Saint Louis Art Museum Bulletin* 14, 1 (January-March
1978): 2-5; Forgey, B. "The Matisse Cut-Outs," *Art News* 76, 10
(December 1977): 66-9; Harris, J. *New Art Examiner* 5, 6 (March
1978): 12; Hudson, A. *Artmagazine* 9, 36 (December 1977-January
1978): 12-17; Kramer, Hilton. *New York Times* (September 9, 1977):

C15; Motherwell, Robert. *New York Times Book Review* (January 4, 1978): 12, 43-3; Russell, John. *New York Times* (September 18, 1977): 1, 29; Wright, M. *Art Int.* 21, 5 (October-November 1977): 51-2; *Apollo* 106, 190 (December 1977): 509.

Austin 1978
The Color of Color
Austin, Texas: University of Texas College of Fine Arts, 1978.

Basel 1978
Petits Formats
Basel: Galerie Beyeler, May-July 1978.

Bielefeld 1978
Graphik des 20. Jahrhunderts aus eigenem Besitz
Bielefeld: Kunsthalle, 1978.
Show organized and catalogue edited by Erich Franz; some prints by Matisse included.

Bordeaux 1978
La Nature morte de Breughel à Soutine
Bordeaux: Galerie des Beaux-Arts, May 5-September 1, 1978.

Des Moines 1978
Art in Western Europe: The Post-War Years 1945-55
Des Moines, Iowa: Des Moines Art Center, September 19-October 29, 1978.
Catalogue by Lawrence Alloway; nineteen artists including Matisse.

London 1978
An Important Exhibition of Works by Henri Matisse
London: Marlborough Fine Art, Ltd., June-July, 1978.
Catalogue with notes by Nicholas Wadley.

Review: Denvir, Bernard. "La Dolce Vita." *Art and Artists* 13, 4 (August 1978): 12-17, no. 464; Review. "Marlborough Fine Arts." *Art Int.* 226 (Summer 1978): 40-2; Mullaly, Terence. *Apollo* 108 (August 1978):131-2.

Matisse, Drawings, Prints, Illustrated Books
London: Lumley Cazalet, June 15-July 28, 1978.

Review: Mullaly, T. *Apollo* 108, 198 (August 1978): 132.

Les Fauves
London: Lefevre Gallery, November 16-December 21, 1978.

*Paintings from Paris, Early 20th Century Paintings and Sculptures
from the Musée d'art moderne de la Ville de Paris*
London: Arts Council of Great Britain: May-June, 1978; traveled:
Oxford Museum of Modern Art (July 2-August 13, 1978); Norwich
Castle Museum (August 19-October 1, 1978); Manchester Whitworth
Art Gallery (October 7-November 11, 1978); Coventry Herbert Art
Gallery and Museum (November 18-December 31, 1978).
Catalogue by Michael Harrison and Joanna Drew; preface by Jacques
Lassaigne.

Review: Roberts. *Burlington Mag.* 120, 905 (August 1978): 552;
Macus. *Art & Artists* 13, 5 (September 1978): 18-21.

New York 1978-79
The Eye of [Alfred] Stieglitz
New York: Hirschl and Adler Gallery, October 7-November 2, 1978.

Matisse in the Collection of the Museum of Modern Art
New York: Museum of Modern Art, October 26, 1978-January 30,
1979.
Important catalogue fully documenting the works, by John Elderfield,
no. 78, with additional texts by William S. Lieberman, no. 291, and
Riva Castleman, no. 268.

Reviews: Bioulès, V. "Matisse: Museum of Modern Art, New York;
exhibit." *Flash Art/Heute Kunst* 88-89 (March-April 1979): 10-11;
idem, *Art Press Int.* 30 (July 1979): 18-19; Blistène, B. "On Matisse:
Museum of Modern Art, New York; Exhibit (with French text)." *Flash
Art/Heute Kunst* 88-89 (March-April 1979): 9, 59-60; Bremer, N.
"Matisse in the Collection of the Museum of Modern Art: Exhibit."
Pantheon 37, 2 (April 1979): 126+; Carlson, Victor. "Matisse in the
Collection of the Museum of Modern Art (review of exhibition
catalogue)." *Museum News* 57 (March 1979): 67; Gibson, E. "Matisse

in the Collection of the Museum of Modern Art, New York, Exhibit." *Art Int.* 22, 10 (March 1979): 43; "Museum of Modern Art, New York; Exhibit." *Burlington Mag.* 121 (January 1979): 64; "Museum of Modern Art, New York; Exhibit." *Flash Art/Heute Kunst* 86-87 (January-February 1979): 39; "Promised Gifts: Museum of Modern Art, New York: Ausstellung." *Kunstwerk* 32 (February 1979): 38; Russell, John. "A Monumental Showing of Matisse's Work." *New York Times*, December 3, 1978, D35; Schwartz, E. "Glory of Matisse: Museum of Modern Art, New York." *Art News* 78 (January 1979): 157; Watkins, Nicholas. *Burlington Mag.* 122, 923 (February 1980): 136-7.

The Evelyn Sharp Collection
New York: Solomon Guggenheim Museum, April 1-October 1, 1978.
Catalogue by Louise Averill Svendsen with Philip Verre and Hilarie Faberman; preface by Thomas M. Messer.

Prints by Old & Modern Masters from Dürer to Matisse
New York: Lucien Goldschmidt Inc., 1978. (Two works by Matisse.)

Paris 1978
Tableaux des maitres et des peintres contemporains
Paris: Galerie Tamenaga, October 18-November 10, 1978.

De Renoir à Matisse, vingt-deux chefs-d'oeuvre des musées sovietiques et français
Paris: Grand Palais, June 6-September 18, 1978.
Catalogue by Anne Distel and Michael Hoog under the direction of Hélène Adhémar. Eleven works from Soviet museums supplemented by eleven cognate works from the museums of Paris; Matisse works exhibited were *Young Girl and Tulips* (1910) and *Arums, Iris and Mimosas* (1913).

Review: Muratova, X. *Burlington Mag.* 120, 905 (August 1978): 560.

Donation Picasso: la collection personelle de Picasso.
Paris: Musée National du Louvre, 1978.
Catalogue with introduction by Jean Leymarie; includes Picasso's works by Matisse.

Importants livres illustrés et oeuvres originales d'artistes modernes
Paris: Hôtel Drouot, December 14, 1978. (Exhibition and sale.)

Rome 1978
Henri Matisse
Rome: Villa Medici and Académie de France, November 24, 1978-
January 28, 1979.
Catalogue with short essays by G. C. Argan, J. Leymarie, and texts by
Matisse; works exhibited are well illustrated and documented. Texts in
Italian, French, and English.

Reviews: Daix, Pierre. "Matisse á Rome: Exposition." *Gaz. beaux-arts*
6, 93 (March 1979): supp. 13-14; Turner, G. "Villa Medici, Rome;
Exhibit." *Connoisseur* 200 (February 1979): 152; "Villa Medici,
Roma; exposición." *Goya* 155 (March-April 1980): 315-16; *Domus
Int.* 592 (March 1979): 48.

Saint-Tropez 1978
D'un Espace à l'autre: la Fenêtre
Saint-Tropez: Musée de l'Annonciade, June 15-September 15, 1978.
Catalogue with important essays by Jean Laude (no. 902), Pierre
Schneider no. 718), Alain Mousseigne, et al. All works reproduced and
fully documented.

Baltimore 1979
*Master Drawings and Watercolors of the Nineteenth and Twentieth
Centuries*
Baltimore: Baltimore Museum of Art, August 1979.
Catalogue by Victor I. Carlson, with entries by Carol Hynning Smith.
Works from the Museum's collection.

Bern 1979
Skulptur: Matisse, Giacometti, Judd, Flavin, Andre, Long
Bern: Kunsthalle, August 17-September 23, 1979.
Exhibition contrasts sculpors of two generations. Catalogue by
Marianne Schmidt-Meischer and Johann Gachnang.

Review: Pohlen, A. *Kunstforum Int.* 5 (1979): 198-9.

Buffalo 1979

Matisse, Picasso, Prints in the Collection
Buffalo: Albright-Knox Art Gallery, July 3-August 5, 1979.
Small catalogue by Charlotte Kotik; fourteen prints by Matisse;
thirteen by Picasso.

*Modern European Sculpture, 1918-1945: Unknown Beings and Other
Realities*
Buffalo: Albright-Knox Art Gallery, May 12-July 15, 1979; traveled to
Minneapolis: Minneapolis Institute of Arts (July 22-September 2,
1979); San Francisco: San Francisco Museum of Modern Art (October
5-November 18, 1979).
Catalogue by Steven A. Nash, organizer of the exhibition, and Albert
E. Elsen. Published as Elsen's *Modern European Sculpture, 1918-1945.*
New York and Buffalo: George Braziller, Inc. and the Albright-Knox
Art Gallery, 1979.

Review: French. *Artweek* 19, 37 (November 10, 1979): 3; Schwartz,
E. *Art News* 78, 10 (December 1979): 60-62.

Huntington 1979
Henri Matisse: Jazz and Other Illustrated Books
Huntington, New York: Hecksher Museum, January 12-February 18,
1979.
Small catalogue with introduction by Katherine Lochridge and essay by
Ellen B. Hirshland. Other books included *Poesies de Stéphane
Mallarmé, Jazz, Repli, Charles d'Orléans, Apollinaire*; maquettes for
Verve IV, 13; ibid., VI, 21-22.

Kyoto 1979
*French Painting of the late 19th and 20th Centuries from the
collections of the Hermitage, Leningrad, and the Pushkin Museum of
Fine Arts, Moscow.*
Kyoto: 1979; traveled to Tokyo and Kamakura.

Leningrad 1979
New Acquisitions of the Hermitage 1978-79
Leningrad, Hermitage, 1979.
Catalogue: *Monuments of Culture and Art Acquired by the Hermitage
in 1978-79*, in Russian.

Peinture française (1909-1939) des collections du Musée National d'Art Moderne
Leningrad: Hermitage, September-October 1979; traveled to Moscow: Pushkin Museum, November-December 18, 1979.

London 1979
Important Impressionist and Modern Paintings and Drawings
London: Sotheby's, April 1-2, 1979. (Exhibition and sale.)

Post -Impressionism, Cross-Currents in European Painting, 1880-1906
London: The Royal Academy of Arts, November 17, 1979-March 16, 1980; traveled to Washington: National Gallery of Art, May 25-September 1, 1980. Handsome catalogue, with extensive documentation and substantive essays.

Review: Cork, Richard. "A Post-Mortem on Post-Impressionism." *Art in America* 68, 8 (October 1980): 149-53, no. 443.

Henri Matisse, Jean Arp
London: Theo Waddington Gallery, 1979.

Review: Lacey, J. *Arts Rev.* 31, 5 (March 16, 1979): 119.

Los Angeles 1979
Grunwald Center Acquisitions
Los Angeles: Grunwald Center for the Graphic Arts, July 1979-June 1980.

New York 1979
Impressionist, Modern and Contemporary Paintings and Sculpture
New York: Sotheby Parke Bernet, Inc., May 11-16, 1979. (Exhibition and sale.)

Matisse and Master Drawings from the Baltimore Museum of Art
New York: The Solomon R. Guggenheim Museum, August 24-October 8, 1979.

Review: Llorens, E. "La coleccion de las hermanas Cone del Museo di Baltimore en el Museo Guggenheim," *Goya* 152 (September-October 1979): 101-02.

Art of the Twenties
New York: Museum of Modern Art, November 14, 1979-January 22, 1980.
Substantial catalogue on this decade edited by William S. Lieberman and E. Kokkinen, with works drawn from the collection (significantly only two by Matisse--a painting and a print). No color reproductions; slight text.

Nice 1979
Henri Matisse, acquisitions récentes
Nice: Musée Matisse, November 1979.

Reviews: "Musée Matisse, Nice; exposition," *Art Int.* 23 (October 1979): 44-45; "Musée Matisse, Nice; Exposition," *L'Oeil* 292 (November 1979): 67.

Paris 1979
L'Oeil écoute de Gaeton Picon
Paris: Musée National d'Art Moderne, April 18-June 18, 1979.

Matisse dans les collections du Musée National d'Art Moderne, acquisitions récentes
Paris: Musée National d'Art Moderne, November 14-December 31, 1979. (Includes twenty drawings.)
Substantial catalogue with text and documentation by Isabelle Monod-Fontaine, no. 139.

Paris-Moscou 1900-1930
Paris: Musée National d'Art Moderne, 1979.
Important, lavishly illustrated, documented catalogue, includes an introduction by Jean-Hubert Martin and Carole Naggar that deals with, among other things, Matisse's role in the Paris-Moscow dialogue, no. 624.

Matisse-Jazz
Paris: Musée National d'Art Moderne, 1979. (Traveling exhibition.)
Catalogue.

Le Salon d'Automne of 1905 (Seventy-fifth anniversary of Fauvism)
Paris: Grand Palais, November 1-December 21, 1979.

Review: Mazars, Pierre. "Les Rugissements de la "Cage aux fauves." *Arts* (October 27, 1979):120-21+; Vignoht, G. "La Porte étroite." *Peintre* 592 (November 1, 1979): 3-7.

Pontoise 1979-1980

Aquarelles et dessins du Musée de Pontoise (acquisitions et dons récents)
Pontoise: Musée Tavet Delacour, Pontoise, December 1, 1979-January 31, 1980.
Catalogue by Isabelle Julia and Edda Maillet, with preface by Victor Beyer; thirty-two artists represented.

Review: "Aquarelles et dessins du Musée de Pontoise, acquisitions et dons récents." *Oeil* 293 (December 1979): 88.

Washington, D. C. 1979
Matisse Prints
Washington, D. C.: Horn Gallery, May 1979.

Review: Perlmutter, J. *Art Voices South* 2, 3 (May-June 79): 49-52.

Basel 1980
Matisse, huiles, gouaches découpées, dessins, sculptures
Basel: Galerie Beyeler, June-September, 1980; traveled to Madrid: Fundación Juan March, October-December 1980.
Handsome, carefully produced catalogue with excellent color plates; no text but selected quotations by Matisse. Catalogue for Madrid venue in Spanish, *Matisse: Oleos, dibujos, gouaches découpées, esculturas y libros.*

Review: [Madrid venue] Figuerola-Ferretti, L., *Goya* (July-August 1980): 39-40; Power, K. *Arts Rev.* 32, 23 (November 21, 1980): 533.

Berlin 1980
Hommage à Tériade--buchillustrationen aus Frankreich
Berlin: Akademie der Künste, February 15-March 16, 1980.
Catalogue by Ute Schuffenhauer, Inge Zimmermann, and Horst Jörg Ludwig.

Chicago 1980

Books Illustrated by Painters and Sculptors from 1900
Chicago: Arts Club of Chicago, September 22-October 31, 1980.
Modest catalogue by J. M. Wells; scholarly documentation.

Dallas 1980
Livres d'artiste by Braque, Matisse, and Picasso from the Collection of the Bridewell Library
Dallas, Texas: Southern Methodist University Pollock Galleries, March 4-April 11, 1980.
Small catalogue prepared by William Jordan and Decher Turner.

Ghent 1980
Henri Matisse en de Hedendaagse Franse Kunst: Vautier, Burri, de Saint- Phalle, Cadéré, Hantaï, Jacquet, Klein, Messager, Pagès, Raysse, Rutault, Toroni, Viallat
Ghent: Museum van Hedendaagse Kunst, October 7-November 20, 1980. Illustrated catalogue in Dutch, French, and German, by C. Millet, foreword by Jan Hoet.

Leningrad 1980
Henri Matisse, L'Art du livre, collection de l'Hermitage (Anri Matiss, Iskusstvo Knigi)
Leningrad: Hermitage Museum, 1980.
Carefully produced, illustrated and documented catalogue of modest format, with extended text by Yu. Rusakov. Color illustration of *Icarus* on cover, no. 252.

London 1980
Important XIX and XX Century Paintings and Drawings
London: Lefevre Gallery, November 6-December 19, 1980.

Henri Matisse: Drawings, Paper Cut-outs, Illustrated Books
London: Theo Waddington Gallery, July 2-August 2, 1980.

Los Angeles 1980
The Graphic Art of Henri Matisse
Los Angeles: Frederick S. Wight Art Gallery, UCLA, September 3-November 2, 1980.
Catalogue of Matisse graphic works in University's collections; by

Lucinda H. Gedeon and Michael W. Schantz; complete list of Grunwald
Center Matisse acquisitions in 1980-81, by M. Schantz, is added.

Henri Matisse, Works on Paper
Los Angeles: Mekler Gallery, November 16-December 1980.
Small catalogue with works reproduced and completely described; no
text.

Minneappolis 1980
French Book Illustrators 1925-1980
Minneapolis: Minneapolis Institute of the Arts, February 7-April 27,
1980.

Montauban 1980
Ingres et sa postérité jusqu'à Matisse et Picasso
Montauban: Musée Ingres, June 28-September 7, 1980.

Montpellier 1980
De Raphaël à Matisse: 100 dessins du Musée Fabre
Montpellier: Musée Fabre, July-September 1980.
Catalogue with all works illustrated.

Münster 1980
Reliefs: Formprobleme zwischen Maerei und Skulptur im 20.
Jahrhundert
Münster: Westfälisches Landesmuseum für Kunst und Kulturgeschichte;
travels to Zürich: Kunsthaus, 1981.
Lavishly illustrated catalogue with text by Ernst Gerhard Güse; 206
works in full survey of modern relief sculpture.

Review: Mai, E. *Pantheon* 38, 4 (October-December 1980): 324-26;
Bauermeister. *Kunstwerk* 33, 4 (1980): 81-82.

New York 1980
Modern Masters: European Paintings from The Museum of Modern
Art, New York
New York: Metropolitan Museum of Art, June 5-October 12, 1980.

From Matisse to American Abstract Painting
New York: Washburn Gallery, November-December 1980.

Small catalogue with artists Norman Bluhm, Richard Diebenkorn, Al Held, Ellsworth Kelly, Lee Krasner, Robert Motherwell, Frank Stella, and Jack Youngerman included.

The Painterly Print: Monotypes from the Seventeenth to the Twentieth Century
Metropolitan Museum of Art, October 16, 1980-January 1981; traveled to Boston: Museum of Fine Arts, January 25-March 22, 1981.
Catalogue with essay, "Modern Monotypes," by Colta Ives which discusses Matisse's work in the medium.
Review: Raynor, V. *New York Times* (October 17, 1980): C24; Kramer, Hilton. *New York Times* (October 24, 1980): C1, C25; Fern, A. *New York Times Book Rev.* (December 14, 1980): 12, 31; Field, R. *Print Collecors Newsletter* 11, 6 (January-February 1981): 202-4.

Paris 1980
René Char, manuscrits enluminés par des peintres du XXe siècle
Paris: Bibliothèque Nationale, January 16-March 30, 1980.
Catalogue by Antoine Coron; checklist of works by Char illustrated or decorated by artists.

Matisse, dessins
Paris: Galerie Dina Vierny, May 28-July 20, 1980
Handsomely produced catalogue with short texts by Pierre Schneider and Dina Vierny.

Cinq années d'enrichissement du patrimoine national, 1975-1980, donations, dations, acquisitions
Paris: Grand Palais, November 15, 1980-March 2, 1981.

Bielefeld 1981
Henri Matisse, Das Goldene Zeitalter
Bielefeld: Kunsthalle, October 18-December 13, 1981. (Includes fifty-five drawings.)
Lavishly produced catalogue with important essays by Hans Joachim Mähl, Ulrich Weisner, no. 763, Douglas Cooper, no. 440, Pierre Schneider, no. 719, Lorenz Dittmann, no. 472, Gottfried Boehm, no. 262 Gerd Udo Feller, no. 497, and Werner Hofmann, no. 562.

Reviews: Growe, B. *Weltkunst* 51, 23 (December 1981): 3647-9; Leinz, G. "Das Goldene Zeitalter [Kunsthalle Bielefeld: Ausstellung]." *Pantheon* 40, 1 (January-March 1982): 53-54; Puvogel, R. [Kunsthalle Bielefeld; Ausstellung]. *Kunstwerk* 35, 1 (1982): 62-63; Watkins, Nicholas. *Burlington Mag.* 125, 969 (December 1982): 771-2.

Cannes 1981

Henri Matisse, dessins, lithographies, sculpture, collage, 1906-1952
Cannes: Galerie Herbage, March 31-June 27, 1981. (Twenty-four drawings, three sculptures, engravings, and lithographs.)
Luxurious catalogue in French and English with preface by Douglas Cooper to inaugurate the gallery; quality reproductions on good stock.

Review: "Henri Matisse, dessins, lithographies, sculptures, collages, 1906-1952: Galerie Herbage." *L'Oeil* 311 (June 1981): 83-84.

Geneva 1981

Henri Matisse: gravures originales sur le thème de Pasiphaë
Geneva: Galerie Patrick Cramer, December 1, 1981-January 22, 1982. Small catalogue in folio form (edition of 2500) explaining the publication of a book of the same name containing all of Matisse's original gravures on the theme of *Chant de Minos*, even though not finally used in the original Montherlant/Matisse book. Extract from the book by Dominique Bozo. U.S. ed. as *Original Engravings on the Theme of Pasiphaë; Chant de minos (Les Crétois).* Paris: Les Héritiers de l'Artiste, 1981. 2 vols., no. 1035.

Hiroshima and Nishinomiya 1981

Matisse et ses amis
Hiroshima: Musée des Beaux-Arts, March 14-April 5, 1981; Nishinomiya: Musée Otani des Beaux-Arts, April 10-May 5, 1981; Kunamoto: Musée des Beaux-Arts Préfecture de Kunamoto, May 9-31, 1981; Tokushima: Maison de la Culture Régionale de la Préfecture de Tokushima, June 6-28, 1981.
The Musée Matisse organized the show from their collection in collaboration with the Otani Museum of Fine Arts, Nishinomiya. Sumptuous catalogue in Japanese and French, preface by Colette Audibert; careful catalogue entries by Patrick Ducourneu; well

illustrated with quality color plates of a broad spectrum of artists from
Cézanne to Giacometti (but mostly Fauves).

Munich 1981
*Maler machen Bücher; illustrierte Werke von Manet bis Picasso--
Lithographien, Holzschnitte, Radierungen*
Munich: Villa Stuck, July 2-September 27, 1981.
Catalogue by A. Ziersch and Erhart Kästner (Munich: Christophe Dürr
Verlag, 1981) provides a history of the illustrated book and
documentation on those exhibited.

London 1981
*Henri Matisse, Drawings. Henri Laurens, Sculpture and Works on
Paper*
London: Theo Waddington Galleries, 1981.
Small catalogue.

New York 1981
*Henri Matisse, Important Line and Charcoal Drawings from 1905 to
1952.*
New York: Wally Findlay Gallery, November 9-December 12, 1981.
Fine catalogue with many of the thirty-three unusual works--originally
from sketchbooks and studies for major paintings--illustrated.

*Twentieth Century French Drawings from the Robert Lehman
Collections*
New York: Metropolitan Museum of Art, November 10, 1981-March
14, 1982; traveled to Oklahoma City: Oklahoma Museum of Art, April
23-July 18, 1983.
Catalogue by George Szabo, introduction by Joan Carpenter.

Paddington and Victoria 1981
Matisse, Graphic Work, 1906-1950
Paddington: Stadia Graphics Gallery, March-April, 1981; Victoria:
Tolarno Galleries, May-June, 1981.
Small, well-printed three-fold catalogue with complete check-list
description of each of the thirty works shown.

Paris 1981

Matisse: Donation Jean Matisse
Paris: Bibliothèque Nationale, March 18-June 21, 1981. (Includes twenty-nine drawings.)
Catalogue by Françoise Woimant with M.-C. Miessner; essay, "Couleurs du blanc, lumière du noir," by Jean Guichard-Meili, no. 279.

Reviews: Bligné, Y. "Matisse." *Peintre* 623 (April 15, 1981): 3-4; "Bibliothèque Nationale, Paris; exposition." *Oeil* 310 (May 1981): 86; Monod-Fontaine, Isabelle. "La Donation Jean Matisse." *Rev. du Louvre* 30, 3 (1980): 185-89.

Paris-Paris, 1937-1957, créations en France
Paris: Musée Nationale d'Art Moderne, May 28-November 2, 1981. Handsome catalogue under the direction of Pontus Hulten with many important essays on the period based on original research; richly illustrated. See especially Marcel Billot's essay "Le Père Couturier et l' Art Sacré." no. 1080.

Review: Beckett, J. *Oxford Art Journal* 4, 2 (November 1981): 66-67; Cunningham, V. *Times Literary Supp.* (August 7, 1981): 907; França, J. A. *Coóquio: Arts* 49 (June 1981): 50-5; Metken, G. *Weltkunst* 51, 10 (May 1981): 1499-1501; Micha, R. *Art Int.* 25, 1 (January 1982): 84-5; Morgan, A. *New Art Examiner* 9, 5 (February 1982): 6-7; Preston, S. *Apollo* 114, 234 (August 1981): 121; Sauré, W. *Kunstwerk* 34, 5 (1981): 72-3; Taylor, J. R. *Times* (June 9, 1981): 8; Trilse, C. *Bildende Kunst* 9 (1982): 434-6.

L'École de Paris
Paris: Daniel Manlingue Gallery, Spring 1981.

Regards sur une collection, XIX et XXe siècles
Paris: Galerie Schmidt, May 13-July 18, 1981.
(Three works by Matisse shown.)

Saint-Paul-de-Vence 1981
Sculpture du XXe siècle 1900-1945: tradition et ruptures
Saint-Paul-de-Vence: Fondation Maeght, July 4-December 23, 1981; traveled to Madrid: Dundación Juan March.
Substantial, well-illustrated catalogue by Jean-Louis Prat.

Review: Le Targat, F. *Connaissance arts* 354 (August 1981): 48-55.

Tokyo and Kyoto 1981
Matisse / Machisu ten
Tokyo: The National Museum of Modern Art, March 20-May 17, 1981; Kyoto: The National museum of Modern Art, May 26-July 19, 1981.
Handsome, well-illustrated catalogue by Kenji Adashi and Tamon Miki; longer essay by Kazuo Anazawa. In Japanese with added titles and bibliography in English.

Henri Matisse, dessins
Tokyo: Galerie Tokoro, April 6-May 9, 1981.
Catalogue in Japanese and French with preface by Pierre Schneider, essay by Dominique Fourcade ("Sur un Autoportrait Lumineux," no. 274, previously also in the Dina Vierny Catalogue, *Matisse, 33 dessins de 1905 à 1950*, Paris, 1980).

Toronto 1981
Gauguin to Moore: Primitivism in Modern Sculpture
Toronto: Art Gallery of Ontario, November 7, 1981-January 3, 1982.
Catalogue by Alan G. Wilkinson on the influence of non-European art on the sculptural experimentation of modern artists.

Review: Casatel. *RACAR, Rev. d'art canadienne, Canadian Art Rev.* 9, 1-2 (March 1982): 195; Mato, D. *Artmagazine* 13, 56 (November 1981-January 1982): 12-20;

Tours 1981
Dessins de Matisse
Tours: Musée des Beaux-Arts de Tours et Musée Rabelais, July 1-31, 1981.
Mimeographed five-page catalogue by Marie-Noëlle Pinot de Villechenon, introduction and check-list of works; drawing of Rabelais in color on the cover.

Wolfenbüttel 1981
Die Welt in Büchern
Wolfenbüttel: Herzog-August-Bibliothek und Zeughaus, September 28, 1981-March 31, 1982.
Catalogue by Paul Raabe.

Calais, Lille, Arras, etc. 1982-83

De Carpeaux à Matisse: la sculpture française de 1850 à 1944 dans les musées et les collections publiques du Nord de la France
Calais: Musée des Beaux-Arts et de la Dentelle, March 18-June 6, 1982; Lille: Musée des Beaux-Arts, June 15-August 31, 1982; Arras: Musée des Beaux-Arts, September 15-November 15, 1982; Boulogne: Musée des Beaux-Arts et d'Archéologie, December 1982-February 1, 1983; Paris: Musée Rodin, Feburary-April 1983.
Important fully documented catalogue (Lille: Edition de l'Association des Conservateurs de la Région Nord-Pas-de-Calais) with introduction by Dominique Vieville; specialized essays by A. Pingeot, C. Martinet, A. Le Normand-Romain, L.-M. Gohel, and F. Maison.

Le Cateau-Cambrésis 1982

Henri Matisse, Inauguration of the Musée Matisse et Herbin dans le Palais Fénelon
Le Cateau-Cambrésis: Musée Matisse, October 24, 1982.

Reviews: Dauriac, J. P. "Le Cateau-Cambrésis, Musée Matisse." *Pantheon* 41 (October-December 1983): 391-92; "Matisse en son musée [Cateau-Cambrésis, France], exposition." *Connaissance arts* 367 (September 1982): 23.

Chicago 1982

Ninety Prints by Henri Matisse: The Legend of Pasiphaë
Chicago: Field Enterprises, Inc., November 1-30, 1982; traveled to other venues.
Catalogue compiled and arranged by Marguerite Duthuit and Gérard Cramer.

Dijon 1982

La Peinture dans la peinture
Dijon: Musée des Beaux-Arts, November 5, l982-January 3, 1983.

Edinburgh 1982

Henri Matisse
Edinburgh: National Gallery of Scotland, 1982.

Review: McCullough, F. *Arts Rev.* 34, 13 (June 18, 1982): 328.

Fribourg 1982

Henri Matisse, gravures et lithographies
Fribourg: Musée d'Art et d'Histoire Fribourg, June 10-September 5, 1982.
Important completely illustrated and documented catalogue with texts by Margrit Hahnloser-Ingold and Roger Marcel Mayou, no. 282. A dossier of press clippings and reviews of the show is available in the Cabinet des Estampes of the Bibiothèque Nationale in Paris.

Review: Watkins, Nicholas. *Burlington Mag.* 125, 969 (December 1983): 771-2.

New York 1982

Matisse, Lithographs, Etchings, Linoleum Cuts
New York: Pace Master Prints, November 5-December 18, 1982.
Small catalogue with all works reproduced; short introduction by Alexandra Schwartz.

Matisse: Pasiphaë - Chant de Minos
New York: Lucien Goldschmidt Inc., February 17-March 16, 1982.

Nice 1982

Dix ans des Musées de Nice; activités et acquisitions, 1972-1982
Nice: Espace niçois d'art et de culture et galerie d'art contemporain, November 27, 1982-January 22, 1983.

Paris 1982

Album Matisse, 33 dessins de 1905 à 1950
Paris: Galerie Dina Vierny, June 9-July 20, 1982.
Handsomely produced catalogue by Mourlot Frères, fully illustrated, with twenty-one photographs (one in color) by Helène Adant of Matisse in the studio. A short, but important essay by Dominique Fourcade, "Sur un autoportrait lumineux," no. 274.

San Francisco 1982

Henri Matisse, An Exhibition of Drawings
San Francisco: John Berggruen Gallery, February 17-March 24, 1982.
(Forty-one drawings.)
Catalogue with essays by John Berggruen, Wayne Thibaud, and Joseph Goldyne.

Review: French, P.D. "Representing Matisse." *Artweek* 13 (March 6, 1982): 16.

Tokyo 1982
Figures révolutionnaires de Cézanne à aujourd'hui
Tokyo: Bridgestone Museum, April 18-May 16, 1982.

Zurich (and Düsseldorf) 1982
Henri Matisse
Zurich: Kunsthalle, October 15, 1982-January 16, 1983; Düsseldorf: Städtische Kunsthalle, January 29-April 4, 1983..
Catalogue with commentary and excellent color illustrations of the 108 paintings exhibited, with fourteen sculptures in black and white; essays by Pierre Schneider, no. 351, Klaus Schrenk, no. 726, Reinhold Hohl, no. 563, Margrit Hahnloser, no. 547, and Franz Meyer, no. 1381.

Reviews: Baumann, F. Review. *Du* 10 (1982): 65-66; Fellenberg, W. *Weltkunst* 52, 22 (November 1982): 3271-5; Micha, R. "Matisse à Zurich." *Art Int.* 26 (April-June 1983): 3-14; Nemeczek, A. "Die wilden Jahre: Henri Matisse, Rebell und Klassiker." *Art: das Kunstmagazin* 10 (October 1982): 20-40; Nicholson, David. "Notes on Matisse." *Artscribe* 40 (April 1983): 20-26; Perlman, M. "Matisse en Suisse," *Art News* 81 (April 1983): 135+; Schneider, P. "Matisse: ou la grandeur de ce qui lutte." *Connaissance arts* 370 (December 1982): 100-107; Stutzer, B. Review. *Pantheon* 41, 1 (January-March 1983): 76-77; Verna, C. Review. *Flash Art* 111 (March 1983): 67; Verspohl, F. J. *Kunstforum Int.* 61 (April 1983): 151-8; Watkins, Nicholas, Review. *Burlington Mag.* (December 1983): 771-72; Zellweger, H. Review. *Kunstwerk* 36 (February 1983): 30-32.

Nabis und Fauves, Zeichnungen, Aquarelle, Pastelle aus Schweizer Privatbesitz
Zurich: Kunsthaus, October 29, 1982-January 16, 1983.
Handsome catalogue with extensive documentation; substantive essay by Jürgen Schultze, "Der Zeichnungen der 'Fauves'," no. 301, and introduction and notes by Margit Hahnloser-Ingold. See no. 1188 for a more complete description.

Amsterdam 1983
100 jaar bekijks: een keuzee uit de affiche-collectie in het Stedelijk Museum Ansterdam [100 Years on View: A Selection from the Poster-

Collection of the Stedelijk Museum]
Amsterdam: Stedelijk Museum, 1983
Catalogue in Dutch and Englishe, with text by Friso Wicgcrsma.

Bordeaux 1983
Hommage à Marcelle et Albert Marquet
Bordeaux: Galerie des Beaux-Arts, January-February, 1983.
Catalogue by Pierre Gassier; preface by Gilberte Marin-Méry. Eight paintings by Matisse are part of the Marquet donation to the museum.

L'Isle-sur-le-Sorgue 1983
Henri Matisse: Protrait d'Artine et autres dessins
L'Isle-sur-le-Sorgue: Musée-Bibliothèque René Char, Hotel de Campredon, August 3-October 16, 1983.
Sixteen-page catalogue, lovingly assembled and dedicated to the memory of Marguerite Duthuit-Matisse; essay by Tina Jolas on the relationship between and the shared projects of René Char and Matisse. Introduction by Antoine Coron on the Artine project.

London 1983
Henri Matisse, 1869-1954; A Selection of Original Lithographs and Linocuts
London: William Weston Gallery, 1983.

Henri Matisse: Paintings and Drawings
London: Theo Waddington Galleries, January 1983.

Review: *Apollo* 117, 251 (January 1983): 55-7.

Celebration of the Cut-Out
London: Anatol Orient Gallery, November 1983.

Review: Hoyal, S. "Celebration of the Cut-Out; Anatol Orient Gallery." *Crafts* 65 (November-December 1983): 51; Auchincloss, E. "Cut to the Quick." *Connoisseur* 213 (November 1983): 18.

Sculpture's Dance
London, Arts Council: Southampton Art Gallery, November 1983; traveled to other British venues until April, 1984.
Catalogue with commentary by Michael Harrison.

Mexico 1983

Obra Gráfica Jazz y Pasiphaé [Graphic work from Jazz to Pasiphäe]
Mexico: Arte Contemporeneo Internacional, March 1983.
Well-illustrated catalogue with color plates on black ground (not true
color brilliance). Texts by Jack Flam ("Maquettes from *Jazz,"*
previously published in *Henri Matisse, the Paper Cut-Outs,*
Washington, 1977, nos. 307 and 1018) and William Liebermann
(previously published in *Matisse, 50 Years of his Graphic Art,* New
York, 1981, no. 243). A short commentary on *Pasiphaë* by Ana
Zagury.

Minneapolis 1983

Book Illustrations: The Armchair of Henri Matisse
Minnneapolis: Minneapolis Institute of Arts, June 17-August 21,
1983.
Single-fold catalogue by Sandra L. Lipschultz; checklist and short
commentary.

Oklahoma City 1983

*Impressionism/Post-Impressionism, XIX and XX Century Paintings
from the Robert Lehman Collection of the Metropolitan Museum of
Art*
Oklahoma City: Oklahoma Museum of Art, April 23-July 18, 1983.
Catalogue with introduction by J. Carpenter, text by George Szabo.

Paris 1983

Matisse, dessins au pinceau
Paris: Galerie Berggruen, April-May, 1983. (Twenty-nine drawings.)
Elegant, well-illustrated small catalogue with text by Pierre Schneider.

Review: "Matisse au Pinceau." *Connaisseur arts* 374 (September
1982): 33; Moulin, R. J. "Henri Matisse, dessins." *Kunstwerk* 36
(September 1983): 141-2; *Goya* 175-76 (July-October 1983): 64.

Bonjour Monsieur Manet
Paris: Galerie Contemporaine, Musée National d'Art Moderne, June 8-
October 3, 1983.
Fine catalogue for this show (at the time of a large Manet exhibition)
of work by Matisse and Picasso at their most Manet-like and by
contemporary artists . A documentary photo of Matisse's remarks

(L'Intransigeant, 1932) on Manet is reproduced; there is an important essay by Dominique Fourcade, "Matisse et Manet?", no. 512. Other essays are by Jean Clay, Marie-Laure Bernadac, and Catherine David.

Raphaël et l'art français
Paris: Grand Palais, November 15. 1983-February 15, 1984.
Lavish catalogue with many illustrations and scholarly documentation; essays by Jacques Thuillier, Martine Vasselin, Jean Pierre Cuzin.

Review: Rosenberg, M. *Art Journal* 44, 1 (Spring 1984): 70-4.

Amsterdam 1984
Le Grande Parade: Hoogtepunten van de schilderkunst na 1940 [Highlights of Painting after 1940]
Amsterdam: Stedelijk Museum, December 15, 1984-April 15, 1985.
Lavish catalogue with foreword by Olle Granath; show organized by Edy de Wilde with Karen Schampers, Alexander van Grevenstein, Hendrik Driessen.

Review: Morgan, Stuart. "Bread and Circuses." *Artforum* 23 (March 1985); Schlumberger, E. "Le droit à toutes les libertés." *Conaissance arts* 394 (December 1984): 54-66.

Atlanta 1984
The Henry P. McIlhenny collection: Nineteenth Century French and English Masterpieces
Atlanta: The High Museum of Art, May 25-September 30, 1984.

Basel 1984
Skulptur im 20. Jahrhundert
Basel: Merian-Park, June 3-September 30, 1984.
Substantive catalogue by Theodora Vischer with many short essays including Franz Meyer's "Henri Matisse." Show organized by Ernst Beyeler, Reinhold Hohl, and Martin Schwander, who commissioned works especially for the show from Beuys, LeWitt, and Serra.

Review: Bischoff, U. *Pantheon* 42, 4 (October-December 1984): 389-91.

Edinburgh and London 1984

The Sculpture of Henri Matisse
Edinburgh: City Art Center, August 3-September 15, 1984; London:
Hayward Gallery, October 4, 1984-January 6, 1985; Leeds: Leeds City
Gallery, February 18-March 24, 1985.
Exhibition organized by Catherine Lampert for the Arts Council of
Great Britain; accompanied by publication of Isabelle Monod-Fontaine's
book, *The Sculpture of Matisse*, London, 1984, no. 178. Well-
illustrated four-page sheet prepared for the exhibit.

Reviews: [Hayward Gallery, London; exhibit], *Art & Artists* 217
(October 1984): 31-32; Brown, Jonathan. "The Play of Light [Review
of two sculpture shows and their catalogs]." *Times Lit. Supp.* (August
31, 1984): 971; Haenlein, C. "Skulpturen und Zeichnungen [Hayward
Gallery, London]." *Du* 12 (1984): 90; Timothy Hyman, "Matisse at
Hayward." *Artscribe* 50 (January-February 1985): 57-58; Neve, C.
Country Life 176, 4555 (December 1984): 1776; "Matisse, dessins et
sculptures [Hayward Gallery]." *Connaissance arts* 392 (October 1984):
21; Spalding, F. *Arts Rev.* 36, 20 (October 26, 1984): 523; Watkins,
N. "Matisse's Sculpture and Drawings [Hayward Gallery]." *Burlington
Mag.* 126 (December 1984): 200.

Fort Worth 1984
Henri Matisse: Sculptor, Painter: a Formal Analysis of Selected Works
Fort Worth, Texas: Kimball Art Museum, May 26-September 2, 1984.
Superb catalogue by Michael P. Mezzatesta, foreword by P. Pillsbury,
no. 136.

Review: Hilton, Timothy. *Times Literary Supp.* (November 23,
1984): 1344-1345.

London 1984
*Henry Matisse: Fifty Fine Prints: Lithographs, Etchings, Aquatints,
Linocuts, 1903-1950*
London: Lumley Cazalet Ltd, October 8-November 9, 1984.
Square-format catalogue of prints, carefully documented, beautifully
reproduced. No text; *La Persane* (1919) on the cover.

Review: Burns, Guy. *Arts Rev.* 36, 19 (October 12, 1984): 495-6.

Henri Matisse
London: Waddington Gallery, Fall, 1984.

Review: Burns, Guy. *Arts Rev.* 36, 19 (October 12, 1984): 495-6.

London and Washington 1984

The Orientalists: Delacroix to Matisse
London: Royal Academy of Arts, March 24-May 27, 1984;
Washington, D. C.: National Gallery of Art, July 1-October 28, 1984.
(Five Matisse canvases shown.)
Lavish, well-documented catalogue (London: Weidenfeld and Nicolson,
1984) edited by Maryanne Stevens with substantive essays by Stevens,
Robert Irwin, Caroline Bugler, and Malcolm Warner.

Reviews: Baddeley, O. *Oxford Art Journal* 7, 1 (1984): 69-71;
Brookner, A. *Times Literary Supp.* (April 6, 1984): 375; Hooker, D.
Arts Rev. 36, 7 (April 13, 1984): 1884-5; House, John. *Burlington
Mag.* 974 (May 1984):307-8; Jamie, R. *Artscribe* 47 (July-August
1984): 57; Levin, Gail. *Arts Mag.* 69, 2 (October 1984): 122-5;
Usherwood, N. *Country Life* 175, 4520 (April 5, 1984): 910-11; von
Gehren, G. *Weltkunst* 54, 9 (May 1, 1984):1240-42; Wood, J.
Pantheon 42, 3 (July-September 1984): 285-7.

London and New York 1984-85

Drawings of Henri Matisse [with The Sculpture of Henri Matisse]
London: Hayward Gallery, October 4, 1984-January 6, 1985; New
York: Museum of Modern Art, February 27-May 14, 1985.
Catalogue, *The Drawings of Henri Matisse,* edited by Magdalena
Dombrowski, John Elderfield, Catherine Lampert and Nikos Stangos;
with major text by John Elderfield and introduction by John Golding
who selected the works in the exhibit, no. 230. Well-illustrated four-
page hand-out prepared for the exhibition.

Reviews: Bois, Yve-Alain. "Matisse Redrawn." *Art in America* 73
(September 1985): 126-31; Cohen, R. *Print collectors Newletter* 16, 3
(July-August 18, 1984): 104-8; Garcia-Herraiz, E. Review. *Goya* 186
(May-June 1985): 385; Klein, J. *Art Journal* 45, 4 (Winter 1985): 359-
67; Middleton, J. *Royal Society Arts Journal* 133, 5346 (May 1985):
428-9; Perl, Jed. "Matisse," *New Criterion* (June 1985): 19-27;
Spalding, F. *Arts Rev.* 36, 20 (October 26, 1984): 523; Vann, Philip.

"The Drawings of Henri Matisse." *Contemporary Rev.* 245 (December 1984): 322-24; Zellweger, H. *Kunstwerk* 38 (February 1985): 50.

Los Angeles 1984
Prints and Drawings. In Honor of Ebria Feinblatt, 1947-1985
Los Angeles: Los Angeles County Museum of Art, 1984.

Review: Davis, B. "In Honor of Ebria Feinblatt." *Bull. Los Angeles County Museum of Art* 28 (1984): 45.

Montreal 1984
Iliazd, maître d'oeuvre du livre moderne
Montreal: Galerie d'art de l'Université du Québec, September 5-28, 1984.

Moscow 1984
Anri Matiss: kniznaja grafika alfisi [Henri Matisse: books, graphics, posters]
Moscow and Leningrad: Pushkin Museum of Fine Arts and Hermitage, 1984.
Catalogue : *Avtor-sostavitel*: V. Sadkov, Leningrad: Aurora, 1984, a small 8-page catalogue with extended essay and check list of works; modest but elegant format.

Review: Sadkov. V. "Knizhnaya Grafika Anri Matissa [The book illustrations of Henri Matisse]." *Tvorchestvo* 10 (1985): 31-2.

New York 1984
Prints by Old & Modern Masters: From Dürer to Goya and from Delacroix to Matisse
New York: Lucien Goldschmidt, Inc., 1984.

'Primitivism' in 20th Century Art: Affinity of the Tribal and the Modern
New York: Museum of Modern Art, September 27, 1984-January, 1985; Detroit: Detroit Institute of Arts, February 27-May 19, 1985; Dallas: Dallas Museum of Art, June 23-September 1, 1985.
Handsome, scholarly two-volume catalogue (New York and Boston: New York Graphic Society, Little, Brown and Co., 1984) edited by William Rubin. Many fine essays on specific aspects of the topic,

including Jack Flam's "Matisse and the Fauves," vol. I , 211-40, no. 1222.

Nice 1984
Nouvelle présentation de la collection d'objets personnels de Henri Matisse
Nice: Musée Matisse, December 1984.
Offset brochure as catalogue.

Paris 1984
Enrichissements récents du Cabinet d'art graphique: "De Bakst à Matisse"
Paris: Musée National d'Art Moderne, April 18-August 20, 1984.

Henri Matisse: oeuvres gravées, réunies par Claude Duthuit à l'occasion de parution du Catalogue Raisonné (829 prints)
Paris: Galerie Maeght Lelong, October 4-November 15, 1984.
Catalogue: *Repères, Cahiers d'Art Contemporain,* No. 16; quality reproductions of twenty-six works, preface by Dominique Fourcade.

Review: "L'Actualité de Matisse." *Connaissance arts* 393 (November 1984): 106.

Henri Matisse, eaux-fortes et pointes-sèches, lithogravures, linogravures
Paris: Galerie Sagot-Le Garrec, October 4-31, 1984.
Catalogue-invitation with checklist of works.

Southport 1984
Matisse, Illustrations to the Amours of Pierre Ronsard.
Southport, England: Atkinson Art Gallery, June 4-23, 1984; travels to Jarrow, Halifax, Liverpool, Lancaster, Frome (1984) and Ashington, Newcastle, Hartlepool, Dewsbury, Barnsley, Coventry (1985).

Review: *Art and Artists* 213 (June 1984): 29.

Stockholm and Humlebaek 1984
Henri Matisse Exhibition
Stockholm: Moderna Museet, November 3, 1984-January 6, 1985; Humlebaek: Louisiana Museum of Modern Art, January 19-April 14, 1985 (slightly revised).

Catalogue by N. Ohman, with foreword by Olle Granath, essay "Om
Eden" by Ulf Linde, the Tériade interview of 1952 *Art News Annual,
21,* in Swedish, also Matisse's "Notes of a Painter"; well illustrated in
color and by black and white photos.
Danish catalogue in *Louisiana Revy* 25, 2 (January 1985), where
whole issue is devoted to the exhibition. Texts by John Russell, Pierre
Schneider, Ulf Linde, Dominique Fourcade, Marit Werenskiold,
Gertrude Kobbe Sutton; complete checklist of the works, profusely
illustrated.

Berlin, Erfurt, Prague 1985-86
Aspects du dessin contemporain en France
Berlin-Est: Centre Culturel Français, November 27-December 23, 1985;
Erfurt: Fischer Museum, January-February 1986; Prague: Centre
Culturel Français, Spring 1986.

Besançon 1985
Dessins et estampes de la collection Georges et Adèle Besson
Besançon: Musée des Beaux-arts et d'archéologie, 1985.

Bologna 1985
Vent'anni d'arte in Francia 1960-1980
Bologna: Galleria Comunale Arte Moderna, March-April 1985.
Exhibition of fifty-six artists working in France, organized by Marcelin
Pleynet and with a catalogue (Bologna: Grafis Edizionai, 1985) edited
by Pleynet. Matisse and Picasso are offered as sources for the
subsequent development of painting in France.

Dallas 1985
Classical Myth in Western Art: Ancient through Modern
Dallas: Meadows Museum & Sculpture Court, November 1, 1986-
January 1987; Amarillo: Amarillo Art Center, January 12-March 2,
1987.
Exhibition organized thematically around specific classical myths, with
thirty-six works shown, including one by Matisse; substantial
catalogue essay detailing the rationale for the show by Carl Kilinski, its
curator. Sponsored by the Eugene McDermott Foundation and the
Meadows School of the Arts and the Texas Committee for the
Humanities.

Edinburgh, Nantes, Humlebaek, Brussels 1985-86
Colour since Matisse: French Painting in the 20th Century [Depuis Matisse . . . La couleur: une approche de la peinture française au XXe siècle]
Edinburgh: August 10- end September 1985; Nantes: Musée des Beaux-Arts, October 11-November 25, 1985; Humlebaek: Louisiana Museum of Modern Art, December 21, 1985-February 6, 1986; Brussels: Palais des Beaux-Arts, February 22-April 6, 1986.
Handsome, full-color catalogue with introduction by Sarah Wilson, texts by Yves Miurnier.

Lausanne 1985
De Cézanne à Picasso dans les collections romandes
Lausanne: Fondation de l'Hermitage, June 15-October 20, 1985.
Catalogue by François Dault; very general treatment of all modern movements.

London 1985
Paper: exhibition of works by Degas, Renoir, Pissarro, Van Gogh, Vuillard, Cézanne, Valtat, Redon, Léger, Matisse, Moore, Bonnard, and others.
London: Thomas Gibson Fine Art, June 4-July 12, 1985.
An elegant catalogue with tipped-in plates; two Matisse drawings from the Nice period in the show.

From Manet to Hockney: Modern Artists' Illustrated Books
London: Victoria and Alberta Museum, March 20-May 19, 1985.
Substantial catalogue by Carol Hogben and Rowan Watson.

Master Prints Old and Modern: An Exhibition of Fine Prints from the 18th to the 20th Century
London: Thomas Agnew & Sons, October 2-31, 1985.
Small catalogue.

Los Angeles 1985
The Spirit of Appreciation: Masterpieces from the Cone Collection of the Baltimore Museum of Art
Los Angeles: Los Angeles County Museum of Art, October 6-

November 24, 1985; Fort Worth: Kimball Art Museum, December 14, 1985-February 9, 1986.

Review: M. Schipper, "From the Beginnings of Modernism," *Artweek* 16 (November 9, 1985): 1.

Mulhouse 1985-86
Henri Matisse, sélection d'ouvrages à l'occasion de l'exposition cinq peintres et quatre écrivains
Mulhouse: Bibliothèque Municipale, December 15, 1985-February 15, 1986.
Catalogue.

New York 1985
Henri Matisse, Selected Drawings from 1907 to 1952; An Exhibition Organized with Heinz Berggruen.
New York: Maxwell Davidson Gallery, April 16-May 18, 1985.
Small illustrated catalogue.

Drawings from the Collection of Mr. & Mrs. Eugene Victor Thaw, Part II.
New York: Pierpont Morgan Library, September 3-November 10, 1985; Richmond: Virginia Museum of Fine Arts, February 17-April 13, 1986.
Catalogue with introduction by Eugene Thaw, texts by Cara D. Denison, William E. Robinson, Julia Herd, and Stephanie Wiles.

Paris 1985
De Corot à Picasso
Paris: Galerie Schmit, May 10-July 20, 1985.

Matisse, vingt dessins
Paris: FIAC, Grand Palais (Galerie Berggruen), October 5-13, 1985.
Small catalogue by Berggruen et Cie.

Présentation des gouaches de Jazz
Paris: Musée National d'Art Moderne, 1985.

Leçon d'anatomie, le nu dans les collections du Cabinet d'Art Graphique
Paris: Musée National d'Art Moderne, October 7-December 1, 1985.

Tanlay 1985
Henri Matisse: 75 dessins; Cinq dessinateurs: les chemins de la création
Tanlay, France: Chateau de Tanlay, and Yonne: Centre d'Art
contemporaine, June 23-September 30, 1985.
Two part show: I) Seventy-five Matisse drawings and books; portrait
photos of Matisse by Cartier-Bresson; II) drawings and prints by
contemporary artists Gerard Bérenger, Pierre-Edouard, Pierre Gaste,
Jeorg Ortner, and Philippe Ségeral.
Catalogue with preface and essay, "Matisse et le portrait," by Pierre
Schneider, [an excerpt adapted from his 1984 book, *Matisse*, no. 157];
twenty-five photographs of Matisse by Henri Cartier-Bresson.

Review: "Matisse portraitiste." *Connaissance arts* 401-402 (July-
August 1985): 92.

Tokyo 1985
Henri Matisse, Drawings, Prints
Tokyo: Fuji Television Gallery, December 6-21, 1985.

Venice and Rome 1985
*From Cézanne to Picasso: Forty-two Masterpieces from Soviet
Museums*
Venice: Napoleonica and Correr Museum, February 23- April 14, 1985;
Rome: Capitoline Museum, April 23-June 15, 1985.
Catalogue, *Da Cézanne a Picasso: 42 capolavori dai musei sovietici,*
Milan: Electa, 1985, edited by Albert Kostenevich who was also curator
of the show.

Washington, D.C. 1985
French Drawings from the Phillips Collection
Washington, D. C.: Phillips Collection, November 23, 1985-January
12, 1986.

Wichita 1985
Prints by Henri Matisse--The Legend of Pasiphaë
Wichita, Kansas: Wichita State University, Fall 1985.

Review: *American Artist* 49 (November 1985): 14.

Baltimore 1986

The Spirited Line, Works on Paper, 1898-1950
Baltimore: Baltimore Museum of Art, September 7-November 2, 1986.
On the occasion of the reopening of the Cone Collection, thirty-nine
drawings, 170 prints, all twelve of the artist's illustrated books.
No catalogue.

Reviews: Gibson, Erik. "The Cones of Baltimore," *New Criterion* 5
(October 1986): 59-66; Review, *Drawing* 8 (September-October 1986):
60-61.

Basel 1986
*Aus Privaten Sammlungen: Monet, Renoir, Gauguin, Cézanne, Braque,
Picasso, Matisse, Laurens, et al.*
Basel: Die Galerie, February 8-April 16, 1966.
Catalogue in German and English.

Boston 1986
Boston Collects: Contemporary Painting and Sculpture
Boston: Museum of Fine Arts, October 22, 1986-February 1, 1987.
Catalogue by Theodore E. Stebbins and Judith Hoos Fox.

Chicago 1986
*Modern Master Drawings: Forty Years of Collecting at the University
of Michigan*
Chicago: Arts Club of Chicago, March 31-August, 1986; Grand
Rapids: Grand Rapids Art Museum, September 20-November 2, 1986;
Ann Arbor: University of Michigan Museum of Art, February 24-April
5, 1987.
Catalogue by Charles H. Sawyer, with essay on the history of the
collection.

Essen 1986
*Aktdarstellungen im 19. und 20. Jahrhundert: Aquarelle, Zeichnungen
und Druckgraphiken aus dem Bestand des Graphisches Kabinetts*
Essen: Folkwang Museum, July 13-September 21, 1986.
Catalogue by Hubertus Froning.

Fort Worth 1986
Matisse Prints from the Museum of Modern Art
Fort Worth, Texas: Kimball Art Museum, October 5-November 30,

1986; Corpus Christi: Art Museum of South Texas, January 3-
February 28, 1987; Winnipeg: Winnipeg Art Gallery, March 11-May
10, 1987; Cincinnati: Cincinnati Art Museum, June 3-September 7,
1987: Minneapolis: Minneapolis Institute of Arts, September 26-
November 15, 1987; Iowa City: University of Iowa Museum of Art,
January 2-February 27, 1988.
Well-produced documented catalogue, no. 225, with substantive essays
by Riva Castleman, no. 268, and John Hallmark Neff, no. 294.

Iowa City 1986
The University of Iowa Museum of Art: 101 Master Works
Iowa City, Iowa: The University Museum of Art, April-August, 1986.
Scholarly catalogue by Robert Hobbs.

Leverkusen 1986
Im Lichte der Ägypter [In the Light of the Egyptians]
Leverkusen: Städtisches Museum, Spring, 1986.
Matisse sculpture shown.

Review: Glozer, L. *Wolkenkratzer Art Journal* 2 (April-June 1986):
78-81.

Lille 1986
*Matisse, peintures et dessins du Musée Pouchkine et du Musée de
l'Ermitage*
Lille: Musée des Beaux Arts, October 4, 1986-January 5, 1987.
Valuable catalogue with introduction by Albert G. Kostenevich on the
Shchukin collection; texts by Kostenevich on the development of
Matisse's style, others by E. B. Georgievskaja, A. S. Kantor-
Gukovskaja, and V. A. Misin. Excellent documentation and
reproductions of seldom reproduced works.

Reviews: Fauchereau, Serge. "Henri Matisse dans les collections
russes." *Beaux-Arts Mag.* 40 (November 1986): 45-51; "Matisse
[Review]." *L'Oeil* 377 (December 1986): 81; "Matisse venu du froid."
Connaissance arts 416 (October 1986): 34; Oursel, Hervé. "Matisse,
peintures et dessins du musée de l'Ermitage et du musée Pouchkine."
Rev. du Louvre 36, 6 (1986): 454-55.

London 1986

Recent French Acquisitions
London: National Gallery of Art, 1986.

Review: Levey, M. "French Acquisitions of Recent Years at the
National Gallery," *Apollo* 123 (June 1986): 385.

In Tandem: The Painter-Sculptor in the Twentieth Century
London: Whitechapel Gallery, March 27-May 25, 1986.
Catalogue with introduction by Nicolas Serota, major essay by L.
Cook, which traces the history of artists working in both media from
the Renaissance. Along with Matisse, work by Degas, Gauguin,
Kirchner, Picasso, and others shown.

Munich 1986
Albertina, Wien: Zeichnungen, 1450-1950
Munich: Kunsthalle der Hypo-Kulturstiftung, 1986.
Catalogue by Walter Koschatzky, featuring one hundred drawings from
the Albertina in Vienna; history of collection is given and types of
drawings detailed.

New York 1986
After Matisse
New York: Queens Museum, March 30-May 25, 1986.
An exhibition organized by the Independent Curators Incorporated;
catalogue by Tiffany Bell, Dore Ashton, and Irving Sandler, no. 1351.
Thirty-seven American artists included with work from 1936 to 1984.

Nice 1986
Matisse et Tahiti
Nice: Galerie des Ponchettes, July 4-September 30, 1986.
Catalogue: *Matisse et Tahiti,* Cahiers Henri Matisse 1, edited by
Xavier Girard with an important interview with Pierre Schneider, no.
722.

Matisse: photgraphies
Nice: Musée des Beaux-Arts Jules Chéret, July 4-September 30, 1986.
Catalogue: *Matisse: photographies,* Cahiers Henri Matisse 2, edited by
Xavier Girard with an important essay by Jean-Francois Chevrier, no.
432.

Notice: Girard, Xavier. "Matisse Photographies." *Art Press* 10 (January 1987): 32-33.

Henri Matisse, l'art du livre
Nice: Musée Matisse, July 4-September 30, 1986; traveled, augmented, to Lyons, 1986.
Catalogue: *Henri Matisse, l'art du livre,* Cahiers Henri Matisse 3, no. 235, with introduction by Yu. Roussakov, and two essays--Jérôme Peignot, "Henri Matisse: calligraphe de l' amour," and Christian Arthaud, "L'Emotion première." A complete bibliography and chronology of illustrated books, albums, books, revues, monographs, catalogues, posters, and programs with Matisse illustrations or designs. Handsomely produced in the format of the first four *Cahiers Henri Matisse.*

Paris 1986
Extraits de la Collection du Reader's Digest
Paris: Musée Marmottan, April 8-May 11, 1986.

Matisse
Paris: Galerie Maeght, November 1986. [On the occasion of the publication of the book, *L'Apparente facilité. . .Henri Matisse, peintures de 1935 à 1939* by Lydia Delectorskaya, no. 72.]

Saint-Paul-de-Vence 1986
Peintres-illustrateurs du XXe siècle
Saint-Paul-de-Vence: Fondation Maeght, March 22-May 4, 1986.

Tempe 1986
Matisse and the Printed Page, Ninety Prints by Henri Matisse
Tempe, Arizona: Arizona State University Art Collections, January-February 1986; Oklahoma City: Oklahoma City Museum of Art, April 15-May 3, 1986.
Exhibition of linoleum prints made for Pasiphaë, only eighteen of which were used in the published book.

Review: Weiman, L. *Southwest Art* 15 (February 1986): 82.

Tokyo 1986

Matisu-Matisse
Tokyo: Shueisha, Art Gallery 10, 1986. Series: Gendai Sekai no
Bijutsu.
Catalogue by Tono Yoshiaki and Ishioka Eiko.

Toulouse 1986
Matisse : Ajaccio-Toulouse: 1898-1899, une saison de peinture
Toulouse: Musée Paul-Dupuy, October 9-December 15, 1986; Nice:
Galerie des Ponchettes: December 19, 1986-January 30, 1987.
Catalogue: *Matisse : Ajaccio-Toulouse: 1898-1899,* Cahiers Henri
Matisse 4 with texts by Pierre Schneider, no. 721, Xavier Girard, no.
530, and Alain Mousseigne, no. 625.

Review: Gouttenoire, B. "Henri Matisse." *L'Oeil* 377 (December
1986): 80.

Warsaw 1986-87
Paris en quatre temps
Varsovie: Galerie Zacheta, October 12, 1986-February 12, 1987.

Washington, Los Angeles, New York 1986
Impressionist to Early Modern Painting from the USSR
Washington, D. C.: National Gallery of Art, May 1-June 15; Los
Angeles County Museum of Art, July-August 12; New York:
Metropolitan Museum of Art, August 23-October 5, 1986
Excellent catalogue by Albert Kostenevich and Marina Besanova (Los
Angeles: Armand Hammer Foundation, 1986).

Review: Renshaw, Janet. "A Russian Revelation." *Art and Artists* 239
(August 1986): 19-22; Schipper, Merle. "A Time of Greatness."
Artweek 17 (July 26, 1986): 5.

Washington 1986-87
Henri Matisse, The Early Years in Nice 1916-1930
Washington, D.C.: National Gallery of Art, November 2, 1986-March
29, 1987.
Important catalogue, no. 69, with essays by Jack Cowart, Dominique
Fourcade and Margrit Hahnloser-Ingold, nos. 450, 513, and 548. See
no. 69 for an extended description of the catalogue.

Reviews: Gibson, Eric. "American Round-up." *Studio Int.* 200, 1016 (May 1987): 32-34; idem, "The New Matisse: Explorations of Interior Space." ibid., 1017 (August 1987): 48-49; Gilot, F. "Henri Matisse at Peace." *Arts and Artists* (October 1988): 92-96; Hobhouse, Janet. "Odalisques: What Did These Sensuous Images Really Mean to Matisse?" *Connoisseur* 217 (January 1987): 60-67; Kramer, Hilton. "Matisse Triumphant: Who Was the Greatest Painter of the Twentieth Century?" *Art and Antiques* (February 1987): 91+; Neff, John. Review. "The Exhibition in an Age of Mechanical Reproduction." *Artforum* 25, 5 (January 1987): 86-90; Masheck, Joseph. "On Art: Matisse in Nice." *New Leader* 7011 (January 12-26, 1987): 23-4; Perl, Jed. "Matisse: into the Twenties." *New Criterion* 5 (February 1987): 6-13; Schiff, B. *Smithsonian* 17, 8 (1986): 80-86; Silver, Kenneth. "Matisse's Retour à l'Ordre." *Art in America* 75, 6 (June 1987): 110-23, 167-69; Watkins, Nicholas. Review. *Burlington Mag.* 129, 1009 (April 1987): 273-74.

Gifts to the Nation: Selected Acquisitions from the Collections of Mr. and Mrs. Paul Mellon
Washington, D.C.: National Gallery of Art, July 20-October 19, 1986.

Buffalo 1987
Modern Masters from the Permanent Collection
Buffalo: Albright-Knox Art Gallery, January 16-March 15, 1987.

Le Cateau-Cambrésis 1987
Henri Matisse, Pasiphaé-Chant de Minos
Le Cateau-Cambrésis: Musée Matisse, June 27-October 4, 1987.
Elegant catalogue with brief introductions by Dominique Szymusiak and Jean Guichard-Meili.

Dallas 1987
A Century of Modern Sculpture, The Patsy and Raymond Nasher Collection
Dallas: Dallas Museum of Art, 1987; travels to Florence: Forte di Belvere; Washington, D. C.: National Gallery of Art.
Handsome catalogue with major essay by Stephen Nash, no. 207; also published in Italian, no. 1319.

Flaine 1987
Arbres
Flaine: Centre d'Art, February 6-April 16, 1987.

Jerusalem 1987
Peintre dans la lumière de la Méditerranée
Jerusalem: Israel Museum, July 16-September 1987; Marseille: Musée
Cantini, October-November 1987.
Substantial catalogue by Yona Fischer, Elisabeth Merian, and Jean
Lacambre; in French and Hebrew.

Liège 1987
Henri Matisse: l'oeuvre gravé
Liège: Musée d'Art Moderne, November 20, 1987-January 3, 1988.
Very handsome catalogue by Françoise Dumont, with introductory
essay by Jean Guichard-Meili.

Los Angeles 1987
Degas to Picasso: Modern Masters from the Smooke Collection
Los Angeles: Los Angeles County Museum of Art, April 16-June 28,
1987.
Catalogue by Carol S. Elie on the Nathan and Marion Smooke
collection which is strong in works by Degas, Matisse, and Picasso.

Lugano 1987
Impressionisten und Post-Impressionisten aus sowjetischen Museen II
Lugano: Villa Favorita, August 9-November 15, 1987.
Excellent catalogue (Milan: Electa, 1987; English and Italian eds.) with
texts by Albert Kostenevich, Marina Besanova, and E. Georgievskaya.

Lyon 1987
*Henri Matisse, l'art du livre; Matisse dans les collections du Musée de
Beaux-Arts de Lyon*
Lyon: Musée des Beaux-Arts, Palais Saint-Pierre, April 9-June 4,
1987; Nancy: Musée des Beaux-Arts, May 3-June 30, 1986.
Matisse: L'Art du livre by Christian Arthaud and Dominique
Brachlianoff; Milan: Mondadori, 1987, published on the occasion of
this exhibit as catalogue. Brachlianoff's essay focuses on the portrait of
the antique dealer Georges Demotte, painted in 1918, no. 914.

Reviews: Gouttenoire, Bernard, "Matisse et le livre.' *L'Oeil* 382 (May 1987): 85.

New York 1987
Iliazd and the Illustrated Book
New York: Musuem of Modern Art, June 18-August 18, 1987.

Paris 1987
Henri Matisse, dessins et gravures (Matisse: Le rythme et la ligne)
Paris: École Nationale supérieure des beaux-arts, February 25-May 10, 1987.
Small fold-out catalogue-guide to the exhibition; the latter was the occasion for the commemorative volume, *Le rythme et la ligne,* by Jacqueline and Maurice Guillaud, no. 109, a luxury volume that also served as a kind of catalogue.

Review: Watkins, Nicholas. "Matisse," *Burlington Mag.* 129 (June 1987): 417-18. A review of the book (catalogue) as well as the exhibition.

Maîtres impressionnistes et modernes
Paris: Galerie Daniel Malingue, November 18-December 19, 1987.
Small catalogue with each work's provenance.

Stuttgart 1987
Henri Matisse, "Der Rucken"
Stuttgart: Neuerwerbung desr Staatsgalerie Stuttgart, 1987.
Small catalogue with text by Ina Conzen-Meairs.

Tokyo 1987
Les Chefs-d'oeuvre du Musée Matisse et les Matisses de Matisse
Tokyo: Isetan Museum of Art, Shinjuku, October 22-November 17, 1987; Yamaguchi: Prefectoral Museum of Art of Yamaguchi, November 20-December 27, 1987; Osaka: Daimaru Museum of Art, Shinsaibashi, January 3-February 18, 1988; Yokohama: Sogo Museum of Art, February 10-March 27, 1988.
Excellent catalogue (Tokyo: Art Life, 1987) edited by Norio Shimada, in French and Japanese; commentaries on the works by Xavier Girard

and Nicholas Watkins. Illustrations in color of works in Japanese
collections less often seen in the West.

Venice 1987
Henri Matisse: Matisse et l'Italie
Venice: Napoleonica and Museo Correr, place Saint-Marc, May 30-
October 18, 1987.
Catalogue with illustrations of all the works and full entries (exhibition
history, bibliography) by Tamara Préaud. Also four essays--by Pierre
Schneider (curator), no. 723, Attilio Codognato, no. 437, Xavier Girard
and Christian Arthaud, no. 532, and Giandomenico Romanelli , no.
704--that explore the role of Italy and Italian art on Matisse's work.

Review: Di Piero, W. S. "Matisse's Broken Circle." *New Criterion*
(May 1988): 25-35; Meyer, Laure. *L'Oeil* 386 (Summer 1987): 80;
Minola de Galliotti, M. *Goya* 202 (January-February, 1988): 238.

Yamanashi, Shirakaba, Kiyoharu 1987
Verve, hommage à Tériade
Yamanashi: Shirakaba, Kiyoharu, December 15, 1987-February 15,
1988; Yamaguchi: Municipal Museum, March 8-April 3, 1988;
Yokohama: Takshimaya Art Museum, April 21-May 3, 1988.

Andros 1988
Henri Matisse
Andros, Greece: Musée de l'art moderne (Foundation Basil and Elise
Goulandris), July 3-September 30, 1988.
Handsome catalogue by Kyriakos Koutsomallis in Greek and French.

Barcelona and Madrid 1988
*Henri Matisse: Pinturas y dibujos de los Museos Pushkin de Moscú y
el Ermitage de Leningrads*
Madrid: Ministerio de Cultura, Centro de Arte Reine Sofia; Barcelona:
Ajuntament de Barcelona, Museu Picasso, 1988.

Review: Socias Palau, J. *Goyá* 207 (November-December 1988): 173-
74.

Le Cateau-Cambresis 1988

Henri Matisse, autoportraits
Le Cateau-Cambresis: Musée Matisse, June 4-September 11, 1988.
Well-illustrated substantive catalogue with many seldom-seen drawings not in public collections. Substantive essay by John Klein on Matisse's self-portraits, "Matisse et l'autoportrait: Démarche individuelle et relation avec le public," no. 584.

Geneva 1988
Collection Heinz Berggruen
Geneva: Musée d'Art et d'Histoire, June 16-October 30, 1988.
Catalogue with texts by Gary Tinterow, "Heinz Berggruen Collectioneur," and John Rewald, "Les Cézanne de la Collection Berggruen;" full documentation and reproduction of all the works exhibited. Excellent chronology and bibliography of the gallery.

Jerusalem 1988
Monet to Matisse: Modern Masters from Private Swiss Collections
Jerusalem: Israel Museum, October 1988-January 1989.
Catalogue in English and Hebrew, edited by Stephanie Rachum.

Kaiserslautern and Regensburg 1988
Matisse und seine deutschen Schüler
Kaiserlautern: Pfalzgalerie Kaiserslautern, May 28-July 17, 1988;
Regensburg: Ostdeutsche Galerie, July 28-September 18, 1988.
Extensive, well-documented catalogue edited by Gisela Fiedler-Bender, Heinz Höfchen, and Wolfgang Stolte. The German students of Matisse are: Friedrich Ahlers-Hestermann, Otto Richard-Langer, Rudolph Levy, Marg and Oskar Moll, Franz Nölken, Hans Purrmann, Walter A. Rosam, and William Straube.

Review: Bauermeister, V. "Matisse und seine deutschen Schüler." *Kunstwerk* 41 (August 1988): 94-95; Meyer-Tönnesmannm, Carsten. "Drei Matisse-Schüler aus Hamburg." *Weltkunst* 58, 18 (September 15, 1988): 2604-06.

Liège 1988
Chefs d'oeuvre des Musées de Liège à Lausanne
Liège: Musée de l'art Wallon; Lausanne: Fondation de l'Hermitage, November 24-March 12, 1989.

Works from the Musée d'art moderne, Paris, and the Musée de l'art
Wallon in Liège, Belgium.

Review: Daulte, F. Review. *L'Oeil* 400 (November 1988): 58-65.

London 1988
Henri Matisse, Etchings, Lithographs, Linocuts, Aquatints and Illustrated Books
London: Waddington Galleries, September 28-October 22, 1988.

Henri Matisse: Sculpture, Dawings and Prints, 1904-1952
London: Lumley Cazalet, June 22-July 29, 1988.
Square-format catalogue with Matisse's *Dance I* reproduced on the
cover; four sculptures, nine drawings, thiry-seven prints all in superb
quality reproduction, fully documented.

Review: Burns, Guy. *Arts Rev.* 40, 1 (July 1, 1988): 446.

Lucerne 1988
Von Matisse bis Picasso: Hommage an Siegfried Rosengart
Lucerne: Kunstmuseum Luzern, June 19-September 11, 1988.

Important catalogue with substantive essays and many illlustrations;
see no. 1325 for a detailed description.

Review: Von Kageneck, C. "Von Matisse bis Picasso." *Kunstwerk*
41 (February 1989): 72-73.

Nantes, Nîmes, Saint-Etienne 1988-89
Henri Matisse, dessins: Collection du Musée Matisse
Nantes: Musée des Beaux-arts, December 22, 1988-January 22, 1989;
Nîmes: Musée des Beaux-arts, February 15-March 27, 1989; Saint-
Etienne: Musée d'Art Moderne, Summer 1989.
Important catalogue by Xavier Girard, Geneviève Monnier, and
Christian Arthaud, published as *Cahier Henri Matisse 6* (Paris:
Maeght, 1988), no. 236. A small paper-cover catalogue was also
produced as a bulletin (#10) from the Musée des Beaux-arts at Nîmes.

Review: "Matisse en Voyage." *Connaissance arts* 443 (January 1989):
123.

New York 1988

Prints of Henri Matisse
New York: Museum of Modern Art, Paul J. Sachs Gallery, August 6-
November 6, 1988.
Small catalogue by Riva Castleman and Diane Upright.

Paris 1988
Le Peintre et l'affiche de Lautrec à Warhol
Paris: Musée de l'affiche et de la publicité, March-April 1988; traveled
to five other venues in Europe.
Catalogue in French and English (Paris: Spadem-Adagp, 1988).

Les Années 50
Paris: Musée National d'Art Moderne, June 29-October 17, 1988.
Lavish, superbly documented catalogue.

Maîtres impressionistes et modernes
Paris: Galerie Daniel Malingue, November 10-December 24. 1988.
Catalogue.

San Francisco 1988
Decorative. . .
San Francisco: Iannetti-Lanzone Gallery, May 1987.

Review: Gregor, K. "The Decorative at Issue," *Artweek* 19 (June 4,
1988): 1.

Sydney 1988
Biennnale de Sydney
Sidney: Art Gallery of New South Wales, May 17-July 3, 1988;
Melbourne: National Gallery of Victoria, August 4-September 25,
1988.

Le Cateau-Cambrésis 1989
Matisse, fleurs, feuillages, dessins
Le Cateau-Cambrésis: Musée Matisse, July 8-September 30, 1989.
Catalogue with fine introduction by Isabelle Monod-Fontaine;
beautifully produced with photos by Helène Adant given to the museum
by Lydia Delectorskaya.

Reviews: Thomas, G. "Dessins de fleurs: Musée Matisse." *Oeil* 408-9 (August 1989): 88.

Cluny 1989
Matisse et l'heritage antique
Cluny: Écuries de Saint-Hugues, June 17-September 10, 1989.
Fold-out catalogue, carefully prepared by Brigitte Maurice, conservator of the museum.

Hamburg 1989
Das Café du Dôme und die Académie Matisse
Hamburg: Galereen Herold und Levy, January 1989.
Exhibition of some nine artists influenced by Matisse. The book of the same name by Thomas Levy and Carl-Jürgen Thomfor is detailed in no. 1385.

Hanover 1989
Das Buch des Künstlers: die schönsten Malerbücher aus der Sammlung der Herzog August Bibliothek Wolfenbüttel
Hanover: Kestner-Gesellschaft, April 18-July 16, 1989.
Fine catalogue by Harriet Watts.

L'Isle sur la Sorgue 1989
Henri Matisse dessins/ Cornelius Zitman, sculptures et dessins
L'Isle de la Sorgue: Musée Campredon, May 1989.
Small catalogue (Bern: Bentelli, 1989) with introduction by Pierre Schneider for an exhibition of drawings from the Dina Vierny collection; drawings from 1922-1947 handsomely reproduced.

London 1989
Henri Matisse, Edgar Degas
London: Waddington Galleries, June 21-July 15, 1989.
Catalogue of thirty-one portrait and figure studies by Matisse and ten sculptures in bronze by Degas; no text.

Important Works on Paper
London: Lefevre Gallery, June 26-July 28, 1989.
Catalogue, works mainly nineteenth and twentieth centuries.

Marcq-en-Baroeul 1989-1990
Gustave Moreau et ses élèves: Rouault, Matisse, Marquet, Manguin, et al
Marcq-en-Baroeul: Fondation Septentrion, October 22, 1989-January 28, 1990.
Slender, paperbound catalogue with major text by Geneviève Lacambre; preface by Dominique Paulette. Exhibition organized thematically; some valuable data gathered in the catalogue.

Munich 1989
Von Courbet bis Picasso: Schätze des Museums Sao Paulo
Munich: Villa Stück, March 15-May 28, 1989.
Substantial documented catalogue by Ettore Camesasca and Manfred Fath (Milan: Mazzotta, 1989).

New York 1989
Matisse, Drawings from 1915-1951
New York: Helen Serger/ La Boetie, Inc., October 26-December 16, 1989.
Well-documented and illustrated small catalogue with essay by Michael O'Brien; dedication to Pierre Matisse, recently deceased. Reproduction of unusual pencil portrait of Pierre Matisse by his father.

Review: Perl, Jed. *New Criterion* 8 (March 1989): 60-61.

Twentieth Century Modern Masters: The Jacques and Natasha Gelman Collection
New York: Metropolitan Museum of Art, December 12, 1989-April 1, 1990.
Handsome catalogue edited by William Lieberman, no. 1294, with important essay by Pierre Schneider on Matisse's fauve *Sailor II* of 1906, no. 935.

Paris 1989
Oeuvres de Matisse
Paris: Musee National d'Art Moderne, May 24-August 27, 1989.
Exhibition on the occasion of the publication of Isabelle Monod-Fontaine's revised and enlarged catalogue of the museum's collection of Matisse, *Matisse: Oeuvres de Henri Matisse du Musée national d'art moderne*, no. 140.

Reviews: Monnier, G. "La Joie et la science: Matisse et les arts graphiques." *Connaissance arts* 449-450 (July-August 1989): 80-87; "Ligne complète." *Connaissance arts* 448 (June 1989): 9.

Philadelphia 1989
Masterpieces of Impressionism and Post-Impressionism: The Annenberg Collection
Philadelphia: Philadelphia Museum of Art, May 21-June 1989; Washington, D. C.: National Gallery of Art, Summer 1990; Los Angeles: Los Angeles County Museum of Art, August 16-November 4, 1990.
Well-produced catalogue with texts by Colin B. Bailey, Joseph J. Rishel, and Mark Rosenthal.

Rome 1989
Magnificat: La Grande arte e il religioso oggi: Omaggio à Paulo VI
Rome: Chiatro Nord della Basilica di Sant'Eustorgio, December 2, 1989-February 1990.
Works from the Vatican collection; catalogue by curator Giorgio Mascherpa, texts by Paul VI and, on contemporary art, by Mascherpa.

Saint-Paul-de-Vence 1989
L'Oeuvre ultime, de Cézanne à Dubuffet
Saint-Paul-de-Vence: Fondation Maeght, July 4-October 4, 1989.
Catalogue with preface by Jean-Louis Prat.

San Francisco 1989
Matisse: Works from Bay Area Collectors
San Francisco: San Francisco Museum of Modern Art, 1989.
Small four-fold single-sheet brochure with color illustrations of four paintings, three black and whites of drawing and sculpture; John Lane introduction with historical commentary on works in the show.

Valence 1989
Henri Matisse, l'art du livre
Valence: Centre de Recherche et d'action culturelle, November 12, 1989-January 23, 1990.
Catalogue originally used in Nice in 1986 (Cahiers Henri Matisse 3), no. 235, used for this show.

Bern 1990-91
Henri Matisse 1869-1954: Skulpturen und Druckgraphik-Sculptures et Gravures
Bern: Kunstmuseum Berne, November 30, 1990-February 10, 1991.
Catalogue essays by Xavier Girard, "La sculpture de Henri Matisse: échanges et transpositions," and by Sandor Kuthy, "Le Gravure de Henri Matisse: la traduction directe et la plus pure de son émotion." Works are richly illustrated and described but without other documentation. Texts in French and German.

Le Cateau-Cambrésis 1990
Matisse: Les Platres originaux des bas reliefs Dos I, II, III, IV
Le Cateau-Cambrésis: Musée Matisse, July 1990.
Important catalogue by Dominique Szymusiak and Isabelle Monod-Fontaine; the original plaster versions of the four *Backs,* recently given to the Museum, beautifully reproduced. See no. 987 for fuller description of catalogue.

Colmar 1990
Collages: collections de musées de provinces
Colmar: Musée d'Unterlinden, June 30-September, 1990; Villeneuve d'Ascq: Musée d'art moderne du nord, September 1990-April 1991.
A fine catalogue with a number of essays: Germain Viatte on "Notre avenir est dans l'air," Irène Elbaz on "Les Premiers collages, les premiers papiers collés," Sylvie Lecoq-Raymond on "Le Collage dadaïste ou la peinture contestée," Marc Borman on "Aspects du collage dans les années soixante," and Joëlle Pijaudier on "Années 80."

Libourne 1990
La Tapisserie et les maîtres de l'art au XXe siècle
Libourne: Musée des Beaux-arts et d'archéologie, August 4-October 19, 1990.
Matisse's *Le Ciel* the only one of his works exhibited.

London 1990
Henri Matisse, The Lithographs, 1913-1930
London: Waddington Galleries, 1990.
Very beautifully produced catalogue with excellent reproductions of all thirty-one documented works; no text.

*On Classic Ground: Picasso, Léger, De Chirico, and the New
Classicism 1910-1930*
London: Tate Gallery, June 6-September 2, 1990.
Important, well-documented catalogue edited by Elizabeth Cowling and
Jennifer Mundy; a major publication on the theme of the "return to
classicism" during these decades.

Review: Snell, Robert. "A Dialogue with Tradition (Early Modernist
Art, Tate Gallery)." *Times Lit. Supp.* 4551 (June 22, 1990): 669.

Los Angeles, New York, and London 1990-91
The Fauve Landscape
Los Angeles: Los Angeles County Museum of Art, October 4-
December 30, 1990; New York: Metropolitan Museum of Art,
February 19-May 5, 1991; London: Royal Academy of Arts, June 10-
September 1, 1991.
Sumptuous, well-documented catalogue by Judi Freeman with
contributions by Roger Benjamin, no. 1200, John Klein, James D.
Herbert, no. 1236, and Alvin Martin. See no. 1179 for a complete
description of the catalogue.

Reviews: Dudar, Helen. "In Turn-of-the-Century Paris, An Explosion
of Brash New Art." *Smithsonian* (1990); Flam, Jack D. "Taming the
Beasts." *New York Rev. Books* (April 25, 1991): 40-42; Julius,
Muriel. "Fauvism and the Supremacy of Color [London venue]."
Contemporary Rev. 259 (August 1991): 93-97; Kramer, Hilton.
"Fauvism sans Matisse." *Modern Painters* 4, 2 (Summer 1991): 18-21;
Philips, J. "The Fauve Landscape (Metropolitan Museum of Art; Travel
Exhibition)." *American Artist* 55 (October 1991); Pissarro, J. "The
Fauve Landscape, Metropolitan Museum of Art [Traveling Exhibit]."
Burlington Mag. 133 (February 1991): 144-46; Thomson, Richard.
"Young Man's Painting." *Times Lit. Supp.* (June 28, 1991): 16;
"Biggest Matisse Ever [Museum of Modern Art, New York, Exhibit]."
Connoisseur 221 (February 1991): 33.

New York 1990
Matisse Drawings
New York: La Boetie, February 1990.

Review: Perl, Jed. Review. *New Criterion* 8 (March 1990): 60-61.

Gifts of Associates: 1975-1990
New York: Museum of Modern Art, November 27, 1990-February 19, 1991.
Catalogue with text by Riva Castleman; gifts are all prints.

Paris 1990
De Manet à Matisse: sept ans d'enrichissements au Musée d'Orsay
Paris: Musée d'Orsay, December 1990.

Review: Bouyeure, C. "De Manet à Matisse: sept ans d'enrichissements au Musée d'Orsay." *Oeil* 425 (December 1990): 72-79.

Tokyo 1990
Masterworks: Paintings from the Bridgestone Museum of Art
Tokyo: Bridgestone Museum of Art, 1990.
Catalogue with text by Yasuo Kamon.

Vence 1990
Henri Matisse: hommage de la ville de Vence
Vence: Centre Culturel de Vence (henceforth the Centre Culturel Henri Matisse), July 6-28, 1990. (One tapestry, five engravings, eleven books, six posters, twenty photos.)
Small handsome catalogue of photographs of the artist at Vence, the Chapel of the Rosary, and drawings made in Vence, with prefaces by Christian Iacono (Mayor of Vence) and Zia Mirabdolbaghi (Director of Cultural Affairs); major text by Xavier Girard. Matisse's *Le Ciel* lithographed on cover.

Washington 1990
Matisse in Morocco, The Paintings and Drawings, 1912-1913
Washington, D. C., National Gallery of Art, March 18-June 3, 1990; New York: The Museum of Modern Art, June 20-September 4, 1990; Moscow: State Pushkin Museum of Fine Arts, September 28-November 20, 1990; St. Petersburg: State Hermitage Museum, December 15, 1990-February 5, 1991.
Catalogue, no. 70, with important essays by Pierre Schneider, no. 724, Jack Cowart, no. 1031, John Elderfield, no. 488, Albert Kostenevich, no. 1335; complete scholarly catalogue entries (paintings) and documentation by Laura Coyle and Beatrice Kernan. (Washington

and New York: National Gallery of Art and Abrams, 1990. Trans by
Anne Michel, except for essays by Pierre Schneider and John Elderfield.
French ed: *Matisse au Maroc, Peintures et Dessins, 1912-13,* Paris:
Adam Biro, 1990), no. 70. A slim paper-bound catalogue with text in
Russian also appeared in l990; good color reproductions.

Reviews: "Aux Couleurs de Tanger [National Gallery of Art, traveling
exhibit]." *Connaissance arts* 457 (March 1990): 21; Benjamin, Roger.
"Matisse in Morocco: a Colonizing Esthetic?" *Art in America* 78
(November 1990): 156-65+; Bernier, Rosamond. "Travels with
Matisse." *House and Garden* (March 1990): 162-67+; Bryson,
Norman. *Times Literary Supp.* 4554 (July 13-19, 1990): 749; Händler,
Ruth. "Visionen vom iridischen glück." *Art: das Kunstmagazin* 7
(1990): 82-9; Hughes, Robert. "A Domain of Light and Color:
Morocco's Impact on Matisse Is Traced in a Radiant Show." *Time*
136, 1 (July 2, 1990): 53-54; "Matisse in Morocco: the Paintings and
Drawings 1912-1913." *Drawing* 11 (March-April 1990): 131-32;
Meyer, L. "Matisse au Maroc [Museum of Modern Art]." *Oeil* 420
(July-August 1990): 113; Perl, Jed, and André L. Talley. "Matisse's
Eastern Eden." *Vogue* 180, 3 (March 1990): 430-45; Plagens, Peter.
"Bright Light of Tangiers." *Newsweek* 115, 13 (March 26, 1990): 50-
51; Watson, Nicolas. *Burlington Mag.* 133, 1054 (June 1991): 43-43;
Wilkin, K. "Matisse in Morocco." *New Criterion* 8 (June l990): 30-
36.

Boston 1991
Matisse, Picasso, and Impressionist Masters from the Cone Collection
Boston: Boston Museum of Fine Arts, October 2, 1991-January 19,
1992.

Canberra 1991
Manet to Matisse, French Illustrated Book
Canberra, Australia: Australia National Gallery, 1991.
Catalogue by Christine Dixon and Cathy Leaky.

Dijon 1991
Les Chefs-d'oeuvre du Musée Matisse de Nice
Dijon: Musée des Beaux-Arts, July 6-October 6, 1991.
Catalogue by Xavier Girard (Cahiers Henri Matisse 7), handsomely
illustrating a rich selection of oils, bronzes, drawings, prints, as well as

other books and objects from the collection, especially its wealth of material related to the Chapel at Vence. The extended essays by Girard interpret the works in broad thematic and stylistic contexts; the works are fully documented in provenance, exhibition history, and bibliography, no. 96.

Jerusalem 1991
Matisse at the Ballet: Le Chant du Rossignol
Jerusalem: Israel Museum, Fall 1991.
Small but well-illustrated and informative catalogue by curator, Vivienne Barsky, in English and Hebrew; the definitive work on this ballet, no. 1055.

Nagoya 1991
Henri Matisse Retrospective [Machisu ten]
Nagoya: Nagoya City Art Museum, the Chunichi Shimbum, August 24-September 29, 1991; Hiroshima: Hiroshima Musuem of Art, October 5-November 4, 1991; Kasama: Nishido Museum, November 9-December 8, 1991.
Handsome catalogue with colored plates of an exhibition drawn from the Hermitage Museum (twenty-five selected oils and fourteen drawings) and from American, European, and Japanese collections (seventy-two other works.) Essays in English and Japanese include: "Henri Matisse and the Russian Collectors," by Albert Kostenevich, "Matisse in Russia in the Autumn of 1911," Y. A. Russakov, and "Matisse, 1908, *The Red Room [Harmony in Red]*," by the curator and editor of the catalogue, Katsunori Fukaya.

Review: *Oeil* 438 (January-February 1992): 89.

Saarbrücken 1991
Henri Matisse: Zeichnungen und Skulpturen
Saarbrücken: Saarland Museum, May 12- July 7, 1991. (Forty-nine bronzes, 180 drawings, 142 lithographs, etchings, and aquatints, fifteen book and multiple contributions to the editions, serigraphs, tapestries, ceramics, and maquettes for the chapel at Vence.)
Handsome, carefully-produced catalogue, edited and with a sensitive general introduction by Ernst-Gerhard Güse, good quality reproductions of all works exhibited, and commentaries on about one-third of the drawings (thirty-five out of ninety-seven) by Xavier Girard, Christian

Arthaud, and Ernst-Gerhard Güse, and over half of the sculptures (twenty-three out of forty-one) by Ernst W. Uthemann; each work given scholarly historical and bibliographic documentation. Drawings from the Musée Matisse in Nice have notes reproduced from *Henri Matisse, Dessins, Collection du Musée* (Cahiers Henri Matisse 6), 1988, no. 236. Abridged English edition, *Matisse, Drawing and Sculpture,* Munich: Prestel Verlag, 1991, trans. by John Ormrod with Ian Taylor, no. 237.

Basel 1992
transFORM: PictureObjectSculpture in the 20th century
Basel: Kunstmuseum and Kunsthalle, June 14-September 17, 1992.
(Matisse's *Blue Nude, the Frog* was shown.)

Review: *Flash Art* 165 (Summer 1992): 69.

Le Cateau-Cambrésis, Cambrai, Tourcoing, etc. 1992
De Matisse à aujourd'hui, la sculpture du XXe siècle dans les Musées et du Fonds Régional d'art contemporain du Nord-Pas-de-Calais
Le Cateau-Cambrésis: Musée Matisse et Cambrai: Musée des Beaux-Arts, February 15-April 26, 1992; Tourcoing: Musée des Beaux Arts, May 8-June 28, 1992; Calais: Musée des Beaux-Arts et Dunkerque: Musée d'Art Contemporain et Musée des Beaux-Arts, July 10-September 14, 1992; Arras: Musée des Beaux-Arts, late September-through October, 1992.
Exhibition in several parts: "Du Renouvellement à la continuité de la tradition, 1900-1920," "Sculpture comme attitude," and "Sculpture anglais." Well-illustrated and documented catalogue by Jean Etienne Grislain with texts by Patrick Le Nouëne and an important essay by Roger Benjamin, "L'Arabesque dans la modernité, Henri Matisse sculpteur," no. 183, with a list of all sculptures by Matisse exhibited in Paris and principal foreign exhibitions from 1904-1913.

Review: Nouëne, P. "De Matisse à aujourd'hui, la sculpture du XXe siècle dans les Musées et le Fonds Régional d'art contemporain du Nord-Pas-de-Calais." *Rev. du Louvre* 42 (April 1992): 127-8; *Connaissance arts* 481 (March 1992): 20.

Le Cateau-Cambrésis 1992

Matisse et Baudelaire
Le Cateau-Cambrésis: Musée Matisse, June 27-September 1992.
Handsome catalogue edited by Dominique Szymusiak.

Review: Giovannoni, L. "Matisse et Baudelaire." *Rev. du Louvre* 42
(June 1992): 97-98.

Grasse 1992
Matisse, comme dans les dahlias
Grasse: Villa Fragonard, July 27-September 30, 1992.
Catalogue is *Cahiers Henri Matisse 9* in the beautifully produced series
published by Xavier Girard of the Musée Matisse. Curator of this
exhibit which features works that contain flowers, Girard is the author
of two short essays in the catalogue, "Comme dans les dahlias, II" and
"Le mystère de la chambre claire." The third brief essay is "Trouver la
joie dans les arbres," by Christian Arthaud.

London 1992-94
Matisse, the Inuit Face [Matisse, Visage inuit]
London: Canada House, October 16, 1992-February 26, 1993;
Washington, D. C.: Canadian Embassy, March 21-June 11, 1993;
Calgary: Glenbow Museum, June 26-August 14, 1993; Musée de
Québec, November 10, 1993-January 9, 1994; Art Gallery of Nova
Scotia, January 22-April 3, 1994; Winnipeg Art Gallery, April 24-June
19, 1994.
An exhibition of all known drawings and prints--charcoal, pencil,
aquatint, lithographs--made by Matisse from a collection of Inuit masks
belonging to Georges Duthuit. From the Matisse Archives and the
collection of Jean-Paul Riopelle, the works are reproduced in a fine
catalogue with foreword by Michael Regan, curator of the show,
assisted by Patricia Anderson; short text by Claude Duthuit, and a
splendid essay, "Surrealism, Structuralism and the French Collecting of
American Ethnography" by J. C. H. King, Museum of Mankind.

Martigny 1992
De Goya à Matisse, estampes de la collection Jacques Doucet
Martigny: Donation Pierre Gianadda, March 14-June 8, 1992.
A handsome and well-documented catalogue.

Review: *Domus* 739 (June 1992): xvi.

Nagoya, Kyoto, Tokyo 1992-3
Fauvism and Modern Japanese Painting [Fovisumu to nihon kindai yōga]. Nagoya: Aichi Prefectural Museum of Art, October 30-December 20, 1992; Kyoto: National Museum of Modern Art, January 5-February 14, 1993; Tokyo: National Museum of Modern Art, February 24-March 28, 1993.

Richly produced and fully documented catalogue, with essays in Japanese and English (Monod-Fontaine essay in Fench). Tokyo: Shinbun, 1992. The essays include: Roland Pickvance, "Post-Impressionism, Van Gogh, and Fauvism"; Isabelle Monod-Fontaine, "Matisse's Fauvist Painting;" and Toru Asano, "Fauvism and Modern Japanese Painting --The Roles Played by Yori Saito and Kotaro Takamura." See no. 1177 for a fuller discussion of the essays.

New York 1992
Henri Matisse, A Retrospective
New York: Museum of Modern Art, September 24, 1992-January 12 (19),1993. Exhibit was extended one week.
Large, important catalogue by John Elderfield with Beatrice Kernan; all works illustrated in color, substantive new chronology of the artist's life by Judith Cousins, and an important essay, "Describing Matisse," by Elderfield. See no. 79 for a complete description of this catalogue.

Reviews: Alexander, Max. "Matisse Sizzles at Red-Hot MOMA." *Variety* 349, 12 (January 18, 1993): 1-2; Barringer, Felicity. "Matisse: 'He's Kind of Cast a Spell on Me.'" *Art News* 92, 4 (April 1993): 150; Bernier, Rosamond. "An Insider's Glimpse." *Newsweek*, September 28, 1992: 44; Cembalist, Robin. "Just Wild About Henri." *Art News* 92 (February 1993): 41-42; "Colorful Seducer." *Economist* 325, 7779 (October 3, 1993): 94; Crisp, George. Review. *Arts Rev.* 44 (November 1992): 545-6, back cover; Danto, Arthur. "Henri Matisse." *The Nation* 255, 15 (November 9, 1992): 553-56; *Drawing* 14 (September / October 1992): 58-59; Dubner, Stephen. "MoMA Splashes a Once-in-a-Lifetime Matisse Extravaganza Across Its Walls." *New York* 25, 36 (September 14, 1992): 66-67 and cover; "Exhibition of the Year: Henri Matisse, a Retrospective." *Apollo* 136 (December 1992): 349; Feaver, William. "Saint Modern Art." *Art News* 91 (October 1992): 108-13; Flam, Jack. "Passions of Matisse." *New York Rev. Books*, November 5, 1992: 28-32; Fraser, Kennedy. "Matisse

and His Women." *Vogue* 182, 9 (September 1992): 544; Gardner, James. "Homeboys of the Bourgeoisie [Matisse and Magritte]." *National Rev.* 44, 21 (November 2, 1992): 64-65; Golding, John. "New York, Henri Matisse: A Retrospective." *Burlington Mag.* 134, 10077 (December 1992): 833-36; Gopnik, Adam. "The Unnatural." *New Yorker* 68, 34 (October 12, 1992): 106-113; Heron, Patrick. "Late Matisse." *Modern Painters* 6, 1 (Spring 1993): 10-19; Robert Hughes, "Matisse: The Color of Genius." *Time*, September 28, 1992: 67-69; Kimmelman, Michael. "A Matisse Encore with Picasso for Just a Week." *New York Times, Living Arts* 142 (January 22, 1993): B6, C12; Kramer, Hilton. "Reflections on Matisse." *New Criterion* 11 (November 1992): 4-7; Larson, Kay. "This Side of Paradise." *New York* 25, 39 (October 5, 1992): 105-06; Larson, Kay. "The Name Game [Lothar Baumgarten , Guggenheim; Henri Matisse, MoMA]." *New York* 26, 7 (February 15, 1993): 108-09; Lyon, Christopher. "Seeing Matisse Whole." *MoMA Members Quart.* 13 (Fall 1992): 2-12 [group interview with Catherine Bock-Weiss, Yve-Alain Bois, Jack Flam, John Neff, and William Tucker with Elderfield's catalogue essay as point of departure]; Madoff, Steven H. "Matisse: Imagining Paradise." *Art News* 91, 10 (December 1993): 107-08; "A Matisse Collage." *Art and Antiques* 9, 8 (October 1992): 66-73; "Matisse: Creativity and Experimentation." *USA Today* 121, 2572 (January 1993): 20-27; "Matisse, The Year Starts Here." *Mirabella* (September 1992): 58-61; McLean, Alison, "Matisse: A Rare Look." *Smithsonian* 23, 7 (October 1992): 48-53; Nochlin, Linda. "'Matisse' and Its Other [Russian Avant-Garde at Guggenheim]." *Art in America* 81, 5 (May 1993): 88-97; Perl, Jed. "Blockbusting Matisse." *Salmagundi* 97 (Winter 1993): 10-20; Phillips, Jonathan. "Matisse: Master of Color." *American Artist* 47, 612 (July 1993): 20-29; Pissarro, J. "Henri Matisse: A Retrospective." *Apollo* 736, 370 (December 1992); Peter Plagens. "The Most Beautiful Show in the World." *Newsweek* (September 28, 1992): 40-47; Raver, Anne. "Where the Plants Are as Indolent as Odalisques." *New York Times* 142, B5, C7; Rosenblum, Robert, Peter Schjeldahl, Brook Adams, Lynne Tillman, Francis M. Naumann, Jeff Perrone, Kenneth Silver, Richard Hennessey, et al. "Matisse: A Symposium." *Art in America* 81, 5 (May 1993): 74-87; Russell, John. "Matisse au MoMA." *Connaissance arts* 487 (September 1992): 76-82+; Wilkin, Karen. "Matisse at MoMA." *Partisan Rev.* 60, 1 (Winter 1993): 78-94; idem, "After the

Retrospective: Matisse and Picasso." *Hudson Rev.* 46 (Spring 1993):195-200; Zerner, Henri. "Matisse and the Colors of Light." *Times Lit. Supp.* 4677 (November 20, 1992): 13-14.

Nice 1992
Donation Marie Matisse
Nice: Galerie des Ponchettes, Summer 1992.

Nîmes 1992
Henri Matisse: sculptures et gravures
Nîmes: Musée des Beaux-Arts, Summer 1992.

Oberlin 1992
The Living Object: Art Collection of Ellen H. Johnson
Oberlin, Ohio: Allen Memorial Art Museum of Oberlin College, 1992.

Review: Brown, E. A. "The Living Object, collection of Ellen H. Johnson." *Bull. Allen Memorial Art Mus.* 45, 1-2 (1992): 75.

Paris 1992
La Dation Pierre Matisse
Paris: Musée National d'Art Moderne, June 18-September 13, 1992. Handsome informational catalogue with essay, "Pierre Matisse, compagnon en route," by Pierre Schneider.

Review: Burns, Guy, "Letter from Paris." *Arts Rev.* 44, 9 (September 1992): 413; Monod-Fontaine, I. "Dation: Oeuvres provenant de la collection Pierre Matisse (attribué à differents institutions de province)." *Rev. du Louvre* 42 (April 1992): 19-29; Picard, D. "Manifeste, à quelle fin?" *Connaissance arts* 485-86 (July-August 1992): 86.

Bahnhof Rolandseck 1993
Pflanzenwelten-Blütenträume: Ellsworth Kelly, Paul Klee, Henri Matisse.
Bahnhof Rolandseck: Stiftung Hans Arp und Sophie Täuber-Arp October 23, 1993-January 2, 1994.
Catalogue, beautifully produced and illustrated, by Siegfried Gohr; thirteen Matisse works.

Cannes 1993

Matisse, La Danse
Cannes: La Malmaison, January-March 1993.
A very handsone catalogue (Cahiers Henri Matisse, 10) by Xavier
Girard on the studies for the Barnes Foundation Mural. These include
paintings, drawings, cut-paper designs, and sculpture, no. 1145.
Girard's essay is both informative and poetic and deals with the works
in the exhibition in a general way, dealing above all with the artist's
love of the theme of the dance.

Le Cateau-Cambrésis 1993
Matisse, sculptures-dessins, dialogue
Le Cateau-Cambrésis: Musée Matisse, November 6, 1993-February 6,
1994.
A handsome catalogue of an exhibition that pairs individual sculptures
with their pertinent drawings, creating between them the dialogue of the
title that offers surprising and rewarding affinities. A sensitive
introductory essay by Dominique Szysmusiak; illustrations are large
and beautifully reproduced--each work is given documentation by
Laurent Giovannoni, one of the show's organizers. An exhibition that
offers a fascinating meditation on the rapport between Matisse's graphic
and sculptural thinking.

Review: "Matisse: Sculptures-Dessins, dialogue." *Cimaise* 227
(November-December 1993): 54; Review. *Rev. du Louvre* 43 (June
1993): 101; Rose, Matthew. "No Wait at Musée Matisse in Cateau-
Cambrésis," *Art & Antiques* (January 1994): 15.

Compiegne 1993
Tisserands de légende: Chanel et le tissage en Picardie
Compiegne: Abbaye de Royallieu, December 1993.
An exhibit that celebrates both the work of Coco Chanel and the
weaving industry in Picardy, the northern region of France from which
Matisse's family came. It was the weavers of Matisse's native region
who supplied the luxury fashion and home decoration industries with
woven and patterned fabrics. Among other essays in this small, but
richly produced, catalogue is Hilary Spurling's informative "Henri
Matisse et les tisseurs de Bohain," no. 355.

Copenhagen 1993

Matisse. Kapellet i Vence
Copenhagen: Ordrupgaard Museum, 1993.
An extremely well-documented and beautifully produced catalogue in
Danish and English, edited by Hanne Finsen with Mikael Wivel, for an
exhibition unusually rich in materials pertaining to the gestation,
flowering, and final realization of the Chapel of the Rosary at Vence.
Over one-hundred items, many from the Musée Matisse, but others
from private collections and other museums, are reproduced and
documented, using letters and sketchbooks as well as published sources,
no. 1069.

Review: Fonsmark, Anne-Birgitte. "Matisse in Denmark, The Chapel
at Vence." *Apollo* 138 (October 1993): 258.

Minneapolis 1993
Minnesota Celebrates Matisse
Minneapolis: Minneapolis Institute of Arts, October 10, 1993-January
9, 1994.
Small, handsome catalogue by George Keyes with Patrick Shaw Cable;
general essay by Keyes. Works in all media from Minnesota
collections.

New York 1993
Homage to Matisse
New York: Sidney Janis Gallery, Summer 1993.

Revue: Pinchbeck, Daniel. "Homage to Matisse, Sidney Janis Gallery,"
Art & Antiques 15 (Summer 1993): 27.

Henri Matisse, illustrated books
New York: La Boetie, October 1993.
Elizabeth Phillips and Monica Strauss, curators.

Review: Perle, Jed. "Booked." *New Criterion* 11 (May 1993): 37-43.

Nice 1993
Matisse--Paintings, Stage Scenes, Costumes and Accessories
Nice: Musée Matisse, July to August 1993.

Review: "Matisse à Nouveau" [on the reopening of the museum in its
renovated building], *Connaissance arts* 497 (July-August 1993): 8. A

special issue of *Connaissance arts* was also published to highlight the reopening.

Exposition Dossier III: Window in Tahiti, Fauteuil rocaille et Chapel at Vence; Exposition contemporain I-Claude Viallat, Pierre Buiraglio: Vatiations on Window in Tahiti, Fauteuil rocaille et *Chapelle de Vence* Nice: Musée Matisse, September-November 1993.

Matisse: L'Enlèvement d'Europe Nice: Musée Matisse, December 1993.

Paris 1993
Henri Matisse, 1904-1917
Paris: Centre Georges Pompidou, February 25-June 21, 1993.
Substantive, richly illustrated catalogue by Dominique Fourcade and Isabelle Monod-Fontaine, curators of the exhibition. An important essay by Yve-Alain Bois, "L'Aveuglement," no. 403, is followed by a detailed chronology, based on new documentation of the years in question, by Monod-Fontaine and Claude Laugier. Fourcade and Eric de Chassey have also assembled an "Anthologie," a valuable selection of critical comments and writings--often rare--from the period, concerning the works in the exhibition.

Review: Daix, Pierre. Matisse." *Connaisance arts* 492 (February 1993): 24-33; Girard, Xavier. "Matisse, L'Espace de la couleur." *Beaux-Arts Mag.* 110 (March 1993): 54-75; Review. *Rev. du Louvre* 43 (February 1993): 108-9.

Autour d'un chef-d'oeuvre de Matisse; Les Trois versions de la Danse Barnes (1930-33)
Paris: Musée d'Art Moderne de la Ville de Paris, November 18, 1993-March 6, 1994; traveled to Philadelpha: Philadelphia Museum of Art, April-June 12, 1994.
Handsome catalogue that reprints Jack Flam's essay on the three versions of *Dance,* no. 1143, with contributions by Pierre Schneider, Xavier Girard, Laurence Louppe, Jackie Monnier Matisse, and Germain Viatte. Dominique Gagneux provides a conservation report and Jacqueline Munck details the history of the Paris version's acquisition and its exhibition history. See no. 1137 for a complete description of the catalogue.

Review: de Chassy, Eric. " La Danse à Trois Temps." *Beaux-Arts Mag.* 110 (December 1993): 84-9; Shone, Richard. "Paris: L'Hiver de l'Amour; Matisse," *Burlington Mag.* 136 (April 1994): 256-57.

Saint Louis 1993

Matisse, Image Into Sign
Saint Louis: The Saint Louis Art Museum, February 19-April 25, 1993.
Slim full-color catalogue af all twenty-five paintings and paper cutouts exhibited; substantial text, "Image into Sign," by Jack Flam, the show's curator, no. 507. Of the works exhibited--primarily from the 1930s and 1940s--five important paintings and three drawings were loaned from the Musée National d'Art Moderne in Paris.

Stuttgart 1993

Henri Matisse: Zeichnungen und gouaches découpées
Stuttgart: Staatsgalerie Stuttgart, December 11, 1993-Febrary 20, 1994.
Large elegant catalogue edited by Ulrike Gauss, curator, with contributions--by Lydia Delectorskaya, no. 1045, Xavier Girard, no. 1048, Jack Flam, no. 1047, Ortrud Dreyer, no. 269, Richard Hennessey, no. 332, and Andreas Stolzenburg, no. 1028--that revolve primarily around the series *Thèmes et variations* and *Jazz.* Text in German, also in French or English when either was the original language of the essay.

Vence 1993

Chapelle du Rosaire, 1948-51: études
Vence: Chateau de Villeneuve, Summer 1993.

Washington, D.C. 1993

Great French Paintings from the Barnes Collection
Washington: National Gallery of Art, May -August 15, 1993; Paris: Centre Georges Pompidou, September 1993-January 2, 1994; Tokyo: ; Philadephia: Philadelphia Museum of Art, 1994.
Catalogue, published by Alfred A. Knopf in association with Lincoln University Press, on the impressionist, post-impressionist and early modern works from the Barnes Foundation Collection, that serves for the international exhibition with all its venues. Essays by Richard K. Wattenmaker, "Dr. Albert C. Barnes and the Barnes Foundation," and

Anne Distel, "Dr. Barnes in Paris," precede entries by distinguished scholars on paintings by, among others, Manet, Renoir, Monet, Gauguin, Cézanne, Picasso, Soutine, and, of course, Henri Matisse. Jack Flam writes substantive entries on the important works by Matisse in the Barnes Collection including *The Joy of Life (Bonheur de Vivre), The Red Madras Headdress, Interior with Goldfish, Seated Riffian, The Three Sisters Triptych, The French Window at Nice,* and *The Dance Mural,* no. 1142, among others. Flam brings his formidable knowledge and the latest documentation to bear on these paintings, which are for the first time reproduced in quality color plates--a major concession which overturns Dr. Barnes' longstanding interdiction on color reproductions of his paintings. This is a publication of highest importance on a major body of important, long-sequestered Matisse works, no. 1278.

Review: Editorial. *Burlington Mag.* 135, 1083 (June 1993): 379; Kimball, Roger. "Betraying a Legacy: the Case of the Barnes Foundation." *New Criterion* (June 1993): 9-13; *Philadelphia Mus. of Art Bull.* 89 (Winter-Spring 1994): 16, 21; [Paris venue] Lloyd, Jill. "Pennsylvania Station in Paris." *Times Lit. Supp.* (October 1, 1993): 17.

Le Cateau-Cambrésis 1994
Henri Matisse, sculpures, dessins, les années Fauve
Le Cateau-Cambrésis: Musée Matisse, Autumn 1994-February 1995. (Seventy works.)

Review: Rose, Matthew. "No Wait at Musée Matisse in Cateau-Cambrésis," *Arts & Antiques* (January 1994): 15.

Liverpool and London 1994-5
Venus Redefined: Sculpture by Rodin, Matisse, and Contemporaries
Liverpool: Tate Gallery, Liverpool, 1994-5
Exhibition of modern sculpture using themes related to Venus; compiled and edited by Judith Nesbitt.

Philadelphia 1994
The Dance and Fifty Studies
Phildelphia: Philadelphia Museum of Art, April-June 12, 1994.

A modified version of the exhibition of the three versions of *The Dance*, which first were exhibited in Paris in 1993-4.

Brisbane, Canberra, Melbourne 1995
Henri Matisse
Brisbane: Queensland Art Gallery, March 29-May 16, 1995; Canberra: National Gallery of Australia, May 27-July 9, 1995; Melbourne: National Gallery of Victoria, July 19-September 23, 1995.
The first full-scale retrospective exhibition of Matisse in Australia; in all media, with an ambitious, well-illustrated catalogue (Brisbane: Queensland Art Gallery and Art Exhibitions Australia, 1995) edited by Caroline Turner and Roger Benjamin. Important essays contributed by Roger Benjamin, nos. 389 and 390, Yve-Alain Bois, no. 1138, John Elderfield, no. 272, Jack Flam, no. 318, Xavier Girard, no. 1094, Anne Kirker, no. 285, John Klein and Elizabeth Childs, no. 731, Laurie J. Monahan, no. 840, Isabelle Monod-Fontaine, no. 650, Richard Shiff, no. 731, and Caroline Turner, no. 220, are included.

Index of Authors

Numbers in index refer to entry numbers

Index of Subjects and Themes

Numbers in index refer to entry numbers

Index of Artworks
Titles in French
Numbers in index refer to entry numbers

Titles in English